TRANSMEDIA FRICTIONS

TRANSMEDIA FRICTIONS

The Digital, the Arts, and the Humanities

EDITED BY

Marsha Kinder and Tara McPherson

UNIVERSITY OF CALIFORNIA PRESS

University of California Press, one of the most distinguished university presses in the United States, enriches lives around the world by advancing scholarship in the humanities, social sciences, and natural sciences. Its activities are supported by the UC Press Foundation and by philanthropic contributions from individuals and institutions. For more information, visit www.ucpress.edu.

University of California Press
Oakland, CA

Cataloguing-in-Publication Data on file at the Library of Congress.
ISBN 978-0-520-28185-1 (cloth)
ISBN 978-0-520-95769-5 (ebook)

Manufactured in the United States of America

23 22 21 20 19 18 17 16 15 14
10 9 8 7 6 5 4 3 2 1

The paper used in this publication meets the minimum requirements of ANSI/NISO Z39.48–1992 (R 2002) (*Permanence of Paper*).

Cover image: From *Tracing the Decay of Fiction: Encounters with a Film by Pat O'Neill* (2002). Image courtesy of Pat O'Neill and The Labyrinth Project.

We dedicate this volume to all those who have created new demands by working at the pressure point between theory and practice—not only those historic filmmakers like Eisenstein, Vertov, and Deren whose experimentation we are still mining for theoretical implications, but also those contemporary theorists who have generated transmedia frictions by venturing into the realm of production.

One of the foremost tasks of art has always been the creation of a demand which could be fully satisfied only later. The history of every art form shows critical epochs in which a certain art form aspires to effects which could be fully obtained only with a changed technical standard, that is to say, in a new art form. Every fundamentally new, pioneering creation of demands will carry beyond its goal.

WALTER BENJAMIN

CONTENTS

CONTRIBUTORS

STEVE ANDERSON
University of Southern California (USC)
Los Angeles, California

CAROLINE BASSETT
University of Sussex
Brighton, United Kingdom

EDWARD BRANIGAN
University of California at Santa Barbara
 (UCSB)
Santa Barbara, California

JOHN T. CALDWELL
University of California at Los Angeles
 (UCLA)
Los Angeles, California

DAVID WADE CRANE
Independent Scholar
San Francisco, California

GUILLERMO GÓMEZ-PEÑA
Artist
San Francisco, California

ERIC GORDON
Emerson College
Boston, Massachusetts

HERMAN GRAY
University of California at
 Santa Cruz
Santa Cruz, California

MARK B. N. HANSEN
Duke University
Durham, North Carolina

N. KATHERINE HAYLES
Duke University
Durham, North Carolina

JOHN HESS
Coeditor of *Jump Cut*
Oakland, California

MARSHA KINDER
University of Southern California (USC)
Los Angeles, California

RAFAEL LOZANO-HEMMER
Artist
Montréal, Québec, Canada

STEPHEN MAMBER
University of California at Los Angeles
 (UCLA)
Los Angeles, California

LEV MANOVICH
City University of New York
New York, New York

TARA MCPHERSON
University of Southern Califronia (USC)
Los Angeles, California

YURI TSIVIAN
University of Chicago
Chicago, Illinois

CRISTINA VENEGAS
University of California at Santa Barbara
 (UCSB)
Santa Barbara, California

GRAHAME WEINBREN
School of Visual Ats
New York, New York

HOLLY WILLIS
University of Southeren California
 (USC)
Los Angeles, California

PATRICIA R. ZIMMERMANN
Ithaca College
Ithaca, New York

ACKNOWLEDGMENTS

We thank all the scholars who helped make the original Interactive Frictions conference at the University of Southern California (USC) in June 1999 such a transformative event—not only for those who attended and participated in the program, but also more generally for the field. We are especially grateful to Alison Trope, who cohosted the conference; Holly Willis, who cocurated the exhibition at USC's Fisher Gallery; and Steve Anderson, who produced the written program that detailed all of the papers and performances. Doctoral students in cinema at the time, all three subsequently emerged as innovative media scholars working at the cutting edge of experimentation and expanding the boundaries of the field.

We acknowledge the crucial contributions of those who collaborated with us on the pioneering projects that grew out of the conference and enabled us to enhance the interplay between theory and practice: Rosemary Comella, Kristy H. A. Kang, and Scott Mahoy at The Labyrinth Project (a research initiative on database narrative and the digital humanities); Steve Anderson, Craig Dietrich, Erik Loyer, Raegan Kelly, and numerous others at *Vectors* (a born-digital online journal that enables humanities scholars to create truly transmedia publications); and Anderson, Dietrich, Loyer, Micha Cardenas, and Alexei Taylor and many others at *Scalar* (a free, open-source authoring and publishing platform that makes it easy for authors to write long-form, born-digital scholarship online).

We especially thank all the authors who contributed essays to this volume, most of which were originally presented at the conference. They have been extraordinarily patient

and loyal to this project, willing to look back at their earlier work with hindsight and see how it helped shape their later writings.

At the University of California Press, we are especially grateful to Mary Francis, who not only has been committed to the project over the years but has also been open to changes in how it has been framed. She never lost faith in us or our project. At the press we were also fortunate to be working with Kate Hoffman as project editor and Kim Hogeland and Aimee Goggins. We also want to thank our superb copy editor Richard Earles and excellent indexer J. Naomi Linzer for their thoroughness and attention to detail. And at USC we are grateful, as ever, to Carolyn Tanner for her patience and efficiency.

Most of all, we want to acknowledge the crucial contribution of our talented editorial assistant Andy Myers, who proved invaluable in helping us prepare the manuscript.

PREFACE
Origins, Agents, and Alternative Archaeologies

Marsha Kinder and Tara McPherson

Sparks. Heat. Conflict. This is what friction generates. Using friction as a
catalyst, our event features work produced at the pressure point between theory
and practice. It brings together artists and scholars from different realms, at
different stages of their careers, working both individually and in collaboration
to spark an array of transmedia frictions.

"PERFORMING INTERACTIVE FRICTIONS," CONFERENCE PROGRAM, 1999

A familiar tale now circulates as an origin story for the emerging field of the digital
humanities. In its Wikipedia entry, the story goes like this:

> Digital humanities descends from the field of humanities computing . . . whose origins
> reach back to the late 1940s in the pioneering work of Roberto Busa.
>
> The Text Encoding Initiative, born from the desire to create a standard encoding scheme
> for humanities electronic texts, is the outstanding achievement of early humanities com-
> puting. The project was launched in 1987 and published the first full version of the *TEI
> Guidelines* in May 1994.
>
> In the nineties, major digital text and image archives emerged at centers of humanities
> computing in the U.S. (e.g. the *Women Writers Project,* the *Rossetti Archive,* and *The William
> Blake Archive*), which demonstrated the sophistication and robustness of text-encoding for
> literature.

The term "digital humanities" is widely attributed to the editors of the 2004 volume *A
Companion to Digital Humanities* (Schreibman, Siemens, and Unsworth). That work, like
the Wikipedia excerpt, frames the digital humanities in a direct lineage from the compu-
tational humanities and "half a century of textually focused computing." (It also includes
a preface by Father Busa which functions rather like a benediction for the field.) The
book's introduction goes on to note that "especially since the 1990s . . . advances in tech-
nology have made it . . . possible . . . to embrace the full range of multimedia," and the

expansive volume includes entries on multimedia, film, music, and the performing arts. Nonetheless, across the various stories we tell and are told about the digital humanities, certain aspects of "textually focused computing" such as TEI remain quite central. In the *Companion,* the 1990s may add new media to the mix, but computationally processed text is still where it all began. *Transmedia Frictions* seeks to expand these familiar tales and offer up other, parallel histories for the origins of the digital humanities. These alternative archaeologies include film and digital media studies, narrative studies, the visual arts, design, and visual studies.

While work in the encoding and marking up of text is undoubtedly important for the digital humanities, broadening the precursors for the field opens up new possibilities for engaging the richly mediated and deeply visual culture in which computation came of age. During the same time frame in which the computational humanities were taking root, scholars, technologists, and artists were exploring the potential of computers for many modes of expression and narrative, in spaces ranging from the collaborative arts group E.A.T. to SIGGRAPH to early efforts in electronic literature.[1] These experiments, in turn, drew upon long traditions in film and media culture, linking the arts, the humanities, and the digital in powerful ways. A broadened understanding of the origins of the digital humanities will be necessary if we are to have any hope of mining the complexity of our contemporary moment. Text is certainly important to computation today, but so too are still and moving images and audio, as the seventy-two hours of video uploaded every minute to YouTube's servers underscore. Imagining the digital humanities as descending from E.A.T. collaborator John Cage as much as from Father Busa also helps to route aesthetics and politics back into the origin stories.

Transmedia Frictions had its own origins in a three-day event in June 1999 on the campus of the University of Southern California (USC) in Los Angeles. Sponsored by The Labyrinth Project, a research initiative at USC's Annenberg Center for Communication, Interactive Frictions comprised plenary sessions, juried papers, a digital salon, and an art exhibition at the Fisher Gallery that explored interactive narrative at the pressure points between theory and practice. It brought cutting-edge artists and media practitioners together with cultural historians, traditional narrative theorists, and the then emergent voices of digital media theory. The energy generated across that weekend was palpable, and the discussions mapped the contours of this new field of digital media studies in ways that continue to resonate today in areas such as the digital humanities, software studies, database narrative, media archaeology, and new media arts.

This volume argues for the value of tracking earlier media and the discourse that helped define their functional differences from what is new, encompassing text but also other media forms. The emphasis, then as now, was on dialectics—on the frictions produced by productive juxtapositions between past and future, history and fiction, theory and practice, change and continuity, text and image, visuals and sounds, narrative and database. Another such friction is that between various origin stories for the digital humanities. We see these frictions as generative and positive.

This anthology serves at once as documentation and expansion of the original symposium, providing a record of the conversations begun in 1999 while also tracking their unfolding across a variety of disciplines for more than a decade. The intervening years have been a generative time for digital media, both as a set of cultural and industrial practices and as a subject of critical reflection and theory. From mobile phones to video games, from social networks to iPads, electronic platforms and proliferating devices are a ubiquitous aspect of daily life in industrialized society and, increasingly, in developing nations, transforming our concepts of political activism and revolution. In ways we couldn't have precisely predicted in 1999 (even as we somehow knew that they were coming), "interactive frictions" now seem thoroughly woven into the texture of everyday living. The very ubiquity of digital media forms only reinforces the need to develop critical vocabularies to evaluate and ideologically interrogate this world we now inhabit.

The original participants at our 1999 event were pioneering agents in honing these very vocabularies, and most are still leaders in the study of the digital. From N. Katherine Hayles to Lev Manovich and Wendy Chun, from Yuri Tsivian to Edward Branigan and Mark Hansen, from Margaret Morse to Anne-Marie Duguet and Pat Mellencamp, from Henry Jenkins to Justine Cassell and Yasmin Kafai, from John Caldwell to Cristina Venegas and Hamid Naficy, from Lisa Parks to Anna Everett and Alison Trope, from Vivian Sobchack to Janet Murray and George Landow, from Ellen Seiter to Randal Packer and Eric Freedman, from Ian Bogost to Steve Anderson and Holly Willis, from Steve Mamber to Peter Lunenfeld and Richard Weinberg, these scholars who joined us in 1999 continue to define and shape the study of the digital today. Collectively, they have published numerous books and articles, produced new models of digital publishing and interactive scholarship, launched innovative new graduate programs, revamped undergraduate curricula, influenced national policy debates, initiated various subfields, and shaped the agenda at national foundations. Other contributors to the symposium included international artists and industry leaders: Rebecca Allen, Mark Amerika, Cindy Bernard, Sawad Brooks, Nancy Buchanan, Rosemary Comella, Vilsoni Hereniko, Fran Ilich, Adriene Jenik, Isaac Julien, Glenn Kaino, Kristy Kang, Brenda Laurel, George Legrady, Erik Loyer, Laird Malamed, Pedro Meyer, Michael Nash, Pat O'Neill, Christine Panushka, Sara Roberts, Vibeke Sorensen, Beth Stryker, Bill Viola, Femke Wolting, Norman Yonemoto, Jody Zellen, and Eric Zimmerman, to name just a few. Most importantly, these groups—scholars, artists, entrepreneurs—interacted in fruitful and productive ways.

Across the weekend and as the conversation percolated and flowed, it was often hard to tell the artist from the scholar—particularly with figures like Michele Citron, Allison DeFren, Mary Flanagan, Norman Klein, Marcos Novak, Sandy Stone, James Tobias, and Fabian Wagmister. We were very much operating in the zone between theory and practice, honing a shared language at the interstices. The original participants as well as the authors and artists gathered together in this volume continue to mine this fertile terrain.

The move from the 1999 Interactive Frictions conference to this anthology published fifteen years later is marked by a significant change in title. We replaced "Interactive"

(a concept now taken for granted with digital media) with "Transmedia." Introduced in 1991 in Marsha Kinder's book *Playing with Power in Movies, Television, and Video Games*, this term proved central to arguments about medium specificity, both then and now. To maintain the line of continuity between conference and anthology, we retained the word "Frictions," which still evokes not only the vigorous debates being generated by the convergence of rival material forms rubbing up against each other but also (through rhyming consonance) a productive vacillation between fictions and histories, the virtual and the real.

Paradoxically, even within our current era of postmedia pronouncements, one of the most vibrant transmedia frictions is the debate over medium specificity—whether it's still meaningful or now obsolete. Given the increasingly rapid emergence and convergence of new media forms, it is possible to argue that a discourse on medium specificity enables us to explore the social and aesthetic potential of each and thereby recuperate unique possibilities that otherwise might be lost. As N. Katherine Hayles puts it most succinctly, precisely because of the accelerating speed of these combinations, "clarity about the functionalities of different media is now more crucial than ever." Or to state it another way, transmedia networks share similar dynamics with transnational studies; movement beyond the boundaries of any specific medium or nation does not render those entities or their borders meaningless, but rather requires us to look more closely at the cultural and historical specificity of the particular combination. Otherwise, "transmedia" and "transnational" would become meaningless buzzwords like "global." As Alan Liu and others have argued, such debates are also deeply relevant to what fields like the digital humanities and digital media studies will become.[2]

This volume gave some of the symposium participants a chance to reflect on a decade of changes in the field—not only in their own creative and scholarly work, but also in the new breed of students they are mentoring and the new programs they helped generate, both in and outside of the academy. In the past fifteen years, many of the symposium participants moved from theory to hands-on production, if they were not already combining both at the time of the conference. So this volume also enables us to gauge the growing interplay between theory and practice that has been central to fields like the digital humanities, software studies, and digital media studies. More specifically, it gives us a chance to assess the practices that grew out of the conference, the various models of digital scholarship, interactive narrative, database documentary, born-digital dissertations, and social networks that have helped define the study of digital media across the university.

Across their range and scope, these projects and partnerships model new modes of collaborative practice, emergent forms of research and scholarship, and exciting models of community and connection. Such work also makes tangible our original call to experiment with narrative forms and immersive pleasures. Excerpts from many of these projects are included on the website (http://scalar.usc.edu/works/transmediafrictions) that accompanies this volume, allowing them to be experienced in a format that better respects their interactive, temporal, sensory, and affective dimensions.

This volume's essays are divided into two sections. The first focuses on medium specificity and transmedia precursors, which includes many of the key arguments from the conference between formalists and cultural historians and extends them to other, more recent cultural forms, including mobile phones. The second looks forward to digital possibilities and to the "rewiring" of politics, place, and the self, with an emphasis on the kinds of cultural debates and discursive frictions these changes, both real and imagined, have generated. Yet in both sections the essays interweave issues of form, cultural context, and ideology—the division is primarily a matter of emphasis.

Of particular value is the sense of historical scope the volume as a whole provides, serving as a robust document of the relations between digital theory and practice. Many of the essays represent work originally presented at the conference, some deliberately retaining the flavor of those earlier discursive frictions. Other essays have been added to supplement the original material. Although we gave all contributors an opportunity to revise their essays with historical hindsight and to add a brief "update" commenting on this process, not everyone thought it was necessary. Others built the update into their revisions. What has been added is a website with interactive notes, excerpts, and illustrations that help make the essays come alive. The website helps fulfill our original call for generating new productive frictions across a wide range of cultural forms, including database narrative and archival cultural history. Together, the book and website map alternate archaeologies for the study of the digital within the arts and humanities that push beyond the computational manipulation of text. Across this conversation, all narrative texts—including history, theory, and artistic practice—must remain open. Our origin stories should be broad, catalytic, and expansive. Or, as Grahame Weinbren puts it in this latest version of his essay, "When we enter the realm of the digital, change will always be an option."

NOTES

1. E.A.T. (Experiments in Art and Technology) was a nonprofit collaborative established to foster connections between artists and engineers. It was formally launched in 1967 by engineers Billy Klüver and Fred Waldhauer and the artists Robert Rauschenberg and Robert Whitman. The group was closely affiliated with Bell Labs and produced a broad array of work. Similar efforts were also underway on the U.S. West Coast, especially the Art and Technology Program at the Los Angeles County Museum of Art, also begun in 1967. These endeavors, as well as early work in electronic literature, music, and animation, offer rich origin stories for today's digital humanities that push far beyond the domain of TEI.

2. Debates around the role of cultural theory and ideology within the digital humanities have recently been picking up steam. See, for instance, the collection *Debates in the Digital Humanities*, edited by Matthew K. Gold, as well as online discussion on the HASTAC Scholars' site, at http://transformdh.org, and at http://dhpoco.org. Forthcoming special issues of *Differences* and of *American Literature* also take up these debates.

MEDIUM SPECIFICITY AND PRODUCTIVE PRECURSORS

MEDIUM SPECIFICITY AND PRODUCTIVE PRECURSORS
An Introduction

Marsha Kinder

In this era of transmedia discourse and postmedia pronouncements, we might question whether it is still productive to talk about medium specificity. Yet, given that new media forms are replacing each other so rapidly—usually before we have time to fully explore their social and aesthetic potential—perhaps a discourse on medium specificity might enable us to recuperate unique possibilities that otherwise would have been lost.

In 1999 at the Interactive Frictions conference, one could still hear echoes of Marshall McLuhan's famous refrain that fetishized medium specificity for the fifties—"the medium is the message!" Adopting this idea from turn-of-the-century modernism, McLuhan applied it to the emerging new medium of television as it began displacing cinema as the reigning mass medium worldwide (129). But by 1999, at the end of the millennium, this utopian refrain was being repurposed for computers, the Internet, digital media, and the database documents they spawned.

This refrain was challenged at the conference by even stronger echoes of Raymond Williams's influential critique of "technological determinism," which, he claimed, was based on a medium specificity that ignored the way old power struggles were inevitably remapped onto newly emergent forms (*Television* 5). In the late 1970s and 1980s, this critique sharpened the ideological edge of British cultural studies and its "thick" descriptions of reception, a cluster of politically engaged methodologies that privileged active readings by a diverse range of historically situated spectators over technological or aesthetic mastery by any single artist in any specific medium. Still, the analysis of medium specificity survived these cultural debates, for even Williams recognized the value of

defining the formal specificity of television—its unique combination of segmentation and endless flow.

By the end of the 1990s, medium specificity had regained considerable force within the emerging discourse on digital media yet was still frequently accompanied by some form of defensiveness. For example, in *Visual Digital Culture* (2000), British new media theorist Andrew Darley felt compelled to vigorously defend his interest in the formal aesthetics and medium specificity of popular visual entertainment genres (such as spectacle cinema, computer animation, music video, simulation rides, and computer games) because he knew such discussions would be read as deviations from the ideological rigors of British cultural studies (1–8). Despite the assumed postmodernist erasure of the distinction between high and low culture, he realized that such aesthetic concerns would be deemed more appropriate to the elite "marginal practices" of avant-garde computer art (his usual object of study) than to the "low" forms of popular entertainment he was now discussing (which typically fell under the scrutiny of cultural studies). To bolster his case, Darley turned to Susan Sontag and David Bordwell (odd bedfellows), whose *Against Interpretation* and *Planet Hong Kong* used phenomenology and neoformalism, respectively (in different decades and with different ideological goals) to legitimize the aesthetics of medium specificity both for popular and for experimental forms.

These later digital versions of medium specificity opened a space for a revival of structuralism, generating a new mode of discourse that I call "cyberstructuralism." These emergent objects of study seemed to arouse a desire for clear-cut distinctions between old and new media, showing (as Williams had warned) that technological determinism dies hard. Cyberstructuralist dynamics are especially apparent in Lev Manovich's pioneering book *The Language of New Media* (2001). The reemergence of medium specificity as a driving force is an idea that is not only implicit in his title but also explicitly defended against potential charges of naive obsolescence:

> In fact, regardless of how often we repeat in public that the modernist notion of medium specificity ("every medium should develop its own unique language") is obsolete, we do expect computer narratives to showcase new aesthetic possibilities that did not exist before digital computers. In short, we want them to be new media specific. (237)

While satisfying this desire for medium-specific distinctions, cyberstructuralism frequently performs three other collateral moves that prove problematic: it privileges formalism while ignoring the ideological implications of structural choices; it treats narrative as a rigid formal structure defined by a chain of causality and a set of binary oppositions, while minimizing its cognitive, affective, and social functions; and it fosters an illusion of wholeness without leaving room for the unknown.

Many contemporary media theorists have called attention to these limitations, including Diana Taylor, who sees computer-based archival histories not as neutral repositories of data but as forms of knowledge-production with dire ideological effects.[1] Taylor chal-

lenges the illusion of wholeness found in these archival histories by exposing what has been excluded. In *The Archive and the Repertoire: Performing Cultural Memory in the Americas* (2003), she argues for the inclusion of live performance genres, for otherwise the ephemeral knowledge they are based on will be lost and their performers relegated to the margins of history. Even before the digital era, these limitations in structuralism had been exposed by Roland Barthes, whose work (as we see in this volume) is frequently referenced by new media theorists and historians of digital culture. His critique was most powerful in those works that revealed his own crucial move from structuralist binaries to open-ended post-structuralist networks. For example, in *S/Z* (1970; the quotations used here are from the translation by Richard Miller, published in 1974), a theory of reading that transforms narrative into an open-ended database, he famously claims that the "text is a galaxy of signifiers, not a structure of signifieds. . . . [T]he systems of meaning can take over this absolutely plural text, but their number is never closed, based as it is on the infinity of language" (5–6). As the emergent post-structuralist feminists of the 1970s and 1980s acknowledged, Barthes's *S/Z* had thereby redefined the goal of narrative theory: it was no longer focusing (as Teresa de Lauretis succinctly put it) on "establishing a logic, a grammar, or a formal rhetoric of narrative . . . (its component units and their relations)" but rather on understanding "the nature of the structuring and destructuring . . . a production of meaning which involves a subject in a social field" (105). As soon as Barthes moved the process of inquiry into the social field, all textual meanings necessarily took on ideological implications—even those posing as neutral denotations, as if to falsely suggest that language could ever be "innocent." In *S/Z*, Barthes seemed to take great delight in introducing precise structuralist binaries (e.g., denotation/connotation, readerly/writerly, sequential narrative/agglomerative database) and then playfully exploding them with his dialectics (e.g., making "denotation" the last of the connotations, and performing a writerly reading of the readerly). It was as if he were underscoring his own movement beyond structuralism into the more complex ideological realm of post-structuralism, where gaps in our knowledge are exposed and room is left for the unknown. It is this insistence on the inevitability of *both* open-endedness *and* ideological meaning that keeps Barthes so crucial to the ongoing debates on medium specificity and postmedia discourse, particularly as argued in this volume.

This section of our anthology addresses some of the ways these arguments about medium specificity were voiced at the conference and continued to be revised in the years that followed, particularly with the emergence of transmedia migration, mobile technologies, and other digital forms of social networking. Focusing on four pairs of essays, this introduction stages these texts as a series of interwoven dialogues that give different narrative accounts of what is at stake in medium specificity historically and ideologically; which precursors, contemporary theorists, or artists are the main protagonists in this unfolding discursive drama; and how the interactive frictions and continuities between old and new forms can be read most productively within their social and historical contexts.

The first pair of essays are by N. Katherine Hayles and Lev Manovich, who were then (and have remained) two of the most rigorous and influential new media theorists in the field. Although she hails from literary studies and he comes from cinema, they both engage medium specificity from a cyberstructuralist perspective, even though Manovich explicitly acknowledges the "severe limitations" of structuralism. Despite their dedication to considering new media's relations with earlier forms, their primary contributions lie in their ability to identify formal and material differences with great clarity and precision.

Hayles's contribution to this volume is the original paper she delivered at the conference, "Print Is Flat, Code Is Deep: The Importance of Media-Specific Analysis." Although she would later publish several major books, *How We Became Posthuman: Virtual Bodies in Cybernetics, Literature, and Informatics* (1999), *Writing Machines* (2002), *My Mother Was a Computer: Digital Subjects and Literary Texts* (2005), and *Electronic Literature: New Horizons for the Literary* (2008), her distinction between flat print and deep code still lies at the heart of her work on medium specificity. As she puts it in her "Afterthoughts," this distinction is "the beginning of a trajectory that continues to spin out its implications in my work and thought." With her signature lucidity and elegance in structuring a line of argument and her astuteness in selecting a rich assortment of persuasive concrete examples, this essay presents a coherent case on behalf of a medium-specific analysis that addresses both the particularity of the form and one medium's citations and imitations of another. In this way, it attends to what she calls "simulation and instantiation" rather than merely "similarity and difference." Thus, she strategically insists that the term "hypertext" be applied to print as well as to digital media—to traditional encyclopedias and brilliant experimental novels like *Dictionary of the Khazars* as well as to electronic CD-ROMs and websites. Otherwise we would lose a valuable opportunity "to understand how a literary genre mutates and transforms when it is instantiated in different media." Although she frames these mutating movements from one medium to another as a historical process that forces us to deal with the materiality of literary texts, she does not address how these formal changes relate to larger social or cultural histories.

The rest of her essay is concerned with defining "what distinguishes hypertext instantiated in a computer from hypertext in book form." Listing eight concrete characteristics, she creates a useful typology that considers both the medium itself (their instantiation in digital computers) and the extent to which their effects can be simulated in print. Like a mathematical problem of subtraction, this two-step calculation repeatedly yields a singular functional difference: "print is flat, code is deep."

Like most of the writers within this section of the anthology, Hayles designates Barthes as a crucial precursor of hypertext, particularly because he was singled out so convincingly by George Landow (also a keynote speaker at the conference) in his groundbreaking book *Hypertext: The Convergence of Contemporary Critical Theory and Technology.* Focusing on Barthes's essay, "From Work to Text," Hayles begins by agreeing with Landow (and David Bolter) that Barthes "uncannily anticipates electronic hypertext." Yet she is equally

convinced that Barthes's "vision remains rooted in print culture." Thus, she catalogues his works along with those other print hypertexts—old encyclopedias and experimental novels whose relationship to electronic hypertext is simulated. Following the same strategy that she pursued with her typology, she uses this close comparison to uncover a key functional difference: "In positioning text against work, Barthes was among those who helped initiate semiotic and performative approaches to discourse, arguably one of the most important developments in literary studies in the past century. But this shift has entailed loss as well as gain. . . . [I]t also had the effect . . . of eliding differences in media."

Although Hayles argues that nondigital literary works can only "simulate" computer-mediated hypertexts and that "we have moved [far] beyond" Barthes, she denies that she is implying any teleological sense of progress or that literature is doomed. While she claims that books are "too robust, reliable, long-lived, and versatile to be rendered obsolete by digital media," she also acknowledges that books *are* subject to change, which she embraces as part of living form. With historical hindsight, we see how the Kindle and iPad uphold these observations. Undoubtedly used to reassuring her more traditional literary colleagues that she is still committed to books, Hayles makes her arguments appear less radical than they actually are. In fact, they appear compatible with the more traditional tactics of comparative literary analysis: the more similar the works we compare, the more precise we can make the distinctions between them. This rhetorical strategy of reassurance contrasts sharply with that of Lev Manovich, who frequently emphasizes the sense of rupture even while arguing for continuities between old and new forms.

Designed as a provocation, an attack on the very concept of media, Manovich's essay, "Postmedia Aesthetics," is not only postconference but also postpublication of *The Language of New Media* (2001), the groundbreaking book that has led him to be perceived by many as the world's leading new media theorist and (along with McLuhan, to whom he is frequently compared) a strong advocate for medium specificity. Always privileging the new, Manovich presents himself as an avant-garde theorist who is constantly driving the discourse on computer culture into new conceptual domains. With its teleological position signaled by the "post" in its title, the essay implies that those who have not adopted his most recent "postmedia" vocabulary risk obsolescence or being left far behind. It attempts to settle this running argument on medium specificity through a bold act of renaming. However, Manovich was not the first to reach this conclusion. Quoting from the contributions of Anne Friedberg and Henry Jenkins in his anthology *The New Media Book* (2002), Dan Harries claims that

> With the growing use of digital video, computer-based editing and special effects, we are witnessing a convergence of media images. As Anne Friedberg notes, "the movie screen, the home television screen, and the computer screen retain their separate locations, yet the types of images you see on each of them are losing their medium-based specificity". . . . As Henry Jenkins suggests, "because digital media potentially incorporate all previous media, it no longer makes sense to think in medium-specific terms." (171)

Friedberg, Jenkins, and Harries come to this conclusion from the side of reception, whereas Manovich converts it into a formalist argument aligned with technological determinism, for he argues that one of the primary causes of this "postmedia" condition is "the digital revolution of the 1980s–90s." This move represents another break from *The Language of New Media,* wherein Manovich tried "to avoid using the word *digital* because it ambiguously refers to three unrelated concepts" (52). Dubbing our new era a "postdigital, postnet culture" (the prefix signaling not obsolescence, as in the case of "postmedia," but a functional difference or rupture), this essay now substitutes "media" (and, by implication, its derivatives "transmedia" and "medium-specificity") for "digital" as the primary term under attack and erasure.

Although this line of argument would seem to place Manovich in sharp opposition to Hayles, who claims that medium specificity is more important than ever, it actually proves to be uncannily similar to hers. He ends up arguing for the specificity of the computer, privileging it as the technology through which all other prior forms should be reconceptualized. After presenting a series of compelling arguments for why medium specificity is no longer significant, Manovich proposes a new postmedia aesthetic that focuses on a cultural analysis of software and informational behaviors. These two terms prove very useful, for they can be applied both literally to current practices of computer-mediated communications and metaphorically to past works from precomputer culture. Like Hayles, he leads us to address the materiality of texts and the transmission of data by creating a communications typology (in this case, consisting of six characteristics rather than her eight) that considers both (to use her terms) their "instantiation in digital computers . . . and the extent to which [their] effects can be simulated in print." Yet, to justify his application of new digital concepts to earlier, predigital forms, Manovich turns not to an analytical argument for observing the formal process of historical change (as Hayles did in defending her use of the term "hypertext"), but to one more compatible with advertising rhetoric, namely consumer appeal. He strives "to make old culture comprehensible to new generations that are comfortable with the concepts, metaphors, and techniques of the computer and network era."

While those committed to the historical specificity of predigital media might question this strategy of rethinking old cultural forms through the metaphors of new media (perhaps fearing some kind of reductionism, say, in describing Giotto and Eisenstein as "important information designers" who deserve to be compared "alongside" contemporary giants like Allan Kay and Tim Berners-Lee), Manovich claims he is also motivated by an ethical obligation—to see old and new cultures as one continuum, and to enrich new culture through the use of the aesthetic techniques of old cultures. By accommodating young computer-savvy users in this way, one wonders whether Manovich is really adding a new dimension to an already highly complex figure like Eisenstein or (through this act of renaming) merely substituting a more reductive way of seeing him, the same kind of reductionism that was performed by David Bordwell, who stripped Eisenstein of his dialectics so that his pure poetics could be more comfortably appreciated by Bordwell-

ian neoformalists (*Cinema* 114, 137). Unlike Hayles, Manovich wastes no time trying to convince us that he is avoiding a teleological notion of progress.

In the essay's final paragraphs, Manovich acknowledges a blind spot in his informational aesthetic: Its privileging of cognition prevents it from dealing with affect. Although this issue is becoming increasingly important, as empirical work in neuroscience turns in this direction,[2] Manovich minimizes this lack by putting himself in the company of other influential structuralists. He claims that affect has been neglected in cultural theory since the late 1950s "when, influenced by the mathematical theory of communication, Roman Jakobson, Claude Levi-Strauss, Roland Barthes, and others began treating cultural communication solely as a matter of encoding and decoding messages." Like Hayles, he emphasizes the earlier Barthes, without observing that his elision of differences in media (which she saw as a loss) could have been used to bolster Manovich's own postmedia argument. More tellingly for this discussion of affect, Manovich omits the post-structuralist Barthes and his theorization of connotation and the pleasures of the text. He also omits the psychoanalytic wing of post-structuralism, including feminists and queer theorists who have been occupied with issues of pleasure and desire.

Manovich attempts to fill these theoretical gaps with allusions to music—by referring to DJs and their art of sampling as "information behavior," by noting the reliance on data processing for the "bodily experience of clubbing," and by citing the common practice of listening to music while working on a computer. Yet such references to what he calls "affective data" might not convince us that we should give up the language of pleasure and pain, or that informational aesthetics is updating the dynamics of desire.

BRANIGAN AND TSIVIAN ON PIONEERING PRECURSORS

In contrast to these two cyberstructuralist arguments concerning medium specificity, narrative theorist Edward Branigan and early-cinema scholar Yuri Tsivian present essays that focus on nondigital precursors of interactive narratives and database structures from earlier periods and forms. They claim that these precursors are productive because they can potentially expand not only the creative possibilities of new media for the future but also our understanding of the past. By deepening our potential database of precursors, they further complicate the matter of defining the unique dimensions of digital hypertexts and interactive narratives. Since they are addressing works from earlier eras, perhaps it is not surprising that the papers published here are the ones presented at the conference—although both have been extensively strengthened and expanded, by new examples, extended lines of argument, and supporting notes in the case of Branigan, and by expanded visual illustrations in the case of Tsivian.

Both of these essays build on the groundbreaking work of Carolyn Marvin's *When Old Technologies Were New*, which helped deflate the utopian claims of theorists who fetishized the "newness" of digital media. Yet while her detailed cultural history demonstrated how earlier nineteenth-century technologies—like the light bulb, the telegraph, and the

telephone—were subject to discursive debates and power struggles that are very similar to those now being waged around computers and the Internet, these two essays focus on ideas and conceptions that were formulated in those earlier eras but that can now be more readily realized through newer digital technologies. Yet unlike André Bazin's idealist argument in his essay "The Myth of Total Cinema," a drive he traces back to the timeless myth of Icarus, both Branigan and Tsivian (like Marvin) are responsive to the contexts of cultural and historical specificity and to the materiality of the medium. They both subscribe to the following argument by Walter Benjamin, which Branigan cites at the beginning of his essay:

> One of the foremost tasks of art has always been the creation of a demand which could be fully satisfied only later. The history of every art form shows critical epochs in which a certain art form aspires to effects which could be fully obtained only with a changed technical standard, that is to say, in a new art form. . . . Every fundamentally new, pioneering creation of demands will carry beyond its goal. ("The Work of Art" 237)

Branigan's essay, "If–Then–Else: Memory and the Path Not Taken," demonstrates how cognitive models from earlier eras can enrich our understanding of new media. He chooses to focus on "interactivity" (one of those terms that Manovich avoids both in his book and his essay here) because, according to Branigan, "new forms of interactive media may be useful as tools for thinking about thinking." Thus, he sets new media in a historical context, giving what he calls "a drastically abbreviated account of how human *memory* has been conceived with respect to the artifacts that were designed to serve it," thereby demonstrating what is at stake historically and philosophically in the choice of specific concrete metaphors for the mind and its mental processes. In this way, he gives greater historical weight to projects like Manovich's that are bent on changing conceptual terms and tropes. Despite his allusions to history, Branigan deliberately rejects chronological order in presenting his models and any evaluative system of ranking them, for he wants to avoid any teleological implication of progress. Yet his footnotes suggest how these mental models have influenced other latter-day theorists from Metz to Minsky.

Branigan describes four models for theorizing memory, based on five specific concrete metaphors: Plato's wax block, Freud's mystic writing-pad, Descartes's sealing wax, and Plato's aviary and Wittgenstein's language-game (which he sees as two variants of the same model). In discussing their implications, he demonstrates how these four models can be used as a basis for rethinking medium specificity, claiming that "any theory about the nature of a medium must be founded on its interactivity with present thought, and with the memory of other thoughts" and that "an art medium, whether old or new, elicits responses from us as it intermixes with memory systems." Although such arguments might imply an objective basis for medium specificity, he avoids technological determinism by remaining attentive to the specific historical and cultural contexts in which it operates. What he is most interested in tracing is how "these responses, collectively, become part of the historical memory that will shape the next version of a

medium"—the very process that Hayles is also interested in observing. Though Branigan does not address the power struggles that become intermixed with this interaction between a material medium and the forms of human memory it comes to represent, he does leave space where such ideological negotiations can be inserted. For he sees these four theories of memory as attempts to explain how the mind is able to retain impressions and later adapt and mobilize them for social and physical interactions with other persons within a historically defined public sphere.

These metaphoric models of human memory described by Branigan are precisely the kind that Manovich would later attack in *The Language of New Media,* in which he rejects "this modern desire to externalize the mind" because, he claims, "the objectification of internal, private mental processes, and their equation with external visual forms" undermine the uniqueness and privacy of subjective experience and thereby make it easier to manipulate. Or as Manovich also puts it, "What before had been a mental process, a uniquely individual state, now became part of the public sphere" (60). This movement of mental models into the public sphere is precisely what Branigan values, for it creates a historical record of how humans have used their own tools to think about thinking and thereby provides persuasive documentation for the continuing significance of the kind of medium specificity that Manovich's essay rejects. Thus, it is important to see how Branigan's essay fits into his larger theoretical project of exploring the capacity for mental modeling in earlier narrative forms, a goal he pursued in two influential books, *Point of View in the Cinema* (1984) and *Narrative Comprehension and Film* (1992), and pushed much further in *Projecting a Camera: Language-Games in Film Theory* (2006). One way of possibly accounting for this difference between their respective arguments would be to consider the respective cultural influences on both theorists: that is, to see how Manovich's Russian background may have made him more concerned with the dangers of surveillance, political censorship, and ideological manipulation than with the expressive possibilities of individual subjectivity, whereas Branigan's early training as a Bordwellian neoformalist may have helped lead him to emphasize the importance of cognitive models.

In "Cybertext and Its Precursors: Lintsbach, Warburg, Eisenstein," Yuri Tsivian also focuses on the conceptual prefiguring of hypertext and multimedia, but he zeroes in with greater historical specificity on European modernism of the teens and twenties. Still, his chosen precursors come from diverse fields and cultures. From Tsivian's native Latvia, "theory-minded" filmmaker Sergei Eisenstein proposes a multilinear spherical book, one of his many visionary designs that are consistent with his modernist experimentation (yet one that strengthens Manovich's argument for seeing him as an "important information designer"). From Germany, "revolutionary art historian" Aby Warburg presents black velvet screens that function as an atlas of memory with overlapping images. And from Estonia, "visionary" linguist and mathematician Jakov Lintsbach invents a universal multimedia language.

In contrast to Branigan's precursors, these three visionaries are more interested in expanding our tangible means of writing and recording than in merely modeling the

human mind and its mental processes through figurative language. While Branigan's precursors offer metaphors for understanding memory, concepts that retain their status as virtual images and as tools of thinking, they remain embedded in verbal language. By contrast, the communicative modes proposed by Tsivian's precursors are all concrete models for interfaces that they intended to produce as material objects, if only they had the time and means. The realization of this goal is now made easier by the existence of computers, which Tsivian demonstrates in the case of Lintsbach (see examples on the anthology website). Thus, in some ways, Branigan's quotation from Benjamin is more aptly suited to Tsivian's essay than to his own.

Pointing to the pun that lies in the term "precursor," Tsivian urges us to think of his three visionaries simply as "people who happened to be living before the age of the cursor, and whose once impossible projects look more possible nowadays." Arguing that this form of prefiguring is not so rare as some new media theorists might make us assume, he emphasizes that it is commonplace for such ideas to precede their concrete realization. For example, though Tsivian never specifically mentions the writings of Barthes, he finds precedents for concepts like "lexia" and the "networking of texts" that later became crucial in Barthes's theory of reading published in S/Z, a book that Landow (and other new media theorists) may have inadvertently fetishized as a singular precursor of hypertexts.

Rather than merely presenting his three precursors as objects of arcane historical interest, Tsivian demonstrates the productive appeal of interactive comparisons, for just as new media enable us to see old works in new ways (his own primary goal), so do these fascinating examples enable us to design new interfaces. Tsivian has personally demonstrated this process in his own scholarly hypertext, *Immaterial Bodies: Cultural Anatomy of Early Russian Films,* which won the 2001 British Academy Award for best interactive learning project. Although he modestly calls himself "a poor cyber-user" dabbling in multimedia production as an amateur, Tsivian has actually done pioneering work in designing electronic scholarly hypertexts. He was a crucial collaborator in The Labyrinth's Project's online constructivist courseware project, *Russian Modernism and Its International Dimensions*[3] which demonstrates the historical roots of many aesthetic concepts (such as dialectic montage, intertextuality, and constructivism) that are now crucial to digital aesthetics. He also founded a website for film historians called *Cinemetrics,*[4] which provides an online tool for charting the shot lengths for specific films and creates a cyber-community for scholars interested in studying the implications of such measurements. It is not difficult to see the connections between this pioneering project and the works by Lintsbach, Warburg, and Eisenstein discussed in his essay.

ANDERSON AND MAMBER ON DATABASE DOCUMENTARY AND ARCHIVAL CULTURAL HISTORY

Though neither of these papers was presented at the conference, both of their authors attended: Steve Anderson (coeditor of the online journal *Vectors* and founding director

of IMAP, the Interdivisional Media + Arts PhD program at the University of Southern California [USC] School of Cinematic Arts) was one of the co-organizers of the conference, and Stephen Mamber (documentary film historian and digital media specialist in the Department of Film, Television and Digital Media at the University of California, Los Angeles) was a featured speaker but gave a different paper.

Given that Anderson and Mamber both explore the interplay between theory and practice, it is not surprising that their arguments are developed through specific case studies. In contrast to Branigan and Tsivian, their primary examples are contemporary; yet they refuse to fetishize "newness," and they find productive continuities between old and new forms. They use their case studies not as precursors but as concrete illustrations of what is possible or problematic.

Although Anderson focuses on history and Mamber on documentary, they both examine the impact of digital technology, databases, and search engines on nonfiction narrative, exploring what new models have been generated. Although nonfiction is their primary interest, they both see history and fiction as narrative cousins whose commingling and hybridization can be productive.

Perhaps most important, they both recognize that database structures and archival histories offer a seductive promise of "total knowledge," one that reinforces traditional epistemological assumptions about the stabilizing effects of rational order and progress. Yet they both claim that this vision of wholeness is an illusion. Instead they call attention to the inevitable gaps and random combinations in history, which they see as the driving force of narrative desire. By challenging the illusory nature of any totalizing history, they open the path for an open-ended narrative experimentation that always leaves room for the unknown and that exposes the ideological implications of all databases and their search engines.

In "Past Indiscretions: Digital Archives and Recombinant History," Anderson examines the impact of digital technologies and their information systems on the writing of history. He claims that by basing their histories on databases and search engines instead of on literary tropes, contemporary historians have created two contrasting models of database histories: "one seeking to articulate a 'total' history that is encyclopedic in scope and rooted in relatively stable conceptions of historical epistemology, and another that exploits digital technology's potential for randomization and recombination in order to accommodate increasingly volatile visions of the past." Anderson sees both forms of "database histories" as "collections of infinitely retrievable fragments, situated within categories and organized according to predetermined associations." Like all discourse in the "post-Foucauldian world" and despite disavowals to the contrary, these categories and their search engines have ideological implications that shape our vision of human history.

As his primary example of the encyclopedic model, Anderson uses Steven Spielberg's USC Shoah Foundation's Visual History Archive. Also known as *The Survivors Project,* it contains more than one hundred thousand hours of video testimonies from "more than

fifty thousand Holocaust survivors from fifty-seven countries, conducted in thirty-two languages," with "an index of approximately eighteen thousand keywords identified within the spoken testimonies." The temporal urgency of the collection process—gathering these testimonies while the survivors are still alive—speaks to the project's heroic high seriousness in preserving memory and history, and challenging death and oblivion. Yet, according to Anderson, there is little attention to assessing the veracity of any individual account or to drawing meaningful generalizations from the data. These limits, he claims, have already been addressed in earlier, nondigital works, both documentary and fiction—in Marcel Ophüls's documentary films on the Holocaust, including *The Sorrow and the Pity* (1969), and in Jorge Luis Borges's short story "Funes the Memorious" (in which a man with perfect recall is driven mad by these rare powers and their uselessness). Although the sheer size of Spielberg's collection may be its primary value, Anderson claims that this vastness makes its historical contents inseparable from its system of access and thereby reduces them to functioning merely as a resource for future historical narratives. Paradoxically, this vastness undermines the collection's claims to wholeness or even to its status as history.

As the ironic counterexample for the recombinant model, Anderson cites *Terminal Time* by the Recombinant History Project, which he describes as "an artificial intelligence apparatus" that is capable of constructing infinitely variable historical documentaries based on audience biases and beliefs. As performed by a group of artists, filmmakers, and computer scientists, this project generates historical documentaries on the fly, covering the past thousand years of human history while interweaving conflicting responses from the audience (who are periodically encouraged to lie). Though he finds both projects problematic, Anderson seems more comfortable with the parodic *Terminal Time* (illustrated on our anthology website) since it has no claims to truth and blatantly undermines the boundaries between fact and fiction. Giving its users the history they "deserve," it ironically demonstrates the futility of such totalizing enterprises and challenges any lingering utopian assumptions about archival cultural history.

Instead of examining how new digital media can transform a traditional form like history, in "Films Beget Digital Media" Stephen Mamber explores how an "old" medium like cinema can conceptually expand the narrative capacities of new digital formats. Like Anderson, he identifies two different strands in this form of nonfiction, which bridge the move from cinema to digital media: the compilation film and the autobiographical memoir. Less cautionary and more celebratory than Anderson, Mamber selects as his primary examples two works by well-known European filmmakers he admires: *Immemory*, a CD-ROM by French filmmaker Chris Marker, and *The Danube Exodus: The Rippling Currents of the River*, an immersive multiscreen museum installation coauthored by Hungarian filmmaker Péter Forgács and The Labyrinth Project (the research initiative and art collective that hosted the Interactive Frictions conference and that I have directed at USC since 1997). This installation debuted at the Getty Center in Los Angeles in 2001 and has been traveling worldwide ever since.

Given the fragmentary nature of their assets and the obvious gaps in their respective narratives, both works blatantly reject any claim to a "totalizing history." Yet, ironically, these two choices still resonate with the two works selected by Anderson. Like the *Survivors Project*, *The Danube Exodus* deals with the Holocaust, but it focuses only on two specific episodes: in 1939, a Hungarian river captain transported hundreds of Jews fleeing the Third Reich to the Black Sea, where they boarded a ship that took them to Palestine; the following year, the same captain transported hundreds of German farmers from Bessarabia (now Romania) back to Germany once the Soviets annexed their land. Both journeys were documented on film by the same amateur filmmaker, the Hungarian captain who transported them into history. Like *Terminal Time, Immemory* is an ironic compilation film composed of images from Marker's personal collection, including a profusion of intriguing narrative fragments from many different cultures, periods, and categories, which bombard users and challenge them to make sense out of this richly diverse material. Perhaps both of these works chosen by Mamber are the kinds of idiosyncratic historical narratives that (according to Anderson) can be spun out of encyclopedic "total histories" like the *Survivors Project*.

Mamber claims he chose these two works because they expand on narrative tendencies that were already apparent in the respective nondigital works of these filmmakers and also because they present "enlightening alternatives" for how digital media can be presented and experienced. Marker's earlier, nondigital films already had a fragmented database structure, and "Forgács was already making beautiful, tragic collages out of found home movies." Thus, he claims that each filmmaker brings a body of narrative experimentation that can help expand the digital media and their database structures, which is one of the reasons why The Labyrinth Project chose to collaborate with Forgács in the first place.

Like Anderson, Mamber admires any attempt to acknowledge and leverage the limitations of the medium. Thus, he praises the way both works expose the "pastness" of the photographic images and low-res footage that are used in these pieces. Instead of reassuring viewers that the conversion to new media will enhance their visual quality and preserve these historical fragments for all time, both works acknowledge the fragility of all media forms, including the digital. As Mamber puts it, they remind us that "new media will someday be old media." While in *Immemory* this sometimes results in (what Mamber calls) a "charmingly clunky" imagery and interface, in *The Danube Exodus* we actually see material signs of decay on the amateur home movie footage.

Another potential "limit" that Mamber leverages is the present lack of standards for displaying digital art as a museum installation, a stand-alone CD-ROM, or part of a website or online social network. Instead he sees this lack as an advantage because it enables artists to customize the display for the ideological goals and aesthetic pleasures of the specific project—whether for the intimacy of the CD-ROM that suits Marker's essayist tendencies and personal tone, or the large-scale multiple screens of the museum installation that convey Forgács's belief in the epic importance of home movies.

The final pair of essays are by authors who did not attend the conference: Grahame Weinbren, a New York–based artist who has been experimenting with interactive cinema since the early 1980s; and Caroline Bassett, a British-based digital media theorist who extends the dialogic comparison with cinema to mobile media and issues of realism and ideological potential. As if elaborating on Mamber's argument, both are concerned with the kinds of aesthetic and communicative pleasures these hybridized forms can deliver and the kinds of interactive experience and agency they make available to users.

Weinbren's essay, "Navigating the Ocean of Streams of Story," was originally published in *Millenium Film Journal* in 1995 and was revised for this anthology in light of his own subsequent experimentation with interactive cinema (260–271).[5] Like *Immemory* and *Terminal Time*, it is an open-ended project that can never be completed, especially as new versions continually appear in new anthologies. Like Mamber, he moves fluidly from literature to cinema and to interactive installations, showing how a network of early narrative media can enrich and shape those to come. In this way, he demonstrates that open-ended storytelling is not an oxymoron, as some theorists have argued, but a grammar that lies at the heart of narrative networks and predates Barthes's *S/Z*.

Positioning cinema between literature and new digital forms, Weinbren's essay opens with a marvelous epigraph from *Haroun and the Sea of Stories* by Indian novelist Salman Rushdie, a writer (like Chris Marker) with an amazing Shandean capacity for spinning a complex network of interwoven tales. Rushdie's alleged religious sacrilege (in the case of his *Satanic Verses*, 1988) has imbued all his writings with a deep association with death; the mortal sentence imposed on him (and later rescinded) by the Ayatollah has marked him as one of the few contemporary writers for whom the act of storytelling is literally a matter of life and death. Like a postmodernist, postcolonial Scheherazade or like Borges (whose stories each present an interface for an intriguing database narrative), Rushdie has become the ultimate metanarrative icon in both the East and the West, one who embodies the dangers of subjecting any act of writing to a closed reading within a restrictive cultural context or frozen moment of history. Instead of pursuing these political implications, Weinbren focuses on Rushdie's text as an influence on his own work—a pathway to his own experiences of reception. Structured around the ocean as a trope for generating and interweaving abundant streams of stories, this quoted passage from Rushdie projects not an ironic historical machine (as in *Terminal Time*) but an ideal "story space" for interactive fiction regardless of medium, a story space Weinbren used as a model for his own experimental narratives.

In describing some of his own interactive fictions from the 1980s and '90s (*The Erl King*, 1983–86; *Sonata*, 1991–93; and *Frames*, 1999), Weinbren claims they were driven by two pairs of forces associated with medium specificity—Cinema and Cybernetics, and the Projector and the Computer. Although, like Manovich, he denies that the computer is a medium or tool, he calls it "a device that controls and presents existent media," and

he formulates two driving questions that are directly tied to medium specificity: How does cinema change when its apparatus is linked to a computer, and what kinds of story and grammar will suit this altered cinematic medium?

To answer these questions, unlike Manovich, he turns not to contemporary tropes of computer culture but, like Branigan, to Freud's earlier modeling of mental processes, yet he uses them to address issues of pleasure and desire in reception. Specifically, he focuses on Freud's methods of dream interpretation and on the coded nonlinear grammar of his dreamwork theory, particularly the concept of "condensation." Weinbren subjects these theoretical models to the same kind of adaptive process that is now transforming the medium of cinema, rewriting them in light of the problems raised by computer-related interactive forms.

As his privileged metanarrative model of interactive storytelling, Weinbren chooses Freud's case study of *The Wolf Man* (1914–15), the same text used by Peter Brooks in his brilliant work of narrative theory, *Reading for the Plot* (1984) (264–286).[6] Although Brooks focuses on literary narrative rather than cinema or computer-related forms, his theory is ideally suited to conceptualizing a narrative field that is resistant to closure and receptive to story variations. For Brooks reads all stories as obituaries designed to forestall a premature death and posits an expansive middle motored by desire. That's why, he explains, the greatest narratives are usually so long (think of the work of Proust, Melville, Joyce, Scheherazade, and—one could add—Rushdie), and why, as we move through their expansive middles, we experience them as "force fields of desire." Instead of using the story of Oedipus as his master narrative, Brooks props his theory on Freud's *Beyond the Pleasure Principle* (which offers him Eros and Thanatos as primary engines of narrative drive) and on the *The Wolf Man* (an open-ended network of interwoven stories that uses transference and dialogue as models of interactive exchange). Weinbren applies *The Wolf Man* directly to interactive narrative, yet uses it to address some of the same issues that were raised by Brooks: to design a new narrative grammar capable of delivering pleasure and sustaining desire.

Caroline Bassett's essay, "Is This Not a Screen? Notes on the Mobile Phone and Cinema," addresses some of the same issues of medium specificity dealt with in earlier essays, but with reference to a new medium that was not addressed at the conference nor previously addressed in this volume—mobile phones. Resisting the rhetoric of convergence and the kind of ontology for mobile phones that might be imposed by cyberstructuralists, she claims that such strategies would lock this emergent technology into a fixed, formal conception of medium specificity. Instead, she focuses on the new questions it raises about the relationship between representation and action. Exploring mobile phones as a new form of "intimate screen," she makes intriguing observations about the exciting possibilities this new medium has opened—from texts to thumbnails, fireflies to flash mobs, and Happy Slapping to calligrams. Just as Mamber argued for retaining the variability of the image, size, and mode of projection in museum installations, Bassett insists on preserving an ongoing mobility for mobile phones—one that addresses its

historical connections with traditional telephony and photography and includes an open range of possible relations with cinema and visual culture. In contrast to Bazin's arguments for "the myth of total cinema," Bassett claims that "mobile cinema never *will* be invented."

Yet, unlike Weinbren and Mamber, Bassett seems unwilling to grant the mobility she reserves for mobile phones to other forms of digital media, particularly in the case of other interactive formats—CD-ROMs, DVD-ROMs, and museum installations. For, according to Bassett, the prized connectivity and "good enough" aesthetic that are found on the Internet (as well as on mobile phones) have totally prevailed over the lush visual simulations provided by interactive discs—like those produced by Weinbren, Marker, Forgács, and The Labyrinth Project. Bassett assumes that this struggle is over, leaving no wiggle room whatsoever for rival digital technologies, not even for the immersive visuals of lucrative electronic games. She assumes that the drive for "pure connection" has prevailed. Yet she wonders whether this drive is merely a "compensating ideology" that has risen "in response to the difficulty of finding and forging community." Although she is willing to question whether the "good enough" aesthetic is good enough for politics, she accepts it as a fait accompli for artistic and social practice.

Despite this decisive reading of one endgame, Bassett shares Weinbren's belief in the resilience of cinema, yet like Manovich she resists its capacity to absorb and redefine other media, particularly through its alleged capacity for realism. Still, she grants contingency to cinema, particularly in her marvelously detailed description of one particular moment of exchange—a wonderful dialogue between the silver screen and the "firefly" text messages sent by teenage flashmobs in the audience of a multiplex movie theater on an Orange Wednesday in Brighton, England. Sponsored by Orange, one of the UK's largest mobile phone companies, these Wednesday promotional events provide free movie tickets to moviegoers, who can claim them simply by sending a text message.

In the process of describing this transmedia encounter and its cultural and historical reverberations, Bassett redefines medium specificity not as a fixed set of formal properties but as an open-ended set of social practices that grapple with and mediate everyday reality, a perspective supported by the latest proliferation of mobile devices. Though she does not fully address the ideological implications of such social practices, this line of argument sets the stage for the "digital possibilities" addressed in Part II of this volume, which helps us reimagine "politics, place, and the self."

ABOUT THE AUTHOR

Marsha Kinder began her career as a scholar of eighteenth-century English literature before moving to the study of transmedial relations among narrative forms. In 1980 she joined USC's School of Cinematic Arts, where she taught international cinema, narrative theory, children's media culture, and digital culture. Having published over one hundred essays and ten monographs and anthologies, she is best known for her work on Spanish

media culture, including *Blood Cinema* (1993, with a companion CD-ROM, the first interactive scholarly work in English-language film studies), *Refiguring Spain* (1997), and *Buñuel's The Discreet Charm of the Bourgeoisie* (1998); and on children's media culture, including *Playing with Power in Movies, Television and Video Games* (1991), and *Kids' Media Culture* (1999). She was founding editor of innovative journals, such as *Dreamworks* (1980–87), winner of a Pushcart Award, and *The Spectator* (1982–present), and since 1977 has served on the editorial board of *Film Quarterly*. In 1995, she received the USC Associates Award for Creativity in Scholarship, and in 2001 was named a University Professor for her innovative transdisciplinary research.

In 1997, she founded The Labyrinth Project, a research initiative on database narrative (a concept she introduced), producing database documentaries, archival cultural histories, and other new models of digital scholarship in the humanities. In collaboration with media artists Rosemary Comella, Kristy Kang, and Scott Mahoy, and with filmmakers, scholars, scientists, and cultural institutions, Labyrinth combined cultural history and theory with the sensory language of cinema. Presented as transmedia networks (websites, museum installations, DVD-ROMs, and digital archives), these award-winning works have been featured at museums, film and new media festivals, and conferences worldwide and have been supported by grants from the Annenberg, Casden, Ford, Getty, Haas, Irvine, NEH, Righteous Persons, Rockefeller, and Skirball Foundations and from AHRQ (The Agency for Healthcare Research and Quality). In collaboration with documentary filmmaker Mark Jonathan Harris and Scott Mahoy, she recently launched a video-based website called *Interacting with Autism*, and she is writing a book called *The Discreet Charms of Database Narrative: Tales of Neurodiversity in the Light of Neuroscience.*

NOTES

1. I addressed similar issues in my essay "Designing a Database Cinema" in the 2003 *Future Cinema* anthology.

2. I am thinking of works by Antonio Damasio, including *Descartes' Error: Emotion, Reason and the Human Brain* (1994), *The Feeling of What Happens: Body and Emotion in the Making of Consciousness* (1999), *Looking for Spinoza: Joy, Sorrow, and the Feeling Brain* (2003), and *Self Comes to Mind: Constructing the Conscious Brain* (2010).

3. www.russianmodernism.org

4. www.cinemetrics.lv/tsivian.php

5. Other versions also appeared as "Another Dip into the Ocean of Streams of Stories" in Shaw and Weibel, and as "Ocean, Database, Recut" in Vesna, *Database Aesthetics.*

6. See Brooks, chapter 10, "Fictions of the Wolf Man: Freud and Narrative Understanding."

PRINT IS FLAT, CODE IS DEEP
The Importance of Media-Specific Analysis

N. Katherine Hayles

Lulled into somnolence by five hundred years of print, literary studies has been slow to wake up to the importance of media-specific analysis.[1] Literary criticism and theory are shot through with unrecognized assumptions specific to print. Only now, as the new medium of electronic textuality vibrantly asserts its presence, are these assumptions clearly coming into view. Consider, for example, Roland Barthes's influential essay "From Work to Text." Rereading it, I am struck both by its prescience and by how far we have moved beyond it. As Jay David Bolter and George Landow have pointed out, Barthes's description of "text," with its dispersion, multiple authorship, and rhizomatic structure, uncannily anticipates electronic hypertext. "The metaphor of the Text is that of the *network*," Barthes writes ("From Work to Text" 61). Yet at the same time he can also assert that "the text must not be understood as a computable object," "computable" here meaning to be limited, finite, bound, able to be reckoned (57). Written twenty years before the advent of the microcomputer, his essay stands in the ironic position of anticipating what it cannot anticipate. It calls for a movement away from works to texts, a movement so successful that the ubiquitous "text" has all but driven out the media-specific term "book." Yet Barthes's vision remains rooted in print culture, for he defines "text" through its differences from books, not through its similarities with electronic textuality. In positioning text against work, Barthes was among those who helped initiate semiotic and performative approaches to discourse, arguably one of the most important developments in literary studies in the past century. But this shift has entailed loss as well as gain. Useful as the vocabulary of "text" was in expanding textuality beyond the printed page, it also had the

effect, in treating everything from fashion to fascism as a semiotic system, of eliding differences in media. Perhaps now, after the linguistic turn has yielded so many important insights, it is time to turn again to a careful consideration of what difference the specificity of the form makes.[2]

In calling for medium-specific analysis, I do not mean to advocate that media should be considered in isolation from one another. Quite the contrary. As Jay David Bolter and Richard Grusin have shown in *Remediation*, media constantly engage in a recursive dynamic of imitating each other, incorporating aspects of competing media into themselves while simultaneously flaunting the advantages their own forms of mediation offer. Voyager's now-defunct line of "Expanded Books," for example, went to the extreme of offering readers the opportunity to dog-ear electronic pages. Another option inserted a paper clip on the screenic page, which itself was programmed to look as much as possible like print. On the other side of the screen, many print texts are now imitating electronic hypertexts. These range from DeLillo's *Underworld* to Bolter and Grusin's *Remediation*, which self-consciously pushes toward hypertext through arrows that serve as visual indications of hypertextual links. Media-specific analysis (MSA) attends both to the specificity of the form—the fact that the Voyager paper clip is an image rather than a piece of bent metal—and to citations and imitations of one medium in another. Attuned not so much to similarity and difference as to simulation and instantiation, MSA moves from the language of "text" to a more precise vocabulary of screen and page, digital program and analog interface, code and ink, mutable image and durably inscribed mark, texton and scripton, computer and book.

One area where MSA can pay especially rich dividends is literary hypertext. Some theorists working in the area of electronic literature argue that hypertext ought to be reserved for electronic texts instantiated in digital media. In my view, this is a mistake. When Vannevar Bush, widely credited with the invention of hypertext, imagined a hypertextual system, it was not electronic but mechanical. His pioneering article testifies that it is possible to implement hypertext in a wide variety of ways, not only through the "go to" commands that constitute the hypertext link in digital computers. If we restrict the term "hypertext" to digital media, we lose the opportunity to understand how a literary genre mutates and transforms when it is instantiated in different media. The power of MSA comes from holding one term constant across media—in this case, the genre of literary hypertext—and then varying the media to explore how medium-specific constraints and possibilities shape texts. Understanding literature as the interplay between form and medium, MSA insists that "texts" must always be embodied to exist in the world. The materiality of those embodiments interacts dynamically with linguistic, rhetorical, and literary practices to create the effects we call "literature."

In attending to the materiality of the medium, MSA explicitly refutes the concept of the literary work that emerged from eighteenth-century debates over copyright and that has held considerable sway since then, although not without contestations. As Mark Rose has shown in his important book *Authors and Owners: The Invention of Copyright,* legal

theorists such as Blackstone defined a literary work as consisting solely of its "style and sentiment." "These alone constitute its identity," Blackstone wrote. "The paper and print are merely accidents, which serve as vehicles to convey that style and sentiment to a distance" (quoted in M. Rose, 89). Subsequent commentators realized that it was not practical to copyright "sentiment," for some ideas are so general they cannot be attributed to any single author: that men are mortal, for example. Rather, it was not ideas in themselves but the ways in which ideas were expressed that could be secured as literary property and, hence, copyrighted. This judicial history, played out in a contentious environment where conflicting economic, political, and class interests fought for priority, had important consequences for literature that went beyond purely legal considerations, for it helped to solidify the literary author as a man (the author's assumed gender in these discourses was invariably male) of original genius who created literary property by mixing his intellectual labor with the materials afforded him by nature, much as Locke had argued that men created private property by mixing their labor with the land.[3] Consistently in these discourses, material and economic considerations, although they had force in the real world, were elided or erased in favor of an emphasis on literary property as an intellectual construction that owed nothing to the medium in which it was embodied. Although this conclusion was repeatedly challenged in court and in such literary movements as futurism and imagism ("No ideas but in things," William Carlos Williams declared), the long reign of print made it easy for literary criticism to ignore the specificities of the codex book when discussing literary texts. With significant exceptions, print literature was widely regarded as not having a body, only a speaking mind.[4]

Hypertext, understood as a genre that can be implemented both in print and in digital media, offers an ideal opportunity to bring the materiality of the medium again to the fore. MSA aims to electrify the neocortex of literary criticism into recognizing that strands which have traditionally emphasized materiality (such as criticism on the illuminated manuscript, on writers like Blake for whom embodiment is everything, on the rich tradition of artists' books) are not exceptions but instances of media-specific analyses. Literature has a body, or rather many bodies, and it always matters what the natures of those bodies are, even when the text—no, make that codex book or stitched pamphlet or CD-ROM or website—does not foreground its materiality as such.[5]

What kind of bodies, then, does hypertext have? To pursue this question, let me suggest a working definition. Following Jane Yellowlees Douglas and others, I propose that hypertext has, at a minimum, the following characteristics: multiple reading paths, some kind of linking mechanism, and chunked text.[6] In proposing these characteristics, my intent is not to draw a hard-and-fast line that will distinguish between hypertext and everything else. Rather, the boundary is to be regarded as heuristic, operating not as a rigid barrier but a borderland inviting playful forays that test the limits of the form and work to modify, enlarge, or transform them. From the definition, it will be immediately apparent that hypertext can be instantiated in print as well as electronic media. A print encyclopedia, for example, qualifies as a hypertext because it has multiple reading paths,

a system of cross-references that serve as linking mechanisms, and chunked text in entries separated typographically from one another. These hypertextual characteristics of the encyclopedia can form the basis for a print literary hypertext, as Milorad Pavic has brilliantly demonstrated in *Dictionary of the Khazars: A Lexicon Novel*. Other examples of print hypertexts include Ursula Le Guin's *Always Coming Home*, in which the audiotapes afford multiple ways to access the multimedia text; Paul Zimmerman's artist's book *High Tension*, in which a multiplicity of reading paths is created through an unusual physical form that allows the reader to fold over diagonally cut leaves to obtain various juxtapositions of text and image; and Robert Coover's "The Babysitter," a short story that pushes toward hypertext by juxtaposing contradictory and nonsequential events which suggest many simultaneously existing time lines and narrative unfoldings.

If we grant that hypertext can exist in either print or digital media, what distinguishes hypertext instantiated in a computer from hypertext in book form? To gain purchase on this question in the spirit of MSA, I propose the following game. Using the characteristics of the digital computer, what is it possible to say about electronic hypertext as a literary medium? The point of this game is to derive these characteristics from the medium itself, using the content and strategies of electronic hypertexts to illustrate how these characteristics serve as resources that writers can mobilize in specific ways. That is to say, restricting ourselves to the medium alone, how far is it possible to go? This kind of analysis is artificial in that it forbids itself access to the full repertoire of literary reading strategies, but it may nevertheless prove illuminating about what difference the medium makes. To clarify the medium's specificity, I will also offer examples of how these characteristics of digital media can be simulated in print texts. The point here is to explore what Bolter and Grusin call "reverse remediation," the simulation of medium-specific effects in another medium, as when Expanded Books simulated turning down page corners and marking passages with paper clips. My technique, then, amounts to constructing a typology of electronic hypertext by considering both the medium in itself (its instantiation in digital computers) and the extent to which its effects can be simulated in print (the reverse remediation that blurs the boundary between electronic media and print). As I suggested earlier, MSA operates not so much through a simple binary of similarity and difference as through media-specific considerations of instantiation and simulation.

Following these rules, I am able to score eight points, discussed in detail in the rest of this chapter:

1. Electronic Hypertexts Are Dynamic Images
2. Electronic Hypertexts Include Both Analog Resemblance and Digital Coding
3. Electronic Hypertexts Are Generated through Fragmentation and Recombination
4. Electronic Hypertexts Have Depth and Operate in Three Dimensions
5. Electronic Hypertexts Are Mutable and Transformable

POINT 1: ELECTRONIC HYPERTEXTS ARE DYNAMIC IMAGES

In the computer, the signifier exists not as a durably inscribed flat mark but as a screenic image produced by layers of code precisely correlated through correspondence rules. Even when electronic hypertexts simulate the appearance of durably inscribed marks, they are transitory images that must be constantly refreshed to give the illusion of stable endurance through time. This aspect of electronic hypertext can be mobilized through such innovations as dynamic typography, whereby words function both as verbal signifiers and as visual images whose kinetic qualities also convey meaning. In William Crandall's poem "On River Side," for example, words appear and disappear as the cursor clicks over the black screen, evocatively linking up with phrases already visible and sometimes changing them. Similar effects are achieved in a different way in Alan Dunning's artist's book *Greenhouse,* which creates a multilayered reading experience by overlaying translucent vellum pages onto opaque pages. Significantly, the five lines of text on the opaque pages are taken from five of Dunning's favorite works of literary criticism, each line set in different typography and written by a different author. As the vellum pages are overlaid onto these, traditional literary criticism, already interleaved with other critical texts to form a kind of hypertext, is further modified by the visual play set up by the image and Dunning's words printed on the vellum pages.

An important difference between print and electronic hypertext is the accessibility of print pages compared, for example, to the words revealed by the cursor's click in Crandall's electronic hypertext. Whereas all the words and images in the print text are immediately accessible to view, the linked words in Crandall's poem become visible to the user only when they appear through the cursor's action. Code always has some layers that remain invisible and inaccessible to most users. From this we arrive at an obvious but nevertheless central maxim: Print is flat, code is deep.

POINT 2: ELECTRONIC HYPERTEXTS INCLUDE BOTH ANALOG RESEMBLANCE AND DIGITAL CODING

The digital computer is not, strictly speaking, entirely digital. At the most basic level of the computer are electronic polarities, which are related to the bit stream through the analog correspondence of morphological resemblance. Higher levels of code use digital correspondence, for example in the rules that correlate the compiler language with a programming language like C++ or Lisp. Analog resemblance typically reappears at the top level of the screenic image, for example in the desktop icon of a trash barrel. Thus,

digital computers have an Oreo-like structure with an analog bottom, a frothy digital middle, and an analog top.[7] Although we are accustomed to thinking of digital in terms of binary digits, digital has a more general meaning of discrete versus continuous flow of information. Digital computers do not necessarily have to operate with binary code; in the early days of computing, computers were constructed using base ten code.[8] Analog computers, in contrast to digital ones, represent numbers as a continuously varying voltage. In analog computers and analog technologies in general, a morphological resemblance connects one level of code with another. In this sense, iconographic writing is analog because it bears a morphological resemblance to its referent (albeit in highly conventionalized ways), whereas alphabetic writing is digital, consisting of a few elements that can be combined to make many words precisely because the relation between mark and referent is arbitrary.[9] By contrast, iconographic writing requires a much larger symbol set because its elements tend to be almost as multiform as the concepts for which they stand.

Print books and digital computers both use digital and analog modes of representation, but they mobilize the two modes differently. An example of a print book that makes conspicuous use of a digital algorithm is Emmett Williams's *VoyAge,* in which all the words are three letters long (to accommodate this restriction, Williams often resorts to creative spelling). Williams imposed the further requirement that spacing between the words increases as the page numbers go up. On page 1, the three-letter words are separated by one space; on page 2 by two spaces; and so on. The book ends when the number of spaces that must intervene before another word can appear is greater than the spaces available on the page. This example makes clear that the difference between print and electronic hypertext consists not in the presence or absence of digital and analog modalities but rather in the ways these two modes are mobilized as resources in the two media. In *VoyAge,* the effect of using a digital algorithm is to create visual patterns through the placement of words on the page, so that the words function simultaneously as analog image and digital code. When the spacing brings all the words into a single column, for example, the narrator remarks, "NOW/WEE/GET/OUR/POE/EMM/ALL/INN/ONE/ROW. Typically, the computer employs a digital mode at deeper coding levels, whereas in print, analog continuity and digital coding both operate on the flat surface of the page.

POINT 3: ELECTRONIC HYPERTEXTS ARE GENERATED THROUGH FRAGMENTATION AND RECOMBINATION

As a result of the frothy digital middle of the computer's structure, fragmentation and recombination are intrinsic to the medium. These textual strategies can also be used in print texts, for example in Raymond Queneau's *Cent mille milliards de poèmes,* a book in which each page is cut into several strips corresponding to the lines of a poem. By juxtaposing the cut strip on one page with strips from other pages, many combinations are possible, as indicated by Queneau's title. Another example is Dick Higgins's book *Buster*

Keaton Enters into Paradise. To generate this text, Higgins played thirteen games of Scrabble, each of which started with the words "Buster Keaton" orthogonally arranged. He then used the words that turned up in the Scrabble games to create thirteen skits, each corresponding to one of the games. Here fragmentation was achieved using the Scrabble letters, a technique that emphasizes the digital nature of alphabetic writing; recombination is mobilized through the aleatory combinations that make words and Higgins's subsequent use of these game words in the skits.

With digital texts, the fragmentation is deeper, more pervasive, and more extreme than with the alphanumeric characters of print. Moreover, much of the fragmentation takes place on levels inaccessible to most users. This aspect of digital storage and retrieval can be mobilized as an artistic resource, reappearing at the level of the user interface. Stuart Moulthrop's "Reagan Library," for example, uses an algorithm that places pre-scripted phrases on the screen in random order. As the user revisits a screen, the text on that screen gradually becomes more coherent, stabilizing into its final order on a fourth visit, whereupon it does not change further. As if to emphasize that noise is not merely interference but is itself a form of information, Moulthrop has designed the piece so that one level of the text moves in the opposite direction from this trajectory. The screens in "Notes," which offer explanatory commentary, actually lose text as the user revisits, becoming more cryptic and enigmatic the more they are read.

POINT 4: ELECTRONIC HYPERTEXTS HAVE DEPTH AND OPERATE IN THREE DIMENSIONS

Digital coding and analog resemblance each have specific advantages and are deployed so as to make the most of these advantages. Analog resemblance allows information to be translated between two differently embodied material instantiations, as when a sound wave is translated into the motion of a vibrating diaphragm of a microphone. Whenever two material entities interact, analog resemblance is likely to come into play because it allows one form of continuously varying information to be translated into a similarly shaped informational pattern in another medium. Once this translation has taken place, digital coding is used to transform the continuity of morphological form into numbers (or other discrete codes). Intrinsic to this process is the transformation of a continuous shape into a series of code elements. In contrast to the continuity of analog pattern, the discreteness of code enables information to be rapidly manipulated and transmitted.

Human readers, with sensory capabilities evolved through eons of interacting with three-dimensional environments, are much better at perceiving patterns in analog shapes than performing rapid calculations with code elements. When presented with code, humans tend to push toward perceiving it as analog pattern. Although most of us learned to read using the digital method of sounding out each letter, for example, we soon began to recognize the shapes of words and phrases, thus modulating the discreteness of alphabetic writing with the analog continuity of pattern recognition. The inter-

play between analog and digital takes place in a different way with screenic text than with print, and these differences turn out to be important for human perception. With present-day screens, reading speed on screen is typically about one-sixth of that with print. Although the factors that cause this difference are not well understood, they undoubtedly have something to do with the dynamic nature of screen images. Text on screen is produced through complex internal processes that make every word also a dynamic image, every discrete letter a continuous process.

To distinguish between the image the user sees and the strings as they exist in the text, Espen Aarseth has proposed the terminology "texton" and "scripton." In a digital computer, "texton" can refer to voltages, strings of binary code, or programming code, depending on who the "reader" is taken to be. Scriptons always include the screen image but can also include any code visible to a user who is able to access different layers of program. Textons can appear in print as well as electronic media. Stipple engraving, although it is normally perceived by the reader as a continuous image, operates through the binary digital distinction of ink dot/no ink dot; here the scripton is the image and the ink dots are the textons.[10] In electronic media, textons and scriptons operate in a vertical hierarchy rather than through the flat microscale/macroscale play of stipple engraving. With electronic texts there is a clear distinction between scriptons that appear on screen and the textons of underlying code, which normally remain invisible to the casual user. The flat page of print remains visually and kinesthetically accessible to the user, whereas the textons of electronic texts can be brought into view only by using special techniques and software.

In reverse remediation, some books play with this generalization by making print pages inaccessible also. David Stairs has created a round artist's book entitled *Boundless* with spiral binding all around, so that it cannot be opened. A similar strategy is used by Maurizio Nannucci in *Universum*, a book bound on both vertical edges so that it cannot be opened. Ann Tyler also plays with the assumption that pages are visually and kines-thetically accessible to users in *Lubb Dup*, an artist's book in which several pages are double-faced, so that one can see the inside only by peering through a small circle in the middle or prying the two pages apart enough to peek down through the top. These plays on accessibility do not negate the generalization that the flat page is accessible to users, however, for their effect is precisely to make us conscious of the normative rule.

POINT 5: ELECTRONIC HYPERTEXTS ARE MUTABLE AND TRANSFORMABLE

The multiple coding levels of electronic textons allow small changes at one level of code to be quickly magnified into large changes at another level. The layered coding levels thus act like linguistic levers, giving a single keystroke the power to change the entire appearance of a textual image. An intrinsic component of this leveraging power is the ability of digital code to be fragmented and recombined. Although the text appears as a stable image

on screen, it achieves its dynamic power of mutation and transformation through the very rapid fragmentation and recombination of binary code. In addition, the rapid processing of digital code allows programs to create the illusion of depth in screenic images, for example in the three-dimensional landscapes of the video game *Myst* or the layered windows of Microsoft Word.[11] In these cases, both scriptons and textons are perceived as having depth, with textons operating digitally through coding levels and scriptons operating analogically through screenic representation of three-dimensional spaces.

Print books can simulate the mutability of electronic texts through a variety of strategies, from semitransparent pages that overlay onto other pages to more elaborate strategies. In Michael Snow's visual narrative *Cover to Cover*, the sequence begins with a realistic image of a door, with the next image showing a man opening the door to go into a rather ordinary room. With each successive image, the previous representation is revealed as a posted photograph, for example by including the photographer in the picture. As one approaches the center of the book the images begin shifting angles, and at the midpoint the reader must turn the book upside down to see the remaining images in proper perspective. At the end of the book the images reverse order, so that the reader then goes backward through the book to the front, a direction that is then implicitly defined as forward. To facilitate this shift in perspective, the book is bound on both sides so that either cover can function as "front." Thus, such fundamental aspects of the book as forward and backward, up and down, become mutable characteristics that change in the course of reading. Similar strategies are employed in Karen Chance's *Parallax*, wherein cutouts and reverse ordering are used to create two narratives, one seen from the point of view of a straight man who sees gay men as unwanted intrusions in his life, the other from the point of the view of a gay man who sees his life threatened by straight people who refuse to acknowledge his existence. A different approach is taken by Tom Phillips in *A Humument: A Treated Victorian Novel*. Phillips took William Mallock's obscure Victorian novel, *A Human Document,* and "treated" each page by creating images that left only a few words on each page untouched. These words typically are connected by pathways created by surrounding the word paths with colored backgrounds and images. As the word pathways meander down the page, they are often arranged in ways that allow multiple reading paths. Other hypertextual effects emerge from the interplay of the words in the pathways, other "treated" text that remains partially visible, and the striking, diverse images that the treated pages display. Through such manipulations, Mallock's text is made to mutate into an entirely new narrative. Phillips writes, "I took a forgotten Victorian novel found by chance. I plundered, mined, and undermined it to make it yield the ghosts of other possible stories, scenes, poems, erotic incidents, and surreal catastrophes which seemed to link with its wall of words" (quoted on the dust-cover). Although this book is not dynamic in the same sense as Java script, the hypertextual effects it achieves through mutation and transformation are complex and dynamically interactive.

POINT 6: ELECTRONIC HYPERTEXTS ARE SPACES TO NAVIGATE

Electronic hypertexts are navigable in at least two senses. They present to the user a visual interface which must be navigated through choices the user makes to progress through the hypertext; and they are encoded on multiple levels that the user can access using the appropriate software, for example by viewing the source code of a network browser as well as the surface text. As a result of its construction as a navigable space, electronic hypertext is intrinsically more involved with issues of mapping and navigation than most print texts.

When navigation does become an issue in a print text, the effect is usually to transform linear sequence into hypertextual multiplicity. Susan E. King's book *Treading the Maze* is spiral-bound on both lateral edges. The binding on the left side holds pages that display images on vellum; the binding on the right side holds opaque blue pages of verbal text. Different narrative orders are created by intermixing opaque and translucent pages. The author writes (on a page that most readers will not find until halfway through the book) that the most complete reading is achieved by turning back all the pages on both sides so that the back cover is exposed, then interleaving one opaque page with one translucent page until one arrives at the front. In this reading the last two pages are successive translucent images that overlay a labyrinth onto a woman's body, so that the maze the reader has traversed is imaged at once as a female body, an exploration of the labyrinth as a visual and conceptual form, and the body of the book experienced as a maze through which many paths may be traced.

POINT 7: ELECTRONIC HYPERTEXTS ARE WRITTEN AND READ IN DISTRIBUTED COGNITIVE ENVIRONMENTS

Modern-day computers perform cognitively sophisticated acts when they collaborate with human users to create electronic hypertexts. These frequently include acts of interpretation, as when the computer decides how to display text in a browser, independent of choices the user makes. It is no longer a question of whether computers are intelligent. Any cognizer that can perform the acts of evaluation, judgment, synthesis, and analysis exhibited by expert systems and autonomous-agent software programs should, prima facie, be considered intelligent. Books also create rich cognitive environments, but they passively embody the cognitions of writer, reader, and book designer rather than actively participating in cognition themselves. To say that the computer is an active cognizer does not necessarily mean that it is superior to the book as a writing technology. Keeping the book as a passive device for external memory storage and retrieval has striking advantages, for it allows the book to possess a robustness and reliability beyond the wildest dreams of a software designer. While computers struggle to remain viable for a decade, books maintain backward compatibility for hundreds of years. The issue is not the technological superiority of either medium but rather the specific conditions a medium instantiates and enacts. When we read electronic hypertexts, we do so in environments that include

the computer as an active cognizer performing sophisticated acts of interpretation and representation. Thus, cognition is distributed not only between writer, reader, and designer (who may or may not be separate people) but also between humans and machines (which may or may not be regarded as separate entities).

Print books can also be structured in ways that create and emphasize distributed cognition. Examples are telegraph codebooks, which matched phrases and words used frequently in telegrams with code groups that were shorter and thus more economical to transmit. The more sophisticated of these codebooks included "mutilation tables," which enabled a user to reverse-engineer a garbled message to figure out what code element ought to have been there instead of the incorrect element.[12] In this way the distributed nature of the cognition became evident, for part of the cognition resided in the sender, part in the telegraph operator, part in the codebook, part in the mutilation table, and part in the receiver. At any point along this transmission chain, errors could be introduced, making clear that comprehension depended on all the parts working together correctly in this distributed cognitive system.

POINT 8: ELECTRONIC HYPERTEXTS INITIATE AND DEMAND CYBORG READING PRACTICES

Because electronic hypertexts are written and read in distributed cognitive environments, the reader necessarily is constructed as a cyborg, spliced into an integrated circuit with one or more intelligent machines. To be positioned as a cyborg is, inevitably, in some sense to become a cyborg, so electronic hypertexts, regardless of their content, tend toward cyborg subjectivity. This subject position may also be evoked through the content of print texts (e.g., William Gibson's *Neuromancer* and Pat Cadigan's *Synners*), but electronic hypertexts necessarily enact it through the specificity of the medium. Of the eight points, this is the most difficult to simulate in book technology, which for all of its sophistication in content and production remains remarkably simple to use. Book lovers frequently evoke this quality of print, emphasizing that they enjoy books precisely because books do not interpolate them into the speed, obsolescence, and constant breakdown of electronic culture. This distinction between print and electronic forms is becoming more problematic, however, with the introduction of electronic books that look like print but have electronic hardware embedded in the spine that enables the pixels of the electronic "page" to be polarized in different patterns, so that one page can be any page. Hybrid forms like the electronic book show reverse remediation in action: as books become more like computers, computers become more like books.

In articulating these eight points, I hope it is clear that I do not mean to argue for the superiority of electronic media. Rather, I have been concerned to delineate characteristics of digital environments that writers and readers can use as resources in creating electronic literature and responding to it in sophisticated, playful ways. I have also shown how similar—but not identical—effects can be achieved in print books. Whether in print

or on screen, the specificity of the medium comes into play as its characteristics are flaunted, suppressed, subverted, reimagined.

Many critics see the electronic age as heralding the end of books. I think this view is mistaken. Books are far too robust, reliable, long-lived, and versatile to be rendered obsolete by digital media. Rather, digital media have given us an opportunity we have not had for the past several hundred years: the chance to see print with new eyes, and with it, the possibility of understanding how deeply literary theory and criticism have been imbued with assumptions specific to print. As we continue to work toward critical practices and theories appropriate for electronic literature, we may come to renewed appreciation for the specificity of print. In the tangled web of medial ecology, change anywhere in the system stimulates change everywhere in the system. Books are not going the way of the dinosaur but the way of the human, changing as we change, mutating and evolving in ways that will continue, as a book lover said long ago, to teach and delight.

AFTERTHOUGHTS

Since 1999, when I first began working out the ideas for "Print Is Flat, Code Is Deep," my thoughts about media-specific analysis have matured considerably. Perhaps the most important change has been in the way I define "materiality." As someone who has done serious work in a scientific field, I am well aware that the physical characteristics any object may be said to possess are essentially infinite; a computer, for example, could be described in terms of its power cord or the rare earth metals used in a CRT monitor. Of course, it almost never is described like this, because these characteristics are not normally of interest (except to manufacturers of power cords, of course). To deal with this challenge, in my recent book *My Mother Was a Computer: Digital Subjects and Literary Texts,* I describe the materiality of an artistic work as "an emergent property created through dynamic interactions between [the work's] physical characteristics and signifying strategies" (3). Materiality differs from physicality, then, in being inextricably linked with meaning. As an emergent property, it cannot be specified in advance but emerges through interpretation and debate. Thus conceived, materiality is not only about the "apparatus" but also about the meaning-making processes in which communities of users/readers/interactors participate.

Writing Machines was an important advance over this essay because it provided the opportunity to collaborate with Anne Burdick, a media designer, to create the critical equivalent of an artist's book. Conceived as a verbal/visual argument, *Writing Machines* made similar points about media specificity not only in words but also in its material form, including ribbed covers, clay-coated slick papers, shadowed pages, and other visual devices. I returned to the topic yet again in "Translating Media" in *My Mother Was a Computer.* This chapter extended and recast the case for media specificity in terms of editorial practices and received definitions of work, text, and document, arguing that material differences between different editions or versions of a work should not be collapsed into a singular object but rather regarded as an assemblage in which similar

objects are clustered together. The present essay, then, is the beginning of a trajectory that continues to spin out its implications in my work and thought.

ABOUT THE AUTHOR

N. Katherine Hayles teaches and writes on the relations of literature, science, and technology in the twentieth and twenty-first centuries. Her book *How We Became Posthuman: Virtual Bodies in Cybernetics, Literature, and Informatics* won the Rene Wellek Prize for the Best Book in Literary Theory for 1998–99, and her book *Writing Machines* won the Suzanne Langer Award for Outstanding Scholarship. Her most recent book is *How We Think: Digital Media and Contemporary Technogenesis,* along with *How We Think: The Digital Companion,* available at http://nkhayles.com. She is presently at work on a book on finance capital and literary theory.

NOTES

1. Portions of this essay have appeared in Postmodern Culture under the title "Flickering Connectivities in Shelley Jackson's Patchwork Girl: The Importance of Media-specific Analysis." Postmodern Culture 10.2, January (2000). Web.

2. In many ways this is a return to the agenda set by Marshall McLuhan. Particularly relevant is McLuhan's *Understanding Media: The Extensions of Man.*

3. Mark Rose explicitly draws this comparison between liberal economic philosophy and the construction of literary property (*Authors and Owners: The Invention of Copyright* 121).

4. Among these exceptions is the long tradition of shaped poetry, including concrete poetry in the twentieth century.

5. Recognizing the importance of a book's physicality—particularly artists' books, where the book's material appearance and operation may be crucial—I write only about books that I have had the opportunity to see and handle. I am grateful to Jennifer Tobias, reference librarian at the Museum of Modern Art in New York, for granting me access to their impressive collection of thousands of artists' books, to Joan Lyons, director of the Visual Studies Workshop Press in Rochester, New York, for granting me access to their collection of artists' books, to David Platzker at the Printed Matter Bookstore in New York for his kind help and guidance with their stock, and to Nexus Press in Atlanta, Georgia, for the opportunity to see their books. I have also drawn on my own modest collection of artists' books for examples.

6. I am grateful to Jane Douglas for making her book available to me in manuscript form and giving me permission to cite it.

7. For an exploration of what this Oreo structure signifies in the context of virtual narratives, see Hayles, "Simulating Narratives: What Virtual Creatures Can Teach Us."

8. ENIAC, the first large-scale electronic computer, operated with a code that used base ten.

9. Robert K. Logan makes this point in *The Alphabet Effect.*

10. I am indebted to Robert Essex for this example, proposed in a discussion of William Blake's strong dislike of stipple engraving and his preference (which for Blake amounted to an ethical issue) for printing technologies that were analog rather than digital.

11. To create the illusion of three-dimensional landscapes, the computer takes thin horizontal slices that can be approximated as two-dimensional and stacks them together. This requires massive calculations and would be impossible without the very rapid fragmentation and recombination that contemporary computers utilize.

12. I wish to thank Fred and Virginia Brandes of Atlanta for kindly giving me access to their excellent collection of telegraph code books and for their generous hospitality during my visit there.

POSTMEDIA AESTHETICS

Lev Manovich

MEDIUM IN CRISIS

In the last third of the twentieth century, various cultural and technological developments have together rendered meaningless one of the key concepts of modern art—that of a medium. However, no new topology of art practice came to replace media-based typology, which divides art into painting, works on paper, sculpture, film, video, and so on. The assumption that artistic practice can be neatly organized into a small set of distinct media has continued to structure the organization of museums, art schools, funding agencies, and other cultural institutions—even though this assumption no longer reflects the actual functioning of culture.

A few different developments have contributed to this conceptual crisis. From the 1960s onward, the rapid development of new artistic forms—assemblage, happening, installation (including its various subforms such as site-specific installation and video installation), performance, action, conceptual art, process art, intermedia, time-based art, etc.—has threatened the centuries-old typology of media (painting, sculpture, drawing) by the multiplicity of these forms. In addition, if the traditional typology was based on difference in materials used in art practice, the new media either allowed for the use of different materials in arbitrary combinations (installation) or, even worse, aimed to dematerialize the art object (conceptual art). Therefore, the new forms were not really "media" in any traditional sense of the term.

Another mutation in the concept of medium came about as new technological forms of culture were gradually added to the old typology of artistic media. Photography, film,

television, and video gradually appeared in the curricula of art schools and were given separate departments in art museums. In the case of traditional (i.e., predigital) photography and film, thinking of them as separate media in a traditional sense of the term still made sense. They used different material bases (photographic paper or film stock) and neatly fell on opposite sides of another fundamental distinction used by traditional aesthetics in defining the typology of media: that between spatial arts (painting, sculpture, architecture) and temporal arts (music, dance). Since photography dealt with still images and film dealt with moving images whose perception required time, and since they relied on distinct materials, adding these two forms to the typology of artistic media did not threaten the concept of medium.

Things were not so easy, however, in the case of television and video. Both the *mass* medium of television and the *art* medium of video used the same material base (electronic signal, which can be transmitted live or recorded on tape) and also involved the same conditions of perception (television monitor). The only justifications for treating them as separate media were sociological and economic: differences in the size of their audience, in the mechanisms of their distribution (via television network vs. museum and gallery exhibition), and in the number of copies made.

The case of television versus video is one example of how the old concept of medium used by traditional aesthetics to describe various arts came into conflict with the new set of distinctions important in the twentieth century: between art and mass culture. While the modern art system involved circulation of objects which were either unique or existed in small editions, mass culture dealt with mass distribution of identical copies—and thus depended on various mechanical and electronic reproduction and distribution technologies. As artists began to use the technologies of mass media to make art (photography, film, radio, video, or digital), the economy of the art system dictated that they use technologies designed for mass reproduction for the opposite purpose—to create limited editions. (Thus, visiting a contemporary art museum, we find such conceptually contradictory objects as "video tape, edition of 6" or "DVD, edition of 3.") Gradually, this sociological difference in the distribution mechanisms, along with other sociological differences already mentioned (the size of an audience and the space of reception or exhibition), became more important criteria in distinguishing between media than the distinctions in material used or conditions of perception. In short, sociology and economics took over aesthetics.

DIGITAL ATTACK

Along with the arrival of mass media throughout the twentieth century, and the proliferation of new art forms beginning in the 1960s, another development that threatened the traditional idea of a medium was the digital revolution of the 1980s–90s. The shift of most means of production, storage, and distribution of mass media to digital technology (or various combinations of electronic and digital technologies) and the adoption of

the same tools by individual artists disturbed both the traditional distinctions based on materials and conditions of perception and the new, more recent distinctions based on distribution model, method of reception/exhibition, and payment scheme.

On the material level, the shift to digital representation and the common modification/ editing tools which can be applied to most media (copy, paste, morph, interpolate, filter, composite, etc.) and which take the place of traditional distinct artistic tools erased the differences between photography and painting (in the realm of the still image) and between film and animation (in the realm of the moving image) (Manovich, *Language of New Media* 293–309).[1] On the level of aesthetics, the web has established the *multimedia* document (i.e., something which combines and mixes the different media of text, photography, video, graphics, and sound) as a new communication standard. Digital technology has also made it much easier to implement the already existing cultural practice of producing different versions of the same project for different media, distribution networks, and audiences. And if one can make radically different versions of the same art object (for instance, interactive and noninteractive versions, or 35-mm film and web versions), the traditional strong link between the identity of an art object and its medium becomes broken. On the level of distribution, the web has dissolved (at least in theory) the difference between mass distribution, previously associated with mass culture, and limited distribution, previously reserved for small subcultures and the art system. (The same website can be accessed by one person, ten people, ten thousand people, ten million people, etc.)

These are just some examples of how the traditional concept of medium does not work in relation to postdigital, postnet culture. And yet, despite the obvious inadequacy of the concept of medium to describe contemporary cultural and artistic reality, it persists through sheer inertia—and also because instituting a better, more adequate conceptual system is easier said than done. So, rather than getting rid of media typology altogether, we keep adding more and more categories: "new genres," interactive installation, interactive art, net art. The problem with these new categories is that they follow the old tradition of identifying distinct art practices on the basis of the materials being used—only now we substitute different materials by different new technologies.

For instance, all art on the net (i.e., art which uses the technology of the net) is lumped into a single category of "net art." But why should we assume that all art objects that share net technology should have anything in common as far as their reception by users is concerned?[2] The idea of "interactive art" is similarly problematic. As I suggested previously,

Used in relation to computer-based media, the concept of interactivity is a tautology. Modern human–computer interface (HCI) is by its very definition interactive. In contrast to earlier interfaces such as batch processing, modern HCI allows the user to control the computer in real-time by manipulating information displayed on the screen. Once an object is represented in a computer, it automatically becomes interactive. Therefore, to call computer media interactive is meaningless—it simply means stating the most basic fact about computers. (Manovich, *Language of New Media* 71)

Just as we should not assume that all artworks which use the technology of the net belong to the medium of "net art," it is a mistake to put all art objects which use—or, more precisely, form a layer on top of—the interactive technology of modern computing into one category of "interactive art." We may want to put forward a proposition that there *can* be a distinct medium of net art based on the technology of the net, but it is a mistake to automatically identify all art which uses the net as "net art."

A PROGRAM FOR POSTMEDIA AESTHETICS

Within the space of this article, I cannot begin to develop a new conceptual system which would replace the old discourse of media and describe postdigital, postnet culture more adequately. However, I can suggest one particular direction we may want to pursue in developing such a system. This direction would involve substituting the concept of medium by new concepts from computer and net culture. These concepts can be used both literally (in the case of actual computer-mediated communication) and metaphorically (in the case of precomputer culture). Here is what such a postmedia aesthetics might look like:

1. Postmedia aesthetics needs categories that can describe how a cultural object organizes data and structures users' experience of the data.

2. The categories of postmedia aesthetics should not be tied to any particular storage or communication media. For instance, rather than thinking of "random access" as a property specific to computer media, we should think of it as a general strategy of data organization (which applies to traditional books and architecture) and, separately, as a particular strategy of user behavior.[3]

3. Postmedia aesthetics should adopt the new concepts, metaphors, and operations of a computer and network era (e.g., information, data, interface, bandwidth, stream, storage, rip, compress). We can use these concepts both when talking about our own postdigital, postnet culture and when talking about the culture of the past. I think of a later approach not just as an interesting intellectual exercise but as something which ethically we must do—in order to see old and new culture as one continuum; in order to make new culture richer through the use of the aesthetic techniques of old culture; and in order to make old culture comprehensible to new generations that are comfortable with the concepts, metaphors, and techniques of the computer and network era. As an example of such an approach, we can describe Giotto and Eisenstein not only as an early Renaissance painter and a modernist filmmaker, but also as important "information designers." Giotto invented new ways to organize data within a static two-dimensional surface (a single panel) or a three-dimensional space (a set of panels in a church building). Eisenstein pioneered new techniques to organize data over time and to coordinate data in different media tracks to achieve the maximum effect on the user. In this way, a future book on informa-

tion design can include Giotto and Eisenstein alongside Allan Kay and Tim Berners-Lee.

4. The traditional concept of medium emphasizes the physical properties of a particular material and its representational capacities (i.e., the relationship between the sign and the referent). Like traditional aesthetics in general, this concept encourages us to think about the author's intentions and the content and form of an artwork—rather than the user. By contrast, thinking of culture, media, and individual cultural works as software allows us to focus on the operations (called in actual software applications "commands") that are available to the user. The emphasis shifts to users' capabilities and users' behavior. Rather than using the concept of medium, we may use the concept of software to talk about past media (i.e., to ask what kind of user information operations a particular medium allows).[4]

5. Both cultural critics and software designers came to draw a distinction between an ideal reader/user inscribed by a text/software and the actual strategies of reading/ use/reuse employed by actual users. Postmedia aesthetics needs to make a similar distinction in relation to all cultural media, or, to use the just-introduced term, "cultural software." The available operations and the "right" way of using a given cultural object are different from how people actually come to use it. In fact, a fundamental mechanism of recent culture is systematic "misuse" of cultural software, such as scratching records in DJ culture or remixing old tracks.

6. Users' tactics (to use the term of Michel de Certeau) are not unique or random but follow particular patterns. I would like to introduce another term, "information behavior," to describe a particular way of accessing and processing information available in a given culture. We should not always, a priori, assume that a given information behavior is "subversive"; it may be closely related to the "ideal" behavior suggested by software, or it may differ from it simply because a given user is just a beginner and has not mastered the best ways to use this software.

INFORMATION BEHAVIOR

Just as the term "software" shifts the emphasis from media/text to the user, I hope that the term "information behavior" can help us think about the dimensions of cultural communication, which previously went unnoticed. These dimensions have always been there, but in information society they have rapidly become prominent in our lives and, thus, intellectually visible. Today our daily life consists of information activities in the most literal way: checking email and responding to email, checking phone messages, organizing computer files, using search engines, and so on. In the simplest way, the particular way in which people organize their computer files, or use search engines, or interact on the phone can be thought of as information behavior. Of course, according to

a cognitive science paradigm, human perception and cognition in general can be thought of as information processing—but this is not what I mean here. While every act of visual perception or of memory recall can be understood in information-processing terms, today there is much more to see, filter, recall, sort through, prioritize, and plan. In other words, in our society, daily life and work largely revolve on new activities which involve seeking, extracting, processing, and communicating large amounts of information—from navigating a transport network of a large city to using the web. Information behaviors of an individual form an essential part of individual identity: they are particular tactics adopted by an individual or a group to survive in an information society. Just as our nervous system has evolved to filter information existing in the environment in a particular way suitable for the information capacity of a human brain, to survive and prosper in an information society, we evolve particular information behaviors (Adilkno, 99).[5]

Like other concepts of information society such as software, data, and interface, the concept of information behavior can be applied beyond specific information activities of the present, such as our use of a PalmPilot, Google, or a metro system. It can be extended into a cultural sphere and also projected into the past. For instance, we may think about information behaviors used in reading literature, visiting a museum, surfing TV, or choosing which tracks to download from Napster. Applied to the past, the concept of information behavior emphasizes that all past culture was not only about representing religious beliefs, glorifying rulers, creating beauty, legitimizing ruling ideologies, and so on—it was also about information processing. Artists developed new techniques of encoding information while listeners, readers, and viewers developed their own cognitive techniques of extracting this information. The history of art is not only about the stylistic innovation, the struggle to represent reality, human fate, the relationship between society and the individual, and so on—it is also the history of new information interfaces developed by artists, and the new information behaviors developed by users. When Giotto and Eisenstein developed new ways to organize information in space and in time, their viewers also had to develop the appropriate ways of navigating these new information structures—just as today every new major release of a new version of familiar software requires us to modify information behaviors we developed in using a previous version.

Surrounded by information interfaces in their everyday life, critics and artists have already begun to selectively think about past culture in terms of information structures. A good example of this is the prominence given to Frances Yates's book *The Art of Memory* in new media discussions. What I am suggesting, however, is that such concepts as information interface and information behavior can be applied to any cultural object, past or present. In short, every cultural object is partly a PalmPilot.

SOFTWARE AS A NEW OBJECT OF CULTURAL ANALYSIS

How would postmedia aesthetics, as I briefly sketched it here, fit within the history of cultural theory of the past few decades? If we are to think of cultural communication

following the basic information theory, that of author–text–reader (or, in proper terms of information theory, sender–message–receiver), this history can be summarized as a gradual shift in attention from the author to the text and then to the reader. Traditional criticism focused on the author, his or her creative intention, biography, and psychology. Arriving at the end of the 1950s, structuralism shifted the focus to the text itself, analyzing it as a system of semiotic codes. After 1968, the critical energy gradually shifted from the text to the reader. This shift has taken place for more than one reason. On the one hand, it became apparent that the structuralist approach had severe limitations: in treating every cultural text as an instance of a general system, structuralism did not have a lot to say about what made a given text unique and culturally important (Barthes, *S/Z*).[6] On the other hand, after the events of 1968, it also became clear that the structuralist approach inadvertently supported the status quo, the Law, the System. Because structuralism wanted to describe everything as a closed system and because it treated every individual cultural text as an instance of a more general "deep structure," structuralism turned out to be on the side of the norm rather than the exception, the majority rather than the minority, the society as it existed rather than as it could have been.

The shift from the text to the reader took a number of forms and can be thought of as following two stages. At the first stage, the abstract text of structuralism is being replaced by an abstract, ideal reader, as imagined by psychoanalysis (Kristeva) and psychoanalytically informed criticism, apparatus theory in film theory, or reception theory in literature. By 1980, this abstract reader was being replaced by actual readers and reader communities, both contemporary and historical, as analyzed by cultural studies, ethnography, the study of the historical reception of early cinema in film studies, and so on.

Having traversed the trajectory from the author to the text and to the reader, where can cultural criticism go next? In my view, we need to update the information model (author–text–reader) by adding two more components to it and focusing our critical attention on these components: software used by the author and by the reader. The contemporary author (sender) uses software to create a text (message), and this software influences or even shapes the kinds of texts being created—from Frank Gehry relying on special software in his architectural design, to Andreas Gursky using Photoshop, to DJs whose whole practice depends on actual software and/or software in a metaphorical sense (i.e., the operations allowed by turntables, mixers, and other electronic equipment). Similarly, a contemporary reader (receiver) often interacts with a text using actual computer software, such as a web browser, or software in a metaphorical sense, including older hardwired interfaces—particular controls provided by various electronic devices such as a CD player. (Given that modern computer software often imitates existing hardware interfaces—for instance, a QuickTime Player simulating controls of a standard VCR—this distinction is not as relevant as it may at first appear.) This software shapes how the reader thinks of a text; in fact, it defines what the given text is, be it a set of separate tracks on a CD or a set of multimedia components and hyperlinks presented as a web page.[7]

So far, I have talked about the communication model formulated in information theory as consisting of three components: sender, message, and receiver. In actuality, this model was more complex, having seven components all together: sender, sender's code, message, receiver, receiver's code, channel, and noise. According to the model, the sender encodes a message using his own code; the message is then transmitted over a communication channel; in the course of transmission, it is affected by noise. The receiver decodes the message using his own code. Because of the limited bandwidth capacity of the channel, the presence of noise, and possible discrepancies between the sender's and receiver's codes, the receiver may not receive the same message as sent by the sender. Developed originally for such applications as telecommunication (telephone and television transmission) in the 1920s–30s and code encryption and decoding during World War II, the goal of information theory was to help engineers construct better communication systems.

Different problems emerged as the communication model was adopted as a model of cultural communication. The engineers who developed this model were concerned with the accuracy of message transmission, but in cultural communication the idea of accurate transmission is dangerous: to assume that communication is successful only if the receiver accurately reconstructs the sender's message is to privilege the sender's meaning over the receiver's meaning. (We can say that cultural studies, which focuses on "subversive" uses of dominant culture, goes to another extreme as it assumes that only "unsuccessful" communication is worth studying.)

In addition, the communication model treats code and channel (the latter corresponding to "medium" as this term is commonly used) as passive, mechanical components: they are simply the required tools necessary to transmit a preexisting message. Because the model originally emerged in the context of telecommunication, it assumes that unmediated oral or visual communication—two people talking to each other or a person looking at reality—is ideal. It is only because we want such communication to take place over a distance that we need to bother with codes and a channel.

I think that adding the components of author's software and reader's software to the model emphasizes the active role that technology (i.e., what the original model calls "codes" and "channel") plays in cultural communication. Authoring software shapes how the author understands the medium she or he works in; consequently, the author plays a crucial role in shaping the final form of a technocultural text. For the reader who accesses this text through the software interface, this interface similarly shapes his or her understanding of the text: what types of data the text contains, how is it organized, what else is possible or not possible to communicate. In addition, software tools (again, both actual computer software and software in a metaphorical sense, i.e., a set of data operations and metaphors employed by a particular medium or representational technology) are what allow the authors and the users to remix new cultural texts out of existing texts. Again, the example of DJ practice can be invoked here.

What are the dangers of the postmedia aesthetic theory sketched here? Like any other paradigm, it privileges some directions of research at the expense of others. So while it

can be productive to begin approaching history of culture as the history of information interfaces, information behaviors, and software, such a perspective can make us less attentive to other aspects of culture. The most immediately obvious danger is that in its emphasis on information structures and information behaviors, postmedia aesthetics privileges cognitive dimensions of culture without providing any obvious way to think about affect.

Affect has been neglected in cultural theory since the late 1950s, when, influenced by the mathematical theory of communication, Roman Jakobson, Claude Lévi-Strauss, Roland Barthes, and others began treating cultural communication solely as a matter of encoding and decoding messages. Barthes begins his well-known article "The Photographic Message," published in 1961, in the following way:

> The press photograph is a message. Considered overall this message is formed by a source of emission, a channel of transmission and a point of reception. The source of emission is the staff of the newspaper, the group of technicians certain of whom take the photo, some of whom choose, compose, and treat it, while others, finally, give it a title, a caption, and a commentary. The point of reception is the public which reads the paper. As for the channel of transmission, this is the newspaper itself. . . .

Although later critics avoided such direct application of the terms of mathematical theory of communication to cultural communication, the legacy of this approach continued to linger for decades as the general paradigm of cultural criticism that even today focuses on the concepts of "text" and "reading." By approaching any cultural object/situation/process as "text" which is "read" by an audience and/or by critics, cultural criticism privileges informational and cognitive dimensions of culture over affective, emotional, performative, and experiential dimensions. Other influential approaches to cultural criticism of recent decades similarly neglect these dimensions. Neither Lacan's psychoanalysis (1960s–) nor the cognitive approach in literary studies and film theory (1980s–) deal with affect.

Postmedia, or the informational aesthetics I am sketching here, cannot directly deal with affect either, and thus its approach will need to be supplemented by some other paradigms. But it is important to remember that we cannot do full justice to contemporary culture by considering an information worker working on his or her computer and ignoring the music he or she is likely to listen to simultaneously on a CD or MP3 player. In short, we cannot just consider the office and ignore the club.

The office and the club: both rely on the same machine (digital computer). What is different between the two is software. At the office, we use web browsers, databases, spreadsheets, information managers, compilers, scripting tools, and so on. At the club, the DJ uses mixing and music-authoring software, either directly (on stage) or indirectly (by playing tracks composed beforehand in the studio).

If the same data-processing machine can be used for highly rational, cognitive processes (for instance, writing computer code) and for making possible the affective, bodily

experience of clubbing, this means that data do not belong just to the side of cognition. If data streams move our brains and our bodies, perhaps informational aesthetics will eventually learn how to think about affective data as well.

AFTERTHOUGHTS (2006)

My article was written in 2001. It argues for the need to focus on software as a new object of cultural analysis. Thus, it adds some detail to a provocative statement made in my book, *The Language of New Media* (written in 1999, published in 2001): "From media studies, we move to something which can be called software studies; from media theory—to software theory."

Today (2006), software theory is just beginning to take shape, with a few books already published or currently being prepared for publication: Alex Galloway, *Protocol* (2004); Katherine Hayles, *My Mother Was a Computer* (2005); Matthew Fuller (ed.), *Software Studies* (forthcoming); and Noah Wardrip-Fruin, *Expressive Computing* (forthcoming). But we are still at the very beginning of thinking critically about what lies underneath all media surfaces in our culture and what, until now, has largely been ignored: software.

ABOUT THE AUTHOR

Lev Manovich is the author of *Software Takes Command* (Bloomsbury Academic, 2013), *Soft Cinema: Navigating the Database* (MIT Press, 2005), and *The Language of New Media* (MIT Press, 2001), which has been described as "the most suggestive and broad ranging media history since Marshall McLuhan." Manovich is a professor at The Graduate Center, CUNY, a director of the Software Studies Initiative, and a visiting professor at the European Graduate School.

NOTES

1. For a more extensive discussion of this shift, see the chapter "Digital Cinema and the History of a Moving Image," in Manovich, *The Language of New Media*.

2. Outside of art, the net is perhaps best thought of as a number of distinct mediums that share some technologies and communication but, ultimately, have their own distinct identities. For instance, the net used for email is one medium, and commercial websites are another.

3. An excellent example of a new category which takes into account recent computer-based texts but at the same time can be used to talk about precomputer texts is "ergodic literature" developed by Espen Aarseth.

4. We can make a parallel here with the trajectory of cultural criticism in the past few decades. Beginning in the 1970s, cultural criticism shifted attention from the author and the text to the strategies and practices of readership (psychoanalysis, cultural studies, ethnography). Critics emphasized that each reader constructs her or his own text and that readers

employ various strategies of reading/interpreting/reusing cultural texts. In parallel, the designers of human–computer interfaces and software in general started to study the actual ways in which users employ software and other information technology.

5. Geert Lovink's ironic description of a figure of "Data Dandy" focuses our attention on the extent to which dealing with information has become a defining cultural characteristic of our time. See Adilkno, 99.

6. In that respect, Roland Barthes's *S/Z*, which describes the functioning of five semiotic codes in a Balzac short story, represents the unintentional admission of structuralism's defeat: Barthes selectively chooses to show the functioning of some codes in the story, unsystematically using different parts to illustrate the work of this or that code. So rather than producing a scientific structural analysis, he ends up writing a stimulating but completely idiosyncratic work of cultural interpretation.

7. Earlier, I said that the concept of software allows us to think about particular information operations that a user can perform in a given medium. It is interesting that historically, modern media theory and modern cultural criticism never systematically met, except in the works of Friedrich Kittler and his students and followers.

IF–THEN–ELSE
Memory and the Path Not Taken

Edward Branigan

For time is not to be laid out endlessly like a row of bricks. That straight line from the first hiccup to the last gasp is a dead thing. Time is two modes. The one is an effortless perception native to us as water to the mackerel. The other is a memory, a sense of shuffle fold and coil, of that day nearer than that because more important, of that event mirroring this, or those three set apart, exceptional and out of the straight line altogether.

WILLIAM GOLDING, *FREE FALL*

[Each element in a narrative film] is intended to advance the story to which it belongs, but it also affects us strongly, or even primarily, as just a fragmentary moment of visible reality, surrounded, as it were, by a fringe of indeterminate visible meanings. And in this capacity the moment disengages itself from the conflict, the belief, the adventure, toward which the whole of the story converges. . . . This dimension [of indeterminate meanings] extends, so to speak, beneath the superstructure of specific story contents; it is made up of moments within everybody's reach. . . .

SIEGFRIED KRACAUER, *THEORY OF FILM: THE REDEMPTION OF PHYSICAL REALITY*

[T]he whole experience of viewing works of art, from start to finish, is memorial in character; it is steeped in memory throughout; it is massively memorious. 'Memorious,' . . . means 'memorable' as well as 'mindful of.' . . . '[M]emorable' [means] being worth remembrance. As images they [works of art] are truly memorable and not merely recollectable: they stay with us in primary and secondary memory, and staying with us as they do they change us. . . .

EDWARD S. CASEY, "THE MEMORABILITY OF THE FILMIC IMAGE"

"One of the foremost tasks of art," observes Walter Benjamin, "has always been the creation of a *demand* which could be fully satisfied only later. The history of every art form shows critical epochs in which a certain art form aspires to *effects* which could be fully obtained only with a changed technical standard, that is to say, in a new art form. . . . Every fundamentally new, pioneering creation of demands will carry beyond its goal" ("The Work of Art" 237, emphases added). For Benjamin, a new art form and the necessary technical changes are not due to science working alone, driving a grand evolution toward a perfection of technology. Changes do not occur in a vacuum, nor is 'perfection'[1] defined a priori. Rather, a set of materials and techniques that has become—has been designated as—an 'art medium' represents the outcome of many competing social and historical demands within a community that is fabricating (not necessarily realistically) its sense of what is real with the technology at hand. For Benjamin, the historical situation is a key factor in determining which effects— which properties of a set of materials—will be desired by a perceiver and, hence, which changes and unintended consequences will be seen (retrospectively) as merely a 'natural evolution' of a 'medium.' What will be counted as the important effects and properties of a material is subject to change from time to time, thus changing the boundaries of an art medium.

One of the ways to study changing social demands and the rise of new art forms is to study the mind and language. Art is, of course, made by and for humans, and is designed to produce persuasive "effects" on a consumer. To me this suggests the pertinence of cognitive psychological concepts, such as the many kinds of mental schemata, each of which draws together presuppositions, clusters of knowledge, various inferential strategies, procedures, scenarios, metaphors, and heuristics, all imbued with social utility for a person confronting specific tasks in a given environment. The intersubjective world of society and culture is prominently embodied in, and shaped by, the personal and subjective. A vast literature in cognitive science bears upon the interactions between social demand and the architecture of the mind.[2]

Thus, I would like to suggest that the ever new forms of interactive media may be useful as tools for thinking about thinking—about how it is possible to have a thought, and the ways readers read to construct and (re)experience effects. In asking this question, one will also uncover some of the distinctive features that make these new information appliances complicit with the larger world of our problems, projects, and values. I will pursue the general nature of interactivity by offering a drastically abbreviated account of how human *memory* has been conceived with respect to the artifacts that were designed to serve it. I will examine several of the views of Plato, Freud, Descartes, and Wittgenstein that have implications for creating theories of art media, old and new. We will discover that the sharp differences among these views can be relativized to four different contexts, all of which bear upon memories of past media engineered to fit a conception of interactive media.

PLATO'S WAX BLOCK: AN OBJECTIVE FRAME

Every image is to be seen as an object and every object as an image.

BAZIN, "ONTOLOGY" 15–16

There is ontological identity between the object and its photographic image.

BAZIN, "IN DEFENSE OF ROSSELLINI" 98

My impatience with the idea that photographs and paintings never really project or represent reality (when, that is, they obviously do) expresses my sense that, as elsewhere, a fake skepticism is being used to deny . . . human responsibility. . . . Film is a moving image of skepticism: not only is there a reasonable possibility, it is a fact that here our normal senses are satisfied of reality while reality does not exist—even, alarmingly, *because* it does not exist, because viewing it is all it takes. Our vision is doubtless otherwise satisfiable than by the viewing of reality. But to deny, on skeptical grounds, just *this* satisfaction—to deny that it is ever reality which film projects and screens—is a farce of skepticism.

CAVELL, "MORE OF *THE WORLD VIEWED*"
188–189, EMPHASES IN ORIGINAL

Plato likens human memory to a *block of wax* that receives impressions from the world as well as makes imprints of thoughts and ideas (*Collected Dialogues: Theaetetus* 191c–d, 193c, 194c–195a, 196a). Memory is conceived as a *copy* rendered in a malleable medium, like a footprint in sand. The delicacy of the medium means that the remembered impression is inherently *fallible*. Plato elaborates the analogy by saying that in different individuals the block of wax may be relatively large or small, pure or muddy, hard or soft. These properties of the wax are linked to various features of memory. A quick, accurate, and lasting memory is produced by images that are "clear and deep," "distinct and well spaced" (*Theaetetus* 194c–195a).

Plato does not discuss how *motion* might be captured in memory even though elsewhere he treats motion as a fundamental constituent of the world which, for example, is an intrinsic part of the condition of the soul (i.e., of learning, practice, knowledge, intelligence, and judgment) as well as intrinsic to many forms of existence (being), causation (becoming, bringing into being), and perceiving (be*holding* in mind).[3] One can only speculate whether motion for Plato would be registered (held) in the wax as a single blurred impression or else as an ordered sequence of discrete impressions whereby each impression would differ from its neighbors by a small increment (or else be registered in some other way not based on producing a copy). Questions about what constitutes a memory of "knowing about motion" and the various types of "knowing" and "motion" are obviously crucial to an explanation of moving-image technologies. For example, does the memory of an unfolding event, or the memory of a sound, have a temporal component like the memory of an actual or inferred movement? These unanswered questions

about motion do, however, suggest that there may be a resemblance between Plato's hypothetical wax and certain conceptions of the *photograph* as a medium that holds an impression of an instant and *film* as a medium that reproduces motion through a sequence of impressions, as well as between Plato's wax block and the moving *phonograph* record with its etching in wax. The point of such media theories is to affirm the existence of an objective memory of the world in the form of a facsimile or document that has been *taken* whole from the world to be held in mind.

André Bazin, Siegfried Kracauer, Stanley Cavell, and Gregory Currie are theorists who argue that the essence of film is just this sort of wax-like photographicity and who derive from the assertion a variety of aesthetic prescriptions that often hover and touch upon a visualism as they ponder which effects will be desired by a spectator, made relevant and real. There is no claim in these theories that the objectivity is complete for either the wax medium of memory or the waxy emulsion of a photograph. It is clear, for example, that the "softness" of the wax—analogous to the response time of a film emulsion along with the time required to move a frame into its exposure position—places limits on which times and movements can be "duplicated" in memory, and with what accuracy, while the "density" of the wax will limit overall resolution. A film's sensitivity to light (its exposure "speed") would be broadly analogous to the "receptivity" of the mental wax, which is affected by a perceiver's attention, skills, and intention. Thus, at least for some cases, the mental wax must necessarily be *too slow* and inadequate in responding to a sensation or thought, or to an effort at accurate retrieval. Still, objective theories (and interobjective theories to be discussed below) do seek to distinguish sharply between "true" and "false," in spite of the fact that important aspects of aesthetic truth depend on counterfactuals, emotions, expectations, hypotheticals, abduction, abstract figuration, vague feelings, and a spectator's plausible but false memories in the form of narrative confabulation (Black).

PLATO'S AVIARY AND CAVE: TENSIONS WITHIN AN OBJECTIVE FRAME

Why then should cinema in its forms follow theatre and painting rather than the methodology of language, which gives rise, through the combination of concrete descriptions and concrete objects, to quite new concepts and ideas? [Language] is much closer to film than, for instance, painting, where form derives from *abstract* elements (line, colour).

EISENSTEIN, "DRAMATURGY OF FILM
FORM" 178 (EMPHASIS IN ORIGINAL)

In order to account for certain ordinary processes, such as our ability to search memory, Plato offers a second analogy: memory is like an aviary stocked with many kinds of birds in *groupings* of different sizes, including solitary birds. Each bird represents a bit of knowledge that has been captured for one's aviary, and knowing something at a particular moment is a matter of catching hold of the appropriate bird. Most importantly, the

birds may *move* in any direction and so, presumably, form new groupings (*Theaetetus* 197b–199b). Thus, Plato tries to solve the problem of process and change by simply embodying it within knowledge itself (i.e., in the flying birds), since it would seem that if a search procedure were simply to be stamped into wax, one would still need an explanation of the process that was capable of summoning the wax record of a search procedure, which would, in turn, animate and implement an examination of wax record inventories of wax records. A person who is remembering how an object *moved* in the world, then, would perhaps be catching hold of the relevant bird but continuing to move along with it, or else move in some other way in relation to the bird when one imagines oneself moving *within* the memory. Furthermore, the fact that the various groupings of knowledge themselves have a conspicuous mobility (connectivity, association), both within a group and among groups, would allow one to describe still other changes to the configurations of knowledge in memory, such as one's capacity for possessing knowledge about knowledge (i.e., seeing that a flock of birds has a certain relationship or associative connection to another flock), for utilizing testing procedures, for evaluating progress toward a goal, for weighing probabilities, and for managing links among clusters. This pervasive mobility is an essential feature of memory, since in general we remember not isolated "facts," nor "copies" of facts, but carefully interrelated collections of *generalized* data together with certain practices which allow *inferences* to be made to things not stored explicitly in memory; that is, we use memory to find and do new things, for which there are no records. In addition, whenever we 'rereremember' something, it is overwritten, updated, and reshaped in a process called "reconsolidation." When we remember something, our memory is of the last time we remembered it. The aviary analogy would seem to make a beholder's 'inner eye' (and 'inner ear' for birdsong) more active since one may move around the aviary, assume different points of view, nearly capture a bird, be distracted, notice a new bird, and so forth. Memory is active and itself shifts with/in time.

The aviary analogy, when it is applied to photography and film, suggests that there are limitations to waxy theories of media. The reason is that the aviary permits entirely new sorts of mobilities—that is, manipulations of knowledge—to emerge in a spectator's memory that are *not visible* on the screen at twenty-four frames per second because they were not visible to be photographed by a camera. (The birds may move on their own to a certain degree as well as respond to prevailing "environmental" factors of the mind.) For example, experiencing narrative structure, narration, and point of view, as well as interpreting fictively and ascribing value, emerge as decisive operations for comprehension not because they were in front of a camera, but only through particular kinds of active attention that a spectator pays to a text. If these forms of intelligibility based on procedures and routines of seeing were confined to the realm of the visible, they could not also "appear" in such verbal forms as a novel, drama, or poetry. Furthermore, if these kinds of attention could somehow be "subtracted" from the experience of a medium, then how much would remain to be called a "medium"? Would the remnant amount to

some sort of empty waxen slab or "container," an immutable Platonic core? What would be explained by such a barren material residue? An art form may imitate because it is animate(d), but the world or a material may not imitate, since it only is. The chemistry of photography is a fact, one of an indefinite number of facts and causal factors about any film; the important question, however, concerns to what degree this chemical fact is able to explain the diverse effects produced on a spectator, and the myriad uses to which he or she puts a film in anticipating, watching, thinking, believing, wishing, finding merit, intending, and (re)remembering. The issue here—to which we will return when considering interactive media—involves the degree to which the material characteristics of a medium determine its effects and uses, and thereby map in advance the medium's history, its figuration of memory.

Plato's conception of memory as an image copied into wax is consistent with his general view of art as merely a copy or imitation. Indeed, his famous cave parable suggests that the perception of art is several stages removed from the real. In effect, Plato argues that a beholder/prisoner in the cave forms (i) an idea or mental image of, for example, cat-ness based on [identical to?] (ii) a shadow being cast on a wall of the cave[4] being only (iii) a copy of a cat-puppet casting the shadow being only (iv) a copy of an artist's idea or mental image of cat-ness when the puppet was fabricated based on (v) an idealization of an actual (particular) living cat being only (vi) a copy of the 'invariant form' for all cats being (vii) a reflection of the Idea of the Good/God's 'vision' (the absolute real source of cat in an Ideal of rational order). The 'invariant form' for all cats is like a permanent, invisible wax impression that embodies the true being of a cat, or Idea of a cat, and is the defining principle of the class containing all actual and particular cats (including past and future cats), by which, finally, any specific cat can be recognized to be a cat and, in fact, thereby is a cat, for example, is a Norsk Skogkatt named Mia Ulrikke Toftner. (An absolute Form, unlike a cat or a human, does not die.) Therefore, in this scheme the beholder/ prisoner is six removes from the original creator of the Idea/Ideal (the truth) of cat-ness, namely God. Hence art lacks a true being, for how can a false appearance (a shadow cat) have a real existence rather than merely be ephemeral and imperfect? For Plato, art is an illusion, a systematic deception in which each copy loses something of reality by being composed of new (substitute) materials and effects in successive alien media platforms.[5] Taking the example of the shadow on the cave wall, we find that the shadow cat, as compared to the puppet cat casting the shadow, is composed of quite different materials (light and dark wet rock) and has a different color, larger size, and moves faster (since it covers a greater distance in the same time as the puppet); we also find that the puppet's volume has been replaced by a flat area on the wall even though the motion of the shadow—its time—on the cave wall as well as the contour of the shadow *do accurately preserve* the direction of movement and contour of the puppet.[6] For Plato, artists systematically create (semi-)counterfeits, lies, and delusions, stirring the emotions in bad faith and making what is real indistinct and unknowable. It would seem that for Plato, one's memory (say, of an art medium and its possible effects) is not sufficient in all cases for a beholder to

"trace backward" to find the real. Therefore, artists are to be excluded from the Republic (*Republic X* 605b, 607–608a).

Plato does not make clear whether the aviary analogy is meant to replace the wax analogy, compete and coexist with it, or in some more peaceful way interact with it. (Suppose, for example, that the birds confined in the aviary were considered to be themselves shadows or in some other way a product of shadows in a cave.) He also does not consider whether the aviary analogy might alter his conclusions about artists and art. It would seem that for Plato, art cannot be about processes and ways of knowing (like the way of grasping a bird or grasping how it moves or affecting its flight); nor can art effectively construct/imagine arguments about the world since this task is best (better?) performed by philosophical discourse and dialectic. Instead, the various art media seem to take on only the fatal, material qualities of the wax block: a fallible substance that lacks resolution and produces only a shadow copy of a chain of copies and that substitutes entirely new materials and transient, deceptive forms for original ones. However, if one takes Plato's aviary seriously, then one might argue that the goal of art is to allow the construction of emerging propositional attitudes and *ongoing propositions* about *relationships not pictured;* that is, the goal would not be to imitate the appearance of a thing or to reproduce its being, *to be it* in some way, but instead to *relate* it and to relate *to* it. Art, then, would merely be itself in order to work upon and reconfigure the *abstractions* within memory (i.e., the relationships in memory that make knowledge and belief cohere). Art would be a shadow, paint, or wax employed *to draw attention* to material properties; or, alternatively, be a triangle, green, moving, balanced, and a *link* to something *elsewhere* rather than being merely a *surface* approximation to something more fundamental and deeper, to a hidden inaccessible being. In what "medium" might such *linkages* be made? In language? Later we will examine Wittgenstein's ideas about the close connections among knowing a language, memory, knowledge, and acting in a world.

Plato does not apply his aviary analogy to the medium of written language. With apparently only the wax block in mind, Plato says that the art of words "presents a shadow play of words" and is designed to *imitate actions and feelings,* "exhibiting images of all things in a shadow play of discourse" (*Sophist* 268d, 234c; *Republic X* 603c).[7] Language, like painting, remains static imitation. With only the wax block as a model, language processes are reduced to the picturing of special marks (lines, letters, symbols), as if language were a form of painting. By contrast, if the aviary were taken as a model, language could be conceived as dynamic, creative memory.

FREUD'S MYSTIC WAX WRITING-PAD: A SUBJECTIVE FRAME

The action [of George Sand's novel *François le Champi*] began; it seemed to me all the more obscure because in those days, when I read, I often daydreamed, for entire pages, of something quite different. And in addition to the lacunae that this distraction left in the story, there was

the fact, when Mama was the one reading aloud to me, that she skipped all the love scenes.

<div align="right">PROUST, TR. LYDIA DAVIS, 42</div>

Today, watching [John Boorman's 1981] *Excalibur* . . . I had a strange experience: as the story unfolded, other stories—heard in childhood, or seen in other films—converged upon its symbolic images. By absorbing these other stories without actually mixing in with them, it renders them, nonetheless, all the more present.

<div align="right">RUIZ, 43</div>

ROBERT WILCO: [D]o you realize what it takes to make a movie? Like funding, for starters.

BUCKY KATT: Oh, I have that all figured out. The only real problem I can foresee will be getting it by the censors . . . you know, 'cause of the violence.

ROBERT WILCO: Violence? What violence? You're not allowed out of the house . . . the only people you interact with are Satchel and me.

BUCKY KATT: It's mostly dream sequences. [pause] I really shouldn't be more specific at this time.

<div align="right">GET FUZZY (CONLEY)</div>

Sigmund Freud also employed wax as a model for memory by drawing an analogy with a mystic writing-pad ("A Note upon the 'Mystic Writing-Pad'" 227–232). His prototype, however, has crucial new properties. Plato's wax block has been transformed into a wax scratch pad that is now used to prominently record writing and symbols. These linguistic elements, along with other markings internally generated by a person, reflect the fact that consciousness and short-term memory are dominated by a phonological stream that, together with subvocal rehearsal in intermediate memory, actively structures long-term memory into a proposition-like superstructure (i.e., mentalese or gist representing the "significance" and "associations" of something, biased by context).[8] The physical properties of the wax block discussed by Plato—such as its relative size, purity, and hardness—have been de-emphasized by Freud in favor of the dynamism of a process of writing using a pointed stylus on two sheets that cover the wax pad—the top one transparent celluloid, the bottom one translucent waxed paper. As the wax pad is etched by pressure from the stylus, the resulting pattern of grooves is traced back up onto the waxed paper and becomes visible. The appearance of writing is then followed by a kind of ghostly erasure when the sheets are lifted from the pad, allowing, in turn, new writing and ideas to appear as if by magic in a continuous process analogous to the "flickering-up and passing-away of consciousness" (231). For Freud, it is as if the wax pad were sending out pulses of excitation (i.e., when the paper is in contact with the wax) that make possible the "writing," thus activating consciousness and creating our *sense of time*. When the wax pad is not transmitting energy during an extended period (i.e., when the paper is not in contact

with the wax), consciousness and time are dormant (e.g., during sleep). This activity of writing, the flow of consciousness, and subsequent erasure is one of ceaseless motion and change that apparently is always new and always in the same place, thus instantiating the sort of contradiction (fluid immobility) by which the mind is felt to be incommensurate with the body, mere inert material.

Where Plato's wax was equally available to input from the sense organs and the mind, Freud's wax interacts with conscious and preconscious systems (i.e., the two sheets) whose function is to *mediate* between the sense organs and long-term memory.[9] Thus, it is not the *physical wax* that is slow to act, as Plato believed, but the interactions among the various processes answering to memory that require (and then create) conscious time. Hidden beneath the writing, analogous to the unconscious of a person, is the pad of wax that retains a history of *all* the writings—including all the contradictory writings—arranged in layers and strata like a palimpsest stretching back to infancy and to the womb. It is not a perfect history, of course, because of the effects of overwriting, rewriting, insertion, shifts, blotting out, censorship, and indeed because of an enormous number of other 'events' and psychic 'scenarios' that Freud describes as taking place, forming special groupings among the commingled writings inside the wax pad (e.g., deferred revision, retrospective screen memory, cathexis, fetishism, narcissism, fantasy, castration anxiety, seduction, the uncanny, negation, family romance, and the primal scene). This is the very opposite of Plato's ideal that the waxen mental images be "clear and deep," "distinct and well spaced" (*Theaetetus* 194c–195a), that is, that the images become a whole, perhaps ideally a panorama like a landscape painting, or perhaps better, like a photograph or tracking shot which responds/corresponds to the clarity, depth, and order of the familiar perceptible world.

Moreover, what appears as writing upon the topmost sheet has not really come from a stylus (i.e., from the external world) but has come up from the waxiness below as the condition for writing, as a trace of (unconscious, involuntary) memory. It is this wax of a deep psyche that facilitates the registration of external percepts and their 'interpretation' by a preconscious–conscious system. This *unsolicited* projection from memory into conscious awareness, similar to the work of dream, provides a ready conduit for trauma, desire, anxiety, ambivalence, fantasy, and so on, to be keenly felt in shaping a person's perceptions and behavior no matter how such motivations may be disguised, deferred, denied, displaced, distorted, misrecognized, rationalized, elaborated, fragmented, condensed, "forgotten" (i.e., repressed), and so on, in conscious thought. Thus, it is not the physical wax that is fallible, as Plato believed, but the transactions among the processes of memory that fashion, not physiognomy but projection, not errors but eros, not false impressions but telling mistakes.[10] Plato stood for the primacy of reason and the rule of law over sense impressions and human "appetites" and urged that justice in the widest sense, and the good life, would come from the *future* attainment, through careful reflection, of a more perfect knowledge. By contrast, Freud emphasized the importance of the involuntary and irrational as well as the relationship of conscious thought and knowledge

to a person's unique developmental *history,* to his or her inner accumulation of symbolic representations of unconscious drives, which symbols may then reemerge as images to structure an embodied human being. These "traces" on the mystic writing-pad can only be fragments (like a close-up shot or dreamlike sequence), not wholes, and only partial and distorted, not definitive.

A robust critical tradition has explored numerous ways of applying psychoanalytic theories to artists and their art and, more recently, to a spectator who is caught up in a relationship with a text that mimics unconscious symptoms by presenting itself as something like a mysterious writing-pad upon which the spectator both reads and writes. In this sort of interactive relationship, neither the text nor the "medium" for the text determines precisely which streams of thought and bodily disturbances (unexpected emotions, 'absurd' thoughts, strange gaps) must be enacted by the spectator who wishes to participate. Furthermore, the key psychic processes being enacted are *not visible* and lie closer to metaphor, parable, scenario, and narrative structure than to some archive of hard *copies* held in a material medium where remembering is like activating cues to open a file cabinet containing relevant folders or else to play back excerpts from a mental film strip. Instead the wax pad has an inherent mutability caused by such internal pressures as the ceaseless renarrativization of drives/instincts that provides a stream of multiple possibilities for a spectator's emotional identification. Thus, for Freud, it is not the physical wax that makes copies of the world as Plato believed but the interactions among the processes of memory that drive a person's encounters with the world. The unconscious must work to sample/imagine and fit/create bits of a continuous memory time that will intermingle with each lived occasion, given that time itself in the wax of the pad is spatialized, and timeless. Since Freud avoids the notion of a copy or imitation that is resident in memory, there is no necessity to adopt Plato's negative evaluation of artists and art.

Freud's wax writing-pad is therefore more complex than Plato's wax block. With Freud, one has moved farther away from material and formal definitions of memory and closer to the notion that memory is an active causal factor in determining how we perceive and act—how we *make* something of time and make it *count.* As a result, the impact of memory on the definition of an art medium becomes greater. This may be illustrated by recalling the implications of Plato's cave parable for a definition of "medium." If, instead of Plato's search for a thing's "true being," we measure the representations that appear in the cave according to their *significance for long-term memory* (i.e., in the above case of the "shadow cat," a search for generic knowledge or world knowledge lying *behind* appearance), then the "medium" for Plato simply reduces to the (sinister) machinery inside the cave (which includes a parapet behind which artist-ventriloquists hold puppets up into the light from a bonfire to create shadows on the wall in front of the prisoners) or else reduces to the appearance of visible appearances on the cave wall or, in a more subtle variation, reduces to that which "frames" the appearances on the "screen" of the cave wall. Plato's own interpretation of his cave parable stresses the inadequacy of these

moving shadows and echoes by describing the meaningless prizes that the prisoners award each other: prizes for those persons who are the quickest to recognize a shadow and who best remember ones already seen, who know which elements belong together in what order, who have the keenest memory for a continuous movement of shadows, and, finally, who are the most successful in anticipating what will appear next (*Republic VII* 516c–d). These prizes would seem to have analogues in the watching of film—namely, in the perceiving of mise-en-scène, narrative causality, camera movement, and editing, respectively.

The conclusion would seem to be that in defining a "medium," from the perspective of Freud, one cannot, as Benjamin argues, rely on the technology or materiality of the machine alone (be it sinister or benevolent or of whatever objective character), nor can one set aside a person's *experience* so that the medium is again left behind as a pure residue—that is, left behind as the "true being" of an art that directs an aesthetic embellishment of forms or else acts as a catalyst to a pure and clear perception—as if a bright line could divide a visible and/or visual appearance from its meaning or divide a sentence from its meaning or divide present sensory experience from knowledge (i.e., from memory and interpretation). Freud's intuition would be that the most important apparatus in the cave is psychic (i.e., mnemonic). Consequently, any theory about the nature of a medium must be founded on its interactivity with present thought, and with the memory of other thoughts. A "medium" would not be a priori or ahistorical but founded on the human psyche, body preferences, and interactions with an environment. As Proust suggests in the epigraph, the effort of engaging a text is much more complex than the fact of words on a page or, by extension, the visibility of forms on a screen.

DESCARTES'S SEALING WAX AND WITTGENSTEIN: INTEROBJECTIVE AND INTERSUBJECTIVE FRAMES

This photograph was made in September of 1960. [The photograph is being described in a voice-over but is seen only later in the film, thus forcing a spectator to exert great effort in attempting to recall the fine details of its description and interpretation, and recall them in a hurry, because when the photograph is finally seen in the film, it is slowly burning on a hotplate—as if it were, perhaps, being melted like Descartes's sealing wax, leaving only an incomplete memory. At the same time, a new unseen photograph is being described in voice-over.] The window [in the photograph] is that of a dusty cabinetmaker's shop. . . .

I first photographed it more than a year earlier, as part of a series, but rejected it for reasons having to do with its tastefulness and [Platonic cave-like?] illusion of deep space.

Then, in the course of two years, I made a half-dozen more negatives. Each time, I found some reason to feel dissatisfied. . . . Once a horse was reflected in the glass, although I don't recall seeing that horse. . . .

Finally, the cabinetmaker closed up shop and moved away. I can't even remember exactly where he was anymore.

But a year after that, I happened to compare the prints I made from the six negatives. I was astonished! In the midst of my concern for the flaws in my method, the window itself had changed, from season to season, far more than my photographs had! I had thought my subject changeless, and my own sensibility pliable [like Freud's wax writing-pad?]. But I was wrong about that.

So I chose the one photograph that pleased me most after all, and destroyed the rest. That was years ago. Now I'm sorry. I only wish you could have seen them!

VOICE-OVER NARRATION FROM HOLLIS FRAMPTON'S 1971 FILM,
(NOSTALGIA); MOORE, 82, MY ELLIPSES; FRAMPTON, 204

If I say 'I meant *him*,' a picture might come to my mind, perhaps of how I looked at him, and so forth; but the picture is only like an illustration to a story. From it alone, it would mostly be impossible to infer anything at all; only when one knows the story, does one know what the picture is for.

WITTGENSTEIN, *PHILOSOPHICAL
INVESTIGATIONS* § 663 (EMPHASIS IN ORIGINAL)

René Descartes also wrestled with wax. Descartes worried about the ontological implications of a piece of wax from a honeycomb after it had been melted in order—we shall imagine—to seal an envelope. "I put the wax by the fire, and look: the residual taste [of the honey] is eliminated, the smell [of the flowers from which the honey was gathered] goes away, the colour changes, the shape is lost, the size increases; it becomes liquid and hot; you can hardly touch it, and if you strike it, it no longer makes a sound" (*Philosophical Writings* II, "Second Meditation" of "Meditations on First Philosophy" 20 [30]).[11] Although melting the wax—in preparation for a new use—changed its perceptible qualities, there continued to be an urge to say that its *identity* remained unchanged, that it was still wax; in fact, that it was still *the same* wax (20–23 [30–34]). But what is this concealed thing called "identity"? Is it similar to Plato's "true being," that is, an absolute Idea or defining principle of, for example, wax (or Wax)? Most importantly, how do we come to know about "identity"? Why should we speak of it, what is its use (i.e., what is the use of "classifying" and "distinguishing" things, and deciding when they change or not)? A similar problem arises in the case where perceptible qualities are the same and yet the identity is said to be different (e.g., gold and fool's gold). The implication seems to be that there is something more to objects than appearance, just as there seems to be something more to knowledge and memory than sensation. Plato's analogy with an aviary would be an admission that memory is more than a wax copy of sensation. For Plato, memory was without doubt "deeper" inside a human being, closer to true identity and to the soul than changeable facsimiles like painting and writing.

Descartes sought to understand how he was able to judge the nature of (changeable) objects (e.g., wax) because it helped him understand how to judge his own nature.[12]

Descartes's well-known answer about his own nature focused on something internal and intangible, and perhaps innate: the ability to think, or, rather, thinking.[13] He thus raised the general issue of cognition that leads, in turn, to an epistemological inquiry concerning 'the means by which something is known' (see *Philosophical Writings* II, 22 [32]). Knowing, for Descartes, is a matter of the proper exercise of mental scrutiny (and the will), of intelligence, intellect, or reason, of "the faculty of judgment which is in my mind"; it is not a matter of sense impression or imagination (18, 20–22 [27, 31–32]).[14] In his discussion of the wax, Descartes seems to say that in order to know the nature (identity) of an object, one must understand (judge) the object's place *within or under causal law;* that is, one must understand the *general way* in which an object is "flexible and changeable" and capable of assuming "various forms" (20 [30–31]).[15] This suggests that a material object registered in memory is informed by cognition, by our knowledge of some general thing(s) or causal process(es), and, thus—like prototype schemata or a set of associated categories or canonical representations—what is in memory is not necessarily a copy of an actual thing but rather is a constructed or *composite* 'object' that has never been seen, that is, a generic object that helps us identify many actual things and their various realized and unrealized forms. A 'composite' object is created in memory through processes that discard 'difficult-to-assimilate' information, highlight 'important' traits, fill in 'gaps,' and revise what is experienced until it fits a 'norm' and fits with 'personal' experience, causal hypotheses, and expectation.[16] Thus, material objects and mental objects are *equally* (!) abstract entities. This suggests that for Descartes, the diverse processes of thinking and memory that define the human being have a reciprocal in the methods of science and in the processes and regularities of physical law.[17] He says, "I regard the difference between the soul [mind, consciousness, self] and its ideas as the same as that between a piece of wax and the various shapes it can take" (*Philosophical Writings* III, 232 [113]). By contrast, in the cave parable, Plato argues that an Idea (e.g., the Idea of the Good) is to Intelligence (the intelligible) as Light (the Sun) is to Vision (the visible, the perceptible). Although both Descartes and Plato build on objective physical laws, Descartes maintains a parallel type of separation between mind with its contents and the material world with its changing shapes. Plato, however, entwines mental faculties (e.g., seeing) with the Forms of the world (e.g., light) such that the same set of laws should govern both realms (as in the double meaning of 'seeing the light'). Since for Plato art is manufactured, its identity can only be parasitic on the basic laws and Forms of the world—a mere imitation of the real.

Now, if one thinks about the identity of objects (e.g., the nature of waxiness or birds of a feather, leaves on a tree, coins in a pocket, types of triangles), one might ask how an identity is to be known and *in what context it is to be thought about,* that is, how it is *to function* in serving our interests in thinking about it. What is identity itself, so to speak (i.e., the identity of "identity" . . .)? Perhaps a partial answer is that we make use of the idea of "identity" in order to control the objects that surround us and to keep the objects from changing too fast—that is, to maintain a moderate continuity in our perception of

the world—much as we construct a self-definition, a *conscious* Self, in order to control oneself and prevent one from changing too fast.[18] As Freud suggests, the conscious Self may be simply a kind of manufactured entity that is fit to a situation (according to the "reality principle" rather than the "pleasure principle"), albeit an artifice necessary for survival. Furthermore, the Self is subject to the vicissitudes of developmental stages from infant to adult as well as pressures from memory (trauma, desire) and present exigencies (the Other). If true, then the idea of an "identity" for something carries with it an aspect of *convenience and efficacy.*[19]

In this way, we have returned to Walter Benjamin, to his notion that the art object—its identity—is relative to a historical situation. "Identity" or "being" without any context, like the number "1," is too static to *accomplish work* in the manner that, for example, perception, calculation, and memory would seem to work, for these latter are embedded in and responsive to a situation. Benjamin believes that a medium for art is called into being by a demand for certain new effects in relation to a particular situation. The desire for effects arises from a community of persons interacting with their environment. Thus, the four theories of memory that we have been considering may be regarded as attempts to explain how the mind is able to retain impressions, later reworking and redeploying them to create/adjust a person's responses. For example, art objects believed to be made out of, as it were, Plato's wax block may come to be seen as dangerous and alluring copies, mere imitations of other things, perhaps all the more seductive for being themselves incomplete and less than perfect in some respects, hence necessarily inaccurate, much as viewing something from a distance will make many of its features indistinct and may lead to mistaken judgment. Alternatively, the copies may be too perfect, leaving one trapped in simulacra and forgeries. Versions of the waxen block theory would seem to be especially popular today among politicians decrying the deleterious effects of popular and/or mass culture, imagining spectators as robots or prisoners in a cave.

Other theories of memory recast the identity of art in distinctive ways. For example, art objects made out of Freud's wax pad may become mysterious and symbolic entities, lodged deep within the psyche, and indeed wholly other than their visible, or even their imaginary/imagistic, appearances.[20] Art in the spirit of Descartes's sealing wax speaks a more ordinary language and is set within, or against, familiar (determinate, certain) contexts and causal sequences, often as a *message* or expression of authorial or authoritive reason (e.g., taking on a sequence of rational intentional forms) cued by an institutional setting, not unlike a letter sealed by wax in an envelope that is caught up in multiple causal transactions. And finally, I would argue that the art, ironically, that emerges from Plato's aviary is dynamic and transformative, aimed at analysis and problem-solving; it is an art based not on the accuracy of objective or subjective "facts" or on "reproduction/communication," but on *skills,* on applying knowledge *to do* (grasp) something. Art, under the aviary description of memory, has an external flexibility about it, not unlike the internal mutability of Freud's wax pad, because 'skills' and 'protocols of seeing' are fit differently to different contexts and are adapted to particular occasions of use. Paradoxically, art under this description may

possess a value greater than the traditional attribute of esteem, namely a somewhat static 'timeless-ness,' by being instead simply 'timely,' by being capable of being fit continuously to (several, many) new practical contexts. Such an approach sees the visual arts in the subjunctive mood so that an act of seeing is about more than what is *pictured* and includes, for example, implicit 'what-if's,' as in the following expressions of a "virtual" reality ("it is as though"), to which we will return: what if, if only, as if, if then else, what else.[21]

By assembling aviaries, we seek to impose our will on circumstances. The skills and imagination necessary for our projects may be glimpsed in the "meanings" created through various uses of language. Through language, we select a vocabulary appropriate to the actions we wish to perform. A noteworthy theory of language that highlights this pragmatic dimension is that found in the later work of Ludwig Wittgenstein. "A meaning of a word is a kind of employment of it," he states. "For it is what we learn when the word is incorporated into our language. That is why there exists a correspondence between the concepts 'rule' and 'meaning.'" Wittgenstein continues:

> If we imagine the facts otherwise than as they are, certain language-games lose some of their importance, while others become important. And in this way there is an alteration— a gradual one—in the use of the vocabulary of a language. Compare the meaning of a word with the "function" of an official. And "different meanings" with "different functions." When language-games change, then there is a change in concepts, and with the concepts the meanings of words change. (*Philosophical Investigations* §§ 61–65)

In order to describe the specialized goals and particular circumstances in which words are employed to accomplish tasks and hence acquire meanings, Wittgenstein divides "language" in general, which is vast and amorphous, into a series of specific "language-games" with their own rules for interacting with and creating various 'worlds,' or in his phrase, "forms of life." A meaning of a word is neither an abstract tool for all occasions nor an instance of some generalized institution, nor is it part of a universal logic; rather, it is 'local' like the conduct of someone acting in an official capacity in performing a job on a particular occasion. 'Learning' a language-game is acquiring the skills necessary to accomplish work in a particular situation, or as Wittgenstein says, "knowing how to go on," that is, knowing how *to continue* acting appropriately in a given kind of situation and in accordance with a chosen *story* (see epigraph).[22] Thus, the analogue to the wax of Plato, Freud, and Descartes for Wittgenstein would be the plasticity of language to play many games, which is itself derived from the plasticity of human behavior to enact many stories. Whereas the lines etched on a wax block, tablet, and seal may be thought of as mapping out a definite "path," Wittgenstein draws attention to the collection of paths *not* taken that, by being virtual, define how it is possible to use a particular, waxen language-game to speak about a single path.

Wittgenstein's later theory of language as pragmatic use may be contrasted with his earlier theory in *Tractatus Logico-Philosophicus,* and broadly with Platonic waxen block

theories of language, where words are "copies" of things in the sense that each word has a strict, one-to-one, timeless *denotative* relationship with a thing (i.e., the word is fit to a single archetypal story) and so is able to substitute for the thing while the thing verifies the meaning of the word. Other approaches to the use of language envision meanings as tied to particular *psychological* states (cf. Freud's *free* association) or to efforts to establish a causal pathway, a *communication* with someone, including being alert to conversational implicatures (cf. Descartes).

One may classify these four theories of memory (and language and art) in a still different way by locating each of them within its primary domain of application. Plato's wax block, which produces copies of things (e.g., a mental copy of a shadow cat on a cave wall), is designed to locate and measure memory within the domain of the *objective*. Freud's mystic wax writing-pad, which carries traces of psychic processes, is designed to fix memory within the domain of the *subjective*.[23] Descartes's sealing wax, which manipulates information about the future of things, initially through rational thought and then through exchanges with others and with the world (relying on causal regularities), fixes memory in the *interobjective*. And finally, Plato's aviary and Wittgenstein's language-games, which investigate a person's pragmatic skills and procedures of problem-solving (where problems and stories are relative to situation and culture), fix memory in the *intersubjective*. Similarly, assumptions about art objects and media—and, thus, also the aesthetic prescriptions and values that are associated with these assumptions—may be framed by, or in relation to, the objective, subjective, interobjective, and intersubjective.[24] Moreover, the definition of "history" (so important to Benjamin), and even the definition of "material object," will depend on which of the four frames we take as background.[25] An important way in which the interobjective and intersubjective differ from the objective and subjective is that the former pair incorporate emergent sets of laws dealing with the dynamics of elements within an *interactive group*.[26]

Frampton's nostalgia in the epigraph for what has become lost to view (in several senses) and seen only in hindsight is the dark twin of Descartes's faith in the power of causal thinking to explicate what must or might be next, rather than no longer. A second aspect of Frampton's nostalgia comes from intersubjective qualities that emerged when he compared his memory of the six photographs of the cabinetmaker's window with all of the other photographs in his film and began to create a story. Qualities that previously were latent and contingent in individual photographs intermingled to produce a more complicated memory than the cabinetmaker's shopwindow or Frampton's feelings of personal loss or artistic failure. It was a new, virtual memory because it was based on the possibility of *relationships* among a series of photographs that pointed toward what may have been missed in everyday, lived experience. Of the destroyed photographs, he says, "I only wish you could have seen them!" Frampton's strong emotions at the end arise from his recognition that memory and photography had reached a limit, having been replaced by the language-game of a story being told about memory and photography.

INTERACTIVE MEDIA IN FOUR FRAMES AND FREUD'S INTERACTIVE UNCANNY

Have you ever dreamed about a place, you never really recall being to before? A place that maybe only exists in your imagination? Someplace far away, half remembered, when you wake up. When you were there though, you knew the language, you knew your way around. That was the Sixties. No, it wasn't that either. It was just '66, and early '67—that's all it was.

THE LIMEY, DIR. STEVEN SODERBERGH

I do hope you enjoy these rainy New Mexico evenings. They have a fabulous melancholy to them. They bring us closer to some greater design. [pause] At least I hope so.

GOVERNOR WALLACE'S WORDS TO PAT GARRETT IN *PAT GARRETT AND BILLY THE KID*, DIR. SAM PECKINPAH

The theories of memory discussed above yield identities for art based on notions of an illusory copy or apparition of something (wax block); an enigmatic psychic rebus (mystic writing-pad); a kind of causal communication game (sealing wax); and, lastly, a procedure for seeing and acting in response to a situation or task (aviary and language-games). How might each of these theories formulate an identity for the "interactive media"? I believe that these theory templates[27] allow one to speak of the interactive media in terms of virtual realities and simulations (wax block); as a startling new eruption/intrusion of the human into nature (mystic writing-pad); and as an unprecedented manipulation of databases, connectivity, and information (sealing wax). Finally, and importantly, from the standpoint of an aviary-inspired theory in which art is the embodiment of *procedural* knowledge (i.e., of learned skills summoned from memory to fit tasks), the interactive media would be defined in terms of its most fundamental practice—its overt "interactivity"—which is generated by the basic computer instruction or command: "if-then-else." More exactly: if Boolean condition a is true, then execute instruction b; but otherwise, when a is not true, then execute instruction c.

The command "if-then-else" is the basis of all comparisons, tests, computations, branches, loops, and subroutines that occur in a computer, that is, in the "memory" of a computer.[28] This single, powerful command is the logical, language-like "hot wax" that defines the operation of the memory of these media and, hence, defines how effects can be produced. I believe that a broad form of interactivity strives to maximize the "else" of "if-then-else" by creating for the user the *promise* of a multitude of paths *not* taken. Thus, interactivity may be thought of as a flaunting of the *possibility* of what the user might do: places the user has not yet encountered, knowledge and fantasies not yet entertained, skills not yet discovered or mastered, and so forth. The future is made to coexist with the present, but underneath it, on the next screen that opens from within, lies nearby, or is a few keystrokes or clicks away. This is an art form that has staked its difference from the

other arts on what the user has not accomplished, on effects that he or she has not experienced, but that may come to mind, like it or not. In short, the interactive media aim to suspend the user in a permanent state of suspense, or better, to stir perpetual expectation.

How might the "if-then-else" operation be conceptualized by the other three theories of memory? For Plato, what exists *else*where is the certain proof that objects made from the wax block are only imperfect copies and forgeries, and thus failures. By contrast, for Freud, the *else* is a memory of a deeper memory—a manifestation of otherness, a trace of the Other—while the 'path not taken' may be a sign of repression (an absence) strangely linked to the path that *is* being taken. For Descartes, the existence of some thing *else* (e.g., sealing wax taking on a new form) furnishes a necessary destination for thought, that is, affords the basis for *intention*—an exercise of will—that must always have an object somewhere else, must always be a state of consciousness *of* something or *about* something, even if only *of* the act of thinking by a *self* that is conscious of its thought. Moreover, for Descartes, there is a definite path—a logic, a science, a rationality—that surely and effectively connects a starting point to a goal, just as solid wax is connected to melted wax.

To summarize: for Plato, memory exists to recover the likeness of what one already knows of the world of appearance through experience (i.e., the wax imprint of an object in the world) and, more generally, to recover an innate knowledge of the Forms forgotten by the soul responsible for appearance.[29] For Freud, memory exists to recover, or to keep under cover, what one has repressed and lost to an inner, primordial elsewhere.[30] For Descartes, memory exists as an expression of the will/intention to know—to judge the certainty of—one's self by discovering the laws that govern objects in the world. The discovery of the outer is certain because the self is certain. And finally, for Wittgenstein, memory exists as a reminder of what one already knows about the form(s) of life that one has chosen to live through the language-games one plays.[31]

I believe it would be instructive to elaborate an aspect of Freud's theory of memory—the concept of a "double"—that is relevant to the eerie fascination that the user of interactive media may feel concerning the presence of his or her avatar facing available and alternative paths that seem strangely similar. Freud says that originally, the procedure of "doubling" was invented in order to preserve life. The soul was the first double of the body, and Egyptian images of the dead were an early practice of doubling. Today there are "waxwork figures, ingeniously constructed dolls and automata" as well as shadows and mirror reflections ("The 'Uncanny'" 226, 235). (Recall that shadows made up the world for the prisoners in Plato's cave and that mirror reflections in water were encountered by the prisoner who left the cave.) Freud, however, extends the concept of the "double" beyond an "objective" context. He claims that "an uncanny effect is often and easily produced when the distinction between imagination and reality is effaced. . . . " (244), that is, effaced by a sudden memory of memories—a cluster of memories. (Is this cluster somewhat like a flock of birds in an aviary?) Furthermore, our "conscience" or moral sense, the superego, is a double of our ego and, as such, the double in general

contains "all the unfulfilled but possible futures to which we still like to cling in fantasy, all the strivings of the ego which adverse external circumstances have crushed, and all our suppressed acts of volition which nourish in us the illusion of Free Will" (236).[32]

Freud is here introducing a major shift away from, say, Plato's look-alike shadows, toward a new conception of the double and its uncanny effect. He argues that the uncanny is produced by something which has been criticized (e.g., by the superego) and left behind but which nevertheless *recurs*. The thing that has unexpectedly reappeared may be linked to archaic modes of thought (e.g., infantile beliefs, primary narcissism, immediate gratification, the omnipotence of thought [Descartes?!], superstition, sorcery and magic, animism, guardian spirits, demons, the return of the dead, or a fear of silence, darkness, and solitude). Or the thing that returns may be linked to repressed thought (e.g., an intrauterine fantasy, the primal scene, symbolic castration, or one's relationship to death). For Plato, the mirror reflections seen in water by the prisoner were imperfect and the product of what Plato called an "alien medium" (*Republic VII* 516b), whereas for Freud, an uncanny doubling is nothing new or alien at all, but rather something quite familiar—a previous path—that has become alienated from us because it has been surmounted, sublimated, or repressed, though not annulled ("The 'Uncanny'" 236, 240–244, 247–249).[33] Its sudden reappearance is uncanny even though originally the thing may not have been frightening. For example, the usual meaning associated with the *soul* has been reversed: "From having been an assurance of immortality, it becomes the uncanny harbinger of death" (235).[34]

In Freud's approach, the 'path not taken' may remain familiar in an uncanny way, for although it has been suppressed, it is still 'expected' in the form of some coincidence or repetition that will engender a feeling of (pleasurable?) helplessness, of being caught by fate, of being trapped and punished during a dream state—like the inevitable return during day or night of certain psychic (frames for) *impulses*. Freud notes, "whatever reminds us of [an] inner 'compulsion to repeat' is perceived as uncanny" (238). Dread is provoked by the unknown becoming strangely familiar and close (cf. epigraph from *The Limey*) or by the familiar 'screening' some half-hidden design (cf. epigraph from *Pat Garrett*). Perhaps it might even be said that we may deliberately and perversely seek out the "double," for it confers on us the illusory power to be other than we are at present (cf. Pat Garrett seeking his double in Billy the Kid). What is being doubled, split, divided, or interchanged in obsessive (re)play is the self itself, an alter ego or avatar (cf. *Lost Highway*, dir. David Lynch; *The Double Life of Veronique*, dir. Krzysztof Kieślowski; *The Double Hour*, dir. Giuseppe Capotondi).

Moreover, it would seem that 'memory,' considered as an entity, is essentially a vibrant *double* for the repressed, for what has been (deliberately) 'forgotten.' By contrast, for Plato, 'forgetting' results either from a malfunction of the wax that should be holding mental images that are "clear and deep," "distinct and well spaced" (*Theaetetus* 194c–195a), or from a failure to develop the necessary skills to capture the relevant bird from the mental aviary, to properly 'grasp' an item of knowledge. For Descartes, 'forgetting' is due

to a failure of *reason* to form *ideas* that are "clear," "distinct," derived from neither sense experience nor the imagination, and that would have led along a path toward the specific goal that embodies the relevant causality.[35] Presumably, for the later Wittgenstein, 'forgetting' would be due to changes in *behavior* in response to changes in a "form of life" and, hence, changes in language-games. Freud adds that although "a great deal that is not uncanny in fiction would be so if it happened in real life . . . [,] there are many more means of creating uncanny effects in fiction than there are in real life" ("The 'Uncanny'" 249; italics omitted).[36] One reason for this imbalance—as Frampton discovered about his story that remade his sense of self—may be that fiction is able to create a *virtual,* poignant memory for the perceiver that surrounds—or rather, lies *within*—real memory.[37] The virtual memory created by fiction (and language- and video-gaming) opens many new possibilities for the existence of "doubles" and "doubling," pleasures within dread.

It is clear that the uncanny anxiety brought forth by Freud's irrational "double" endows Plato's copies/doubles (as well as memory itself) with not just a different significance or property, but with an entirely new, underlying substance. In a psychoanalytic frame, interactive media would be seen to be building its effects on a *paradoxical else,* a 'non-path once taken,' so that what has yet to happen, we may already expect, will seem strangely tied to the past or to previous thought or previous desire, much like "narrative structure," which shapes its beginning by imposing the condition that the "beginning" of the journey is already past and the "end" already known.[38] One is reminded (but . . . why . . . ?) of Freud's own one-way journey to an experience of the uncanny: when walking one hot summer afternoon in a strange, seemingly deserted town in a foreign country, he unexpectedly found himself in a narrow street lined by brothels, being watched (surveilled) through windows of small houses by women. Though he quickly hurried away, he found to his greater dismay that he was somehow moving in a circle and had abruptly returned by some detour to the small houses with the strange women whose attention to him was now increased. And then, yet again a third time, a deviation from the detour brought him back to the spot, now (finally) arousing in him an intense feeling of/for the uncanny. At no time did he seek direction (237).[39] We may conclude that the uncanny arises when one loses one's way—or has found one's way—in a way not entirely unfamiliar.

Repetitions, doubles, and reversals—already the sign of an ambivalence and of a paralysis brought on by determined "coincidence"—that are firmly embedded in the appearance of the "uncanny" would seem also to underlie Freud's theory of fetishism, which describes a kind of irrational devotion that has been displaced onto an object, conferring on it a "fictional," though efficacious, quality related to a thing temporarily lost, deliberately misplaced.[40] The magical appearance of both a double and a fetish trigger feelings of the uncanny and the erotic. We might say, then, at a global level—drawing on science fiction writer Arthur C. Clarke's comment, "Any sufficiently advanced technology is indistinguishable from magic"—that so long as the interactivity of new media

remains *new and magical* to a community, such a technology is capable of generating feelings of the uncanny and the erotic.

IMPLICIT MEMORIES OF THE ANTICIPATED FUTURE: EXTENDED COGNITION (ARCADES MEMORY), MIRROR NEURONS, MULTIPLE FRAMES

There is that awful moment when you realize that you're falling in love. That should be the most joyful moment, and actually it's not. It's always a moment that's full of fear because you know, as night follows day, the joy is going to rapidly be followed by some pain or other. All the angst of a relationship. You go, "Oh, no. Please, no." You go, "Yes, I'm in love. No, I'm in love."

HELEN MIRREN, IN LAHR, 62

Memory is like a dog that lies down where it pleases.

NOOTEBOOM, 1; DRAAISMA, 11; CF. 161, 217

[A cartoon in *The New Yorker* shows a man with a drink at a bar, deep in thought:] I cried because I had no shoes, then I met a horse who had no hooves, and a turtle who had no smoking jacket, and I laughed, because of something funny I remembered.

DUFFY, 59

We can be sure that in constructing theories of how various art media work on our memory, we will need to consider memory's negative: what is presently not a memory, the path that has not been taken, though this path may already be vaguely marked or implicit or apparently concealed, ready to emerge like the uncanny as a thing that 'will have happened'[41] and be shown to have been anticipated.[42] Even in rereading a favorite novel, we would seem to enter the fiction again by pretending not to know the paths, and then finding ourselves being surprised, frightened, and pleased anew in accordance with a prior anticipation.[43] The theories of memory that have been so far discussed are specimens meant to illustrate four quite different contexts for theorizing memory and its negative: the objective (Plato's wax block that yields an illusory copy or apparition of something); the subjective (Freud's mystic wax writing-pad that mines an enigmatic psychic rebus); the interobjective (Descartes's sealing wax that initiates communication with self and world by relying on causal law); and, lastly, the intersubjective (Plato's aviary and Wittgenstein's language-games that are procedures for seeing and acting with/on knowledge in specified circumstances, for knowing how to go on). These four contexts will require differing methods of interpretation when applied to a text. Examples in film scholarship are approaches based on photographicity (objective); psychoanalysis (subjective); historical poetics,[44] and constructivism (interobjective); and ordinary language, and feminism (intersubjective).

Further complicating the situation (but, after all, art is complicated) is the fact that with twenty or so—just to pick a number—types of human memory systems, simple definitions of art and value must fail; for example, the Russian formalist reliance on "defamiliarization" (as in nondeclarative, nonassociative "habituation memory") and the phenomenological reliance on immediate awareness (as in the episodic buffer of short-term memory) are merely local effects of larger systems. It has been established that memory is modular and distributed, and that learning is processed in different parts of the brain. (Learning, knowledge, and memory are virtually identical. As Plato recognized in the *Theaetetus*.) Furthermore, aesthetic texts and interactive media may call upon different *conjunctions* of memory capabilities as described within objective, subjective, inter-objective, and intersubjective contexts. Combining the "uncanny" in the subjective realm, for example, with traits from the other three contexts may begin to locate interactivity on a relative scale of memory-driven activities. Being "interactive"—in the sense of exchanging and using information—will certainly be found in many places besides on a display monitor, and patience will be required to delineate the cases.

Natural language is the single most powerful mental modeling system possessed by humans. It appears prominently in the form of the phonological rehearsal loop (inner speech) of working memory. Wittgenstein, in his later work, shows a special interest in exploring the close relationship between conscious thought and a public, intersubjective "language," that is, higher-order interpretive thinking based on public rules and criteria. Wittgenstein also sought to extend "language" into sensory perception; for example, in his work on the Necker cube, duck-rabbit, puzzle-pictures, and color. A recently conjectured type of memory may be relevant to this relationship between language and sense perception when considering the representation of knowledge within an intersubjective context. Cognitive scientists have raised the possibility that in routine perception (e.g., depth perception), and in some other tasks, an individual may use *the world to store (collect/recollect) information*. Such a process of "extended, situated cognition" would greatly expand the capacity of memory since it does not depend on collecting *from* the world to fashion a series of mental vitrines. Instead it uses the world itself as an interface and requires a person to navigate a mental map or model of the world in order to know (1) where approximately to *search*, if-only certain information were needed, that is, how to move within a larger design containing paths not (yet) taken, and (2) which *procedures* if-then to use to access/decompress knowledge previously stored at a location. Although the world is concrete, the stored knowledge may be intangible since it is being coded/decoded through the use of methods and habits that are adaptive to an environment, presumably including environments created by aesthetic texts, which may, in turn, remodel what is seen when looking at the world. Such a memory would make of the world a personal set of (what I will call) "arcades," drawing on close observations of typical (intersubjective) community behavior—and here I am remembering Walter Benjamin's *Arcades Project*, the photography of Eugène Atget, Frampton's (*nostalgia*), Wittgenstein's "language-games" (i.e., language fit to a specific arcade), James Joyce's *Ulysses*

(a day in the arcades), and even Freud's notion of fetishism, which involves the removal of a certain fear-desire onto something less threatening in the everyday.

A commonplace arcade should not be thought banal. Pierre Bourdieu:

> If all societies . . . set such store on the seemingly most insignificant details of *dress, bearing, physical and verbal manners*, the reason is that, treating the body as a memory, they entrust to it in abbreviated and practical, i.e. mnemonic, form the fundamental principles of the arbitrary content of the culture. The principles em-bodied [sic] in this way are placed beyond the grasp of consciousness. . . . (94, emphases in original)[45]

We are embedded in a community's expectations for behavior and in the physical environment that society has created for behavior. Being "em-bodied" means that we have implicit memories of—knowledge of—anticipated futures, that is, of how we might act in certain situations in our community. The games we play with language ("verbal manners") and with sight cannot fail to track our embodiment in that (customary) environment.[46] When the environment is lost, so are the memories. In these terms, I would conclude that some interactive media explicitly depict aspects of an arcades memory in the form of landscapes and command functions directed at the Internet while other interactive media solicit multitasking and an arcades memory tacitly, as on the page of a novel. Therefore, a style of "naturalism" in the arts may be more than an empty copy of reality; it may serve to store and release a cascade of pertinent memories.

We may not presently be in a position to select one of the four general contexts, or some other one, as the master framework for developing a theory to explain all aspects of memory. Even Plato's wax block, with its many limitations, cannot be dismissed. It turns out that the brain does, in fact, make copies of some sensory data. There is, for example, a visual iconic and echoic memory that is held for only a fraction of a second. This memory store is thus below the threshold of awareness and attention (the subjective "present" is about three seconds in duration). Nevertheless, it preserves the exact pattern of data long enough to be accessed by other constructive processes, such as the multi-component working memory of consciousness that produces our *"feeling* of knowing" (Damasio, *Feeling of What Happens* 172; Baddeley) along with a consciousness of self. Without these transitory forms of memory, we would not be able to reason from step to step, connect an effect to a cause, synthesize adjacent sounds or spaces, or recognize a face or object, because we would not be able to remember the previous moment (cf. anterograde amnesia in the film *Memento,* dir. Christopher Nolan). Indeed, it is likely that we would not be conscious at all, and so could not summon a sense of self from long-term memory to interface with a currently active goal hierarchy when making a decision or waking in the morning.

In addition, Plato's wax block has found an important application in the recent discovery of "mirror" neurons. Several such systems of neurons operate in the human brain at a high level (perhaps *above* consciousness), producing records that imitate the objective

actions of other persons. The result is a complex set of feature detectors that are able to learn skilled behaviors (e.g., playing soccer and chess), judge another's intention (e.g., whether someone is planning to drink from a cup or clear the table), form expectations (about, say, a girlfriend or boyfriend), pinpoint social emotions (e.g., guilt, pride, shame, embarrassment, humiliation, aggression, disgust, lust, rejection), and create empathic feelings. Mirror neurons represent the world through direct *simulation* of sights and sounds, not through reasoning. These brain systems apparently do not work well with virtual or simulated inputs (e.g., from an art object, video, or computer display),[47] although, for example, a reader of a novel may be induced to adopt (mimic) the point of view of a literary narrator with respect to memorizing the positions of objects described in scenes. It seems reasonable to envision the camera as playing a narrational function in pictorial media analogous to a literary narrator, even though other types of memory will also be reworking the spatial layout and significance of a visual scene, since full understanding will depend on spatial and motivational models that allow events to be seen from angles not explicitly provided and attitudes that are not visual, that is, seen from paths not taken but only implicitly anticipated. When these other types of memory are included in a spectator's interpretations of a shot or pictured scene, it will be evident that our notion of "the camera" has been radically reconfigured, making it something much more than a physical apparatus that "mirrors" the world.[48]

I believe that an art medium, whether old or new, elicits responses from us as it intermixes with memory systems. These responses, collectively, become part of the historical memory that will shape the next version of a medium. How will these memories focus our desires? Which brain mechanisms within the four cognitive domains will be prominent? What emergent properties must a technology be seen to possess in order to become *of use* for present purposes? In short, what precise form of old or new interactivity will serve? The answer may turn on how we manage the operations of our memory when in contact with the textual memoria of an artful prosthesis.

AFTERTHOUGHTS

A keen interest of mine has been film theory and one of its key concerns, epistemology, the nature of knowledge. When we think, we are remembering information, and when we reason about something, we must remember what was thought a moment ago—while reading this sentence, for example. Thus, knowledge of something is *virtually* identical to the state and activity of our memory. (Knowledge is virtual memory; memory is virtual knowledge.) The word "memory," however, is at least quadruply ambiguous, referring to the hardware and software of an architecture, of the basic (neurological, computational) units that are chosen, of algorithms and processes making use of units, and of a resultant output—that is, again, "memory," now in the form of its content, a specific remembrance. Furthermore, there are many systems of human memory. Consequently, what is "seen in" a film—or equally in some other media display—is relative to the memory system

presently active as well as to various specific *alternative* memories, positioned nearby ("what [is] else") that might have been recalled but instead remain potential, hypothetical, virtual. Thus, the core of a spectator's "interactivity" with media, and the frictions felt among media forms, lies with a study of memory—with what memory tells us about media and what media tell us about memory.

My approach to the epistemological issues of film theory may be found in Branigan, "Concept and Theory."

An early version of this essay was presented at the Interactive Frictions conference at the University of Southern California, June 5, 1999. I thank the organizers, Marsha Kinder (a longtime friend), Tara McPherson, and Alison Trope, for encouraging this work and Ralph Bravaco, Philipp Schmerheim, and Melinda Szaloky for their indispensable and thrilling commentary.

The original paper was expanded eight times through the years by readings on memory and philosophy, which readings fortunately never age and have been beneficial generally to robust afterthought, despite mnemonic knots. The exact details of these years, however, have been forgotten due to a fear that I am rushing into print, and would wish for another decade, and ten thousand more words, to better collect my thoughts.

ABOUT THE AUTHOR

Edward Branigan is professor emeritus in the Department of Film and Media Studies at the University of California, Santa Barbara. He is the coeditor with Warren Buckland of *The Routledge Encyclopedia of Film Theory* (2013). He is the author of *Projecting a Camera: Language-Games in Film Theory* (2006); *Narrative Comprehension and Film* (1992); and *Point of View in the Cinema: A Theory of Narration and Subjectivity in Classical Film* (1984). With Charles Wolfe, he is the general editor of the American Film Institute Film Readers series.

NOTES

The Kracauer epigraph is from p. 303 and may be compared with "The Two Directions of Dreaming" 164–166.

1. I employ both single and double quotation marks in this essay. If I am in the midst of discussing and quoting an author's ideas (using double quote marks), then I will use single quote marks to show that something is not a quote from that author but is either my use of the author's term in a new special sense or my use of a general concept in a new special sense or my new term. This greatly reduces the number of endnotes that would otherwise be needed to distinguish every quote from an author from every highlighting of a word or concept attributable to me when quotes from an author and my special terms appear together in the text. If, however, the context is perfectly clear (i.e., I am not discussing another author and quoting his or her concepts), then I only use double quote marks for indicating words with special meanings.

2. To mention a few authors who have explored the topic of society and mind: John Anderson, Bernard Baars, Pierre Bourdieu, Leda Cosmides, Daniel Dennett, Susan Fiske, Jerry Fodor, Ray Jackendoff, Mark Johnson, Ziva Kunda, George Lakoff, Marvin Minsky, Steven Pinker, Shelley Taylor, and John Tooby. Some recent books in the field of "theoretical biological anthropology": Tattersall; David Martel Johnson; Richerson and Boyd.

There is an enormous literature on memory. A good place to start is Sacks, followed by Carter, and Fara and Patterson. Draaisma's exceptional book examines forty-three major metaphors that have guided the study of memory. See, generally, Tulving and Craik, and Wilson and Keil.

Space forbids a listing of important works on memory and film. However, a few recent works: Bordwell, "Grandmaster Flashback"; Burgin; Deleuze, *Cinema 2* (e.g., chapter 3); Kilbourn; Sinha and McSweeney; van Dijck. A major type of "mind-game" film attacks a spectator's memory systems; see Branigan, "Butterfly Effects upon a Spectator"; Hesselberth and Schuster.

3. On Plato's discussion of motion as an essential component of certain entities, states, and processes, see, for example, *Theaetetus* 152d–157d; *Timaeus* 88e–89b, 89e; *Laws X* 893b–899b. But for complications, see, for example, *Cratylus* 439c–440; *Sophist* 250–256. Aristotle expands and revises Plato's ideas in *De Memoria et Reminiscentia* (*On Memory and Reminiscence*).

4. Notice that in Plato's allegory, as applied to my example of cat-ness, the prisoners cannot have concepts of "cat," "wall," "cave," and "shadow," since they are blind to the fact that there is an illusion in front of them and blind even to the existence of light, which projects the cat figure. They cannot move their heads or see each other or know that they are chained in place or know that there is a space "behind" them from which the shadows are being projected. Similarly, although the prisoners can hear, they cannot know that a sound is an "echo"; instead, they believe the sound to come directly from what they see. Plato's allegory harbors a strain of skepticism: how will one truly know when the "final illusion" has been reached and penetrated? Plato, like many narrators, has provided us, at least provisionally, with an objective and omniscient point of view on the scene, which (also) offers no escape.

5. Strictly, Plato's cave parable in *Republic VII*, 514–518, concerns the problem of "education," not the nature of art. However, it is frequently interpreted as a vivid depiction of his views on art, which are made explicit in *Republic X*, 595–608b. For a more extensive treatment of the relationships among art, imitation, and existence, see Plato's *Sophist*, as well as *Ion*, *Phaedrus*, and *Philebus*. Also see Asmis. For further implications of Plato's cave parable for film epistemology and aesthetics, see Branigan, "Apparatus Theory (Plato)."

6. What would Plato say if it were a *shadow* that were being represented by a shadow on the cave wall, or on a theater stage? Is it really an answer to Plato to claim that art-objects represent only their manifest, perfectly objective properties (e.g., shape, color, pattern, and motion) when appearing on a screen? Or else to claim that an art/ifact is simply presence itself or about only itself, and thus analogous to (or a projection of?) the Self being aware of awareness in short-term memory? These sorts of common answers simply reduce the power of art in order to accommodate Plato's objections.

7. In a famous passage of the *Phaedrus* (274c–277a), Plato asserts that writing is "truly analogous to painting" and "a kind of image" since "written words . . . seem to talk to you as

though they were intelligent, but if you ask them anything about what they say, from a desire to be instructed, they go on telling you just the same thing forever." Paintings, too, "stand before us as though they were alive, but if you question them, they maintain a most majestic silence." This harsh judgment, however, does not apply to "living speech" or to the "art of dialectic."

8. I am referring in the text to so-called "semantic" (or "generic") long-term memory for general world knowledge (i.e., context-free, third-person knowledge of/about facts, concepts, objects, numbers, and language) as opposed to processes of perceptual long-term memory, of emotional memory (localized in the amygdala), and especially of "episodic" (or first-person, "autobiographical") long-term memory for "reexperiencing" the *visual* details of particular events (sometimes called "source memory"), which take an especially intense form in Freud's "screen memory" and Roger Brown's "flashbulb memory." Is episodic memory the basis of the visualist bias found in many classical and contemporary film theories? Is emotional memory the source of a bias toward action and emotion in many films? Studies have clearly shown that emotional content in a film leads to a much greater retention rate than neutral content.

Semantic long-term memory alone is arranged hierarchically. This powerful type of organization allows a person to use semantic memory to make *inferences* and *generalizations* about information that has *not* been experienced. One common and powerful inferential strategy (a judgment heuristic) known as "availability" is based strictly on the ease or difficulty of *recalling examples* that fit a case under scrutiny. Typically, an actual experience that is to be remembered will be *broken up* by semantic memory into various "components" and dispersed hierarchically in different locations (thus also updating other information and hypotheses), leaving no coherent whole that represents the event or data. Although memory functions are highly specialized and modular, even a simple piece of information is distributed across multiple areas of the brain.

Long-term memory in humans is exceedingly powerful because it is distributed, content-addressable (hence, we usually know instantly when we do *not* know something), and based on pattern recognition, principles of matching, approximation under constraint (incomplete resemblance!), and prototypes, rather than on explicit criteria, searchable "indexes," and location-addressable information (the method used by computers).

When a person narrates from long-term memory or recalls an event for the self or to others, he or she often draws upon already-existing protocols from a *story-based* semantic memory that acts to refashion and fix the event's importance or significance. Because of their hierarchical form and their causal and other connective logics, stories are more resistant to fading over time than many memories organized in other ways. Note that these story-based mechanisms work in a nonconscious manner, making decisions about whether, and how, something will be remembered and setting in place expectations. (The "expectations" posited by cognitive theories of mind are mostly not conscious. Some of this "thinking" is more abstract than what appears in "consciousness," while some is less abstract.) To mention only a few studies of story-based semantic memory: Schank, *Tell Me a Story*; Bruner; Hogan; Herman; Branigan, *Narrative Comprehension and Film*.

9. Strictly, the top sheet of the mystic writing-pad is meant to represent a "protective shield" or filter system against external, intense stimuli while the bottom sheet represents the "per-

ception-consciousness" system that Freud in other writings calls the "preconscious-conscious" system. On the mystic writing-pad and memory time, see Doane, "Temporality, Storage, Legibility"; and Elsaesser. For a psychoanalytic account of interactive media, see Žižek, "Cyberspace."

10. By "telling mistakes," I have in mind Freud's concept of parapraxis that covers certain failures of speech, reading, writing, action, and memory, including mislaying or losing an object, where each such failure—instance of forgetting—nevertheless represents a successful compromise between conscious and unconscious intentions; see Freud, "The Psychopathology of Everyday Life." For another perspective on forgetting, see Schacter. Analogous effects can be found in the many types of perceptual "masking."

11. Descartes discusses the sealing wax in the "Second Meditation" of *Meditations on First Philosophy*. The nature of *change* discussed by Descartes has a long history in philosophy. For Plato's answer, see *Timaeus* 48e–54d. In my citations of Descartes, roman numerals refer to the volume, page numbers refer to the English translation (Cottingham et al.), and numbers in brackets refer to page numbers of the relevant volume of the standard French edition of Descartes's writings (Adam and Tannery). Clarke has written a wonderfully thought-provoking biography of Descartes. It is an informative book not least because it shows how little has changed since the time of Descartes concerning academic life, introductory textbooks, conferences, controversies, publishing (or not), and dissembling.

12. In the *Meditations*, Descartes employed his famous method of radical doubt in order to isolate knowledge that is certain:

> For if I judge that the wax exists from the fact that I see it, clearly this same fact entails much more evidently that I myself also exist. It is possible that what I see is not really the wax; it is possible that I do not even have eyes with which to see anything. But when I see, or think I see (I am not here distinguishing the two), it is simply not possible that I who am now thinking am not something. . . . Moreover, if my perception of the wax seemed more distinct after it was established not just by sight or touch but by many other considerations, it must be admitted that I now know myself even more distinctly. (*Philosophical Writings* II, 22 [33])

13. "At last I have discovered it—thought; this alone is inseparable from me. I am, I exist—that is certain. But for how long? For as long as I am thinking. For it could be that were I totally to cease from thinking, I should totally cease to exist" (*Philosophical Writings* II, 18 [27]). Descartes does not rest his argument on what one happens to be thinking about or on its truth or falsity, but on the simple fact that during the process of thinking an action is being performed by someone (who must exist). This is reminiscent of Plato's aviary, where a memory is defined by *the fact of being grasped* through a mental process of acting and doing. It is also reminiscent of "maintenance rehearsal" in the phonological loop of short-term memory and the 150-second loop of working memory.

14. Descartes says, "imagining is simply contemplating the shape or image of a corporeal thing." He argues that "I can grasp that the wax is capable of countless changes of this kind, yet I am unable to run through this immeasurable number of changes in my imagination, from which it follows that it is not the faculty of imagination that gives me my grasp of the wax as flexible and changeable" (*Philosophical Writings* II, 19, 20–21 [28, 31]).

15. Also see Descartes's *Objections and Replies*, "Appendix to the Fifth Set of Objections and Replies" (*Philosophical Writings* II, 277 [216]). Compare Descartes's assertion that

I know that in matters regarding the well-being of the body, all my senses report the truth much more frequently than not. . . . [W]hen I distinctly see where things come from and where and when they come to me, and when I can connect my perceptions of them with the whole of the rest of my life without a break, then I am quite certain that when I encounter these things I am not asleep but awake. (61–62 [89–90])

Why should the identity of an object (as above) be seen in terms of *causal* contexts? Part of the answer, I believe, lies in the fact that helpful and hurtful objects are distributed not uniformly, but only regularly, in time and space.

16. A classic study of how memory is an ongoing construction, not a static, imperfect copy, is Bartlett. The various processes of memory that Bartlett discusses operate over a period of time that renders the "memory object" fluid and labile, not fixed. Also, the manner in which something is being remembered has an important relationship to the pragmatic situation through which the memory object is being evoked: to attitude and purpose, to connections with other data, to what are taken to be "similar" experiences in the past, and to a larger social and cultural context. According to Bourtchouladze, "Bartlett challenged many artificial memory metaphors [e.g., he rejected the use of nonsense syllables to test memory] by arguing that memory is an active reconstruction of, rather than a passive store for, things past, and this reconstruction is in important ways a social act" (176). Bartlett's approach has been expanded by, for example, Schank and Abelson.

17. I believe that Descartes's causal argument for the existence of God in the "Third Meditation" can be seen clearly by using Plato's wax block theory of memory: God leaves His *mark* on the material objects He creates and these objects, in turn, leave their *mark* on our memory, which, when we are thinking, is a source of knowledge of the existence of God. Indeed, Descartes's *physical* theory of memory resembles Plato's wax block. Descartes posits that ideas leave an impression in memory because they "trace figures" in the gaps between tiny fibers in a special part of the brain. As the fibers are bent and arranged, the gaps are enlarged and take on shapes that "correspond to those of the objects" to be remembered. However, it is important to notice that Plato's conclusions are avoided since memory for Descartes is not a material (e.g., wax) directly imitating other materials in the world, but rather a shaping of immaterial voids to create *abstract* figures as the result of the continuous functioning of a (nonmechanical) cognitive power or process involving ideas located in another part of the brain.

On the tracing of figures within gaps, see *Treatise on Man* (*Philosophical Writings* I, 107 [177–178]). On Descartes's adoption of a kind of 'wax' as the medium for memory impressions, see *Rules for the Direction of the Mind*, Rule Twelve (I, 40 [412]). On his insistence that the "figures" or "images" imprinted on the 'wax' are of abstract design and represent abstract ideas, sensations, feelings, movements, and emotions, see *Treatise on Man* (I, 106 [176–177]); Rule Twelve (I, 40–41 [413]) (which includes an illustration of abstract patterns for white, blue, and red); *Discourse and Essays*, "Optics," Discourse Four: The Senses in General (I, 165–166 [112–114]) (the figures imprinted in memory are not "little pictures formed in our head"); Rule Twelve (I, 43 [417]) ("abbreviated representations"). On the transformative power of cognition in relation to memory, see Rule Twelve (I, 42–43 [415–417]). A hydraulic component in Descartes's model of memory was responsible for replicating the patterns of flow within nerve ducts of animal spirits. These spirits were a type of subtle matter similar to that found in fire. Freud, too, made use of a hydraulic model of memory—the so-called "economic" point of view.

See, generally, Cottingham, "Memory" (*A Descartes Dictionary*, 119–121), and Draaisma (218–221).

18. The claim in the text above that there is survival value in preventing objects from "changing too fast" is a reference to the fact that our concepts are arranged into hierarchies (creating relationships of hyponymy) according to their "relative entrenchment" (stability). For instance, the prototype of a category is relatively more entrenched than other instances of the category. As an example, consider that in ordinary usage the so-called "push-pull" concept of billiard balls moving on a table (or cars on a highway) is a more central case, or model, for defining causality than otherwise perfectly valid concepts about the social causes of crime, the management of foreign policy, the history of ancient Greece, why one likes a particular film or wishes to act in a certain way or selects a mate, a theory of film, the history of art (cf. Benjamin's remarks quoted in the text at the beginning of this essay), and quantum probability. On the importance of things not "changing too fast," compare Goffman (573, 575–576) and Minsky (42, 50–51). On how we talk about varieties of causation, see Lakoff and Johnson, chapter 11, "Events and Causes" (170–234).

19. In the text, I assert that the "identity" of a thing—which provides the ground for the appearance of "properties" in the thing—is relative and may undergo change. Descartes would strongly disagree, arguing that identity is permanent.

20. On the nonvisual figurations at the core of psychoanalytic theory, see, for example, Heath.

21. See Branigan, "Nearly True." Also see the special double issue of *SubStance* 94/95 (2001): "On the Origin of Fictions: Interdisciplinary Perspectives" (H. Porter Abbott, ed.).

22. On "knowing how to go on," see Wittgenstein, *Philosophical Investigations* §§ 151, 154, 155, 179, 323, 363, 525–534. "Language-games" are a central topic of this book. I discuss in detail Wittgenstein's philosophy and its implications for film theory in *Projecting a Camera: Language-Games in Film Theory*. Keeping in mind the different types of human memory, I believe, lends a new perspective to the many sorts of cases that Wittgenstein discovers in *Philosophical Investigations* when ordinary language attempts to describe a particular mental process.

23. For non-Freudian theories of subjective effects in film, see, for example, Plantinga; Plantinga and Smith; Greg M. Smith; Persson.

24. Are the four categories—the objective, subjective, interobjective, and intersubjective—simply a Cartesian dualism times two? I do not wish to make an ontological claim for these categories but merely to use them to indicate four convenient contexts, or descriptive schemes, within which one may pose questions, construct accounts, and represent knowledge. Here are some illustrations: the objective frame (the chemistry of an ink blot on paper; the velocity of a car; the frequency of reflected light); subjective (seeing an ink blot as some thing; the sense of an autobiographical self; a sensation of redness; a remembrance and its emotion); interobjective (the Equator; the behavior of an ideal gas; the center of gravity of, e.g., an ink blot); intersubjective (English grammar; myth; a nation as opposed to a country; typical responses to an ink blot). The four categories come from the work of Ken Wilber (and others). See, for example Wilber; Combs; Hernadi (*Cultural Transactions;* "Why Is Literature"). One way to think of the difference between the interobjective and intersubjective is to adopt Clifford Geertz's distinction between studying social structure through the methods of experimental science (searching for interob-

jective laws) and studying culture through interpretations and thick descriptions (searching for the meanings of symbols in use by a local community).

It should be noted that Cartesian dualism is more complicated than it first appears. Consider:

> There is nothing that my own nature teaches me more vividly than that I have a body, and that when I feel pain there is something wrong with the body. . . . Nature also teaches me, by these sensations of pain, hunger, thirst and so on, that I am not merely present in my body as a sailor is present in a ship, but that I am very closely joined and, as it were, intermingled with it, so that I and the body form a unit. If this were not so, I, who am nothing but a thinking thing, would not feel pain when the body was hurt, but would perceive the damage purely by the intellect, just as a sailor perceives by sight if anything in his ship is broken. (Descartes, *Philosophical Writings* II, 56 [80–81])

Note that Descartes uses an unusual "negative simile" here to make his point: 'I am not in my body as a sailor is in a ship.' Perhaps Descartes's dualism is instead a "trialism" of extension, thought, and sensation; see Cottingham (*Descartes* 127–132) and, generally, Dicker.

25. What is the writing of history? Is it a "wax copy" of past facts, things done, geography, and germs (objective); an analysis of beliefs, motivations, technological needs, and human nature (subjective); a description of the laws and patterns of politics, economics, and society (interobjective); or the expression of present cultural conflicts and group memories, impressions of the past, and myths (intersubjective)? Consider also the problem of defining a "material object." In an objective frame it is composed of the so-called primary qualities (e.g., extension or size, shape, relative motion, solidity, and number); in a subjective frame it is the secondary qualities (e.g., color, sound, taste, smell, and touch); in an interobjective frame it is the tertiary qualities (e.g., physical dispositions like solubility, fragility, and corrosiveness; a propensity to melt or be scratched upon like wax, along with many more properties, including perhaps "supervening" aesthetic qualities); and, finally, I believe, in an intersubjective frame it is the pragmatic qualities, *our dispositions and problems,* our assessment of contingencies, that count in giving an object qualities (e.g., probably useful as a paperweight; could pry open a can; might be either hung on a wall or used to patch a hole in the roof; appears so changed as to be conveniently called a new medium). In general, an objective frame emphasizes ontology; a subjective frame emphasizes epistemology; an interobjective frame derives its epistemology from an ontology; and an intersubjective frame derives its ontology from an epistemology. Film theories may be divided into these four frameworks as well.

26. Compare Abbott, who cites the following as examples of irreducible, "emergent" behavior, which is a key feature of the contexts that I have called interobjective and intersubjective: flocks of birds, schools of fish, ant trails, beehives, the immune system, the neurology of thought, traffic jams, the growth of cities, the World Wide Web, the movement of slime mold, cancer, the price of stocks, and the economy. Emergent action has no central control, but rather is governed by dynamics that are distributed and dispersed (unlike a thermostat or billiard ball). See, for example, Cilliers.

27. When speaking of theories of memory as "templates," one may wonder what sort of "wax" or "aviary" a particular *theory* is using in order to model how it models (recalls, embodies) knowledge. One of the issues that arises here involves the nature of "framing," which provides a template for our comprehension, and in film is often a displaced figure for the

"camera," "camera-eye," or "camera-consciousness," and indeed is often a disguised recognition of our own conscious awareness in marking out the significance of a film ("camera-I") and in explaining how we have come to know. See Branigan (chapter 4, "How Frame Lines (and Film Theory) Figure," *Projecting a Camera* 97–149).

28. The Turing Machine is the model for all computation by all computers. It has been proven that all computation can be reduced to three procedures: the procedure for the most basic instruction, "if-then-else"; the procedure that dictates the sequence in which instructions are read (e.g., one after another); and, finally, the procedure that repeats instructions in order to create a loop (e.g., "*while* Boolean condition x is true, *do* instruction y"). No other form of computation is presently known (except the theoretical possibility of quantum computing). It has been shown that there exist a large number of important kinds of mathematical problems that cannot, in principle, be computed on this basis, no matter how much time is available.

29. In *Meno*, Plato famously claims that *learning* is the recollection (re-collection, anamnesis) of knowledge that is *already* present in the soul and has always been present, in the form of certain essences (the Forms). Also see *Phaedo* and *Phaedrus*. Most scholars in the humanities today have an imperfect understanding of the Forms and of the serious issues they are designed to address; see, for example, *Parmenides* and *Hippias Major*.

30. An artwork solicits not just a spectator's unconscious, but also that which has been lost to view in an *analyst's* unconscious: "Interwoven into every analytical undertaking is the thread of a self-analysis." Christian Metz argues that such an analysis of the self proceeds by "breaking" the art object:

> To study the cinema: what an odd formula! How can it be done without "breaking" its beneficial image, all that idealism about film as an "art" . . . ? By breaking the toy one loses it, and that is the position of the semiotic discourse [of analysis]. . . . Lost objects are the only ones one is afraid to lose, and the semiologist is he who rediscovers them *from the other side:* . . . "there is a cause only in something that doesn't work." (80, emphases in original; also see 14–16)

For Metz the art object is lost in the effort to refind the (deep) source of its pleasure/fear as a fetish. I have omitted Metz's footnote above, which refers to Lacan's distinction between a physical cause and the Law of the unconscious.

31. What is the relationship of truth and language? In *Philosophical Investigations*, Wittgenstein considers, and answers, the following question:

> "So you are saying that human agreement decides what is true and what is false?"—What is true or false is what human beings *say;* and it is in their *language* that human beings agree. This is agreement not in opinions, but rather in form of life. (§ 241, emphases in original)

32. One of Freud's examples of "doubling," found in Egyptian images of the dead, is reminiscent of the use of Egyptian mummies by Bazin ("The Ontology of the Photographic Image" 9) in his construction of a revisionist Platonic theory of cinema (in effect, based on the waxen block). Compare Baudry's attempts to mate this Plato/Bazin to Freud in "Ideological Effects" and "The Apparatus." On Bazin and Baudry, see Branigan, "Death in (and of?) Theory." On the uncanny, see, generally, Masschelein.

33. In general, experimental research on memory has demonstrated that a loss of information over time "does not necessarily imply that the forgotten information has vanished from the brain; testing at any interval with more powerful retrieval cues would show recovery of the

forgotten information." Roediger and Goff (260, emphasis in original). That is, information may not be explicitly "accessible" to recall, but it is implicitly "available" to retrieval through recognition cues. Presumably, fictions, narratives, and events in daily life may function as powerful retrieval cues, though such cues may also lead to memory *illusions*. In addition, there is strong evidence for a so-called "implicit memory" (which includes "priming," "covert recognition," "implicit learning," intensely visual but inactive forms of traumatic memory, and certain kinds of nonconscious conditioning) that has measurable effects even though the "memories" are not formed by conscious intention and cannot be consciously retrieved. See Allen and Reber; and Leake. Also see Bourtchouladze—"It seems that nothing is forgotten, provided we know how to ask if it is remembered" (62). Kvavilashvili and Mandler have characterized a common form of long-term implicit memory (priming) that results in an involuntary recall of a word, image, or sensation (e.g., an intrusive thought) as "mind pops." These memories may be creative or destructive and often appear when one is not concentrating hard, as in the middle of a routine or habitual activity or perhaps when bored with a film.

34. One wonders about the opposite of this typical uncanny reversal; that is, from something that was originally frightening to something reassuring. Perhaps the suddenness of such a reversal might itself be unsettling and raise doubt in an uncanny way, as in, for example, black comedy. The uncanny is a species of déjà vu, which is an illusion of remembering something that is actually being seen for the first time. The opposite mental state is an illusion of forgetting—*jamais vu*—which occurs when something that should be familiar appears, or has been made, strange. Is this akin to the Russian formalist notion of "defamiliarization"?

35. Descartes defines his notion of "clear" and "distinct" in *Principles of Philosophy* as follows:

> A perception which can serve as the basis for a certain and indubitable judgment needs to be not merely clear but also distinct. I call a perception "clear" when it is present and accessible to the attentive mind—just as we say that we see something clearly when it is present to the eye's gaze and stimulates it with a sufficient degree of strength and accessibility. I call a perception "distinct" if, as well as being clear, it is so sharply separated from all other perceptions that it contains within itself only what is clear. (*Philosophical Writings* I, 207–208 [22]; also see II: "Fourth Meditation")

Note that Descartes is arguing that the mind's eye, the intellect or "judgment," is analogous to the "eye's gaze." But are these powers similar? What process causes with certainty the 'sharp separation' (into distinct and pure parts) for the mind's eye that is similar to the cause of a 'sharp separation' for the eye's gaze? What plays the role of 'light' for the mind's eye? How is the light in the mind 'controlled' or 'experienced' by us—through a 'window' and from where, into or onto what? Is there a 'space' of reasons and a 'movement' of ideas for the mind analogous to space and movement for the eye's gaze?

36. Doubles and recurring similarities are a prominent device in fiction (e.g., rhymes, motifs, parallels, metaphors, rhythm, closure) and perhaps may be tied to an unconscious repetition-compulsion based on instinctual activity (cf. Freud, "The 'Uncanny'" 236–238). This suggests an interesting connection between an uncanny effect, which arises from a tension between the familiar and the unfamiliar in the same event, and the Russian formalist effect of "defamiliarization," which strikes at memorialized habits and preferences. Some of the factors that Freud discusses in fiction that bear on whether or not a device induces an uncanny feeling are genre, point of view, and identification (237, 249–252).

37. For Plato, *all* the contents of a "virtual" memory would probably be seen as simply *false*. In reply one might say that not all fictions need be "false" and that the mind itself (much like science) may construct, and encode in memory, useful "fictions"; for example, hypotheses, contingencies, metaphors, generalizations, simulations, counterfactuals, and determinable (rather than determinate) properties. "Narrative" is also fundamental to thought, for it depicts "causal logic" as well as a "causal efficacy" of objects (i.e., desired possibilities for being) in both fictional and nonfictional formats. Moreover, narrative, like memory, is structured to activate a dispersed series of connections and elaborations.

38. The "tense" of fictional narration is essentially the epic preterite or historical present; that is, the present telling of a story includes a (covert, implicit) narrator recalling it. For example, "She *saw* the letter, *read* it, and *now* felt bad." Based on *The Wrong Man* (Hitchcock, 1956): "It *was now* early morning and Manny *was* [*now*] leaving the club after he *had played* in the band all night when two policemen suddenly *come up* behind him as he *walks* slowly toward the subway station." This suggests that one reason we choose to infer a narrator when confronted by apparently objective and "nonnarrated" passages (e.g., descriptions or foreshadowing) is in order to reduce to a single image the "artificial memory" of a text that is known to be present though not yet fully realized or explicit. The presence of an end in the beginning of a narrative, for example, can be felt, but not yet grasped. A future that is already present (as in the epic preterite)—or later remembered to have been present—will require an anomalous or uncanny formulation in order to be itself described after the narrative has concluded: for example, as baseball manager Mike Scioscia said (in an entirely different context), "Whatever wasn't there from the beginning is over" (Shaikin).

39. I have been careful to choose my words while (re)imagining Freud's story of his uncanny experience. Compare also Freud's remarks on the intimate connection that exists between the saying "Love is home-sickness" and a "mother's genitals" ("The 'Uncanny'" 245).

40. On certain complexities of fiction and fetishism (each with three "twists"), see, for example, Metz, "Disavowal, Fetishism" (69–78; see 72, 75).

41. Compare Champigny.

42. For the title of this section, I have borrowed the phrase "implicit memories of the anticipated future" from Damasio (*The Feeling of What Happens* 174); compare Damasio (*Looking for Spinoza* 270), and see Žižek (*The Parallax View* 224). There are several varieties of *explicit* memories of the anticipated future, known as "prospective memory" (i.e., remembering now to remember later [not to forget] *to do* something in the future; e.g., to take medicine at a specified time or to act if a certain event occurs). Robert Frost's famous poem about making choices, "The Road Not Taken," contains a startling temporal shift in its final stanza, signaling a prospective memory: "I shall be telling this with a sigh/Somewhere ages and ages hence." (Isn't it the existence of both a path taken and one *not* taken that in the final line "has made all the difference"?) Another example: Los Angeles Lakers General Manager Mitch Kupchak stated, "There will be a time when I look back on it and I'll feel certain emotions. I don't know what they'll be" (Beck). A related case is the future present tense: "Are you coming tomorrow?"; "Let's meet next month sometime." Consider also the future perfect tense: "I will have finished the essay the previous week." The following is LeBron James's attempt at the future perfect in answering a question after losing the final game of the 2011 NBA Championship: "[A]t the end of the day, all the people that was rooting on me to fail, at the end of the day they have to

wake up tomorrow and have the same life that they had before they woke up today. They have the same personal problems they had today." Finally, some paradoxical dialogue from *Hiroshima Mon Amour* (Resnais, 1959): "In a few years, when I will have forgotten you, and when other adventures like this one will [have] happen[ed] to me from sheer force of habit, I will remember you as the symbol of love's forgetfulness. I will think of this story as of the horror of forgetting. I already know it."

Functional magnetic resonance imaging studies have demonstrated that similar brain regions are involved in both thinking of the past and imagining—projecting—the future. Does prospective memory include remembering to forget? Can one superimpose a new memory on one's old memory? Consider the response of Frank McCourt to an attorney's question during a divorce trial seeking to determine the ownership of the Los Angeles Dodgers: "Are you asking my memory now? Or my memory then?" (Hall and Shaikin).

43. See, for example, Gerrig; and Murray Smith.

44. See, for example, Bordwell, "Historical Poetics of Cinema."

45. See, generally, Mack; and Neisser and Hyman.

46. See, for example, Shanahan; Clark; Tomasello; and Wertsch. I believe that an 'arcades' memory is based on a "recall," not "recognition," process and would be a type of what is known as a "reconstructive memory" as opposed to a "reproductive memory." "Recovered memory" and "redintegrative memory" are two other types of reconstructive memory. A fascinating form that is perhaps intermediate between 'arcades' and 'vitrine' memories is evidenced by a 'cabinet of curiosities,' for example, Joseph Cornell's wooden-box and collage constructions. See generally (and particularly) Cavell, "The World as Things." See Bruno as well.

Another form of extended cognition, first proposed in 1985 by Wegner, Giuliano, and Hertel, is "transactive memory," which is a sharing of memory duties with one's spouse or group of people or with a device.

47. Mirror neurons are linked to the social emotions and to what Damasio (*Looking for Spinoza*) calls the "as-if-body-loop," not to either primary or background emotions. See Blakeslee; Rizzolatti, Fogassi, and Gallese; and Humphrey.

48. Some examples of "mirroring" activity based on Plato's wax block that occur in different guises in the four domains are as follows: mirror neurons (objective); Freud's transference/countertransference (subjective); Richard Dawkins's and Susan Blackmore's memes (interobjective); and George Lakoff's notion of a radial category/family resemblance (intersubjective). On methods of reconfiguring a camera, see Branigan, *Projecting a Camera*.

CYBERSPACE AND ITS PRECURSORS

Lintsbach, Warburg, Eisenstein

Yuri Tsivian

I know I need to explain this unlikely company of names, for indeed it may not be imme-diately clear what a visionary linguist, a revolutionary art historian, and a theory-minded film director have to do with each other—and why I yoke these three thinkers with the notion of cyberspace coined well after their death. In this essay, I am going to tap cyberspace not to preview the future, but to review the past. This, I must add, I do out of necessity: hindsight is the only vantage point that my background makes available to me. Unlike most people I had the honor to be with at the Interactive Frictions conference, I am not a cyber expert, and I am a poor cyber-user (for instance, I seldom browse, though I do believe that "browsing" is a more precise and more honest term for what we call research). What I do is early film history, with occasional sallies into art history and the history of semiotic ideas.

The reason I was invited to give a talk at the conference was this: it so happened that at that time I was working on a CD-ROM designed as a tool for exploring and teaching early Russian films (Tsivian, *Immaterial Bodies*).[1] The little I know about cyberspace comes from this hands-on experience plus a few basic books on the subject which I consulted to check out how much of what I am going to say has been said already. So, the cyberspace evoked in this essay is not the vast space fronting onto the future, but more of a small, private, experiential site, which nevertheless offers an unusual perspec-tive on the past—the perspective that allows us to glimpse three distant figures whose separate (and different) efforts, as viewed from our time, can be seen as adumbrating the medium the Interactive Frictions conference was called to discuss.

In other words, these notes are about electronic behavior before the chip—about a 1916 attempt by Jakov Lintsbach to write up a multimedia language, about a multilinear book imagined by Sergei Eisenstein in 1929, and about Aby Warburg's late-twenties project which envisaged using clusters of images instead of word strings to communicate his ideas about art.

I will address these three stories in three separate chapters, but let me first try to explain why I think the huge and impractical things these people imagined segue into my own limited and very practical experience with that 2001 CD-ROM. The moment I was faced with the task of writing film history in cyberspace, I felt that my usual historian's toolkit was at once enriched and impoverished. Impoverished because in this space, you cannot rely on what we call "the line of argument"—there is no way to tell which button your user will click on next. The first tool I thus found myself robbed of was a neat causal path, a historical narrative leading from one event to another. Computers won't let you think in terms of narrative time; instead, you find yourself thinking in terms of narrative space. If I tell someone that my CD-ROM has ten beginnings and no "end" title, it will sound like a mess; but if I say that it has ten possible entrances and no prescribed exit, it makes perfect sense. Here, you do not "tell" your story, you design it. This feature—known in modern usage as hypertext or "non-linear linkage"—is both limiting and liberating, and it is this liberating aspect that links cyberspace models of history (and theory) to Warburg's "black velvet screens" or Eisenstein's "spherical book," two models designed to counter the confinement of linear argument.

What makes me bring up the third thinker, Jakov Lintsbach, with his offbeat idea of a universal language, is that, strictly speaking, the cyber-medium is not a medium but a multimedium. As your interface designer warns you from the outset, making your project talk, play clips, and display images is not a luxury, but a condition—for even though the computer is a perfect took for writing, it is not well geared for reading. In cyberspace, you do not speak about images—you make them speak for themselves.

Is this yet another limitation, or perhaps a window that opens on the future "republic of signs" that is coming to replace the empire of letters? If so, it should be instructive to connect this feature of cyberspace to "logoclastic" movements within art history and the history of semiotics, which is all this essay is trying to achieve.

A quick comment on the word "precursors" in my title. To those versed in philosophy, it may signal exactly the kind of Hegelian, linear, timebound, teleological understanding of intellectual history that I have just argued cyberspace usefully helps to pass up. If so, take it as a pun: think of my three "precursors" as "pre-cursors"—people who happened to be living before the age of the cursor, and whose once impossible projects look more possible nowadays.

EISENSTEIN'S SPHERICAL BOOK

The term "spherical book" belongs to Soviet filmmaker Sergei Eisenstein (1898–1948), who is known not only for his films but also for his theory books on film and art.

Eisenstein wrote fast and well, but, as his diaries indicate, he was not happy with the very medium of writing. From 1929 on, Eisenstein's mind becomes increasingly occupied with a utopian image of the ideal book. Let me quote an entry from his diary dated August 5, 1929:

> This book is very hard to write. This is because books are two-dimensional affairs. The quality I want this book to have would make it unlike any other book ever written, but also not fit to print. I require two things. First, the cluster of my essays must not to be seen and perceived in sequence. I want people to access them in their totality, for each segment of the cluster only makes sense in its relation to the whole. On the other hand, I want my book to become a space in which any element can be directly linked to any other, transform into any other, reference and interact with any other. Such synchronicity and mutual interpenetration of essays is only conceivable in a book that would have the form of a . . . sphere! Its segments should form a sphere so that any transition between them is unmediated—via the center. But alas . . . Books are not made as spheres. . . . We use palliatives instead. We flatten the sphere to a plane, and stretch the plane into a line. To give then a semblance of unity I present my essays as leading up to each other, while in reality they exist simultaneously, as a whole. To meet my second requirement I am forced to do what we always do when dealing with the inadequate form—to substitute form with the process. I supply my essays (and then, only where it is strictly necessary) with cross-references pointing both forward and backward. It remains for me to hope that this book, which talks so much about mutual reversibility, finds a perceptive reader who will figure out my method, and do while reading what I failed to do while writing. In the meantime, let us wait till we learn to read and write books as revolving spheres! The soap bubble books are around already, particularly among the books on art. (*Montazh* [Montage], fourth cover page)

Seventeen years later, hospitalized after a heart attack, Eisenstein found himself facing a similar problem. On May 1, 1946, he took a decision to write a book of memoirs. He started, as memoirists are prone to, with his early childhood in Riga, but felt stalled after the first draft. On May 5, he resolved to discard any order or chronology, becoming, instead, a "*flaneur* across one's own past" (quoted in Kleiman, 9). Instead of recording this past, as Eisenstein soon discovered, writing without a plan became his way of exploring it. This is what he wrote in a note dated May 9, 1946:

> There is as much reading as there is writing! Beginning a page, or a section or a phrase, I have no idea where it will take me as it develops. It is like flicking through a book: I do not know what I will find on the other side of the page. No matter that the "material" is mined from the "depths" of my own resources; never mind that the "factual" material is the product. There are whole new tracts of utterly unexpected territory whose existence I never dreamed of, much that is completely new. Juxtaposition of material, conclusions, reached from these juxtapositions, new aspects and "discoveries" which flow from these conclusions. (*Beyond the Stars*)

Loathing as he did any form of narrative or logical linearity, it is not easy to imagine how Eisenstein might have pieced together the data he had mined from his unconscious mind had he lived to see his last book finished. What remains of it is an archive of fragments with scarce clues as to their best possible arrangement. Looking at them, one is reminded of Eisenstein's old dream about the spherical book. Two volumes of Eisenstein's memoirs came out recently, edited by Naum Kleiman, whose unique insight helped to arrange the fragments of Eisenstein's past as their author might have. It is an excellent book; still, it is a book, not a ball. When I spoke about Eisenstein's spherical book at the Interactive Frictions conference, it sounded like a fantasy. Today, it sounds more and more like a project.

WARBURG'S MNEMOSYNE

My next cyberspace precursor is German art historian Aby Warburg (1866–1929), who, like Eisenstein, did not publish much, and whose legacy comes down to us interpreted by other people. The number of such people has rapidly grown within the last ten years, as has Warburg's acclaim among students of the humanities. One reason for that is Warburg's unique interest in movement. He was not the first to notice that a large part of what constitutes the history of art are images of bodies arrested in motion, but he was the first to say that movements and gestures should be seen as a legitimate subject of art history studies. This sounded less conventional a hundred years ago than it may appear to us today, when so many images around us are images in motion, and when cultural history is increasingly viewed as the story of bodies rather than as the time-honored *Geistgeschichte*. It is Warburg's unconventional interest in the way people move and perceive space that explains why recent studies put Warburg's name side-by-side with Darwin,[2] Marey,[3] and, unsurprisingly, Eisenstein,[4] whose entire theory of film is rooted in the psychology of gesture.

Another reason why Warburg is viewed with much interest today is his belief in parataxis—the power of explaining things by simply putting them next to each other. Much like Eisenstein's, Warburg's legacy consists of drafts and fragments rather than of evolved and finished texts. Some explain this by Warburg's uneasy time with writing, others by his impatience with linear ways of building a scholarly argument—a syndrome which, we recall, he shared with Eisenstein and, as others remind us, with Walter Benjamin, who once wrote this about his *Arcades Project:* "Method of this work: literary montage. I have nothing to say, only to show" (quoted in Rampley, 137). To show was something Warburg's last project, called *Mnemosyne,* was meant for, too, but there was nothing literary about Warburg's montage: here things were, literally, shown.

Many people have read about this project, but not many have seen the authentic thing stored in the vaults of the Warburg Institute in London. Neither have I, so let me present it here by quoting those who have—as a montage of quotations (*litmontazh,* to use the word in vogue in 1926 in Moscow), with my own remarks serving merely as splices.

Ernst H. Gombrich (*Aby Warburg: An Intellectual Biography*, 1986) describes Warburg's last project as an art historical study conceived in terms of music. Two visual themes that occupied his mind—the vicissitudes of the Olympian gods in the astrological tradition and the role of the ancient pathos formulae in postmedieval art and civilization—were to provide the material for the principal movement of a vast pictorial symphony to which other themes were to be added that might have formed a scherzo and a triumphant. Gombrich goes on to explain what the project looked like:

> Warburg had announced in December 1927 that he proposed to compose such a work in the form of a "picture atlas" the title of which would be *Mnemosyne*. All the lectures and investigations on which he was henceforward engaged were to be incorporated into this large work of synthesis. In practice that meant that he pinned the relevant photographs on the screens and frequently re-arranged their composition, as one or the other of the themes gained dominance in his mind. On Warburg's death there were forty such screens, most of them crowded to capacity with photographs, large and small, making a total of nearly one thousand. (283)

In a more recent study of *Mnemosyne,* Charlotte Schoell-Glass specifies that Warburg's screens were roughly five by seven feet in size:

> They consisted of a light metal frame on which a dark cloth was tightly fixed. On the cloth, reproductions of artworks could just as easily be attached with metal clasps as they could be rearranged, or removed. (185)

We will return to Schoell-Glass's recent essay in a moment, but now, let us change the view back to Gombrich's point. That Warburg would rather shift pictures around than sit down to write a book about them was due, Gombrich thinks, to the fact that Warburg found writing a painful task.

> He was always so deeply convinced of the complexity of the historical processes that interested him that he found it increasingly vexing to have to string up his presentation in one single narrative. Every individual work of the period he had made his own was to him not only connected forward and backward in a "unilinear" development—it could only be understood by what it derived from and by what it contradicted, by its *ambiente*, by its remote ancestry and by its potential effect on the future. (Gombrich, 284)

If Gombrich is right and it was the fear of linearity that deterred Warburg from writing, his description looks similar to how that entry from Eisenstein's diary quoted earlier explains Eisenstein's dream of writing a spherical book. "Dream" is also the word that Gombrich uses to interpret Warburg's unconventional ways of working with pictures:

> In a sense, its title *Mnemosyne*, "Memory", is more fitting even than Warburg intended it to be. It shows the memories of a scholar's life as if they were woven into a dream. To those

who can read its mute language and expand its references it has indeed the intensity of a dream; its affinities are less with works of history than with certain types of poetry, not unknown to the twentieth century, where hosts of historical or literary allusions hide and reveal layer upon layers of private meanings. (302)

If Gombrich, looking at Warburg's plates for *Mnemosyne,* thought of their similarity to music and poetry, some later students of Warburg found it instructive to compare *Mnemosyne* to coeval avant-garde practices in visual arts—from Cubist collages to Dada.[5] This is what one of them, Kurt W. Forster, claims:

In 1926 Alexander Rodchenko manufactured a series of posters whose subject was the history of the Communist Party in the Soviet Union. This work lived up to Lissitzky's demand that "the traditional book must be broken up into separate pages which, hundred times enlarged, must be put out in the streets." What else were Warburg's plates for *Mnemosyne* if not broken up pages of a gigantic book whose endless links that intertwine its subjects blow up the framework of the linear presentation and of the bookish kind of logic? The tendency as a result of which discourses unfold and branch as if on a map instead of being broken down into consecutive steps informs Warburg's methods much as it did various form of photomontage practice by many an artist at his time. Warburg's tables hardly pursued the same formal goals as were pursued by these, but the logic of their construction and the fact that Warburg had worked this logic out to the last detail *long before editing them into a semblance of texts* testify to the strong affinity between the "state of pictorial material" in Warburg's art history and the artistic practices of his time. (192–193, emphasis in original)

The similarity indeed becomes apparent as soon as a reproduction of one of the *Mnemosyne* screens is put side-by-side with a Rodchenko poster, as Kurt W. Forster does to illustrate his point. Warburg himself might have done this, for going by visual analogies between otherwise disconnected gestures or images is very much in the spirit of Warburgian thought. Some Warburg scholars, however, seem to be slow to embrace the idea of posing Warburg next to avant-garde artists. Rather than thinking of the *Mnemosyne* screens as Warburg's canvases, Schoell-Glass suggests, we should see them as Warburg's tools. She pays attention to the fact that the final (unrealized) goal of the *Mnemosyne* project was to make it available as an atlas, not as a series of screens or posters, which fact allows us to connect the whole thing to traditional science, not to innovative art:

The choice of the *tool* of the *atlas* ("our atlas"), tells us just as much [as its title, *Mnemosyne*], as an atlas is an instrument with a long and dignified history in European culture. *Bilderatlasse* abound in the 19th and early twentieth centuries, predominantly in Medicine (dermatology), in geography for city-views, and in other areas where a comparative approach to objects had its place within different methodologies. The introduction of the tool to Art History today seems to be an easy move; however, it may not have been so obvious a choice

then. And rather than connecting it by way of analogy with Cubist collages, I suggest seeking an analogy for Warburg's "invention" in the realm of science. After all, he saw his research institute (and the atlas) as a *laboratory,* where information was assembled and then processed and worked with just as in a chemistry or a physics lab, as well as a *seismograph* to register underground movements that would not be noticed otherwise. (185–186, emphasis in original)

The conundrum about *Mnemosyne,* as it arises in various writings on Warburg, seems to be how to contextualize that strange medium this art historian was committed to—clusters of pictures clipped onto a series of black screens. If he did intend them to form an atlas, this atlas would have to be a huge and hard-to-manage affair—for the relative size of clipped reproductions do diminish dramatically when the screens are reduced to fit the book-size format. It is size and format that another observer, Georges Didi-Huberman, pays attention to in his recent monograph on Warburg. These are not artworks that Warburg clipped to his tables, the French art historian reminds us, but rather diminished photographs of artworks and of their details. For the historian of art to be able to work with a library of photographs [*phototéque*]—and Warburg's collection had around twenty-five thousand of them in 1929—was an "epistemological mutation" that took art history in the epoch of photography to a new level, Didi-Huberman claims:

> Making tables [*tableaux*] of photographs (notably, of photographs taken of pictures [*tableaux*]) could easily be a minimal definition of art history viewed as a practice. What does the art historian do in practice? He begins with going to off-beat and diverse places; he moves from one culture to another, from one epoch to another, from the familiar to the strange, from one museum to another, from a church to a library, from a miniature to a fresco cycle in a cathedral. . . . His common denominator is a cascade of photographs which he can put on his desk and organize according to a hypothesis, thus producing a *comparative series* of objects that belong to different real places and times. (455, emphasis in original)

Historians of photography are of the same mind. This is what Ulrich Pohlmann has to say—not about Warburg, but about the late-nineteenth-century tide caused by that then new medium which, according to Didi-Huberman, carried Warburg along:

> In retrospect, the significance and practical value of photographic art reproductions for the reception of art can certainly not be overestimated. In anticipation of Andre Malreaux's thesis, put forward in his *Musee imaginaire,* the mid-nineteenth century already had at its disposal a widely available pictorial universe of works of fine art, which fundamentally altered the perception and understanding of art, given that from then on it was possible to study a work irrespective of its location. (45–46)

While it is true that Warburg's use of photography to study art was an accepted (if new) practice at the time, his ways of handling these photographs went far beyond the

accepted, as others point out. What he strived to achieve by clipping and reclipping pictures into clusters and sequences reminds us of what Warburg's younger contemporary, Sergei Eisenstein, was trying to do with film shots. Indeed, Eisenstein's revolt against linear books found in his 1929 diary was but an echo of a similar battle he was waging at the film front—for it was his contention that the path toward the cinema of the future lay through denouncing continuity editing and replacing it with montage. Montage, according to Eisenstein, was the art of juxtaposing ("colliding") two film shots in such a way that their contact sparks in the viewer a thought not contained either in each of the shots separately or in both of them taken as a sum. In other words, it is not so much shots per se that the montage director taps for meaning as cuts between shots. No wonder that both art theorist Didi-Huberman and film scholar Philippe-Alain Michaud found things in common between Warburg's *Mnemosyne* and Eisenstein's experiments of 1927–29. *Mnemosyne,* the former says, was not a "resume in images," but *thinking in images* (*pensée par images*), not just memory, but live memory, as it were (452). The latter goes into more detail:

> [S]equences of images are used like ideograms in *Mnemosyne* to produce a new art-historical language that is similar to Eisenstein's visual syntax. The very development of the concept of the interval on which the structure of the atlas rests, which would remain the dominant concept of twentieth-century montage, dates from 1920s Russian film theory. In *Mnemosyne*, the subjective dimension that Panofsky assigned to the contents of the image is displaced among the images. Their contents are photographic or documentary; only their insertion in a sequence of images transforms them into unities of expression. Within the panel, the fragment has no separate existence; it is the specific representation of a general theme running through every element and leading to the formation of an "overall global image effect" comparable to Eisenstein's *Obraznost* [image-ness]. (283)

Still, no analogy is perfect. It is true that Eisenstein's montage theory sees cinema as a form of thinking in images, yet film images succeed each other in time, whereas the *Mnemosyne* story is told in space. Distinct from the way art historians from Vasari to Gombrich have been telling their stories of art, *Mnemosyne* tells hers in terms of contiguity, not continuity, in visual clusters rather than verbal narratives—something that makes Warburg's screens look more and more like the ones we use now to cut, paste, click, or drag our digital pictures.

JAKOV LINTSBACH'S LIVING SCHEMES

My third cyberspace precursor is Estonian philosopher and mathematician Jakov Lintsbach (1874–1953), whose name may be less familiar that Warburg's or Eisenstein's, but whose media-related ideas were as radical as theirs. Like Lull in the fourteenth century, Bacon in the seventeenth, Blake in the eighteenth,[6] or the initiator of Esperanto

Dr. Zamenhof in the nineteenth, Lintsbach was a visionary linguist. He was of the mind that the natural languages we all speak shall eventually give way to the-same-for-all universal language to be created by science and adopted by all. In 1916, Lintsbach, then living in Petrograd, published a book (in Russian) which began with a criticism of all artificial-language projects from Volapuc to Esperanto and ended by offering Lintsbach's own, based on entirely different principles.

The mistake of Esperanto and its like, Lintsbach claims, is that these artificial languages merely emulate the natural ones. They use words, they have grammar, and they are spoken. The true universal language of the future, Lintsbach goes on, should base itself on a medium different from speech.

His philosophical underpinning is this: speech that once helped human beings to rise above the other animals is nowadays holding humans back. To convey their vision of nature, modern painters use pigments, not words; likewise, to house their formulae and graphs, mathematicians use a blackboard or a book. The printing press made modern literature what it is, and that recent invention, the cinematograph, will do for gestures and movement what the printing press once did for words. Oral speech has always been a source of all misunderstandings, Lintsbach insists, and the present-day atrocities which we all witness with horror stem from the fact that people and nations still communicate using natural languages—the medium of lies and confusion, not of empathy and truth.

Remember, Lintsbach wrote his book in 1916, at the height of World War I, and it is hard not to be moved by the following passage in his foreword:

> We apologize for any defect the reader might find in this book. The circumstances under which its author wrote it were far removed from the peace of mind and the luxury of free time he had counted on. As one of those waiting to be drafted from the day the war was declared he was no longer a master of his time or of his very life. He needed to write in a hurry for fear that the research which took him almost a quarter of a century, that is, one half of his conscious existence, might perish without being written. (XII)

Lintsbach was not the first to blame languages for human misfortunes and to hope that these misfortunes will end once we all adopt a more perfect one. Nutshelled in the very name of Zamenhof's "Esperanto," this tradition goes back at least as far as Francis Bacon (Rossi, 148–149). What makes the quest for a universal language interesting is not so much the messianic idea that fuels it, but specific recipes which change across time. Lintsbach's was to go from speaking to writing and from grammar to math. While the proposal per se was not entirely his (it was Bacon again, and some of his followers who saw their universal language consisting of written hieroglyphs and governed by "Logick and Mathematicks"[7]), Lintsbach's term "written" is not confined to words on paper. In his vision, the writing of the future will include a variety of things: pictures, formulae, body language, the language of music and color, glossalalia, geometrical graphs, and, not least, a kind of schematized animated cinema which Lintsbach variously called "living

FIGURE 1.
This passage from Lintsbach's book presents the kernel illustration, which consists of five elements: a tree, a mountain, a road, a horse and sledge, a man.

FIGURE 2.
"Road, sledge, horse, man." In this illustration, Lintsbach presents the five elements from Figure 1 devoid of the visual grammar, in disarray.

FIGURE 3.
In the five-frame strip to the left, Lintsbach shows how the visual message from Figure 1 would look if its constituent elements were presented one by one, as a "picture phrase."

FIGURE 4.
The four-storey structure visually encodes a story summarized beneath it. "Column 1: a man lives in a house at the foot of a mountain. Columns 2, 3, 4: early in the morning as the sun rises, he gets up. Column 5: he leaves the house. Column 6: he brings the horse. Column 7: he harnesses it. Column 8: he gets into the sledge. Column 9: and departs."

FIGURE 5.
"The road leads him to the city." 10 stands for lead to; 11 for road; and 12 is Lintsbach's "mental image" of the city; the real city is still far away.

FIGURE 6.
Lintsbach's "living schemata," which presents a number of adventures of the man on his way from home to the city.

FIGURE 7.
In this six-storey dictionary, Lintsbach shows how an alphabet of concepts can be conveyed by means of body movements (upper row), by zeros and ones (bottom row), and by other graphic codes.

FIGURE 8.
Lintsbach's "digitized image" shows how a visual message (upper picture) can be mathematically transcoded into a musical (middle) and a gestural (bottom) system of signs.

FIGURE 9.
This is how Lintsbach's kernel illustration (to the left) looks when "hand-digitized" by using a numbered grid (to the right).

FIGURE 10.
Lintsbach's visual system is mechanically projected onto the music notation, as a result of which the verbal/visual utterance above is transformed into a musical one. The kernel image from Figure 1 can now be played or sung. (Dashed arrows are mine—Y.T.)

FIGURE 11.
Lintsbach's visual system is projected onto signs standing for codified body movements. (Dashed arrows are mine—Y.T.)

FIGURE 12.
Thus, every point of the grip is assigned a corresponding body position. The kernel image from Figure 1 can now be danced. (Dashed arrows are mine—Y.T.)

(28)

FIGURE 1

(29)

FIGURE 2

(31)

FIGURE 3

(45)

FIGURE 4

(46)

FIGURE 5

(53)

FIGURE 6

(133)

FIGURE 7

FIGURE 8

FIGURE 9

FIGURE 10

FIGURE 11

FIGURE 12

schemes," "the cinematograph of icons," and the "manual language of the mind." This semiotic ensemble comes close to what we call "multimedia" today and what was called "synesthesia" in Lintsbach's day.

Visionary as it is, Lintsbach's project is more than a vague philosophical prophecy. It is a consistent system of strict rules, following which any utterance formulated in a natural language can be rendered by means of any other media. Even though the system is complex and detailed (there are more than two hundred graphs and tables in the book), a few samples should suffice to get a bedrock sense of Lintsbach's line of reasoning.[8]

Let us say that it is winter and we are in the countryside, Lintsbach writes. A man driving a horse and a sledge passes by. This brief phrase, or one like it, will suffice to communicate this information verbally. Now, suppose you don't want to use words but want to use visual images instead. The first thing you will be faced with will be a necessity to specify the character of the space in which the action takes place and the direction of movement. To do this, you may need to add a mountain in the background, and a road which leads the sledge leftward (figure 1).[9]

These are two different ways of saying the same thing, Lintsbach explains, using a text and using a picture. Both have one thing in common—they are composite structures whose elements are held together by a certain grammar. But there is also a distinction: the verbal grammar relates words in time, while the grammar whereby pictures make sense has to do with the way in which its five elements interrelate in space. Pull the spatial grammar out of the picture, and it will collapse into a meaningless heap of unintelligible lines (figure 2).[10]

Even though when we say "picture" we routinely refer to arrested images, Lintsbach goes on, nothing precludes us from trying to reconnect the five elements in time rather than space. That this has never been done does not mean we cannot do it. Imagine a strip consisting of five frames, much like those used in the cinematograph. Now, if we place each of our picture elements in a separate frame going left to right, they will form a consecutive picture phrase, much as words do (figure 3).[11]

Compare the conventional picture with its frozen grammar (the right-hand end of the strip on figure 3), Lintsbach suggests, with the five frames to the left of it. Only a language based on images that succeed each other will combine the tangible presence peculiar to pictures and the flexibility peculiar to spoken words. If we swap the road and the mountain frames, for instance, we will change the emphasis, as we do when we change the word order in Russian.[12] And so on. A truly systematic mind, Lintsbach offers five more frame transpositions, each time rephrasing the text below them to show how the meaning changes slightly, and adds:

> But while not every word order is legitimate in verbal languages, no limitations are imposed on the language of the Cinematograph. Here the speaker is allowed to rearrange frames as he likes, depending on his artistic hunch. He can begin with what pleases him more, and end with what pleases him less. Or, conversely, he can save the last position for a more

important thing, and begin with a less important one. Finally, if he prefers symmetry, he may group the frames he wants to highlight in the middle. To conclude, the artist will find here the creative freedom not to be found in any other language. (79)

Now take a more complex message in which not one but a series of actions is involved, Lintsbach goes on. Suppose we want to tell more about the man riding the horse and the sledge—say, specify where he lives and where he goes. Take this story: *At the foot of a mountain there is a house in which a man lives. Early one morning he got up, came out of the house, brought out a horse, hitched it to the sledge and took off. His road led to the city.* How will we communicate this message using our schematic pictures?

Evidently, at one point or another the "picture-speaker" will be faced with a necessity to deal with the notion of time—something the language-speaker handles using a system of tenses. This means that our picture language will need two axes along which to align the picture frames: the space axis and the time axis. In agreement with this principle, Lintsbach's next graph lines up space-related frames vertically and time-related ones horizontally, as is routinely done in mathematics (figure 4).[13]

The graph now looks like a four-storied structure, four frames high and eight frames long. The four vertical (spatial) frames slice the space of the story into four grounds. The lower one forms the foreground—the slice of space closest to the observer. The one above is the quarter-foreground, where the house in which the man lives is situated. Consequently, the mountain behind the house occupies the "third floor" (the quarter-background), and the upper frame, split in two by the line of horizon lurking behind the mountain, is the background, as far as the visible space goes.

It is this horizon that will allow the picture-speaker to add the time dimension to his story, Lintsbach explains. Granted that the nine horizontally arranged frames tell the story as it unfolds in time, it is only natural that we attach a small circle denoting the sun to the horizon line, which will tell us how high the sun was at each given moment of the story. We need no sun for the first, leftmost column, of course, for the sentence that opens the story (*At the foot of a mountain there is a house in which a man lives*) is a nontemporal utterance, its timeframe defined only by human mortality. But as soon as we go on to columns 2–3–4, the horizon scale becomes of use. That the sun is below the line in the second column explains why the man in the house is still in bed; he is shown sitting up in his bed as the sun is shown half-risen; and as the sun is above the line, the man is already standing on his feet. These three columns, thus, correspond to the phrase *early one morning he got up.* The rest of it hardly needs further explaining, but pay attention to the fact that after the *came out of the house* column, the action shifts to the foreground, where the man is shown bringing out a horse, hitching it to the sledge, and taking off.

Lintsbach goes on: the more complex the story we want to convey, the more interesting the problems the designer of universal language will be required to solve. Now, it may be less evident how the last phrase in our textual example (*His road led to the city*) should be translated into a series of pictures, for here we are not talking about what actually happened,

but about what we want the person we address to know.[14] To convey this, Lintsbach inserts a "mental picture" that tells us where our sledge rider is heading (figure 5).

The diagram in figure 4 has taken us through the morning part of Lintsbach's sample story. Another diagram (figure 6) tells what happens next. It shows how Lintsbach's "living scheme" is supposed to render the forest the sledge road is running through, atmospheric events (clouds and snowstorm), and the fact that a person whom the sledge rider offers a lift happens to be carrying a rifle (another "insert"—this time visual, not mental). The rifle comes in handy: the triple icon that awaits our travelers as soon as the road snakes out of the forest stands for a pack of wolves. All ends well: they scare off the wolves, find an inn, dine together, and go to bed as the sun sets (the fact that the two guests appear to be sharing the same bed is a touch of realism: in the 1910s, roadside inns in Russia had big bedrooms, with a large hay-covered bed designed for several bedfellows).

How long will it take to tell the story? Not as long as it may seem. That Lintsbach's space-time grid looks to us like a storyboard for a sizable movie is no more than the fallacy of hindsight. The case he made for using "living schemata" instead of words was exactly their speed and compactness—two features that complement the fullness and immediacy of the picture-based language that people will use in the future. The latter will not duplicate cinema, but rather take up its basic principles and improve on it. Distinct from the "physical cinematograph" (as he called films he would have seen up to 1916), Lintsbach's "manual cinematograph" was all about *mental* images. On the strength of a psychological theory current at his time, Lintsbach held that the speed at which mental images flashed in the human mind was seven images per second.

I have barely reached the middle of Lintsbach's book at this point, for the book is not about mental pictures alone. Not uncommonly for a thinker living at that time, Lintsbach believed in synesthesia, that is, in the reality of things like colored vowels, visual music, melodious landscapes, eurhythmics, or even different smells pertaining to different geometrical figures (figure 7). In 1910, one did not have to be out of one's mind to discuss, as Lintsbach does in his book, the ways in which the sledge story can be communicated by a succession of abstract color messages or by mixing, to the same effect, various chemicals to obtain certain chemical reactions.

Nor would a person living in 1916 be too surprised to find out that, as a result of assigning definite consonants and vowels to specific configurations of lines of the sledge drawing, Lintsbach has arrived at the linguistically nonsensical but mathematically impeccable utterance *hy'chop sha'ppolchop hy'po, ky'siifju a'tyu ka'po, fa'aapo, poooo*, conveying, of course, the message about the man riding a horse and a sledge—for the resulting line was not unlike what the Italian futurist Marinetti used to call "words in freedom" or what Russian futurist poets called *zaum*, or transrational poetry.

Far from being a polymath like Lintsbach, I will skip the algebra and chemistry sections of Lintsbach's linguistic project and look briefly at the way his master example—the man, the sledge, and the horse—can be communicated through two other media—music and gesture.

A brief digression. It so happened that Lintsbach, like many a European intellectual in the 1910s, was swayed by eurhythmics—a system of rules devised by a Swiss music teacher, Émile Jaques-Dalcroze, that allowed one to move in strict conformity with music. Dalcroze's rules were simple (though not simple to master): your arms should move so as to show the number of beats there are in a measure, while your steps respond to the note value.[15]

Although to an outsider a eurhythmic show like the ones staged by Dalcroze and performed by his students must have looked like a symbolist version of ballet,[16] those familiar with his teaching knew there was more to it than that. In the eyes of its devotees, eurhythmics was not about moving to music, but about music itself transformed into motion. As a result of Dalcroze's exercises, synesthesia was, literally, embodied. "Music acquires bodily forms, and our bodies transmute"[17]—this line alone from Dalcroze's speech addressed to first-year students at his eurhythmics institute in Hellerau is enough to recognize the elevated, messianic overtone typical of turn-of-the-century synesthesia projects—Lintsbach's dryly scientific study of the universal language not excluded.

If Dalcroze's eurhythmic gymnastics embodies music, the gestural language developed in Lintsbach's book is called to embody everything: music, pictures, speech, various systems of calculation, and, yes, colors and chemistry as well.

Consider the system of message-encoding by means of human gestures explained in a six-level diagram from Lintsbach's book (figure 7). On the upper level, we see a human figure that moves its elbows and knees, raises or lowers its face, and turns its head to the left or to the right. Zeros and ones found at the bottom level translate Lintsbach's four body positions in terms of the binary calculation. As the human body has two sides, right and left, each side can be turned "on" and "off," that is, assume an active or passive attitude. This already meets the minimal requirement for being used as an information device, Lintsbach says, for if we express passivity through 0 and activity through 1, we will obtain four binary combinations: 00, 01, 10, and 11, depending on which side of the body is active or passive at this given moment. But then, Lintsbach argues, since the human body has not only two sides, but also two pairs of extremities (that is, two arms and two legs), each of which can be either raised or stretched, plus one head which can be either turned left or right, or be lifted or lowered, it is a system with six degrees of freedom. On the basis of this, Lintsbach proposes that the six-bit calculation instead of the binary one be used as the best mathematical fit for the body register of his universal language. The shorthand for this is the two-rows-three-columns system of little circles found right beneath the dancing figures. The upper row encodes the head positions, the middle row encodes both hands, and the bottom row encodes the legs. As is easy to see if we collate these groups of circles with the attitudes assumed by the figure above each, blank circles correspond to passive attitudes and the filled ones to active ones. Now, if we raise 2 (the number of columns in each circle-group) to the sixth power (the number of circles in each group), we'll obtain 64—the total number of different combinations our bodies can yield as a system of signs.

I have but a vague idea of what happens inside computers, but some of what Lintsbach does strikes me as coming close to digitizing. Before converting a picture to music or music to dance, he works to reduce them to mathematical diagrams and numbers. Take Lintsbach's kernel image, in which a man is shown driving a horse and a sledge (figure 1). Using more recent terms, one might say that, for all its schematic and composite character, this icon belongs to the analog category of signals—its lines fluctuate to repeat the shape of the five objects it depicts. Forget for a moment, Lintsbach says, that what we are looking at is a recognizable (we might say, "analog") picture and imagine that this combination of lines represents a diagram or a graph (figure 8). Let's assume that the left-hand vertical side of this graph is the y-axis of coordinates, while the horizontal side below is the x-axis. If we now calibrate each of the axes numerically, each point of the graph can be assigned two coordinates, Lintsbach goes on, and the whole picture can then be transcribed as a string of numeric values. One is tempted to call this process "digitizing a picture," even if in Lintsbach's time the term was not yet born.

In the upper section, set against a sixteen-square grid, is a graph in which we will easily recognize, despite the grid and the dots, five familiar shapes: the flat road, the towering mountain, and the outlines of the horse, the man, and the sledge the man is shown driving (figure 9). Let us agree, Lintsbach suggests, that we scan this drawing left to right (+ X) at equal intervals (as we see, all dots are indeed situated in the center of consecutive squares). Knowing this condition, we need only list the vertical readings of dots to render the picture numerically. Following the numeric scale along the left-hand side of the grid bottom-up, we will arrive at 045, 05, 036, 036, 037, 037, etc. . . . 017, 0126, 0126, 0145, 015, 0, 0. As is easy to notice, the 0 digit always stands for the road because is perfectly flat, anything beyond 5 belongs to the mountain, the two-digit 05 signals that at this point the profile of the mountain overlaps with the horse's ear, the four-digit series indicate that the scanned area now includes the man, and so on. In theory, if you cable these numbers to a friend who will feed them into a drawing mechanism, of sorts, the sledge picture should be able to regenerate itself into a drawing.

Now look at two musical staffs below the grid (figure 8, middle part). They show how a pianist might play our sledge-ride picture. Though Lintsbach gives us no clefs, we can assume that the upper staff, written for the right hand, is in the treble clef while the lower, left-hand one is in the bass clef.

What is it that allows Lintsbach to say that this music is an exact sonic equivalent of the sledge picture? To answer this, we must relate the two music staffs to the diagram above it (figure 10). Both staffs are scaled to the horizontal axis of the diagram, much as the numbers we discussed earlier were scaled to the vertical axis. Look for bar lines to see that they are matched to four four-square steps of the sixteen-square width of the diagram. Accordingly, the music is divided into four measures, 4/4 each, with as many notes in the sixteen-beat music staff as there are dots in the diagram above. The length of the piece equals the time it takes us to scan the diagram left to right—say, seven seconds.

All this is pretty straightforward, but how to render the vertical dimension of the sledge picture by means of music? To someone as given to synesthesia as Lintsbach, the answer comes naturally. The higher the dot found in the visual diagram, the higher the pitch of the corresponding note. The road, for instance, is rendered by way of your right hand tapping the E key sixteen times, for, as the road is flat, there must be no change in the pitch. Conversely, the mountain outline climbs and falls, and so does the sequence of notes written for the right hand. Thus, the double C in the upper staff—two highest notes in the sequence—stands for the mountain top; following this system, you will easily find which note corresponds to the man's head.

It is in the same spirit of synesthesia that Lintsbach suggests that the music-speaker varies dynamics and timbre to make the sledge picture musically more vivid. If we play louder to render the objects that are close to us and softer for the more distant ones, Lintsbach writes, we will give our picture a sense of depth; likewise, if we want to make the picture more tangible, we need to use one timbre for the earth, another for the horse and the man, a third for the sledge, and still another for the mountain (186).

Let us move ahead. To convert the sledge-ride picture to the Lintsbach-designed dance, two steps must be taken. Step 1 will be similar to what we did as we were converting the picture to numbers, and step 2 will replicate what we did to convert it to music. Aligned along the right-hand side of the grid—right opposite the numbered one—are funny little signs that Lintsbach uses as shorthand for the codified body movements discussed before (figure 11). As we recall, the complete alphabet of these gestures equals 64, but 16 is more than enough to calibrate the vertical axis of the grid, exactly as Lintsbach did with the numbers. It is only natural that the flat road marked by zero on the numeric scale will be marked by complete inactivity on the gestural scale (the I-like sign means "legs straight, arms hanging, head down"), and that more body activity is observed in the upper regions of the diagram.

Having assigned a "gestural value" to each dot of the diagram in relation to the y-axis, we can turn to "performing" the picture as a dance (figure 12). The dance score found below the music part is, like the latter, scaled to the x-axis of the diagram. Here, too, we find four measures separated by bar lines, with four attitudes in each, performed in 4/4 time. But while in the medium of music the sledge ride picture can be brought home by a single pianist using four fingers, here we need four dancers: one for the mountain, one for the horse, and so on. It is true that the part that falls on the road dancer is somewhat boring (the bottom line is all I's), but it is only as long as the road is flat. And so on.

Does this make sense? Apparently, to a computer it does. To demonstrate this, a computer scientist from Latvia, Gunars Civjans, designed a flash program which I used at a synesthesia conference in Berlin. This is a small-scale audiovisual animation that brings Lintsbach's synesthesia fantasy to life.

Did Lintsbach really believe that one day his multimedia language project would become a reality? At the end of his book, Lintsbach lifts his eyes from diagrams and numbers to ask exactly this question. This book is about principles, not about solutions,

he says. What specific forms the universal language will take in the future is up to future poets and artists, as I leave it to future engineers to decide how to convert my ideas into a fact. The time they'll need for this, Lintsbach adds optimistically, is a mere few centuries, no more (221). Reading this prognosis today, only ninety years away, one wonders if Lintsbach's optimism was not too cautious.

ABOUT THE AUTHOR

Yuri Tsivian is William Colvin Professor in the Humanities at the University of Chicago, where he teaches art history, Slavic studies, comparative literature, and cinema and media. A native of Riga, he studied film at the Institute for the History of Arts in Moscow and received a PhD in film studies from the Institute of Theater, Music, and Cinema in Leningrad. Before joining the University of Chicago in 1996, he worked as a senior research fellow at the Latvian Academy of Sciences in Riga and taught at the University of Southern California in Los Angeles. In addition to English and his native Russian and Latvian, he speaks Polish, French, and German.

In addition to many journal articles on Russo-Soviet and world cinema, Professor Tsivian has published several books, including *Silent Witnesses: Russian Films, 1908–1919* (1989), *Early Cinema in Russia and Its Cultural Reception* (1994), *Ivan the Terrible* (2002), and *Lines of Resistance: Dziga Vertov and the Twenties* (Pordenone, 2004). He is also involved in restoring and video-mastering silent films. You can hear his voice on the DVD version of Dziga Vertov's *Man with the Movie Camera* (Image Entertainment, 1995), on the audiovisual essay on the DVD of Eisenstein's *Ivan the Terrible* (Criterion Collection, 2001), and, both in English and in Russian, on his own CD-ROM, *Immaterial Bodies: Cultural Anatomy of Early Russian Films* (USC, 2000), which won the 2001 British Academy Award for best interactive learning project. He is also the recipient of the prestigious Jean Mitry Award for his contribution to film history.

Professor Tsivian's latest interest is in digital methods of film studies. He is the creator of Cinemetrics (www.cinemetrics.lv). In 2007–08, Cinemetrics won the ACLS Digital Innovation Fellowship. From 2010 through March 2013, it was awarded the National Endowment for Humanities Start-up Grant in Digital Humanities; in February 2013, a collaborative research project of Cinemetrics data has been selected for the Faculty Fellows funding by The Neubauer Family Collegium for Culture and Society for the years 2013–14.

NOTES

1. Part of the Cine-Disc series of bilingual CD-ROMs on national media cultures, this CD-ROM won the 2001 British Academy of Film and Television Arts Award for best interactive learning project and now is being distributed by the British Film Institute.

2. Gombrich, "Warburg Centenary" 39. Also see Gombrich, "Evolutionismus" 52–73.

3. Michaud, 86–90.

4. Michaud, 282–287. Also see Didi-Huberman, 483.

5. For more on this, see Didi-Huberman, 481–482.

6. See W. J. T. Mitchell.

7. Rossi, 145–151. Besides Bacon, Rossi refers to John Wilkins's 1698 project laid out in Emery.

8. For more on the subject, see Tsivian, "Jakov Lintsbakh as Film Semiotician."

9. Lintsbach, fig. 28.

10. Lintsbach, fig. 29.

11. Lintsbach, fig. 31.

12. Lintsbach, fig. 32.

13. Lintsbach, fig. 45.

14. Lintsbach, fig. 46.

15. Institute Jacque-Dalcroze, *Ritm,* figures, pages 34–35.

16. Lintsbach, fig. 55.

17. Lintsbach, fig. 40.

PAST INDISCRETIONS
Digital Archives and Recombinant History

Steve Anderson

In 1965, the analytical philosopher Arthur Danto described what he called the "Ideal Chronicler," a theoretical model for the ultimate form of history-writing. Danto's Ideal Chronicler would possess the ability to record and analyze the significance of every historical event from multiple perspectives at the same moment it is happening (155–159). Although originally invoked to demonstrate the impossibility of an objectively perfect form of historiography, the values reflected in Danto's ideal—comprehensiveness, multiple perspectives, and immediacy—are revealingly congruent with those promised by the proliferation of searchable databases and digital distribution networks. Setting aside, for a moment, euphoric expectations of the wholesale transformation of culture that was supposed to accompany the digital age in the late twentieth century, information technologies—for better or worse—have undeniably altered the way historical data is captured, processed, and disseminated. Coupled with the seductive, totalizing historical impulse described by Danto, contemporary digital historiography seems destined to pursue a direct and unproblematic relation to the past that awaits only the technical apparatus capable of rendering it in its wholeness and totality.[1]

At the same time, however, digital technologies have enabled strategies of randomization and recombination in historical construction, resulting in a profusion of increasingly volatile counternarratives, or "docufables" (Norman Klein, 16), and histories with multiple or uncertain endings. At the heart of these alternative visions of the past are the database and search engine, the primary mechanisms for organizing and disseminating information within digital networks. Whereas literary tropes have, since the 1970s,[2] been

recognized as offering a foundation for much historical writing, the database and search engine enable nonlinear accessing and combining of information into forms that defy both literary and historical conventions. Works of history that were once understood as contributing to an expanding field of collective historical knowledge are thereby repositioned as raw materials in infinitely reconfigurable patterns of revision and recontextualization. These two divergent thrusts within digital historiography represent competing conceptions of the past and give evidence of increasingly contested paradigms for historical epistemology.

DIGITAL HISTORIES

It is a truism of the post-Foucauldian world that the existence of categories of knowledge and institutionalized disciplines shapes what and how we think. Just as the emergence of the photographic apparatus altered nineteenth-century perceptions of the world,[3] increasingly powerful digital tools for storing and retrieving historical information now influence the way the past is conceived and reconstructed.[4] The global reach and virtually limitless capacity of the Internet, in particular, has inspired universities, libraries, and archives to position themselves as distributors, rather than simply preservers, of information. As a result, institutional resources are increasingly redirected toward the digitizing and organizing of historical information into databases that are accessible via both public and proprietary computer networks. The growing conception of computers as offering access to a master network of interlocking databases points to a transformation of fundamental notions of the past and the nature of historical research. It is within this milieu that Hal Foster asks,

> Is there a new dialectics of seeing allowed by electronic information? . . . Art as image-text, as info-pixel? An archive without museums? If so, will this database be more than a base of data, a repository of the given? (97)

The answer may be found in the movement toward "database histories"—that is, histories that comprise not narratives describing an experience of the past, but collections of infinitely retrievable fragments, situated within categories and organized according to predetermined associations.

Writings in literary theory and the philosophy of history have demonstrated that the various forms that historical writing has taken are deeply entwined with the prevailing ideologies and literary conventions of their time. In recent decades, similar efforts have been undertaken to theorize relations between motion pictures and history. With the provisional incorporation of visual (film, video, televised) histories into academic curricula, historians have begun to recognize the unique power of cinematic representation to bring the past "to life," promoting public interest in and—with some caveats—knowledge of historical events. A degree of experimentation with form, telescoping of

temporality, and character compositing is even tolerated in the interests of pursuing "serious engagement" with the past (Rosenstone, 206). Although much that is written about film and history remains devoted to domesticating the media industries' more flagrant departures from fact, larger questions of the impact of visual media on fundamental conceptions of the past lie just beneath the surface.

When the perceived reality of the cinematic spectacle is mobilized against, rather than in service to, the interests of a singular historical narrative, a film's strategies of historical construction and rhetorics of authenticity are brought to light. This is particularly important within the realm of digital historiography, where the already problematic ontological status of photographic realism confronts even greater challenges. Rather than focusing on the potential for artifice, however, the majority of public discourse surrounding the move to digital image acquisition has focused on the ability of digital video to capture or emulate the real world beyond the capabilities of conventional cinema. Remobilizing cinema verité's outworn association of authenticity with the immediacy of a newly mobilized cinematic apparatus, the Danish "Dogma 95" movement, for example, eschewed all forms of Hollywood artifice, gratuitous action, and generic convention. Directly inaugurated by the high-quality images captured by small, consumer-grade mini-DV cameras, Dogma 95's "Vow of Chastity" required its adherents to declare, "My supreme goal is to force the truth out of my characters and the frame of the action."

Considerations of the role of digital image processing in Hollywood have likewise tended to emphasize the potential for verisimilitude. Historians have approvingly noted director Ridley Scott's elaborate reconstructions of ancient Rome in *Gladiator* (2000) and Steven Spielberg's meticulously researched, prehistoric microcosms created for *Jurassic Park* (1993). Computer-generated imagery, thus deployed, reinscribes these cinematic visions of the past within a narrative realist tradition that is coextensive with the type of literary history theorized by Hayden White in the 1970s. In spite of its potential for experimentation with genuinely eccentric forms of historiography, digital media's potential to construct willfully counterfactual histories—for example, the compositing of Tom Hanks into archival footage of the desegregation of the University of Alabama in *Forrest Gump* (dir. Robert Zemeckis, 1994)—has been largely written off as a symptomatic excess of postmodern culture (Sobchack, "History Happens" 3).

In practical terms, the implications of digital technology for archiving have largely focused on technical questions of how best to preserve and disseminate historical information using rapidly expanding networks, notoriously transient file formats, and unstable storage media. Equally important debates have emerged around questions of intellectual property and the control of archival images, film, video, and sound recordings. With the concentration of image and sound archives in the hands of a decreasing number of media conglomerates, the ability to construct widely distributable visual histories increasingly necessitates cooperation with or oversight by corporate entities. A few organizations have been established to advocate non-corporate-dominated solutions to these problems, including the Long Now Foundation, which is devoted to long-term

planning for the preservation of digital culture, and the Electronic Frontier Foundation, which promotes freedom of expression in the digital domain. It is ironic that history, at the very moment when it is poised to reap the greatest rewards offered by digital technology in terms of reconstruction, preservation, and dissemination, is instead faced with its greatest threats to innovation, longevity, and accessibility.[5]

TOTAL ARCHIVES

Along with the shift to digital histories comes a change in perceptions of the role of the historian. The Medieval historian, as Hayden White notes, was exemplified by the disinterested chronicler or annalist whose sole responsibility was to record the facts of the past as a realization of God's will, free of interpretation or context (White, *The Content of the Form* 6–9).[6] The historian of the modern era, by contrast, is often characterized as a detective, a lone, single-minded professional trained to seek out and judge the authenticity of historical evidence, artifacts, and testimony. These shifting conceptions of historical work and historical evidence suggest yet another model for the working historian— that of the computer scientist or hacker who is able to freely traverse computer networks and databases, discovering, reproducing, and linking data into new combinations.[7] The primacy once accorded to narrative in the structure of history writing is thus being significantly challenged by the recombinant potential of the database. The work of the historian, once understood as the "assembling of progressively larger historical truths" (Rosenstone, 24), must now contend with the construction of open architecture databases and the accretion of huge volumes of historical events, facts, and images.

Dana Polan has noted that, in literature and film of the twentieth century, the figure of the university history professor is typically presented as an ineffectual and disconnected technician. Polan suggests that this is symptomatic of popular conceptions of the work of the historian as being the production of "reliable mimesis," citing the popularity of E. D. Hirsch's *Cultural Literacy* (1987) as a prime example of the repositioning of the past as "fixed pieces of knowledge and of history as positive retrieval" ("Professors of History" 251). With its list of five thousand references—dates, names, facts—that "every American needs to know," Hirsch's annoying but influential book presents historical information in a database form that is structurally free of narrative and interpretation. Historian Robert Rosenstone likewise notes that historians in popular culture suffer from an "image problem" exemplified by the figure of the history teacher in *All Quiet on the Western Front* (dir. Lewis Milestone, 1930) who misrepresents the experience of war in order to encourage young men to fight in World War I. Rosenstone also describes his profession's gravitational pull toward a mode of investigation that he calls "*Dragnet* history," which is characterized by the single-minded pursuit of "just the facts" (199).

Within popular culture, a notable exception to these characterizations of the professional historian can be found in the figure of Spielberg's Indiana Jones. Played by Harrison Ford, Indiana Jones first appeared in *Raiders of the Lost Ark* (1981), followed by

Indiana Jones and the Temple of Doom (1984) and *Indiana Jones and the Last Crusade* (1989).[8] Although unforgivably anachronistic in their resuscitation of colonialist ideology, Spielberg's films offer a fascinating fantasy portrait of the heroic, modernist historian. In *Raiders of the Lost Ark*, Jones is a mild-mannered, nerdishly bespectacled archaeology professor who turns into a whip-cracking adventurer in order to rescue a biblical artifact from the Nazis. At the conclusion of the film, Jones has successfully subdued the natives on multiple continents, defeated the Nazis, and transported the "ark of the covenant"[9] from Africa to the United States. However, rather than being received as a world-changing historical relic, the ark is packed into a numbered crate and deposited in a massive government archive.[10] The film ends bitterly, with a crane shot that pulls back to reveal thousands, perhaps millions, of similar crates stacked floor-to-ceiling in a warehouse-like archive from which, it is clear, retrieval would be next to impossible.[11] For all his daring and selfless courage, Indiana Jones is, in the end, defeated not by the forces of evil or the supernatural but by the implacable bureaucracy of the Federal Government archive.

More than a decade later, Spielberg would offer his own response to the irrelevance and obscurity of the total physical archive. During the production of *Schindler's List* (1993), Spielberg was so moved by hearing spontaneous testimonies of Holocaust survivors who came to witness the shooting of the film on location in Poland[12] that he decided to begin recording survivor testimonies on video. Following the success of *Schindler's List*, which won seven Academy Awards, including Best Picture and Best Director, Spielberg established the Survivors of the Shoah Visual History Foundation. The Foundation was charged with the Sisyphean task of videotaping testimonies by every living survivor of the Holocaust. Part of the goal was to create an undeniable mountain of evidence that would have a continuing presence generations after the last survivor has died. *The Survivors Project* resulted in interviews with more than fifty thousand Holocaust survivors from fifty-seven countries, conducted in thirty-two languages, and compiled on more than one hundred thousand hours of digital videotape.[13]

Faced with the overwhelming challenge of making this body of material accessible, the Foundation created a proprietary, high-speed delivery network capable of providing access to all hundred thousand hours of testimony at selected sites—mainly Holocaust museums—around the world. The interviews reside in a system that allows viewers at multiple locations to retrieve full-resolution video and sound over a fiber-optic network via a searchable, cross-referenced database. Rather than simply presenting a hundred thousand hours of talking heads,[14] the Foundation experimented briefly with developing a system for automatically generating montage sequences by tying a database of archival film images to an index of approximately eighteen thousand keywords identified within the spoken testimonies. The two databases could then be configured for dynamic combination so that if a survivor refers, for example, to riding on a train, the video will automatically cut to an image of a train while the audio continues in voice-over. In addition to adding somewhat generic visual variation to the interviews, this practice serves to

authenticate the memories of the survivors as direct historical evidence, a strategy that is in keeping with long-standing traditions of oral history and documentary filmmaking.[15]

Although somewhat historiographically anachronistic, the *Survivors Project*'s singular privileging of experience in the case of Holocaust survivors may be viewed as a return to the role of the historian as an impartial chronicler and assembler of evidence.[16] Because of the explicit political motivations of the Foundation, questions regarding the accuracy or verifiability of individual testimonies are largely elided. The need to establish a primary record of these vanishing accounts in the face of historical revision and widely perceived tendencies toward cultural amnesia superceded the historian's conventional need for verification and cross-referencing of testimonial claims.[17] In addition to the stated goals of the Shoah Foundation, this vast archive, the overwhelming size of which renders its contents inseparable from its system of access, may offer its greatest potential not as a total archive but as a resource for subsequent interpretations and narrative combinations—a foundation for future historical discourse as much as an end in itself.

MEMORY PICTURES

The problem with any total archive (as with the general overproliferation of information on the Internet) is that even a searchable database may not adequately represent or make available the range of materials it contains.[18] As an interim solution, the Shoah Foundation has created multiple, edited collections of testimonies on videotape and CD-ROM that distill selected survivor experiences into an interactive format suitable for use in libraries and schools. The interactive format, in particular, has proved effective for teaching Holocaust history and has been replicated in the media divisions of numerous museums. As Janet Murray has argued, the "encyclopedic mode" of data organization creates an illusion of breadth that obscures the actual processes of selection and exclusion to which any data set (including the complete Survivors collection) is inevitably subjected (Janet Murray, *Hamlet*). The textual processing to which all forms of historiography are subjected should not be regarded as detracting from the pure capturing of experiences or memories. Rather, when pursued with rigorous self-consciousness, the processes and problematics built into every form of historical writing may positively contribute to the power and significance of the project.

A particularly eloquent critique of the unproblematized oral history can be found in the documentary film work of Marcel Ophüls. Since the 1970s, Ophüls's production company, Memory Pictures, has created a vast and underrated body of work devoted to interrogating the role of memory in the writing of history. Averaging more than four hours in length, each of Ophüls's documentaries focuses on moments of historical trauma. At least three of his films deal directly with the Holocaust, including *The Sorrow and the Pity, Hotel Terminus,* and *The Memory of Justice,* while others have addressed wars in the Balkans (*The Troubles We've Seen*) and Vietnam (*The Harvest of My Lai*). But more

than merely chronicling the Holocaust, Ophüls's films grapple with the way these moments have been processed—written, remembered, obscured, revised, or forgotten—by historians, media practitioners, and the public. Although Ophüls's work frequently highlights the imprecision and the instrumentalization of individuals' memories, the goal of his work is not to debunk oral history per se, nor is it to render the past unknowable. Meaningful engagement with the past, he suggests, requires an investment of time (at least four hours), intelligent skepticism, and a willingness to engage with the contents of both history-writing and film on a processual level. The responsibility for preventing the erasure, forgetting, or denial of history, Ophüls argues, lies not in the creation of a total archive, but with the cultivation of a formidable audience/public capable of thinking, remembering, and constantly questioning what and how we know.

An additional, cautionary note on the utility of the totalizing historical impulse can be found in Jorge Luis Borges's short story "Funes the Memorious" (Ficciones). Although written long before the advent of digital culture, Borges's story presents a critique of the debilitating weight of perfect recall. The story's eponymous character suffered a head trauma as a child, which left him with the mind-numbing ability to remember every detail (visual, emotional, somatic) of every event he ever experienced. Overwhelmed by the continuing overaccumulation of data in his head, Funes is eventually forced to spend his days sequestered in a darkened room, avoiding all sensorial experience.

> In effect, Funes not only remembered every leaf on every tree of every wood, but even every one of the times he had perceived or imagined it. He determined to reduce all of his past experience to some seventy thousand recollections, which he would later define numerically. Two considerations dissuaded him: the thought that the task was interminable and the thought that it was useless. He knew that at the hour of his death he would scarcely have finished classifying even all the memories of his childhood.

Borges proceeds to suggest that his character's inability to forget has driven him to the brink of madness, devising ever more arcane numerical and linguistic systems in an attempt to structure and regain control over the contents of his mind.

> Without effort, he had learned English, French, Portuguese, Latin. I suspect, nevertheless, that he was not very capable of thought. To think is to forget a difference, to generalize, to abstract. In the overly replete world of Funes there were nothing but details, almost contiguous details. (83–91)

In Borges's story, the burden of recall prematurely ages and eventually destroys Funes's body, while his mind ceases functioning except in its efforts to control the rising flood of memories, compounded by each recollection and recollection of a recollection, like the infinitely compiling data of a computer virus. By the end of the story, Funes can neither process nor make sense of the details he holds in his mind. He can no longer

think, the story's narrator notes, because thinking *requires* forgetting, abstracting, generalizing. It is in the active interplay between remembering and forgetting—what Andreas Huyssen called "creative forgetting"—that historical meaning is constructed. And it is within an interpretive context that memories are transformed from mere data into vibrant, critical histories.

Total historical archives are motivated by an encyclopedic impulse to capture and preserve bodies of knowledge in as near a state of completeness as possible. It is a form of history-writing rarely aspired to in modern times. A monumentally modernist event such as the Holocaust, as Hayden White and Dominick LaCapra have argued, may in fact require a modernist mode of representation such as those exemplified by the *Survivors Project*. However, on a practical level, there is a danger in locking these events into organizational systems that may well prove increasingly anachronistic and naive in light of contemporary modes of historical thinking. The total archive, for all its utilitarian serviceability, risks ossifying the very lives, information, narratives, and interpretations that are most crucial to sustain as evolving, contestational moments of engagement with the past.

RECOMBINANT HISTORY

How can historiography be reconsidered, not in terms of factual reclamation, but as an active process of construction, animation, and recombination? The radical potential of the open-architecture historical database lies in the prospect of reconfiguring the categories of knowledge and understanding on which history is based. Foucault's critique of the archive rested not simply on the fact that the concrete institutional structure of the archive conceals the networks of power from which it derives its authority, but that the creation of static, categorical divisions of knowledge obscures the processes by which knowledge is acquired and deployed. As a repository of historical knowledge, the archive further promotes an image of unity and stability that belies the discontinuity of history (Foucault, *Archaeology of Knowledge* 5). Above all, Foucault reminds us that knowledge does not form itself into discrete unities. Like history, it is discontinuous, disjunctive, chaotic.

In *The Archaeology of Knowledge*, Foucault describes his own historical practice as marking a shift from viewing history as a grand, totalizing narrative to seeing it as a splintered conglomeration of subdisciplinary investigations, each emerging from, and self-consciously subjected to, their own rules of formation. Foucault notes this movement away from a single history toward fragmentary histories as an important step toward acknowledging the chaos of the past and the unruliness of human thought. Discrete statements, he argued, must always be analyzed within a field of discourse and considered in relation to disruptions, discontinuities, thresholds, mutations, and limits (31). Much has been written about the complicity of technology in development of systems of social control and instruments of surveillance—both corporate and

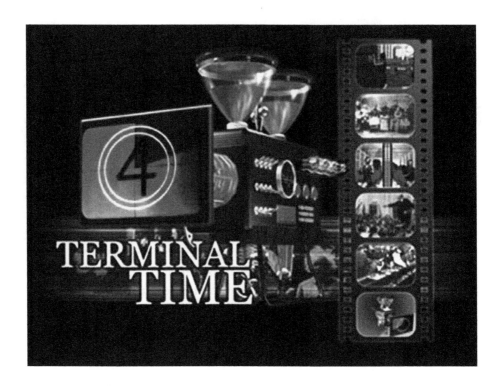

governmental. However, the specific apparatuses of digital information storage and retrieval can also be tactically redeployed against constraining fields of knowledge. Within historiography, one of the most provocative examples of this critical redeployment can be found in a project known as *Terminal Time*.

Created in 2000 by a group of artists, computer scientists, and filmmakers calling themselves the "Recombinant History Project," *Terminal Time* is an artificial intelligence–based interactive multimedia apparatus that constructs real-time historical documentaries covering the past thousand years of human history. The creators of *Terminal Time* describe it as

> a history engine: a machine which combines historical events, ideological rhetoric, familiar forms of TV documentary, consumer polls and artificial intelligence algorithms to create hybrid cinematic experiences for mass audiences that are different every single time.

Utilizing an applause meter to gauge audience responses to a series of questions regarding values and beliefs, *Terminal Time* bases its historical narratives on a database consisting of thousands of still images, video clips, and written commentaries. Each "history lesson" deploys all the characteristic strategies of a mainstream historical documentary—including omniscient narration, reenactment, archival images and film clips, documents, artifacts, and testimony. The resulting mini-documentaries are broken down

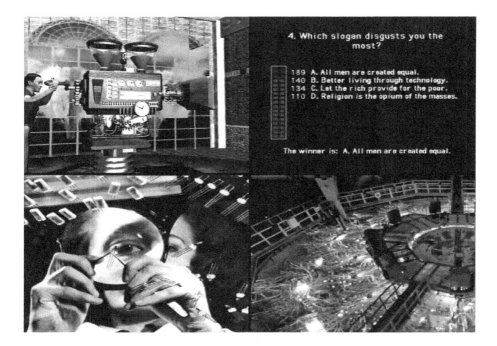

into three parts representing the periods 1000–1750, 1750–1950, and 1950–2000. Following each narrative, the audience is asked a series of questions intended to refine and focus their attitudes toward ideologies of race, gender, colonialism, and technological positivism, and so on. The content of the documentaries reflects a slightly exaggerated version of audiences' stated values, often making humorous associations and carrying historical ideologies to hyperbolic extremes.

Terminal Time's ironic appropriation of the audience-survey format critiques individuals' complicity in electronic data-gathering technologies used to create marketing profiles. As *Terminal Time*'s creators note,

> Especially as more computer-mediated interaction moves into networked environments (e.g., the Web), the very acts of user intentionality, those manifestations of the power of free choice lauded by information technology enthusiasts, have become the raw material for corporate data collection.

The questions asked by the *Terminal Time* apparatus self-consciously mimic the demographic sampling strategies of the consumer survey. Part performance, part installation, and part cinematic spectacle, the project's tag line is, "At long last, *Terminal Time* gives you the history you deserve!" The introduction to the *Terminal Time* apparatus clarifies its operating premises for the audience with the following tongue-in-cheek affirmation of Enlightenment rationality and order:

With every new day, a new chronicle of history is born, arising from the ultimate design of the universe. Yet there is not the slightest theoretical importance in a collection of facts or sequence of facts unless they mean something in terms of reason—unless we can hope to determine their vital connection within the whole system of reality. We, as citizens of history, are obliged to make and to be made by this system of reality since the beginning, and until the end, of time.

At a typical presentation of *Terminal Time,* the apparatus is presented twice to a single audience. During the first presentation, the audience is encouraged to respond genuinely to the survey questions, expressing their actual biases and opinions. The second time, however, audiences are encouraged to elicit different responses from the apparatus in order to demonstrate its ability to respond to varying ideological beliefs.[19]

In one *Terminal Time* presentation, for example, an audience who first described themselves as optimistic white liberals who were committed to technological progress chose, in the second presentation, to describe themselves as African-Americans who believed that the greatest problem facing society was that people were forgetting their ethnic heritage. They also claimed to be in favor of legalizing drugs and continuing the decolonization of the Third World. The resulting "history lesson" portrayed Rastafarians as the central historical players, with the main threat of globalization characterized as the breakdown of ethnic divisions. When the "documentary" reached the twentieth century, Nazi Germany was described as having the right idea about racial purity but as misguided in believing that the European races were superior to Africans. And in a subliminal flourish, each historical segment was accompanied by a Reggae musical score. The stark contrast between these two visions of the past resulted in precisely the kind of humorous, yet critical, juxtaposition *Terminal Time's* creators intend.

What is interesting, however, is not simply *Terminal Time's* illustration of the fairly commonplace assertion that history is open to multiple meanings that are dependent on ideology and preconception. A more provocative historiographical argument is posited in the premise of the apparatus that encourages audience members to lie—to pose as someone other than themselves—in order to generate alternative histories. In *Terminal Time,* historical truth and insight into the past are rendered accessible not through the conventions of academic historiography—exhaustive research or the careful treatment of facts—but through the dynamic interplay of truth and lie. Arguably, *Terminal Time* fails to pursue its own logic much beyond this observation, but in light of the remarkable persistence of positivist history (as seen in the earnest empiricism of the History Channel or the average Ken Burns documentary), there is much to be gained from work that dissolves the binaries that dominate discourses of film and history—fact/fiction, history/memory, real past/invented fiction—and demythologizes the ideological investment of historical documentaries.

In another presentation of *Terminal Time,* the audience activated the antitheological "rationalist" historical narrative via the applause meter. The resulting historical narrative embraced and hyperbolized the premises of Enlightenment rationality:

Amazing technological advances flowed from the minds of the scientists. In England one of the first computers was built to crack the military codes. At the radiation lab at MIT, radar was developed, allowing ships and planes to see through night and fog.

The pro-science narrative voice-over proceeded with its celebration of the advancement of science, accompanied by images of scientists and industrial manufacturing. In a voice-over, linked to images of atomic explosions, the narrative concluded:

And some of the greatest physicists in the world developed the atomic bomb, perhaps the ultimate symbol of science and progress. When the atomic bomb shined the light of reason on Japan, the war was over.

This final, horrific line is delivered—without emotion—by the computerized voice of the Macintosh computer. The impassiveness the artificially synthesized voice adds to the chilling impact of the statement and, by extension, poses a critique of the omniscient narrator's voice in conventional, expository documentary films. The detachment of *Terminal Time*'s narrative voice also invites an ironic critique of the artificial intelligence apparatus as a means of transforming and recombining historical information. The computer faithfully delivers its programmed narrative without regard for the content of the story it tells. In light of the surfeit of computer data, artificial intelligence represents the most likely hope for traversing and channeling the networks of databases promised by information industries. *Terminal Time* thus offers yet another—increasingly problematic—model for the "historian" as an artificial intelligence apparatus, which dispassionately traces associative threads within predetermined fields of possibility.

Overall, then, *Terminal Time* presents a three-pronged critique of documentary conventions, historical authorship, and utopian discourses of interactivity. *Terminal Time* further suggests a radical conception of historiography as enabled by digital technology and the proliferation of narratives driven by the logic of databases and search engines rather than the codified conflict-resolution structure of most commercial cinema and mainstream documentary filmmaking. The possibilities for permutation and recombination of historical information created by the *Terminal Time* apparatus guide viewers to embrace a mode of history that thrives on mutability, multiplicity, and chaos.

The ease with which *Terminal Time* mobilizes historiographical and documentary conventions in the interests of ideology and exploits the digital archive's capacity for repetition and recombination usefully calls into question the epistemological premises that have guided debates over media and history during the past three decades. Significantly, *Terminal Time* offers a form of participatory history in which individuals and groups are positioned as possessing the potential to radically alter conceptions of the past. In addition to highlighting the inherently ideological and mutable nature of history, *Terminal Time* constitutes an unusually elaborate joke at the expense of historical

documentary conventions. But it also poses a serious intervention in an entangled array of cultural discourses related to technology, corporatism, and historiography.

AFTERTHOUGHTS

This essay considers the impact of digital technologies on visual history as it emerged at the turn of the twenty-first century, focusing on an early, artificial intelligence–driven, recombinant narrative system called *Terminal Time*. At the time this essay was written, *Terminal Time* represented a much-needed point of resistance in the inexorable movement of digital history toward archival totality. I argue that the emerging logics of the database and search engine had resulted in two divergent movements—one seeking to articulate a "total" history that is encyclopedic in scope and rooted in relatively stable conceptions of historical epistemology, and another that exploited digital technology's potential for randomization and recombination in order to accommodate increasingly volatile visions of the past. Opposed to the playfully recombinant model offered by *Terminal Time* was Spielberg's roughly concurrent *Survivors Project*. At that point in time, the Shoah Archive had not yet been relocated to the University of Southern California, where it is increasingly mobilized—via an extremely robust, transcript-based search function—to expose the archive's potential to multiple interpretation and contextualization.

Looking back on the past decade or so, during which the capacity of systems for massive data storage and retrieval has increased exponentially (along with such systems' potential for recombination), the balance suggested by the juxtaposition of these two disparate projects now seems a trifle misleading. Although well received as an innovative work of digital media art in its time, *Terminal Time* failed to inspire a generation of related experiments devoted to visions of the past as a chaotic, eccentric mess rather than a series of neatly interlocking stories that lead inevitably to the present. At the same time, the past decade's proliferation of great big historical databases has largely escaped denunciation as naive, uncritical, or overly teleological. Instead, we have witnessed the triumph of massively scaled data as the foundation of much that we consider "knowledge"— including historical knowledge—in the early twenty-first century. For the time being, then, "big data" appears to be winning the battle for digital history; but the potential for recombinant chaos suggested by *Terminal Time* and other deliberately unstable digital systems—many of which are discussed in my book *Technologies of History*—will continue to haunt our visions of the past.

ABOUT THE AUTHOR

Steve Anderson is an associate professor and founding director of the PhD program in Media Arts + Practice at the University of Southern California School of Cinematic Arts, where he teaches classes in Critical Studies, Interactive Media and Games, and Media Arts + Practice. He is coeditor of the interdisciplinary electronic journal *Vectors* and cre-

ator of *Critical Commons,* a fair-use advocacy site and online media archive. He is a co-principal investigator on the Mellon-funded electronic authoring platform Scalar and creator of numerous works of electronic media that blur the boundaries between scholarship and media art. His research focuses on the intersection of media, history, and technology and emerging forms of scholarly expression. His book *Technologies of History: Visual Media and the Eccentricity of the Past* (Dartmouth, 2011) investigates the emergence of experimental history across a broad range of visual media, including TV, film, and digital games. He is currently completing a critical public archive and print supplement examining the computational imaginary in American media titled *Technologies of Cinema.*

NOTES

1. A previous version of this essay was published in Steve F. Anderson, *Technologies of History.*

2. See White.

3. See, for example, Winston or Crary.

4. For a glimpse of the way some historians have viewed computers as tools for communication, archiving, and research, see the section "New Technologies and the Practice of History" in *AHA Perspectives* 36.2 (American Historical Association, 1998).

5. Although it is beyond the scope of the present work to deal in greater depth with these ongoing struggles, their outcomes will doubtless prove crucial to the evolution and preservation of contemporary digital culture.

6. In fact, White's point is that even the most disinterested chronicle reveals hints of narrative.

7. The "Eine Kleine Frohike" episode of the short-lived *X-Files* spinoff *The Lone Gunmen* (Fox, 2001), which revolves around investigating the identity of a suspected Nazi war criminal, offers a case in point. Additional examples of the close relation between computer geniuses and historical manipulation are evident in the television series *Quantum Leap* (NBC, 1989–93) and *Sliders* (Fox, 1995–2000), among others.

8. The film franchise was succeeded by the prequel TV series *The Young Indiana Jones Chronicles* (ABC, 1992–6).

9. The later film, *Indiana Jones and the Last Crusade* (Spielberg, 1989), follows a nearly identical narrative to retrieve the Holy Grail.

10. *Raiders'* final shot is only partially comprehensible as an homage to the inconclusive investigation into the meaning of "Rosebud" in Orson Welles's *Citizen Kane* (1941).

11. The image of the impossibly comprehensive Federal archive also appears with some regularity within the paranoid narratives of *The X-Files* (Fox, 1993–2002), in which smallpox vaccination records secretly double as a genetic map of the world's population in preparation for alien invasion. Originating in the Cold War era, prior to effective computer-based data management, such a total archive was possible only in the form of a massive, top-secret government infrastructure, complete with armed guards and impossibly large document warehouses.

12. So the story goes.

13. The videotaping continues at the time of this writing, though at a greatly reduced rate.

14. The final audiovisual display in the United States Holocaust Memorial Museum consists of talking-head video projections of survivor testimonies (which may well have provided the stylistic impetus for Spielberg's project). The interviews are entirely unadorned and only minimally edited, deriving their power not from the use of iconic imagery but from the stark simplicity of facial expressions, gesture, and the emotional content of the testimony.

15. The conventions of documentary editing dictate that an interview subject whose truthfulness is in doubt should be seen on camera, while those who speak in voice-over acquire a degree of authority from their omniscient speaking position.

16. The goals of the *Survivors Project* are mirrored by the undertakings of numerous libraries, museums, and historical societies, which are in the process of digitizing their holdings.

17. Studies of oral history and cultural memory have demonstrated that individual accounts of traumatic experiences, in particular, are not to be trusted as factual, even when they are relatively fresh in the speaker's memory. Vietnam veterans, for example, have reported discovering that their most vivid personal memories had become indistinguishable from the images and narratives of war films. See Sturken.

18. Shoah Foundation literature puts the time required to watch the entire project at thirteen years.

19. However, *Terminal Time*'s creators note, even if an audience responded with identical responses to each question, the artificial intelligence algorithm would generate slightly varied historical accounts.

FILMS BEGET DIGITAL MEDIA

Stephen Mamber

Two major documentary strands, the compilation and the autobiographical, have been taking hold in digital environments. The affinities are strong enough to suggest that these two forms anticipate narrative capacities of new media formats in significant ways. We will look at Chris Marker's CD-ROM *Immemory* and the installation *The Danube Exodus:The Rippling Currents of the River* created by Péter Forgács and The Labyrinth Project, in order to explore the linkages from both sides of the seeming divide between old and new forms, the tendencies already present which have flowered in the two works, and what they suggest about further possibilities for digital media.

Those media artists who incorporate lost, amateur, personal, and/or decaying materials into their work are clearly implying an alternative—disappearance and forgetting. Such artists are already in league with the archives, libraries, and museums which are also often the sites for the presentation of their work. They are natural allies—institutions that collect and present pieces of the past become the source and also the exhibition space for artists who are essentially doing the same thing. While they may not always share common viewpoints on what constitutes suitable source material (i.e., what is worth preserving), the desire to reclaim histories, whether personal or national, and to recontextualize those materials within new frameworks is a strong common bond.

Marker and Forgács have both been best known as filmmakers, but they have also ventured into digital media and works created especially for museum exhibition. As they create in these realms, not only do they incorporate film extensively, they have been exploring what it means to take moving images and sounds, memories and historical

records, from one period to another, from one place to another, from one medium to another. Both, I would say, have been hugely optimistic about the role their digital media works can play in keeping film alive, and through film, the personal histories they seek to tell. They also have a strong interest in extending narrative possibilities through the flexibility digital media can provide, but what's important in both cases is that those same tendencies were already evident in their work, so this is a natural expression rather than a gimmicky updating. Marker has reveled in the time shift, the fragment, and the unexpected juxtaposition. This is likely why he has moved so willingly into digital forms. Forgács was already making beautiful, tragic collages out of found home movies (Nichols, "The Memory of Loss"). Allowing now for viewers of his work to select the order in which they view segments serves his goal of establishing affinities across unlikely barriers—to find unexpected correspondences that a more linear presentation might never allow.

At the heart of their work is a tension which in digital environments demands fresh attention—what does it mean to preserve and remember? With film it is the tragedy of physical decay, of the medium itself decomposing and disappearing, which seems the overriding concern. While the digital brings a promise of permanence, it also surely contains its own significant risks of loss and neglect. The vagaries of technology, the lack of stable (and long-lasting) standards and platforms, and the ephemeral nature of applications all contribute to digital media's precarious role as a preservation medium. Marker would seem to enjoy the notion that CD-ROMs may someday, in future societies, have to be deciphered and reclaimed. Such reclaiming, for Marker, requires active engagement anyway, even under the best of digital circumstances, so the additional barriers which time will create are already within his world view. For Forgács, that amateur home movies can recover a story and be projected onto large multiple screens to contemporary audiences is a celebration in itself, especially so in a public museum context.

While we know that digital media have converted the analog and the chemical into discrete bits of numerical information, the jury is still out on the consequences of this shift as it relates to display and presentation. Computer workstations incorporated into a museum exhibition (as in the two side displays of *The Danube Exodus*, for instance) seems a compromise solution—one doesn't have to sit at a computer in a museum. But simply creating websites doesn't seem the answer either—these lack the urgency of public performance as well as the sense of shared experience.

In Marker's case, because of his essayist tendencies and his personal tone, the CD-ROM may suit him more, and can suggest that the multimedia art object is best appreciated in an interactive and leisurely way unaided by a public display. (Even his films, such as *Le Joli Mai* and *Sans Soleil*, look better on video than in theaters for these same reasons.) In fact, the emerging form of the hybrid DVD, which can incorporate both good-quality video in large quantities as well as programmable interfaces, will suit him even more. The limited capacity of CD-ROMs to fully utilize video is a temporary stage we're

quickly leaving behind, and Marker will surely be among the first to explore the differences in significant ways.

Another uneasy area of exploration in digital media has been the nature of display itself, so clearly a given in film but now up for grabs again. One issue is screen format and size, where the Labyrinth Group with Forgács have convincingly demonstrated that control over multiscreen displays is indeed a format worth exploring. It has been too easily assumed that digital media means the monitor-sized computer display, whereas one happy consequence of the digital might be that screen images can be reconstituted in a variety of formats. When one sees what were once amateur home movies displayed across wide screens from a DVD in *The Danube Exodus*, the reconfigurability which is now possible becomes very much evident. The majesty provided to these films by large-screen display more than justifies the museum setting.

It may just be another temporary stage we're passing through that digital media seem to lack established presentation standards, especially in public spaces. Much interesting experimentation of the past fifteen years has centered around this question (even longer if we include video wall displays), perhaps not always with the strength of content that Marker and Forgács bring to the table. Neither is playing with digital toys for their own sake, and the formats under discussion here may not be generalizable. But that very flexibility may itself be one of the attractions of digital media. What for Mike Figgis in *Timecode* may lead him to a screen divided into quadrants would not suit Forgács and his panoramic wide screens. What does matter, though, are these shifting alternatives, which allow for rethinking how the screen is divided, what can be multiplied across several or stretched and enlarged. What can look like a drawback (this lack of standards) may be a pronounced characteristic and distinct advantage.

What we can see here perhaps are some benefits of both the small and the large. The home computer screen offers the focus and the one-to-one connection which the individual viewer/user can control. The museum space and large multisectioned screens can, of course, magnify the personal and take advantage of the possibilities which showing before a live audience can bring. *Immemory* and *The Danube Exodus*, among their many reasons to be worthy of our attention, offer enlightening alternatives for how digital media can be presented and experienced.

IMMEMORY

Both of these projects have filmmakers engaging in a hands-on way with new media, and they incorporate a good deal of their preexisting work. Marker especially has made *Immemory* a repository of past material. *Immemory* isn't an adaptation or translation. It's a larger container which foregrounds the role of appropriation and incorporation. Marker is taking his artistic life (already inseparable from his history because of his relentless recording of his personal views and travels) and reformulating it. As Raymond Bellour most aptly states, "Perhaps he started *Immemory* at the moment he chose to write and to

film," in other words, at the beginning of his creative life (Roth and Bellour, 10). So *Immemory* seems a natural consequence of his mode of expression and suggests, along Bellour's line, that he was working in this manner from the start.

And what manner is this? It is tempting to see the mode of *La Jetée* as most suggestive of Marker's narrative impulses—time returning to itself as a story unfolds on multiple temporal levels, sustained through a series of images and a narration which reveal gaps as much as continuities. The opportunities to branch, to juxtapose, to skip, allow us to compose a Marker world—*Sans Soleil* and so much of his work was already constructed this way—its digressions and turns never a departure from the journey. The multilinearity of Marker's previous work makes *Immemory* a natural extension, not a shift.

Along the lines of Lev Manovich's discussion of Dziga Vertov (*Language* xiv–xxxvi), we can readily recognize Marker as a database-oriented media artist (a subject also discussed well by Marsha Kinder in an essay about Luis Buñuel; Kinder, "Hot Spots" 2–15). His collection of material is especially varied, composed of multiple media. Even beyond his own photographs and films, he is an essayist-diarist-tourist-collector, and he gathers together his materials to construct his past, his critical sensibility, his dreams, his imagined occurrences. *Immemory* is brilliantly titled—it could as well be called "Memory" were Marker not simultaneously stressing the impossibility of his enterprise. By its very nature, *Immemory* must be labeled such.

For all the evanescence of both photography and film, the feeling of their impermanence as a physical medium, they come to look as solid as the book or the painting in comparison to digital media. One moving aspect of *Immemory* (and of *The Danube Exodus* too) is its being resolutely preservationist with regard to aging technologies. They record digitally the traces of past media works: the old family photographs, the home movies, film snippets, and scraps of paper. In digital form, these previous media are both found and lost. They can be retrieved, reconfigured, and renarrativized, but in doing so, the newest technology becomes a strongly nostalgic medium—mourning the loss of what can't be retrieved and can't be restored to its original form. A digital photo or a Quicktime movie is an extra step from the real, a large extra step, in that it refers back not only to the events depicted, but to the stage which is now only intermediary to the passage to the digital. *Immemory* tries to preserve not just old photographs and films and the rest, it also attempts to preserve the idea that these decaying media matter in themselves, and that new media will someday be old media, existing as similar traces in forms yet to come.

Film ushered in an important shift in how media could be received. Even with photography, which requires technology to be produced, it was still possible to experience the result without additional equipment. Our modern media world starts with the film projector and extends to television monitors, VCRs, computers, and CD-ROMs. To archive now can mean to shift platforms—conversions from celluloid or videotape or paper to whatever constitutes a current standard, itself on its way to certain and sometimes rapid obsolescence.

When *La Jetée* was brilliantly created from still photographs and one brief piece of moving film, Marker was already signaling this longing for earlier media forms. The pastness of the past can be represented through capturing media—the sense of their origins still much in evidence. *Immemory* ups these stakes. Every piece of media is made to be not just a fragment of history, but a fragment of a media history. The now archaic look of previous media becomes a means to express the passage of time. *Immemory*, while new and up-to-date, already looks like an artifact, as if we are discovering it at some point well into the future.

Immemory is a veritable catalog of forms of longing for old media, nearly sentimental in its reverence for the dreams and memories captured in fragments of silent cinema. And as in his museum pieces, Marker makes *Immemory* look almost charmingly clunky—the interface is clearly the work of an individual and not a design team—the singular creation of an artisan. It's fuzzy in ways you don't expect of digital media, almost resolutely ama-teurish in a good sense, idiosyncratic in its organization and unfolding (and of course full of Marker's signature cats and owls). This functions as both a representation of (im)memory as not being perfectly ordered, but also as a model of digital media—a space with a lot of stuff lying around rather than fully categorized into neat bundles. His collection is more like a back storage room of a museum than a public display, more the database before it's fully structured, more like dream and memory than a catalog.

Immemory is surely the *Citizen Kane* (dir. Orson Welles, 1941) of digital media. While numerous writers about new media arts have opined that we are so early in their develop-ment as to have not yet seen a *Birth of a Nation* (dir. D. W. Griffith, 1915), Marker has leapfrogged the early phase and created a full-fledged mature work. We shouldn't forget that *Kane* too was a collage of media forms, and a work of memory and history. While Marker establishes explicit (and brilliant) links between his own work and Hitchcock's, especially *Vertigo*, his affinities to Welles are equally strong (Bolter and Grusin). (*F for Fake* might even be too close to a Marker essay for either Marker or Welles to have acknowledged, with the great difference being Welles's significant on-screen presence.) *Immemory* is Marker's equivalent to the warehouse of Xanadu, "the junk as well as the art" as Welles described Kane's holdings.

Compilation film is a form of archiving, and also a database construction. While pre-vious footage may be recontextualized, even contradicted or discredited, it is still pre-served and collected, ready even for subsequent reuse. In compilation documentaries, reinterpretation is part and parcel of the process. However, when film uses film, it is consuming itself in a manner that can be difficult to extricate into component parts. Also, films such as those by Ken Burns seek to make "cinematic" the materials being con-sumed: a photograph will be panned and annotated, music and narration added, to make the result film-like. The narrative impact of the "past coming alive" in such works comes often from this adroit manipulation of historical materials.

Marker, by contrast, is a compilation media artist who not only doesn't make "digital" his predigital material, but seeks to underscore their pastness by keeping visible their

origins and intrinsic media qualities. Photos will look photographic—presented in albums, looking as if printed on paper, or differing in visual quality from the backgrounds that frame them. Movie excerpts will be similarly bracketed—instead of being massaged to integrate smoothly and invisibly into a digital environment, they are surviving media remnants of another age and way of seeing, less compiled than existing as a memory fragment barely rising above a tenuous surface of decay and loss. (His museum installation *Silent Movie*, which presented selected early film clips on a series of television monitors, also contained this serial bracketing—in that case, of film within television within installation—maintaining this interplay.) *Immemory* is a testament to the fragility of such media forms and seems to depend as much on his prior museum work as on his films.

Marker has always been among the most personal of filmmakers, but at the same time mysterious and distant. His works are autobiographical not just in content, but in style—he has frequently been openly first-person, a diarist, and a reporter of personal experience. But just as he famously avoids being photographed and rarely shows himself in his own work, the first-person-ness of *Immemory* and the strongly autobiographical nature of its presentation may itself be something of a sham. It is first-person in the manner of Robert Montgomery's film of *Lady in the Lake:* when we see through the eyes of a narrator, we don't know through whose eyes we see, except indirectly. *Immemory* puts us in the head of someone else who obviously we can never fully become, whose memory is never our own—another level of the "falseness" of the work. Exposing the inner workings of his sensibilities, Marker remains hidden, a quality he has perhaps always possessed, as suggested by Laurent Roth when he speaks of the difficulties of remembering Marker's films sometime later, saying that they "are not inscribed in me, as they always are in the case of *real* cinema" (Roth and Bellour, 57). Marker's elusiveness, perhaps a lack of fixedness, becomes even more difficult to pin down digitally, when the viewer-reader must actively participate in traversing possible narrative paths.

Of course, the consequences of interactive choice are one of the biggest issues with digital works, whether in a museum environment or on a computer. To trace these, we should look back briefly to compilation and autobiographical documentaries. Reconciling narrative structure and a database-like collection of material is generally accomplished in these films by some combination of temporal and thematic interplay. Perhaps typical are Burns's *Baseball* or *Jazz:* the structures of these multipart documentaries are not derived simply from ordering oldest to newest, even though, in a general sense, the viewer feels a movement in that direction, however arrested it might be at times. The function of an ambitious work of compilation such as this is to establish causality and borders—to say that all that is here needs to be viewed, and in the order presented. Although much longer than conventional documentaries, they still expect to be viewed in order and in their totality. The museum equivalent would be to walk in a straight line down a corridor on a moving sidewalk at fixed speed. This structure suits these works in that their choices of material and their ordering constitute their argument. Segments

should not be viewed out of sequence or at random, because to do so would destroy the coherence of a steadily building argument and a sequentially revealed historical coherence, as much as deleting parts and scrambling the remainder of most movies would cause similar problems. Linearity is an essential component of these documentary forms, a basis for their existence.

Marker's films were already (and obviously) interested in other temporal and structural arrangements, but his digital work doesn't just present an environment more suited to his experiments; they suggest that the resulting shift to interactivity brings out what was already present. *Sans Soleil* and *La Jetée* could themselves be transposed to the digital in ways that Burns's work would never invite. Marker's 1990 San Francisco Museum of Art installation *Passages de l'image* made this clear. This project also had the strong feel of re-autobiography—it playfully presented Marker's world as a collection of media stuff open to any ordering. This now looks very much like a rehearsal for *Immemory*, but again, as Bellour has said, perhaps all his work is.

A surprising aspect of *Immemory*, given the increased interactivity afforded by the technology, is that Marker still encourages a certain degree of order and, in introductory instructions, suggests a relaxed pace through the work. Within sections, contents are meant to be viewed sequentially, so *Immemory* is a set of multimedia mini-essays, its individual units relatively cohesive. As with Marker's installations, there is an equality to the options. Although sections can be viewed in any order, there is no significant difference between alternative narrative paths.

Where *Immemory* gets challenging is in layering, and in its juxtaposition of sections. Marker has had fun with Photoshop, and is so pleased by visual congruencies that they often pop up, as in facial overlaps of "Jeanne d'Arc et Dracula, les héroes de mon enfance." In a similar vein is a redone Sistine Chapel, with God pointing his outstretched finger to Mickey Mouse's thumb. He also plays with the varied character of his interests, establishing no hierarchy from the significant to the trivial, or between the historical, the filmed, or the imagined. *Immemory* approximates a mental construct in its putting all his concerns together, and laying them out as if in a dream, a database, or a museum.

THE DANUBE EXODUS

The Danube Exodus first existed as a 1998 film by the Hungarian Péter Forgács. The film is composed of home movies from 1939 and 1940 of two journeys on the same ship in opposite directions along the Danube River. The first was by a group of Jews from Bratislava and Vienna, fleeing the Nazis to immigrate to Palestine. The footage was originally shot by the captain of one of the ships, Nándor Andrásovits. In the following year, he made a trip from Bessarabia to carry ethnic Germans forced to repatriate to Poland. The symmetry of the two journeys provides numerous opportunities for comparison; the film sets up juxtapositions and then allows viewers to determine what to make of them. Rather than assert obvious differences between the two groups and the

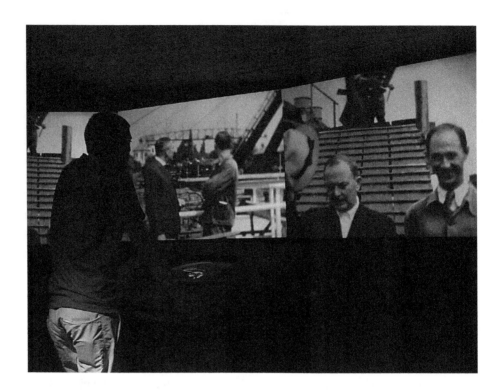

reasons for their journeys, the film tends to invite a sense of similarity between the two journeys and their sets of common events.

A good deal of the fascination the film offers derives from the extensive record being reclaimed from home movies. Not an official history, nor even much of an account of the circumstances of the journeys, the film offers intimate glimpses of life at sea under cramped and difficult conditions. The overwhelming feeling is of life somehow going on, in each direction. It is difficult to know whether the many unanswered questions are so because the found footage doesn't address them, or whether they would continue to be unanswered even if events on the journeys had been shot and assembled in a more conventional manner. A particular uncertainty, in that he shot the footage, is the captain himself. We can only speculate about his multiple motives for undertaking the journeys, just as we don't know whether he had particular sympathies for either group of passengers. *The Danube Exodus* has as enigmatic and elusive a center as a Marker film. Forgács certainly poeticizes his material, but he isn't particularly intrusive or commentative. Captain Andrásovits, the original filmmaker, is a fringe figure in his own work. He appears in these narratives but can't be easily read.

As a museum installation first shown at the Getty Center in Los Angeles in 2001, *The Danube Exodus* became a lustrous multiscreen presentation, with multimedia computer applications in adjoining rooms as well as an introductory room presenting wall displays with information about the journeys. The collaborative process of conversion has been

described in detail by Marsha Kinder (Kinder, "Reorchestrating History" 235–255). The original footage was projected from multiple DVDs, and the journeys are now divided into eighteen sections of material. Viewers could select which parts would play for the audience from a touchscreen monitor.

In its museum incarnation, the films are now projected on five screens. Often the same image is projected on the center three, or occasionally even on all five. The effect of this, together with the beautiful musical score by Tibor Szemzö, is to make an epic, like those of Abel Gance or David Lean, out of the modest original amateur footage. At other points, footage would be reversed on opposite sides, to create mirror images equally panoramic in scope.

Taking advantage of this unusual five-screen palette, Forgács dramatizes certain pieces of footage by multiplying them out sequentially, with slight delays across several screens. An especially striking moment is the placing of a wedding ring, which gets repeated four times from left to right. Inevitably, perhaps, there is a moment when Wehrmacht soldiers multiply across three screens as if in a line, while Jewish refugees are visible on the far left screen, and Bessarabian Germans dance on the screen at far right. Freezing individual segments on faces is a device used in the original film, but with greater effect when it repeats across a series of screens.

Like Marker, Forgács exults in the cinematicness of his original materials. Two particular means to accomplish this are repetition of the same footage deliberately out of synch, like old projectors gone awry, and, very effectively, the magnification of shots with visible sprocket holes, appearing in succession along the three center screens. This process doesn't just poeticize the footage itself—it also celebrates the reclamation of personal stories from an amateur medium. It is as if home recordings of simple tunes have been transcribed for a symphony orchestra.

The narrative segments are divided into three sets of six, and it is interesting to observe how audience members make selections. While watching this room for the better part of an afternoon, I saw that many visitors were choosing a fairly linear sequence, selecting segments in order around a circle of options on the touch-screen monitor. Correctly, I would say, the images frustrated this apparent desire for conventional presentation. Selections from the two principal sets of journey footage would often make for effective juxtapositions, even if it wasn't always easy to keep track of which group one was watching. This is surely one of the main points of the entire work—the differences between the two groups are overridden by the leveling circumstances of their refugee status.

The arguments of the main display are refined by the computers in the adjoining rooms, which present extensive individual tales, focusing on four of the survivors, two from each journey. While the material is presented in fairly conventional digital media fashion, the viewer's desire to absorb all this additional footage is certainly heightened by having been witness to the visual splendor and impact fashioned from the home movies in the multiscreen central room. Perhaps each makes the other

possible—poetry is given the center, surrounded by information and the remembrances of survivors.

CONCLUSION

What *Immemory* and *The Danube Exodus* have in common is a sense of reclaiming history through media artifacts, rescuing lost moments in a manner that still stresses their distance from us. While digital media seem to offer the illusion of encyclopedic mountains of multimedia material at our immediate beck and call, these artists properly bring forth a feeling of simultaneously treasuring what their works reclaim while suggesting that this reclamation will always only be partial, as much a loss as an act of archival salvation. These dual pulls, of retrieval and the inability to retrieve, are heightened by the added element of narrative interactivity. Selecting a segment to view gives more detail and information than a film would likely have offered, but the simultaneous sense is of fragmentation and loss— both for what can never be retrieved and for what our selection may lead us never to see.

Works based on historical compilation and autobiography are ideally placed here, especially now that, as mentioned earlier, DVDs can offer both interactivity and excellent image quality, together with high capacity. The immediate advantage is likely to be works that can function somewhere between compiled collections and deeply personal artistic endeavors. There need not be a conflict between the two, especially when the new medium itself becomes an arena for narrative experimentation. The biggest narrative challenge in creating works such as these is to develop structures which are themselves compelling, by drawing upon interactive capabilities to construct ways of exploring that are themselves worthy of attention. While they highlight media objects from the past, the need to go beyond simply being a container for that work is clear. Digital environments need not be looked at as just new storage or presentation opportunities, as these works convincingly show. Interfaces which invite further discovery, create unanticipated juxtapositions, and are themselves artfully constructed are clearly a significant advance, full of unexpected nuance and possibilities for surprise. Looking like a virtual museum, a newly discovered room of lost artifacts, or the inside of an artist's head, the new media work demands appreciation for far more than its ability to remediate.

These two artists together suggest that there is a certain correspondence between museum display, works designed for the computer, and their earlier films. In each case structured around the reclamation of lost film and other historical fragments (photos, texts), we can see across media the desire to provide contexts which are loose enough not to force strict meanings. Museum display is especially appropriate in that it invites a combination of spectacle and reverence, but still a chance to explore. Whether in a CD-ROM-constructed space or the physical space of a museum, the work of these artists suggests that the digital is an unexpectedly fertile arena for collecting, recovering, and making the past personal, allowing us to travel in time and experience it ourselves for a while, to live briefly again inside these lost worlds.

AFTERTHOUGHTS

The theoretical links between cinema and digital media continue to be a rich vein to mine, so I am happy to have explored the work of two great artists who made the leap. Chris Marker has died, but his towering achievements continue to merit close examination. At this point in time, *Immemory* looks more than ever like the *Citizen Kane* of digital media, and hopefully it will continue to have a life even as CD-ROMs go the way of the floppy disk.

The title of this essay is a tribute to Jay Leyda's pioneering study of compilation films, *Films Beget Films*.

ABOUT THE AUTHOR

Stephen Mamber is the head of the Cinema and Media Studies Program in the Department of Film, Television, and Digital Media at the University of California, Los Angeles. He is the author of the ClipNotes app, available in the Apple App Store. His most recent web project is "Who Shot Liberty Valance?", an experiment in forensic film analysis. Links to these and other projects are at http://mamber.filmtv.ucla.edu.

NAVIGATING THE OCEAN OF STREAMS OF STORY

Grahame Weinbren

He looked into the water and saw that it was made up of a thousand thousand thousand and one different currents, each one a different colour, weaving in and out of one another like a liquid tapestry of breathtaking complexity; and Iff explained that these were the Streams of Story, that each coloured strand represented and contained a single tale. Different parts of the Ocean contained different sorts of stories, and as all the stories that had ever been told and many that were still in the process of being invented could be found here, the Ocean of the Streams of Story was in fact the biggest library in the universe. And because the stories were held here in fluid form, they retained the ability to change, to become new versions of themselves, to join up with other stories and so become yet other stories; so that unlike a library of books, the Ocean of the Streams of Story was much more than a storeroom of yarns. It was not dead but alive.

SALMAN RUSHDIE, *HAROUN AND THE SEA OF STORIES*

It is easy to read the nostalgic tone of Rushdie's 1990 "children's story" as the wish for a return to innocence, to a state of storytelling purity beyond the reaches of politics and intrigue. At the time he wrote *Haroun and the Sea of Stories,* purportedly for his eleven-year-old son, Rushdie was, of course, too sophisticated—and too embittered by the outrageous circumstances of his life—to profess any kind of innocence or naiveté. The novella abounds with metaphors of cruel suppression and mindless censorship. The nostalgia embedded in the Sea of Stories is better seen as a reminder of the creative process a writer (or any artist) craves in his or her darker moments: an ocean of stories, wide and deep, effortlessly tapped. The power of the image is in its erasure of the line between writer and reader—Haroun's father, a professional storyteller, need only drink from his personal faucet plumbed to the Ocean and report to his audience: this alone constitutes writing. Can the image be turned around? Can we imagine the Ocean as a source more for readers than writers?

Could there be a "story space" (to use Michael Joyce's resonant expression[1]) like the Ocean, in which a reader might take a dip, encountering stories and story-segments as

he or she flipped and dived? In these waters, turbulences created by the swimmer's own motion might cause an intermingling of the Streams of Story. The Ocean, as I imagine it, is a dynamic narrative region, a Heraclitean river into which one can never step twice, a lake of Heisenbergian uncertainty where the very attempt to examine a particular story-stream transforms it. What a goal to create such an Ocean! And how perfect as an ideal for an interactive fiction!

FICTION, CINEMA, AND CYBERNETICS

The *idea* of interactive fiction is not new. But the notion of a time-based medium that is *not* interactive is no older than mechanical recording. Before the recording of sound, all music was "interactive," though in this context the term sounds silly. Musicians are always affected by external factors, from the other performers in the ensemble, to the "vibe" of the audience, to the acoustics of the hall, etc. The same can be said for theatre. The risk of variability is an essential ingredient of the thrill of live performance. And before recording, obviously, all performance was live. Though it is true that few works were deliberately designed to be influenced by external factors (but consider Tinker Bell in *Peter Pan*), audiences were always aware of their own potential power. The mythology of theater and music contains many stories of performers either energized or "thrown" by the audience. One of the aspirations of an interactive cinema is to return the medium to this earlier condition, where the potential effect of the viewer on the performance is assumed.

In the process of developing an interactive narrative cinema, I realized early that it will not have the shape of narrative that we have learned to expect since cinema and television—media of the "moving image"—have come to dominate our story-structures. The very idea of user impact opens to question the concepts of end and beginning, of crisis and conflict, of development itself. Traditional notions of cinematic narrative must be rethought.

My own work is in the pull of a pair of forces that defined the late twentieth century—the Cinema and Cybernetics, the Projector and the Computer. In 1995, when this essay was first published, I had made two installations incorporating computers and moving images. In 2002 there were five, and in 2004 the first of these pieces, *The Erl King*, was recreated as a fully digital piece. In all these works, the participant's (inter-)actions affect the temporal conglomerate of images and sounds. The computer itself is not considered a medium or a tool, but a device that controls and presents existent media. Thus, the questions that arise are about how cinema changes when its apparatus is linked to a computer—just as one can investigate changes in the structure of cinematic communication when recorded sound is added to the moving image.

The first two questions that came up can be posed in quite traditional terms. What kind of story will fit the medium, and what will be the grammar of its telling? Crudely: where is the change—in content or structure? One entry point is to find a narrative for which the sequence of events is not salient; if the viewer is to wander around and

through the story, the order in which the depicted events are accessed will need to be open to variation. And this requirement led me directly to Freud's studies of dream interpretation.

A BRANCHING STRUCTURE

I dreamed that it was night and I was lying in my bed. Suddenly the window opened of its own accord, and I was terrified to see that some white wolves were sitting on the big walnut tree in front of the window. There were six or seven of them. The wolves were quite white, and looked more like foxes or sheep dogs, for they had big tails like foxes and they had their ears pricked like dogs when they pay attention to something. In great terror, evidently of being eaten up by the wolves, I screamed and woke up.

FREUD, "INFANTILE NEUROSIS" 173

Freud transcribed and published the case history of the Wolf Man in 1914–15, soon after the end of the patient's analysis. It is the apex of Freud's early period, in which the central concepts of condensation, displacement, wish fulfillment, the primal scene, and so on, reach their full fruition, never to be resolved again in quite the same way.

The analysis revolves around the patient's dream image of the staring wolves. Freud describes the process of gradually uncovering the components of the dream, linking each element with an event, a character, or an emotion remembered but perhaps suppressed. The dream's significance for the dreamer, manifested in the overwhelming emotional effect it had on him and the fact that it remained in his memory for decades, led Freud to seek further explanation. He finally accounts for this power with the proposal that the dream encapsulates the dreamer's greatest fears and desires, as transformed memories of the events that first produced them. For my purposes, the details (and—it goes without saying—the "truth") of the dream-analysis are not important.[2] I wish only to appropriate certain aspects of Freud's methodology in my own search for a paradigmatic story structure suitable for an interactive cinema.

Condensation is the key concept. The dream is formed by compressing and combining a set of mental objects. The dream can function in the dreamer's mental framework as the distillation of a set of emotional charges. Its powerful affect comes from the fact that, in an important sense, it embodies a set of memories and the specific emotions linked with them. Repeatedly, Freud stresses that there is no universal symbol-translation table—every element of the dream image, and every property of every element, is understood by the dreamer in his own individual way. Each element substantiates a combination of particular fears, hopes, desires, or beliefs, transformed, by the laws of the unconscious, into a component of the dream image. Seeing the images through the dreamer's eyes—identifying the underlying atomic parts and understanding how they are altered by the dreamer's mental process into the dream image—is under-

standing the dream. In this understanding is written a page of the biography of the dreamer.

Freud's notion of a dream is a conception of a narrative-type based on a hermeneutic method. Unraveling a dream reveals the narrative of the dreamer's interlocking emotional states. But it is not a narrative that unfolds in time—all its elements are simultaneously present. Freud goes to great trouble to convey this atemporality, but even for him it is a notion that eludes expression. After all, his own mode of communication—writing—is, of necessity, linear, one word following another, forming paragraphs that follow one another, while his conception of the dreamwork is nonlinear, unsuited to the writing forms available in the early twentieth century.

> This task [of forming a synthesis from fragments that emerge in the analysis of a patient] . . . finds a natural limit when it is a question of forcing a structure which is itself in many dimensions onto the two-dimensional descriptive plane. I must therefore content myself with bringing forward fragmentary portions, which the reader can then put together into a living whole. ("Infantile Neurosis" 173)

Considered as a narrative structure, the underlying elements of the dream can be revealed in any order whatsoever, and the same story will emerge. Thus, it is truly a narrative without specificity of sequence.

THE INTERPRETATION OF DREAMS

A film might try to approximate the structure of Freudian dream analysis in a story structure that unravels, step by step, the components of an evocative image. However, the linearity of cinema sequence tends to freeze material into narrative hierarchies, one element gaining in significance while another loses, depending on each one's context and their overall order. How better to reproduce the minimal significance of sequence, the irrelevance of order, than through interactivity? For in an interactive work, the sequence of events can be determined by the viewer. And by the time the viewer becomes aware that the sequence is determined by his or her responses, sequence may already have stopped being a criterion of narrative significance. In normal cinematic circumstances, the weight of an event is given largely by its context: now, with sequence under the control of the viewer, the significance of any given element will be in flux, changing from screening to screening. In these circumstances the viewer's understanding of the events of the narrative can undergo a radical transformation, based entirely on the knowledge that things could have been different.[3] Later in this essay, I shall make an attempt at describing the "subjunctive" state of mind evoked by the interactive cinema.

It would be a gross oversimplification to suppose that the elements associated with a particular dream-image are, by themselves, sufficient to define the biographical narrative underlying the dream. The ways the elements are transformed and combined into the

dream are equally significant, so these methods of aggregation must be considered part of the story. Often this syntax and its application can be expressed only verbally. It is difficult, for example, to imagine an effective visual expression of the transformation of something into its opposite (from "staring" to "being stared at," or from the ornate motions of sexual intercourse to the stillness of the white wolves), or the transfer of a particular quality from one object to another (as the color white is lifted from sheep and flour and attributed to the wolves). Freud's interpretation of the dream is far more than a simple compacting of memory-images into one conglomerate: the grammar of the image-elements' metamorphoses and rearrangements is as significant as the elements themselves.

I am not suggesting that the principles of condensation and displacement cannot form the foundation of a visual narrative, but only that some depiction of the types of transformation will have to be incorporated alongside the results of the transformations. The point is to develop a type of narrative that can retain its identity and make sense independently from the sequence of events. Thus, in *Sonata,* I found that I needed to make the formative elements of the dream (i.e., the grammar of the transformations) into explicit components of the dream-narrative—without them it became a mere medley of scenes connected only by association.

DESIRE

Cinema, of course, cannot be internally affected by its viewers. Turning one's head, far from affecting the visual experience, removes one from the cinematic world and into the mundane space of the screening room. The straight razors and wolves on screen will yield only to forces that are profilmic, within the diegesis, or (commonly) both.

Furthermore, the impossibility of influencing the cinematic is one of the sources of our pleasure in it. "Don't go up(/down) the stairs!" we inwardly cry out during Hitchcock's *Psycho,* first to the private detective Arbogast, and later to the heroine Lila Crane, all the time knowing that, no matter how powerfully felt, our distress will not influence their behavior. The experience of suspense would be fatally distorted by the elimination of the inevitability of the characters' actions. If Lila might turn back because of our pleas, the entire effect of the horror film would dissolve. Much of cinema's power over us is in our lack of power over it. In this sense, suspense is a paradigm of cinematic response. It could be argued that the introduction of viewer impact on the representation is a destructive step for the cinema. The removal of the possibility of suspense is the removal of desire from the cinematic and, ultimately, the removal of the very fascination of the medium.

So my project became this: to find interactive forms in which desire can be sustained. It will require the construction of a new cinematic grammar. If it is to be successful, this search, this construction process, must foreground the temporal aspect of cinematic communication.[4]

Time always moves relentlessly, tautologically, forward, as long as one is alive. "Real time," clock-measurable duration, can always be distinguished from time subjectively felt. The duration of cinema is rigidly defined by the apparatus, fully predetermined by the physical substrate of images projected serially at a regular pace set by an electric motor. A film begins and ends necessarily and predictably, dependent on, and only on, the length of the filmstrip. Whatever its images, however they are organized, a film has a physical beginning, middle, and end. Whether and how this linear temporality structures the image-material in a particular film is a major issue (perhaps *the* major issue) for a filmmaker. It could even be argued that the stance taken by a filmmaker toward temporal structure, how time is articulated in a particular film, is an index of where in the spectrum of cinematic practice (from Hollywood to experimental) a given work falls.

Duration. This gives us the first sense of cinematic time, *duration* or *running time:* the clock-time required for the filmstrip to traverse the projection apparatus.

Story Time. The second sense of time is that of the world depicted in the film. This notion is more or less restricted to the cinema of storytelling and to the time depicted in "diegesis." Mieke Bal, in *Narratology,* calls this the time of the *fabula* or fictional world imagined in the story. A cinema narrative may jump forward, eliminating decades (or centuries) in a single cut; or slide back, perhaps using one of the various narrative strategies that fall under the category of flashback; or remain in the present, so that a given passage of film denotes a continuous passage of time. This latter case (the most frequently used) still allows for a broad range of variation: one continuous two-minute portion of a story can occupy five minutes of screen time, whereas the next portion compresses seven years into as many seconds.

Meanwhile . . .

Experienced Time. Detective Arbogast's walk up the stairs seems painfully extended, so that his stabbing at the first landing is a dreadful shock. This shock puts us on edge for Lila's later descent into the basement, which stretches time even further as each step seems to last a full minute, since we now (rightly) expect the worst to be waiting for her. On one other end of the scale, a contemporary action film can make us feel as if no time passes during its one hundred minutes; while in another discourse entirely, a film like *Wavelength* (Michael Snow, 1967) insists on equating duration and depicted time, a position transformed into an ideology in the 1970s by such "structural/materialist" filmmakers as Peter Gidal. The relationship of film grammar, plot, and the experience of time is a fertile area of study, especially since the compression of time is probably one of the major determinants of the longevity of cinema as a cultural phenomenon.

The question is: what happens to cinematic time when viewer input becomes a component of the screen amalgam? To what extent does the incorporation of viewer impact keep time real, canceling out the magnetism of cinema itself—when does it cease to be cinema and become "multimedia" in its drab information-delivery costume, the slick

transmission of data in fields of "hot spots," "buttons," and "point-and-click menus"? As I revise this essay (in 2002), this wasteland has become transmogrified into the paralytic gloom of the World Wide Web, and most people associate interactivity with clicking though endless linked Oracle database fields.

THE KULESHOV EFFECT

The temporal grammar of classical film continuity can be summed up in a single example, which, like many cinema myths, is often described but never seen. The "Kuleshov Effect" scenario consists of a close-up of a Russian actor, intercut with several emotion-laden images (a dead woman in a coffin, a child playing, a bowl of soup). This supposedly produces in the audience an apprehension of the actor's face as saturated with appropriate emotion. But more interesting than this (presumably a commentary on the actor's ambiguous, doleful expression) is the idea, taken as "obvious and certain" by Pudovkin (1954), that the character is seen to be "looking at the soup"—the man and the soup are linked, across the cut, into a single continuous space. Of course it cannot be as simple as this, because the sense of continuous space requires the support of a number of factors, such as eye-line, lighting, shadow direction, and so on—but the point is clear. I'll suggest a recasting of this fable later in this essay. Here, I introduce it only to restate the homily that in cinema, spatial unification is easily maintained through temporal and spatial disruptions,[5] given a particular sequence. Sequence determines space. And sequence logically requires time.

THE LIBERATION OF THE FILMSTRIP

A standard linear unit of cinema has an A-B-A structure: for example, the look–cutaway–look of a point-of-view moment, the shot–reverse–shot of a dialogue scene, or the performer–audience–performer of the musical. This atomic structure defines continuity of time and space in the cinema.

The equivalent in my interactive cinema is formed by a sequence in which the middle term is produced by an action of the viewer. If the viewer does not act, the first shot continues. But on action by the spectator the B-shot appears, then, after an appropriate period, the A-shot reappears, perhaps transformed by the interspersed shot, perhaps unchanged. In *Sonata*, this structure is used as a bridge to an alternative point of view (e.g., of another fictional character or of the author); as a jump to an earlier (or later) time in the story; as a glance at a different depiction of the narrative situation (e.g., a classical painting of the Judith and Holofernes theme, rather than its continuing narration by a storyteller); or as the momentary introduction of a parallel narrative line. Does the sequence still denote a continuity of space and/or time? The interpretive mode the viewer takes toward the new material is associative. Because the new image or scene was produced (i.e., brought on screen) by the viewer, he or she is forced into connecting to

the image it replaces—an act of association, rather than spatiotemporal suturing. In *Sonata*, the mental act is reinforced by two strategies:

1. An automatic return to the previous image, so that it seems that the image produced by the viewer interaction is a temporary interruption of a continuing logic.
2. Audio continuity: the sound from the first image continues through the interruption, which reinforces the impression that the viewer's actions are disturbing the natural flow, thus demanding that a sense be made of the new complex.

In the environment created by this structure, *duration* becomes variable, not fixed. Though the plot of the unfolding narrative is not affected by the viewer's interactions, the screen can now contain multiple diegetic times simultaneously, and the viewer quickly becomes accustomed to navigating between them.

Experienced Time, on the other hand, becomes open and indeterminate. At one extreme, the viewer can find himself or herself in the extended time-instant of the computer hacker or video-game player compulsively acting on the screen image. It is this semihypnotic state that allows the computer programmer to spend twenty-four hours at a stretch in front of a CRT, "jacked in" as the novelist William Gibson puts it. In his fiction, Gibson compares the state to that produced by imagined mind-altering drugs. In this mental condition, the user's impact on the screen output is paramount, while awareness of content and interpretive distance are subordinated to action. Video-game environments are often designed to stimulate this condition—the content is minimal and ancillary to the actions of the user, which are immediate and powerful, either floridly destructive and dependent on hand-eye coordination, or effortlessly navigational—most often a combination of the two. Unlike a video game, however, changes in interactive cinema are driven by plot and consequence; and consequently, compulsion will not be the overriding ingredient of the mental state of the viewer. Here the need for evaluation, interpretation, and understanding are in the foreground, though the obsessive need to fully explore the narrative space can serve well as an incentive and accompaniment.

Freed from the predicament whereby the apparatus alone dictates the temporal experience, time can now expand or contract according to the extent of the viewer's involvement or attention, no longer only because of the hills, gullies, and plateaus, the changes in elevation of the plot. One can imagine the user of an interactive cinema alternating between compulsive input, loss of self in the flow of the narrative, and a sense of distance and control of one's own experience of time, as the tides of the story ebb and flow on the basis of one's own actions on and in it.

The notion of suspense, for example, can be retained but transformed. If the viewer identifies with a character, seeing him as transfixed with horror at one moment and overcome with relief at the next, there may be some hesitation about accessing the cause of his distress. Now a new emotional affect begins to emerge. "Don't look behind the

door!" we wordlessly warn—but now whether the character opens the cellar door is determined by us, and the vacillation, the holding back, related to a particular experience of suspense, will put the viewer, unexpectedly, in a different grip of the screen. The new pull is a hook of agency—whether we have to face the horror that both terrifies and fascinates is now our decision, and in an effective work we will be equally compelled in both directions.

THEN WHAT CAN THE INTERACTIVE CINEMA DEPICT?

A person's life consists of a collection of events, the last of which could also change the meaning of the whole, not because it counts more than the previous ones but because once they are included in a life, events are arranged in an order that is not chronological but, rather, corresponds to an inner architecture.

CALVINO, 124

Our worlds are disorderly and disorganized, unrestricted and loose. Strands of perception and inner experience are interwoven with actions that affect our immediate environment, causing change in our perceptions and generating new experiences. Time advances relentlessly while our consciousness staggers in and out of it, memories of the past intermingling with hopes for the future as we react to events of the present. Lived experience does not parcel itself into linear, closed structures, though we sometimes represent things that way in order to tell stories about ourselves. But autobiographies, like all narratives based on fact, are always at most distortions and at least abbreviations, omitting many events while inflating others. A complete recounting of the most minor experience (including the mental activity that accompanied it) would last much longer than the experience itself. We compress, excerpt, exclude, and reorganize when we tell stories about ourselves; we must dramatize and deform the facts to fit them into a plotted "story line" with an ending that provides satisfactory closure. If the interactive cinema is a more faithful rendering of reality, it is precisely because it can bypass some of these criteria of narrative structure. Intermixing and interweaving multiple narrative streams, it can create a metanarrative sum that is greater than its component parts, if the subject matter is a match for the potential of the medium. What would be an appropriate model for the subject matter?

We are multitasking units. We can whistle and daydream while working, fantasize while having sex, speak the English translation while listening to the German, and so on. And we can switch from one mental activity—one state, one condition—to another, instantly and without effort. It is easy and natural for most people to keep many thoughts and perceptions simultaneously active in their minds, transferring from one to the next at will. One's current inner experience is a conglomeration of perceptions of the present, memories of the past, hopes for and guesses about the future, along with beliefs and fears independent of time markers, dreams, imaginings, pains, and so on. Each mental element forms an undercurrent in what is happily called the "stream of consciousness,"

and navigating these waters is part of what it is to be human. Rushdie's Ocean can be heard in these shells.

How do we move from one mental entity to the next? One thing is certain: it is nothing like making a selection from a list. The "menu" model incorporated in contemporary computer software is aptly named—using it is like negotiating a meal at a fast-food restaurant. Switching between streams of mental activity involves responding to hardly perceptible internal and external cues, much as one rides a bicycle around obstacles, keeping balance by slight shifts in position, changing direction by combining such shifts with handlebar adjustments and greater weight adjustments. Except in the least significant cases, we affect things in our lives not by making choices, but by actively responding to situations, with speech acts or in behavior, and equally by silence or inaction. Only in restaurants or department stores are we faced with a closed list of alternatives. The interface of an interactive cinema cannot restrict itself to a model of choice. Response is the operative concept.

OPEN ISSUES: WHAT ISN'T THE INTERACTIVE CINEMA?

The story so far: The interactive narrative will be in the form of a story space (again the terminology of Michael Joyce and Jay Bolter) laid out for exploration. This story space may consist of a number of related narratives that the viewer forges or discovers links between, or of a single narrative seen from various viewpoints (e.g., of different characters). It may be the breakdown of a particular situation or image or scene into its (nonhierarchical) historical or constitutive elements.

But it will not be a linear story in which viewer input determines what-happens-next. Such a structure does not contribute to the notion of interactive form, since everything that appears will remain within the limitations of the linear—the fact that a viewer has selected which line the story takes is irrelevant. This particular structure becomes interesting only when the viewer is exposed to different hypothetical situations, so that he or she can see what would happen if the characters took this turn, that path. Only in this case might the overall experience of the piece retain the quality of a story space of multiple narratives simultaneously present for exploration. Generally, registering response alone will not satisfy the basic requirement that the interactive cinema incorporate (reflect, arouse, respond to) the interest or desire of the spectator.

The bottom line for the interactive cinema is that the viewer has some control over what is on screen. He or she knows that what is there will change if she or he acts, that it would have been different if he or she had acted differently earlier. Thus, the viewer is aware of a fundamental indeterminacy. I have called this epistemological state a "subjunctive" relationship to the screen—a constant awareness that things could have been otherwise. This state is grounded in the continuing understanding that what is on screen at any moment is a result of the viewer's interactions—inaction, naturally, counting as decisively as action.

The subjunctive mental state is in direct opposition to the epistemology I identified as essential to a comprehension of the "mainstream" cinema, which depends on a conception of the screen complex as unalterable, the events in the diegesis as inevitable. In an advanced interactive cinema, everything will be in flux, open to the possibility of change—like conversation or competitive sports—and the more sophisticated the system, the more fluid and wide-ranging the possibilities. Awareness of this liquidity has a radical impact on the viewer's relationship to the cinematic material.

Both the structural and the expressive possibilities for the cinema change, expanding in some ways, contracting in others. The details will appear only in the production of new works, not in theory.

A way to examine the issues is to return to the distinction proposed by Maya Deren in the notorious "Symposium on Poetry and the Film" of 1963, chaired by Amos Vogel and including both Arthur Miller and an obviously inebriated, but nevertheless fairly coherent, Dylan Thomas (Sitney, "Poetry"). Deren distinguishes two forms of montage, which she calls "horizontal and vertical investigations of a situation," a division that corresponds roughly to that between narrative and lyric forms of poetic structure. Deren argues that narrative film makes use of both of these modes, the vertical when a specific moment in time is investigated and the horizontal when time moves forward along a narrative path. Her presupposition is that the two are separate and distinct, that they cannot occur simultaneously in a film. I will suggest that the interactive cinema allows both modes to occur together.

Sonata is built on this distinction. Story-time is always advancing, both for Lev, the first-person narrator of "The Kreutzer Sonata," and for Judith, who recalls her encounter with Holofernes (based on the Apocryphal book of Judith). However, at any moment, pointing at the screen produces an alternative view of the current juncture of the story, usually in a visual depiction, while the narration continues uninterrupted. The techniques of film montage are evident, in that the sense of continuity is maintained through the interruption elicited by viewer intervention. Vertical investigations include alternative views of the current situation on screen (e.g., an image drawn from the vast database of art-historical images of Judith at various stages in the story), flash-forwards or flashbacks, or commentary from one of the shifting authors (e.g., Tolstoy, on whose novella *The Kreutzer Sonata* and diaries the piece is based (Tolstoy, 2003), or the filmmaker, who appears in stained-tooth close-up).

Thus, Deren's *vertical* is embedded in the *horizontal,* the lyrical lodged in the narrative, always available at the bidding of the viewer. This story-structure depends on the subjunctivity of the viewer's perception of the screen. It is necessary that the viewer recognize that behind each element of the screen complex, there is a potential set of cinematic data that supports, enriches, subverts, or otherwise amplifies its meaning. Only by viewer action is this meaning realized, but it is always latent. On these grounds, a new relationship of viewer to screen is forged.

Therefore, it is incumbent on the artist of interactive cinema to find techniques to refresh the viewer's awareness that his or her actions in relation to a particular image

produce new sounds or pictures. In my judgment, the most immediately available techniques can be found in the language of montage. A deliberate use of recognizable film-editing strategies can keep reconvincing the viewer of the specificity of connections between old and new elements, between the elements already there and those produced by viewer action. Once the interactive work has brought the viewer to the idea that actions on the screen complex always contribute to the continuing signification of the work, then the associations can roam more freely than in the city zoo of conventional narrative film. Now the fact that the viewer feels *responsible for* the new elements predisposes a comprehension and application of links, associations, and connections that may not have operated in the response to a conventional cinematic work.

BACK TO THE OCEAN

"And if you are very, very careful, or very, very highly skilled, you can dip
a cup into the Ocean," Iff told Haroun, "like so," and here he produced a
little golden cup from another of his waistcoat pockets, "and you can fill
it with water from a single, pure Stream of Story, like so," as he did
precisely that, "and then you can offer it to a young fellow who's feeling
blue, so that the magic of the story can restore his spirits. Go on now;
knock it back, have a swig, do yourself a favour," Iff concluded.
"Guaranteed to make you feel A-number-one."

RUSHDIE, 71–72

So now we have two models of potential structure for an interactive cinema: one drawn from a classical text by the father of psychoanalysis, the other from an introspective view of the mind at work. There are many literary precedents for both models. Furthermore, a number of recent works of fiction have plot structures that eminently suit the form of an interactive cinema, either in that they involve the unpacking of a given image or scene into its underlying components—Graham Swift's *Waterland* provides several excellent instances—or in that their narrative consists of the meeting point of a number of inter-related themes—John Barth's *Tidewater Tales* and his masterful *Last Voyage of Somebody the Sailor* both follow this pattern. More recent examples are Graham Swift's *Last Orders,* a novel in which the person of the narrator changes from chapter to chapter, and John Barth's *On With the Story* and *Coming Soon!!!,* both of which require of the reader an attention split among many chapters simultaneously in order to make sense of the story.

TYING UP AND MOVING ON

There are still, there will always be, loose ends. Given that narrative is imposition of order on chaos, intrusion of form on the formless, and that the order, the form, the logic that narrative imposes is of time and sequence, sequence in time, we must now ask again whether we can retain narrative when we abandon endings, when we are entangled in an endless middle (Brooks, 323).[6] A catchphrase often used by theorists to describe

narrative is "the illusion of sequence," but in Freud's conception of dream interpretation we can see how sequence can be abandoned without losing the narrative thread. Freud's understanding of dream-structure is an alternative to the Aristotelian model, not only because the components can appear in any order, but also because the story is never over, the analysis is always incomplete, there are always more biographical details to uncover. In an interactive cinema, where the desire for closure can also be more or less overcome, the viewer continues to explore the narrative space until he considers it exhausted. There is no totality, there is only withdrawal.

And yet. And yet.

However.

Butbutbut.

Real Time cannot be trashed with the need for closure like potato peels or an old jalopy. There is, there always will be, a Beginning, an End to a viewer's exposure to an interactive cinema work, and a Time Between. She walks up to the device, she interacts with it, she walks away. He walks up, sits down, stays a while, gets up. Do we place a viewer with an interactive work until it starts to repeat on him like rote learning or yesterday's overspiced entree? The interactive cinema will succeed only if, in retrospect, the experience seems substantial.

All and any loose narrative ends will never be knotted; this is one of the features (i.e., not bugs) of interactive cinema. If a viewer navigates through a mass of material, some of it will be seen and some won't, and surely some of what isn't seen earlier will raise issues that remain unresolved in what is seen later. But a system can be sensitized to repetition, either so as to avoid it, or so that as soon as repetition starts the viewer is offered the opportunity to enter a structurally different region, a territory of culmination or summary. In general terms, a map of ground covered can be kept by the system, and once a certain area has been explored, closure possibilities can be introduced.

In *The Erl King* (1983–86), after certain segments have been repeated, a box with the work "END?" appears on the screen. If this box is touched, it produces a mildly interactive segment that starts with images of a few key production-crew members touching the inside of the video screen from within the monitor, followed by a rapid series of production stills. A viewer can switch on or off two cardinal text overlays—passages from Wittgenstein and Baudrillard that describe something of the theoretical underpinnings of the work—by touching different areas of the screen.

Sonata (1991/93) reserves two narrative segments that are acknowledged and indicated throughout the piece. If the viewer perseveres, following a story through to one of its climactic moments, the reward will be one of the two culminating murder scenes, one decorated with the blooming image of a blood-fountain, the other with the voluptuous sounds of a blade severing flesh and splintering bone. The possibility of viewing these scenes emerges when the viewer has covered a certain amount of the narrative ground of the piece. And after the murder, the work ends or, more precisely, returns to the beginning.

Frames (1999) has internal endings, in the form of "rewards" for successful completion of a task. A viewer attempts to transform a contemporary actor into a nineteenth-century mental-asylum inmate, a Mad Woman, based on the first photographs taken in a mental institution (by Hugh Diamond in the 1850s, when photography was in its teens). When the viewer succeeds in fully transforming his or her actor into character (there are some obstacles), she will move, in character, to the center screen, and enact a small drama. If two viewers succeed together, their characters will meet on the third screen. After the drama is over, the piece returns to its opening screens.

All this is to say that despite its need for an open narrative, closure cannot be banished from the interactive cinema. Remove the imminence of closure and we begin to drain cinema of desire. Closure must be recast in a more radical mold.

The most fruitful possibility for me, based on my commitment to multiplying and intermingling narratives, is that several story lines continue until one, some, or all of them end. Here the idea is that numerous diegetic times are constantly flowing forward, many narratives operating in time simultaneously, independently of which one the viewer encounters. Narrative time in this model keeps moving on. This provides another form for the interactive fiction cinema, a picture of multiple narrative streams not interconnected by a central image, theme, or scene. The viewer navigates from one current to an adjacent one in a constantly flowing river, crossing between streams of story at moments of similarity or juncture. Or, to descend one level more, we

might rather think of the narrative streams as potential, elements themselves unformed or chaotic, but taking form as they intersect, gaining meaning in relation to one another.

In *Sonata,* I attempt this by juxtaposing the stories of Podsnyeshev (the antihero wife-killer in Tolstoy's *Kreutzer Sonata*) and Judith (the Apocryphal heroine who decapitated the enemy general Holofernes). Both narratives progress, but it is at their connections, where the viewer can cross from one to the other, that they come into focus and take on meaning. A viewer will access an episode of one or the other narrative but not both, and their forms are similar enough that their plot movements can be seen as concurrent. Each of the killers—Podsnyeshev and Judith—is reflected in the light of the other, since each emerges out of the story context of the other. And thus an act of interpretation is forced on the viewer: the morality of each character comes into question when they are placed in parallel, especially because the former is presented as Evil and the latter as Good.

Without the act of interpretation, the stories are raw and problematic. But when they are clashed together at the points of interaction, the viewer must take on the role of a judge. As Eisenstein recognized explicitly, Griffith at least implicitly, and Kuleshov claimed as his own, the force of a cinematic element is determined by its context—in the multilinear narrative interactive cinema, context is in constant flux, the elements appearing always different as their surroundings shift.

As the viewer is drawn in by the act of interpretation, now the magnetic attraction of the interactive cinema can be felt, and the question of the expansion and contraction of experienced time finally addressed; for it is here that the *hacker* mindset takes over—as we jack into William Gibson's *cyberspace.* Umberto Eco describes the state somewhat more suggestively than Gibson, though Eco is talking about the travels of a steel ball around an electric pinball surface, not a sprite in a graphic representation of a data environment.

> You don't play pinball just with your hands, you play it with your groin too. The pinball problem is not to stop the ball before it's swallowed by the mouth at the bottom, or to kick it back to midfield like a halfback. The problem is to make it stay up where the lighted targets are more numerous and have it bounce from one to another, wandering, confused, delirious, but still a free agent. And you achieve this not by jolting the ball but by transmitting vibrations to the case, the frame, but gently, so the machine won't catch on and say Tilt. You can do it only with the groin, or with a play of the hips that makes the groin not so much bump, as slither, keeping you on this side of an orgasm. (Eco, 222)

More appropriate to the times than Eco's pinball machine is a game like *Tetris,* in which the player arranges falling shapes into an unbroken plane, a theatre of geometry and spatial anticipation often played on long airplane flights—as the time sense is held in abeyance, the magnified time of the cramped Atlantic crossing is compressed into a single moment of hypnotic focus. *Tetris's* hook of involvement is the desire for closure, for the completion of the pattern, an end that is always attainable but just out of reach,

like Eco's "brink of orgasm." It is in this space that the machine absorbs time, providing in its place the never-quite-fulfilled promise of consummation.[7]

RANDOM ACCESS AND THE DIGITAL

The interactive cinematic structures I am proposing require a specific quality of the moving-image streams that constitute them. The system must be able to access *any* frame of *any* cinematic stream and display the stream, from that frame forward, as a flow of moving pictures. The cinematic apparatus, the concatenation of hardware with its software armature, must allow leaps from anywhere to anywhere in the moving-picture database, ideally in no time. *Random access* to the atomic cinematic data (i.e., the individual frames) is, in other words, the primary requirement. It must be noted that digitization is neither a sufficient nor a necessary condition of random access. The laser videodisc, the technology on which all my early works are built, is an analog device: video is encoded using infinitely variable values, not a two-valued "digital" system. However, the achievement of laser disc technology is that its video frames can be accessed and played back in any sequence. It may take up to a second to get from one frame to another on the disc, but all the frames in between are not traversed en route, as is required with videotape or film media. In this way, laser video disc is a random-access, analog medium—encoding and storage are distinct processes and techniques.

In 2003, John Hanhardt and Jon Ippolito, curators at the Guggenheim Museum, proposed employing *The Erl King* as a test case for the concept of preservation of media art that the museum had developed. The key term in their "Variable Media Program" is *emulation*, the idea being that physical devices are emulated in the form of software structures independent of specific manufacturers or technologies, which will become obsolete because of both advances in technology and the requirements of the market-driven economy. However, eliminating all products is far from straightforward and may not be possible, since software development packages require operating systems (which are usually proprietary) and tend to exploit the attributes of specific chips and other hardware. But emulation of hardware on open-source software is an ideal that the Variable Media Initiative is committed to pursuing, despite (or possibly because of) the pursuit's utopian underpinnings. And naturally it was a program I was thrilled to participate in, since the hardware that *The Erl King* depended on was twenty years old and had been off the market for almost as long.

The project was to reconstruct *The Erl King* as software on a single computer—replacing physical video players, switchers, and other hardware devices with data files accompanied by supporting software to access the data and present it as motion images on screen. The programmer Isaac Dimitrovsky developed a scheme in which the original *Erl King* "limosine" source code was installed on a contemporary computer and interpreted line-by-line by a program written in the Java programming language. Video frames are encoded as images, which are presented on screen, twenty-four per second, in a simulation of cinema. Contemporary CPUs and data busses are at last fast enough

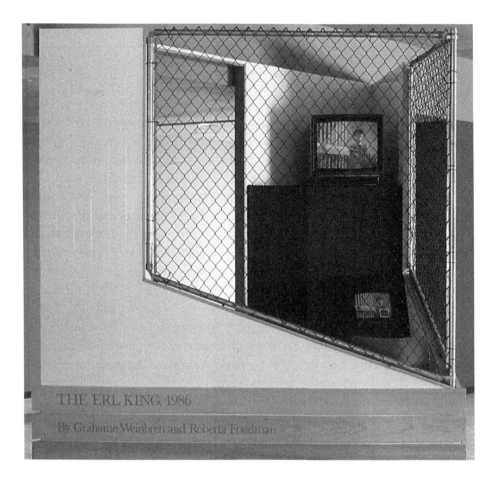

THE ERL KING, 1986

By Grahame Weinbren and Roberta Friedman

to handle video in a way parallel to laser video disc technology. Since each frame is individually encoded, access to it is random, but now the frames are digital data, each frame a single image file, rather than a set of variable physical pits engraved in a groove of a twelve-inch disc. And since access to files on a hard drive is almost instantaneous, the worst-case one-second delay of the video disc player is eliminated.

However, this apparent advantage of minimal access time turned out to be something of a liability. In developing *The Erl King*, we were very much aware of the inherent lags and hesitations of the system, the friction and slippages caused by the physics of real-world gears and bearings. Like the prized delay between pressing a key and hearing the note in church pipe organs, these infelicities became something we exploited as the piece developed. The timings and rhythms of the video flow depend on the "grain" of the system. The physical limitations of the components of the early 1980s were embedded in the program of *The Erl King* to such an extent that they became determinants of the way it produced meaning.

But the very first version of the emulated *Erl King* had no delays. When I touched the screen, the upcoming video appeared and began playing immediately. It was so fast that

one could not believe that one's action had had an effect on the system, and the power and complexity of the piece dissolved into an arbitrary porridge with no distinction between viewer-caused changes and those built in. Isaac Dimitrovsky painstakingly worked on replicating, in computer code, exactly the right balance of delays and pauses, distinguishing between those caused by disc search time (which depend on the distance the focusing head has to travel to find the requested frame), and the time required for the computer to communicate with the laser disc players and the touch screen.

It is an irony that, in order for the emulation to retain a meaning that had a relationship to the original, the very limitations of the original had to be reproduced by software, effectively making the 2004 system appear less efficient, and undercutting some of the advantages and potential of the update.

There is a way that this point can be generalized. Timothy Binkley argues strenuously that the computer is not a medium or tool ("Camera Fantasia"; Weinbren, "PC"), by which he means that it does not have inherent characteristics that can be explored and exposed in a kind of modernist gesture. The computer is a chameleon, the universal tool whose qualities can be defined and redefined from project to project and from use to use. The granularities that we depended on so heavily for *The Erl King* are material properties of film, video, and the laser disc player. When everything becomes software, qualities are indeterminate, undefined until fixed by code. This is simultaneously the liberation and the burden of computer-based art.

VERSIONS

Another way of describing the double edge, the shackles and open spaces simultaneously generated in the conversion to digital, is in the understanding that the notion of the final or autograph text is an anachronism. This is the third published version of this essay. I'd like to add that it is the last, but of course I also believed that about the first two. Digital technologies facilitate change in places and at stages of production where previously it was highly problematic and, consequently, exorbitantly expensive. Even after a text has been printed, editorial changes are easily managed, movable type being a long outdated technology, replaced by digital plates output at the touch of a key. Žižek has pointed out that there is no longer such a thing as a "master" text ("Cyberspace" 150; Weinbren, "Mastery"). So I may be disappointed in my desire for this to be the master version of this essay.

My interest in interactivity is tied to the notion that flux is among the few defining characteristics of the digital. I am seeking a cinema that encompasses variability while retaining cinematic power, a cinema based first on random access to its atomic elements, and now on their digitization. The ironic aspect of the "digital emulation" of *The Erl King* is that its digitization undercuts its *aura* (in the Benjaminian sense of signs of the artist's labor "marking" the medium). Qualities that were inherent to the base media can be peeled away when the base media are no more than simulations, so that these qualities have to be replicated piece by piece, rather than worked with and against as currents or

resistances in a physical world. There are no qualities inherent to the digital: the interplay between artist's desire and friction-encumbered media vanishes when every friction and abrasion is deliberately determined, placed there by the artist.

One component of *The Erl King* was digital from the beginning. This is the routing data set that defines the possible paths through the audio-video streams. Each time the piece was exhibited, we would revise and add to the navigation database, using the authoring component of the software. Thus, not only did no two viewers ever see exactly the same sequence of images, each exhibition (considered as the sum total of all possible paths through the audiovisual database) was a different version of the piece. However, the cinematic material, imprinted on the set of laser discs, remained the same throughout the multiple iterations.

Now that the cinematic database is digital, it can also be effortlessly added to or subtracted from. It is as simple to add an image or a sequence to the database as to change a pathway through the database, using exactly the same data-management techniques. Why would an artist not improve a piece in any way he could if it was about to be exhibited again? Digital emulation has extracted the foundations. The piece can evolve like a city, until an archaeological study would be required to reconstruct the original, through traces unearthed; except that, unlike the physical world, changes of digital data leave few remains. Had *The Erl King* been produced as a one hundred percent digital work (impossible in 1983), the idea of an original would be meaningless. Only the physical videodisc media, encoded with images and sounds, anchor the work. *The Erl King, Sonata,* and *Frames* may be the last interactive cinema works for which the notion of an original is tenable. From now on, there will be only versions.

I plan to move on. But at the same time I constantly look back. In life we can look back in anger or regret or satisfaction, we can misremember or lie to ourselves on the basis of desires or fears, but we cannot alter the past. However, when we enter the realm of the digital, change will always be an option, removed only when data is burned, encoded, imprinted, etched, painted, chipped, engraved, cut, carved, or bitten into a nonreversible medium.

AFTERTHOUGHTS

Earlier versions of this essay appeared in 1995 in *Millennium Film Journal* No. 28 "Interactivities," and in 2003 in the ZKM/MIT Press publication *Future Cinema*. Since the ZKM publication, *The Erl King,* one of the works from which I developed the ideas laid out here, was brought into the collection of the Solomon R. Guggenheim Museum, and rebuilt or "renewed" so as to remove its dependence on outdated and unrepairable technologies. It now runs on a single off-the-shelf computer, while the 1983–85 version requires several pieces of peripheral equipment, some custom built, communicating with a fairly specialized computer, vintage 1982. A number of interesting points emerged during the process of transforming the work from hardware-based to software-based, and the last part of this essay begins to address some of these issues.

However, technology is a minor theme of the essay. The main topic is how the possibility of viewer input into, or interruption of, a time-based work demands radical change in temporal architectures, calling for a revised theory of narrative structure and other forms. As a practitioner, I think through such issues in the construction and production of artworks, and this essay is, above all, a record of the thought-processes I engaged in during 1980s and 90s. Some of the ideas in the essay have been absorbed into the current cultural climate, where interactivity is a given, but I believe that the problem of temporal structure has not yet been well addressed outside the paradigms of the video game and the database, which are, as implied by this essay, only one possible structural model for an interactive, time-based work.

ABOUT THE AUTHOR

Grahame Weinbren's interactive cinema installations have been exhibited since the mid-1980s in museums, galleries, and festivals worldwide. His practice ranges from artists' cinema works to television documentaries as well as writing about cinema, media art, and the philosophical issues generated by emerging technologies. He is the senior editor of the *Millennium Film Journal* and a member of the graduate faculty of the School of Visual Arts in New York City (gw@post-typhoon-sky.com, grahameweinbren.com, grahameweinbren.net).

NOTES

1. Michael Joyce and Jay Bolter developed the software application "Storyspace," which is essentially a hypertext word processor. Bolter theorizes the software and the general notion of hypertext writing in his book *Writing Space: The Computer, Hypertext, and the History of Writing*.

2. In his illuminating and expansive book *Reading for the Plot: Design and Intention in Narrative*, Peter Brooks refers to Freud's acknowledgement that the Wolf Man's vision of the primal scene might have been either fantasy or recollection—its historical truth-status is irrelevant to the effect of the mental image on the subject. This, of course, opens the possibility of the excision of origins and a collapse into endless deferrals, an organizational paradigm developed in detail by Derrida (e.g., as "the chain of supplements"). This conception is useful for interactive works that depend on links, since each link can lead to another, eventually giving the impression of boundlessness, though in practice, of course, repetition is ultimately inevitable: I rely on the structure of one link leading to another in the Wolf Man section of *Sonata*. Brooks's book was recommended to me by the editor of this volume, Marsha Kinder, on the occasion of my revising the present essay for this context, and I have found it extraordinarily useful. In some cases, it confirms and fixes my groping ideas; in others, it has forced me to rethink the more naive presuppositions I was making about the place of plot and structure in narrative. I will refer to the book in footnotes throughout; here, I'd like to acknowledge my gratitude to Kinder for her gentle suggestion that I might find Brooks's work helpful.

3. Brooks's focus on the relationship between a reader's desire and pleasure in the text leads him to propose a *dynamic* analysis of narrative, an analysis which foregrounds *plot* and its multiple temporalities. Thus, the beginning of the classical narrative text engages the reader in the text by breaching the question of how the situation(s) set up in opening scenes will be resolved (i.e., eliciting a desire for an ending). As Brooks puts it, "the end writes the beginning and shapes the middle . . . " (22). Interestingly, Brooks sees the structures of the classical narrative reprised in the mainstream cinema of the twentieth century, while it is challenged in serious twentieth-century fiction. Since the subject of the present essay is an interactivity of cinema, Brooks's analyses are particularly useful, though I will propose that the interactive cinema has much to learn from the contemporary novel. The classical narrative's insistent desire for resolution is immediately apparent, for example, as the basis of the interactivity of computer games, the most recognized and financially successful dynamic interactive works so far, and this same wish to move forward and settle will be the lure for the viewer of the interactive cinema.

4. Brooks's argument for the essential temporality of narrative structure folds into my proposal for a subjunctivity of the elements in the interactive work. If a narrative is endowed with meaning retrospectively, it is the desire for the ending that maintains the reader's interest in the text. In this model, the middle of a narrative becomes a mobile interplay of variation: "repetition as binding works toward the generation of significance, toward recognition and the retrospective illumination that will allow us to grasp the text as total metaphor, but not therefore to discount the metonymies that have led to it . . . " (108). Here we can imagine the viewer replacing one story-element by a structural equivalent, each replacement painting the current story-situation in a different light. Brooks describes the middle as "the place of repetitions, oscillating between blindness and recognition, between origin and ending" (108). For the reader to have the power to see a story-moment in a different way, from an alternate angle, or through another character's eyes, can recharge this oscillation and extend its authority, an authority that, in the best circumstances, will extend to the experience of the whole work, invigorating the desire for the end and at the same time transforming it.

5. See film editor Walter Murch's illuminating discussion of the significance and heuristics of this disruptiveness in *In the Blink of an Eye: A Perspective on Film Editing;* also see Sean Cubitt's extensive analysis of the cut as a determinant of cinematic meaning in *The Cinema Effect.*

6. Brooks's insight about the death of the ending is that although the modernist novel eschews the exhaustive ending as a falsehood, the (now frequently frustrated) desire for the ending is still the tie that binds the reader to the plot. "Since ends have ceased to be simple—indeed, on inspection we realize they never were simple—the end that narrative seeks, in its anticipation of retrospection, may disappoint and baffle. Yet this may only make it the more necessary to construct meaning *from* that end, moving back to recover markings from the past, reconstructing the outposts of meaning along the way" (323).

7. This was written before the emergence of the computer game culture and its conquest of Hollywood. Now (2002) airplanes have games built into screens in the seat backs. But the point about the erasure of the perception of time's passage remains unchanged. I have written about the computer game and its false promises in Weinbren, "Mastery: Sonic C'est Moi."

IS THIS NOT A SCREEN?
Notes on the Mobile Phone and Cinema

Caroline Bassett

The information revolution amounts to: the replacement of analogue languages
by digital: the computation of sensations, whether visual, auditory, tactile or
olfactory by software, through a computer filter.

PAUL VIRILIO, *ART AND FEAR*

Ordinary, familiar reality, this almost never happens.

LEV MANOVICH, *THE LANGUAGE OF NEW MEDIA*

"AFTER THE FASHION OF THE FINGERPRINT"

A parallel: There are parallels to be drawn between the development of visual telephony
and sound cinema. Vision is to the phone as sound was to cinema—it came later and
remains only partially integrated into voice services and mobile routines, operating *serially* (see Virilio, *Art and Fear* 88). Let these two moments merge momentarily and we can
equip Al Jolson, the star of *The Jazz Singer* (1927, dir. Alan Crosland), the film that most
famously bridged the silent and the sound eras, with a mobile phone: "Hullo Mammy
I'm on the train" (but would he say it with intertitle, gesture, or speech, text message,
voice, or image?). With this incongruity in mind, the mobile screen is explored both in
its relation to the traditional cinema screen and in its difference.

A thumbnail sketch: Andre Bazin claimed that cinema operated "after the fashion of a
fingerprint" (*Cinema* vol. I, 15). This essay considers the fingerprint, said by Bazin to
characterize cinema's ontological relation to the real, through a consideration of the
thumbed text and the thumbnail picture characteristic of the mobile phone and of its
portable and intimate screen, raising some questions of realism and ontology in relation
to this new media form. It argues that mobiles have a complex and innovative visual
economy; one that draws upon elements of the telematic and the cinematic to produce a
particular aesthetic, described here as "good enough." This aesthetic may operate partly

as a result of technical constraints, but it has also been *chosen,* emerging through a series of more or less conscious trade-offs made both by users and producers as they negotiate two different sets of possibilities; the first set prioritizes rich forms of connection, the second set richly realized virtual/screen environments. To suggest that this aesthetic is chosen is not to deny the apparently unstoppable rise in processor performance (Moore's Law) and the increases in pixel depths, polygon counts, resolution and refresh rates, associated with this acceleration, nor is it to set aside advances in telecommunications, which allow for faster connection rates. It is to suggest that the way in which these advances are implemented (at the level of design and practice) do not follow a predetermined trajectory and certainly do not lead us inexorably towards the revealed truth of the converged media form, to the essential ontology of the ultimate media object. Rather, I want to suggest that because digital media objects emerge through open-ended processes of convergence, this is also where their (contingent) ontology is to found: *in process and as intersections.*

The mobile phone has emerged as a centripetal node in processes of convergence, drawing in functionalities traditionally offered through other kinds of devices. Mobiles are now (also) mailboxes, digital cameras, video recorders, personal radios, personal organizers, and MP3 players. It is easy to assume that the mobile *becomes* each of these objects rather than simulating them, or remediating them; that it takes on the most advanced characteristics of each media stream it subsumes, and assumes their development trajectories. On this basis, the *visual* economy of the mobile might be expected not only to draw on cinema (which would hardly be surprising given the latter's influence in the construction of a visual grammar), but to take on its priorities and inherit its genres wholesale. This new and more intimate screen might thus be expected to partake in that drive towards total cinema or integral realism which was described by Bazin as a compelling myth of cinema, both impossible to realize and impossible to set aside entirely. In a meditation on Quicktime, Apple's cross-platform multimedia architecture, Sobchack argues that the political economy of the new media industry means that a development trajectory for the new forms of screening that essentially falls into line with Bazin's trajectory is more or less inevitable ("Nostalgia" 4–23). Regretting the "quickening" of Quicktime, the end of its jagged frame rates and patchy image quality, Sobchack mourns an aesthetic that of necessity underscored the work behind the production of illusion. As she puts it, the visible "struggle to achieve the illusion of life" is lost in smoother forms and higher resolutions of later versions of this architecture.

Given that Quicktime is a software architecture that underpins dynamic data operations for multiple platforms, its development path might be expected to influence digital platforms more generally. In other words, we might expect many kinds of devices to follow the kind of cinematic trajectory Sobchack maps out for Quicktime. The mobile phone, however, begins to tell a different story, or perhaps it can be used to excavate a different aspect of the development of new media. Currently at least, the mobile appears to be operating with a screen aesthetic that does not tend towards traditional forms of

cinematic realism, and certainly not towards those forms alone. Disputing the assumption that the mobile screen will simply resolve into another form of cinema and one partaking of the myth of total cinema, I explore this screen as the site of a particular kind of convergence of telematic and cinematic properties. Not only the mobile phone but the mobile screen finds its history and its future not only in the traditions of cinema or broadcast media, but also in those of telephony and communication: evidenced here is not a twin-track linear development trajectory but a process of multiple integration and reinvention.

The screen aspect of the mobile has been neglected in studies of mobile telephony. In fact, despite the data traffic phone networks carry and the growing volume of text messages and pictures mobile phones exchange, most critical work on mobile phones begins with sound. If it goes on to explore space, this tends to be in relation to the reconfiguration of physical space *beyond* or *through* the screen (see Bassett, "Movements" 343–356). The talk is of speech bubbles, musical overlays, channels in and out of a real world. The "Ground Wher U Walk" (as a text poet put it) isn't often connected to the screen where you TXT. Giving some consideration to a poetics or aesthetics for the mobile that *does* attend to its nascent screen economy, that asks *why* being "good enough" visually has often been good enough, and continues to be so, allows some new questions about mobile telephony to be asked and some new claims to be made. In particular, it provides a fresh perspective on how two different forces—two elements of convergence—intersect and connect, producing a particular form of realism.

Bazin's contention was that the (enduring) myth of total cinema, as "a total and complete representation of reality . . . a perfect illusion" shaped and continues to shape the evolution of cinema (*Cinema* vol. I, 20). If the visual economy of the phone is not driven by the impulse towards the kind of *total illusion* that renders even the technology engaged in its construction (*especially* that technology) invisible, then clearly this might be because a different and contradictory drive is also operating here; a drive towards connection, even *total connection*. One possibility, then, is that the mobile, combining different media streams, reaches towards an *additive* totality. Essentially this is what Virilio prophesies in *Art and Fear* (written in 2002), where he predicts "a TOTAL ART" (his capitalization) which emerges not from cinema, but from information and communication technologies, and which both destroys and retools the visual, producing a world in which *only* the image is left but, paradoxically enough, producing no place from which to see (79). The same basic vision is evident, although far less mordantly expressed, in "strong" accounts of convergence within the industry from the 1980s and early 1990s (see, e.g., Brand; Negroponte). It is against this dystopian/utopian (and teleological) vision of absolute convergence, which I find highly problematic, that I posit the mobile aesthetic as (always provisionally) "good enough, right now."

Brief examinations of (i) the gestural quality of text messaging, (ii) mobile photography, and (iii) forms of multiple and one-to-one screen-based association (flash mobs) that find their force partly through their *break* with what Bazin called "integral realism"

(*Cinema* vol. I, 21) are used to begin to explore these questions here, but evidence can also be found in the history of new media (in the still-birth of the interactive CD-ROM industry at the hands of the web), and I refer to this briefly below. Finally, the kind of aesthetic discerned in the mobile screen can also be observed in some other forms of digital media. There is a well-established digital aesthetic that valorizes "good enough" quality *as* an aesthetic: Less is often more (the hacker ethic has this aesthetic, as does much tactical media, as does the popular turn to retro-gaming; see P. Taylor; Fuller).

ORANGE WEDNESDAY

A report on an encounter between two kinds of screen: This took place in a multiplex cinema in Brighton, England, and was staged by Orange, one of the UK's largest mobile phone operators. Every Wednesday, Orange offers free cinema tickets which may be claimed by sending a text message. By definition this audience is made up of mobile phone users. These are screen users and screen viewers. There is, of course, nothing exceptional in this gathering of mobile users, since mobiles are everywhere. However, these events do produce a rather unusual kind of confrontation between the cinematic and the telematic since, inside the cinema, the phone is silenced, focusing attention on its visual aspects alone. This, in turn, provokes comparison between the two kinds of screen in the auditorium, the first located within the immobilizing cinematic apparatus, the second portable, the first prioritizing narrative and spectacle, the second communication and interaction. If these screens have different logics, what are they? If they have different aesthetics, do these aesthetics also begin to connect, to resemble each other?

On the day that I began to think about this confrontation, I went to see *Meet the Fockers* (2004, dir. Jay Roach)—on an Orange Wednesday you take what's there. This was a film that attracted large numbers of teenagers, England's most avid text messengers. As the program began, the cinema screen came slowly to life in the way it always does, projecting advertisements and trailers and injunctions against mobile phone use. This is the traditional cinema screen, the screen space produced in/as a vacuum "which dreams readily fill" (Jean Leirens, cited in Metz, *Film Language* 10), dreams that come from a particular place, of course. The teenagers, however, continued to attend to their own small screens so that myriad mobiles lit up the auditorium as users sent their final pre-film texts. One screen faced many others. Two apparatuses *intersected*. Certainly attention here was divided temporally and, perhaps in a different way, also spatially. At any rate, not everybody in the audience was meeting the Fockers at the appointed time.

This firefly audience, with their light-shedding mobile prosthetics, countered the discipline of the screen apparatus with its injunction to silence and to stillness with a visual workaround, operating a visual/textual/txt message escape: Meet the Tribes of the Thumbs. Setting aside the parallel romance narratives of what was watched and what played out on and off screen here (since many of these teenagers appeared to be practicing romance with each other), I note that what was screened in the hand competed rather

directly—and rather effectively—with what was screened overhead. The confrontation between these two kinds of screens, one marshaling the audience, the other dispersed through the auditorium, was one in which each side seemed well matched. There may, in fact, have been more mobile screen "real estate" in this auditorium than there was cinema screen footage. One question, then, is how those in the cinema managed these two evenly balanced media streams, which not only interpellated them individually as spectators and users (positions requiring different forms of attention perhaps) but which also produced a group at once, and obviously, both singular (a film audience sharing a common experience) and multiple (a collection of users each engaged in an individual pursuit). What I found most arresting, however, was the lit-up quality of these teens, made pure medium by their mobile prostheses. I wonder what forms of sense perception operate in this space and others like it, in spaces that is, which slip between a regime of the visual predicated on a form of closed communion (in structuralist terms, one that joins narrative with narrative, as Metz pointed out long ago, when he argued that cinematic narratology is predicated on a form of phenomenological prefiguration; *Film Language* 17), and one that prioritizes an open-ended act of communication, joining real selves with real others.

I do not want to configure the encounter I have just described in terms of tactical resistance. I am not setting the "murmurous practices" (de Certeau, ix) of the mobile users against the tyrannies of cinematic interpellation (and I certainly do not want to do this by setting process against content and valorizing the one over the other). The fragmented or intermittent is not automatically the tactical, and traditional narrative is not inevitably tyrannical. Media studies and audience studies have taught us, by now, that many forms of spectatorship or interaction demand audience/screener activity; it is the *significance* of this activity that is at issue, as Stallabrass, Lister, and others have noted. Besides which, this is an encounter in which Orange faces Dreamworks, which is to say that it is, among other things, a corporate encounter. If it is typical as a form of contemporary convergence, this is because it is an example of the increasingly seamless penetration of the cultural forms and practices of everyday life by the contemporary cultural industries. So the issue here, the critical question perhaps, is not about "who" is being tactical and with "what" technology. It is about how to conceive of this form of digital media as an advanced expression of the contemporary culture industries. In other words, how are particular industrial logics instantiated in particular kinds of technologically articulated cultural forms and practices that tend to valorize particular aesthetics and particular modes of use and consumption? And how can these logics be understood critically? In thinking about these questions, this essay focuses on the mobile phone, but the physical encounter between two media forms occurring on Orange Wednesdays stands synecdochically for broader processes of convergence, wherein similar dynamics of convergent remediation (the remaking of one media form by another) can be discerned.

There are two caveats here. The first is that I am not taking total connection (or Moravec-style upload fantasies) for granted as a principle governing the design trajectory

of the "purely" telematic object (if such an object could exist). Nor am I taking integral realism for granted in relation to "traditional" cinema. Indeed, as Metz said long ago in *Film Language,* and as Manovich said more recently, there's nothing real about realist cinema; if we are not talking of the illusion of scene, then we are discussing the illusion of perspective (Manovich, "Reality Media"). It is in this context that Manovich can remark of "ordinary, familiar reality" that it "almost never happens" (*Language* 212). Manovich, of course, is referring to reality as it occurs (or doesn't occur) in cinema. However, this remark could increasingly be applied to real life in the sense that it is becoming increasingly not simulated but mediated: and, of course, mobile communications and other intimate media are elements in the extension of that process of mediatization.

This brings me to the second caveat, which is that the use of the mobile phone within art practice is not under direct consideration here, although there are some intriguing digital artworks exploring telematics (e.g., Paul Sermon's *Telematic Dreaming,* turning "real" copresence into redoubled impossibility). However, I *am* framing mobile use as something that *can* be a creative practice, perhaps in the Deleuzian sense that it may entail the creation of "new spaces and times" from the "unexpected, the unrecognized, the unrecognizable" (Deleuze, "The Brain Is the Screen" 370, 369). This implies that if there is an aesthetically driven teleology that pushes developments in phone use, it emerges from users (and from users as medium producers as well as content producers) as much as it does from those who engineer, design, and market these phones. In other words, and keeping in mind the previously explained avoidance of technologically determined forms of "resistance," a practice of use and/or a poetics of everyday life and everyday space, that might also entail *or make possible* a form of politics emerging around mobile use (or one that, at any rate, connects to forms of thinking around questions of digital interpellation and social subjects), may become visible here.

THE RICH AND THE FAST

A fictional and factional return: In *Neuromancer* (1984), William Gibson famously characterized cyberspace as an abstract grid ("lines of light ranged in the non-space of the mind" [51]). However, he also distinguished it from simstim, which was a fully fleshed-out simulation space, a "gratuitous multiplication of flesh input" (55), and not one beloved of hackers or technophiles. The division played out in the *built* (rather than imaginary) virtual spaces beginning to emerge in the mid- to late 1980s and 1990s, a time when CD-ROM-based content (interactive media) stood in contrast to Internet (connected media). In that period, connection won out decisively over verisimilitude: the infant CD-ROM content industry, hailed as the foundation of a whole new form of content which would cover entertainment, information, leisure, and literature, failed, with e-publishing initiatives by Voyager, Apple, and many others foundering (see *Mac-User, Wired, CD-ROM Magazine, Screen Digest*). If the hopes for "interactive multimedia"

were frustrated (at that time, in that form), the Internet, prioritizing real-time connection (although at the time, real-time often *lagged*) over visual quality, or richness of connection, exploded.

The opposition between these two forms of digital media, essentially operating as a negotiation between the rich (fully realized multimodal media) and the fast (forms of media offering immediate or real-time connection) continues to condition the media on offer today. It is perhaps most evident in game design, where "good enough" screen quality is partly determined by the degree to which it can be sustained across networks in ways that also give high levels of connectivity (where high means fast), and is also discernible in the compromise tactic whereby slabs of rendered film are interpolated into playable sections of console and other games. (In some of these cases, real-time connection with "live" others is reduced or re-rendered as internal feedback, providing instant or real-time communication with a machine.) This is schematic, of course; the point I am making is that there is evidence to suggest that the desire for connection and real-time interaction consistently overrides a desire for fully realized (realistic) forms of virtual environments, however those are understood at the time, and that this is reflected in design approaches.

Two complications are worth noting here. The first is that "realism" itself is contested in a particular way in relation to the virtual—and not only for media theorists, but in a more popular sphere; for hackers, coders, and many in the open source community, code "itself" is felt to come far closer to the real than anything that covers its operations over with metaphor, and this realism is felt to be desirable *politically* too. It codes for freedom. As *Next 5 Minutes,* the tactical media festival, once put it, "How low can you go?" A second complication concerns the degree to which I, at least, cannot help but conceive of cyberspace *visually:* lines of *light.* . . . Constellations . . . City lights. . . . Simstim, by contrast, appears to come closer to Virilio's sense of the blindness that arises as a response to a field of obscenely totalized vision, or even to Frederic Jameson's sense of the visual itself as pornographic (*Signatures of the Visible* 1–2).

Picking up these questions, in the final sections of this essay, I will consider two forms of mobile use that cohere around the screen—texting and pixting—and also ask what happens when my cinema audience leaves the cinema and meets each other, rather than meeting the Fockers, who are of course fighting among themselves. These moments/aspects of mobile use point to places where there are fractures or interesting divisions between different (contending) myths circulating around new media technologies and competing and conflicting claims about how "a more direct way to apprehend reality" (Manovich, *Language* 210–211) might be instantiated in relation to the mobile screen. These accounts, the beginnings of a critical exploration rather than a fully fledged ethnographic investigation, are developed in gestural ways here. Happily this is apposite, since the gestural itself forms part of the mobile aesthetic, producing a particular kind of the "good enough" in the form of abbreviated messaging that cross-cuts what might be described as a drive towards combinatorial realism, which in this case would consist

of total communication produced by total immersion in an entirely realized virtual environment, within which absolute presence could be guaranteed.

TXT MESSAGING AND THE CALLIGRAMMATICAL

From now on, what speaks is the image—any image.

VIRILIO, *ART AND FEAR* 86

A light shed on teasing speech: Text messaging, a famously unexpected form of use which was originally driven by users rather than manufacturers, and which was adopted unevenly in different markets, marked the beginnings of popular screen-based telephony. Text messaging is at once a visualized form of speech and a form of writing that becomes graphical. It is a form that fuses alphabetic and other symbols and redeploys alphabetical characters in new ways, in this way "teasing speech from the silence of graphic lines" (Foucault, *Pipe* 21).

The text message might be understood as a form of calligram, a figure Foucault explored with reference to Magritte's paintings of a pipe which is not a pipe (where the placing of legend and image say something about the pipe "itself"). Looking at the place of text and image in these works, Foucault explains that "the calligram aspires playfully to efface the oldest oppositions of our alphabetic civilization: to show and to name; to shape and to say; to reproduce and to articulate; to imitate and to signify; to look and to read" (*Pipe* 21). Drawing on Foucault's account, David Rodowick describes this figure as symptomatic of a new form of the temporal and spatial organization of reading, one based on a confusion between the linguistic and the plastic that inaugurates a particular kind of "chiasmatic" relationship between the two orders of signs, the visual and the linguistic (61). Text messages might embody some of the kinds of general shifts in reading that Rodowick discerns in his account of new media. However, I'd also suggest that the text message is calligrammatical in a way that provokes particular consideration, not only of the text image relationship, but also of the material form this text image takes.

Having established the calligram, Foucault discusses one of the pipe-works as an *unraveled* calligram, since in this work text and image remain in relation but move apart somewhat, no longer trapping the object within the doubly sprung (text to image, image to text) cage. Now, as Foucault put it, in this unraveling "the thing itself escapes" (*Pipe* 28). The pipe is "not there" anymore. The text message, marked both by redundancy and incompleteness, by abbreviation and closure ("GR8"), by open-endedness and a conversational character (U2?), could also be regarded as an unraveled form of the calligram. Further, in the case of the text message, the reorganization of the text–image relationship that might explode the calligram is performed through the act of communication, or *sending*. In other words, if the visual economy of the text message pins down the message, trapping it within a text-image, then sending the message may reopen the circuit or unravel the calligram somewhat. At this point, perhaps the message, as *message*, might

be said to have escaped; only its traces remain, since any answer knows where to find its mark. The communication aesthetic operating is predicated on constant movement between the trapping and the escape of the message, a circuit that repeats (4t Da/*Fort da?*); perhaps, indeed, this repetition is part of the allure of texting. At any rate, it is in this sense that, for the firefly audiences of the Brighton cinema, lit up like McLuhan's lightbulbs, their medium really is their message.

Text messaging, then, does integrate communicational and visual modes. But it does not do so in the service of total communication. On the contrary, it suggests that part of the aesthetic of the mobile is that the message is incomplete, that it is bound up, compressed, and at the same time *lossy* and gestural rather than complete: not all used up, like the tale after its telling (see Barthes, *Image-Music-Text*), but somehow fugitive.

LIVE AND UNSPUN?

Lets you use your mobile as a digital camera.

NOKIA HELP

A truth, held at arms length? On summer days visitors to Brighton beach take pictures when the light is too bright to see the screen at all. Their mobile phone cameras, held at arm's length, are simply passed in front of an object. Mobiles are becoming digital cameras, and mobile screens have become one of a number of sites for the transmission and viewing of mobile images. Standard phone contracts (in the UK at least) now include as standard "free" digital-camera-equipped phones, and recent market reports show that the use of low-cost, relatively low-resolution mobile cameras is overtaking the use of dedicated digital cameras, which simulate traditional photographic equipment (BBC, April, 2005). Once again, this is an encounter with the "good enough," since here is an apparently willing reversion to more basic image standards, in the interests of immediate access to the equipment required to record and transmit events, people, places: any time, anywhere.

So, after the moment of the fingerprint, with its promise of indexicality inhering in the "common being" (Bazin, *Cinema* vol. I, 15) of the photograph and the object photographed, comes the moment of the thumbnail. This new form of photography doesn't promise the real object. What it does promise to deliver is a real and immediate record of the "real," available to save or cache, or available at a distance. I want to suggest that this promise is made through the *instrumentally distanced* shot, through a distancing of the recorder of the image from the image itself. It is the arm's length that suggests that the image might offer an *unspun* record of the event. The quality of the image is not an issue here. Indeed, the aesthetic that emerges is partly operated through distinctions between the mobile camera user as an "amateur" recorder and that of the film or the television production as professional. Two points might be made here. First, it might be low- rather high-quality images that underpin this aesthetic. And second, this kind of distancing does not point to an uncomplicated sense of dis-intermediation, since the

promise of "the real" operating here is *also* predicated on the transfer of the event onto the screen, a transfer that might be felt to make an event more real or, at the very least, to make it *matter more.* "Happy slapping," the UK phenomenon of the recorded attack, might begin to be explained in this way (BBC News, May 8, 2005).

Strangely, the "good enough" is thus seen here to *refresh* rather than *evacuate* still further that supposedly exhausted, but nonetheless potent, sense of the indexical popularly associated with photography, which was always cultural rather than "real," as Bazin himself notes, at least in relation to an ontological identity between model and image (*Cinema* vol. I, 10).

It is ironic that at the moment when the technology which, purportedly, finally guarantees the (already exploded) impossibility of indexical realism as a "real" phenomenon becomes ubiquitous, a new form of documentary, and with it a new and rather different sense of the camera as able to register the real, emerges. An extended narrative manifestation of this kind of dynamic is to be found in *Capturing the Friedmans* (2003, dir. Andrew Jarecki), wherein a similar amateur aesthetic establishes a particular form of documentary realism, one that operates through the intimate distance and promise of "truth" offered by home cinema—in our case, redrawn as *mobile* witnessing.

FIREFLIES AND FLASHMOBS

Let's hear it for ambient murmuring, *the voice of the voiceless!*

VIRILIO, *ART AND FEAR* 41

What connects the technical properties of computer networks and the communication properties of computer networks?

RHEINGOLD, *SMART MOBS* 58

The terms of an oscillation: See the ambient light the teenage fireflies in my cinema shed as they at once light up the shared cinema space and reach through walls that once bounded this kind of collective experience, and compare this with the "flashmob." The latter is a group assembled together for no real reason, the coming together and the mode of its organization being, by definition, more important than the end; often it *is* the end. At the moment of consummation, at the meeting point when any *other* point might be revealed, the flashmob fades away or loses its intensity.

Does the essential *vacuity* of the flashmob, by which I mean its content-free constitution (which is, nonetheless, and like the screen vacuum of the cinematic apparatus, *pressured*), liberate us to consider what else it does, which might be to orchestrate forms of communication that gesture towards, but that rarely produce, forms of community action?

I would here like to return once again to Vivian Sobchack's sense of regret for the loss of an aesthetic of visible construction in Quicktime as a new media architecture. I share this regret, but would perhaps redirect it from questions of the production of illusion, towards questions of the degree to which contemporary forms and aesthetics of mobile use might produce the illusion that the continuous and redoubled act of connection, in

and of itself, produces meaningful forms of (collective) life. It seems to me, indeed, that the requirement for pure connection might operate as a kind of compensatory ideology, emerging in response to the *difficulty* of finding and forging community.

Certainly, new ways need to be found to make distinctions between forms of collective action and forms of collective agency. Perhaps, following Tiziana Terranova, who is herself clearly influenced by Hardt and Negri, this might be understood in terms of an oscillation between mob and multitude, where the latter invokes a changed state of consciousness (or a form of becoming conscious) not on the part of individuals, but on the part of the crowd itself. I say this because it seems to me that Virilio's sardonic cry to "hear it" for the murmuring of the voiceless masks something about this form of social interaction that might be taken more seriously, which is its *potential:* What might happen among those firefly users, if they were lit up with an impulse to do more than "only connect"? If that were not, any longer, quite good enough?

CONCLUSION

Setting the "good enough" ethos of the mobile's visual economy not against, but in relation to, the idea of total cinema, offered up by Bazin, suggests that not only the purchase of Bazin's myth itself, but the form it might take in the current constellation, need to be reexplored. First in relation to new forms of media where screens become sites for interaction in real time (the latter standing as a definition of new media), and second where "real-time" invokes a new relation between places and people who are both proximate and remote. This invokes a series of questions about the relationship not only between text and image (Foucault's question) but between screen and world, and between representation and action. Perhaps it also provokes questions about the *myths* of the technological, which, while they still operate differently in different spheres (going not by way of cinematic realism, but by telematic immediacy, in the case of the web, for instance), now come together in new ways, producing new claims to take us "closer to the real." These are claims that, insofar as they bear a utopian claim, need to be explored for their ideological construction.

Perhaps it can be said of the mobile (but only with the rider that this comment itself is not an absolute assertion but an exploded calligram which lets the object *almost* escape) that the trajectory of new media will not move towards total cinema, or become a cinematic object *merely*. Nor will the mobile screen be characterized by a principle of addition, becoming simply a telematically expanded form of vision (total surveillance?). It is in this sense, perhaps, that despite the centrality of the visual within its economy, it might be said that mobile cinema never *will* be invented.

AFTERTHOUGHTS

This essay explores the mobile phone as a new form of intimate screen. It was originally written in the spring of 2005 for a Society of Film and Media Studies conference at a time

when mobile phones were newly equipped with digital cameras as standard (in the UK at least), something that provoked reconsideration of the phone as screen. Since then, processes of convergence have continued and both the screen quality and communications functionality of mobiles phones in general have increased so that, as their producers put it, new generations of mobile phones are more "fully featured" than ever before.

Despite these developments, tensions remain between the priorities and understandings that might drive mobile phone development when it is regarded as primarily a communications device and those that might drive it when it is regarded as a new form of screen-based and visual media able to handle many different kinds of content. In particular, these tensions concern questions of realism. The mobile screen, that is to say, continues to be constituted through the intersection of (at least) two rather different traditions of realism. The first of these is based on the ideal of total communication and the other on what Bazin called "integral realism" and defined as the impossible ideal of a particular form of cinema. Rather than specific technological advances, it is the negotiations between these two traditions (explored through consideration of the small screen in relation to the larger one, and in relation to particular forms of use, and distilled in that confrontation of medium and message that occurs as cinemagoers become users, and vice versa) that have produced *and that continue to produce* what I describe in this essay as a "good enough" aesthetic.

This is not a fixed aesthetic but one that is intrinsically in process, and there have been some changes in the intervening years. In particular, the use of mobile phone–generated images for documentary purposes of all kinds has increased. These images contribute to the production of a media landscape in which professional and amateur contributions are combined increasingly tightly, often in ways that presage the formation of new ideas about what might constitute "realism," both in relation to news and truth values and in relation to identity and its maintenance. The prominence given to mobile-equipped citizen journalists in the traditional media (press and broadcast) coverage of the 7/7 London bombings makes this clear, as do web 2.0 social media sites which rely on newly organized combinations of owned and appropriated content to substantiate their very different claims to "authenticity" and "realism."

ABOUT THE AUTHOR

Caroline Bassett researches and teaches at the University of Sussex, where she is professor of Digital Media and codirector of the Centre for Material Digital Culture. Her work explores new media/digital media as a material cultural form. She has published widely on critical theories of new media, gender and new media, feminism and technology, mobile media and sense perception, and narrative and digital media. Recent work includes digital humanities–based research into science fiction and innovation. She is currently completing a book on anticomputing for Manchester University Press.

DIGITAL POSSIBILITIES AND THE REIMAGINING OF POLITICS, PLACE, AND THE SELF

DIGITAL POSSIBILITIES AND THE REIMAGINING OF POLITICS, PLACE, AND THE SELF
An Introduction

Tara McPherson

Much has changed since the original Interactive Frictions conference, both on the Internet and in the wider world around us. Less than a year after the conference, the castles in the air built by the mid-1990s Silicon Valley frenzy had collapsed and, soon after that, the twin towers of the World Trade Center fell. The spiraling deflation ignited by the dot-com crash was further fueled by the disastrous events of 9/11. Today, as a second round of economic turmoil continues to wreck havoc with the economy, the United States still feels the effects of a falsely justified war and faces new assaults on civil liberties. This conflict is at least partially virtual, deploying the digital along multiple registers from communication to drone attacks to surveillance and reminding us of the long-standing coupling of war and technology. Yet it is also all too grounded and bloody, marked by a high body count and by images of torture that seem to defy the virtual and to underscore the reality of specific places and of fleshed bodies.

While none of those gathered in the Davidson Conference Center in June 1999 might have predicted the events of September 11 or their aftermath, a few conference speakers did call us to remember other histories, particularly industrial histories that illustrate the degree to which all narrative forms are deeply influenced by their conditions of production. Pat Mellencamp recalled the early, heady days of guerilla video and eloquently underscored the capacity of capital to cut short the possibilities of experimental narrative. We could likewise have turned to the early days of radio, television, or even cable to find similar cautionary tales.

Still, in those heady days of "early" digital media theory, industrial history was not the only terrain eclipsed by the pursuit of specificity. In many ways, the field seemed caught up in a boom of its own, with pioneer spirits eager to brand the scholarly outposts of the digital in their own images, intent on staking their claims in this new academic growth industry. Some of this mindset was on display at the conference, as we hotly pursued medium specificity, limning the multiple contours of the things that were there before us and tracking the many precursors to the forms taking shape in interactive narratives, digital art, and, to a lesser degree, popular practices.

At the conference and in the broader field of "new media theory," this "cyberstructuralism" (as Marsha Kinder refers to it in her introduction to Part I) often proceeded as if critiques of structuralism in film and literary fields had never surfaced at all, erasing decades of challenges to formalist theory by feminists, cultural studies scholars, and theorists of race, and distancing a direct engagement with the politics of media.[1]

Certainly, much of the first half of this anthology complicates a blind cyberstructuralism through a careful attention to the precursors of new media. As such, it performs important work by historicizing the "new" in new media, locating productive antecedents even while parsing what really is different or unique about the digital. In this second half, the volume moves pointedly beyond medium specificity to a broader engagement with social and cultural contexts. If essays in Part I provide important formal and historical lenses through which to examine the specificity and predecessors of digital media, Part II delves even more directly into the cultural, the social, and the political in a post–World War II landscape. In doing so, it is possible to broaden our conceptions of several key terms, including the "political."

I think the ease with which some sense of the "political" was excavated from much work in early new media theory had less to do with the overt intentions of the cyberstructuralists and much to do with the paucity of many conceptions of the political as they related to cyberspace circa 1999. For a variety of complex reasons well delineated in other places, much of the explicitly "political" conversation about cyberspace in the late 1990s was tied to notions of the "digital divide," a concept that quickly became a flash point for academics as well as policy makers and politicians. Essentially, the idea of the digital divide fixated on the notion of access, insisting that many were being left with no entry ramp onto the "information superhighway," a term popularized by then Vice President Al Gore and others. Such claims tied notions of citizenship (or, perhaps more accurately, notions of "empowered" consumers) to digital access but seldom broached more complex issues like multimedia literacy or even diverse content, implying a kind of blind faith in access as panacea. In keeping with the libertarian spirit driving the denizens of Silicon Valley and readers of *Wired* everywhere, the idea of the digital divide implied that providing computers would somehow ensure the flowering of democracy, an attitude we continue to see replayed with successive waves of technology, particularly vis-à-vis education.

Of course, this shorthand sketch of the issue is itself reductive. At its best, the concept did (and can continue to) highlight some very key aspects of digital inequality. For

instance, according to Internet World Stats (www.internetworldstats.com/stats.htm), less than thirty-five percent of the world population uses the Internet. Still, Faye Ginsburg has argued that the "neo-developmentalist language" underpinning much digital-divide rhetoric has led to an "unexamined First-Worldism that has underwritten assumptions about the digital age and its inequalities." She insists that conceptions of the digital divide often devolve into a consumerist discourse that "smuggles in a set of assumptions that paper over cultural and economic differences in the way things digital may be taken up, if at all, in radically different contexts, and thus serve to further insulate thinking against recognition of alterity that different kinds of media worlds present."

This market-driven idea of the digital divide overdetermined the overtly "political" discussions about digital media in the late 1990s and perhaps made it easier for the cyberstructuralists to disengage. Such considerations seemed to smack too much of policy or of communication studies, fields long devalued by film and literary studies, and did not seem to have much to do with the more rarefied and philosophical pursuits of "specifying" the medium. The concerns of those debating the digital divide didn't much impinge upon new media theory, and the two fields seemed engaged in different realms of inquiry. Interestingly, and in ways I will return to, the very forms of the digital may also have underwritten this kind of academic partitioning.

In small pockets of the conference and certainly in the years since, several scholars, including Anna Everett, Lisa Nakamura, Wendy Chun, Jessie Daniels, and Herman Gray (who was not at the conference but is included in this volume), have turned to race as one test bed for rethinking the myriad ways we might broaden our conceptions of the political in this digital age, defusing the hyperformalism of much digital media theory. A productive strand of this work has explored the creative use of new technologies by marginalized communities, particularly communities of color, examining early adopters of the digital in communities like hip hop and DJ culture.[2] This work challenges the rhetoric of the digital divide by locating technological competency and originality in precisely those communities that digital-divide rhetoric tends to pathologize as techno-phobic. At its best, this work also begins to push beyond questions of identity and representation as the primary modes by which we understand the terrain of the political. Questions of representation, in particular, while important, always risk remaining on the surface of our screens and make it harder to see the vast systematic changes unfolding around and enveloping us since at least the Cold War era. They make it difficult to understand our embeddedness in cybernetic systems and networked subjectivities that point toward political terrain not firmly rooted in identity, in representation, in access, or even in traditional conceptions of the left and the right.

I don't think it is accidental or surprising that one important challenge to formalist analysis emerges from scholars also engaged in understanding the work of race in the digital era. Scholars of color have been at the forefront of critiquing the depoliticized nature (and universalizing whiteness) of digital theory for at least twenty years, often drawing on and extending related critiques of 1970s film and literary theory.[3] Many who

had worked quite hard to instill race as a central mode of critical inquiry throughout the late twentieth century were both disheartened and enraged (if not surprised) to find new media theory so easily returning to formalist modes at the dawn of the twenty-first century. One might argue that the "newness" of digital forms necessitated a kind of "formalist period," a sustained time of reflection on the specificity of what was before us in a particular moment. While there may be some value to such an observation, we can also pursue another vector of thought and ask if there is not something *particular to the very forms* of electronic culture that seems to encourage just such a supposition—a supposition that partitions race from the specificity of media forms.

"First-wave" writers on digital technology such as Sherry Turkle and George Landow commented on the parallels between the ways of knowing modeled in computer culture and theories of structuralism and post-structuralism, a tendency much in evidence at the Interactive Frictions conference and in subsequent work by theorists like Alex Galloway. Critical race theorists and postcolonial scholars like Chela Sandoval and Gayatri Spivak have noted the structuring role that race plays in the work of post-structuralists like Barthes and Foucault. We might bring these two arguments together, triangulating race, electronic culture, and post-structuralism, and also argue that race, particularly in the United States, is central to this undertaking, fundamentally shaping how we see and know as well as the technologies that underwrite or cement both vision and knowledge. Specific modes of racial visibility and knowing dovetail with specific technologies of vision: if the digital underwrites today's key modes of vision and is the central technology of post–World War II America, these technologized modalities took shape in a world also struggling with changing knowledges about, and representations of, race.

Scholars have tracked the emergence of a "color-blind" rhetoric after World War II, a discourse that moves from explicit to more implicit modes of racism and racial representation. Referencing those 3-D postcards that bring two images together even while suppressing their connections, I have earlier termed the racial paradigms of the postwar era "lenticular logics." A lenticular logic is a covert racial logic, a logic for the post–Civil Rights era. We might contrast the lenticular postcard to that very popular artifact of the industrial era, the stereoscope card. The stereoscope melds two different images into an imagined whole; the lenticular image partitions and divides, privileging fragmentation.

A lenticular logic is a logic of the fragment or the chunk, a way of seeing the world as discrete elements or nodes, a mode which can also suppress relation. The popularity of lenticular lenses, particularly in the form of postcards, coincides historically not just with the rise of an articulated movement for civil rights but also with the growth of electronic culture and the birth of cybernetics (with both—cybernetics and the Civil Rights movement—born in quite real ways out of World War II). I am not so much arguing that one mode is causally related to the other, but, rather, that they both represent a move toward fragmentary knowledges, knowledges increasingly prevalent in the later half of the twentieth century. They are congruent modes of knowledge production which coincide with (and reinforce) (post)structuralist approaches to the world.

UNIX, a computer operating system, and C++, the programming language that underwrites many of our encounters with the digital, both function, at some levels, as forms of fragmentary knowledge production, making cause and effect and interrelation hard to conceptualize. As early as 1988, Bill Nichols detailed the tendency of cybernetic systems to substitute part for whole. This fragmentation also haunts other digital experiences. Both the computer and the lenticular lens mediate images and objects, changing their relationship but frequently suppressing that process of relation. The fragmentary knowledges encouraged by some forms and experiences of the digital neatly parallel the lenticular logics which underwrite the covert racism endemic to our times, operating in potential feedback loops, supporting each other.[4]

If scholars of race have highlighted how certain tendencies within post-structuralist theory simultaneously respond to and marginalize race, this maneuver is at least partially possible because of a parallel and increasing dispersion of electronic forms across culture, forms which simultaneously enact and shape these new modes of thinking. This is not call for a return to master narratives, but rather a plea for a heightened sensitivity to the sleights of hand that certain formulations of the digital underwrite. We must foreground that race is not something that can be parsed independently of theories of new media and instead insist that race is constitutive of those very media forms, particularly in an American context after World War II. Such a position also recognizes that there might be some potential power in the fragment or the part that can expand our notions of the self or of politics were we to engage it on our own, already politicized terms, terms that also value the potential of linkage or affiliation. The politics of the fragment are not predetermined, but powerful forces push back against certain maneuvers that might spin the fragment elsewhere.

Despite this sustained attention to reconnecting the circuits between race and digital theory, I am not arguing that race is the *only* way to parse the politics of the digital, but it is a central and crucial one. To insist on its centrality is one way of suggesting that we cannot simply "add" race (or other elements of difference) on later once we've specified the forms and theories of new media, as this additive strategy precisely falls prey to a limited and limiting logic of the fragment or the part, suppressing connection and relationality. Further, it does not allow us to see the ways in which race may be embedded in the very root structures of American technology, functioning as a constant ghost in the machine. Thus, many of the essays in this half of the volume engage directly with race, illustrating the relevance of race to technology in registers that exceed (while also including) issues of identity and representation and expanding our conceptions of the political.

A subset of essays in this half tackles the politics of the digital through a rethinking of place, pursuing the contact zones between physical and virtual terrains. These essays resist binary thinking and insist on mapping fascinating feedback loops between the simulated spaces of virtual realms and the physical world, illustrating a certain bleed between screen and street, code and country. They also teach us important lessons about transiting across scales and remind us that places matter in our efforts to ground digital theory in emerging modes of the political.

If reconfigurations of place and of the very terrain of politics cut across and categorize the essays in this second half, the body and identity represent final organizational rubrics. Across the essays, a new possibility for theorizing the relationship of technology to identity or to the body begins to take shape, one that far outstrips the binary logics of difference and sameness. When the self is at least partially constituted within and through the network, a political and politicized engagement with technology must extend beyond questions of representation, identity politics, and access. While body and technology have been intertwined at least since the industrial revolution, if not before, the specific processes, architectures, and systems of the "information age" enact a significant shift in this relationship, a shift that is mutually constitutive of body and of technology. To understand the "political" in relation only to questions of access, of representation, even of interface and identity, is to profoundly misunderstand the age we now inhabit.

Careful considerations of race thread throughout Part II, sometimes receding from an immediate line of sight but resurfacing pages later, forming the context and ground upon which our understanding of the politics of the digital era take shape. I would argue that such a structure also characterizes life in these United States, despite our "color-blind" delusions and desire to see it otherwise.

STRANGE BEDFELLOWS: RETHINKING THE CONTOURS OF THE POLITICAL

The first trio of essays in Part II boldly remap our very conception of politics, engaging directly with notions of the political and imagining new vocabularies that burst out of tired old binaries. Firmly grounding their vibrant technopolitical imaginaries in the social, the cultural, the economic, these authors also move beyond the all-too-familiar dance of technophobia versus cyber celebration, tracking both possibilities and pitfalls in this new digital terrain. In so doing, they engage with various theories of cultural politics, occasionally producing some unexpected pairings and strange bedfellows.

"Transnational/National Digital Imaginaries," by John Hess and Patricia Zimmermann, powerfully envisions the possibility for "alternatives to amnesia" in an era of global capital, a moment of accelerated morphing of the contours of the nation-state as well as new cycles of genocide and violence attendant on those shifts. While fully recognizing the often deadly consequences to this latest global turn, the authors do more than just bemoan this state. Rather, they "want to sketch out an alternative vision of, and response to, the transnational" that remains cognizant of history and that arrests the collapse of space and time so much a consequence of our current post-Fordist moment. The essay turns to early forms of digital documentary in order to reimagine the world we now inhabit and to suggest new politicized aesthetic strategies that might more fully mine the possibilities of the digital.

Their essay pays careful attention to the forms of the documentaries they consider, providing a lively examination of the double movements of history and the future that

the digital can underwrite. They attend to the differences *and* similarities between cinematic and digital forms, noting the ways in which early digital documentary "questions the ontological assumptions of the forms, practice, and argumentative mode of older, more analog, forms of documentary," even as the digital and analog remain in dialectical relationship with each other. Drawing on Timothy Murray and Philip Mallory Jones, they deploy the concept of the fold and the sphere as ways to think this dialectic and, like authors in Part I, extend Dziga Vertov into the digital era. In this, they clearly form a bridge to the essays of the first half of this anthology. However, if the essays of Part I begin with the specificity of forms and often circle out to examine historical context, Zimmermann and Hess enact the opposite strategy, rejecting "some mathematical reorganization of cinematic elements that displaces locations within racialized, sexualized, and engendered subjectivities." They recognize that the ripple effects of the transnational are hardwired into our technological forms from the very outset (many, after all, locate the origins of today's global, post-Fordist economy in the very era that spawned cybernetics) and cannot conceive of a political engagement with the digital that does not begin from this located and embodied knowledge.

Thus, when this essay first appeared online in 1999—about the time our conference was unfolding and at the height of the first wave of formalist analyses of new media—it was voiced in the spirit of fierce polemic. Zimmermann and Hess insist that the very economic structures that were remapping the transnational landscape were, and are, deeply implicated in all digital practices—practices that might at once allow the disabled to communicate and simultaneously create oppressive working conditions for the "men and women, often boys and girls, of the [global] South." Thus, creativity and coercion, BANFF and NAFTA, aesthetic innovation and global capital, are all at once caught up in the movement of the fold. To focus on one without the other is to not understand the digital at all. They refuse to separate political and aesthetic economies even as they pursue just what *is* new in the digital documentary. Throughout this manifesto for a new digital politics, Hess and Zimmermann analyze emergent examples of digital documentaries, works ever cognizant of the bleed between the global and the local, the virtual and the material, the performance and the archive, and the past and the future. They strategically foreground projects that begin from an engagement with memories and bodies, particularly raced ones. They challenge the dream of perfect "phantom realism" so embedded in commercial cinema FX and in computer games and prefer the visible compositing, strategic breakdowns, and disruptive interfaces of many of the works they examine. Nonetheless, they are not naive about these aesthetic practices and recognize the degree to which digital art can function as a "masturbatory, peep-show construction" reinforcing an elitism severed from questions of access and economics.

If their essay moves to a close with the observation "that the analog forms of the racialized body are always embedded within the digital, just not always visualized," this argument also riffs through Herman Gray's "Is (Cyber) Space the Place?" Like Hess and Zimmermann's recombinant pairings of the unlikely figures of Vertov and Reginald

Woolery or Jacques Derrida and Coco Fusco, bringing Herman Gray in dialogue (if only in the covers of this volume) with Lev Manovich enacts a new versioning of "what counts" as digital theory. Although Herman Gray was not at our 1999 conference, his book *Cultural Moves: African Americans and the Politics of Representation* clearly illustrates why he should have been. Including him in this volume suggests that the most useful insights about the digital are not only to be found among the now canonical digital theorists familiar from many "new media theory" anthologies.

In *Cultural Moves*, Gray relocates blackness from the margin to the center of any investigation of the technological imaginary, highlighting the diverse ways in which blackness scaffolds all manner of contemporary popular culture. Extending Gray's earlier work, the book convincingly argues for the central role of culture in meaningful conceptions of the political. If many theorists of the digital have specified the forms of new media while mindful of the pitfalls of technological determinism outlined by Raymond Williams, Gray turns as well to another key figure of the Birmingham School, Stuart Hall, as well as to Cornel West, to think through the implications of the digital for what they, over two decades ago, called the "new cultural politics of difference." In doing so, he asks whether the digital revolution has "disrupted something so fundamental as our collective structure of feeling."

Like many of our contributors, Gray has little use for the "grim tales and happy narratives" of much writing on digital technology. He recognizes that the conditions of production under global capitalism are at once "specific and global as well as abstract and local." As such, they harbor contradictory possibilities for political practice, possibilities most often crystallized through the "experiential and representational . . . apparatus" of culture. He is particularly interested in how the formulations of Hall and West might be rewired for today's technological landscape, querying whether difference can ever "do more than simply serve as the raw materials for flexible forms of capitalist production," another lifestyle choice emptied of political meaning. In short, Gray urges us beyond a binary of sameness and difference and beyond "an attempt to secure a place for 'identity.'" If he is critical of the formalism of early new media theory, he is equally critical of calls for access that do not extend to issues of critical engagement and production. The very same technologies (by which Gray means the computer and the Internet but also the video camera and the mixing board) that seem to serve neoliberal market forces are also intertwined in complex and specific cultural relations, "places of potential (and unwieldy) articulations that interrupt, destabilize, and rearticulate (even if only momentarily)" these same forces of globalization.

If Gray, Hess, and Zimmermann are all interested in a political strategy that can operate from the spaces of contradiction inherent in the logics of late capitalism, pursuing doubled movements and enfoldings across multiple binaries in the pursuit of new possibility, David Crane's essay, "Linkages: Political Topography and Networked Topology," also examines the strange articulations, affiliations, and connections so often produced within digital domains. All three essays in this subsection investigate how modernist

systems (of economics, thought, or politics) will be reconfigured by the digital. Crane's piece takes the notion of the "political" in some ways more literally than the first two essays. He asks how the changes wrought in global politics since the end of the Cold War have reconfigured the political topography, lending an instability to terms like the "right" and the "left" and creating the possibility for new and often unexpected affiliations and transversals. That this reconfiguration coincides with the rise of computer-mediated communication [CMC] suggests interesting feedback loops between digital technologies and political processes that have become fundamentally interlaced. Thus, as his title suggests, he offers theoretical considerations for linking the shifts in political topography to aspects of web typology.

He argues that new, more flexible modes of political affiliation are developing, modes that might facilitate ideological transversals where the margins can play a role in new forms of symbolic political recenterings and hierarchizations. Crane recognizes both the potential and the contradictions of such processes and thus also critiques the claims of early digital enthusiasts like Mark Poster who tended to see these linkages as necessarily transformative or as exceeding the terrain of democracy itself. Crane explores how we might see political topography as partially analogous to Web topology through two extended examples, looking at both early digital libertarian and anarchist discourse.

In examining libertarianism, a political modality that holds particular sway on the Internet and in Silicon Valley, Crane moves through figures of the early "virtual class" as diverse as John Perry Barlow, Timothy May, and Virginia Postrel, detailing their varied attempts to replot aspects of the left/right axis. In different ways, each creates strange hybrid philosophies that combine "traditionally" left or right elements in new political and discursive formations. Taken together, such examples highlight the role of libertarianism (for better or worse) in producing new symbolic topographies, especially in relation to high tech and CMC. Such topographies were crucial in libertarian efforts to gain discursive hegemony over cyberculture, helping to cement certain market assumptions that so drive technological development in the United States and beyond.

Crane also takes up the refractions of anarchism across political topography and web typology and offers an in-depth look at examples that illustrate a kind of DIY approach to building political positions. Many of the sites he examines defy conventional political description, including the "British nationalist, separatist, and anticapitalist organization, Third Way." The group claims inspirations as diverse as the fascism of Julius Evola, the racial separatism of the Nation of Islam, and the critique of mass culture of the Frankfurt School. That such contradictory nodes can be held together in articulating the group's political philosophy stands as a succinct example of the fragmented and lenticular logics increasingly underwriting the discursive and technological networks of the post–World War II era. At any given moment, such a nodal logic can privilege a given analysis while suppressing the contradictory relationality between distinct nodes.

Such sites create their own strange bedfellows, as does Crane himself as he brings together thinkers normally at odds with one another (including Anthony Giddens,

Ernesto Laclau, and Chantal Mouffe) in an effort to make sense of emergent political formations at a moment when many citizens express extreme disillusionment with conventional politics in general.

If Gray insists on the relevance of theorists of difference to new media theory, Crane also builds important bridges to political theory and to scholarship in communication, sociology, and public policy, areas seldom in productive dialogue with registers of new media theory more inflected by film and literary studies. Such bridges are increasingly relevant and important if theorists of digital media's forms are committed to producing analyses that might also engage policy makers and politicians. Digital media theorists can do much more than specify the forms that are before us; we can engage in broader dialogues that might help to shift the conditions of possibility for creating those very forms. In different ways, each of the essays in this subsection introduces rich conceptual models that can invigorate a politically grounded engagement with the digital.

AUGMENTING REALITY: THE PLACES OF THE VIRTUAL

If the earliest days of "cybertheory"—fueled by both the fanciful futurism of cyberpunk and ever-present images of the data glove and the headset—imagined disembodied souls floating free in the heady realms of virtual reality (VR), today's engineers and technologists are much more likely to speak of augmented reality (AR) and locative media. If VR implied a complete immersion in the system, AR layers the virtual over the physical and is currently in development or use for a number of applications, ranging from medical diagnosis (where doctors might, for instance, see a virtual interior layered over an actual patient's body) to advertising (where pedestrians could view embedded commercials in a variety of everyday cityscapes by donning Google glasses.) While engineers tend to parse the differences between VR and AR in precise terms, cultural theorists have argued that even the most advanced VR systems are, of course, always already augmented to the degree that they incorporate viewers situated in precise social and historical contexts. The essays in this subsection might all be seen as helping us to understand different (if not always literal) versions of AR, for each illustrates the bleed between physical and virtual spaces in varying degrees. All three also transverse different scales, helping us to track the ripple effects of globalization across multiple levels: global, national, and local(e).

In "The Database City: The Digital Possessive and Hollywood Boulevard," Eric Gordon investigates the $615 million entertainment monolith "Hollywood and Highland" in order to plot a precise example of the ways in which the virtual and the physical were deeply intertwined at the start of the twenty-first century. If Crane argues for linkages between web typology and political topography, you might say that Gordon maps the transversals between digital spaces and city places, recognizing certain circuits of exchange between new urban-renewal strategies in the 1990s and the spatial metaphors of the web as a growing city portended in William Mitchell's *City of Bits*. The essay specifies the forms of this new mode of urban development, one that, in the case of

Hollywood and Highland, sought to mobilize particular Tinseltown histories of glamour, style and stardom (but not its more noir underbelly) via the new navigational sensibility being experienced on the web at the time. Thus, the complex was designed as a legible interface to the city, providing a searchable, interactive environment via which the user could explore the city. Here, AR takes the form of the database city, a space that is more about structuring access than about pure simulation (as some have described an earlier Los Angeles urban project, Jon Jerde's Universal CityWalk).

By exploring the parameters of the database city (and, in turn, this augmented city's use of the database image), Gordon draws upon and extends the very different theorizations of the database by theorists Lev Manovich and Marsha Kinder. While he finds value in Manovich's reconfiguring of film theory's delineation of the paradigmatic and the syntagmatic, he is also drawn to Kinder's figuration of the database narrative as a potentially subversive form. Gordon spends a good deal of the essay detailing the architecture and hot spots of Hollywood and Highland, noting the degree to which the development structures interactivity and narrative, providing a kind of formalist analysis of the new media forms of the city. But he also pushes beyond this structural analysis to imply a politics, one that moves beyond Frederic Jameson's nostalgic critique of pastiche to hint at the possibility of the individual user's transgressive mobility within the spaces of crass commercialism.

These transgressions largely remain latent in Hollywood and Highland but are more fully exploited in a screen-based project, the DVD-ROM *Bleeding Through: Layer of Los Angeles, 1920–1986,* that also provides a kind of interface to Hollywood. Here, a multiple-tiered interplay of database and narrative works to destabilize master narratives and reclaim alternative, often racialized, histories of the city, illustrating the subversive potentials of the database narrative that Kinder theorizes. Yet, if *Bleeding Through* creates its possibilities through a certain incompleteness that allows the user freedom in "filling in" the gaps, Gordon argues that Hollywood and Highland is specifically designed to disenable aporia, foreclosing some registers of possible transgression. Still, Gordon hopes that, by holding these two modes of database together, we can begin to imagine new modes of selection and combination that might spin the politics of culture elsewhere. I would add that such a politics might also unearth the varied struggles over specific places that are partially concealed in the mega-developments of the urban renewal projects— stories of displacement, immigration, and community that are not fully evident in either tales of "old" Hollywood glamour or the gritty fantasies of noir.

If Hollywood and Highland tries to recapture a romanticized slice of Los Angeles history in a precise physical locale, Cristina Venegas investigates a reverse process in her essay "Cuba, Cyberculture, and the Exile Discourse." She articulates Cuba's status as an "infinite island," a kind of "portable homeland," that is constantly reclaimed and refigured by Cuban-American exiles. Since the rise of the web, this process increasingly unfolds on the Internet, augmenting both physical reality and memory in an elaborate staging of a lost and finally irretrievable home. This exilic discourse also responds to

official Cuban websites, sites that seek to present a utopian view of the nation for global consumption. Exploring the tension between these interlocked but very different modes of virtualizing Cuba, Venegas observes that the Internet, at the very least, extends the sphere in which differing views of democracy in Cuba are discussed. She simultaneously recognizes that such a sphere may also expand the space for xenophobic and extremist discourses.

In a close examination of the Cuban and exilic digital responses to the Elián González episode of 1999, Venegas illustrates the degree to which the boy functioned as a kind of node or hot link to polarized positions. In Miami, this augmented reality revitalized the most vehement of anti-Castro rhetoric and gave a renewed legitimacy to extremist points of view. While these two modes of representing Elián and Cuba seem polarized, she goes on to illustrate that official and exilic imaginings of Cuba are always intertwined and mutually constitutive. Further, "narratives about the past define . . . the contours of what is said about Cuba" and emphasize the liminality that characterizes life in exile. The syncretic in-betweenness of the exile dovetails with the emergent enfolding so characteristic of the digital, scaffolding the ambivalence wrought of displacement across the nodal slippages of the web.

Many of the personal websites of Cuban-Americans that Venegas surveys create digital "mirror cities" of the hometowns that the web pages' authors left behind. Such database cities stage elaborate and poignant reenactments of memory and desire, illustrating the limits of the many claims (dating back to Joshua Meyrowitz) that electronic forms untether us from the physical and undermine a sense of place. Rather, the digital becomes another realm in which places, memories, and identities are symbolically constructed. Both proponents and critics of online community have noted the Internet's ability to free us from physical spaces, propelling us into, on the one hand, the disembodied play of the virtual, or, on the other, bottomless dimensions of placelessness. Venegas's exploration of Cuba on the web highlights the complexity of the many ways in which space is augmented by and through the digital, creating powerful virtual geographies that serve as engines of memory and desire. She also illustrates the ease with which augmented realities can replicate "the worst excesses of xenophobia and nationalism" as well as occasionally map paths that "go beyond the confines of unitary notions of community."

If Venegas and Gordon offer largely reserved and cautionary tales regarding the digital's capacity to outstrip the excesses of global capital's desires, John Caldwell provides a case study of how even low tech can empower those most marginalized by the forces of neoliberalism and networked globalization. Caldwell's "Think Digitally/Acting Locally: Interactive Narrative, Neighborhood Soil, and La Cosecha Nuestra Community" examines a more voluntary and nomadic form of exile than that of the Cuban-American in Miami and maps a very different trajectory of technologically mediated Latino existence. Still, both Caldwell and Venegas understand that digitally augmented reality is often about being here and there at the same time, especially for those displaced by the border

flows and stoppages of the post–World War II era. Caldwell begins his essay, originally written for the 1999 conference but substantially revised, by revisiting the histories of media theory in the 1990s.

He draws out telling and insightful parallels between the vaporware and inventive accounting models of late-1990s dot-com venture capitalists and the disembodied speculations of Baudrillard, Virilio, and Levy. As he wittily observes, "both of these different worlds-of-practice gave producers and scholars alike institutional cause to traverse and violate industrial, economic, and cultural boundaries." Caldwell then moves to provide his own quick (and very useful) breakdown of three "successive periods of digi-space theorizing"—the "virtual-spatial, material-tactical, and pod-mobile." If Caldwell is quick to point out the easy bleed between corporate speak and new media theory in the 1990s, he is equally suspicious of the emancipatory fantasies now surrounding all things mobile. Rather than stake his digital future on the mobilized privatization that i-devices now repackage and brand, Caldwell tests out these happy, liberatory claims through several years of alternative-media fieldwork among migrant workers in Southern California. This experience suggests to him that the border theories born of critical geography may have as much to tell us about technologically mediated existence as do many theories of digital media.

The fieldwork, a project called La Cosecha Nuestra, was undertaken in northern San Diego County and was intended to address nutrition-related health problems specific to Latinos in California. Aware of the paternalistic realities of many early forms of good-intentioned "portapak activism," Caldwell sought to sidestep the "give-the-camcorders-to-the-indigenes conceit," so the project used participatory media to increase the sense of ownership of participants in a community garden project. All involved soon came to realize the complexity entailed in creating meaningful dialogue among previously segregated groups. The irony of persistent diet-related health problems among the very workers who pick California's bountiful produce is not lost on Caldwell, but he also realizes the likelihood of failure of video art deployed "in the service of the four food groups." The outcome of the project expanded Caldwell's conception of the digital, radically repurposing his understandings of tactical failure, interactivity, narrative databases, and multiple-user platforms. It also maps useful political registers of these familiar digital tropes when they are firmly situated in a racialized, and often racist, physical geography.

This leads Caldwell to privilege "two wrenches": the analog and the soil, tools that reject the glitz of shiny, new commercial products. There's brilliance in Caldwell's reclamation of dirt and of "old" tech *as tools*, a polemical move that pushes back against the thinly veiled technological fetishism of so much digital theory (and so many consumer purchases). But Caldwell is no Luddite; rather, he aims "to liberate the notion of interactive media away from an explicit linkage to specific and always immediately obsolete digital tools" in order to reground our theories of interactivity and distributed cognition in the fleshy, dirty, hopeful realms of cultural politics and contested landscapes. If the dreams of engineers and technologists are of a seamless mapping of the digital over the

physical, perfectly integrating the two, the experiences of La Cosecha Nuestra suggest the ideological stakes of such a dream of flawless union. From Hess and Zimmermann's transnational imaginaries to Caldwell's two wrenches, new strategies for the digi-political take shape. Augmented realities that account for the messy flows between the physical and virtual, the material and the immaterial, the global and the local, will form the ground for engaged, multilateral, and politicized theories of the digital.

POSTIDENTITY: THE FRAGMENT, COLLECTIVITY, AND VIRTUAL EMBODIMENT

Caldwell's essay also hints at new possibilities for agency in the digital era, briefly sketching a notion of agency that moves beyond identity politics toward a shifting, contingent network of willed affiliations. Such a framework rejects the rigid essentialisms of the Cuban-American exiles busy policing the border of virtual Havana but still values commonality as a ground for strategic struggle. Nonetheless, these processes, while routing around a fixed binary of sameness versus difference, are very much tied to fleshy bodies, bodies that die if they do not eat well. This last subsection of essays also engages themes of identity and of the body, although there is little consensus among them as to what the interface of body and technology might produce.

If La Cosecha Nuestra deployed video to enable a participatory, hybrid agency, Mark Hansen pursues the relationship of video as a specific artistic practice in a very different setting: the rarefied spaces of the museum and the gallery. If Zimmermann and Hess worry about the elitism of art practices that are not widely accessible, Hansen instead argues that, because video installation art "affords a heightened experience of the presencing of worldly sensation" in a dimension both presubjective and prerepresentational, it is ineffable by its very nature. In its attempt to understand the precise experiential modalities underwritten by such art, his "Video Installation Art as Uncanny Shock, or How Bruce Nauman's Corridors Expand Sensory Life" parallels many of the essays in Part I of this anthology. However, in specifying the particularities of this evanescent art form, Hansen is less concerned with form per se and more interested in how the experience facilitated by video installation art actually takes place in the experiencing body of the viewer.

In a journey through the theories of Walter Benjamin, Steven Shaviro, Brian Massumi, and Gilles Deleuze as well as the video art of Bruce Nauman, Hansen carefully parses the differences between the materiality of film and video. Importantly, because the "shock" of video does not occur at the perceptual level, "the video image injects perception directly into matter, entirely bypassing the mediation of memory." In fact, the video image, "unlike its cinematic counterpart, does not *of necessity* generate any shock whatsoever." Thus, in video, shock "has become a contingent and extrinsic correlate of the actualization of a nonhuman, virtual form of perception," a function of how human interaction with the work at hand is staged. For Hansen, this is a crucial shift because it

underwrites video art's capacity to deform our clichéd body images and embodied points of view. This adaptation is an affective one without cognitive or representational correlates, produced as video installation art opens "the lived body to the intensity of sensation."

As such, the body emerges as the key circuit of digital exchange, and Hansen's work challenges a neoformalist privileging of the medium in and of itself. It simultaneously pushes ideas of media "reception" into bold new arenas even as it seems little concerned with the many ways in which reception theory historically served to nuance the universal spectator of film theory. While Hansen suggests that the shocks and passion of video art exist at a level that precedes representation and ideology, he is perhaps more convincing on the former than on the latter. Even if the bodily and affective adaptations produced via an engagement with video installation are precognitive and before representation, these bodies are still marked by history, culture, race, and ideology before they enter the space of the installation. As such, the encounters that unfold there are never entirely free from the marks the body already bears, even if they remain at the level of sensation. While Hansen has reinserted the body into digital theory, this is a body curiously without a history or a past, a body in some ways as unmarked by its transit through the rest of the world as the body of 1970s film theory.

Even as he theorizes embodiment, he joins the neoformalists in a distancing of culture, perhaps missing an opportunity to tease apart the mutually constitutive feedback loops between culture and technology. For instance, if the filmic image displays complete images that the viewer perceives to move, while the video image is always partial and in the process of becoming, such a technological development (the switch from film to video) occurred precisely at the moment U.S. society was coming to terms with a forcefully articulated claim for civil rights by several subjugated groups. That racial representation and racism shift from overt to covert at the same time our technologies also mutate is, I'm suggesting, more than just coincidence. The fragmentary, always partial becoming of the electronic image serves to reinforce broader epistemological and cultural patterns, much as did the partitioning and black-boxing of code. Hansen is positing a collision of body and technology that exists beyond identity in the realm of the cannot-be-known, and he also imagines some new, even utopian, form of posthuman collectivity, a collectivity that escapes the dirtier, messier collisions of culture and technology where theorists like Caldwell and Gray dwell. It is an interesting conceit that might usefully point toward different conceptions of the political, as does much emerging theory in vitalism, posthumanism, and phenomenology. There is potential in the fragment, the fold, and in becoming even if we do not yet inhabit a world where technobodies float free from the burdens of history and of race in the streets or in corridors of video.

Holly Willis also turns to video art as a kind of transit zone between the flickering cinematic image and digital ephemerality. And, like Hansen, her interests lie in the making and unmaking of bodies as they encounter the video image. Nonetheless, the bodies she limns painfully bear the marks of situated history, even as elements of affective

becoming remain crucial aspects of the artistic practices she surveys. While there are compelling points of connection between the essays by Hansen and Willis, the latter enacts a crucial shift of focus, locating the force of its analysis in history and culture. Throughout the piece, Willis attentively and carefully situates the pieces and artists she considers within a broader sociopolitical frame that helps us align the affective registers (presubjective and prerepresentational as they may be) of emergent forms with the particularities of specific bodies, particularly grotesque ones. In turning to the precise histories and motivations of feminist artists in the 1960s and in the early digital era post-1990, Willis also insists that the body exists in a complex nexus of affect, precognition, becoming, and experience. She refuses to privilege one strand of this complex tangle and suggests that, for a politicized feminist praxis, such a parsing would be unimaginable.

In her brief survey of feminist video art, she challenges typologies that have consistently overlooked the contributions of these artists to a project of theorizing what Amelia Jones has called the "technophenomenological subject." The works that Willis investigates foreground, as does Hansen, that analyzing representation alone is an insufficient mode of inquiry when confronted with the video (or the digital) image. Thus, pieces by artists as diverse as Joan Jonas, Linda Dement, and Marina Zurkow engage with the "diverse incarnations of the body/machine conjunction" by positioning the body (of the viewer) in space in specific ways. Yet Willis also recognizes the necessity of grappling with the slippages between a kind of prerepresentational movement of bodies through space and a cognitive engagement with the digital image. The impact and import of video installation art reside at once in its ability to open the body up to "the intensity of sensation" (in Hansen's terms) and in its capacity to mobilize this relationship along other phenomenological, and sometimes conscious, registers.

To be clear, Willis does not lament an imagined past era of a "whole" or privileged body or take recourse in simplistic notions of identity. Her analysis moves far past an earlier expectation in identity politics that political presence might be guaranteed through "indexical facticity" and the representation or visibility of "real" bodies on our screens. Rather, she is interested in how bodies—both in representation and in the space of installation—can be pressured to reveal fractured, complex, and situated experiences and to formulate a "language for discerning insights gleaned through the body." She insists that feminist theory and feminist practice offer the best starting point from which to understand shifting networks of corporeality; after all, this has been the active terrain of engagement for feminists for decades.

In the essay that draws this subsection to a close, the contours of the machine-body assemblage and their ties to postidentity politics achieve a new level of clarity (and fun) in the "tech-illa" theoretical stylings of Rafael Lozano-Hemmer and Guillermo Gómez-Peña. Since the mid-1990s, both artists have actively battled against the fantasy of a universal, placeless, or color-blind "cyberspace" and against a formalist turn in new media theory. Separately and together, in performances, installations, web projects, and critical writings, they have investigated the possibilities and dangers of networked living

for the hybrid, global subject. A site like Gómez-Peña's Pocha Nostra (www.pochanostra. com/) mobilizes theory in an exploration of the forms of new media that route back into the messy terrains of dirty, fleshy worlds, refusing the disembodied, shiny dreams of so many early cyber-utopians, and calling to mind the two wrenches of John Caldwell. Here is a brave new world laced at once with possibility and with danger. The all-too-easy binary logic of sameness versus difference is jettisoned in favor of a jacked-up, low-rider-meets-cyber aesthetic that simultaneously underscores that we do not yet inhabit a world where technobodies float free from the burdens of history, of culture, and of race. But that does not mean that our machines (and our theories) might not take us elsewhere if we'd let them.

The flexible (post)identities that these two artists create throughout their various productions stage a series of shifting, mutable avatars, modeling a digitally enabled trickster who draws from networks of many flavors. This cyber-vato inhabits and reroutes multiple traditions and cultures, high and low. His body gets made and remade, plugged into global networks of machines and meanings. Here, borders—of the self, of the machine, of the nation—shift and morph, hinting at both danger and desire. Identity is neither authentic nor originary but grounded in history and materiality even as it parses the ephemeral and mutates into the network and the fold. "Tech-illa Sunrise" speaks back to any notion of a universal spectator/viewer, a hermetically sealed body, or a raceless network. Instead, these artists insist that, given the complex histories of empire and immigration in the United States and around the globe, we cannot understand or think code without also thinking race and culture. They vibrantly illustrate that the task at hand is not simply "to add" race into our analyses or art but, rather, to come to terms with the fact that race has infected the systems. It is part and parcel of the coded environment we unequally inhabit, creating the very grounds from which our networked economies and ecologies spring. We end with this speculative fiction not to marginalize it as the wacky coda at the end of a "scholarly" volume but to illustrate a productive blur between art and theory. Its vibrant technological imaginary points to new configurations of the self, of the global, and of the political. If Hansen imagines (but doesn't name) a postethnic world where bodies are opened up to sensation through a spatialized body–technology hybrid, this sample of ethno-techno-poetics suggests that race is always already embedded in our codes and systems.

FRAGMENTS OF POSSIBILITY

Obviously, some key areas of the "politics" of media are not fully developed in this introductory essay or in the essays that follow it. While I began this introduction mapping the move beyond questions of the digital divide, the issues of access always at the heart of that formulation remain a key terrain of struggle, particularly as the uptake of social media increasingly reveals various forms of (in Henry Jenkins's term) participation gaps. Equally important are a number of policy issues, including debates over fair use, net neutrality,

and immaterial labor. Legal and philosophical investigations around these issues represent crucial aspects of the politics of the digital today. Finally, while essays like Eric Gordon's map the wily ways of capitalism vis-à-vis our digital imaginaries, and Hess and Zimmermann remind us of the pitfalls of aesthetic elitism, very important issues of privacy, surveillance, and digital human rights are given less than their full due here. These and other issues mark essential terrain for ongoing work and struggle.

One consistent through-line of the essays in this section is a cautious optimism that ripples just below the surface of the very different styles collected here. It is a modulated optimism, to be sure, but there nonetheless, foregoing the kind of knee-jerk pessimism so familiar on the left while also sidestepping a greedy libertarian euphoria. Perhaps this is the engaged optimism partially born of the bleed between theory and practice, an optimism that often also characterizes those working in the digital humanities. In myriad ways, many of the authors in this volume theorize about new media while also creating it, from the soft cinema of Manovich to Kinder's Labyrinth Project to Patricia Zimmermann's and Steve Anderson's activist curating to Caldwell's vibrant community practices, modes of extending academic production that are sampled on the companion website to this book. That theory and practice are perhaps even more closely wedded now than in 1999 suggests a sustained faith in the possibilities laced through the transformative powers of the digital. In the folds, fragments, nodes, and networks of the electronic era, there resides a kind of bottom-up possibility that can speak back to power, an aspect of the very decentralized systems cybernetics has privileged. There are multiple points of entry into and pathways through these networks, points mined by immigrant communities, exilic diasporas, activist organizations, experimental artists, Tea Party participants, military optics, and corporate rhetoric alike. If the histories of race and racism and of Cartesian mind/body dualisms are embedded in the very partitioned logics of code and the tendrils of the network, there too lie the possibilities for their remaking and undoing, but only if we remain mindful that the forms of the digital are never neutral or innocent.

ABOUT THE AUTHOR

Tara McPherson is an associate professor of Critical Studies and Media Arts + Practice at the University of Southern California's School of Cinematic Arts. Her research engages the cultural dimensions of media, including the intersection of gender, race, affect, and place. She has a particular interest in digital media. Here, her research focuses on the digital humanities, early software histories, gender, and race, as well as the development of new tools and paradigms for digital publishing, learning, and authorship. She is author of *Reconstructing Dixie: Race, Gender, and Nostalgia in the Imagined South* (Duke University Press, 2003), coeditor of *Hop on Pop: The Politics and Pleasures of Popular Culture* (Duke University Press, 2003), and editor of *Digital Youth, Innovation, and the Unexpected* (MIT Press, 2008). She is the founding editor of *Vectors* (www.vectorsjournal.org) and a founding

editor of the MacArthur-supported *International Journal of Learning and Media* (launched by MIT Press in 2009). She is the lead principal investigator on a new authoring platform, Scalar, and for the Alliance for Networking Visual Culture (http://scalar.usc.edu).

NOTES

1. Here it might be useful to distinguish between "new media theory" and other terrains of scholarly inquiry into the digital. Work on computer-mediated communication, often based in fields like communication or sociology, was generally more engaged in questions of the social and the cultural than was work in "new media theory" in the late 1990s, with the latter often taking place in film studies or literature departments and often utilizing textual and formal analysis. This divide, of course, is not absolute and reflects different trajectories that have driven different disciplines; the two tend to come together in some ways in a field like cultural studies, particularly in its Birmingham incarnation, and also in television studies, itself greatly influenced by cultural studies. Nonetheless, it is a fair characterization to say that the Interactive Frictions conference skewed toward "new media theory," particularly in the plenary sessions.

2. See, especially, work by Anna Everett and Herman Gray.

3. See edited volumes by Kolko, Nakamura, and Rodman; Chow-White and Nakamura; and Nelson, Tu, and Hines; as well as Nakamura's *Cybertypes* and *Digitizing Race* and the work of Wendy Chun.

4. I develop this argument about the intertwining of race and UNIX in "Why Are the Digital Humanities So White? Or Thinking the Histories of Race and Computation."

TRANSNATIONAL/NATIONAL DIGITAL IMAGINARIES

John Hess and Patricia R. Zimmermann

All new technologies in our century—film, radio, television, 16-mm film, video—
have been greeted with equal measures of hope and despair, of optimism and
pessimism. The digital simply followed these same 20th-century historical patterns
of technological innovation and diffusion.

ERIK BARNOUW, PRIVATE CONVERSATION

If the new language of images were used differently, it would, through its use,
confer a new kind of power. Within it we could begin to define our experiences
more precisely in areas where words are inadequate. . . . Not only personal
experiences, but also the essential historical experience of our relation to the past:
that is to say the experience of seeking to give meaning to our lies, of trying to
understand the history of which we can become the active agents.

JOHN BERGER, 33

INTRODUCTION: AMNESIA AND ITS ALTERNATIVES

Currently, much intellectual and political debate over the concepts of the transnational
and the national has arisen as the "new world media order" reshapes the globe (Time
Warner/CNN, ABC/Capital Cities, Bertelsmann) and as nationalist passions dismember
its "Others" in brutal ways (Cambodia, Rwanda, Bosnia, China, Kosovo, Chiapas).[1] Arjun
Appadurai has advanced our understanding of this deadly relationship between globaliza-
tion and genocide: "In ethnocidal violence, what is sought is just that somatic stabilization
that globalization—in a variety of ways—inherently makes impossible" (Appadurai,
"Dead Certainty" 244).[2] Zillah Eisenstein puts it even more succinctly. In her book
Hatreds, she traces how globalization rethreads ethnic violence into a gendered and racial-
ized hatred that is fueled by cannibalizing its Others—a fantasmatic construction of
otherness.

In economic terms, the "transnational era" refers to the period of global capitalism in which capital knows no home: manufacturing increasingly disperses, labor becomes ever more mobile, amorphous networked communities disavow body-time corporate loyalties, corporations earn more money than 95% of all nations, mergers across industries create convergences that redefine media economics, and information has come to matter more than bodies or things.[3]

For some, the nation-state lies groaning on its deathbed. Other observers see it undergoing a rapid metamorphosis into a solely economic form, shedding its roles in nation-building, history-making, culture-preserving, and identity-forming. Bill Readings has recently written, for example, that the university as an institution "no longer has to safeguard and propagate national culture, because the nation-state is no longer the major site at which capital reproduces itself. Hence the idea of national culture no longer functions as an external referent toward which all of the efforts of research and teaching are directed" (13). Although the nation may survive as some mutant leftover from a James Cameron film, or as an organizer and provider of military and police services to the highest bidder, it more and more wants to delete history and memory from its hard drive as hangovers from the old world orders.[4] Yet history and memory, always incomplete and unfinished, circling around each other, refuse to be expunged. They appear in new forms with new faces and interfaces, as digital imaginaries that are sometimes alternatives to amnesia, a new kind of hard drive, a new interface with history and memory.

However, we want to suggest a slightly different formulation, one perhaps more imaginary than real, situated somewhere between the material realities of the political era enveloping us and our ability to radically reimagine different ways of thinking, acting, and producing visual works. Hoping to rewire some of these circuits of control, power, dismemberment, and amnesia, we want to sketch out an alternative vision of, and response to, the transnational. In our conceptualization of adversarial transnational documentary practices, there are no immigrants, no border patrols, no closed-off national fantasies, no monolithic linear narratives, no English-only, no high-tech/low-tech divides.[5] These plural and hybrid practices—dedicated to what some have called "electronic disturbance"—signal a recuperation by and for radical politics of three troubling terms: history, the transnational, and convergence (Critical Art Ensemble, *Electronic Disturbance*).

In all of the work discussed in this essay, artists and activists work to force back into history the immediacy, spontaneity, and collapse of time and space, so often identified with the digital zeitgeist. Particularly fascinating to us are works that arrest what Paul Virilio has called "dromology" (*Open Sky* 1997, 22–34) and what Mark Dery has termed "escape velocity" with a notion of history as that which embeds us in time and place.[6]

Operating in double movements between historical modalities and future imaginaries, the digital realm of documentary suggests provocative and contradictory areas for analysis. Peter Hughes has suggested that documentary, always in a dialectical contradiction between the demands of the nation-state and the social project of emancipatory

goals, shifts in the digital age. He contends that it is dangerous to link documentary to any specific technological delivery system, and calls instead for seeing documentary as a "project" which "stresses documentary as a process." He cautions that different modes will produce different truth claims and different epistemologies that may not be generalizable across forms. Hughes provocatively inquires how a form based on modernist truth claims will adapt to the digital, which is "more open, more reflexive, perhaps even more performative" (3, 5).

In digital work, history and the future can morph together, assembling a new imaginary construct that repairs this fracturing of space and time but does not fully restore it to its previous, analog configurations. This recombinant structure, part history, part future, is always provisional, always nomadic, constantly changing to meet the political exigencies of the present, which then becomes a nodal point, a confluence of the past and the future. Raymond Bellour has called for a notion of "the double helix," a configuration of photographic analogy and the reproduction of movement. The double helix suggests that cinema as a system of sequential images has opened into a new formation where images, sound, movement, and interactivity oscillate within each other in endless mixtures, the "discourse-image" (173–199). The digital realm, then, does not supercede or displace cinema; rather, it installs cinematic practice into a mobile interactivity among its constituent elements of sound, image, movement, space, and representation.

However, we do not wish to argue that digital space is some abstraction, some mathematical reorganization of cinematic elements that displaces locations within racialized, sexualized, and engendered subjectivities, a tactic prevalent in much digital theory which, de facto, displaces material power relations as it exalts whiteness as a hidden formation. As Guillermo Gómez-Peña says, "we want to 'brownify' virtual space; to 'spanglishize the net,' to 'infect' the lingua franca; to exchange a different sort of information—mythical, poetical, political, performative, imagistic; and on top of that to find grassroots applications to new technologies and hopefully to do all this with humor and intelligence" (179).

In this article, we want to sketch out several interrelated realms of contradiction and political struggle within the rhetoric and practices of digitality. We are looking for ways to think about the operations and the discourses of the transnational and its far reaching collateral effects within these new media forms to begin to think through how they might galvanize changes in how we theorize documentary practice and where we locate it. We believe that artists and activists have used digital technologies to produce exciting, important, and effective adversarial transnational documentary work which questions the ontological assumptions of the forms, practice, and argumentative modes of older, more analog, forms of documentary.[7]

In this piece, we will tease out the interplay of the transnational and the national primarily in the examples we use from digital work. Ziauddin Sardar and Jerome R. Ravetz, in an anthology called *Cyberfutures*, demonstrate the impossibility of retracting from contradictions when analyzing the digital. Indeed, film studies' own Vivian

Sobchack gracefully contends in that volume that we must begin to think about electronic media within the contradiction between the utopian democratic desire and the reactionary politics that infuse virtually all digital theory and practice ("Democratic Franchise" 77–89).

The "real," it seems, no longer awaits representation in quite the way it did even a decade ago, and this multiplication of the real, whether figured in the Lacanian, Derridean, Griersonian, or *Wired*-magazine sensibilities, can potentially shift how we even frame questions about transnational/national documentary practices. Our old ways of thinking about documentary representation have become clearly antiquated in the face of the complexities of the digital revolution.

For example, analyzing digitized imagery in both photography and electronic art, Margot Lovejoy has asked how the capability to invade images and invisibly alter them has rendered truth, authority, authenticity, and the image itself unstable (154–178). We don't see our queries here as the last word or even perhaps the first word, but as indicating areas lacking resolution and requiring our collective discussion as the digital creeps into fields like mint in a garden, invasive but sweet smelling.

We want to investigate how the contours of the transnational and the national may change in cyberspace in ways that may or may not differ from their relations in more analog forms.[8] In contradistinction to much digital theory, we see the analog and the digital in a continual dialectic relationship (each containing elements of the other), a relationship of process and processing. We do not see the digital as a separate realm distinct from the material, lived world, analog forms, the real, or psychic trauma. Nor do we define the digital as only one technology—computers. In using the term "digital," we mean to suggest a multiplicity of technologies and practices that pluralize and problematize our notions of delimiting media on the basis of a delivery system or format. If anything, the digital realm is marked by its multiple and transportable delivery systems, whereby data and images can be moved, remade, stored, and retrieved in different ways.

Rather, we see the digital as itself a cover term for a plethora of technologies for harvesting and planting images: satellite, CD-ROM, websites, digital video, digital effects, word processing, computer-generated imagery (CGI), the Internet. We concur with Timothy Murray, who has described this relationship between the analog and the digital as a "fold," itself constantly enfolding as a major trope in radical digital work. Murray views this fold as a passage between inner and outer, between the secular and spiritual, between meaning and identification, and between the material and the virtual. He explains that the digital enfolds us in thought, an architecture of light manipulated by touch on the mouse that provokes critique through an unfolding in contradistinction to the light associated with nationalist monumentality that projects national unity ("Digital Lights").

We use the word "digital" in this discussion to suggest the contradictory materiality of cyberforms, even as they attempt to disavow their own substance, rather than virtuality, which suggests a more phenomenological position outside of our discussion here. The digital, then, functions as a subset of the virtual, a somewhat different tense in the

same language. Margaret Morse, in her provocative and important book *Virtualities*, has defined the virtual, for example, as embodying "fiction as presence" (18). Extending her work, our ongoing project is to decipher how digital works inscribe histories and memories simultaneously, within new forms of address, interfaces, and subjectivities. We are interested in works that present digitality, which we will tentatively define as a process that refigures the nonfiction mode as past/future traces.

THE POSTHUMAN VERSUS THE BODY

Much digital culture theory suggests that computer communication moves us beyond postmodernism and postcolonialism into the posthuman, that nonplace where bodies don't matter anymore and where all matter becomes digitized and disembodied and ethereal. Within these discussions, found in art-world discussions of virtual reality and interactive web art, on listserves which claim empowerment by discarding bodies, and in medical writing which figures computers not as machines but as prostheses that enable disabled bodies to go beyond themselves, there lurks a kind of latent catholic religiosity, where the sins of the flesh will be transfigured into heavenly spirits, etherealized by binary codes.

Slavoj Žižek finds this mythology of the body-plus-machine symptomatic of the new world order in which machines so dominate our economic world that we must psychically imagine a world where we are them. We repress the economic in order to live the fantastic desires of a present with no referent, no obstacles, no lack, a hallucination which is symptomatically expressed as a simulation (*Plague of Fantasies* 127–167).

The ecstasy of the bodiless cyber-psyche infused a Spring 1998 EYEBEAM listserve discussion. It propelled cultural theorist and artist Coco Fusco to counter that any political individual must seriously reject the posthuman spirituality without materiality and start instead with bodies that do matter: the impoverished women assembling computer parts in maquiladoras in Mexico and factories in Silicon Valley and Korea that transnational capital exploits to create the machinery for this so-called autonomous zone for cyber intellectuals. Ample and compelling evidence shows that digitality has aided international public health initiatives around agriculture, clean water, and food; and a myriad of stories, from Stephen Hawking to our friend, curator Leslie Burgevin, who died recently from throat cancer, show that computers can open up possibilities for disempowered and disabled people to communicate. Ample and irrefutable evidence also exists, as documented by the National Labor Committee in New York City and Labor News Now in Korea, that NAFTA and GATT trade agreements have created increasingly dire working conditions for men and women, often boys and girls, of the South.[9]

Against this cyber-spirituality of greater living and art-making through interactivity, Fusco pondered why so much digital culture theory from the art community so represses any discussion of the bodies of these workers in the South (and workers across the globe, for that matter). Perhaps digital thinking should start with bodies so that our ecstasy can

be tempered with the contradictions of the new labor relations etched within the digital on a global scale.[10] As historian David Noble has so trenchantly pointed out, we academics also have a new set of labor issues as our courses go online and we are asked to participate in various distance-learning schemes and work speedups—teaching more students with fewer teachers and producing mandatory web pages by spending our summers learning how to write JAVA script ("Digital Diploma Mills" 38–52).[11]

AESTHETICS VERSUS POLITICAL ECONOMY

The scholarly as well as popular discussions about digitality illustrate an old, but still relevant, contradiction: aesthetic innovation and dazzlement on one side, and on the other the political economy of digitality working as the engine of transnational concentration, making electronic space one of the most important sites for global capital and new power structures. We have no doubt that digitality provides a wonderful new infrastructure for the arts, and that digital tools, when accessible, offer a way to counter the limitations recently imposed on access to image production on a global scale in nearly every country by arts defunding, a faltering independent media infrastructure, deregulation, and privatization.

By altering the language of media aesthetics in significant ways, digitality asks us to think in different ways about images, their structures in spatial imaginaries, and their circulation. However, most discussions ignore the function of the digital within the transnational economy as they assess the operation of the digital within national art contexts. As political economist Saskia Sassen has shown, growing digitalization and globalization have contributed to an unprecedented massive concentration of resources, making electronic space one of the most important sites for global capital and new power structures (179–185). Both the growing service industry and the globalization of the economy depend on, and are shaped by, new information technologies.

We would want to consider reconnecting aesthetic production to political economy analysis in assessing the digital so that these repressions of discourse and induced amnesias can be treated. And we urge political economists, so prone to pessimism, to consider digital art forms.

There are many examples of this relation between the aesthetic and the economic yielding projects that suggest the emergence of a new millennium in the sites, practices, and interfaces of political media. We want to suggest two excellent examples that exemplify how political documentary forms have changed into infinitely expandable spheres of discourses. The Corporate Watch website enables the user to connect to more than three hundred links of exposés about corporate concentration around the world. In tracking the transnationals through hypertextual linkages that multiply concentrically, this site creates an online digital archive of transnational activity that expands into every sector imaginable. The McSpotlight website, created in response to the McDonald's libel trial in England, has a depth and complexity that encourages one to spend days there just

learning about the nefarious practices of the transnational fast-food industries and their international network of agricultural reordering. Even that cybercapitalist cheerleader *Wired* named it one of the most popular of the alternative websites, with more than twenty thousand hits per day.

METAPHORS MATTER: INFORMATION HIGHWAY OR DIGITAL LIBRARY

In a provocative anthology entitled *Internet Dreams: Archetypes, Myths, and Metaphors,* Mark Stefik illustrates how the metaphors we deploy to think through the digital realms matter, forming epistemological structures for thinking and practice. The metaphor of the "information superhighway," used by the Clinton administration, suggests a linear direction and commercialization inherent in laying down a digital infrastructure. Highways imply traffic, control, planning, physicality, and mapping, according to Stefik, which counters the actual formation of the Internet, which is/was deliberately much more chaotic and disorganized (xix). Invented by the Department of Defense as a way to deploy decentralization and rhizome structures as a defense against complete national annihilation, the Internet was designed to embody diffuse deterrence years before Deleuze and Guattari invented a theory of nomadic activity.

The notion of the library often stands as the counterpoint to the more privatized model, suggesting public access to knowledge. Projects to put university libraries completely online, or the French project to digitize all of French literature, figure digitalization as opening up the library, expanding it and creating a new public sphere of information that will invigorate and revive the embattled, hybrid nation.[12]

Other metaphors abound, ranging from rhizomes, to digital worlds, to the environmental ecological metaphors, to the "Frontier" idea of the Electronic Frontier Foundation, to the medical prostheses as psychic formation, to the psychoanalytic dysfunctions as normality (Stone; Turkle), to death-of-the-author piracy, to the mantra of immersion and interactivity as a new religion to escape the new world order's loneliness.[13]

We think that all these metaphors are partially right and illuminate some intriguing latent aspects of digitality, but none of them alone provides sufficient explanation or insight into the transnational/national documentary practices embedded within digitality. These heuristic metaphors seem to function as phenomenological descriptions of immersion into cyber-realms rather than theorizations of significance. Our argument urges a more multiform and hybrid tactic: we think that we need all these metaphors and, more, that we need to interrogate and deconstruct each metaphor. We find the digital to be more like a cottage garden, with weeds as well as flowers, mass plantings and specimens, seeds that grow and roots that die, unexpected color combinations, an ever changing artistic design. But we remain tentative about even this far-too-organic metaphor for what is a material practice and interface, a memory machine that produces new interfaces with the future.

Metaphors indeed matter, but we think that we need more meta-thinking on digitality and how it functions in the world we live in. We would like to consider returning to, or underscoring, the "meta" in metaphor. For example, Shu Lea Chang's amazing interactive website "Brandon," funded by Canadians, with finishing money from the Netherlands, now up on the Guggenheim Museum's server, engages a strategy of mixing and layering digital metaphors, the materiality of bodies and spaces, and the immateriality of sexualized psychic spaces. It ostensibly looks at the case of the young woman who changed her name from Teena Brandon to Brandon Teena, who dressed as a man in Nebraska, had girlfriends, and was murdered. The site catapults one into multiple layers of subjectivities, metaphors, and locations, from queer sexuality, to children and pornography, to Internet censorship, to the international traffic in sexual images.

However, one of its most salient features remains the fact that its sophisticated and ambitious technical infrastructure crashes most computers, even the one in the public space of Guggenheim Soho in New York. We like the idea of art whose conception and execution produces excess beyond its technological delivery system. System crashes in digital art shift our interface and positioning within the work in a way that differs significantly from cinema; they interrupt the seamless flow of the cinematic narrative apparatus and its suturing effects by physicalizing disruption both temporally and spatially.

With crashing as one of the central artistic temporal modalities of digital art and mundane word processing, which metaphor can best help us understand the ontology and epistemology of this not-working-condition that in fact conditions all digital art and communication transnationally, and where different national locations condition different crashings?

PRIVILEGE VERSUS ACCESS

Two interesting, publicly funded CD-ROM projects examine the contradictions between privilege and access as well as between North and South. Keith Piper's *Relocating the Remains,* an impressive and intricately designed CD-ROM that created connections between the colonized black body and the black body as spectacle in sport, was produced with public funds in England and suggests new forms of racialized subjectivity possible within the digital and its layering operations within a refigured spatiality.

ZKM in Germany similarly produced the ARTintact series, a CD-ROM magazine of international digital artists, featuring some of the most astounding imagery and multimedia design that itself rethinks the possibilities of representation, including works by Perry Hoberman, Jean Luc Boissier, Miroslav Rogala, and Ken Feingold.[14]

However, the problems of obtaining this work beyond the privatized art markets for the digerati of the North not only suggests the incipient elitism of digital forms, but replays debates about distribution and exhibition of 16-mm and video from thirty years ago, debates about access, community, audience, and distribution.[15] It should also be noted that the presence of this kind of work in Northern Europe and North America

reflects the pattern of digital diffusion noted by Cees Hamelink: most digitality and most of the world's information flows across the globe among the richer countries of the North.

No less than Umberto Eco has questioned the problem of the relative privatization of digital art—its masturbatory, peep-show construction. Arthur and Marilouise Kroker have noted a similar contradiction in the digital, arguing that computers bunker us in and dumb us down (247–257). As Minister of Culture in Italy, Eco has fiercely advocated a state-supported plan to create digital osterias, where eating, drinking, flirting, and web pages would intermingle to imagine a new kind of hybrid public space—part body, part digital, part desire. He envisions large screens where digital art and websites could be running while we sip chianti and gossip in body-time. For Eco, the digital should take its proper place in comfortable public spaces, where imbibing and indulging means something, and where the digital constitutes just one more layer of the psychic surround rather than a privileged space (Marshall, 145–148ff.).

We want to suggest putting access first, or, at least, thinking about the relationship between privilege and access as an indispensable aspect of how we think through what Zillah Eisenstein has labeled this "cyberfantasy," which promises so much, yet most frequently delivers old wine and old world orders of inequality in new bottles for the new world orders, repackaging enormous disparities and creating new class divides (70–100).

Clearly, a digital apartheid has emerged.[16] Only twenty-five percent of all households have a modem. As one might guess, this group is predominantly white, male, upper middle class, and urban. Ninety percent of the world's computers are in fifteen countries of the industrialized North; Finland is the most wired of all. Five countries have fifty percent of the world's phone lines, representing fifteen percent of the world's population. The United States has as many phone lines as all of Asia. In Africa, some countries have only one phone line per one thousand people (39–60). As documented by UNESCO, there are more phone lines in Manhattan than in all of Africa, and Internet growth in the United States is thirty-five hundred times that of Asia, Africa, and Latin America combined (*Our Creative Diversity* 104).

This digital apartheid accelerates, intensifies, and increases gender and racial inequalities, as we might imagine. Women around the world represent the poorest of the information poor and sixty percent of all illiterates across the globe. In the United States, white children are two and a half times as likely to have computers as African-American and Hispanic children. UNESCO estimates that the digital revolution combined with the "globalization of cultural processes" has largely bypassed over a billion poor people (*Our Creative Diversity* 30). The international NGO (nongovernmental organization) movement together with the MacBride Commission produced documents to connect with the fiftieth anniversary of the Declaration of Human Rights in 1998 under the title "The Right to Communicate," called for universal access, information accessibility, and the urgency of situating new communication technologies within more public sectors as a transnational policy agenda for activism.[17]

The case of James Cameron's *Titanic,* once the highest-grossing film of all time, with its invisible digital effects that replicate the verisimilitude of history and attempt to visualize trauma (Parisi, "Lunch" 148–158, Riding sec. 2:1), swing us back to film theorist André Bazin. The ontology of the digital image in its transnational capitalist moment bases itself on a digital realism that conceals, as best as possible, the seams of production (Bazin, *What is Cinema?* vol. 1). In some sectors of the new digital Hollywood, *Titanic* is not so much a movie as a laboratory for the future of computer-imaging systems that will facilitate virtually total control over the manufacture of commercial imagery as it shifts from production to postproduction.[18] Cinema, then, is migrating from a referential index located in the real to a virtual index of transnational capital's phantasm of total control over production of the fantastic, an intensification of the sign at the expense of diminishing the signified and, even, signification (Cove, 73–78).

In an ironic double movement, the digital, the site of endless reiteration of cultural forms and visual change, a carnivore of an endlessly recycled image culture, becomes the apparatus which creates a phantom realism at the very moment the real itself poses as a phantasmic vision. The money and time required to seal the seams are hailed as "the new Hollywood," a post-Fordist, outsourced global assembly line for production.[19]

Where not completely possible in Big Hollywood films, the digital often becomes the focus itself—the film foregrounds technology, or the technological plays an important role in it, such as how the whole search for the *Titanic* renders the technology in that film natural, or the emphasis on tracking devices in *Men in Black* (1997, dir. Barry Sonnenfeld), or the use of computers in *Contact* (1997, dir. Robert Zemeckis).

However, as the technology and the digital effects become increasingly realistic and unnoticed, their invisibility and evaporation become an index of their realism. As *Variety* has pointed out week after week, the studios are now undergoing their greatest labor challenge since the coming of sound, with the emphasis in moviemaking shifting increasing from production to postproduction digital effects which create enormous barriers to entry and ensure global domination. Computer-generated imagery is more complicated than it seems, and more expensive, with individual shots costing between $20,000 and $100,000 each, the cost of a low-budget documentary (Karon, "Hollywood Dread"). For example, in *Titanic,* some shots entailed nearly five hundred layers of images. One forty-second shot on the deck of the boat cost more than a million dollars.

On the other hand, there are digital imaginaries in new digital art forms that are transnational and national simultaneously, each as separate layers of transnational/national flows. In video, the work of Alex Rivera, who uses digital animation to rethink American borders between the United States and Mexico in pieces like *Why Cybraceros?,* and Daniel Reeves, who figures trauma as a series of visible layers of psychic and political combustion in his masterpiece, *Obsessive Becoming,* migrate between the transnational and national. On the web, The Zapatistas website, the efforts of the Serbian

opposition in the radio B92 website, and the Third World Network electronic disturbance of the MAI trade agreement talks suggest not only organizing across borders, but new formations that torque the symbolic orders of the TNCs (Dominguez; Drohan). On CD-ROM, Native American Melanie Printup Hope's *Prayer for Thanksgiving* layers Tuscarora beading, multiple languages, and digital art as a collision of the indigenous imaginary, while Adrienne Jenik's *Mauve Desert*, a lesbian road movie sedimented into three languages and multiple driving routes, suggests that interactivity should be figured as a twist between mapping and being lost.

In these various works, digitality invokes Vertov, summoning the possibilities of technology and collage to make us see differently, to alter social and visual relations. As Vertov said, in an eerie anticipation of radical digital culture practice, "My path leads to the creation of a fresh perception of the world. I decipher in a new way a world unknown to you" (Michelson, 5).

The seams show in this exciting new image-making system, montage giving way to the idea of layered image compositing. We use the term "image composting"—rather than compositing—in contradistinction to the commercial Hollywood and photographic language of image compositing to suggest that the harvesting, decay, and transformation of images into new forms seems a more dialectical and political process. As Bill Nichols has argued, the digital creates a new image ecology that changes the relationships between image production and distribution, between the social and the individual: "The cybernetic metaphor invites the testing of the purpose and logic of any given system against the goals of the larger ecosystem where the unit of survival is the adaptive organism-in-relations-to-its-environment, not the monadic individual or any other part construing itself as autonomous or 'whole'" ("Work of Culture" 142–143).

A distribution of national, transnational, psychic, social, and political layerings within one image and one work create new fluid forms of collision that extend Vertov into the digital age. New aesthetic imaginaries emerge as a result, reminiscent of the political photomontage of the 1920s and '30s but with a transparency of the layering process only possible in digital or installation work. This transparent, or what we might call "see-through layering," creates different spaces and politics, and completely negates linear narrative and deductive argumentation, structures identified with more analog genres like fiction and documentary film and video.

In these digital documentary works, gaming apparatuses, route finding, and open textualities unsettle and unlearn linear and realist forms. This does not just negate the linear in favor of the nonlinear, however.[20] Digital artist Philip Mallory Jones has argued that digital art—web pages, CD-ROMs—be considered not as nonlinear but as spherical, new shapes that suggest a 3-D form of emergent, racialized, gendered, and located subjectivity. CD-ROM and web pages are thus designed within this spherical modality, with multiple ways to navigate through time, space, and place, creating new spaces and new angles, both around and through, that disrupt national and transnational space and time. This spherical modality is both narrative and nonnarrative, linear and nonlinear. Rather

than an operation in negation of the linear, with narrative sequencing always posing as the structured absence, this more spherical system suggests that the digital is itself a recombinant hybrid of different structures of knowledge and experience. While some writers contend that web pages have an infinite expandability and invoke chaos theory, we suggest here that political sites are mapped not simply for linearity, but for a series of vectors of argumentation, all of which lead to new spheres, both metaphorically and concretely, a mise-en-abyme transposed into a digital interface rather than an image.

THE PERFORMATIVE VERSUS THE ARCHIVAL

As we consider the transnational and national imaginaries for documentary within digitality, the question of distribution and exhibition simply won't go away. As one curator has said, the digital is the curatorial challenge of our era (Roy). We need to think through public performative web surfing and CD-ROM exhibition to counter the loneliness of the long-distance emailer, which allows transnational capital to completely reform labor relations through fragmentation and isolation, and utter identification with institutional prerogatives.

But even this challenge falls into a contradiction or debate between the digital performers and the digital archivists. The digital performers argue that CD-ROMs, websites, and immersive virtual reality (VR) should not be exhibited along the same lines as analog film or video, which assume passivity of delivery and reception, figuring spectatorship along older lines of suturing, restricted and unrestricted narrative control, and psychic identification. Although interactivity often seems more fantasy than reality in CD-ROMs and websites and needs much more consideration as a process of signification and operation, many curators have hearkened back to performance art modes from the 1960s for models of how to present digital work to larger, less private audiences in different kinds of public art spaces (Duguet).

Reginald Woolery's CD-ROM titled *www/mmm* analyzes multiple, conflicting subjectivities and their interacting collision of layers made possible by the convergence of the different community formations and technologies. *www/mmm* provokes an imaginary space where digitality itself becomes problematized by racialization processes of the Million Man March, black male subjectivity, and the nexus of digital desires for identity and community. In this stunning poetic piece, the repressed psychic formation of black male subjectivity and collectivity unfolds into content. The CD-ROM uses the Million Man March of 1995 and the web as two nodes whose relationship may exist only in cyberspace, but when connected up become no less "real," a new territory invented in the digital that suggests that the analog forms of the racialized body are always embedded within the digital, just not always visualized.

However, despite the cybertitle of the piece, the CD-ROM is structured to be performed like spoken-word poetry, with Woolery pointing and clicking, determining length and mapping, asking the audience where to go next, and how long. The CD-ROM artist,

then, is not presenting work, but is a shaman between the audience and the piece on the screen, creating a space for public ritual and contemplation of the new connections of the digital. In Woolery's figuration of digital performativity, the artist and the audience are not privileged but are relocated as hyperlinks out of the text and into the text. In Woolery, textuality itself is performative and public.[21]

Similarly, Art Jones's CD-ROMs deploy a hip hop aesthetic and ask the driver/user to figure out how to sample the work without providing any directions; the immersion is complete disorientation, a aesthetic of being lost-in-whiteness until one can read-in-blackness.

Yet, on the other hand, digital exhibition invokes the archive, the place where trauma is registered. In *Archive Fever,* Derrida writes that "there would indeed be no archive desire without the radical finitude, without the possibility of a forgetfulness which does not limit itself to repression" (19). This archival dimension of the digital suggests it not as a public performance space, but as a performing of the public memory which can grow infinitely, avoiding repetition. Muntadas's website and installation *The File Room* is a site where anyone can register incidences of international censorship in any language within an architecture that dispenses with archival gatekeepers in order to register trauma to public speech. His site *On Translation* creates a transnational archive to make invisible translation newly visible.[22]

Finally, *The Gate of Heavenly Peace,* Carma Hinton's epic masterpiece on the Tiananmen Square protest in 1989, found that even a three-and-a-half-hour 35-mm film was not up to explaining this complex transnational/national event. The website project, one of the first of its kind, created a digital archive of all the amateur footage from all over the world of Tiananmen Square protests, including the full shots from which the edited film was made, as well as all documents that went into the making of the film, and all essays and explanations that created social and political context for the images. It even includes a virtual tour of Tiananmen Square where the viewer can experience architecture as historical, physical, and social memory. We imagine a politically useful fold between the performative and the archival in projects such as these.

CONCLUSION: COMPOSTING CONVERGENCE

To conclude, or rather not to conclude, we have raised these seven areas of contradictions to emphasize the importance of the digital in the imaginary of adversarial transnational documentary practices. We think that attempts to repress these contradictions lead unequivocally to bad art-making and bad politics. We want to suggest here that the opening up of these contradictions does not suggest that one is more significant than the other, but that they are themselves layered into digitality.

We urge a thinking that recuperates the term "convergence" for political thought and work. We need to understand that works themselves now migrate across formats, styles, technologies, and audiences and are no longer fixed in one technology or in one territory.

We also want to suggest that digital image composting represents a significant historical shift in visuality that requires careful attention and bold thinking. We have entered a new ecology of image-making that is irrevocably transnational, a international process of harvesting images, piling them up on each other, and composting them for new fertile soils out of which the visions of the future will grow.

Finally, we want to advocate an unsettling of old ways of thinking that tend to anchor and delimit digitality within tropes comfortably imported from analog film studies. At best, the analog film theories that have settled around us like old pajamas can help us to see what is new and what isn't in these transnational/national digital imaginaries. But we should not get trapped in their complacency and familiarity, translating the new into the old forms. Rather, we need to understand the dialectical contradictions in the new digital realms as both old and new, the past and the future. But we also want to imagine, like Derrida, how history and the archive can open out to the future, a future where contradiction is not effaced and repressed, but celebrated as the only fold in which to live.

ABOUT THE AUTHORS

John Hess is a coeditor of *Jump Cut*. He has taught film studies as a contingent faculty member at Sonoma State University, San Francisco State University (SFSU; fourteen years), the University of Maryland, and American University. Along the way, he taught as an associate professor on the tenure track at Ithaca College. While at SFSU, he participated in the successful effort to unionize the faculty in the California State University system. Thereafter, he worked to organize the contingent faculty (full- and part-time temporary) and served in several elected and appointed leadership positions in the California Faculty Association (CFA). After returning to California from the East Coast in the late 90s, he worked as a staff member for the CFA for seven years and was responsible for organizing the contingent faculty. He is now retired but remains active in the Coalition of Contingent Academic Labor (COCAL) and other political projects. In his role as film scholar and teacher, he specializes in the fiction and documentary cinemas from Latin American and other Third World cinemas.

Patricia R. Zimmermann is a professor in the Department of Cinema, Photography and Media Arts at Ithaca College, Ithaca, New York. She is also codirector (with Tom Shevory) of the Finger Lakes Environmental Film Festival (www.ithaca.edu/fleff). She has also held endowed chair appointments as the Shaw Foundation Professor of New Media in the School of Communication and Information at Nanyang Technological University in Singapore and the Ida Beam Professor of Cinema and Comparative Literature at the University of Iowa. She is the author of *Reel Families: A Social History of Amateur Film* (Indiana, 1995) and *States of Emergency: Documentaries, Wars, Democracies* (Minnesota, 2000). She coedited *Mining the Home Movie: Excavations in Histories and Memories* (California, 2008) and, with Erik Barnouw, *The Flaherty: Four Decades in the Cause of Independent Cinema* (Wide Angle, 1996). Her current book project on digital arts, *Reverse*

Engineering: Documentary Migrations across Platforms, analyzes the relationship between historiography, political engagements, and digital art practices. She has published many scholarly research articles and essays on film history and historiography, documentary and experimental film/video/digital arts, amateur film, political economy of media, and digital culture theory in a wide swathe of international journals, including *Screen, Genders, Journal of Film and Video, Afterimage, Framework, Asian Communications Quarterly, Cinema Journal, Wide Angle, Cultural Studies, DOX, Film History, Socialist Review, Journal of Communications Inquiry,* and *The Moving Image.* Her blog, *Open Spaces,* explores openings, closings, and thresholds in international public media, especially documentary.

WEBSITES

www.ctheory.net/

An online journal of digital theory from international contributors, edited by Arthur and Marilouise Kroker.

http://grzinic-smid.si/?cat=367

Web page on media, feminism, desire, and the war in Bosnia by Marina Grzinic and Aina Smid.

www.amnesty.org

Amnesty International web page with updates on ethnic violence and human rights abuse around the globe.

www.mcspotlight.org

This site not only documents the famous McLibel trial in England against McDonald's, but provides a virtual online archive of the transnational agriculture business.

www.globallabourrights.org/

Website of the Institute for Global Labour and Human Rights, formerly known as the *National Labor Committee,* with action alerts to interventions against the maquiladora system for textile manufacturing.

http://corpwatch.org

The infamous CorpWatch site, with links to investigations of the operations of a massive number of transnational corporations. A very deep site with many links.

http://enlacezapatista.ezln.org.mx/

One of the many Zapatista websites.

www.guggenheim.org/new-york/collections/collection-online/artwork/15337

The Guggenheim home of Shu Lea Chang's collaborative site on the Brandon Teena case.

www.adaweb.com/influx/muntadas/

One of Muntadas's sites, *On Translation,* which investigates the migration of translation as a political act.

www.thefileroom.org/

Muntadas's *The File Room* site, documenting international cases of censorship against freedom of expression.

www.echonyc.com/~confess/Guillermo

Gómez-Peña and Roberto Sifuentes's *Temple of Confessions* site, employing Spanglish, now available only through the Wayback Machine (https://archive.org/web/).

http://obn.org/

Transnational feminist digital media site, featuring the cyberfeminist manifesto and other art projects.

http://covesoft.com/underwired/

A feminist spoof of *Wired* magazine, now available only through the Wayback Machine (https://archive.org/web/).

www.pocho.com

Alex Rivera and the Animaquiladora Animation Sweatshop website, featuring Chicano digital art and "netbacks."

www.tsquare.tv/

Website for the documentary film *The Gate of Heavenly Peace* (1996) by Carma Hinton and Richard Gordon.

www.aicap.org/

American Indian Computer Arts Project (AICAP) produced by Turtle Heart, to allow the exchange of ideas and works related to Native American art and new media.

NOTES

1. We thank Ulises Mejias for his primary research and curatorial work on this project. We also acknowledge conversations and emails with artists Branda Miller, Anne Marie Duguet, Reginal Woolery, and Philip Mallory Jones that significantly shifted our thinking about digital documentary forms.

2. Also see J. Bhabha; Feldman.

3. For trenchant discussions of globalization, see Sassen; Barnet and Cavanagh; Barnouw et al., *Conglomerates and the Media;* and Wilson and Dissanayake. For discussions of nationalism, see Udovicki and Ridgeway; McClintock, Mufti, and Shohat; and Jameson and Miyoshi.

4. For an excellent overview of the cultural manifestations of globalization, both in terms of transnational corporate reorganization and localized interventions, see Jameson and Miyoshi.

5. For a fuller explication of our term "transnational documentaries," see Hess and Zimmermann, "Transnational Documentaries: A Manifesto"; as well as Hess and Zimmermann,

"Towards a Definition of Transnational Documentaries." For a discussion of how an adversarial transnationalization across borders is located in the debates about civil society, see Korten.

6. For a fuller definition of dromology in relation to the digital reorganization of time and space, see Virilio, *Open Sky* 22–34. For a discussion of how cyberculture creates art and experiences that emphasize speed and changes in psychic topographies, see Dery.

7. For an example of some of the exciting new developments in this area of transnational digital alliances, see the catalog for the First Cyberfeminist International, September 20–28, 1997, Hybrid Workspace, Kassel, Germany.

8. Bender and Druckrey edited an important collection of essays which attempted to heuristically map out the new contours of the digital on the arts, the body, the nation, disease, war, and performance that challenges old conceptions of borders.

9. The Spring 1998 Eyebeam discussion list is archived at www.eyebeam.org.

10. For a more pessimistic view of the impact of digitalization on daily life, the body, work relations, art, and the political economy of media activism in the digital era, see Brook and Boal.

11. For a trenchant discussion of the changes in higher education as a result of new technologies, see Edmundson. For a more extended historical discussion analyzing how technology has always been embedded within labor struggles for autonomy, see Noble, *Progress without People.*

12. A cautionary tale of how digitalization engenders the privatization of information and, thus, endangers the notion of public libraries can be found in H. Schiller, 27–58.

13. For a representative sampling of how these various metaphors are deployed in the literature of digital culture, see Stone; Ludlow, *High Noon;* Dertouszos; Farina; Critical Art Ensemble, *Electronic Civil Disobedience;* Levy. For a look at how these conceptions of digitizing the body emerge as prosthetic art forms, see S. Rogers, *Body Mechanique,* the catalog to accompany the important and provocative digital arts show on the body at the Wexner Art Museum. This show included works by Daniel Canogar, Merce Cunninghanm/Paul Kaiser/Shelly Eshkar, Toni Dove, Greg Lynn, Chris Marker, Joseph Nechvatal, Alan Rath, Thecla Schiphorst, Bill Seaman, Beth Stryker/Sawad Brooks, and Laurie Anderson. For discussions of media piracy in the historical and technological context of digitality, see Cowie; Patricia R. Zimmermann.

14. For a discussion of the role of the Zentrum für Kunst und Medientechnologie in the development of new media art, see Fifield.

15. For in-depth historical analysis of the importance of access, distribution, and exhibition for oppositional documentary and experimental practice, see Waugh; Nichols, *Newsreel;* James; Rosenthal.

16. For detailed case studies of how the new information technologies have created new inequalities and magnified old inequalities across the globe, see Loader. For a view on how the digital economy has exacerbated class divisions in new formations, see McChesney, Wood, and Foster.

17. A report from the MacBride Commission is available at http://unesdoc.unesco.org/images/0004/000400/040066eb.pdf. http://people.rfem.or.kr/macbride/. The People's Communication Charter can be found at www.waag.org/pcc.

18. See Magid, "Epic Effects Christen Titanic" and "An Expanded Universe"; McDonald;

Orwall; F. Rose; Goodfellow; McWilliams; Parisi, "The New Hollywood"; Kelly and Parisi, "Beyond Star Wars: What's Next for George Lucas"; Voland; Karon, "Hi-tech Hits 'Digital Coast'"; DiOrio.

19. For a cogent outline of the contours of the New Hollywood, often referred to by film scholars as the "post-classical cinema," see Neale and Smith.

20. For a discussion of how hypertext alters linear narrative into a series of connected, every evolving links, see Landow, *Hypertext 2.0*.

21. An example of this performativity occurred during the 43rd Annual Robert Flaherty Seminar at Ithaca College, October 5, 1997, where Woolery projected the CD-ROM in a large auditorium on a huge screen, operating the hyperlinks in the piece and the music as a form of scratch and mix projection that responded to the audience, changing the pace and looping back to salient features that were repeated for emphasis.

22. For a sample of the many essays on Muntadas's work, see the archival "interom" *Muntadas* (Duguet, ed.). Besides including drawings for installations, video documentations, and website links, it features extensive texts—critical writings on Muntadas linked to the installations and video work, as well as web-specific works.

IS (CYBER) SPACE THE PLACE?

Herman Gray

Can black cultural production function as a critical counterknowledge? In the new information order and with the emerging new communication technologies, what are the conditions of possibility for the production of such knowledge? In this essay, I aim to work through popular conversations and sentiments about the new information technologies as they bear on issues of blackness, difference, and identity. I consider the political salience of identity and representation under conditions that Stuart Hall and Cornel West, over a decade ago, called the "new cultural politics of difference."[1]

HAPPY PASTORALS OF PROGRESS AND GRIM NARRATIVES OF DOMINATION

Does it make sense, I wonder, to continue to speak about culture and identities as sources of critical counterknowledge, in the context of rapidly shifting global conditions of capitalist production, innovative technologies, new structures of media ownership, and unprecedented transformation of spatial and temporal relations? In the United States and other electronically wired countries around the world, has the digital revolution disrupted something so fundamental as our collective structure of feeling, so that the collective map that gives shape and meaning to our lives and activities is no longer legible? For the most skeptical, the configurations of global economic power enabled by the new communication and information technologies are simply the mature expression of capitalist logic and administrative rationality that Marx and Weber anticipated well over a century ago.

The anticipated effect on social relations (exploitation and domination), democratic possibility, and cultural traditions is a very old tale indeed, told by those on the left and the right who are worried about the corrosive effects of a global corporate capitalism on culture, community, and tradition.

An equally familiar tale is the more celebratory and utopian vision of neoliberalism: economic freedom, Western-style political democracy, and cultural openness that is not just enabled by the new media and communication technology but is almost synonymous with it. In this hopeful tale of unlimited economic prosperity, political freedom, and cultural openness, information technology and free markets facilitate the production and circulation of information and, thus, are the measure of progress and freedom. Through new communication technologies and the openness of free marketplace culture—including information and entertainment—information is accessible everywhere. Consumer sovereignty, choice, and the availability of commodities—cultural and otherwise—are the economic expression and political realization of this neoliberal vision of democratic possibility and economic freedom. The new town halls and unregulated marketplaces of cyberspace are the sites of participation and choice, all ensured by the efficient operation and coordination of Western market capitalism, neoliberal Western democracy, and new communication technologies. This is the inevitable and celebratory march of progress (Robins and Webster).

James Carey calls these two sets of tales "happy pastorals of progress or grim narratives of power and domination" (9). My concern is not with rewriting or updating either of these old stories (Rodman).[2] Instead, I want to try and think through the relationship between operations of knowledge/power around culture and the new technologies of communication and information, particularly for organizing alliances, identifications, and articulations that form the terrain of political struggles for new hegemonies. For starters, consider some of the ways that new communication technologies actually get inscribed and articulated by social relations and logics that produce greater exploitation, domination, and inequality—represented through narratives of freedom, choice, and progress.

In the modern nations of the West, dispersed sites of production, flexible modular production processes, decentralized administrative structures, and the capacity for rapid circulation of information, goods, and people across geographical and spatial boundaries now profoundly organize the flows and encounters with popular commercial media, commercial popular culture, and other forms of information (Appadurai, *Modernity at Large;* D. Schiller; Castells). Of course, these flows and exchanges are variable, elastic, and often uneven, which means (as in the case of cinema or television) that with new and increasingly more sophisticated means of marketing and distribution, both fragmentation and homogenization are the defining logic of global capitalism (and of the production of information and entertainment under conditions of global capitalism) (Curtin, "Feminine Desire," "Gatekeeping"; Caldwell, *Business of New Media*). Like the limited conception of "grim tales and happy narratives" of new technology, encrusted binary

distinctions between high and low, pure and corrupt no longer make real sense. New production, distribution, and exhibition capabilities are possible, since more dispersed and flexible forms of global production are coordinated and administered through the new technologies (Fiske, 239; D. Schiller).

The historical forms and conditions within which the media/culture complex operates are specific and global as well as abstract and local. Despite their growing technical sophistication, global distribution, and transformation into the digits and bits of the information superhighway, the meanings we make and the uses to which we put them are experienced socially and culturally in local and specific circumstances. (But, one might be tempted to ask, is this too just another version of a very old story?)

This means, as Allucquère Stone suggests, that technology, no matter how complex, removed, or abstract, must still be understood socially and culturally:

> [T]echnologies are visible and frequently material evidence of struggles over meaning. They don't exist outside of complex belief systems in whose social and political frames they are embedded. Their apparent obduracy is an artifact, a technology of its own. A VCR remote control is merely a ritual object in the absence of the dense social networks, capital structures, and manufacturer-drive expectations that manifest as cable and satellite technology, market share, leisure time and entertainment. (Stone, 169; Carey)

Suggesting that media and technology are embedded in social and cultural relations implies that their operation and control involve matters of politics and history rather than the mere workings of disinterested technical know-how. John Fiske states the matter directly: "[T]he computer requires categories to link its separate bits of information together and turn them into knowledge. But the categories are social, not technological, so constructing them is where the power of the computer is politicized" (Fiske, 250; Robins and Webster).

My own conception of culture, then, emphasizes the salience of historical contexts, the centrality of social relations, and the specific conditions of practice and use as the bases for making sense of the social world (R. Williams, *Marxism and Literature*). I urge a view of culture that stresses the popular and the everyday because I am interested in the practical maneuvers that people use to shape their circumstances and fashion lives out of the cultural and social resources—symbolic and material—at their disposal. Culture (including technologically mediated and commercially produced forms) is particularly important in this regard, for it is also a place for making sense of social life through negotiation, contestation, and struggle (*Marxism and Literature;* Fiske).

By focusing on the terrain of the popular (and the specific ways in which popular sentiments and understandings are structured, structure, appropriate, and are appropriated), I want to critically face up to, as George Lipsitz puts it, the contradictory possibilities that the new media and the attendant technologies of information, communication, and commercialization present for thinking about cultural politics in general and black

cultural politics in particular. These new technologies—in the form of the Internet, digital storage, retrieval, and network—are now, perhaps more than ever, the predominant places of mediation, transformation, and translation of vernacular and everyday practices into commercial forms. As such, they are easily packaged, taken up, and circulated as popular styles, products, and images where they are registered in the public imagination as the basis of popular understandings. It is where new social relations are forged and where new cultural practices are made from the meeting between the local and the global, the vernacular and the commercial, which to one degree or another are shaped by new technologies that facilitate global flows of people and information. In fact, so profound are these new information and communication technologies as sites of mediation, that Fiske claims that they result in

> images [that are] so promiscuous as to defy any attempt to control and organize them. The mediated world is not only the world that we in the west live in; it is a world that has overtaken one in which an unmediated experience seemed possible. It never was, of course, but the rapid growth of our technological media does make a world of oral language, print, live performances, and nonreproduced (sic) visuals appear unmediated by comparison. (237)

Culture, then, is the experiential and representational—in a word the "discursive"—apparatus through which technologically mediated information, experience, and perception circulate, are regulated and contested, and are made both knowable and meaningful. Where media institutions and communication technologies are the conduits through which information and data circulate, "culture" refers to the assumptions in which this information and technology are embedded and the cultural logic though which and by which this information and experience gain meaning and coherence. As it concerns communication technologies, media, information, and knowledge, this approach suggests that culture is a "conceptual system that creates and defines the world in the act of discovering it" (Carey, 195). In the absence of sustained critical interrogation and political contestation, these historically constructed processes and assumptions seem natural and inevitable (Lewis, 18–22).[3]

These are crucial matters. In the new global information order, defined largely by the structuring logic of neoliberalism and free trade, communication technologies are designed to serve corporate financial and administrative interests (D. Schiller). In the absence of sustained critical sensibilities, the forms of social resistance and cultural struggles—forms of "diversity and difference" which have historically and politically meaningful points of cultural memory, struggle, and aspirations for social justice—easily become consumer-focused market indices of consumer choice, "a multiplicity of commodities, of images, of knowledges and of information technologies" (Fiske). The distinction here is vital. I agree with John Fiske and others that there is a significant difference between a diversity produced by social formations (particularly subordinated

ones) that wish to maintain productive cultural traditions, histories, and identities relative to other groups and formations (particularly dominant ones), and a so-called diversity that is produced by and for capitalist industries (Fiske). Culture is a decisive site of struggle over efforts to make visible and reconfigure the social, political, and epistemological terms of the social terrain. It is to this specific set of issues that I turn in order to say something specific and particular about black cultural politics, cultural struggles, cultural difference, and the new communication technologies.

THE CULTURAL POLITICS OF DIFFERENCE AND NEW TECHNOLOGIES

In two seminal essays, Stuart Hall and Cornel West argue that black cultural politics and, by extension, black subjects have entered a new stage of history (S. Hall, 21–37; West, 19–39). In his 1990 essay, West challenged critical scholars of color, especially black intellectuals, to think about culture, representation, and difference in new ways. In the realm of cultural politics and representation, he called for a project of critical interrogation and cultural production that moved beyond mere contests over positive/negative images or the displacement of stereotyped depiction of African-Americans in visual culture. Similarly, in 1992, Stuart Hall challenged critical black diaspora intellectuals to move beyond disputes over access to media production and the means of representation, suggesting that a more urgent challenge was to produce work that would show how a politics of culture assumed that difference might serve as a basis for emergent social formations, political articulations, and cultural practices that would change the balance of power (S. Hall).

Both West and Hall recognized that new global processes and capitalist forms of flexible production, coordination, circulation, and accumulation were the structuring conditions of these new critical black cultural politics. Both writers recognized, moreover, that the discursive and aesthetic distinctions between high/low, margin/center, and commercial/pure were no longer salient or especially productive for such a project. The appearance of new technological means and relations of representation, the emergence of new categories of description (postmodernism), and the appearance of theoretical discourses (poststructuralism) are all significant, Hall concedes, because they emphasize the terrain of difference, the salience of identity, and the centrality of the "popular" and the discursive as social and cultural terrain where politics are made.

West and Hall located their analysis of new cultural possibilities in a historic conjuncture where analytic conceptions and cultural representations of "blackness" posit the end of essentialist discourses (social science, cultural, and political) about race. For them, formulations prior to this period were rooted in naive conceptions that took race and identity as natural givens rather than historical and cultural products. Such conceits were not only innocent culturally; they were politically ineffective.

What Hall calls the "end of innocence" for such naive formulations about race, identity, and cultural politics appeared, more importantly, at the time of erosion of European

empire and global hegemony, the subsequent rise of American global hegemony, and the challenge to modernist conceptions of culture. Politically, the social and cultural terrain of the popular and the discursive is necessary for critically interrogating, constructing, and organizing popular understandings. This popular common sense can then be linked to critical enterprises that illuminate and challenge strategies used in projects of conquest, colonization, displacement, exploitation, and domination by the West (often in the name of Western modernism, capitalism, and democracy).

In the decade or so since Hall and West first offered these insights, developments in the structure, organization, and technologies of new communications and information have quickened (as have the scholarly and popular discourses through which these developments are represented and legitimated). The structures of interlocking control and administration of global media and communication technologies are more composite and their reach more expansive. In conjunction with developments in communication and information technologies, the means and relations of representation are being restructured and ordered into new spatial and temporal relations (Auletta, "The Big Ten" 25–28; McChesney, 78–118).

Not surprisingly, the direction, control, and benefits of these new structuring relations favor global corporations. For some observers, however, the possibilities for more democratic uses are still an open question, but one that requires a measure of political will and outright struggle. Although he puts the matter in terms that hearken back to "pastoral images" and "grim narratives" of access, MIT's William J. Mitchell, professor of architecture and media arts and sciences, nonetheless seems to appreciate the enormity of the challenge required to change the balance of power:

> By redirecting access to services and opportunities, the growing information infrastructure has the potential to create winners and losers on a vast scale. It is pleasant to imagine a nation of networked Aspens and cyberspaced Santa Monicas peopled by convivial bicycle-riding locals, but the obvious danger is that such restructuring will instead produce electronic Jakartas—well connected, well serviced, fortified enclaves of privilege surrounded by miserable hyperghettos, where investment in information infrastructure and appliances are not made, electronically delivered services do not reach, and few economic opportunities are to be found. The poor could be left with the obsolete and decaying urban remnants and isolated rural settlements that the more privileged no longer need. Surely the most fundamental challenge in building the bitsphere will be to deploy access according to the principles of social equity—not in ways that heighten the privilege of the haves and further marginalize the have-nots. (*City of Bits*, 170–171)

In places like Japan, Europe, Australia, and the United States, more and more of our daily lives are structured by the capacities made available by the communication revolution. We negotiate even the most rudimentary social activities of school, banking, courtship, travel, entertainment, leisure, shopping, and work through some aspect of the new

communication media and information technology. For almost all of us, moreover, the cultural terrain of popular entertainment (movies, music, television, electronic games) and information is mediated by the capitalist market economies, administered by global commercial organizations, and structured by the digital grammar of new technologies of communication and information.

With increasing technical capacity and social necessity to manage, coordinate, distribute, and store information also comes the need to make legible and intelligible this information. Where global economic logic, postmodern culture, and new technologies of communication all restructure social relations and produce new spatial territories, can the cultural terrain of the popular ever do more than constitute significant and often intractable difference (e.g., tradition, culture, nation, race, gender, ethnicity) as market indicators of "multiplicity and diversity" (age, tastes, preferences, habits, and so on)? Can the cultural politics of difference, in the sense that Hall and West suggest, ever form the basis of social formations that do more than simply serve as the raw materials for flexible forms of capitalist production or as the basis for systems of subjugation and repression? Exactly what will become of countermemories and alternative traditions of modernism as sources of critique and opposition to such tendencies? Can we produce critical cultural projects that actively contest for popular hegemony when the very representations over which we struggle and the cultural practices in which they are embedded are structured in the logic of global capitalism and grammar of digital bits, cyberspace, and the information superhighway that defines the technological revolution in communications? At stake, then, is not just the "social distribution of economic, technological, and discursive resources" or mere access to those resources, but the very procedures, perceptions, and categories through which we imagine such possibilities.[4]

In some of the scholarly and popular discourse about the new communications and information technologies, there is an explicit and often enthusiastic assurance that with these new capacities come greater possibilities for creating and participating in a truly democratic public sphere (Naomi Klein; Yuen, Katsiaficas, and Rose). When they are broached at all, questions concerning cultural difference, communities of color, women, and the poor are almost always couched in terms of access or a concern with inequalities of access (Schon, Sanyal, and Mitchell). In the utopian world of information and connectivity made possible by the new technologies, distinctive histories and traditions are translated, preserved, and accessed through digits, bits, and chips that constitute the defining lingua franca of the information age.

Discussions of black cultural politics like those by Hall and West imagine new hegemonies of subalterns and appreciate the structuring power of new technologies of information and their effect on collection, storage, sharing, and representation. There is a good deal of critical commentary, for instance, on the powerful role of technologies for the production of citizenship, the fortification and control of national boundaries through the surveillance made possible by new technologies (Fiske; Davis; Gooding-Williams; Penley and Ross; Caldwell, "Televisual Politics" 161–195). There is also considerable

appreciation and hope for the potential use of low-tech forms such as video cameras, low-power radios, copy machines, faxes, and telephones against various forms of high-tech policing and regulation. In the case of new technologies, some see considerable promise for the potential use of the Internet and the personal computer for forging new critical networks of opposition (Fiske, chapter 5; Lull; O'Donnell and Delgado, 36–39).

For those most hopeful about the capacity of these technologies to help establish a new openness, the specific historical problems of racism, sexism, and, to a greater extent, class are still framed largely in terms of the struggle over access. That is to say, from the perspective of those interested in the ascendancy of subordinated and subjugated communities, the issue of cultural politics is largely defined in terms of access; hence, there is less sustained critical attention to the historical, epistemological, political, and aesthetic conditions that structure the new technologies, particularly what they mean for questions of cultural politics. The possibilities of the Internet and cyberspace are like a post-structuralist dream (or nightmare) come true: one can be anybody, disembodied, and reembodied all at the same time. In cyberspace, subjectivity and identity are indeed severed from the body; gender, race, sex, and age are all potentially severed from their materialist moorings in biological discourse. The raced and gendered bodies that circulate in the material world of history and the cultural discourse through which they are produced and acquire meaning are all potentially interchangeable bits of data that may or may not be revealed in the virtual community of cyberspace (Hayles, *How We Became Posthuman;* Mitchell, *City of Bits;* Poster, *Mode of Information*). In one sterling exception to the "happy pastorals of progress" that excites many enthusiasts of the new information technologies, Beth Kolko and her colleagues have dealt directly with the issue of race, showing in the process the inscription of racial assumptions and racial thinking in the organization, structure, operation, and experience of various dimensions of these technologies (Kolko, Nakamura, and Rodman). With subjects ranging from the use of computers in urban schools to the organization of mutual-user domains to the production of art spaces on the web, the essays in their collection suggest that the new technologies are not and will not serve as the cultural nirvana in which all traces of difference disappear.

In a racial order that depends on specific cultural meanings of race to sustain regimes of domination, we have not yet arrived at the point where the cultural significance of blackness is no longer derived from its specific construction and meaning in history. On the other hand, we may be (with the aid of new technologies) at that moment in history when cultural representations of race serve as nothing more than indications of cultural difference which have been emptied out and resignified as cultural commodities indicating mere "lifestyles."

Of course, critics interested in the cultural politics of difference do recognize the necessity to struggle for new alignments, meanings, traditions, and hegemonies on the terrain of commercial popular culture. Some of the most sophisticated and powerful critiques of the logic of globalization and its reliance on the hollowing-out and proliferation of differences have come from those who also recognize that counterhegemonic

cultural possibilities are articulated, disarticulated, and rearticulated most effectively on the terrain of popular commercial culture (S. Hall; Lowe and Lloyd; Lull; R. D. G. Kelley). The point of disarticulation and contradiction is in the realm of culture, that intersection of the symbolic economies of culture, the information and coordination systems of global capitalism, and the regulatory and management "acts" of the nation-state (Lowe).

In instances where such work is most critically and politically far-reaching, the insights have been most relevant to modernist media—the novel, cinema, television, and recorded popular music. But what happens, to return to Hall and West for a moment, to the force of these critical insights and the possibilities they offer when they are applied to the new forms and modes of representation (and communication) offered by the new technologies? Given that forms are already structured by and embedded in social relations and cultural meanings that are historic and specific, can the critiques of modernist cultural operations both expose the cultural logic on which the new technology depends and establish the groundwork on which new possibilities might be imagined?

Perhaps this is too much to expect. I hope not. My query here is really about the project that must, of necessity, inform a critical interrogation of the new technologies, the cultural logic on which they rest, and the operations through which they produce twenty-first-century societies. I still think it is possible to disarticulate and rearticulate the narrative of Western progress and democracy in such a way that it does not lead inevitably to the grim scenarios described by Mitchell in *City of Bits* (or hearken back to the role of technology in the terror, removal, and subjugation of black people in the new world). Are the critiques and insights urged by Hall and West (and already enacted by artists and critics like Isaac Julian, Kara Walker, Lorna Simpson, Stan Douglas, Greg Osby, Pamela Z, Steve Coleman, Anna Everett, Alondra Nelson, Beth Coleman, Tal Kali, George Lewis, and Paul Miller) simply translatable into the logic of digital bits, so that even their most progressive possibilities are, in the end, just so many zeroes and ones in the cyber age? Under such a logic, does the potentiality of "difference," specifically blackness, as a cultural and political category simply get translated into one more commercial version of liberal multiculturalism, one more option in the crowded field of global-style politics?

As with the recognition (perhaps it is capitulation) that the commodity logic that structures the terrain of commercial popular culture is necessarily contradictory, perhaps we must concede a similar point with respect to the structuring logic of the digital revolution and the new communication technologies. It seems necessary to acknowledge this, given all that we know about where and how culture is made and its potential impact at the level of everyday life. Political struggle on the terrain of culture organized by new technologies is altogether more compelling, since we realize equally well that all technologies, regardless of their historical age or material form, are constituted in and express the social and cultural relations of their time. This recognition is what makes so important the linkage between discourses of technology and discourses on the (black) cultural politics of difference.

Recognizing that the terrain configured by the new technologies is already structured by dominant political and corporate interests, my specific concern in the relationship between the debates over the black cultural politics of difference and the new media technologies is not an attempt to secure a place for "identity."[5] Neither is it my aim to add to the debate over the political efficacy or the critical limitations of essentialism. The new communication technologies offer interesting possibilities for reconsidering some of the main positions in this debate, particularly on the issue of subjectivity and its relationship to (em)bodied experience.

Blackness as a cultural sign still carries significant political and historical meaning—hence the potential for structuring identifications, affective investments, and understandings at the level of cultural representation. This potentiality is still most obvious in areas of traditional media representation where race, ethnicity, gender, and tradition still operate as powerful markers of difference through which to interrupt, remind, and remember the projects of terror, conquest, and subjugation that accompanied the formation of the modern West. Cultural politics mobilized through the sign of raced, gendered, sexed, and former colonial subjects continues to carry specific histories, traditions, and memories of social struggle. In contrast to the political investments in the cultural politics of difference (which critiques difference as the basis for inequality and nationalism), the discourse of new media technologies often works to depoliticize difference, making it, in effect, an inconsequential niche market of shared lifestyles and taste. One of the challenges of trying to make sense of the critical affinities and articulations of practicing cultural politics in the global time of new media is precisely how to put these discourses in productive conversation so that they might articulate the terms of a critical cultural analysis of new information technologies, the politics of difference, and cultural politics. To the extent that the new information order of global media institutions, communication technologies, administrative units, political interests, and corporate capital makes possible projects of displacement, terror, subjugation, and exploitation, as opposed to projects of justice, equality, and democracy, then the politics of representation, popular culture, and difference remains important for the production of counterhegemonies and new hegemonic possibilities (Lull, 113–159).

In the end, I offer a modest elaboration of the formulation of cultural politics about difference as it applies to new media and technologies of communication. The force of both West's and Hall's critical insights applies most directly to modernist or representational forms of communication media. Their identifications of these modes of representation as seminal sites for organizing and expressing popular loyalties, sentiments, affective investments, and critical suspicions are signal contributions.

Yet, as I argue in my book *Culture Moves,* the challenge to move beyond mere questions of access, stereotypes, and idealized representation (i.e., homogeneous black subjects) remains as urgent as ever. Engagement with new communication technologies and the terms they establish for the practice of identity and the cultural politics of difference is central to this challenge.

From the perspective of the new information and communication technologies, as well as global media organizations, the specific concern with how popular meanings are made and struggled over may pose a very different kind of challenge. Culture and media have always been inextricably entwined, and never more so than at the dawn of the twenty-first century. Commercial culture represents the neoliberal market logic aimed at controlling global consumer markets as natural, inevitable, and preferable. By such reckoning, the availability of consumer commodities and consumer choice is equated with consumer sovereignty—progress, choice, and freedom—and thus helps to shore up (and hide) relations of power built on social inequality, labor exploitation, force, and cultural domination. At the same time, popular commercial culture and technologies are still important sites for the circulation (and, in some cases, the production) of local, specific, and alternative cultures and traditions. They are places of potential (and unwieldy) articulations that interrupt, destabilize, and rearticulate (even if only momentarily) the neoliberal logic of global capitalism and narratives of Western progress that equate the free market and consumer sovereignty with democracy and freedom (Lipsitz; Lowe and Lloyd; Lull). In either case, the terrain of the commercial and the popular is still potentially vibrant as the political site for exposing and building upon the contradictions of this new global logic.[6]

In a social field organized by a digital revolution that translates signs, commodities, and identities into "bits" of information, yesterday's representation (including the social relations and the politics that structure and produce them) becomes just so much software to fill neoliberal global-market demands for new cultural products that will circulate on the information superhighway.[7] As a matter of cultural politics, then, I want to treat these relations of representation as more than just so much software made available through new forms of communication technology, controlled by and used largely in the interests of global corporations. In a chapter of *Culture Moves,* I look to Afrofuturists, black composers, and performance artists for insights about how music might operate as a productive site of encounter between new technologies and new cultural politics of difference. I explore what the current condition of possibility means for those moving beyond access to critical engagement and production.

Applying the insights of West and Hall about the new cultural politics of difference to the new media might begin with noting the multiple and uneven capacities, means of access, and modes of representation of contemporary media technology. Modern forms of communication media like the press, film, television, recorded music, photography, and radio are significant sites where the politics of representation certainly include, but are no longer just limited to, issues of access. Following Hall, critical understandings of these media emphasize representation as well as the logic, grammar, and history that structure such forms and the representations of difference that they produce. New communication technologies like the Internet, email, Pentium processors, the desktop and laptop computer, and the satellite bear some relation to the social and cultural structure of their predecessors—newspaper, radio, telegraph, telephone, and television (Caldwell,

Electronic Media and Technoculture). These new forms, moreover, remain linked to the administrative and economic logic of the Western market economies and corporate bureaucracies that generate, finance, and promote them (Ross, 7–34; D. Schiller; McChesney, "Media System Goes Global"; Robins and Webster). So long as the content of these new media depends on cultural representations generated in specific historical conditions, a cultural politics interested in production still requires struggles for access and representation. That is, a rearticulation of the possibilities of the new media that struggles to represent the subjects' new cultural politics of difference (as opposed to simply including multicultural representations of subjects as more commodities for the market) requires critical analyses of the logics, structures, signifying systems, and relations of representation not only within the new media, but also between the new and the old medias. In particular, scholars might consider the cultural implications, uses, and possibilities of the new media for how they organize, circulate, represent, exploit, and smooth over differences, including differences of place and class (Robins and Webster; Morley).

What are the specific sites and ways that popular desires and sentiments are organized and made representable under the emergent conditions made possible by the new technologies? In the context of the Internet, for example, can such representations serve as points of identification that might form the bases of cultural and political disruption, transgression, and critical intervention? Or will they simply serve to consolidate and reproduce the existing social relations of exploitation and subordination (Yuen, Katsiaficas, and Rose)? In cyberspace and the new communications media and technology that structure it, can difference function as the basis for the production of counterhegemonic cultural representations and formations that link critiques of the existing order with new imaginative possibilities for a very different order? In other words, as Allucquère Stone asks, "Will virtual systems mean the end of gender binarism? Will virtual systems create a level playing field for everyone regardless of ethnicity, color, gender, age, education, financial status, or the ability to load and fire semi-automatic weapons?" (*War of Desire*). These are, as I see it, some of the twenty-first-century challenges for implementing a critical cultural politics of difference. These challenges are marked by struggles over the meanings of culture and technology that are made in history and not merely given in nature or cyberspace.

ABOUT THE AUTHOR

Herman Gray is a professor of sociology at the University of California at Santa Cruz. He is the author of numerous books and articles, including *Producing Jazz: The Experience of an Independent Record Company* (Temple University Press, 1988), *Watching Race: Television and the Sign of Blackness* (1995), and *Culture Moves: African Americans and the Politics of Representation* (2005). He teaches courses in cultural studies, media studies, and cultural politics.

NOTES

1. This essay is reprinted from Herman Gray, *Cultural Moves: African Americans and the Politics of Representation* (University of California Press, 2005).

2. In addition to being very old tales, for Gil Rodman these responses are also problematic because they are fundamentally binary and thus offer no possibility for thinking about these issues outside of the binary logic on which they depend. See Rodman, 48.

3. Perhaps the most explicit conception of new technology as natural is one that aligns the capacities for information transfer, rapid market transactions, and consumer access to business and commercial interests; see Lewis.

4. For an interesting history of technology and culture that includes, for example, questions of embodiment and gender, see Hayles, *How We Became Posthuman*.

5. Though I would still claim that in the case of modern black diasporic formations in the West, there remains much critical work to be done.

6. On this point, the insights of James Hay, Bruce Robins, Frank Webster, John Caldwell, and David Morley are especially interesting. Each writer critiques the equation of market, technology, and access to commodities with democracy and freedom; each writer also considers the new technologies in relationship to older modernist forms of representation like cinema and television, and especially the ways that electronic technologies transform spatial relations, in particular within the domestic sphere. See Robins and Webster; Caldwell, "Theorizing the Digital Landrush"; Morley.

7. Bill Nichols considers Benjamin's observations on the impact of mechanical reproduction on art as a beginning for thinking about issues of culture, representation, and the digital revolution ("The Work of Culture"). At the same time, as the velocity and volume of these cultural forms and products increase, all kinds of people and communities are available and accessible to each other both inside and out of the structuring logic that others have been trying to expose and interrogate.

LINKAGES
Political Topography and Networked Topology

David Wade Crane

PROLOGUE (JULY 2013)

This essay was written over 2004–05. Other than this prologue, a brief 2009 postscript, occasional notes, and some editing, it has not been updated.[1] Yet despite its anachronisms, I don't think it's now just an archaeological relic. Its references may be "outdated," but the dynamics it addresses are still in force. Perhaps more so.

For example: not long ago (June 14, 2013), I happened to catch Lawrence Lessig on the radio, as a guest on Tavis Smiley and Cornel West's eponymous show. The topic was the NSA surveillance programs recently exposed by Edward Snowden. Guest and hosts agreed that the response to this particular revelatory event—as well as to the larger condition of the U.S. security state—could bring about a new political alignment, one joining "liberty-loving" (in West's words) citizens from both left and right. Lessig specifically cited Rand Paul as a figure well articulating this potential realignment. Whether this was observation or endorsement, I can't say for sure (I was making lunch at the time and missed some nuance). Either way, his point is somewhat banal, and rather naive. Yet it's not without significance, especially as Lessig himself quite well articulates the links, and tensions, between liberty, technology, and politics. And in doing so he does endorse—in a generally centrist liberal way—a reasonably free and open networked topology over an insular and entrenched political topography, in hopes that the former can reform the latter. Or remix it.

In his own right-wing libertarian way, Rand Paul—following his father, Ron—has leveraged networked topology into an apparent transversal of political topography and its

established left/right polarity (although this topographic transversal seems somewhat limited to online topology). Indeed, one significant development since this essay was written (in American politics at least) has been how the Pauls have managed to power-law themselves up from the political long tail—this due more to their network-savvy adherents than to their own technical skills. The Pauls' rise, however, is not just a left/right transversal, particular as that may be. It owes more to the uneasy linkages between traditional and libertarian conservatives making up the broader Tea Party reaction to Barack Obama's presidential victories, and its right-wing obstruction of his fairly centrist policies—a crucial limit to a liberty-loving left/right realignment.

My point here is not to analyze these events (which will soon enough be artifactual anyway), but only to note, perhaps more banally, that the question of political realignment in relation to communication technology is still being posed. And that it's still a questionable question. And it's still worth following its questionable contingencies, and the ways those articulate shifting hegemonies, both in space and over time.

OF POWER LAWS AND LONG TAILS

Are "left" and "right" still valuable in delineating political topography? Since the Cold War ended, its features have become dominated by globalized trade and increasingly influenced by emerging social, cultural, religious, and national movements—themselves linked to nongovernmental organizations and new political parties. Concurrently, the proliferation of computer-mediated communication (CMC), most notably the Internet and World Wide Web, have intensified and expanded the ways that information and communication technologies (ICT) shape the political terrain. Certainly these two sets of changes are connected—although the causality or contingency of that remains an open question.

For Mark Poster, the connection is profoundly transformative. Due, he proclaims, to the Internet's merging of decentralized communications with discursive subjectivities, "the political as we have known it is reconfigured" and "authority as we have known it will change drastically" ("Cyberdemocracy" 224, 225). In technologically enabled postmodern politics, the left/right spectrum, along with the grand narrative of liberation—and even democracy itself—become outmoded relics of modernist, progressive temporality and its pre–socially mediated individuality ("Cyberdemocracy" 213–214). That's a grand story itself! Yet maybe Poster's hyperbole can suggest some tangible ways in which CMC's hyperlinked topology might make ideological links across political topography, if not rearticulate the entire thing.[2]

The suggestion is debatable, however. Todd Gitlin blames CMC for a general reduction of public discourse into "public sphericules," while Cass Sunstein and Valdis Krebs claim, respectively, that it individualizes information consumption and insulates ideological positions. Lada Adamic and Natalie Glance show how sustained intra-ideological linking on "A-list" liberal and conservative blogs make them "mild echo chambers" (9–10). Still,

the authors wonder if less mainstream blogs might be more interideological—as is implied by John Kelley, Danyel Fisher, and Marc Smith's analysis of large-scale political discussions. Cross-spectrum debate dominates both ideological and issue-based USENET newsgroups, they argue, resulting in a diverse public commons that "J. S. Mill would approve" (31). Even in mainstream blogs, Eszter Hargittai, countering Adamic and Glance, finds "evidence of substantial cross-linking," which suggests that bloggers "are certainly reading across the ideological divide to some extent"—even if half those links make straw-man arguments ("Cross-ideological").

While these diverse results could come from methodological differences, they also grant a presumed—and undeserved, if Poster's authority is trusted—stability to the binary categories of "liberal" and "conservative" (or "left" and "right"). In fact, when Hargittai posted her preliminary findings on the blog Crooked Timber, the commons' very first comment (from David T. Beito of the group blog Liberty and Power) made just that complaint: "The blog world is not neatly divided between conservatives and liberals. What about libertarian blogs? Many of them completely defy this dichotomy and, for example, are stridently anti-Bush on both the Iraq and drug wars."[3]

That response won't surprise anyone who's ever surfed the web. And while libertarians' oft-claimed defiance of the left/right axis is also debatable, its repeated insistence says something about that axis's possible instability and potential reorganization. And on whose terms, and in what medium, those get articulated, discursively and systematically.

Which does not mean that libertarianism has successfully transformed, or transcended, the left/right dichotomy, via CMC or otherwise. However, certain issues and/or events hinging on shared (yet erstwhile unacknowledged) ideological elements can involve transversal[4] links between different political positions—links that may, if only momentarily, supercede other differences. Opposition to the Iraq war is such a transversal issue-event. Dominated by the left, it also includes traditional conservatives and libertarians. Despite their other antagonisms, each has a particular ideological stance against foreign interventions and uses of state power—although differently reasoned and separately enacted.[5] Similar differentiated correspondences can occur around other potentially transversal issue-events involving globalization, environmentalism,[6] technology (especially dealing with privacy, surveillance, and free speech), and civil/individual liberties.

Research focused on the conjunction of ICT and political structures indicates a loosening of the ideological coherence that has been regulated through established cartel-style political parties and their related bureaucratic institutions. Bruce Bimber describes an emerging postbureaucratic political environment, characterized by information abundance and accelerated pluralism (22–23), that has become "organized around events and the intensive flow of information surrounding them" (22) instead of conventional interests and issues. Informational associations gain importance over organizational membership, and collective action multiplies into "opportunistic responses to the flow of political events" (105). Richard Rogers also observes the displacement of single-issue

social-movement actors by "a more free-floating protest network potential . . . that moves from issue to issue" ("Narrative" paragraph 5).[7]

For both Bimber and Rogers, communication networks help constitute (but do not determine) these flexible forms of political affiliation, in which urgent yet temporary articulations around issue-events[8] become more important than sustained and coherent mobilizations.

But not necessarily more democratic. For Bimber, the intensification of information in linked and mobile political networks also involves the stratification of that information as it's channeled through "potentially viable mobilizers"—those who can take advantage of the opportunities for collective actions which, in turn, "are more sensitive than ever before to the flow of events and information and are less reflective of the traditional organization of interests" (230). In the still-dominant Western liberal-representative cartel parties, ICT mainly provides the "functional linkage" connecting voters with elected leaders and party members with intermediaries and officials, according to Karl Löfgren and Colin Smith. Drawing on Eva Etzioni-Halevy, they further maintain that ICT may foster "elite desertion" by those who are informationally advantaged, generating new vertical, as well as horizontal, linkages between political participants—even in the "consumerist" and "cyberdemocratic" political models they see emerging (41–42).

Those models are identified with "new parties and fringe groups," and neither is as reliant as the cartel on keeping permanent members (43). The consumerist model is a rational and utilitarian derivative of the cartel party, and it treats citizens as stakeholders who participate in politics "through market mechanisms" (48). It uses ICT mainly for gathering potential voter information. The cyberdemocratic is movement-oriented, grassroots, and extra-parliamentary. It uses ICT as a component in fostering deliberative relationships between participants, which are organized around democratically empowered identities rather than established sets of interests (48–49).[9] Both models offer what Rogers and Ian Morris call the "neo-pluralistic potential" for "transdiscursive viewpoint engagement" (155).

One can only speculate how far this transdiscursivity might go—how it might modify the left/right spectrum, disarticulating positions and making their differences make less difference. Or different differences, able to be rearticulated into an altered spectrum—or maybe a new one. My analysis here will attempt such speculations—but not, I hope, wildly. In contrast to the larger-scale studies of politics and CMC mentioned above,[10] it navigates a more circuitous and incomplete route—guided, in part, by Ernesto Laclau and Chantal Mouffe's understanding of hegemonic articulation as an always incomplete fixing of political positions within an open social space. But also, in part, by PageRank, the algorithm that ranks websites according to how often they are linked to, and upon which Google's search methods are based. Despite their massive scale, those methods are imagined around particular, though still abstracted, actions. Sergey Brin and Lawrence Page, no less, describe PageRank "as a model of user behavior. We assume there is a 'random surfer' who is given a web page at random and keeps clicking on links,

never hitting 'back' but eventually gets bored and starts on another random page. The probability that the random surfer visits a page is its PageRank" (2.1.2).

My path, both hyperlinked and theoretical, is not exactly random, nor completely idiosyncratic. It does aim at a fairly typical web surfer's experience (including the momentary obsessions and tangential discoveries) as it follows certain ideologically transversal links, and as it contextualizes those links within the broader and multifaceted—and inconclusive—interactions of CMC/ICT with politics. Here are my own leading questions. Has political topography become less organized around the left/right axis? And, if so, could the topology of CMC/ICT, and its capacity for hyperlinking, play a role in this? Admittedly, these questions are too simple. And rest assured, there will be no definitive answers. No fantasies of completion. But some partial answers, and further questions, can come from following those leads. I will say with confidence, however, that left and right are not yet confined to the dustbin of modernity; nor will they be any time soon.

But they ain't what they used to be. What makes them up, and keeps them apart, has been affected by accelerated (neo)pluralism and information abundance. Maintaining their topographical dominance in a deinstitutionalized and postbureaucratic field becomes more reliant on organizing the fluid positions of partially and multiply fixed political identities around transitory and informatically saturated issue-events. This dynamic field is also more conducive to transversal connections. That those might occur at the topographical margins, or the topological "long tail," doesn't make them insignificant. Margins can grow more salient in a pluralizing and rearticulating topography with multiplying centers. They can occasionally make their way into the centers—or up the rankings. This process is facilitated by the topological structure of CMC and ICT.

Although commonly considered the exemplar of "bottom-up" development, the topology of the web is actually, as David Gibson, Jon Kleinberg, and Prabhakar Raghavan first showed, well organized around linked communities of authorities and hubs. That organization increases as the web expands: a larger number of relevant pages combined with a higher density of hyperlinking leads to a greater degree of orderly structure.[11] Similarly, Michalis, Petros, and Christos Faloutsos show that "surprisingly simple power-laws" can be used to depict and predict the Internet's structure of routers and domains" (251). As they explain it, "the topological structure of the Internet is the collective result of many small forces in antagonistic and cooperative relationships," and their power-law captures the "equilibrium in a state" of self-similar node expansion and increased connectivity (260). "Power law distributions are ubiquitous," declares Clay Shirky about patterns of blog popularity. The more options for linking lead, paradoxically, to a greater concentration of selections, increasing "the gap between the Number One spot and the median spot" (49). Shirky offers this maxim: "Diversity plus freedom of choice creates inequality, and the greater the diversity, the more extreme the inequality" (46)—which could serve as an informal algorithm for the web's libertarianism. And even its conservatism.

This kind of bottom-up hierarchy, in which just 20% of the options get chosen 80% of the time, augurs poorly for CMC's much-heralded democratic potential—at least in

terms of equal selection of diverse information sources (in terms of shared selection of common knowledge, it's not so bad). However, along with the distribution of popular nodes at the authoritative centers of topological linkings—that is, at the peak of a power-law graph or as the top-ranked result of an Internet search—comes increased access to the less popular nodes on the long tail. That is, to the 80% linked-to 20% of the time. Chris Anderson argues that, by combining the economics of abundance with greater availability, digital networks make material on this "long tail" more accessible than it had been in a physical world governed by scarcity. And more valuable. He gives the example of Amazon, which does half its book business beyond its top hundred and thirty thousand items—the maximum number of items carried in your average Barnes & Noble bricks-and-mortar store. He quotes venture capitalist Kevin Laws to make his point: "The biggest money is in the smallest sales."

Anderson's concern is business, not politics. Yet this increased significance of the long tail's marginal positions can translate to the pluralized politics of information abundance, especially given the concurrent weakening of traditional institutional authorities. Still, as with the business models Anderson proposes, that significance makes more difference when there's awareness of, and links to, what's on the long tail. There must be interplay between the dominant choices and those on the long tail, especially for the marginality of the latter to challenge the dominance of the former. Here is where topology might affect topography, and even play its own significant role in the discursive concentration of political power.

AXIAL SUPPLEMENTS (OR, HEGEMONIC LIBERTY)

That the left/right distinction has been challenged from the start is the best sign that it's far from dead.[12] Certainly, recent American punditry has been obsessed with, and invested in, liberal/conservative antagonism—partly tied to the respective ideological homogenizations of the Democratic and Republican parties, tracing back through Reaganism to Nixon's southern strategy. A more analytical, but still invested, defense is Norberto Bobbio's *Left & Right: The Significance of a Political Distinction*. Italy's top-selling book of 1994, it argues that the left/right dyad functions as a sort of political equilibrium that, if disrupted, eventually restores and reorganizes itself around its poles. What left and right signify may change, but their relational antagonism stays fundamental to political topography (56). Their key difference is that the left's goals are more egalitarian while the right's are more inegalitarian (62)—which Bobbio distinguishes from the more conventional "equality/freedom" differentiation contrasting "the egalitarian left with the libertarian right" (78). The left can be concerned with liberty, too, he maintains. And to acknowledge, in part, that concern, he supplements the left/right x-axis with an intersecting authoritarianism/libertarianism y-axis that extends and modulates a wider range of positions (97). On the left, Jacobinism (or Maoism) combined egalitarianism with authoritarianism, whereas social democrats have been more libertarian with equality. Center-right conser-

vatives use liberal parliamentary and legal procedures, but they still restrict their egalitarianism to "equality before the law." Fascism and Nazism have been both antiliberal and antiegalitarian (78–79). But more recent political formations—specifically, the Greens—are harder for Bobbio to plot into this new schema. He calls them a *"transversal movement"*—though one moving toward its own left/right division (10–11, emphasis in original).[13]

Yet when it comes to liberty, the left and right modulate their concerns in different ways. The left extends and pluralizes the range of civil liberties (in the sense of Isaiah Berlin's "positive liberty"), often under the larger banner of liberation. The right stresses "individual liberties" (following Berlin's "negative liberty"), especially in the neoliberal and libertarian senses influenced by, among others, Friedrich Hayek (e.g., *Road* and *Constitution*). This sense of liberty is often linked to sovereignty as well, whether individual, national, cultural, and/or ethnic. And despite what Bobbio says about the left and liberty, it's the right's modulation that has become a hegemonizing articulator in political discourse, particularly in the United States.

And especially on the web. Of the eight political sites in the top twenty returned from Google on the search term "liberty,"[14] four are clearly on the right: Jerry Falwell's Liberty University (www.liberty.edu); the Library of Economics and Liberty (www.econlib.org), a forum on neoliberal political economy; the site for *Liberty Unbound*, a libertarian /individualist magazine (www.libertysoft.com/liberty/)[15]; and Liberty Online (http://libertyonline.hypermall.com), which collects the texts of historical documents in the tradition of classical liberalism, plus some recent antiregulation articles. Only two could be considered left: the top-ranked one, UK-based Liberty (www.liberty-human-rights.org. uk), dedicated to "protecting civil liberties and promoting human rights"; and the Global Internet Liberty Campaign (GILC; www.gilc.org), an international, multilanguage consortium site addressing human rights and civil liberties issues, mainly in the context of CMC concerns with free speech, intellectual property, privacy, cryptography, and access. In fact, the GILC's focus on technology issues make its overall ideological leanings difficult to fix, though its positions tend toward the libertarian. Significantly, these two are the least "American" sites.

Other than Falwell's, the right-wing sites also skew libertarian, showing that while the significance of "liberty" can vary, its (hyper)linkages vector discursive hegemony toward libertarianism. This perspective becomes even more dominant when "politics" gets added to the search. Of those top twenty-five sites, fourteen are right-leaning libertarian (seven of the top ten); two could be characterized as neoconservative; one is of the explicitly racist right; and three are left or left-libertarian.[16] So, the left may well be concerned with liberty; but liberty seems less concerned with the left, at least as that term plots out through the web's search algorithms.[17] On the basis of these far-from-conclusive results, web topology seems to rearticulate Bobbio's expanded political topography by placing more emphasis on the *y*-axis—and a specific direction on it. Could this mean that, between these *topoi*, the left/right distinction has been supplanted by its supplement?

Taking a broader view, Anthony Giddens—the left/right distinction's most prominent English-language critic—gives ICT indirect credit for displacing and transforming that alignment. Expanding globalization, which he finds "deeply bound up" with "the communications revolution and spread of information technology" (*Third Way Renewal* 31), has been the more direct reason why the left/right alignment no longer "covers as much of the political field as it used to do" (43). Instead of addressing this situation with an additional axis, Giddens advocates a new direction: a "Third Way" politics to revitalize social democracy at the "radical center." Insisting that this center is not a compromised moderate middle ground, he intends the Third Way to be "a critical riposte" to the neo-liberalist vision of globalization ("Neoprogressivism" 2). Its main neoprogressive thrust comes from culturally based "life politics" that can both reengage disaffected citizens and allow for more complex and less bifurcated "alliances that social democrats can weave from the threads of lifestyle diversity" (*Third Way Renewal* 44–45).[18]

The center woven from those alliances would also include conservatism and aspects of neoliberalism—so long as "social justice and emancipatory politics remain at its core" (45). In orienting political positions less aligned by the left/right axis around the radical center, Giddens seeks a topography less favorable to (yet still in some consort with) neo-liberal hegemony—along with a privileged Way to engage that reconfigured space. And while meant to favor the left-of-center, the reconfiguration is made at the expense of the left/right binary. This, Giddens argues, is necessary, since those spatial binaries have changed their fundamental temporal momentum. The left now legitimates itself in the legacy of planned economies and welfare states, not at the vanguard of historical progress. Conversely, the right now locates its legitimacy at the forefront of market-driven globalizing transformation instead of in traditionalist resistance to change—thus claiming hegemony through its radical relation to time. Paraphrasing the chapter titles in Giddens's *Beyond Left and Right,* socialists have retreated from radicalism while conservatives have embraced it.

Yet there's more to this than a simple switch, as each binary has also had its own internal destabilizations and reconfigurations. Conservatism "understood in the usual ways," notes Giddens, is now fractured between neoconservatism, philosophical conservatism, and neoliberalism (*Beyond* 49). The latter's "market fundamentalism" (inspired by Milton Friedman and, again, Hayek) is especially at odds with philosophical conservatism's distrust of capitalism, rooted in its organicist and particularist sense of tradition (inspired by Edmund Burke and sustained by Michael Oakeshott) (Giddens, *Third Way Renewal* 15; *Beyond* 27–30).[19] This distrust, and its roots, are shared by the more identity-based "new right" groups as well.[20] The left, in turn, has had to deal with the increased hegemony of neoliberalism, competition from new social movements (including forms of populism), and—most significantly—the erosion of its working-class constituency in advanced capitalist countries. It too has turned to particulars, emphasizing democratic cultural (ethnic, racial, gendered, sexual) pluralism and locally focused environmentalism.

Giddens's reconfiguration of these multiplying positions into a center-left counter to neoliberalism is done in the name of not only a new Way but also an emerging cosmopolitan global democracy that can make vertical linkages between governing institutions and local regions, reconcile the nation-state with cultural pluralism, and stand against free-market globalization (*Third Way Renewal* 129–146). That implies a new cosmopolitan class, one empowered in part through the very forces of globalization that it is expected to work against.

In contrast to this cosmopolitan radicalization of the center, Ernesto Laclau and Chantal Mouffe call for a "radicalization of democracy," and they take Giddens to task for viewing politics as a process of technocratic consensus-building dialogue rather than a conflicted articulation of adversarial social relations. While his radicalism takes place "in a neutral terrain, whose topology would not be affected," theirs seeks "a profound transformation of the existing relations of power" (xv). That is, he makes symbolic topographical rearrangements that maintain capitalist and state dominations, whereas they stake out oppositions amid a wider range of social relations.

But like Giddens, Laclau and Mouffe recognize that pluralized cultural antagonisms have supplanted the significance of class struggle. They reduce the proletariat's privileged agency in revolutionary change and reject an economistic historical necessity reliant upon the intelligibility of a finite social totality. Thus, they replace the orthodox "scientific" Marxist concept of a social revolution based in economic conditions with that of a political revolution structured through the articulation of a "*complementary* and *contingent*" logic of hegemony (3, their emphasis). The meaning-fullness of the social and its subjects neither found nor transcend the nodal structures of articulation, which, as contingencies, are open and unfixed. "The practice of articulation," they explain, "consists in the construction of nodal points which partially fix meaning; and the partial character of this fixation proceeds from the openness of the social, a result, in its turn, of the constant overflowing of every discourse by the infinitude of the field of discursivity" (113).

This partiality, along with the overflow, precludes any historical or teleological fulfillment brought about by a single (class) agent in a social revolution. Instead, the political field remains contested and unstable, composed of articulated and antagonistic agents in positional struggles over hegemonic relations. Of course, Laclau and Mouffe engage these struggles through a democratic socialist strategy, so they retain the overarching antagonism of left and right. It, and the division between its terms, supplies their primary relational signifier: keeping key distinctions intact, holding the precariousness of contingent identities and linkages in check, and minimizing the risk for ideological transversals.

Still, to expand "the chain of equivalents between the different struggles against oppression," they urge the left to adopt the liberal discourse of individual rights—despite that being, at that time, a banner issue in Thatcherism and Reaganism's dismantling of the welfare state and renewal of social inequalities. Laclau and Mouffe insist that individual rights could still serve as a discursive transversal node advantageous to the left, given

the fact that *the meaning* of liberal discourse on individual rights is not definitively fixed; and just as this unfixity permits their articulation with elements of conservative discourse, it also permits different forms of articulation and redefinition which accentuate the democratic moment. (176, emphasis in original)

Fair enough. But as with liberty, the articulation of individual rights in CMC and cyberculture (which gained considerable cultural dominance, and even self-claimed revolutionary status, since 1985, when their book was first published) has become linked more to libertarian discourse and its efforts to disarticulate the left/right axis.

NEW ARTICULATIONS

By the 1990s, the definitive, and self-defining, discourse of cyberculture tried to assert a symbolic hegemony over new forms of CMC, typically hitching its claims to the open and nodal structure of the Internet, as well as the supposed revolutionary momentum of all ICT. These digerati—the most articulate of what Arthur Kroker and Michael Weinstein at the time called "the virtual class"—sought to universalize cyberculture as a democratic (yet exclusive) *topos* of informatic freedom, situating its netizens (and especially themselves) as the privileged agents of technosocial transformation. Collectively they were, in Laclau's words, "a limited historical actor" presenting "its own 'partial' emancipation as equivalent to the emancipation of society as a whole"—although because such an equivalence can never be realized, the process required domination, making the "it" inherently unstable ("Identity" 47).

Instead of proceeding through a Third Way, many in the virtual class asserted their domination in the spirit of Alvin Toffler's "Third Wave." Raising universalization to the level of an ultimatum, this promised inevitable and sweeping change to the entire cultural, social, and political landscape—as well as an advantageous position to those most technologically savvy. Although not everyone would be wired for this new technosocial order, its full participants would need to be. Participation would also demand new forms of liberty; and until those could achieve general consensus, the advantaged would have to declare their own independence.

As John Perry Barlow did in his famous 1996 "Declaration of the Independence of Cyberspace." Originally an incensed email responding to the passage of the Communication Decency Act portion of the Telecommunications Act of 1996, the Declaration asserts cyberspace as a social and political territory and announces its secession from—and transcendence of—the illegitimately governed and now outmoded material world. Instead of trying to fix cyberculture's hegemony over the existing social and political terrain through an imminent universalism, Barlow posits an alternative universe where hegemony can already be immanent. Both symbolic and imaginary, this "civilization of the Mind" is an ostensibly open territory (a frontier) accepting of differences—yet also a totality demarcated and united by its assumed alterity from the material world. Barlow directs his

cyberlibertarian ire at the state, which he deems hostile to civil society, particularly the one developing online. An independent cyberspace, he proclaims, will be an extended community, even a nation,[21] without a state—one that is stabilized not through governmental coercion but through the unity of a shared culture in which difference won't matter. Or, put differently: where that cultural independence is dependant on the linkage between technology and politics—that is, a technopolitics that forecloses governmentality.

Eight years before Barlow's Declaration, Timothy May proposed a more limited secession in his "Crypto Anarchist Manifesto": the segregation of information transfer by means of encryption technology. Rejecting national sovereignty, freely flowing encrypted data would have the power to generate a social and economic revolution. Based in his belief that "the Net is anarchy" ("Crypto Anarchy" 69), May's "crypto anarchy" is, in fact, a variant of anarchocapitalism[22] and prioritizes individual rights—so long as those don't extend to intellectual property rights. Strong cryptography would be anarchocapitalism's technological guarantee for maximized free-market exchange, including piracy (no longer considered as such)—with hierarchies based on technical skills a side benefit. "Whimsically" ("Crypto Anarchy" 69) modeled on the Communist Manifesto (it opens: "A specter is haunting the modern world, the specter of crypto anarchy"; "Crypto Anarchist" 61), May's manifesto turns Marx's on its head, reworking a radical attack on capitalism into a radical endorsement of it.

This reversal is not just whimsy, however; nor is it just a reversal. Instead, it's symptomatic of a broader ideological loosening and emblematic of the political transversals dominant in, and particular to, cybercultural discourse—what *Wired* magazine editor Louis Rossetto would later (and with confusing parallelism) call the "right/left fusion of free minds with free markets." The term "anarchy" holds the most transversal significance for May. Already a deviation for the party-line left, May rearticulates it with the right in order to undo the political spectrum from this newly announced position of power. *Wired* contributor and underground comics pioneer Jay Kinney would dub the political position of the cyberculture's privileged class "anarcho-emergentist-Republicans."[23] Also nodding to Marx, Kinney shows some ambivalence toward this position's universalizing efforts, if not the position itself:

Someone, probably Marx, made the observation that emerging classes tend to envision utopia in their own image. Small wonder then that here in the heart of the information economy the dream that seizes the imagination of our rising cyber class of entrepreneurs and code-warriors is one of empowerment and autonomy through greater information and technology. It's not a bad dream, really, although like most utopian visions it hinges on a certain mode of behavior becoming universalized—in this case computer literacy, gadget acquisition, and a voracious appetite for ersatz reality. ("Anarcho-Emergentist")

Kinney's ambivalence extends to the left/right schema. Introducing a symposium called "Storm Warning: Are Left and Right Obsolete?" that he edited for the *Whole Earth*

Review, Kinney expresses his own disillusionments with each side of the divide, concluding that neither fits the complexities of current social and cultural circumstances. Nor does he have much faith in cyberlibertarian free-market absolutism or New Democrat/ New Labour Third Way programs. But he seems to favor liberation more than liberty when he criticizes cyberculture's revolutionary discourse for encouraging affluence instead of fighting oppression ("Beyond").

That's not a criticism found in Virginia Postrel's best-selling 1998 polemic, *The Future and Its Enemies*. Although not specifically cybercultural, that book did acquire "demi-cult status in the high-tech world"[24] when first published—in no small part because of how it argues for the obsolescence of left and right. According to its promotional website, "conflicting views of progress, rather than the traditional left and right, increasingly define our political and cultural debate."[25] Elements of both the left and right have become similarly resistant to progress, Postrel claims, especially when dealing with new technological, scientific, and economic developments. She labels this retrograde coalition "stasists" and opposes them to "dynamists," the emergent heroes in her new dichotomy.

Like Giddens, Postrel links certain left and right positions in an effort to address, and fix, a political terrain that has grown less welcoming. But she outdoes him in her broad remapping of the symbolic topography. And instead of aligning left and right in a neo-progressively centrist way that can keep up with the times, she does so to marginalize those deemed out-of-touch. Postrel bases her argument, and antagonisms, on a commitment to progress, which the dynamists naturally dominate—they're on the future's side, after all. The future returns the favor in the form of a nondeterministic necessity: whatever happens, the change will be good—and the dynamists can be the force for this good. Postrel's elaborate straw-man argument disarticulates the future-phobic portions of both left and right and makes them metronyms for their respective wholes, rearticulated as "stasists." She could have easily done the same with the "dynamists" (as Giddens does with Third Way). But she doesn't. That may have made progress too progressive; plus, it would reduce dynamism's newness effect—the hegemonic temporality, at the threshold of the future, that justifies its transformation of spatial topography and grants it the natural right to lead.[26]

Postrel's dismissive left/right linkage contrasts with the adoptive one more prevalent in cybercultural political discourse: its "bizarre hybrid" of "New Left" and "New Right" liberalisms derided by Richard Barbrook and Andy Cameron as the "Californian Ideology." Ultimately, they believe, a cooptation by the neoliberal right, its "contradictory mix of technological determinism and libertarian individualism" has become "the hybrid orthodoxy of the information age" (366). Along with its utopian antistatism, this ideology masks (and justifies) the economic and social inequalities that empower the virtual class, stabilizing its dominance in an otherwise precarious configuration.

Much makes sense in Barbrook and Cameron's formulation; still, their older left Marxism overlooks the complexities and partialities of the transversal articulations making up the Californian Ideology's hegemonic efforts. They see those simply as "contradic-

tions" within the Ideology. This emphasis on ideological contradictions presumes an ontological coherence and discreteness for left and right; and it assumes that those should hold true for its hybrid, as well. But an articulatory structure comprises partially, incompletely, and unstably linked positions. The Californian Ideology may well signal the virtual class's desired hegemonic rearticulation (and reifying it with such a catchy name might even help with that). But Barbrook and Cameron's critique of its contradictions, targeting hybridity itself, is less an analysis of a complex context than an attempt to restore, and fix, the oppositions of left and right. It even acquires a tone of moral protection against a not-so-veiled sexualized and racialized threat (especially in relation to California) when Barbrook refers to that hybridity as "promiscuously mixing New Left and New Right" ("HyperMedia" 55).

The "new" seems to be Barbrook and Cameron's real problem, however[27]—especially regarding the left, where that newness implies a cultural political turn (though they reduce this to "hippy" culture)—and may even encourage promiscuity, since left and right apparently hook up through their mutual newnesses (in a hot tub, no doubt). In implying infidelity, "new" marks off a deviationist segment of the left that, in consorting with the right, constitutes a new antagonism—a new enemy. In this way, Barbrook and Cameron's position becomes a strangely contrasting complement to Postrel's. The former project their dangerous left/right hybrid onto the future-driven high-tech vanguard, while the latter projects her more pathetic one onto the backward-looking neo-Luddites.

Whether sublation ensues from this is hard to say. If so, its affirmation and cancellation may articulate an unresolvable antagonism not only around the dynamics of newness, and not only around the intersection of left and right, but also around the discursive force of libertarianism in reorganizing the future political terrain. Of course, the libertarian leanings of online political discourse (and, as Paulina Borsook recounts, the high-tech industry as a whole) has been commonly accepted. Others fear the more hard-right luring of unsuspecting web surfers by means of "a few misleading and confusing links" (Hoffman, *High-Tech* 9; cf. Hoffman, *Web*). However, the demographic data on CMC's relation to political and ideological positioning is more ambiguous. It does indicate a rightward direction—including in topological preferences in topographies. Still, that "right" is not singular, and its multiple positions attempt transversal links cutting across the political spectrum and between top-ranked centers and long-tailed margins.

LIBERTARIAN LINKINGS

A 2004 Nielsen//Netratings survey presents an American "online population" more politically active[28] than the general one, with the web increasing its political importance during the 2004 presidential election—although only 12% of that population regard the web as their most important source for political information. Moreover, the more active members of that population (those who have contributed to a political organization) skew considerably

to the right, judging by their online news sources. Their top four are National Review Online, NewsMax.com, the Drudge Report, and WorldNetDaily (Nielsen//Netratings).

By contrast, a 2004 report on "The Internet and Democratic Debate" for the Pew Internet and American Life project shows an even split between those who visit partisan liberal and conservative websites, with broadband users favoring more liberal ones.[29] The survey's authors also conclude that, far from "insulating themselves in information echo chambers," Internet users are "exposed to more political arguments than non-users" (Horrigan, i–ii).[30] More respondents supported George W. Bush (44%) than John Kerry (39%) (iii), though they claimed more knowledge of issues than of the candidates (v). Majorities supported the Iraq War (53% to 39%) and opposed gay marriage (70% to 26%), reflecting an overall center-right orientation. This shifts more left—or populist— on the question of free trade: 41% find it mostly bad for the U.S. economy and workers, while 31% find it mostly good (vi). Significantly, twice as many respondents had heard the arguments against free trade more than the ones for it (30), challenging assumptions about the dominance of proglobalization discourse—and also suggesting possible links between traditionally conservative and left/liberal positions.

In further contrast, the measured optimism of both the N//N and Pew studies over the Internet's vital role in political discourse is tempered by a Peter D. Hart Research Associates/Panetta Institute for Public Policy study, also released in 2004. It shows deteriorating confidence in the political process on the part of American college students, with those who believe that voting in a presidential elections results in "a lot" of change dropping from 47% in 2001 to 35% in 2004. Yet 79% of the total 2004 respondents—a higher percentage than the general population—also think that a presidential election matters for specific issues (Peter D. Hart, "Attitudes" 11; cf. Peter D. Hart, "Making").[31]

The 2004 respondents broke down as 44% Democrats, 30% Republicans, and 21% Independents. They were fairly evenly split on whether the country was heading in the right direction (40% yes, 42% no) and on satisfaction with the country's leadership (48% each for yes and for no, down from 68% satisfied in 2001). Black (59%) and Hispanic (50%) students were more likely to say that the country was misdirected ("Attitudes" 2, 5). Yet only 36% of computer science majors said politics was relevant in their daily lives, compared to 67% of social science majors and 72% of humanities majors (12). This shows that prospective members of the virtual class are some of the least satisfied with the political landscape (though little about their specific ideological perspectives).

The web itself seems to share their dissatisfaction, based on how it ranks depictions of that landscape. Its topology seems to favor a more libertarian-oriented topography. Of the top one hundred images returned on a Google search of "political spectrum"[32] (of which thirty-three were actual images of political spectra), one third (the highest plurality) were variations on the Nolan Chart, the dominant libertarian alternative to the left/ right axis, followed (at 27%) by a dual-axis schema similar to the one Bobbio recommends. Of the rest, 15% were circular, 6% were authoritarian/anarchist continua, and 14% were too idiosyncratic to classify. The conventional left/right axis had only one

image (3%), although as the dominant schema, it needs less depiction. Plus, it's not too visually striking.

The Nolan Chart is a more structurally sophisticated version of the tendentious authoritarian/libertarian (or anarchist) continuum meant, in part (and when used without an intersecting left/right axis), to align fascism and socialism. It was introduced by Dave Nolan, one of the founders of the Libertarian Party, in the January 1971 issue of the Society for Individual Liberty's magazine, *The Individualist*, and later "resurrected," according to Nolan, for use as a Libertarian "recruiting and promotional and mind-changing tool" (Harris). Literally based around a concept of "freedom," it arranges politics into an equiangular diamond measured by two converged forty-five-degree axes at its foundation: one for degrees of "personal freedom," the other for degrees of "economic freedom." These plot out corners for "authoritarian" (or "populist") at the bottom, "liberal" on the left, and "conservative" on the right, leaving a "centrist" square in the middle. "Libertarian" is at the top. This placement not only constitutes libertarianism as a distinct and fixed entity worthy of its own corner; it graphically asserts libertarianism's position beyond left and right, at the apex of hegemonic domination in the symbolic political field. Of course, with "freedom" as a twofold measure, libertarianism's chances to win are doubled. Topographical victory remains wishful thinking, however, since libertarianism—and anarchism—still tend to modulate other positions (as Bobbio maintains), not stand solely on their own. Yet those modulations can take on new power in an openly networked topology, more so than in a closed diamond—and especially if the topographic dominance of left/right axis diminishes. In conjunction with particular issue-events, such as those involving government surveillance, intellectual property, and the Iraq War, libertarianism and anarchism can be modal articulators enforcing potential transversal linkages.

Such is the case with the website antiwar.com. Cocreated by Justin Raimondo in response to the NATO bombing of Serbian forces in Bosnia and Herzegovina, antiwar.com's critique of the second Iraq war is, likewise, based on objections to international military intervention. Featuring contributions from right-libertarians (like Raimondo), conservatives (like Pat Buchanan), and both (like Ron Paul), it also culls pieces from liberals and leftists (like Juan Cole and Noam Chomsky). Similar ideological intersections can be found in visits and hyperlinks. True, Alexa.com (July 2005) shows that antiwar.com visitors mainly went to other conservative and/or libertarian sites opposed to the war (LewRockwell.com, and its related Ludwig von Mises site; the Cato Institute site (http://cato.org); and iraqwar.com, "a conservative/libertarian coalition opposed to wars & hypocrisy whereby we create our own enemies"). However, some also visited AlterNet (http://alternet.org), *The Guardian* (http://guardian.co.uk), the American Friends Service Committee site on Iraq war (http://afsc.org/iraq), actagainstwar.org (an anticorporate San Francisco Bay Area group), and globalsouth.org (concerned with improving conditions of poor countries in the context of globalization). Links into antiwar.com include ones from *CounterPunch* (http://counterpunch.com), TalkLeft.com, and a number of indymedia centers. Regarding this last example, user-generated anarchist/libertarian-inclined sites could

be particularly significant in articulating limited and partial links between traditionally left and right positions.

THE OTHER THIRD WAY (OR, WARS OF POSITION)

How does the Third Way's topographical revisionism situate topologically? A Google search on "third way"[33] returned 12.3 million hits, with three of the top ten in the spirit of Giddens's project, at least in its New Democrat/New Labour versions. Two of those were for sites affiliated with the Democratic Leadership Council, the main forum for New Democrats in the US.[34] The other (www.third-way.com) was an amateurish-looking site advocating Clinton/Blair progressivism and endorsing John Kerry for president.[35]

The top-ranked site, www.thirdway.org, bills itself as "the voice of the radical centre"; but it has nothing to do with the policies or politics of Giddens, Blair, or Clinton. Instead, it's the site for the British nationalist, separatist, and anticapitalist organization Third Way, which was formed in 1990 from the splinters of the far-right National Front by one of that group's former—and most notorious—activists, Patrick Harrington. Inspired by a tradition of right-wing third-way and third-positionist movements, this Third Way, like other similar groups, purports to have abandoned (explicit) white-supremacist policies for a form of ethno-cultural-national segregation espousing mutual self-determination, justified as a variant on the politics of difference. Inspired by, in its view, the working-class and anti-Hitler national socialism of Otto and Gregor Strasser, along with the mystical-pagan fascism of Julius Evola, it aligns itself with nationalist-religious revolutionary movements (as in Iran), the racial separatism of the Nation of Islam, and the participatory democratic ideals of Muammar al-Qaddafi's Libya (it promotes his *Green Book*). Moreover, it draws on the Frankfurt School's critique of capitalist mass culture (especially Adorno; Horkheimer and Adorno), tinged with Oswald Spengler's notion of the decline of the West.

In one sense, this Third Way is just some marginal far-right particularist group using the web to out-position a more established left-leaning cosmopolitan program—helped by Giddens's own choice of a signifier already used on the right. A long-tailer that lucked into the top rank. Only the most politically naive surfer would think thirdway.org has anything to do with Giddens, New Labour, or the New Democrats. Still, according to Alexa.com (May 2004), visitors did move between that site and those of other minor UK political parties: nationalist ones (including the British National Party), socialist ones, and some more liberal/democratic ones. What motivated, or resulted from, these intersite visitations is unknown; but they at least mean that, given the abundance of information in the long tail of politics, users can more easily maneuver through various ideological positions, whatever their reasons. And if the search terms align, power laws might even push something from the long tail into a top ranking.

The site itself creates left/right transversals through particular issues (more so than events), combining Third Way–authored and –aggregated articles that support native and indigenous peoples, advocate green politics, and condemn globalization—including one

on the 1999 anti-WTO demonstrations in Seattle.[36] These led George Monbiot to warn in *The Guardian* that, generally, "The far right is trying to hijack the green and anti-globalisation agendas"; and, specifically, Third Way "most clearly articulates the direction in which the politics of the hard right are shifting." Monbiot's warning is in keeping with Chip Berlet's earlier one about, in the United States, the right "wooing" the left by providing conspiratorial political research to progressive organizations such as the Christic Institute and Pacifica Radio.[37]

The Southern Poverty Law Center (SPLC) goes further than Monbiot or Berlet, depicting all antiglobalization radicalism as, fundamentally, an extremist mixture of left and right that is, ultimately, the tool of the racist far right. "What was behind this truly remarkable mix?" an article archived on its website asks about the anarchist-blamed riots at the WTO protests in Seattle. "How was it that members of the far 'left' and 'right' found themselves facing down police together? In the answers to these questions may lie the shape of future American extremism" (SPLC). While Monbiot attempts to differentiate left agendas from right usurpers, the SPLC, in a discursive move recalling both Postrel (with "stasism") and Barbrook and Cameron (with "new"), uses "anarchism" as a term through which a deviationist "extreme" can be symbolically merged and purged. From its own radical center, the SPLC distinguishes itself from radicalisms not only too hard right but too hard left—or, worse yet, too hard to define. Instead of confronting the more precise nodes, and modes, of transversal articulations—and antagonisms—among anarchist movements (many of which support nonracist democratic politics), the SPLC pushes all radicalism to the extreme, and to the right.

Still, the SPLC has a point. "Anarchism" has gained prominence as a discursive modulator for some right-wing groups—namely the factious alliances of the evolving "national anarchist" movement.[38] Like Third Way, these groups typically disavow explicit racism, while still avowing European traditional heritage (Protestant, Catholic, and/or pagan) and espousing anti-immigration policies. Their politics are based in an ethno/cultural concept of stateless tribal nationalism: a form of natural community governed through organic hierarchy, in which the affinities of shared ethnicity and culture surpass those of the modern liberal state by providing a homogeneously self-organizing social order.

The movement's web presence centers mainly around the "Smash the System" webring and the Terra Firma website (www.national-anarchist.org), and the links from the latter give a glimpse into some of the movement's ideological connections. Most of those links, and the categories that organize them, make clear its position on the far right. Categories include "national revolution," "traditionalism," "falangists," "paleoconservatives," "paleolibertarians" (with two links, one to antiwar.com and the other to LewRockwell.com), and "immigration reform." However, "red browns" points to the communist/fascist amalgams of Central and Eastern Europe, including "national bolshevist," or "nazbol," groups.

A few of the categories (like those for "alternative media" and "ecology") and a significant number of links are more ideologically transversal. The "cultural terrorists" category

links to the neo-Situationist "Adbusters" site. The links to information and commentary sources mix conservative/religious (WorldNetDaily, Christianity Today) and neoracist "European descent" (Altermedia) websites with left and progressive ones, including those for AlterNet, *Democracy Now!*, *Mother Jones*, the *Village Voice*, the *Utne Reader*, Molly Ivins, *CounterPunch*, and the Huffington Post. (These last two make their own less extreme challenges to the left/right schema, though from the left.) None of these linked-to sites are anarchist themselves (and the links are out, not in); still, "anarchism" facilitates the linking by functioning, in this situation, as an ideological dis- and re-articulator more than as an ideological perspective. Indeed, most self-identified anarchists would probably call "national anarchism" an oxymoron, if not a downright corruption.

Yet there it is. And the question is whether (returning to Bobbio's schema) it pulls anarchism/libertarianism to the right—or pulls the right, and some of the left, to the anarchist/libertarian position. That is, which axis—or which quadrant—has hegemony? Or has the very topography of axes and quadrants (and even triangles), given way to a more networked topology of hubs and links? If so, left and right certainly remain major hubs—but maybe on less of a bipolar linear continuum. And anarchism, in addition to disarticulating, also serves as a modal articulator that traverses, and transverses, between different positions, different nodes (such as nationalism, capitalism, republicanism, and cryptography), modulating their possible articulations and antagonisms with others. There are limits to this, of course; national anarchism (or Third Way—which does not identify as anarchist) seems worlds away from anarchocapitalism and crypto-anarchism—or dynamism and cyberlibertarianism, for that matter. Its anticapitalist traditionalism, not to mention its ethno/cultural communitarianism, is at odds with their faith in the global entrepreneurialism of technoscientific innovation.

Nonetheless, both national and crypto-anarchists (as well as many left-aligned anarchists) are tangentially, if not tangibly, connected through their use of Hakim Bey's concepts of pirate utopias and temporary autonomous zones—making him a transversal authority (or mother-ship) in an extended potential community. More significantly, both national anarchists and cyberlibertarians (Barlow, at least) imagine a social order constituted by individuals situated in self-organized, self-regulated, relatively homogeneous, and organically hierarchical communities—although the homogeneity and hierarchy are based on very different measures of identity and rank.

There is even a curiously semidirect link between thirdway.org and cyberlibertarians: Jay Kinney, who in his aforementioned introduction to the *Whole Earth Review* symposium on the status of left and right, endorses that Third Way over Giddens's (actually, he only mentions Clinton and Blair), praising it as "a small but feisty British group" that "represents a genuine attempt to break out of old ideological traps" ("Beyond"). Third-way.org, in turn, lauds Kinney as "a real character and one of our favorite freelance writers,"[39] and counts his (aptly named) Clinic of Cultural Confusions site (http://jaykinney .com) among their eleven recommended links. The others, tellingly, include the Agrarian Society (distributivist, ruralist agriculture reform), a site promoting Swiss canton-based

direct democracy, the Global Justice Movement site (religious-based social justice in response to globalization), a Malcolm X research site, and Stalking the Wild Taboo—a site using "scientific" proof of racial differentiation to justify population and immigration control, though Third Way simply describes its "ethos" as "anti-censorship and pro-debate."

This connection doesn't make Kinney some right-wing mole within cyberlibertarianism (which he has reservations about, anyway). Still, one has to wonder how his desire for the virtual class to combat oppression squares with his approval of Third Way. Well, we can't read his mind. But we can read him as a minor, though not insignificant, link in the contingent articulations of transversal ideological positions—or portions of positions—which can, in turn, make up transitory web communities (in R. Gibson et al.'s sense). True, those articulations, and potential communities, are on the fringe (topographically) and the long tail (topologically). But if the value of the latter could be invested in the pluralization of the former, this might yield returns in the center.

At least, that seems to be Third Way's wish: that a multiform topography less anchored by the terms "left" and "right," combined with an expanded topology that makes the less popular more available, might produce a techo-cultural-political field in which fringes and centers have greater interaction. In its pursuit of discursive hegemony, Third Way tries to shape "the very language" of debate around "'fringe' activities" that it expects to become crucial areas of cultural and political struggle. This is part of its "long-term game" of cultural politics, where, "as in Chess, early dominance of the central squares is an important aim." More to the point, and more transversally, Third Way articulates this as a "war of position," citing Antonio Gramsci's

> view that the Fascists had come to power because what we would now call the "cultural landscape" was favorable to the development of their political position. We can now take this concept further—the key element in the forthcoming struggle will be a battle for domination of key "concept" areas. We do not intend to lose.[40]

One can hope that Third Way is *too* fringe to actually win. However, the event of its top web ranking can be conceived as some sort of partial and temporary victory—and, hence, one fitting a dynamically pluralized postbureaucratic transdiscursivity organized around informationally abundant flows around issue-events. That is, one fitting the potential ways in which a shifting political topography and an expanding networked topology interact. Not only does Third Way borrow from and attempt links to the left, it also makes connections between libertarianism, traditional conservatism, and identity-based neoracism. These connections are the ones most likely to be effectual.

Of course, Third Way is only one point, one node in the techno-cultural-political spectrum; and despite how it articulates itself, it's not representative of the multiplicity of ideologically networked nodes—though it *is* of a subnet, and of particular modes of transversal interaction. My own point is not to warn that the interactions between

topography and topology ensnare politics in the far right, nor that libertarianism provides a slippery slope to more "extremist" positions. I am, however, trying to counter some of the more optimistic claims about the transformative interactions between politics and CMC by following some links that are either overlooked or obscured by alarmism. Still, these links do indicate some of the modes and the routes that a politics transiting through issue-events and informatic identities does take, and might continue to take, especially as the dominance of neoliberalism reaches a crisis point. And especially as the resistance to neoliberalism continues to (re)articulate itself—and replot the terrain from which it speaks and links.

POSTSCRIPT (2009)

The domain thirdway.org continues to be the top return in a "third way" Google search. However, it has changed hands, belonging now to the nonpartisan, but (U.S.) Democratically inclined Third Way, which had until 2008 been at www.third-way.com. This Third Way describes itself as "the leading moderate think-tank of the progressive movement." "Moderate" is the operative word. Its honorary chairs are all members of Congress; its trustees are mainly financial industry executives. And during the 2009 debates over health-care reform, it came under fire from less moderate progressives for strategically leaking a memo of its draft position against a public option (Zaitchik). Perhaps that domain is meant for interlopers as much as transversals. The old thirdway.org is now thirdway.eu, and it doesn't even reach the top 100 "third way" sites.[41] This change is itself indicative of the transitory ways in which political topography and networked topology interact. Still, that example suggests how other similar transversals might take place, and become displaced, particularly as disaffected political agents transit through other political events.

ABOUT THE AUTHOR

David Wade Crane produces critical and creative work, in collaboration with others and on his own.

NOTES

1. Sincerest thanks to Amelie Hastie, Tara McPherson, Edward O'Neill, Catherine Ramírez, Warren Sack, and Lily Woodruff for advice, discussion, and support; and to Michella Rivera-Gravage for research assistance (funded through a University of California, Santa Cruz, Academic Senate Committee on Research Grant). The preliminary ideas were presented in 2000 at Refractions and Revolutions: Beyond Convergence, part of the Confronting Convergence: Critical Interventions in New Media seminar series sponsored by the Annenberg Center at the University of Southern California—though next to none of that remains in this version. Most of the work was done while in residence at the University of California Humanities

Research Institute during the Winter 2005 quarter, as part of the Law and Humanities in an "Information Age" research group.

2. Mainly for purposes of distinction, I will use "topography" in reference to politics and "topology" in reference to the web and other forms of CMC/ICT. This is also conventional, particularly topology's use in the computing technology literature. The terms overlap semantically, however, and both can be used in reference to politics. For example, Laclau and Mouffe, influenced by Lacan, use "topology."

3. Hargittai's post and Beito's response are at http://crookedtimber.org/2005/05/25/cross-ideological-conversations-among-bloggers. Liberty and Power (http://hnn.us/blog/author/32) is a libertarian blog, part of the History News Network, a multiblog project of the Center for History and New Media at George Mason University. In a later response (13) to Hargittai, Beito says that Liberty and Power would "like to link more on the left but an obvious problem is that liberal blogs are less interested in exchanging links with us than the conservative ones. [Arianna] Huffington's blog [then www.ariannaonline.com/blog/; now www.huffingtonpost.com/], for example, has almost a total blackout on libertarian blogs, especially antiwar ones."

4. I will use the term "transversal" because it denotes limited points of intersection rather than more widespread "blurrings" or "fusions" between left and right; however, the intersections may not be strictly at 90 degrees. Bobbio also uses the term (see below).

5. Sack (*Actor–Role*) uses actor–role analysis, and a software application of it called "Spin-Doctor," to complicate Jameson's ideological analysis based on semiotic squares. Using the tactical alliance between antipornography feminists and fundamentalist Christians as a model, he illustrates how actor–role analysis "allows one to unpack some of the internal structure of the various positions and thereby more specifically articulate the tensions and affinities between points of view" (33). The upshot is that alliances between groups and interests over an issue do not negate the other differences between them, even on that particular issue. The downshot is that, if politics becomes organized more around events than issues, this analysis may no longer square.

6. The Green movement has long used the slogan "beyond left or right."

7. Rogers is discussing Issue Crawler, a software application designed to map colinked websites that are networked around particular issues and organizations. Issue Crawler was developed by Govcom.org, the Amsterdam-based foundation that Rogers directs.

8. "Issue-events" is my hedge between Bimber (event) and R. Rogers (movement between issues), and shorthand for an event-focused issue.

9. See van Dijk for a detailed analysis of the various ways that ICT have been applied to Held's democratic models. Using van Dijk's terminology for communication concepts, the consumerist parties use ICT for consultation and registration (though more for views than for membership), while the grassroots use ICT for conversation (38–41). In their study of American political parties and the web, Margolis, Resnick, and Levy find "major-party dominance rather than a trend toward the equalization of competition among major and minor parties"—although the Libertarian Party's numbers were anomalously strong (66).

10. Besides those mentioned, key examples include those by Dodge, Dodge and Kitchin, R. Rogers ("Introduction"), Sack ("What Does" and *Agonistics*), and Smith and Kollock.

11. See Kleinberg, as well as Brin and Page, for searching based on authority/hub communities, and R. Rogers (*Preferred*) for critiques of such approaches. "Community" in this case

is more a structural term designating the organization of websites, not a CMC-based social relationship or a "virtual community" (see Rheingold). In their work confirming and expanding on Gibson, Kleinberg, and Raghavan's hypotheses, Toyoda and Kitsuregawa define community as "a set of pages densely connected by symmetric derivation relationships" (30). Compare Sack ("What Does") on mapping USENET conversations through pivotal issues.

12. Giddens (*Third Way Renewal* 38, drawing upon Sternhell).

13. Torben Bech Dyrberg offers another model for the expansion of the left/right dyad by adding three new sets of directional metaphors: up/down, dealing with power, authority, and status; front/back, dealing with openness, transparency, and direction (progress/regress); and in/out, dealing with inclusion and marginalization (355). Left/right would still be fundamental to this multidimensional schema, but it alone, he believes, cannot adequately capture the complex arrangement of contemporary political and ideological positions (357). While the model's own complexity precludes it from ever replacing the left/right axis in public discourse, it can provide a useful model for more analytical work and a way to plot more logically what can otherwise seem to be "contradictory" transversal articulations. Or it may be symptomatic of the increasing complexity of the political spectrum.

14. All searches discussed in this sequence of paragraphs were conducted on May 4, 2004, with follow-ups. The remaining two of the eight are associated with U.S. government agencies: Radio Free Europe/Radio Liberty (www.rferl.org) and the American Liberty Partnership (www.libertyunites.org), which supports disaster relief. The categories that I used are as follows: left libertarian, left progressive, left socialist/communist, governmental (nonaffiliated), libertarian, right libertarian, conservative, racist right, neoliberal, and neoconservative. Usually I was able to rely on the site's self description.

15. Added February, 2014: A clear sign of this essay's anachronism—and perhaps more so, of fleeting postbureaucratic political articulations within the long tail—is that many, if not most, of the hyperlinks cited here are now dead, with their material sometimes relocated. Except for when those dead links are under discussion (as in the postscript), I won't flag each example. It is an inevitable situation and an unavoidable condition of the web's always out-of-date presentness.

16. A small number of sites (7) did not readily fit these categories.

17. Equality seems to remain associated with the left, however. Searches on "equality" and "equality politics" yielded results almost exclusively on the center/left or left, with most focusing on issues of gender, sexuality, and/or race—though few explicitly on class. One site appeared in both the equality politics (ranked 10 and 11) and liberty politics (ranked 25 and 26) searches: the left/progressive Open Source Politics (www.ospolitics.org), for two archived articles. One supports equal marriage rights for gays and lesbians (www.ospolitics.org/legal-writes/archives/2004/01/15/equality_0.php); the other is about liberties lost because of the USA Patriot Act (www.ospolitics.org/legalwrites/archives/2003/11/05/the_phanto.php). Open Source Politics does not deal with open-source software issues, although it clearly evokes them.

18. Giddens's most thorough handling of the topic is in *Beyond Left and Right: The Future of Radical Politics* (1994), which initiated numerous authored (*Third Way Renewal, Third Way Critics*) and edited (*Global, Progressive*) works on the Third Way. In political practice, it is most associated with the market-liberalized centrist progressivism of Tony Blair's "New Labour"

and Bill Clinton's "New Democrats." Giddens insists on the distinction between their policies and his proposals (See "Introduction" 2 and *Third Way Critics,* though in the latter he responds mainly to criticisms of New Labour).

19. The epithet "paleoconservative" used in the United States by neoliberals and libertarians expresses this tension.

20. The term "new right" is a fluid one. I'm using it for particularist groups inspired by Alain de Benoist's *Nouvelle Droite* ideas and that emphasize cultural (and ethnic) rather than class differentiation, while also drawing on "old" conservatism. Giddens tends to use "new right" for neoliberalism. Neoconservatism (also frequently called "new right") shares neoliberalism's geopolitical aims, but it subjects the market and, more so, foreign policy to critique along moral and traditionalist lines.

21. Jon Katz's "Birth of a Digital Nation" highlights this particular kind of cybercultural nationalism (including its "postpolitical" aspects). However, borrowing the title of a film that celebrates the antistate "alternative politics" of the Ku Klux Klan and fantasizes its unifying role in white supremacist American nationalism might say something about how homogeneity and exclusion are foundational to, while disavowed in, cyberculture's own discursive demos.

22. May's ideas about anarchocapitalism are influenced by David Freidman and, yet again, Hayek.

23. The article title, "Anarcho-Emergentist-Republicans," may actually belong to a magazine headline writer, as that position isn't really the focus of Kinney's article (although he snidely calls it "ever popular"). It comes from the self-description of one respondent to an informal survey by *Wired* on the political perspectives of "a potpourri of techno-buffs, online denizens, Silicon Valley employees and observers of digital culture"; and it is idiosyncratic within the range of responses. In a longer draft of the article, called "Digital Politics 101" and hosted on Kinney's website, he reveals that the largest plurality (17.5%) describe themselves as "progressive," followed by "libertarian" (15%). "Anarchist" got 10% ("Digital"). Still, that a minority position is given such signifying power by *Wired* is important. Kinney's comics of the 1970s and '80s include *Anarchy* and *Young Lust.*

24. According to a *Vanity Fair* blurb quoted on the book's website (www.futureand.com /index.html). Also, Postrel (at that time, editor of the libertarian magazine *Reason*) puts the new class of computer technology producers at the forefront of dynamism, which is itself exemplified by the ethos of Silicon Valley. Postrel is tech-savvy herself, having blogged long before it was popular (the latest version: http://vpostrel.com/blog).

25. Originally at www.futureand.com/about.html, but currently at http://vpostrel.com /future-and-its-enemies.

26. An economic antagonism entwined with the dynamists/stasists dyad is that of an independent entrepreneurialism against a statist and corporatist technocracy.

27. Postrel does imply that Barbrook and Cameron are statist stasists (225, note 20).

28. "Politically active" means being registered to vote (86% of online population, 70% of general), signing a petition, sending an email or letter to a politician, and/or "wearing a button" (Nielsen//Netratings).

29. Ten percent each for liberal and conservative sites, but this is out of only 16% of those surveyed who visit partisan sites at all—all of whom also visit mainstream ones. Broadband users split 15% for liberal and 10% for conservative sites. Kerry supporters were more

likely to visit a "non-mainstream" media site than Bush supporters (36% to 29%) (Horrigan et al., vii).

30. Although 42% of respondents had received information about the 2004 Kerry and/or Bush campaigns through CMC (Horrigan et al., iii), only 15% named the Internet as their primary source for campaign information, ranking it next to last (ahead of only magazines [4%] and just behind radio [16%]) of the five choices. Television led with 78%, followed by newspapers with 38% (vi).

31. Not surprisingly, the Internet ranks higher as the primary source of political information for college students (25% in 2004) than for the overall population, but this is still well below television (61%) and slightly behind newspapers (26%) (Peter D. Hart, "Attitudes" 12). More surprisingly, the primacy of the Internet as a political news source declined slightly from 29% in 2001 ("Making" n.p.).

32. Conducted on February 3, 2005.

33. First conducted on April 26, 2004, with follow-ups. During this period, the sites in the top ten remained relatively stable, and the number-one site remained the same. In more recent searches (June and July 2005) that site has dropped, though it remains in the top ten.

34. The New Democrats Online (www.ndol.org/ndol_ka.cfm?kaid = 128), the DLC's "online community for political leaders," characterizes the Third Way as "a global movement dedicated to modernizing progressive politics in the information age"; and the Progressive Policy Institute (www.ppionline.org), "a research and education institute" and part of the nonprofit Third Way Foundation, promotes "new progressive politics for America in the 21st century."

35. This refers to www.third-way.com as accessed on April 26, 2004. A later iteration (www .third-way.com/leadership, last accessed on June 15, 2005) became more professional in look and content, with a "management team . . . composed of political entrepreneurs who have served in senior positions in Congress and the Clinton Administration and also have extensive experience running successful national advocacy groups."

36. Harrington also gives a positive review of the *Left Book Club Anthology* (Laity), also posted as the first of three at amazon.co.uk (seven of eight users found it helpful) and under the screen name "doublethink" as the only review at amazon.com (one of one found it helpful). Mother Earth, a Third Way–affiliated organization with a different website (www.geocities.com /CapitolHill/2229), publishes an eponymous print magazine that addresses environmental issues from the perspective of traditional conservative values. The WTO/Seattle article is by Michel Chossudovsky, of the Canadian leftish-conspiracist Centre for Research on Globalisation (globalresearch.ca), itself a transversal organization. Third Way also promotes a special issue of the journal *Telos* 98/99 (Spring 1994): *The French New Right–New Right–New Left–New Paradigm?* The overall political project of *Telos*, which uncritically combines right-wing antiliberal political theories of Carl Schmitt, the communitarian European new-rightism of Alain de Benoist, and left-wing critiques of liberalism and mass culture (based mainly on the Frankfurt School and Walter Benjamin), might be the academic complement to Third Way.

37. Berlet ignores some of the ways in which right-wing groups also draw upon left-wing analysis (granted, a more recent phenomenon) and relies upon a kind of seduction theory that casts the left as the ingénue.

38. National anarchism is as much a rival as an ally to Third Way, as it is associated with a different splinter of the British National Front.

39. www.thirdway.org/files/weblinks/links.html. This link now redirects to the homepage of the completely different Third Way organization that now uses this url, as discussed in this essay's postscript.

40. All quotations in this paragraph are from www.altculture.org/ccult/ccult1.html, the site for Third Way's affiliated magazine, *Counter Culture,* which in turn is part of the group's website addressing popular culture, http://altculture.org.

41. Added February, 2014: And as of now, this domain is up for sale. The last capture of the functioning site by the Internet Archive's WayBackMachine was on December 17, 2013. http://web.archive.org/web/20131216044136/http://thirdway.eu.

THE DATABASE CITY
The Digital Possessive and Hollywood Boulevard

Eric Gordon

The development of visual media in the twentieth century made photography and movies the most important cultural means of framing urban space, at least until the 1970s. Since then, as the surrealism of *King Kong* (1933, dir. Cooper and Schoedsack) shifted to that of *Blade Runner* (1982, dir. Ridley Scott) and redevelopment came to focus on consumption activities, the material landscape itself—buildings, parks, and streets—has become the city's most important visual representation (Zukin, 16).[1]

In the summer of 2000, I took a bus tour of Hollywood. I went into the experience with the assumption that the tour would primarily be about the media spaces that make up the city—this film was shot here and that one was shot there. But what I did not realize was how much emphasis would be placed on photographing and reproducing those media spaces—"If you snap this picture, it'll be the exact scene from the movie," the tour guide repeatedly instructed. The trolley tour departed from Grauman's (then Mann's) Chinese Theatre on Hollywood Boulevard and headed north to Franklin, where we were instructed to photograph the steps of the Hollywood United Methodist Church, where the opening scene of *Sister Act* (1992, dir. Emile Ardolino) was shot. Next, we were taken to the top of Beachwood Canyon, otherwise known as the "best place in the city to photograph the Hollywood sign." The trolley pulled over to the side of the road and the guide instructed the passengers to take a picture. After a few minutes for the photo-break, the tour continued. On the corner of Yucca and Ivar, we found the "best perspective of the Capitol Records building." And with the trolley blocking traffic on Melrose Avenue, we were instructed to snap a picture of the Paramount Studios gate. Before arriving back

where we started, we drove by the not-yet-finished "Hollywood and Highland" development, where we were told about the upcoming photo opportunities. "Right there," the guide said, "will be the place to take the ultimate picture of Hollywood." Interestingly, the guide didn't suggest that one would want to photograph the development—only that one would want to use the development as a staging ground for photographing Hollywood.

The Hollywood and Highland development, which opened in 2001, is an urban entertainment district (UED) built in the heart of Hollywood. It is composed of six hundred and thirty-five acres of retail, dining, and entertainment spaces, all structured around a central courtyard, which is a reproduction of Babylon Square, the set of D. W. Griffith's epic film *Intolerance* (1916). This stage set, both a historical referent and an access point to other historical referents, was designed to be the primary interface to the "concept-city" of Hollywood. Looking through the arch to the Hollywood sign "will be the postcard shot for millions of American tourists who flock to Hollywood each year," said David Malmuth, the project's lead developer, in a press release. "Walking on the Boulevard today you see people craning their necks to find the sign and the best vantage point to photograph it. Hollywood and Highland will not only capture this moment, but create the *true* Hollywood memory" (TrizecHahn).

Of course, this truth is composed of fantasy. The urban sociologist John Hannigan suggests that consumer fantasy is the primary building block of the contemporary UED. They are developments that set out to create "a new kind of consumer who feels 'entitled' to a constant and technologically dazzling level of amusement" (70). He likens these spaces to what Sharon Zukin calls a "theme park": seamless narratives spaces where the surrounding "authentic" urban fabric is downplayed, if not consciously repressed. To be successful, themed spaces need to mask their boundaries by obfuscating the distinction between the fantasy city and the real city that contains it (Baudrillard). For example, "New York, New York" on the Vegas strip and "Hollywood Boulevard" at Disney's California Adventure operate as self-sufficient representations, where all the essential interpretive components are contained within the structures.

But despite the surface similarities to the theme park, Hollywood and Highland is different. Its narrative is composed by pointing the spectator's attention outside of the development's physical boundaries. It is a representation of Hollywood *in* Hollywood. The city's context defines its content—a point emphasized in the development's press material. According to Malmuth, "Hollywood and Highland embodies the same glamour, excitement and emotion in an environment which goes beyond the seeing to the being there" (TrizecHahn). Mann's Chinese Theatre is now, once again, called Grauman's Chinese Theatre in an attempt to rekindle the glamour associated with that space in the 1920s. Even the reconstruction of the set of *Intolerance* is in reference to the historical space of the city—the set existed in Hollywood as a tourist attraction for more than a decade after the film's opening. The spaces of Hollywood and Highland all link outside the development into a database of Hollywood imagery. The difference between a simu-

lacrum like "Hollywood Boulevard" in Disney's California Adventure and a database space like Hollywood and Highland is that the former claims to be a perfect simulation of the city, while the latter claims to avail its referents to spectators. The former denies access, while the latter grants it.

This is the "database city"—a city with no content other than to grant access to content. Hollywood and Highland, despite its vulgarity, resists the singularity of narrative repetition by providing a platform for spectators to assemble their own narratives. It was built for a spectator who wants to reconnect with the city but doesn't want to be told precisely how that connection is to take place. This is the same spectator, steeped in the language of digital networks and databases, who desires a city he can possess and organize into a personalized urban narrative. I call this mode of spectatorship the "digital possessive"—a form of urban spectatorship that corresponds to everyday navigation patterns of digital landscapes. Possessive spectatorship becomes quite literal in the digital possessive as the practices of networked media encourage, if not mandate, the possession of thoughts, actions, and memories in personal folders, accounts, and devices. Just as information online is assembled and ordered in digital aggregators, in the city, material structures, physical spaces, narratives, imagery, and other people are assembled and ordered in urban aggregators—physical spaces built to construct a sense of possession and control over urban experience and history. The example of Hollywood and Highland, while extraordinary in some respects, is an archetype of an urban development built to accommodate this spectatorship. What follows is a reflection on the parallel developments of urban and digital spaces—and how the corresponding practices that emerge from each are becoming increasingly difficult to distinguish.

TOWARD A DIGITAL POSSESSIVE

In 2006, *Time* magazine named "You" the person of the year. As part of what the magazine called a "revolution" in networking technology, they described how the new web is ushering in a culture of participation where users are just as likely to produce as they are to consume. This technological and cultural phenomenon first found a name in 2004, when Tim O'Reilly organized a conference called "Web 2.0." The term has since become the most recognizable designation of new trends. While it remains controversial to many critics (Scholz; Zimmer; Lanier), it has had unquestionable influence in solidifying economic investment in the post-dot-com network landscape. Americans are contributing to wikis, keeping their own blogs, writing reviews for Amazon, keeping their photo albums on Flickr, and making movies to post on YouTube. They are entrusting their most intimate thoughts and records to corporate servers and services. And yet, in what *Time* calls the "new digital democracy," the consumer holds the power. "You control the media now," reads a headline, "and the world will never be the same" (Grossman, 42). This is a rather strong declaration, especially coming from a major media company with a lot at stake in continuing to control the media.

Time is not alone in this apparent capitulation to the power of the people. In January 2007, CBS announced that users could clip, share, and "mash-up" television content. Companies that once clutched to the control of content with all their might are now saying they want users to "make it their own." Leslie Moonves, the chief executive at CBS, announced that he supports this strategy because it enables the network to tap into the passion of dedicated viewers. "If somebody spends the time to take 20 clips from *CSI Miami*, I think that's wonderful," Moonves said, "That only makes him more involved with my show and want to come to CBS on Monday night and watch my show" (Associated Press). Moonves, along with many other top executives at networks and production companies, are realizing that the rules of the game have changed. There are different tactics involved in being a successful gatekeeper of content. Now, many companies are adopting the strategy of hiding the gate and giving everyone the key. In other words, they're giving users the perception of control while blurring the boundaries between control and consumption.

This transition has been years in the making. After the dot-com bubble burst, the commercialization of the web continued, but in a more cautious and orderly fashion. The flood of money into new ventures all but dried up as venture capitalists sat back and watched users populate cyberspace. This time, however, they weren't coming for preprogrammed content, as everyone thought they would only a few years earlier; they were coming to do things—chat, hang out, share "cool stuff" (Weinberger, *Small Pieces*). Digital networks were taking on a different character. In 2002, the social networking site Friendster was an overnight success. And with the popularity of Myspace in 2003, Facebook in 2004, and Google's IPO also in 2004, the consumer web was making a comeback. Of course, when the video-sharing site YouTube went from start-up in February 2005 to commanding a $1.65 billion purchase price from Google in November 2006, it became quite clear that there was big money in no longer "controlling" the media.

While the reverberations of these deals extend to every sector of the American population, they have been most notable with teenagers. According to a study by the Pew Internet & American Life Project, fifty-five percent of American youth between the ages of twelve and seventeen use online social networking sites (Lenhart and Madden). As such, companies are focusing on this demographic to demonstrate and alter the norms of online interaction. According to Chris DeWolfe, one of the founders of Myspace, "The Internet generation has grown up, and there are just a lot more people who are comfortable putting their lives online, conversing on the Internet and writing blogs" (Cassidy). The comfort level that users have in putting their lives online is not a natural product of the Internet. Companies like Myspace have normalized the expanding perception of privacy in online public spaces. By giving users personalized access to networks, they have perpetuated the impression of stability and control. Certainly, this phenomenon is much bigger than Myspace alone; most social media platforms employ at least a few possessive adjectives to identify user access points (i.e., *my* page, *my* box, *my* favorites, etc.).

The personalization of online spaces produces user behaviors whereby marketable details of personal data are exchanged for the convenience of network interaction and consumption. It's not that users are being deceived, but, rather, that they perceive the conveniences of online acquisition, personalized product suggestions, and the pleasure of "just hanging out" as outweighing the potential threats of data harvesting and surveillance. In the United States, it is much easier for corporations to collect and use personal information than it is for the government. The consumer data collection industry in the United States spends millions lobbying against more restrictive data policies so that the imbalance doesn't change (Dash). This friendly climate toward personal data collection by corporations suggests a willingness to be monitored as long as it results in the convenience and perceived control of consumerism. For instance, just as most major retail outlets monitor consumer habits for future marketing campaigns, consumers have come to expect the resulting convenience of that surveillance. If you want to return something purchased at a different store, you expect the data to be networked; if you lose a receipt, you hope that the store has kept your records. Regardless of the threats that accompany this compromised privacy, the payoffs are much more immediate.

Most users understand that digital actions are recorded and archived. But few have an understanding of the life of those actions. Daniel Solove suggests that privacy concerns that emerge in contemporary digital culture are not simply a matter of total surveillance by a malevolent overseer; instead, they are a matter of data disclosure to "objective" machines. Each user builds for herself a "digital dossier," personal data connected to an IP address or username, that can easily be recalled by a machine. For instance, Amazon's "recommend" feature, or YouTube's personal statistics or private channels, or even automatic forms, are silently customized through everyday use. Microsoft is working on software that could predict the gender, age, occupation, and location of a user by analyzing search histories (Marks). In essence, the machine is watching our every move, recording it, and then playing it back for us. Solove argues that instead of looking to Orwell's *Nineteen Eighty-Four* as a descriptive metaphor for digital surveillance, it is more accurate to look to Kafka's *The Trial*. We are being watched, but by whom and for what reason is unclear, even for those doing the watching.

So why are users comfortable with this kind of uncertainty? The answer rests in the suggested transparency of many networked interactions. Personal data, even those with little practical application, are made available to users. For example, Google gives users access to their personal search histories. Even though the same information is shared with marketers, the ability to see it within one's personal (and personalized) interfaces suggests the ability to control it. Through the process of personalization, the conception of one's computer as private receptacle of personal data is extending to the larger network. As Vito Acconci explains, "the electronic age redefines public as a composite of privates" (914). As a result, users have come to expect access to personal data from multiple computers and multiple devices. Freeing information from spatial constraints has become associated with personal freedom and mobility. Private space is no longer

limited to a singular physical location; rather, private space in networks is wherever we happen to be. And network privacy is the manageability of complex information environments through the personalization and adaptability of those environments.

Consider Microsoft's 2007 advertising campaign for its Internet Explorer 7 browser. In the video ad, a man runs through his daily routine: brushing his teeth, buttering toast, and feeding the cat. But instead of using a toothbrush, a knife, and a can opener, his bare hands take on these tasks. He steps outside in his bathrobe to take out the trash and sees a very attractive female mail carrier approaching on a bike. He uses his hands to transform his bathrobe into an ironically "stylish" seersucker suit. He then frames the woman with his hands, snaps an imaginary photograph, and pulls a Polaroid from his wrists. The commercial concludes with the caption "Everyday tasks made easier." Within the always-on culture of network communication, users have become dependent on the technology that enables their access to people and things. Accordingly, Microsoft is not only selling access to the network, they are selling freedom from the anxiety that goes along with being detached from the network. And ultimately, they are selling access to the roving private spaces users have come to expect.

This is the digital possessive. It implies a different kind of access to the sensations and experiences that compose the world. What once were the invisible traces of social life—browsing, consuming, and talking—have become visible building blocks of digital environments, on par with buildings, streets, and nature. The connective tissue between objects, the searches and networks that assimilate data into meaningful organizations, has itself become the object of engagement. Relations have become "empirical" in the traditional sense. They are fully visible and accessible phenomena for the spectator to assemble in the process of composing her experience of networks.

As such, the digital possessive can be described in two parts: (1) it is the transformation of relation into observable and lasting objects—in digital networks, relations are material; and (2) it is the ordering of those objects within personal interfaces. For example, at any given moment, a Facebook page is the externalization of the subjectivity of the user (boyd). It is where objects, broadly conceived, are organized into comprehensible experiences. To be clear, this externalization does not replace the experiencing subject; it only extends the processes of experience into networks.

Indeed, the need to order relations should be considered a product of modernity, rather than a product of the Internet. Consider this quote from Marcel Proust:

> Even in the most insignificant details of our daily life, none of us can be said to constitute a material whole, which is identical for everyone, and need only be turned up like a page in an account-book or the record of a will; our social personality is a creation of the thoughts of other people. Even the simple act which we describe as 'seeing someone we know' is to some extent an intellectual process. We pack the physical outline of the person we see with all the notions we have already formed about him, and in the total picture of him which we compose in our minds those notions have certainly the principal place. (20, translated by Moncrieff and Kilmartin)

Well before the Internet made it possible to plot one's personal thoughts and physical navigations, the social need to order was apparent. Speaking of a social personality that is composed of tiny bits of information stored in the minds of the multitude of people we come across, Proust asserts that an objective self is impossible. It does not exist; it is assembled again and again in every context. Thus, "seeing someone we know" is a complex process whereby we aggregate memories and impressions into a singular experience. Imagine if those impressions, for Proust merely relegated to the minds of observers, were externalized and uniformly available. Imagine if one's private thoughts as well as public actions could compose the impressions on which others relied to assemble your social personality.

Digital social networking is ostensibly transforming the social personality as such. Instead of relying on the whimsy of others, users can manufacture their own data to be ordered by others, and likewise, they can obtain greater control in ordering the data of people and places with which they come into contact. But these external processes require maintenance. As every personal action leaves a data trace, what once was only a fleeting sensation to be immediately experienced by another subject is now materialized into the network to be ordered by human and machine. From reading to driving to dating, data, even if not always accessed, is always accessible. As a result, the ordering of the "plural world of things in interaction" has become the primary task of network spectatorship. This is reminiscent of Martin Heidegger's understanding of modern technology, where instrumental ordering converts the objects and activities of experience into what he calls "standing reserve," a process through which "everywhere everything is ordered to stand by to be immediately on hand, indeed to stand there just so that it may be on call for a further ordering" (220). *My*-oriented spaces, ready-to-hand and organized to suit the spectator's needs, constitute an entry point to this "standing reserve." Within these spaces, data, including personal data, is "on call" and can be ordered and reordered in line with emerging interests and needs. Now that personal search histories are ready-to-hand, it is just as much a part of one's orderable world as a favorite movie or favorite song. Heidegger makes clear that this process of converting experience into data implies a double loss: (formerly) stable subjects not only become alienated from objects in the world—which are being converted into "objects-for-personal-use"—they also become alienated from themselves. The human subject, according to Heidegger, "in the midst of objectlessness is nothing but the orderer of the standing reserve . . . he comes to the point where he himself will have to be taken as standing-reserve" (220).

Heidegger's rather bleak formulation of technological subjectivity would seem to be manifested in every act of network consumption, "producing not docile subjects," according to Drew Hemmet, "so much as better consumers." Each act of consumption is premised on the ability to access a seemingly infinite data set of images and references, while having the impression of being able to assemble that data set to meet the immediate needs of experience. And as digital social media have effectively blended the details of user experiences with the details of urban history, the complex composition of urban

space, once relegated to individual interpretation, is now both collectively composed and composed from the data traces of the collective.

THE DATABASE CITY

As one enters Hollywood and Highland from Hollywood Boulevard, the first thing she sees is the Hollywood Walk of Fame—a renewal effort in its own right that started in 1960.[2] With over two thousand names etched into the city's sidewalk, a walk down the Boulevard is already an interactive experience. One is literally reading the street and making connections between it and familiar cultural texts. The already established Walk of Fame functions as a kind of gateway into the complex. Unlike a mall, Hollywood and Highland has an expansive and quite dramatic connection to the boulevard—a large, spectacular staircase spans the distance from the courtyard to the street, encouraging visual and physical connection to the surrounding city.

Once the Walk of Fame ends at the limit of the boulevard's sidewalk, another sidewalk text immediately begins. This one is a public art project by the satirist Erika Rothenberg entitled "The Road to Hollywood." The artwork contains forty-nine stories of how different people in the entertainment business came to Hollywood, gathered from interviews, books, oral histories, and articles. Rothenberg assembled brief sound bites from Hollywood actors, directors, musicians, and others and sprinkled them within a red road that spirals throughout the complex. To enhance the mystique of the quotes, they are all anonymous. One of them reads as follows:

> I parked my car in front of each movie studio, posed, and waited to be discovered. That never happened, but eventually I got a manager. He turned me into a movie star.—Actor

And another:

> I drove out from Missouri with my luggage piled up to the back of my head and all the way to the top on the passenger side. I couldn't see behind me, but I was heading west, and that's all I needed to see. —Movie Star

The road ends on Highland Boulevard at an oversized chaise lounge made of glass-reinforced concrete over a steel frame. Visitors can sit on the lounge and take their pictures with the Hollywood sign in the background.

Rothenberg's piece can be read in a number of different ways. For many of the tourists who visit the site, the road is read as a straight, rather sincere documentation of the Hollywood dream. They seem to consume the individual stories with an ardent excitement and conclude their experience with what seems an unironic photo opportunity in front of the Hollywood sign. However, it is not difficult to imagine that the piece can also be read as a satire—a series of understated stories from anonymous people spread along a

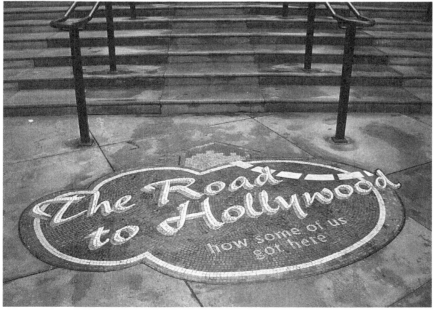

red carpet to a big glass casting couch. In other words, along the road to success, there is only fantasy, with the inevitable result of exploitation. In either case, the road serves as an interactive narrative of the stereotypes and mythologies of Hollywood. Whether one reads it ironically or sincerely (or both), the text passages are search strings within the broader database of the city.

Once one arrives in the central courtyard, it is impossible to miss the replica of the set of *Intolerance*. The set piece, as I mentioned above, is significant to the city's history on a number of levels. For quite a while, it held the distinction of being the largest, most expensive set ever built. In addition, the stage set remained in Hollywood on the corner of Hollywood and Sunset and served as a tourist attraction for years after the film had wrapped. Its connection to both the soft city of the cinema and the hard city of architecture make it an apt metaphor for the new Hollywood. Whether or not one is knowledgeable of these histories does not preempt a user from experiencing the space in the intended way, because the possibilities of its interpretation are built into the database.

INTERACTING WITH THE DATABASE

If, in the middle of the twentieth century, the promise of machine intelligence was the self-sufficiency of the machine and its ability to interact with the world of humans, interactivity, as it is now understood, is more aligned with the *user's* ability to interact with the world through machines. While this may not seem like a dramatic departure, it has wide-reaching rhetorical effects: interactivity now represents our ability to transcend the machine—to use it to enhance human experience, as opposed to using human experience to enhance the machine.

Interactivity has become a defining feature of digital media. And yet, there is no agreement as to the meaning of that feature. Many theorists and artists have invoked interactivity as the liberator of consciousness from linear narrative and passive consumerism (Landow), while many corporations have appropriated interactivity as a means of focusing narrative and enhancing commodity consumption. Interactivity, therefore, does not necessarily equal a greater degree of freedom in narrative interpretation—it does, however, equal an enhanced perception of this freedom. Janet Murray, in her book *Hamlet on the Holodeck,* suggests that two complementary forces define interactivity: procedure and participation (72). "Authorship in electronic media is procedural," she writes. "Procedural authorship means writing the rules by which the text appears as well as writing the texts themselves" (152). In other words, a sense of authorship, or participation, in digital media is not simply premised on the creation of content, but also on the way in which that content presents itself. Participation, according to Murray, is the ability for a user to at least have the *impression* of having an effect on the text.

Murray focuses on the beginning of the interactive computer-game phenomenon, with "role playing" adventures like *Zork* that were designed in the 1980s. In this realm, she admits, all that could be expected was an "interactivity-effect," as the technology was

not yet available for "high latency" interaction in which the user could actually change the preprogrammed environment (Meadows). Today, interactivity has become the chief motivator for media spectatorship. News sites such as CNN.com consistently feature opinion polls about the news of the day as a means of inviting participation. And most market sites such as Amazon.com and Target.com appropriate user reviews into their format. The benefit to these companies is less the value of the content provided by users and more the seduction of interactivity to compel users to stay.

As the web has changed the audience's ability to interact with content, the "old" media are trying to adapt (Bolter and Grusin). Most new television game shows have an "audience version" where people can call or text in to "play at home." *American Idol* has perhaps been the most successful at this, giving the television audience an opportunity to vote for the winner by dialing a phone number. Websites (fan created or official) for television shows offer episode recaps, discussion forums, and games to extend the text beyond the allotted broadcast time. Movies, too, commonly offer games, forums, character profiles, and other small content areas with which users can interact (Jenkins). While these sites extend existing content through what is commonly referred to as "transmedia," the content is not their most important attribute. Interaction has, itself, become the content of the media—a self-perpetuating system, as each interaction expands the size of the database.

DATABASE NARRATIVE

To further explore what I mean by the "database city," I turn to a discussion of a DVD-ROM produced by The Labyrinth Project, entitled *Bleeding Through: Layers of Los Angeles, 1920–1986* (2003). This visual piece uniquely illustrates the complex interactions between urban practices and practices within a database environment. Appropriately, its producer, Marsha Kinder, characterizes the project as a database narrative—something she defines as a narrative

> whose structure exposes or thematizes the dual processes of selection and combination that lie at the heart of all stories and that are crucial to language: the selection of particular data (characters, images, sounds, events) form a series of databases or paradigms, which are then combined to form specific tales. (6)

Every aspect of the narrative's unfolding is theorized within this framework. It explores the story of a real-life woman named Molly and her memory of 66 years of life in Los Angeles. It's a murder mystery, or rather a mystery about things that disappear, whether a human being or the city around her. But ultimately, the things that go missing are all the inevitable casualties of narrative.

Bleeding Through is a work of fiction. It's also a work of urban documentary. Each bleeds through to the other, leaving only a database of information and images. Conceived as story

and archive, the inner workings of the database illuminate the dual processes of narrative and cultural context. The narrative is divided into three tiers. In the first, the cultural critic Norman Klein, positioned in a little window in the upper right portion of the screen, recites Molly's story. The story is divided into seven chapters, each representing a major period in her life. The user can move about these chapters in any order she chooses, effectively constructing the sequence of the narrative. But as becomes clear within the first moments of engaging with the project, the story itself, like all stories, is just the beginning. While Klein talks, the user glides through a number of sequences of images, all loosely related to the narrative, but none directly so. The images—some of old buildings from Bunker Hill, some of now defunct nightclubs, and others of domestic interiors—are related memories. They don't fill in the gaps left by the narrative; they don't complete a thing, but instead supply the context for storytelling. As Molly's story is reduced to a linear narrative through Klein's narration, her life—all the things that might have composed her perceptions and memories—are brought to the front. We quickly realize the limitations of biography as we search through its details—entranced by all those scraggly components unwilling to get into narrative line. The images hang on to the story, but because we have freedom to peruse them at our own pace, they take on a life of their own; they form a narrative of their own.

Some of the images are clips from movies, further fictionalizing the details that compose Molly's past. Still others are what the producers call "bleed throughs." These image

compositions are archival pictures of downtown Los Angeles coupled with modern pictures taken from the exact same location. A slide bar beneath the image allows the user to move from old to new and back again, fully illustrating the city's erasures and the sometimes dire manipulations of personal memory. These compositions expose the process of remembering, sometimes filled with sadness as we realize what's no longer there, and sometimes with comfort as we notarize the past with our gaze. In these images, the workings of the database are unveiled; as the past bleeds through to the present, we are given the impression of access; the archive promises to flesh out experience.

These images can, by themselves, support some kind of narrative structure. Molly's story, as told by Klein, is by no means the central aspect of the experience. The user can actually choose to turn off the commentary and just navigate the database, further highlighting the tenuous nature of narrative within the DVD. In the novella that accompanies the DVD, Klein writes Molly's story in a linear fashion but questions his own position as narrator. He distances himself from the novella's authorship by citing his own name in the third person and suggesting that the narrator, in fact, doesn't exist:

> Of course, first, I must tell you that I do not quite exist—that is, in the *a priori* sense. I am contingent, an invention of Norman Klein. He and I mostly coexist on the page, but once you close the book, not much of me will be following you into the DVD-ROM. I am the opening act, so to speak. But I have been doing my homework. I believe I have found a program that allows me to function as a ghost inside the DVD-ROM. . . . So if while operating the DVD-ROM you sense another presence breathing down your neck, it will most likely be me. (Norman Klein, "Bleeding Through" 42)

Klein is here referring to the first-person perspective of the novella as narrative itself. In the DVD, he implies, there is no linear narrative to guide the user through. She will inevitably construct the narrative through the materials given her, but it will not be an overwhelming presence. *Bleeding Through* de-emphasizes the master narrative within the overall experience. The user moves through the DVD in expectation of narrative moments but learns quickly not to rely on them. What might be "breathing down your neck" while navigating the DVD is that glimmer of narrative, a fulfilled expectation that is quickly taken away and replaced by the equally compelling drive to search and interact.

In the project's two additional tiers, the story, and Molly's life, grows deeper. The second and third tiers bring together archival material both related and unrelated to Molly. In the second tier, we are given access to the process of historical writing, seeing for ourselves how documents turn into plot and movies turn into flourishes. Klein delivers a bit more background on Molly, but for the most part, the user gets the opportunity to reverse-engineer her story. The third tier is composed of all the things Molly never mentions but that are influential nonetheless: politics, the bevy of movie murders committed in her general vicinity, even maps. Interviews with Japanese Americans talking about internment, Los Angeles residents talking about race relations, and clippings from

newspapers are just some of the materials to navigate through. Taken alone, they construct elements of a narrative—that hook on to which we always latch the second we feel it "breathing down our neck."

Bleeding Through provides a means to visualize that tension between personal control and narrative structure that exists in the city. But the question remains: what is the motivation for users to interact with this text when it requires such sustained engagement? Espen Aarseth provides some insight into this by defining these sorts of texts as "ergodic." The term is borrowed from physics and is derived from two Greek words, *ergon* and *hodos,* meaning "work" and "path." Aarseth argues for the distinction between traditional texts and what he calls "cybertexts," which for our purposes here can be correlated to the database narrative. In a cybertext, he argues, narrative meaning is constructed through the "work" of the user; whereas in a traditional text, the "reader, however strongly engaged in the unfolding of a narrative, is powerless. Like a spectator at a soccer game, he may speculate, conjecture, extrapolate, even shout abuse, but he is not a player." The reader of a cybertext, conversely, *is* a player—with all the problems that accompany that distinction. On this topic, it is useful to quote Aarseth at length:

> The cybertext puts its would-be reader at risk: the risk of rejection. The effort and energy demanded by the cybertext of its reader raise the stakes of interpretation to those of intervention. Trying to know a cybertext is an investment of personal improvisation that can result in either intimacy or failure. The tensions at work in a cybertext, while not incompatible with those of narrative desire, are also something more: a struggle not merely for interpretative insight but also for narrative control: "I want this text to tell my story; the story that could not be without me." In some cases this is literally true. In other cases, perhaps most, the sense of individual outcome is illusory, but nevertheless the aspect of coercion and manipulation is real. (4)

As one engages in urban practices within the database city, the presence of the database provides incentive to interact—it makes the spectator a player. A successful development communicates from the outset that outcomes of walking through the space are never entirely predetermined—they are dependent on the user's engagement with references and her willingness to control the space's unfolding narrative to accommodate immediate desires. While "individual outcome" is almost certainly illusory, the impression of that outcome is one of the main rhetorical goals of the database city.

COMPOSING THE DATABASE

It we accept that the presence of the database influences urban practices, it is important to scrutinize just how the database is composed and how it is ultimately integrated into the city. To this end, I look to the most common database interaction—Internet search. When I type the word "Hollywood" in Google's image search, a seemingly endless stream

of pictures is retrieved. Everything from the Hollywood sign to that famous picture of William Faulkner lounging poolside to a postcard shot of the Capitol Records building. These pictures have an obvious connection to the city. They each represent a Hollywood icon. With some of the results, however, the connection isn't so clear. An image of a dog named Hollywood and a roadside diner in the Midwest grace page 19 of the search. A studio executive and a drawing of dinosaurs are on page 26. While these images don't seem to be immediately relevant, their inclusion in the list is determined, most likely, by something to which they're linked. Google crawls through every available website and retrieves relevant images on the basis of the frequency and quality of links to and from the image. The set of images is not displayed in alphabetical order; rather, it is displayed in the order of their PageRank, which is an algorithm designed to determine the relevance of the results. Essentially, it determines how well a particular link is cited throughout the web; the logic is that a page hyperlinked to many other pages is probably worth looking at. Put another way, PageRank is the probability that a random surfer will visit a particular page. Regardless of the relative obscurity of some of the 57,500,000 pictures included in the results of my search, taken as a whole, these pictures mark the existence of an important representational device: *the database image.*

In using Google, the user is able to transform any word or phrase into a collection of images. At the time of this writing, "Los Angeles" is rendered in 91,100,000 image files and "New York" in 197,000,000 image files. While it is difficult to imagine a situation in which one would view all of these images simultaneously or take them all to constitute a particular meaning, the very existence of these data sets, constantly expanding with the scale of the Internet (these numbers have grown threefold in the course of a single year), produces a particular relationship between the user and the image. When I perform a Google search, the single image with which I interact is always in the context of all similarly classified images online. This relationship might be described as "paradigmatic." According to Saussure, words are always situated within two simultaneous contexts: the syntagmatic and the paradigmatic. The syntagmatic is the relationship between words in any given sentence, and the paradigmatic is the relationship between words in abstract categories (e.g., nouns, verbs, and adjectives). In this sense, just as my use of a noun in a sentence is informed by its status as a noun, my engagement with any given image online is informed by the set in which it is found. It exists within a database image—an image that is the whole of any particular paradigm.

But according to media theorist Lev Manovich, new media has forced a change in Saussure's linguistic model. For Saussure, the syntagm implies presence, in that words are brought together either verbally or textually; and the paradigm, appropriately, implies absence, in that relations exist only within the minds of the speaker or writer. Film theorists such as Christian Metz (*Language and Cinema*) have taken up this model to explain the semiotics of narrative—an approach that became the foundation of structural film theory. But Manovich suggests that new media have reversed these semiological categories. "Database (the paradigm) is given material existence, while narrative (the syntagm)

is dematerialized. Paradigm is privileged, syntagm is downplayed. Paradigm is real; syntagm, virtual" (*Language of New Media* 231). The data set, not the narrative, according to Manovich, is the primary means through which meaning is made in contemporary new media. He goes on to say that "regardless of whether new media objects present themselves as linear narratives, interactive narratives, databases or something else, underneath, on the level of material organization, they are all databases" (228).

Underneath every representation is a database image—the correlated search results to any particular query. "Hollywood" provides a database image; "Love" provides another. These too-big-to-be-comprehended images are the assumed backbone of every representation. Each act of possession or organization within digital networks presumes an interaction with a database image. David Weinberger (*Everything Is Miscellaneous: The Power of the New Digital Disorder*) refers to the possibility of this interaction as the "third order of order." The first is the organization of things themselves, and the second is the organization of things into categories (the Dewey decimal system, for instance). The third, enabled by digital media and without physical restrictions, makes it possible for each bit of datum to serve multiple functions and occupy multiple places. A table is a type of furniture; it is also a wood product, perhaps a chair (if it's low), an object for lamps to sit on, and a place to eat dinner. The table does not have to exist in only a single category because of the limitations of library subject headings or traditional encyclopedias; in the third order of order, the table can be all of those things at once. In Weinberger's language, it is "miscellaneous." It doesn't need to be limited to a single category, because it can (and should) occupy multiple categories. The same is true of the database image: each of the 57,500,000 images that answer my Hollywood image search can just as easily be found in other searches.

Search is integrated into nearly every aspect of the web—from social networking services to restaurant review services, the web becomes usable when its vast information can be logically aggregated to accommodate a situation. Likewise, search is being integrated into urban interactions. This is the emerging spectatorship that gives unprecedented leeway to the user to determine the parameters of the city. And as most digital social networking is accessible via mobile phone, these parameters can be set while one is physically located in the urban context. Pictures from a mobile phone can be immediately uploaded to Flickr, Twitter, or any number of location-based applications. Places have become networked through the building of a geolocated information layer (Gordon and de Souza e Silva). The city is framework, never subject; scaffolding, never structure; the city becomes an interface through which data can be accessed. And as data proliferates and is accessible from wherever we are, ordering that data into meaningful categories to inform encounters with people, places, and things has come to define the city. The sheer amount of data that needs to be ordered, and the number of users now doing the ordering, has considerably altered how spectators interact with the city. The city can be assembled at any time, and in any context, to construct an impression or narrative. And while one can still engage in unmediated physical space, the city presents itself as data excess, bursting its bonds with dialogue, notes, opportunities, historical references, and other people.

SELLING THE DATABASE

So how does this play out in the physical space of the city? Although not explicitly stated, it is commonly understood among developers that providing access to the above-described excess is what makes the city sustainable. This means that the two most important pieces of any urban production are the mechanism to produce a constant supply of data and a platform from which the spectator can access it. With these pieces comes an understanding that the crowd is data, the landscape is data: if the city is a database, then all of its components must become data sets. And the function of an urban development must be directed toward granting access to that data. The reason that Hollywood and Highland is such an intriguing example of the database city is that, even before the proliferation of Web 2.0 technologies, it was built with this functionality. It is both media producer and aggregator. With every movie premiere, every broadcast, every representation of the city, the database image, or the material to which the hyperlinks connect, expands.

Consider the Dolby Theatre (originally the Kodak Theatre). Located within the Hollywood and Highland complex, the 136,000-square-foot, 3,300-seat theater is the new permanent home of the Academy Awards. It is equipped with accommodations for a 1,500-person press corps, a setting for the Governors' Ball in the adjacent five-star hotel, and a staging area to choreograph the gala arrival of the guests. The grand design of the theater is based on the structure's media accessibility. As evidenced in the theater's "media cockpit," the space is designed for broadcast. The media cockpit is an enclosed

platform on a movable lift directly above the orchestra pit. During live broadcasts, it is the technical heart of the production, containing steadicams and specially constructed small crane-mounted cameras, so as to make every corner of the complex photographable. The theater is wired throughout to handle multiple transmissions and is flexible enough to be adapted for future technological advances.

The Dolby Theatre is literally a media space, conceived with the intention of its representation. According to the theater's press release, "it will tell the story of the legend and lore of Hollywood while looking forward to the future" (Rockwell Group). This story will be told, not in the traditional architectural sense, but as an edited and interactive space. The theater is essentially the producer of new images that eventually filter back into the overall space of Hollywood and Highland. It's like an in-house content provider for the constantly expanding database of Hollywood imagery. And with each broadcast of the Academy Awards—"live from Hollywood and Highland"—more imagery filters directly into the historical foundation of the city.

The database image is complex. Likewise, the database city is not a pastiche or a schizophrenic collection of unrelated surfaces. As Frederic Jameson declares in his essay on postmodernism, "depth is replaced by surface, or by multiple surfaces (what is often called intertextuality is in that sense no longer a matter of depth)" ("Postmodernism" 559). In the database city, the user is not lost to an avalanche of signifiers; she is given the authority, motivation and framework to filter them. So while the database becomes surface, the interaction with the database becomes depth. The individual representations in the structure are not directly correlated to a specific meaning, but instead grant access to a multitude of representations and meanings. Representations are transformed from objects into tools. So what's to be learned from the commercial manifestation of the contemporary city is not some perfect image of urbanism to be emulated, but a significant structural transformation in the city. Despite the fact that Hollywood and Highland began as a commercial disappointment, with Trizec unloading the property to the CIM Group at a significant loss for $201 million in March 2004, the development continues to be relevant in the rapid transformation of Hollywood. Hollywood and Highland has functioned as a catalyst for development throughout Hollywood, not simply by bringing economic opportunity to the area, but by granting access to the long dormant database.

TOWARD A DATABASE URBANISM

Since Hollywood and Highland opened, the surrounding area has gone through significant changes. Despite the real estate crash, there are many major commercial/retail projects and residential and mixed-use projects currently completed or under construction within a two-mile radius. The majority of these developments are conceived around the renovation of historical structures. The "Hollywood Passage" project on the 5500 block of Hollywood Boulevard includes the rehabilitation of two existing buildings, including the Louis B. Mayer building and the Bricker building. There is a large event

space and more than 250 residential units. The Metropolitan Hotel on Sunset and Van Ness has been converted to creative office space. And the "Sunset + Vine" development, which takes up an entire city block, includes the art deco facade of the former TAV Celebrity Theater (home of ABC Radio and the Merv Griffin Theater). "The times are right for this kind of project," said William Roschen, one of the design architects for the development. "There is a genuine love of our cities, and that empowers designers and urbanists to go out there and be a part of that" (Stein). The Sunset + Vine development was an explicit effort to connect the city's future with its past. "Sunset and Vine will restore its immediate neighborhood in a style that ties back to Hollywood's glory days and heralds the return of a new, cool Hollywood urbanism," said Larry Bond, cofounder of Bond Capital, the project's principal developer (Aragon). One of the main features of the development, which opened in 2004, was the reproduction of the storied Schwab's drugstore (the original, which closed in 1983, was on the corner of Sunset and Crescent Heights, about two miles west of the new development). Whether in the historical place of Schwabs or the present space of the condominium lobby, the spectator is encouraged to move freely between past, present, and future, between impersonal spaces and meaningful places. But while many of these developments are anchored by at least one historical building, material structure is not the only method of granting access to the database.

"Hollywood and Vine" is a $500 million mixed-use project on five acres. While it did not renovate any historical structures, the new buildings remediate traditional urban forms. The buildings are framed by the sidewalks of two major boulevards, with the aim of bringing the urban context into the development. The W Los Angeles hotel, three hundred and seventy-five luxury rental units, one hundred and fifty luxury condominium units, and over sixty thousand square feet of retail are available from street level. The development looks outward to the street so that it can use the database of the storied corner as its content. There are hopes that the development will function as a content generator for the surrounding streets. According to Leron Gubler of the Hollywood Chamber of Commerce, "It will be the catalytic project for the rest of the Hollywood and Vine area" (NBC4).

All the developments presently under way in Hollywood are dependent on the current high market value of "urban experience" for their success. The people buying urban condominiums or traveling into the city to do their shopping are not interested only in the convenience of the location; they want to "be" in the city, they want to access its history, and they want to have new, yet familiar, experiences of urban space. They do not, however, want those experiences to be hand fed to them—they want to feel as through they have been personally obtained, worked for, and adapted. This is the nature of the digital possessive—where personal agency is as important as narrative cohesiveness in the formation of urban experience. The database city necessitates the re-membering (opposite of dismembering), the putting back together, of experience (Dewey, 99). It is in the active process of re-membering that perceptions of community and tradition are formed—a process built into the structure of new urban developments. By referencing nostalgic

urban forms, including grand vistas and spectacular sidewalk displays, new developments consistently prompt spectators to assemble ideal urban narratives. The experience of the present is communicated as a reframing of the past—not in the form of a static representation, but as an interactive re-membering. According to Dean MacCannell, spectators understand the reframing of the past as more authentic than any original display:

> Walter Benjamin believed that the reproductions of the work of art are produced because the work has a socially based "aura" about it, the "aura" being a residue of its origin in a primordial ritual. He should have reversed his terms. The work becomes "authentic" only after the first copy of it is produced. The reproductions *are* the aura, and the ritual, far from being a point of origin, *derives* from the relationship between the original object and its socially constructed importance. (MacCannell 48)

This important reversal of Benjamin's terms explains the logic of the database city. The ritual of urban experience, as MacCannell explains it, is dependent on the context that is built around the material structures of the city. The corner of Hollywood and Vine is unimportant outside of its representations, Schwab's drugstore is just another restaurant outside of its representations, and the larger flows of the city are important only in that they represent a "golden age." The assemblage of "auratic" urban reproductions has become the primary goal for developers, and the process of unpacking those references has come to define urban spectatorship. One cannot directly experience the database image; one can, however, experience the process of interacting with it.

While the developments in Hollywood are spectacular, they are by no means unique. Urban developments throughout the country are appropriating the rhetorical strategies of the database city. Capitalizing on historical images and narratives and referencing previous iterations of spectatorship, new developments are primarily concerned with producing a legible city by enabling spectators to possess or aggregate only the data they choose. As the housing and office booms of the twenty-first century's first decade produced an influx of construction into almost every major American city, each new condominium and office-tower project is marketed as a conduit to the perpetual stream of urban data. Urban developments don't need to communicate with one another; each can be a self-sufficient search engine, granting access to a unique set of urban data. The database city is soft and portable, fully contained within the conduit of the database image. While it looks out onto the surrounding urban fabric, it actually depends less on the materiality of that fabric than ever before.

AFTERTHOUGHTS

When I wrote the original version of this essay, I was responding to a particular moment of correspondence between the popular conceptualization of networked media and American urbanism. At the turn of the twenty-first century, both seemed personal and

experiential, with seemingly limitless archival possibilities. Social media was transforming every mediated thought and action into an artifact, and American downtowns, through vast UEDs, were being reimagined as repositories for cultural memories. Online social networks and the reimagined American downtown seemed distinctly urban in configuration—dense settlements defined by complex flows of people and information. And both were positioned as highly personalized spaces, creating the impression of having been designed specifically for the user.

For many commentators, these themed urban spaces cropping up in cities throughout the United States were crass representations of nostalgic urbanism, no different than a theme park. But unlike suburban malls and exurban theme parks, UEDs could be defined by how they wove representations into the physical geographies from which the representations originated. Hollywood and Highland reinscribed a classic narrative of Hollywood into the geographic space of Hollywood.

While the narrative of Hollywood in this context was limited to particular moments in history, what was interesting was the form of the narrative. Walking through the space, the story is meant to unfold over time, contingent on the location of the user and in dialogue with the existing streetscape. The narrativized city was more like an interactive database than a cohesive story or structured system.

When I started this research, I was intrigued by the possibilities of narrative interaction and play that these newly configured urban spaces embodied. They were manifestations of a moment in history that represented the novelty of digital exploration. They were imbued with the potentialities of online databases, where the user's seemingly infinite access to data could come to bear on every interaction in the city.

Walking through Hollywood and Highland today feels almost anachronistic. It represents a time in the very near past that sought to capture the contemporary enthusiasm of a new digital user. As social media evolve and mobile and locative technologies transform space into highly variable referents for personalized narrative, themed urban spaces can seem disruptive to that desired user experience. If spatial narratives can exist within and between tiny mobile screens facilitated by accessing geolocated data, then the conceptual hyperlinks built into the structure of Hollywood and Highland might be broken.

In reflecting on this work, I think its continued value has less to do with explaining the logic of a specific urban development in Hollywood than figuring a framework for understanding urban form (specifically, the articulation of cities) that fundamentally connects urban practices to media practices and vice versa.

A version of this essay was published in my book *The Urban Spectator*, which situates this moment in the history of contemporary urban and media practices within several other twentieth-century configurations, including early film and television. My next major project was a book about locative media called *Net Locality* that teased out the specific affordances of technologically mediated location awareness for urban experience. In 2010, I founded the Engagement Game Lab, which does applied research on the intersection of digital games and urban civic life. In my work now, I build games and

playful systems as a means of intervening in proscribed spaces and institutional processes that correspond with shifting expectations of usability, discoverability, and play. I strongly believe that there remain possibilities for new experiences and new forms of empowerment in urban spaces that are rooted in online practices and discoverable through digital design. I am keenly interested in uncovering how to forge a *new urbanism* beyond architectural interventions.

ABOUT THE AUTHOR

Eric Gordon is a game designer and scholar who studies mediated civic engagement, location-based media, and serious games. He is a fellow at the Berkman Center for Internet and Society at Harvard University and an associate professor in the department of Visual and Media Arts at Emerson College, where he is the founding director of the Engagement Game Lab (http://engagementgamelab.org), which focuses on digital games and playful systems that foster civic engagement. In addition to many articles, he is the author of two books: *Net Locality: Why Location Matters in a Networked World* (2011, with Adriana de Souza e Silva) and *The Urban Spectator: American Concept-cities From Kodak to Google* (2010).

NOTES

1. This chapter is an adaptation of a chapter in my book *The Urban Spectator: American Concept-cities from Kodak to Google* (2010). *The Urban Spectator* situates the concept of the digital possessive within the larger concept of possessive spectatorship and makes an argument that the American city, since the late nineteenth century, has been conceived and consumed through this peculiar form of mediated spectatorship.

2. The stars stretch for eighteen blocks (east–west) along both sides of Hollywood Boulevard, from Gower Street (on the east) to La Brea Avenue (on the west). The Walk of Fame also runs for three blocks (north–south) along Vine Street, beginning at Sunset Boulevard (on the south), crossing Hollywood Boulevard, up to Yucca Street (on the north).

CUBA, CYBERCULTURE, AND THE EXILE DISCOURSE

Cristina Venegas

In the music of Cuban composer Jose Maria Vitier, Cuba is an infinite island, a familiar romantic trope of never-ending natural and cultural plenitude. The boundless metaphor is carried over to the Internet, where homeland persists as portable, nostalgic, elusive, even forbidden—to U.S. citizens.

Cuba was still surviving inestimable odds at the end of the twentieth century, and such resilience interested new audiences and consumers of yesterday's pleasures and utopian hopes. It also appealed to book publishers, tour operators, filmmakers, and scholars who increasingly produced Cuban images and stories inside and outside of Cuba. The Cuban leadership's moniker for the moment was "Socialism or Death," characteristically organizing the future in terms of extremes. The government aggressively pushed to develop a tourist economy when the dissolving Soviet communist block forced them to chart a new course. It also renewed nationalist longings of Cubans scattered worldwide. The vestiges of communism became kitsch collectibles for consumers of popular culture and ideologies, and the Cuban government's openness to new foreign investment made all things Cuban cool. The range of imaginings about Cuba—rediscovered tropical destination, dilapidated but enchanting cities, controversial films, rediscovered musicians, thriving Black culture, and new web-inspired networks—surpass the parameters of territorially bounded national identities. In migrating to digital platforms, Cuban imaginings challenge any notion of solidity. Do the new tropes of homeland reinvention on desktop screens use familiar forms of nationalism? How do websites mediate different aspects of Latino culture, in this case Cuban-Americans, forming a dialogue with a broader Latin American social sphere?

The ideological tug-of-war expressed on websites about Cuba extends the struggle over representation, only now in the unique temporality of the Internet. Home pages and cyber-communities tap into complex personal, political, and psychological economies, exhibiting anxieties, gatherings, and intriguing possibilities for building and liberalizing spaces of discussion. As a new stage for representation, and in the face of a potential change in the island, web pages and chat groups are animated by the possibility for scattered communities to become both "discursively emplaced" and "virtually present." Carlos Lage, the Cuban vice president, believes that the Internet can best be utilized to represent Cuba's realities and its sovereignty to the world. In a 1996 speech announcing the State's official position on Internet use—which would also limit access by broad segments of the population—he states that "one of the essential advantages of this new technology is that it is the proper means through which we can reveal to the world, on a more even field of struggle, the realities of our country" (Davila).[1] Since then, the growing number of official Cuban websites reveal the strategic advantages that the Internet offers the government in terms of self-definition, visibility, and greater participation in global markets, contributing to scientific discourse, rebuilding business culture, expanding domestic and international communications, and supporting the cultural and educational sector. They are primarily aimed at an international user or to a select local audience, given the present restrictions on access to online navigation.[2]

Websites about exile narratives are authored by people outside the official realm and oppose utopian and official discourse. They engage in historical rewriting, denunciations, and, in general, disagreement with the Castro regime. At the very least, the Internet broadens the space in which to exchange competing content about democracy in Cuba, even if this includes xenophobic and extremist discourses.

The visibility of Cuba in the American news media is also as high as it has been since the Revolutionary triumph more than forty years ago. By extension, increased visibility— not necessarily more in-depth analysis—underscores the centrality of media for the Cuban government, as well as the limited range of political discourses. The story of Elián González, the six-year-old Cuban boy found barely alive, holding on to an inner tube in the Florida Straits in November 1999, which became an extraordinary media event, revealed the limited range of expression within the Miami exile community that links Cuba and Miami, in an uncanny similarity of political strategies. The incident is of special importance because Cuba and its exile community were treated to a media barrage culminating in daylong coverage of the return of the child to his father in Cuba. Elián became a symbol of the struggle between both Cubas—the defiant island and Miami's exiled community—and ended up on websites tracking the daily drama. In Cuba, an official site (www.cubaweb.cu) strategically created a link to "Elián," with his name and photo as an index of the national and international dimension of the conflict. The State politicized the significance of children for the future of Cuban revolutionary society. After his return to Cuba, a general link to *Niños de Cuba* led to a site dedicated to children's cartoons inspired by Elián's own favorites. The permanent Elián website is part of

the online archives of *Granma,* the official party newspaper. The official press covered the daily developments, and *Granma,* in particular, took on the job of attacking the Miami relatives and the exile community for their immoral acts, exposing their "deviant" life-style. The multilingual *Granma* website had its own coverage of the event, and the banner image in bold letters read "Secuestro en Miami," kidnapping signaling the crime. This site has a photo gallery and a press archive containing more than two hundred articles from *Granma* alone, covering the six months of the conflict. The list of Cuba supporters reads like a Who's Who list of the intellectual Latin American Left, reiterating their solidarity with Cuba to a global audience. All the official websites in Cuba, including the Chamber of Commerce, had a link to the Elián site, alongside trade and business information for the foreign investor, showing the regime to be a deft strategist of media.

The exile community generated equally vociferous anti-Castro websites that criticized the American government for a perceived betrayal of Cuban-American interests. Not technologically sophisticated and with crude graphics, the websites are passionate and personal, as individuals thrust themselves into highly public debates. LibertyforElian.org set up a "Help Elián Task Force," and to encourage participants to sign, it featured photos of the U.S. Government's raid to recover the boy from the great uncle's Miami house.[3] It documents the sea-crossing odyssey with extensive articles from the exile press and requests donations to help the boy. A prominent image on the site bears a mischievous Elián in the foreground against a distant Statue of Liberty. Another "Elián" website shows the mystical symbolism that the boy acquired, situating his image against that of a white dove, Fidel Castro (in Cuba), and the Statue of Liberty. The divisions and similarities between the opposing sides were never so palpable, nor so public. The war was to be fought through images and slogans. Sensing victory from the outset, the Cuban government orchestrated a media campaign around the issue. Cuban television premiered *Mesa Redonda* (Round Table), a daily political talk show, State websites and radio dedicated coverage, and mass demonstrations were strategically deployed. The use of websites at this time coincided with politicized media campaigns that revealed the State's greater investment in visual culture. "Cuba Demanda," a $181 billion wrongful-death lawsuit resulting from the Bay of Pigs invasion in 1962 and filed in 1999 by the Cuban people against the U.S. Government, took center stage on television and the on the Internet.[4] The coverage of the Elián case by both the U.S. and Cuban governments followed established but expanded patterns of official media use for political propaganda against the "enemy."

The U.S. media, both English and Spanish-language, used the Elián media event to construct a narrative of escape from communist Cuba, with the attendant subplots of survival, freedom, and politics. The U.S. presidential candidates weighed in on various sides of the issue, talk radio exploited the topic, and the rescue raid by the U.S. Border Patrol received twenty-four hour news coverage. The absurd situation culminated when U.S. Attorney General Janet Reno argued that the U.S. Government could not decide a custody case on the basis of the parent's political ideology.

The divisive issue at once reenergized and damaged the image of the exile community in South Florida. While the political character of this community has become increasingly diverse, the most radical anti-Castro voices have consistently monopolized political power and public opinion. The Elián González case revived the anti-Castro discourse in a way that no other issue had and brought back the radicalism of earlier decades, now more ensconced within official political circles of both state and local power. But just as the media helped to bring the exile cause to national attention, it also linked the Cuban community's acts with images of rioting, violence, vandalism, and extremism.

CUBAN EXILE

The Cuban exile community is defined by a complex set of historical, political, and cultural factors. The 1959 Revolution shaped the cultures of both Cuba and Miami and the ways in which the media portray them. Memory is a fetish in the ambivalent imagination of now scattered citizens. Two descriptions of the travels between Havana and Miami underscore the same point as they address different audiences: the specialized affluent reader of *Cigar Aficionado,* and an academic one. The authors observe the uncertainty of imagining these locations, sodden with historical baggage, in the experience of the exile. In "Unforgettable Cuba," James Suckling is an eyewitness of fin de siècle Havana:

> Caught in a time warp, the island serves up yesteryear's treasures to visitors while its residents struggle on. . . . Being in Havana is like living a Cary Grant or Jimmy Stewart movie of the 1940s or '50s. Though the city often feels remote compared to life in the United States, time spent here makes you reflect on the pluses and minuses of contemporary society. (62)

In her book *Havana, USA,* Maria Cristina Garcia accounts for the dislocation of travelers:

> Recent arrivals from Cuba joke that arriving in Miami is like stepping back in time into the Cuba of the 1950s. All around are visible reminders of pre-revolutionary Cuban society: schools, businesses, and organizations that shut down in Cuba reopened in exile. (4)

These descriptions point to the inextricable bond between the cultures of Cuba and the United States—a continuous link going back and forth for more than one hundred years. The movement, from here to there, contributes to the multifaceted identities emerging from the political rupture of 1959 that led to thousands of family separations. That upheaval, including the emigration of about a million Cubans, has an equal emotional weight for the exile as for those who stay behind, and it bears an indelible mark on the cultural and historical development of both places.

There are many material and historical reminders of earlier epochs in both cities, none more prominent than the figures of José Martí and Fidel Castro. Discussions about

Castro influence politics, culture, identity, personal relations, and American domestic policy. This is evident both in satirical websites from the United States that have called for Fidel Castro, "the ultimate outsider," to run for president,[5] and in the NoCastro.com conservative site, which demonstrates that "Communism by the Book," referring to the ration card, was proof of the Cuban government's infinite control over the Cuban people.[6] In Havana, physical markers of the past are part of the present living environment. Old Chevys, Mafia-era hotels, and the plumed dancers of the Tropicana club are icons of the 1950s, part of present-day life, but repurposed for the 1990s tourist trade. The absence of unfettered consumerism drives the different experience, conveying a feeling of faded glamour, as if Havana existed only in the past. Time, however, does not stand still, despite descriptions insistent on the opposite. On one hand, the hundreds of collapsed buildings throughout Havana are a testament of the cruelty of briny ocean breezes and neglect, and of the link of architectural restoration of Old Havana to new spaces of tourism. Socialist culture, on the other hand, shifted after the end of the Cold War into an ambivalent profit-seeking economy that Ariana Hernandez-Reguant described as "socialism with commercials."

Miami, too, weathers the passage of time. The old Freedom Tower in Miami, the "Ellis Island" of South Florida, now in danger of collapsing, is a museum that collects the history of all these comings and goings.[7] Despite the continuous reminders of old Cuba in Little Havana, the exile community, through consolidated political power, made Miami a major center for transnational business ventures, between North and South America, and an important cosmopolitan city. Over the past four decades, with the increasing number of exiled Cubans taking up residence in South Florida, there is no doubt that the Cuban archipelago extends through the ninety miles of the Florida straits to include Miami and that it will be transformed again as a multinational Latino community redefines the Caribbean flavor of Miami.

On websites, the debate over representation of the island and its history is played out as nostalgia for a place, an era, and a way of life. Narratives about the past, the pre-Castro era, define the contours of what is said about Cuba. They emphasize duality and stasis: living outside Cuba but reconstructing the home culture in exile, the constant need to return. Regarding exile home pages, Hamid Naficy suggests that "incorporation or assimilation is neither total nor irreversible . . . for most, liminality is a continuous state, a 'slipzone' of denial, ambivalence, inbetweenness, doubling, splitting, fetishization, hybridization, and syncretism" ("Exile Discourse" 86). More importantly, Naficy suggests, "exile must not be thought of as a generalized condition of alienation and difference . . . all displaced people do not experience exile equally or uniformly . . . exile discourse thrives on detail, specificity and locality. There is a there *there* in exile" ("Framing Exile" 4).

The space that is defined by exile is also contingent upon the length of the stay, cultural and historical signifiers, and, in this case, the geographical proximity and similarity of the natural environment. For the Cuban exile in Miami, or for those in Cuba who share

the emotion of exile through split-up families or through films that mediate an internal exile like *Madagascar* (1994, dir. Fernando Pérez) or *Miel Para Oshun* (2001, dir. Humberto Solás), Cuba can almost be seen on the other side of the straits, just as Celia del Pino, a character in Cristina García's novel *Dreaming in Cuban*, sees it (3). Radical anti-Castro exiles yearn for old Cuba, particularly those that live in Florida and invest in essentialist notions of genuine cultural heritage. Seventy-five-year-old Celedonio Gonzalez, an expatriate in Miami, argued in the *Los Angeles Times* that "the new generations have been tainted by a Stalinist upbringing. When we die, there will be no more real Cubans left" (Tobar). Moderate thinkers interested in fomenting dialogue attempt to move away from generational perspectives that contribute to distorting memories and creating essentialist cultural logic. Max Lesnick, a proponent of easing tensions in order to encourage closer relations, also speculates on a different version of the future where "those who became exiles in the 1960s [including himself] are beyond the possibility of exercising political power in a future Cuba" (Tobar). To have potential, the dialogue needs to include the new generation of leaders who will have a different vision, people who recognize and understand the changes in Cuba.

In the past decades, the political debates of the exile community continue to monopolize the airwaves, the newspapers, and the imagination. Chat groups and websites not only expand the sphere of influence of these ongoing debates beyond the desktop, but also point to new spaces for representing Cuba through information derived not just from the exilic imagination and official Cuba, but from global discourses—through advertising, feedback, non-Cubans contributing to the discussion, and so on. But while the territorial struggles find a new and fluid space for representation, the tenor of the discussion is firmly rooted, at least for now, in the passion of politics. Electronic space has a transformative power for exilic longing, prolonging the temporal dislocation (at least until the websites disappear) and personalizing the ambivalence characteristic of exile. It also creates a digital duplicate of physical places.

A survey of websites reveals that the complex and expressive culture of Cuban exile has migrated to the World Wide Web. For many years, the temperament of *el exilio* was characterized in the media as staunchly anti-Castro, which emerged principally from South Florida. While the Cuban diaspora can be located in, among other places, Spain, Mexico, Venezuela, Puerto Rico, New Jersey, New York, and Florida, Miami has the largest Cuban population outside of Cuba. There are more than a million Cubans living in South Florida, and thus, without negating the influential nature of other host cultures or their constitutive power for life in exile, the focus of this discussion will be on the South Florida community. Politically radical groups like the Cuban-American National Foundation, Alpha 66, Brothers to the Rescue, and others have, with their incendiary rhetoric, monopolized the media, cultural politics, and exile politics and even dictated the significance of being Cuban.

With each wave of migration, new challenges emerged for the Florida exiles, challenges that in turn redefined the community. Those who left after the 1959 Revolution came in

four distinct periods: 1959–62; the "freedom flights" of 1965–73; the "Mariel boatlift" of 1980; and the "balsero crisis" of 1994.[8] The first group to leave was, of course, the most immediately affected by the policies of the new Revolutionary government. Within this group, there were both those who wanted no part of the Castro government and those who had at first been supporters, some of whom even held government posts but became disillusioned. One of the loudest critics of the regime today, and a member of the U.S. House of Representatives, is Lincoln Díaz-Balart, Castro's ex-nephew, which makes it clear that the dispute is also tied to bloodlines. From the personal accounts of first- and second-generation Cuban-Americans, this generation defined itself as exiles and not émigrés. They were there, temporarily in *el exilio,* until Fidel Castro could be overturned. And so, most of the early narratives of life in exile were defined by a longing for a place that was temporarily out of reach, yet so close in geographic proximity.[9]

The subsequent waves of exiles were first political prisoners, and later, people who had lived in Revolutionary Cuba for twenty years. Reaction to their arrival was contradictory, for although the new exiles pursued the ever elusive "freedom," they had lived on the island for two decades under Castro's rule and were perceived, by the first wave, to be poisoned with communism. The first generation did not see them as "real" Cubans. The exiles interpreted the mass emigrations as further evidence of the failure of Castro's government, at once embracing the new arrivals and rejecting them both because of class differences and because they believed them to be convicted criminals. In time, the initial clashes abated as émigrés and refugees made their way into the economic and social fabric of the city, thereby expanding the character of the exile community. One way or another, subsequent arrivals to South Florida were eventually welcomed into the fold, as long as they joined the fight against Castro. Failure to do so meant remaining quiet and neutral, at least in public. As more and more Cubans arrived over the years, the exile community has come to be more demographically representative of old Cuba itself.

CUBA ON THE WORLD WIDE WEB

Seeing and discussing the totality of websites generated by the exile community would be impossible. At the time of this writing, the U.S.-based Cuba Megalinks Center had more than seventeen hundred links to Cuba-related topics.[10] This site functions as a gateway for all sorts of information regarding the Cuban community, interest in Cuban affairs, and political commentary. Areas of interest and topics include many categories: Cuban books, collectible merchandise, Cuban media, human rights reports, memorials, photography, architecture, genealogy, official documents, personal home pages, music, general information, literature, art, José Martí, Cuban organizations, culture and folklore, religion, history, sports, radio, and academic research. The list is expansive and also includes links to URLs on the island for official and unofficial information. There are hundreds of different pages related to Cuban topics. Several sites are gateways to hundreds of links about Cuba and an exponential variety of topics and political views. The

topic-specific sites focus on either dissent or solidarity with Cuba. Either way, the number of sites increases as the demand for information about Cuba grows.

Analysis of the websites looks at the ways in which these online spaces negotiate the idea of exile, whether it is through personal exhortation or organized political action. On the personal pages, nostalgia for old Cuba mixes with political rhetoric reaching out to a global Cuban diaspora. Websites attempt to recreate familial relations, sometimes using the trope of the family album, or by referencing old neighborhoods to locate friends and neighbors. Group forums denounce Fidel Castro's regime and discredit the official news coming out of the island. Strictly political sites like the Bureau of Independent Journalists,[11] created in 1995, and human rights organizations provide alternatives to the official news of Cuban websites.[12] Just as in Cuba, sites that personalize exile urgently use digital tools to represent national territory, whether physical or emotional, contesting the historical version of the old days that are in danger of being forgotten.

MIRROR CITIES

The prerevolutionary past is clearly fetishized in websites dedicated to Cuban cities. The narratives seek to recapture the culture of the city's prerevolutionary past and are another means through which to dispute the discourses of the Revolution. The websites commemorate small, regional cities and provinces like Cárdenas, Cienfuegos, Camagüey, and Güines, apprehending local Cuban identities. The city homage forms part of a memorial to the homeland, and to an idyllic lifestyle. It is curious that neither Havana nor Miami, the two most significant cities for the Cuban experience, are the subject of these personal virtual reconstructions. They appear as travel destinations and as a part of photo collections, embedded in other narratives.

Miami is obviously much more than home to the largest and most politically influential group of exiles in the United States. As David Rieff writes, Miami is the closest living representation of Cuba. But it is, "for all its outward prosperity and jauntiness, [a] city in pain, a place where the dead are never far from people's minds and in which the past and the present are constantly being elided" (22). Like Havana, Miami is a place where the conflation of memory and location is almost complete, and the two places exist, at least in the imagination of exilic experience, as extensions of each other. For those constructing the virtual cities of Cárdenas or Cienfuegos, remembering the homeland through its rural environment privileges less cosmopolitan spaces than the capital city of Havana.

The website for the city of Cárdenas is an interesting example. This Cuban city is located about two hundred kilometers east of Havana and is known as "Banner City," a nickname derived from its being the first place on Cuban soil where the Cuban flag was raised. It is also the home of Elián González, and the author has included a link to his own opinion of the Elián saga. The site is authored by a first-generation exile, an attorney, as a personal "tribute to my parents, grandparents and family as it is to all *Cardenenses* and their ancestors who, over a period of 170 years, built a small village on Cárdenas Bay

into a prosperous and progressive city." The single image on the anchoring page is that of an illustrated postcard, an old romantic representation. He suffers with the physical destruction of "his" city, which he says was abandoned by the revolution "as a result of 'pots and pans demonstrations' carried out on the streets by residents during the early years of the Revolution." Although he says that he and his family will never return to Cuba until it is free, he knows that the city turned into a ghost town, "except for the passing of occasional bicycles or horse-drawn carts." Instead of going home, he has created the city's cyberspace duplicate, where the homeland of his childhood exists through his parents' and his own memories (de la Fé).

The forty-nine-year-old author of the virtual Cárdenas created this online altar to his city because of a perceived elision, and perhaps this is also the reason for the existence of its municipality in exile, which is located on Flagler Street in Miami, complete with a board of directors, a social and cultural commission, and other services to the community. When return is impossible, the Internet provides a transitory space for the construction of an identity and a relationship to a place.

The city thus exists through new and old photos and the reconstruction of certain segments of society: medicine, industry, and education. The trip via a select menu takes us through Cárdenas's private schools, eleven of them, giving us their history, in some cases before and after the Revolution, and a series of graduation photographs, all from the 1940s. The layout is simple and straightforward, without flashy titles or animations. There are many photos, some of which are disconcerting in that they attempt to be something familiar, part of the author's past, but they are not. They clearly point to another generation and culture, a culture which he can only be a part of through images that someone else selects (the photos come from books and from relatives who took them) and through borrowed memories. He brings the images together with a narrative of loss, nostalgia, and national pride. There is an emphasis on representing the city—its houses, streets, churches, official buildings, the bay—by providing details of the locations where the pictures were taken: "Looking southwest on Calle Real with the once proud 'La Dominica' Hotel on the street corner in the foreground. Carts, bikes and carriages are about all you see on the main street these days." This description belongs to a link to "Images of the present, under Castro," making the contrast of before and after. The first image of the "Allegory of Today's Cuba" section is of the author's family home. The photo shows an old colonial structure with wrought iron railings, the ones that Alejo Carpentier wrote about in his exploration of the baroque in Cuba, where the author observes that "a biker sits outside the dilapidated structure that was once home to three generations of the author's family." The desire to hold Cuba, to contain it, is passed down through the father, who, now deceased (there is a memorial on the website), inspires the author to create the digital reconstruction.

Contrary to the image of prerevolutionary Cuba that the Revolution has established— a place of oppression, poverty, and corruption—de la Fé insists that it was a glorious and creative social environment. A section of this website on the history of medicine in the

city of Cárdenas impresses its readers with the numbers of doctors and intellectuals that were part of the social milieu prior to the Revolution, arguing that the achievements in health are not to be credited only to Castro. This type of nostalgic refiguring is common among first-generation exiles, frequently leading to selective memories of the homeland.

The website dedicated to the city of Cienfuegos, *"La Perla del Sur"* (pearl of the south), located in the south-central part of the island, provides a second interesting example. The website invites a more playful interactivity with the visitor.[13] The first link solicits political action against U.S. Democrats. This is followed by a request for a vote in favor of keeping Elián González in the United States, a link to a chat group, and a photo gallery with music. The photo gallery is the main interface. Created as an interactive game, the image is a puzzle in the shape of a large square subdivided into fifty smaller photos. Clicking on each photo enlarges the image and brings forth a red arrow pointing to a space on or off screen. A series of directions follows each image. The text provides a real Cuban address for the location, along with questions about the spaces and landmarks of the pre-Castro era. The question for photo 36 asks: "If you follow the arrow and cross San Carlos street, you would run into a business that was right on the corner. What did they produce and what was its name?" Others reveal some humor. On photo 39, the author says that the picture really has nothing to do with anything but is just an attempt to find out who the real masters are in remembering the city. Another question: "This man is walking along Cienfuegos Street. If he keeps walking in the direction of the arrow, what is the name of the street in the next corner?" Under the photo of a hotel, the author acknowledges that he ignores the answer and asks not only what the name of the bar was on the first floor of the hotel, but also the name of the piano player. The payoff for answering questions correctly is the pleasure of reviving those memories, and the author's convivial style and humor determine a certain cultural flavor. The game, however, highlights the differences between then and now, and although the focus is on remembering the past, this also puts us squarely in the present. There is a sense of moving on, maybe less intended than implied, since reminders of the physical and social changes underscore the passage of time. In this instance, old Cuba can be accessed through a virtual connection from another era, and the fact that the writer himself doesn't remember some of the details adds another layer to the experience of forgetting.

Aside from the many political organizations that have a presence on the web, there are hundreds of e-commerce sites capitalizing on the popularity of all things Cuban. The businesses for many of the sites are based in South Florida, and they range from the idiosyncratic Cuba Collectors' Page[14] to Casa Cuba, a virtual boutique with a "nostalgic line of merchandise evoking the allure and seduction of Cuba," and Cuba Store, an American-owned souvenir store in Key West that is "strictly non-political."[15] Its mission is modest, "to celebrate the culture of Cuba, which is but 90 miles from Key West . . . so close, but yet so far." There are sites that sell cigar art, boxes, lithography, and labels, as well as cookbooks, general books, calendars, stamps, photos, maps, and so on. Anything that accentuates the sentimental yearning for the homeland can be found online.[16] Cuba

is to be consumed, and maybe this new consumerism is the closest link back to the island where consumption of everything is up, even when it's not clear where the money comes from.

Online spaces have played an important role in the fragmented and contested imagination of exile communities and construct what Luis Ortega has called a "portable homeland" (11). Moreover, Homi Bhabha has rightly pointed out that "the organic or biological metaphor through which the concepts of community and communication are constituted . . . does not permit the life world of cyberspace to reach beyond the homogeneous empty time of the imagined community of the nation and its largely consensual, unitary peoples" (ix). If the virtual community shares the temporal structure of the modern nation, then, he asks, what would prevent it from replicating the worst excesses of xenophobia and nationalism? This question is particularly probing for thinking about the way that cyber communities and home pages could possibly go beyond the confines of unitary notions of community, or for further ruminations on cultural identity as hypertext.

AFTERTHOUGHTS

This essay was written in 1999 and is an earlier version of the final chapter of my book *Digital Dilemmas: The State, the Individual, and Digital Media in Cuba* (Rutgers, 2010), which analyzes the political and technological context for the emergence of digital media and the Internet in Cuba. Originally a critical investigation of online exile narratives and their relationship to Cuba's early Internet use, I use a text-based approach to compare the content and style of the websites, reading them against the prevailing social winds of the time. Early Cuban and Cuban-American websites crudely, but creatively, expressed painful histories of Cuban migration. Like films, literature, and talk radio, their content focused on traumatic dramas, nostalgia, and condemnation. The enthusiasm of early users has been extended by a bold Cuban blogosphere that sees the Internet, social networks, and international human rights organizations as the new venues for creating political communities.

In the book, I examined a broader context: the impact of 9/11 and the culture of antiterrorism on Cuban attitudes toward the Internet, as well as the transition of power from Fidel to Raul Castro. This early version, informed by debates about Cuba's survival, the reinvention of socialism, and the crippling effects of the U.S. embargo, stands as a snapshot of early web analysis. Without adhering to a technological utopia, the essay focuses on the ineffable quality of individual emotional dramas of survival facing dispersed populations.

ABOUT THE AUTHOR

Cristina Venegas is chair and associate professor of Film and Media Studies at the University of California, Santa Barbara. The focus of her research is on international film and media, with an emphasis on Latin America, Spanish-language media in the United States, and

digital technologies. She is the author of *Digital Dilemmas: The State, the Individual, and Digital Media in Cuba* and has written about film and political culture, "revolutionary" imagination in the Americas, telenovelas, contemporary Latin American cinema, and coproductions. Since 1999, she has also been curator of numerous film programs on Latin America in the United States and was cofounder and artistic director (2004–10) of the Latino CineMedia International Film Festival, part of the Santa Barbara International Film Festival.

NOTES

1. This is my translation. The original reads, "Tal y como se ha expresado hoy, una de las ventajas esenciales de esta nueva tecnología la constituye el hecho de ser un mecanismo idóneo para divulgar al mundo las realidades del país y de la Revolución en condiciones de lucha más parejas que con los otros medios de difusión masiva. Por eso hay que decir que además de una necesidad estratégica del país, es también un reto importante no solo en el campo tecnológico sino también en el terreno económico y político."

2. The restrictions on Internet access vary. On one hand, the government controls "licensing" of individuals to access email and web content through institutional affiliation and work sites. On the other hand, a poor infrastructure means that broadband is quite limited, and dial-up access makes web navigation difficult and costly. Fees have been paid partly in dollars and, later, in convertible pesos. Hotels and business centers have access for their clients and a growing number of Internet cafes, mostly in Havana, provide navigation through an intranet of Cuban official websites. The government controls computer sales through specific stores, but this does not prevent the sale of computers and accessories on the black market. Repeatedly, the government has said that restrictive measures are temporary and are due to national security concerns, limited infrastructure, and a crisis economy. The emergence of the Internet has thus been particularly linked to the growth in foreign investment and travel.

3. Internet Archive Wayback Machine: http://web.archive.org/web/20031218042239/http://www.libertyforelian.org/.

4. Cubademanda.cu is no longer online. The Cuban government's website archives the lawsuit against the United States website at www.cuba.cu/gobierno/DEMANDA.html; Cuba Net also archives the information at www.cubanet.org/htdocs/CNews/y99/jul99/0601.htm.

5. The website is no longer active.

6. This site was voted the conservative site of the day on April 18, 2001. The NoCastro website is now available only through the Wayback Machine: http://web.archive.org/web/20070811100648/http://nocastro.com/.

7. The Freedom Tower, which operated as an immigration center for refugees from Cuba in the 1950s, was eventually sold to developers who wanted to tear it down to build a condominium high-rise. Eventually, members of the community succeeded in preventing this, and the building was donated to Miami Dade Community College, which will use it for classroom space. The developers, however, will also be able to build a high-rise building adjacent to the tower.

8. Maria Cristina Garcia has studied the South Florida community and discusses, at length, the first three periods of migration. Also see the website for the Cuban Rafter Exodus at http://balseros.miami.edu/.

9. There is a growing fiction and nonfiction literature by Cuban exiles and second-generation Cuban-Americans in the United States, Europe, and Latin America (see Rieff; Pérez Firmat). The novelists include Cristina García, Zoe Valdez, Jesús Diaz, Reinaldo Arenas and Severo Sarduy.

10. Website URL no longer exists and is not archived. There are various sites like AfroCuba Web (www.afrocubaweb.com/cubalinks.htm#collectives) and Cuba Solidarity Web Links that offer typical examples but are not the websites I initially wrote about.

11. Originally, the website was at www.bpicuba.org; it is now hosted on CubaNet at www.cubanet.org/CNews/y98/feb98/25a2.htm.

12. www.cpj.org/attacks96/countries/americas/cubalinks.html

13. Cienfuegos website is no longer available or archived. New websites about the city of Cienfuegos do not capture the playfulness of the old website discussed here.

14. Although the URL for the website that I wrote about is no longer available, similar websites abound. See Cuba Collectibles at www.cubacollectibles.com/.

15. Websites written about originally are no longer available. Havana Collectibles is representative of the type of nostalgic products. See www.havanacollectibles.com/.

16. Website URL is no longer available. Cigar art and cigar boxes are sold on many sites, including Cuba Collectibles (www.cubacollectibles.com), eBay, Amazon, and many others.

THINKING DIGITALLY/ACTING LOCALLY

Interactive Narrative, Neighborhood Soil, and
La Cosecha Nuestra Community

John T. Caldwell

When the histories of media theory in the 1990s are written, they will no doubt acknowledge what some might consider an odd congruence between industrial and academic worlds.[1] This was a period of high-technology expansion (fueled by fiduciary boosterism from the financial markets) on the one hand, and of rich but unusually grand theorization (fueled by "new media" and disciplinary boundary crossing) in the academy on the other. From *Wired*'s inaugural celebration of the World Wide Web as the second coming prophesied by McLuhan, to NASDAQ's collapsing exorcism in 2000 of the dot-com way of life, industry had learned well the efficacy (and consequences) of commercial, theoretical intervention.[2] The practices of marketing and "theorizing" vaporware[3] together with the mind-altering, pre-Enron accounting models used extensively in business plans of many high-tech start-ups, functioned for venture capitalists in a manner not unlike the ways that the disembodied speculations of Baudrillard, Virilio (*Open Sky*), and Levy functioned for an emerging generation of new media artists and humanities scholars. Both of these different worlds-of-practice gave producers and scholars alike institutional cause to traverse and violate industrial, economic, and cultural boundaries. The love child of these two odd but converging institutional worlds came in the form of new and broadly accepted conceptions of space (typically collapsed and virtual) and time (typically instantaneous and accelerated).

As it did for other scholars and media artists, this period provided all sorts of opportunities for me to reconsider the principles of media theory and alternative production and practice that I had held as central working tenets throughout my career. After all, the

history of "alternative media" had been regularly conceptualized (and industrially constrained) in spatial terms—as "outsider art/media," or "media on the margins," or "media from the ground up"—which the now facile and fluid boundary-crossings presupposed by new media theory and web-speak promised to break. On the other hand, the theorized temporal transformations—instantaneous worldwide access, the increasing velocity of information—promised to break the inertia and constraints that have kept alternative media practice in what are arguably institutionalized ghettos (the art world, universities, PBS's token "TV Labs," etc.) whose functions are largely symbolic for the dominant order. Yet pre-crash, 1990s new media theorization emerged alongside a countervailing tendency, one with far more grounded and much less optimistic conceptions of the new media world order.

Alongside the expansive McLuhan/Baudrillard/Virilio-esque "yin," there came another (also largely French) influence: the theoretical "yang," as it were, proposed by Michel Foucault ("Space, Knowledge, and Power," "Of Other Spaces") and Henri Lefebvre (*Critique*). Foucault and Lefebvre articulated a second spatial paradigm for media and culture wherein power still very much remained a problem. Foucault attacked the recurrent Western intellectual tendency to hail time as rich, fecund, living, and dialectical, while ignoring or denigrating space as "the dead, the fixed, the undialectical, the immobile."[4] He proposed instead a new historical methodology based on spatiality that would examine the "great strategies of geopolitics [and] the little tactics of the habitat."[5] Lefebvre's *Critique of Everyday Life* laid out a model for studying culture, politics, and history as the very "production of space." While theorizers of virtuality and cyber-culture fueled new media developments, these other theorists of spatiality-and-power helped transform ranks of scholars, across many disciplines, into "critical geographers" or cultural mappers. While cyber-theory sanctioned explorations of digital immateriality and disembodiment in new media conferences and exhibitions, the new critical geographers (in literary theory, the humanities, and the social sciences) had made "border studies" (conferences, publications, and curricula) a cottage industry in academia by the late 1990s.

A third, highly commercial mode of digi-spatial theorizing—something that might be termed "branded pod-space" theory—has displaced and problematized both the McLuhan/Virilio and the Foucault/Lefebvre variants of digi-spatial theory. New media space in 2005 neither looks appreciably virtual, nor is it typically materialized as acts of domination and cultural control. Admittedly, the massive popularity of instant messaging (IM), the iPod, and peer-to-peer file sharing ostensibly accomplished some of the tenets of the two academic digi-space/theory schools. (IM enabled the formation of fluid, boundariless communities via real-time interactive talk; the iPod offered blueprints through which "resistant" users could master the "little tactics of the habitat.") Yet the speed with which the emancipatory potential of IM's virtuality was rationalized as a commercial, branded service, and with which the unruly decentralization inherent in the iPod spurred new forms of cultural exclusion and personal marginalization, has been astonishing. The iPod was launched as an edgy, post-Napster "people's medium." Yet, in

practice, iPod-use exploits the kind of acute, "mobile, privatized consumption" Raymond Williams so presciently theorized in 1975. The migratory, quasi-impenetrable iPod/cellphone "bubble" that announces a user's presence in public furthers the notion that individual consumers can privatize even public spaces via the songs/services they purchase and mark boundaries with. In addition, the now trendy flaunting and self-posting of iPod playlists on blogs are recognized as pronouncements of cultural distinction and games of cultural posturing. Likewise, the constant monitoring, judging, ganging, and blocking of anyone with divergent interests or aberrant political points-of-view in chat rooms, peer-to-peer networks, and fan sites suggest at least two ways that branded pod-space theory has transformed the "public sphere." First, users of pod-space technologies immediately reestablished "regimes of exclusion" (digital interaction is now almost immediately about who's *not* in the circle), and they did so "from the ground up" (no easy-mark capitalist corporation to blame for schoolyard tactics in the pod/chat worlds). Second, pod-space technology-users willingly cooperate in establishing commercial entertainment brands as affective, lifestyle strategies. Throughout the successive periods of digi-space theorizing, one of my recurring questions has been this: How can the enabling potential in each technology phase (virtual-spatial, material-tactical, and pod-mobile) avoid the "black-boxing" that occurs when corporations economically "discipline" new technologies?[6] A series of video projects in the North County area of San Diego County gave me the opportunity to test some of my hunches and hopes in these areas.

Theories of cybernetics and virtuality initially provided me with a set of emancipatory assumptions that led to several years of alternative-media fieldwork among migrant workers and migrant camp residents in Southern California. Yet the "production of space" theorists described something far more evident that I soon had to reckon with in fieldwork: a complicated play of forces, identities, and boundaries could be fully understood only if one considered the ubiquitous plays of power and the material conditions that define the space of *actual* neighborhoods. The third (and current) phase of digi-space theorizing suggests just how high the stakes currently have become in the rush to mark, claim, and brand actual, lived spaces within communities.[7] I will return to consider this final point at the end of the chapter.

GROUNDED THEORY

The disembodied temporal assumptions of early-nineties cyber-theory meant that digital culture is posed in networked, space- and scale-altering terms (McLuhan; Virilio, *Open Sky*); that virtuality is characterized as mediated engagements with imagined and alternative worlds (DeLeuze, *Difference;* Morse, *Virtualities*); and that telepresence articulates an electronic metaphysic of being "here" and "there" at the same time (Hillis, "Geography," "Perfect Clarity"; Sconce). Space, that is, has (perhaps unavoidably) become a mental construction, a cognitivist ghost in the machine of digital culture. However, following Foucault and Lefebvre's critique outlined above—which targeted the scholarly penchant

FIGURE 1

Migrant homes versus landed developments, facing off in the "no-man's land" and "contact zones" between the suburbs of Oceanside, Carlsbad, and San Marcos in North San Diego County, California. Photo by J. Caldwell, copyright 1999.

for deploying allegorical, idealizing, or metaphorical constructions of space—cultural and critical geographers today tend to find something far messier when examining the many actual uses of "new media" in culture. My experience in new media community-organizing certainly involved this sort of phenomenological and institutional messiness.

Spatializing the digital in terms of cybernetic "reach" (that is, as a technically induced cognitive phenomenon) helps reinforce a vague sense of social consensus. For as the marketers have often spun it, the sheer scale of connectivity will ostensibly elicit agency from all who are fortunate enough to fall in the shadow of the wired, telecom, entity. Yet we must not confuse the idealized mythologies that author digital space (the very kind that Foucault and Lefebvre critiqued) with the actual historical and social spaces that digital and electronic media depend on and work through. This essay considers both theory and production practice to examine the ways in which interactive narrative and electronic media were used by a low-income immigrant neighborhood in South Escondido, California, to engage systemic health and nutrition problems in the community. A project called "La Cosecha Nuestra" (or "Our Harvest") set in motion a network of activities linked to the availability of land in the neighborhood and the formation of an organic gardening project. Video, audio, and digital postproduction were utilized to enable improvisational theatrical scenes and participatory narratives intended to address problems, and to give the participants "ownership" over solutions to nutrition-related health problems specific to Latinos in California. I will discuss how "interactive analog" processes make problematic the now celebrated textual politics of digital interactivity and virtuality.

There are, then, two wrenches that I want to throw into (and include in) the digital interactivity debate: analog rather than digital narrative and imaging tools, and lived or soiled space (terra firma) rather than virtual space. Both wrenches, analog and earthly, functioned in La Cosecha Nuestra to perform the ideals usually attributed to digital technologies. Both phenomena, for example, facilitated interactivity, initiated forms of social agency, focused on the generation of mediated narratives, and animated networks utilizing distributed cognition. Of course, these traits in practice did not simply illustrate a set of truisms from the digital mantra. They also created a slippery and unstable social configuration that had real-world political consequences, a prospect that I will address at the end this essay.

These real-world instabilities are worth taking seriously, for experiments in interactivity and participatory media are usually discussed in terms of theoretical design and intention rather than the kind of limited successes, contingencies, and tactical failures that we experienced. Some of the earliest forms of portapak activism in the pre-Internet age were decentralizing efforts intended to enable disadvantaged populations. Yet many were simultaneously naive and opportunistic forms of liberal paternalism (Boyle). Orthodoxies in contemporary documentary practice, on the other hand, now favor only two modes of production: autobiography (diaries, self-disclosures, meditations) or complete efface-ment (the give-the-camcorders-to-the-indigenes conceit). We were well aware of the uto-

pian traps of total producerly effacement. With a meager $1,500 budget for the entire year—for media supplies and videotape for a half-hour production involving about forty people—our version of participation would be less about gifts to a few from Circuit City than about the circulation of electronically recorded personal narratives in mediated forms and community discussion formats. The real interactivity here did not just involve user-interface rituals, but arm-twisting and consensus as well. La Cosecha Nuestra involved face-to-face dialogue by a range of previously segregated citizens who would never otherwise have engaged in dialogue, let alone cooperative work. Electronic media facilitated this process, but access to land made it possible in the first place.

There is a now recognizable, predictable, and tired genre of theorization on new media and society, one that poses as an angry, prophetic, antitechnology call-to-arms in the name of humane values (Ellul; Postman; Roszak). Even though my project might accurately be relegated to the level of "interactive dirt" and involves lived social spaces rather than virtual ones, I do not share the antitech genre's suspicion and easy denigration of all things mediated and all things digital. In fact, I hope to liberate the notion of interactive media from an explicit linkage to specific and always immediately obsolete digital tools (PCs, CD-ROMs, websites, MUDs, MP3s), in order to demonstrate how the principles of digital technology extend usefully far beyond mere machines. Of course, this idea—that technologies are conceptual and social as well as technical—stands as a common thread in media thinking after McLuhan's "deterministic" excesses in the 1960s. Raymond Williams, for example, noted how electronic media must be understood in terms of programming and "mobile, privatized consumption" (*Television*). French "apparatus" theory psychologized that media technologies included not just cinematic machines but the ideologies of dominant culture that "produced" viewing "subjects" as well (Comolli; Baudry, "Ideological Effects"). More recent research similarly looks beyond the machine by embracing Bruno Latour's "actor-network" model to explain how new technologies are produced in social practices that circulate in and around the adoption and diffusion of those technologies (Cockburn; Silverstone and Hirsch; Silverstone). Despite these traditions of extra-hardware technology assessment, digital tools are still regularly fetishized in theory as launching pads for all kinds of perceived experiential and cognitive effects. There has been, that is, a rebracketing of the machine and its effects in many discourses on digital culture.

In calling this project "Thinking Digitally/Acting Locally," I propose breaking open the standard model of digital that makes electronic culture "box-centric" (pc-based) or "wire-centric" (net-based), or cell-mobile (cell-based). If electronic culture is actually about interactivity, multiuser narrative, mediated agency, and distributed cognition—and not about the hardware—then we gain nothing by waiting for developers at Intel or Microsoft or Macromedia to sanction interactive spaces defined by products. Academic and artistic communities would do well to look beyond commercial products in order to explore how electronic media might enact and enable digital processes for social subjects to "act out" in lived worlds and social communities.

FIGURE 2

A migrant in Kelly Camp, Carlsbad, California, using a camcorder for self-representation.
Photo by J. Caldwell, copyright 1999.

PROJECT BACKGROUND

My involvement with La Cosecha Nuestra developed through a series of referrals. I had
been working on a documentary on migrant farmworker encampments in northern San
Diego County. That project detailed how meticulously the landscape—integral to local
economies in rural–suburban communities—is managed as part of the racial formation
in Southern California. It also suggested to me how central the contest over space and
access to land had become in the region, a theme that would resurface in provocative
ways in La Cosecha Nuestra in Escondido. Through this work I came into contact with
California Rural Legal Assistance (CRLA) in Oceanside, an advocacy group engaged in
rural poverty issues. Together with a coalition of nonprofit social service agencies, CRLA
was awarded a grant from Food For All and Healthy Cities and asked to administer a
community garden and "food security" education project in South Escondido. Vietnam
Veterans of California and the City provided plots of land, the Escondido Clinic provided
community health outreach, and a master gardener and nutritionist from University of
California (UC) Extension exchanged knowledge with community members in a "teach-
the-teacher" methodology. The first garden coordinator, Arturo Gonzalez, came to the
project after having worked for El Frente Indigena Oaxaqueno Binational. I offered to

provide media production resources, students, and myself from UC San Diego in order to help with the formation of the community and with educational initiatives. Media use was seen as a way to build-in interactivity and to encourage participatory "ownership" of the project among members of the community.

For someone trained in the traditions of independent film/video, the idea of doing a creative project on food and food security seemed like a sure ticket to failure. The obligatory "eat your vegetables" objective of the project seemed to guarantee that viewers—in any culture—would inevitably disengage. Yet nutrition-related illnesses were endemic to this specific community, and the need for intervention was compelling. The Latino immigrant community faced a far higher incidence of diabetes and anemia than the population as a whole, and pregnant women, in particular, faced medical risks due to poor diets during pregnancy (U.S. Department of Health and Human Services; Squires; Richardson; Schrader; DeJesus, "Latino Children," "Focus"). Although many of the indigenous Oaxacans (Mixtecos) and Guatemalans (Mayans) in the community came from remote villages where gardening and fresh produce were commonplace, their eating habits once in California typically involved diets high in starch and cholesterol, canned goods, and fast-food. This fact was particularly ironic for the recent and ex-farmworkers in the community. Although imported labor of this sort helps make California a celebrated breadbasket of international proportions, the human labor force that fuels agribusiness does so on a diet directly linked to medical risk. Given this context, video art would stand in the service of the four food groups, and artistry in the service of group authorship.

On the basis of dialogue and focus groups with community members, the media team intended to facilitate, cocreate, and videotape short *teatros* or "telenovelas" that addressed food security issues from the community's point of view. Chicano and UFW organizing in the late 1960s set in motion a long and rich tradition for the *teatro* in social activism. Since telenovelas are pervasive parts of Hispanic broadcasting in California and elsewhere, we intended to use this televised genre as an updated starting point for creative participation. Taking our cue in part from changes in HIV and AIDs awareness programs, our rationale was that this kind of "bottom-up" participant origination—even on pedestrian health and nutrition issues—would stand a far better chance of success than "top-down" applications of "administrative" knowledge by "experts." A lottery to give away garden plots was announced, and the coalition of nonprofits and the city invited the press to cover the ground breaking for La Cosecha Nuestra on a gray winter day in January 1997. The video team began research in January and February in interviews with area master gardeners and in meetings with community members. This was followed in March and April with door-to-door interviews and surveys by garden coordinator Arturo Gonzales and my student, project codirector and story editor Devora Gomez. Devora's family resided in the neighborhood, and their home served as temporary residence for the video team during filming.

These dialogues and exchanges served two purposes. First, they aimed to solicit involvement in the garden from nearby residents. Many of these renters were initially

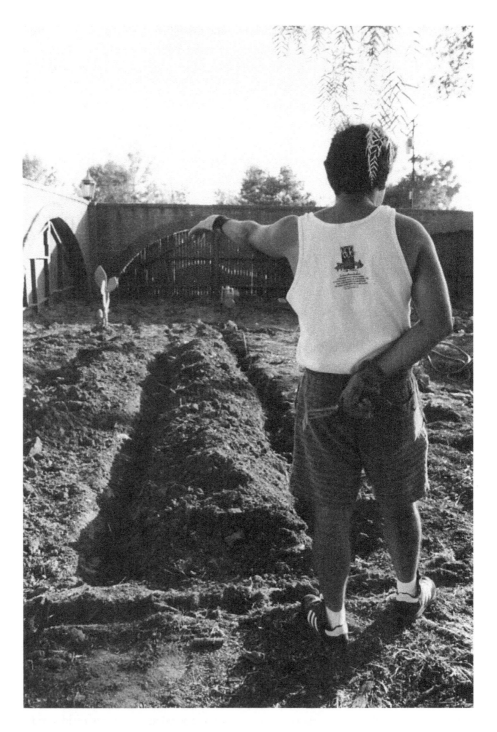

FIGURE 3

A community gardener in South Escondido, California, breaks ground for his family's garden. Photo by J. Caldwell, copyright 1999.

FIGURE 4
A production still/improvisational scene in a South Escondido backyard with La Cosecha
Nuestra project family. Photo by J. Caldwell, copyright 1999.

rightly suspicious of any offer of free land. Because of high rents, for example, several of
the video participants—single male Guatemalan workers—shared one-bedroom apart-
ments and very little furniture with as many as six other workers. Second, these com-
munity dialogues served as script or story sessions intended to build a body of insights
on eating and health issues specific to cross-cultural experiences. Additional ideas for a
scripting and creative performance were elicited from the gardeners in a meeting on May
21 and in telephone conversations that followed. A schedule for the first on-camera inter-
views and filming was circulated and discussed at the garden meeting of June 4, and
filming and interviewing began on June 9.

Three or four of the gardeners expressed an interest and willingness to "act out" their
ideas on cross-cultural food issues. Their short scenes were dramatized and filmed in
June and July. One dramatized the risk of heart attack from a macho diet of pizza and
beer. One focused on a gardener's recurrent obsession with advertising-induced binging,
called "fast-food noir." A short, campy telenovela scene was performed entitled "The
Many Loves of Chavelita." Finally, a cryptic spot was produced about the "indigenous"

anti-(food)-pyramid, based on discussions of indigenous diets as they related to both FDA norms and commercial food in the United States. The majority of gardeners, however, politely but systematically challenged the initial premise behind our methodology. "Why not simply let us appear and speak on camera as ourselves, rather than forcing us to be like someone else in a drama?" Identity was going to be important in the project as a whole. These participants did not want to dramatize someone else's knowledge in third person. Speaking and disclosing directly to the camera, apparently, offered a far more compelling draw for the gardeners than any attempt to aestheticize and "virtualize" their knowledge, or to dramatize and masquerade their perceptions in the form of third-person allegories. These people wanted viewers to know who they were and where they were from. They were not afraid to assume a position of authority on either medical issues or cross-cultural analysis. I will return to the significance of this shift in the gardeners' involvement (from virtuality to self-disclosure) later in this essay, for it resonates with practices in the digital world of the net.

Since the project we set out to produce was to grow out of interaction between community members, media makers, and teachers, we agreed to shift the project in format and scope to address this new concern of the gardeners. As a result, the final video was now to be less of a telenovela, and more a contemporary video "portrait" of the community—a video "magazine" that combined on-camera interviews with participants, oral histories, recipes, dramatized segments, nutrition teaching, and music video. I surmised that the mixed-mode approach—collaging documentary, fiction, music, and a garden "making-of"—also reflected the usefully contemporary look and style now common on television. While this alignment of direct subject ownership with televisual style made sense conceptually, the tactic also built multiple perspectives into the tape that would complicate distribution and end-use later on.

This new reliance on self-disclosure on camera provided—in addition to the shift to an inordinately high (and more expensive) shooting ratio—some surprising revelations. This included a thread of talk across numerous interviews (and ethnic groups) that linked food preparation with interpersonal romance. This segment—termed "Amor Vegetal"—became the title for the piece as a whole. Talk about "vegetable love" suggested a far less utilitarian spin to the wisdom-from-the-ground nature of the project. Some gardeners talked of anxieties about raising children in American culture. Other gardeners used camera time to mimic traditional Mexican proverbs, or "dichos," intended to pass rules for life from one generation to the next. Although interviewing continued into the early fall, the major part of production concluded, after two months of filming, with a festive "first harvest" open to the entire community and the city as a whole. Traditional dishes were provided from each family garden plot. A group of kids DJ'd multiracial hip hop and Beck on the sound system, before another gardener's young daughter belted out a Selena hit from the stage. Adding to the collision of traditional and contemporary, an indigenous Zapoteca dance group from North County performed traditional Oaxacan dances to ceremonially bless and inaugurate the garden. Many participants came to the

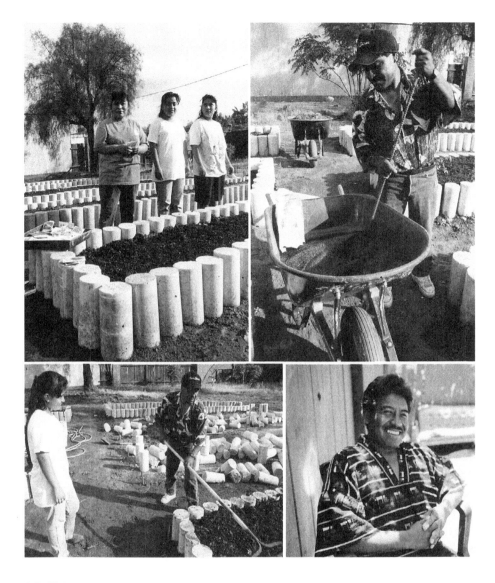

FIGURE 5
La Cosecha Nuestra work day, Saturday in Escondido. Photo by J. Caldwell, copyright 1999.

microphone to reflect on how La Cosecha Nuestra had formed a community and "family" where none had existed before. The final video production uses this cycle of the land—from ground breaking in winter, to planting in spring, to harvest in late summer—as an arc that organizes gardener meditations on food, identity, and life.

The South Escondido garden project was successful enough that an even larger project of the same sort was started up in East Escondido the very next year. This La Cosecha Nuestra "sequel" included a larger, four-acre community garden that would

allow for higher-quantity agricultural production, including small-scale commercial produce. One hundred gardeners would now produce food that would benefit five hundred residents (City of Escondido, "Project Workplan"). The videotape that resulted was used locally in *platicas*, or group discussions on health, food issues, and nutrition by the Escondido Clinic and Migrant Education Project in North County. Additional public screenings took place, formally, at the Eye Empowerment Community Center, and informally at numerous weekend barbecues and meetings in the garden itself. The tape, *Amor Vegetal: Our Harvest*, was also exhibited at festivals in Chicago and Barcelona, at the Field Museum in Chicago, and at national conferences on nonprofit legal work and food security marketing. One hundred and twenty VHS dubs of the production (in both Spanish and English) were given to all of the video and garden participants and their families, as well as to the coalition of supporters who had either managed or donated in-kind resources.

DIGITAL TROPES AND PRACTICES

La Cosecha Nuestra had absolutely none of the financial or technical infrastructure needed for even a fleeting foray into the world of the net or cyberculture.[8] This was instead a world of rented apartments (many without phones), a world where composting and tilling (rather than net surfing or video-gaming) served as activities for families with small children. Yet electronic media functioned in La Cosecha Nuestra community in three important ways that mimicked the kind of "digital performativity" now celebrated at academic venues.[9] First, the project utilized interactivity far beyond purely technical interfaces, in filmed improvisational scenes and interview situations. Interactivity served as well as a working guide in door-to-door surveys, focus groups, and dialogues between workers and story editors. Second, documentation of oral histories—involving memories of growing up, curative recipes, and gardening and horticulture wisdom—provided a foundational "narrative network database" from which visual, sound, and scripted representations of this community emerged. Third, active involvement by thirty to forty community participants—many indigenous Oaxacan and Guatemalan workers—made the electronic production that resulted a model for multiuser interactivity in the social sphere. But if this characterization rings true, where was the hardwired "device" or machine that constitutes the third term of a traditional multiuser device (or MUD)? La Cosecha Nuestra was not a machine, but rather a composite bit of civic engineering and coalition building by numerous participants. La Cosecha Nuestra animated a social force and coalition that appropriated the unseen—but far from unvirtual—land of vacant lots overlooked by institutional bureaucracies. La Cosecha Nuestra was very much an interactive, narrativized, multiuser, databased network—and a self-empowered community—in the fullest sense of those words.

La Cosecha Nuestra also challenged the ways that marginalized populations had been typically posed in net talk. At the first "Information Superhighway Summit" in 1994,

Vice President Al Gore warned of the coming split in the digital age between "information haves" and "have-nots," and many since have echoed this duality. Such a binary stands as the worst form of conceptual reification, however, for it defines human subjects in externally quantifiable ways. These folks are either connected to a digital technology that fills them with information, or disconnected in a way that empties them of any meaning. Considering the Escondido gardeners as "information have-nots" naively reduces human agency to data storage, to a level that insults intelligence. Cybernetic thinking—even in bastardized, liberal, policy forms like Gore's—must take as a starting point the lay theoretical competencies of media users. Neither "haves" nor "have-nots," these gardeners—even without AOL accounts—were data-authors and social agents that both generated and processed networked information.

In retrospect, La Cosecha Nuestra also questions several other truisms associated with "new media," especially the caricatured notion that "linear" narrative involves texts that dominate spectators while nonlinear digital ones are somehow more "open" to customization and individuation. The ostensibly "nonlinear" interactivity of digital CD-ROM or website construction has proved to provide the acute forms of parameter setting and constraints typical of "games." The "analog" interactivity of La Cosecha Nuestra, on the other hand, allowed participants months to more fluidly form the parameters before "lock-down" in linear, digital video form. These multiusers, that is, engaged each other in very "nonvirtual" ways; as coworkers, allies, competitors, and (sometimes) contentious colleagues. There were fights and arguments in Escondido over directions and policies, and there still are.

This fieldwork—and the transformations the project underwent—suggested to me a split in "agency" that evoked a classic shift in media theory. Revisionist theorists in the 1970s proposed that scholars move from the model of "spectator positioning" by texts to the notion of social "interpretive communities." In many ways, the virtual communities of MUD and interactive CD and websites offer very constrained (no matter how hyperactive) spectator positions for users. Fieldwork utilizing electronic media, however, can be far more unstable and volatile, even as it encourages forms of electronic agency that are community based. La Cosecha Nuestra animated an institutional configuration that worked to challenge a number of local and regional interests. This project worked, that is, to problematize received wisdom in electronic media about "open" and "closed" texts, a wisdom that lives on in current celebrations of the digital.

RESULTS/FALLOUT

Throughout the year in Escondido, I was most struck by how the project and the community became a political football for various bureaucratic factions. Social service advocates and nonprofits recognized the importance of the needs of this low-income population. Official recognition of the city by the funders of La Cosecha Nuestra gave the city the opportunity to take credit for someone else's forward-thinking notion of service. La

Cosecha Nuestra, after all, provided a handy mechanism whereby people—in the words of the vice-mayor at both the ground breaking and the first harvest celebrations—could "help themselves." But the idea of publicly promoting images of this specific community—comprising people of color, farmworkers, and immigrants—also flew directly in the face of a newly elected city council intent on selling an image of the city as a bastion of country clubs and comfortable suburban living. At several meetings and events, I was repeatedly asked if the production, once completed, could be used to promote the image of the city—both to the council and to those outside of the city. Having spent almost two months interviewing and filming in homes and garden plots, I knew that the city council had no idea how alienated they were from these neighborhoods. Working mothers talking about diabetes and concerns over the childhood lures of local fast-food businesses would never serve the interests of the Escondido Chamber of Commerce. Nor would the endless images of people of color in our production comfort council members intent on transforming Escondido—once considered a sleepy farmtown in the country—into the kind of classic elegance afforded by other North County enclaves like La Costa, Carlsbad, and Rancho Santa Fe. Race was a particularly sensitive issue in the aftermath of the contentious Prop 187 controversy. While protection against immigrant "hordes" animated conservative forces in the county and state, community La Cosesha Nuestra showcased a Mexican and Central American population actively involved in the life of a city. The council and chamber of commerce were simply in denial.

We set about through coalition-building to help enable a community to form where there was none before. This effort mostly worked with the garden community, but largely failed with the coalition of nonprofit organizations involved. The city alternately misperceived La Cosecha Nuestra as either a timely opportunity to exploit for PR or (once underway) as nagging evidence of the kind of city they did not want to publicly celebrate or promote. The culture of nonprofits, on the other hand, exists with a very different set of perpetual needs and severe financial constraints. Because funding is always so short, competitive tensions arise and define the process by which organizations seek to perpetuate themselves. Cooperative projects like this one inevitably face the question of whose interests are most served by the "group" effort. Although the tape was exhibited, used, and distributed as planned, in some ways each contributor had reason to question the utility of the piece. Clinic workers wanted more health care and less process footage. Nutritionists wanted more pedagogy and less dialogue and reflection by those who needed the knowledge most. Even the dramatized responses to food security choices carried a symbolic, imaginative dimension—something difficult to lock down within any single NGO's mission statement. The problem, at root, was that we took the opinions and insights of a large number of community members on the ground seriously. Dispersing the authority to "reflect" and teach in this way unsettles even those committed to the long fight to provide resources to the neighborhoods. But doing so seemed even more important given this contact and contestation. The city was seeing people it had never seen before; NGOs confronted other groups with overlapping objectives and ideals;

and everyone was having to deal with the sheer presence of newly empowered constituents. The arm-twisting I was feeling during the production process was probably an indication that many levels of the bureaucracy would now have to consider forces and interests beyond their own.

The media component of La Cosecha Nuestra provided the opportunity to reconsider the nature of a set of terms central to digital thinking: user "competencies" (real-world knowledge was showcased rather than technical–textual facility), "narrative pleasures" (identity and ownership were performed rather than mapped or "gamed" discursively), and user "gratifications" (ownership of expertise and "local knowledge" were claimed instead of ownership of pc technologies or Internet access). The project also gave a different spin to two other notions: first, to "virtual" thinking (defined as imaginative exercises via inductive focus groups, phone, and meeting dialogues, rather than by deductive, "menued" computer parameters); and second, to the goals of interactivity (social–spatial change in Escondido animated the project rather than textual–electronic permutations). La Cosecha Nuestra media provided a tangible text-image-sound catalyst for community formation—one that continues to be used in migrant health education—as well as electronic representations that unsettled the status quo positions of elected officials and social service "experts."

Distribution of the tape *Amor Vegetal: Our Harvest* involved focus groups that showed that tensions over bureaucratic ownership were less important than how interactivity gave even local residents outside of the garden community the opportunity for identification. A series of responses by teenage viewers in the Migrant Education Project repeatedly connected the opportunity to garden with memories of their villages in Oaxaca, and with how and why parents were doing this to prepare their children for acculturation in the United States (focus group with migrant education youth, May 24, 1998). They also raised the specter of day-to-day discrimination faced by Oaxaquenos—currently occupying the lowest "caste" strata in North County—in local schools. Most striking, however, was the way that harvesting became a repeated trope for ethnic identity. One discussant noted that this was the exception that proved the rule—that the video meant finally "that they are taking the Latino community into account." But others were more specific in their critiques of media representations and stereotyping. *Amor Vegetal* was not just about harvesting. For one, the tape offered "active, participating," and "positive image(s)." Another noted that these are "very different from the (media) images of the Latino as fat and lazy." Although the community was multiracial and comprised gardeners from many different countries and states—Guatemala, Michoacan, Sinaloa, Oaxaca, Jalisco, Argentina, Puerto Rico, the French Caribbean, and Canada—it stood symbolically as both a strategic foothold and a world of "willed affinity," a world where diverse ethnic groups coexisted productively. The migrant youth focus-group members, for example, consistently saw the tape not as a celebration of bounded, racial essentialism, but as an ethnic indigenous strategy open to all viewers. "There is no difference—everyone should feel like indigenous." (*No hay diferencia—que todos se sientan indigenas.*)

"Thinking digitally" is not just about web surfing, electronic poaching, and digital performativity. It can also involve social intervention, community formation, and real-world networking. Much of South Escondido was, after all, a world without personal computers or phone hookups for modems. Yet everyone had access to a VCR. Because of their competencies as television viewers, these gardeners knew how to claim tangible, on-camera, identities. It is indeed simply a waste of time to harden differences between analog and digital, "old media" and "new media," as the commercial trade press must do. Thinking digitally is not, ironically, an either/or situation. Given vast disparities in income and access in real-world communities, it never will be. Analog narrative interactivity in La Cosecha Nuestra shifted the terms—not of authorship, but of authority. Thinking digitally means ignoring the neat, and needlessly delimited, categories defined by computer products. Thinking digitally means acting in a way that animates frozen and sedated power relationships. Thinking digitally means making the world interactive and volatile. Doing so can make social communities cybernetic, rather than making social agents cyber-subjects. Understanding this process requires understanding the ways that material and physical marks of the land—buildings, landscapes, locations, *and* media technologies—shape and are, in turn, shaped by human subjects who inhabit and work the land.

These lessons seem to fly in the face of Apple's current marketing campaign for the iPod, and in the face of legal battles being waged over file sharing. Ecstatic, silhouetted iPod user/dancers in Apple's spots suggest that social spaces in the city can be colonized as transient, private spaces. Although iPod promises public self-mastery of one's image, iPod use involves little of the real-world networking and political negotiation entailed in the Escondido projects. The Supreme Court's ruling against file-sharing software companies Grockster and StreamCast on June 27, 2005, furthermore, pivots around the question of who owns and can control new media technologies in public and private space. For over a century, Hollywood and the entertainment industries have aggressively mounted cease-and-desist campaigns against any and all new media technologies capable of altering their top-down, linear distribution flows (starting with the player piano and including Betamax and MP3 downloading services). Like an eight-hundred-pound gorilla, the Motion Picture Association of America (MPAA) derails anything that it does not control (that is, almost *all* new technologies), confident that litigation proves far more expedient than actual research and development in financially harnessing new media technologies. This recurring battle typically boils down to who controls the space of new media duplication and consumption. The rhizomatic multidirectionality of digital-media file sharing and blogging are far too unruly for the economies of scale or scope that industry favors.

Yet we fail if we let this reductive, bipolar battle between "proprietary" industry and "democratic" user dominate the terms of what should be a *multilateral* new media debate. My questions are neither those of the MPAA nor those of Grockster and StreamCast. Lawyers on both sides in these cases have unfortunately reduced new media contestation

to questions of *intellectual property* that are *socially symbolic,* rather than to *material proper-ties* that function as *social forces and boundaries* in their own right. La Cosecha Nuestra showed me that very real gratifications come from media networking and from the tan-gible, tactile experiences that media forms can produce for users. New media spaces in Escondido, like the iPod, worked because of their tactile, artifactual, holdable, grounded qualities. Unlike the transient, iPod "bubble" in public, however, La Cosecha Nuestra's mediation constantly forced participants to confront, recognize, and deal with identities and interests other than their own. The consumerist brilliance of the iPod, camera-phones, podcasting, mobcasting, and the Blackberry show that the industry now sees the interpersonal spaces of real neighborhoods (not virtual spaces) as every bit as valuable and strategic as the community organizers in Escondido do.[10] Recent developments in new media materiality (new technologies that you can wear, carry, flaunt, transport, and cocoon), show that the land-claiming impulses in La Cosecha Nuestra are every bit as valuable now as they were in the community garden. Questions about the "ideological effects of the digi-spatial apparatus," however, need to be rethought to more convincingly explain the very real cultural differences between interactive gardening on the one hand and branded, merchandizing pod-space on the other. Understanding such differences may help us push new media theory from the global, totalizing urges involved in "think-ing digitally" to the grounded, new media production possibilities of "acting locally."

ABOUT THE AUTHOR

John T. Caldwell is a professor of Cinema and Media Studies at the University of Califor-nia, Los Angeles. A scholar and a filmmaker, he has authored several books, including *Production Culture: Industrial Reflexivity and Critical Practice* (Duke University Press, 2008), *Televisuality: Style, Crisis, and Authority in American Television* (Rutgers University Press, 1995), *Production Studies: Critical Studies of Media Industries* (Routledge, 2009, coedited with Vicki Mayer and Miranda Banks), and *Electronic Media and Technoculture* (Rutgers University Press, 2000). He is also the producer/director of the award-winning feature documentaries *Freak Street to Goa: Immigrants on the Rajpath* (1989) and *Rancho California (por favor),* which premiered at the Sundance Film Festival in 2002.

NOTES

1. This essay was written for the Interactive Frictions conference at the University of Southern California in Los Angeles in 1999. I am especially grateful to Marsha Kinder and Tara McPherson for their invitation to be a part of that event. I am also grateful to California Legal Assistance for their coordination of the community garden project, and especially to Victor Gomez, Sergio Mendez, Arturo Gonzales, and Devora Gomez, for the crucial roles they played in the projects described in this article. None of them should be held responsible for the views that I express in these pages. I also thank Sage Journals for allowing me to excerpt,

adapt, and revise portions of an article they published for use in this book (see Caldwell, "Alternative Media in Suburban Plantation Culture," which interrogates alternative media practice rather than the digital media theories examined here).

2. For the most influential statement by McLuhan on his theory of media, see McLuhan, *Understanding Media*.

3. For discussions of relationships between "vaporware" and media theory published in the same year, see Caldwell, "Theorizing the Digital Landrush," and the section on "vaportheory" in Lunenfeld.

4. See Foucault, "Of Other Spaces," for elaboration of this proposal.

5. I am grateful to Mark Williams for his suggestions, in conversations with me, on the development of critical spatial analysis in the humanities and social sciences.

6. Cynthia Cockburn provides a particularly good and detailed account of how "blackboxing" functions culturally and industrially in her essay "The Circuit of Technology: Gender, Identity, and Power."

7. It is fairly clear, in retrospect, that the 1990s cyber-talk described above helped produce the conceptual conditions needed for the emergence of a broad-based, commercial and technocultural social formation. As much as this talk about digital temporality has ostensibly focused on technologies or machines per se, it has also tended to involve specific reconceptualizations of "space" (reformulations that dematerialize and cognitivize space).

8. The next section is adapted from an earlier essay entitled "Racial Off-Worlds" and focuses on the cultural implications of the social and economic contexts involved in the Escondido projects.

9. For perhaps the most influential research on this notion of how identity is "performed," see Turkle. For a very good critique of this general approach, and a less optimistic view of the extent of user agency through identity "performance," see Seiter.

10. To clarify, podcasting services provide downloads to mobile iPod users of media content (e.g., Harry Shearer's "Le Show" from KCRW/NPR to Apple's iPods, beginning in June 2005), whereas "mobcasting" refers to the provision of film/television content to mobile phone users—as in Fox's ancillary "mobcast" of show info/elements from the series 24 to cell-phone users for a commercial fee in 2004–05.

VIDEO INSTALLATION ART AS UNCANNY SHOCK, OR HOW BRUCE NAUMAN'S CORRIDORS EXPAND SENSORY LIFE

Mark B. N. Hansen

"YOU HAD TO BE THERE": THE PARADOX OF VIDEO INSTALLATION ART

In her particularly insightful account of video installation art, media critic Margaret Morse emphasizes what is certainly the most vexing element of this art form: its problematic accessibility to the public (Morse, "Body"). Because of their site- and occasion-specificity, video installations present difficulties not simply for the viewing conditions and expectations endemic to traditional museum culture, but also for the traditional tasks of art historical and cultural critical analysis. Indeed, in Morse's quite apt characterization, video installations present a particular paradox to historians and researchers, for they have to be experienced in person to be experienced at all. For Morse, this problem of accessibility has resulted in a critical neglect of the arts of presentation in general, and of video installation in particular, and must be countered through a general call for more (informed) discourse.[1]

While Morse is certainly correct in this assessment, her call for more discourse must be complemented by a deeper appreciation of the constitutive paradox of video installation art: its rootedness in an evanescent experience of presence that Morse so concisely captures in her slogan "You had to be there." What I shall offer in this paper is just such a deeper appreciation, one that approaches and understands the problem of accessibility to video installation art not (solely or primarily) through the contingency of exhibition conditions or viewers' knowledge, but rather as an *intrinsic factor* of the particular aesthetic experience afforded by this art form. As I understand it, video installation art

affords a heightened experience of the presencing of worldly sensation that breaks with the overcoding of memory and consciousness central to the cinematic accounts of experience (up to and including those developed by some new media theorists). In this respect, we might situate video installation art of the late 1960s and early 1970s as an inaugural moment in an alternate media theoretical model of correlation between self and world—one that opens up the possibility of "direct experience" rooted in the temporally fine-grained granularity of sensation.[2] Needless to say, such an understanding would place video installation art at the opposite pole from where Rosalind Krauss (in-)famously put it in her 1976 article: far from representing the very apotheosis of narcissism, video installation art would, in fact, broker a crucial contact between human "mindbody" and media environment on the hitherside of, if not indeed "prior" to, their multiple differentiations.

Two distinct elements of video installation art obtain particular significance for my purposes here. On one hand, there is the temporal granularity of the video image that, precisely on account of its differences from cinematic and photographic images, has led critics to identify it with the flux of the material real beneath the threshold of common sense and recognition, the twin figures of the Kantian image of thought identified by Gilles Deleuze in *Difference and Repetition*. On the other hand, there is the specific affordance of so-called "real-time" closed-circuit video that allows one's mirror image (self-image or body-image) to be detached from one's "natural" (self- or body-) perspective and presented in the real-time present tense as an autonomous image, a self-image that deserves to be called "virtual" to the extent that it presents a view of the self from a perspective that cannot be that of the (natural) self.

Together, these two elements position video installation art as a successor, of sorts, to cinema understood as a cultural apparatus for adapting sensation to the demands of the technological environment. Just as cinema, according to the compelling account proffered by Walter Benjamin, furnished a physiological training—the infamous "shock experience" (*Chockerlebnis*)—which helped to acclimate modernist mindbodies to the rhythms of the urban environment, video installation art helps to acclimate its spectator-participants to the molecular fluxes of contemporary televisual images. More specifically, and this is the thesis I propose to develop here, video installation art is able to mobilize a technical facility of video toward a particular technical-historical end: for if the constantly refreshing video image gives the ability to target and modulate the "delay" that is constitutive of sensory presencing, the "installation" of the video image within certain spatial-institutional configurations can direct this targeted and modulated delay to address the social, technical, spatial, and temporal conditions of real experience in our world today. Such a well-nigh homeopathic view of video installation art dovetails in important respects with Morse's account of the privilege it holds as an art form capable of exposing the particular interpenetration of image and built environment characteristic of our contemporary cultural moment. Importantly according to Morse, video installation art achieves this exposure not primarily through critical means, by bringing that

interpenetration to reflective awareness, but rather corporeally, by stimulating a process of learning "not with the mind . . . but with the body itself," "at the level of the body ego and its orientation in space" ("Body" 161, 156). As Morse sees it, the crucial element of any installation is "the space-in-between," and the "art is the part that collapses whenever the installation isn't installed." To the extent that this space-in-between—this space of sensory singularity—is actualized *in the body of each participant,* the video installation is as much *in* the body of the participant as the participant's body is *in* the installation.

WHERE BODY MEETS IMAGE

No one has put more pressure on the body-image nexus than Bruce Nauman. In a series of explorations beginning with neon and 16-mm film, passing through video and language work and continuing since then in a plethora of media, Nauman has staged complex confrontations linking—but also dissociating—various technical intervals constitutive of minimal change and the embodied sensory intervals that both breathe life into them and transform them into more complex entities. In his essay "Nauman's Kinematic Cinema," François Albera has distilled this process of confrontation to its essence:

> Given that in the 1960s Nauman shot several films (notably *Art Make-Up, Nos. 1–4, Playing a Note on the Violin While I Walk Around the Studio, Black Balls*), as well as numerous videos recording the duration of a performance (*Slow Angle Walk (Beckett Walk), Manipulating a Flourescent Tube,* etc.), we cannot but note this attention to the minimal relation between two phases of a movement, two stases as the inscription of time issuing from a discontinuity, for we can suppose that it *grew out of* these same experiences which, in contrast, played on the continuity of the sequence (a single shot) and undivided temporal unfolding. One could consider, in fact, that by questioning this "given" of recording by means of the discontinuities that he presents in terms of framing, angle and the movements of the filmed subject, Nauman has managed to produce the opposite effect and go back to the "(optical-) technical foundation" of cinema. (Albera, 51)

And when he does go back to Eisenstein's "(optical-)technical foundation," Nauman doesn't undo the cinematic creation of continuity in the name of a conceptual revelation, as would an experimental filmmaker such as Eisenstein himself, whose overriding interest would be simply to interrupt the ideological mechanism of cinematic continuity. Rather, Nauman's concern is to mine this interruption for its experience-generating potential.

That is why, as his most astute commentators never tire of pointing out, Nauman does not so much facilitate prosthetically positive conjunctions as foster unease and dysfunction. "Nauman's central interest," notes Marco De Michelis, "was not—and is not—the experiential event but the experience of unease, the challenge to individual identity and to the boundaries between inside and outside, public and private, the dilemma or

question that might produce a condition of tension and might require not just awareness but a certain degree of physical involvement. All of his architectural installations propose this condition." De Michelis describes Nauman's corridors as "traps into which visitors slip without suspecting the consequences, only to find themselves in situations that elude univocal interpretations" (De Michelis, 75). We might say, then, that Nauman's installations extend our body's capacities, but always in the name of exploring what the body can do when thrown out of its normal patterns of activity, its ordinary balance between habit and change. A case in point here is the elemental neon piece *Hanged Man,* which through its simple oscillation between two states (erect/nonerect, hanged/not hanged) maps the conjunction of discrete "digital" discontinuities onto the analog embodied continuum of gravitational movement. The crucial point here is that in viewing the perpetual oscillation of *Hanged Man,* we are not engaging simply with a frictionless pendulum, but rather with a conjunction laden with embodied meaning.

One culminating moment in Nauman's practice of body-image confrontation that bears particular relevance for my exploration here is his video installation work from the early 1970s. In a series of corridor installations, Nauman plumbed the potential of this medium as an interactive form of performative body art that engages the affective experience of the audience.[3] In this series of works, Nauman sought to introduce an interactive component into his artistic concerns of the late 1960s, and specifically to bring viewer activity (if not agency) into his work with media, which had, up to this point, been limited to temporally protracted performances of elementary bodily activities captured on film and video.[4] By shifting the locus of the aesthetic performance to the spectator (in an environment from which the artist is physically absent) and by introducing certain spatial and architectural constraints that compelled the spectator to experience just what the artist wanted her to, the switch to the video installation format, as Nauman himself put it, allowed him to overcome the problem of the artist as "court jester" and to exert a literally tyrannical control over the sensory situation afforded by his environments.[5]

Nauman's experiments with video corridors culminated in the *Corridor Installation (Nick Wilder Installation)* of 1970. In this duly famous work, Nauman constructed a series of walls dividing the space into six passages, only three of which were passable. The longest of these corridors (the "Performance Corridor" used in Nauman's video *Walk with Contrapposto*) narrowed from two feet to eighteen inches as the spectator-participant walked through it. Three live video cameras were mounted at the top of the walls, one in this central corridor, and corresponding monitors offered images of empty (impassable) corridors as well as images of any visitors who might enter the central corridor, always captured from a bird's-eye view and from behind. Thus, as the spectator-participant approached the monitors, her image grew increasingly small, affording a disturbing, counterintuitive perceptual experience. In a contemporaneous report, *Los Angeles Times* art critic William Wilson described the feeling elicited by the installation as one of "vague dread" and "invisibility": "At the end of the first passage two TV monitors are stacked, showing the passage itself. Enter and you see yourself on TV, from behind. The back of

your neck prickles slightly as if someone watched. The other screen shows the same scene but your image is absent. You feel vaguely that you have disappeared. Looking back at the image of the figure behind, you wonder if that is really you. The camera is located so that it is impossible to see one's face" (Benezra, 28). Morse's own description specifies the nature of this feeling of dissociation: "To me it was as if my body had come unglued from my own image, as if the ground of my orientation in space had been pulled out from under me" (Morse, "Body" 155–156).[6]

Precisely this effect of bodily dissociation captures video installation's privilege as one of the exemplary art forms for our times: by rupturing our habitual patterns of (self-)perception, video installation environments facilitate an affective apprehension of the self-image-in-itself—the self-image made autonomous from our natural, single-perspectival viewpoint. Thus, in *Corridor Installation (Nick Wilder Installation)*, the spectator-participant's habitual perception of herself is perturbed by a certain splitting—by the real-time relay of her image, displaced from its habitual perspective and with a slight delay, onto a monitor placed within the space of the installation. As Morse suggests, such splitting dismantles the "symmetrical relationship of the body and the image" in a way that "breaks the illusion most fundamental to mass culture and to broadcast television—that . . . broadcast images are meant 'just for you'" ("Body" 171). And, far from functioning as a form of cognitive critique, video installation accomplishes such a dismantling through a process triggered by sensory shock, through affective response.[7] As Morse sees it, this possibility arises directly from the reconfiguration to which video installation submits the standard cinematic circuit: "Unlike film, in which the camera, the optical printer, and the projector occupy the same position at different times, in live closed-circuit video, the monitor operates simultaneously with the camera *and must be placed asymmetrically to it* . . . " ("Body" 171).

SHOCK AND THE SENSORY

Benjamin is rightfully renowned for having correlated reproductive technologies with broader technologically facilitated changes in the structure of early-twentieth-century labor conditions and in the modern metropolis more generally. As he explains in one duly famous passage from "On Some Motifs in Baudelaire," filmic temporality forms a kind of aesthetic analogue to the repetitive temporality of the factory assembly line: "[T]echnology has subjected the human sensorium to a complex kind of training. There came a day when a new and urgent need for stimuli was met by the film. In a film, perception in the form of shocks was established as a formal principle. That which determines the rhythm of production on a conveyor belt is the basis for the rhythm of perception in the film" (*Gessammelte Schriften* 175). By isolating a distinctly tactile dimension of film, Benjamin puts a novel stress on the physiological processes underlying cinematic spectatorship: insofar as filmic perception involves what Benjamin calls a "shock-effect" (*Chockwirkung*), the practice of viewing film functions to modify our physiological, embodied being in ways that acclimate it to the experiential conditions of technological modernity.

In his inspired extension of Benjamin's thesis, film critic Steven Shaviro develops a properly physiological understanding of cinematic perception that resists the temptation, manifest in the vast majority of Benjamin's interpreters, to understand shock through the dialectical image.[8] Rather than resulting from an explosive encounter of two (or more) *already articulated* images, shock, for Shaviro, is an effect of the prearticulated "materiality of sensation" presented by film. Shock, in other words, emerges directly from the new kind of perception that film makes possible, a perception that is "below or above the human," that is "multiple and anarchic, nonintentional and asubjective . . . no longer subordinated to the requirements of representation and idealization, recognition and designation" (Shaviro, 31).[9] This new form of perception, moreover, concerns images not simply as vehicles of signification, but as *visual forces in themselves*. Citing the famous scene from Godard's *Les Carabaniers,* in which the young protagonist covers his eyes on seeing the Lumière film of a train arriving at the station, Shaviro convincingly suggests that cinema's efficacy does not concern the representational verisimilitude of the image, cinema's alleged "reality effect," but stems rather from a more profound verisimilitude: "its visceral insistence and its movement," its ability to directly stimulate "the optic nerves, bypassing cognitive and reflective faculties altogether" (33). As a gloss on Benjamin's shock-effect, the sensory agitation and "compulsive fascination that overtake the viewer" serve to specify how film affects the spectator's material body: the product of the sensory immediacy of images, shock functions by catalyzing a *physiological shift in our embodied habits of vision*.

Generalizing Benjamin's account of the suspension of perceptual processes of association in montage, Shaviro correlates shock with what Maurice Blanchot calls "passion for the image." Such primordial passion, Shaviro leaves no doubt, is what makes cinematic spectatorship possible in the first place: "Visual fascination is thus a precondition for the cinematic construction of subjectivity, and not a consequence of it. It is not the gaze that demands images, but images that solicit and sustain—while remaining indifferent to—the gaze" (20). As cinematic spectators, we are put in the position of *victims* of images, forced to endure their sensory violence, whether because of the persistence of vision or the illusion involved in "short-range apparent motion."[10] In either event, what cinematic perception involves is some challenge to cognitive processing, and whatever *passivity* we experience in front of the image emerges not as the result of a generality about human perception, but rather as an effect of the specific, constructed reception situation of cinema. Immobilized and positioned in front of a mechanically progressing image, this irreducible experience of passivity is precisely what generates the physical, or as Benjamin puts it, *tactile* effects of cinematic perception: in the experience of film, the immaterial image "hit[s] the spectator like a bullet, it happen[s] to him, thus acquiring a tactile quality" (*Gessammelte Schriften* 238).

Shaviro's introduction of an irreducible interval or gap within perception helps to unpack this tactile experience;[11] in his account, the shock effect both results from and betokens a split between two levels of perception: a "primordial or preoriginary" level at which the image imprints itself on the retina as unarticulated, excessive sensation and a

derivative level at which qualitative perception (what Shaviro calls "reception") first emerges (51). The experience of shock results from the temporal discord between these two levels: shock simply *is* the physical or physiological impact generated by the image's imprinting *prior to* its reception, by an imprinting of the image that is autonomous from the qualitative perception to which it subsequently leads.

Let us call this shock experience the "cinematic model of sensation." In it, the experiencing of sensation is necessarily deferred or delayed in relation to its actual occurrence, and subjectivity, or perception proper, remains secondary in relation to the intensity or passion from which it emerges:

> The retention of virtual images is concomitant with an irreducible gap between stimulus and response, or more precisely between the imprinting of a sensation and its reception. This gap or interval is, for Deleuze (1986), constitutive of but irreducible to subjectivity: it is the ungraspable nonperception that alone makes subjective perception possible. The gap is a wound at the heart of vision: the phenomenon of shock that fascinates Benjamin, or the exorbitation of the eye, the blindness at the heart of sight, that so obsesses Bataille. In Blanchot's (1981) words, "The split [between eye and object], which had been the possibility of seeing, solidifies, right inside the gaze, into impossibility. In this way, in the very thing that makes it possible, the gaze finds the power that neutralizes it." The disengagement of a primordial or preoriginary level of perception violently excites, and thereby fascinates and obsesses, the film viewer. Perception is turned back upon the body of the perceiver, so that it affects and alters that body, instead of merely constituting a series of representations for the spectator to recognize. (Shaviro, 51)

Shaviro would be well advised to correlate this "primordial or preoriginary level" with sensation rather than with perception, as he does at an earlier moment in his argument when he states that "the dematerialized images of film are the raw contents of sensation, without the forms, horizon, and contexts that usually orient them" (31). Were he to do that, he could demarcate in the clearest way possible this primordial level of preperceptual, preexperiential intensity from the level of qualitative perception that emerges from it.

The crucial point here, however, concerns the nature of the gap or interval that characterizes this cinematic model of sensation: it is a *nonperceptual* gap or interval, which means that the perceptual experience that both is and is elicited by a given film—together with the subjectivity that is homologous with it—emerges *through the process of memory*. Put another way, it means that the sensory source for the perceptual experience—the "primordial or preoriginary level"—is forever lost to the past and can only be recuperated as the content of memory, as an imprinted image, recollected by perceptual consciousness.

VIDEO IS A MODULATION OF FLOWS

We have already said what distinguishes video from the cinematic image where it is a question of delay. In modeling a certain relation between sensory intensity and qualitative

perception, the cinematic image, as Shaviro's specification of Benjamin helps to demon-strate, is built upon a memory—or more exactly, a virtual retention—of what will have always already been imprinted. By contrast, because of its capacity to modulate the sensory flux directly and in the present of "real time," the video image injects perception directly into matter, entirely bypassing the mediation of memory. With the video image, in other words, there is no imprinting, prior or otherwise, but only perpetual scanning; as a result, there is no distinction between levels, nor any mediation performed by memory or by the brain. There is, simply, direct perception of movement. "When we look at film and video," John Belton argues, "the difference we perceive between the kind of image pro-duced by each is, in part, the product of the different technologies each uses to produce an illusion of movement. We see video movement directly—*it is not mediated for us by the brain; it is immediate and uninterrupted*" (Belton, 67, emphasis added). The corollary of this autonomy of video perception is a certain autonomy from the form of the image, as Belton goes on to note: "At the same time, with video and unlike film, there is never a whole image either on the TV screen or on our retina; what we have, instead, is *always a partial image*—a single pixel or dot of visual information is conveyed every four-hundred-thousandths of a second—in a continuous chain of electronic scanning. Video images are always in the process of their own realization. Their association with immediacy and presentness is partly because they are always in the process of coming into being" (Belton, 67, emphasis added).

Far from being a mere technical element, however, it is precisely this autonomy of video from the form of the image that allows it to directly modulate the flux of matter. It is, in short, what anchors the video image—or rather, the constantly refreshing video raster—firmly within a specious present, and also, correlatively, what prevents it from opening any interval that would require the mediation of memory and the recollective brain. Philosopher Maurizio Lazzarato helps us to appreciate this affordance of video: "The video image," he notes, "is not an immovable still set in motion by a mechanical arrangement. Instead, it is a constantly reshaping profile painted by an electronic paint-brush. It takes its movement from the oscillations of matter; it is this oscillation itself. Video technology is a modulation of the flows—the image is nothing more than a rela-tionship between flow—the video-image is a result of contraction or dilation of the time-matter. . . . [V]ideo technology captures movement itself: not something moving in space, but the 'pure oscillations' of light" (Lazzarato, 284).

Delay as memory or "real-time" delay: the difference at stake between cinema and video is both aesthetic and technical, which is why Gilles Deleuze can help us in our quest to grasp the specificity of video modulation. In Deleuze's study of movement- and time-images in the cinema, the technical and the aesthetic are everywhere profoundly imbricated: thus, to give only the most fitting example, the simultaneity at issue in Welles's overlapping sheets of the present cannot be understood or appreciated without considering the significance of depth-of-field technique and the correlative film stock that allowed the massive expansion of the camera's focal range. When he broaches the topic

of the electronic image in the "Conclusions" chapter of *Cinema 2*, Deleuze extends this aesthetic-technical parallelism into the new domain, or at least poses this as a possibility on which hangs the future of cinema itself:

> The modern configuration of the automaton is the correlate of an electronic automatism. The electronic image, that is, the tele and video image, the numerical image coming into being, either had to transform cinema or to replace it, to mark its death. We do not claim to be producing an analysis of the new images, which would be beyond our aims, but only to indicate certain effects whose relation to the cinematographic image remains to be determined. The new images no longer have any outside (out-of-field), any more than they are internalized in a whole; rather, they have a right side and a reverse, reversible and non-superimposible, like a power to turn back on themselves. They are the object of a perpetual reorganization, in which a new image can arise from any point whatever of the preceding image. The organization of space here loses its privileged directions, and first of all the privilege of the vertical which the position of the screen still displays, in favor of an omni-directional space which constantly varies its angles and co-ordinates, to exchange the vertical and the horizontal. And the screen itself, even if it keeps a vertical position by convention, no longer seems to refer to the human posture, like a window or a painting, but rather constitutes a table of information, an opaque surface on which are inscribed "data". . . . In all these senses, the new spiritual automatism in turn refers to new psychological automata. (265–266)

When he recognizes that "a new image can arise from any point whatever of the preceding image," Deleuze puts his finger on precisely what would—in the years following the publication of his study of cinema—come to define the specificity of the electronic as against the cinematic image: namely, the independent addressability of each element (pixel) of the image itself or, put another way, the collapse of the image as the fundamental unit of manipulation. This difference is crucial to the process of modulation, a process of great importance to other areas of Deleuze's thinking (e.g., subjectivation and control), if not to his account of cinematic images.[12] Situated in the context of the confrontation of cinema and video, modulation captures the differential specificity of video, the fact that video does not generate a continuity of images or a movement between images, but a continuity *beneath the level of the image*, a continuity of the flux of movement itself.

This leads to a somewhat paradoxical situation with respect to our engagement with Deleuze: for if video's capacity to directly modulate the flux of matter is tied to its freedom from memory and from the form of the image and its capacity to link onto other images, then we cannot entirely follow Deleuze when he situates video in the wake of American experimental film. Ultimately, what is at stake in video and what is at stake in American experimental film differ, if only because a similar aesthetic aim must be approached via two very different technical trajectories. Thus, whereas the experimental filmmakers must seek to purge the image of all subjectivism, artists using video are free from the get-go to engage with a flux already, as it were, purged of a mediating human

perceptual element. Once we have acknowledged this fundamental techno-ontological difference, we are in a position to appreciate the perspective Deleuze's commentary affords on the common aesthetic project at issue here. According to Deleuze, both American experimental film and, subsequently, video art carried further Vertov's effort to reach the "genetic element of all possible perception": the "point which changes, and which makes perception change, the differential of perception itself" (Deleuze, *Cinema 1, 83*). This expansion occurs in two stages: first with the photogramme, which effectively virtualizes photography by situating it (following Bergson's formula) "in the interior of things and for all points of space" (85); and then with video, which expands this virtualization by facilitating "the formation of an image defined by molecular parameters" (85). Despite his apparent embrace of a dynamism of the space within the image, which should have led to a substitution of modulation for the concept of linkage, Deleuze retains the fixed parameters of the image, and positions the time-image as a bulwark against the assault of television.[13]

And yet, with his specification of two distinct types of cinematic images and his succinct comments on the electronic image, Deleuze gives us what we need to define video modulation. Operating in relation to units far more microscalar than the image (even if it is typically framed as and by an image), video modulation brings the virtuality normally associated with the interstice between-two-images (the time-image) into the domain of the sensorimotor. Instead of stemming from the brain's capacity for retention of virtual images, video's virtuality tends toward radical equivalence with things themselves. Through the continuous becoming that constitutes its specificity, the video "image" thus *materializes* the universal variation and modulation, the "in-itself of the image," that constituted the aim of Vertov's pure perception and of Cézanne's world before man. In short, its virtuality is the virtuality of the *perceptual* image, freed from its anchoring in the human point of view; with video, the image surmounts the one limitation that the human eye can never surmount: its "relative immobility as a receptive organ," which anchors perception to one actual perspective and varies images in relation to a single privileged image.[14]

NONPERCEPTUAL SHOCK?

Let us pause to accumulate what we have gathered, thus far, from our comparison of film and video. Whereas film operates by means of a virtual suturing of discrete whole images *in memory,* video attains a distinct virtual dimension that is properly *internal to its technical production.* Movement in video is not constructed after the fact, by the brain, but occurs in a continuous becoming of images through ongoing scansion. *This material property is precisely what confers autonomy on the video "image."* And since it no longer requires memory for its completion, the video image, unlike its cinematic counterpart, does not *of necessity* generate any shock whatsoever. If shock is, as we have suggested, the affective experience that puts us in contact with our own perceptual processes, the important question

thus arises: has this experience—like affect itself—withered in the age of video? Or has the correlation between shock and media itself perhaps changed in significant ways?

Once again, Deleuze's conceptualization of the cinematic image can help us specify the situation of video. For if video modulation differs from the movement-image in not integrating shock as an *intrinsic* element, it also differs from the time-image in not embracing shock as a purely cognitive element. If shock must be introduced into video modulation from the outside, as I have already suggested, it nonetheless takes the form of a modification—a particular appropriation—of that very modulation. That is ultimately why shock *must be* introduced into video, or at least why its introduction is productive, for the modification it catalyzes not only occurs in the sensorimotor interval but insistently fixes this interval within and as the measure of a specious present.

What Deleuze calls the cinema of the movement-image corresponds roughly to what Benjamin understands by cinema, and the notion of shock it effects seems to correlate with what Benjamin and Shaviro describe:

> [O]nly when movement becomes automatic [is] the artistic essence of the image . . . realized: producing a shock to thought, communicating vibrations to the cortex, touching the nervous and cerebral system directly. . . . Automatic movement gives rise to a spiritual automaton in us, which reacts in turn on movement. The spiritual automaton no longer designates—as it does in classical philosophy—the logical or abstract possibility of formally deducing thoughts from each other, but the circuit into which they enter with the movement-image, the shared power of what forces thinking and what thinks under the shock; a nooshock. . . . It is this capacity, this power, and not the simple logical possibility, that cinema claims to give us in communicating the shock. It is as if cinema were telling us: with me, with the movement-image, you can't escape the shock which arouses the thinker in you. (Deleuze, *Cinema 2*, 156)

What Deleuze adds to the picture given earlier—though perhaps we will ultimately come to see this as a distortion—is the link of shock with thought: for Deleuze, the crucial point is that shock forces us to think: it is always, necessarily, *nooshock*. For Benjamin and Shaviro, by contrast, shock is important for itself: as the affective correlate of the sensory excess that preconditions the emergence of cinematic perception.

This is why, of course, Deleuze's cinematic philosophy culminates in the concept of the time-image which, for our purposes here, amounts to an internalization of shock within thought and a correlative sublation of its sensorimotor origins. Shock, if it exists at all in the cinema of the time-image, must exist *within the image itself,* which means in radical subordination to the progress of a demonstration or theorem, the necessity of which stems from the demands of thought, not from the *external* provocation of association. From the pioneering introduction of depth-of-field in Renoir and Welles to the *theorematic* cinema of Pasolini, thought acquires an immanence in the image that suspends the crucial role performed by sensory shock in the cinema of the movement-

image. With the introduction of depth-of-field, Deleuze explains, "[t]here is . . . no room for metaphor, there is not even any metonymy, because the necessity which belongs to relations of thought *in the image* has replaced the contiguity of relations of images" (*Cinema 2*, 174, emphasis added). "*Theorem* and *Salo*," he continues, "aspire to have the paths of [thought's] own *necessity* follow on from thought, and to carry the image to the point where it becomes deductive and automatic, to substitute the formal linkages of thought for sensory-motor representative or figurative linkages" (*Cinema 2*, 174). Here, then, shock becomes the result of thought's self-affection by itself, it being understood that this necessarily involves contact with the virtual, the force of the Outside.[15]

Like shock generated purely through thought, shock in relation to video modulation of the flux of matter results from a simultaneous apprehension of overlapping and incompatible virtual perspectives—a confrontation with the pure perception of things, the nonhuman in-itself of the image. In both cases, shock has become extrinsic and, in some sense, optional: no longer a structural element of the mechanism of perception, either because the human is excluded from the perceptual circuit (video modulation) or because there is no perceptual circuit (time-image), shock will be experienced *if and only if a human subject seeks to appropriate perception to herself.* Whereas sensory-motor shock once inhabited the interval between images as a negative prefiguration of the human subject, whatever shock occurs in the time-image concerns the voluntary and purely cerebral appropriation of a virtual and nonhuman perception of time, while the shock sparked by the video image comprises a supplementary spatiotemporal displacement of perception that is at once *contained in* the sensory flux of the perpetually becoming video signal and yet is *external* to its mechanism of formation. Rather than the necessary result of an actual form of perception that remained strictly coupled to embodied enaction, shock in both the time-image and in video has become a contingent and extrinsic correlate of the actualization of a nonhuman, virtual form of perception.

Since shock-experience is no longer intrinsic to technology, as it is in the cinema of association, shock can be produced only through a carefully engineered confrontation between human perception and the pure virtual perception of things themselves as it is embodied in the time-image or in the video image. Moreover, this new emphasis on the staging of human interaction with technology introduces an important difference *between* the time-image and video that will be decisive for my understanding of video installation art as a "redemptive" aesthetic practice: whereas the confrontation with the virtual perception of things themselves is intrinsic to the conditions under which the time-image can be perceived, it must be built into the continuously becoming and perpetually present video image. Much like the camera-less cinema of the American experimentalists, the time-image offers a purely cerebral confrontation with the virtuality of time and in this sense, can be said to *celebrate*, in the cognitive mode proper to it, the triumph of the nonhuman and the liberation of the image from the constraints of embodied perception. The video image, by contrast, calls for an *extrinsic* staging, one that can exploit its freedom from human anchoring not to celebrate the nonhuman, but precisely to recon-

nect the image-in-itself, the virtuality of the perceptual image, *with the embodied perspective of human sensory life.*

UNCANNY SHOCK

Let us now return to the scene of shock in video installation art. In Nauman's video corridor works, including *Corridor Installation (Nick Wilder Installation)*, this scene always involves a confrontation with the self-image detached from one's embodied "natural" perspective and presented as autonomous. This confrontation constitutes a contemporary instance of the uncanny, not in its dominant Freudian determination as a return of the archaic, but rather in the sense of a skewed phenomenal confrontation with one's self-image, such as Freud reports in a curious and remarkable footnote to "The Uncanny":

> [I]t is interesting to observe what the effect is of suddenly and unexpectedly meeting one's own image. . . . I was sitting alone in my *wagon-lit* compartment when a more than usually violent jerk of the train swung back the door of the adjoining washing-cabinet, and an elderly gentleman in a dressing-gown and a travelling cap came in. I assumed that he had been about to leave the washing-cabinet which divides the two compartments, and had taken the wrong direction and come into my compartment by mistake. Jumping up with the intention of putting him right, I at once realized to my dismay that the intruder was nothing but my own reflection in the looking-glass of the open door. I can still recollect that I thoroughly disliked his appearance. (Freud, "The 'Uncanny'" 248)

What makes the mirror-image so dreadful is precisely its noncoincidence with Freud's ordinary self-perception through his reflection in a mirror: not only is his self-image at an oblique angle to his natural line of sight, but it is in motion toward him. What Freud confronts in this paradigmatic scene is nothing less than his *virtual* self-image: himself (or his self) as he (it) would appear to the gaze of another. Understood as a category of phenomenal experience, the uncanny thus designates a moment in which one gains a perception of one's virtual self-image, an "objective" or absolute grasp of what is ordinarily outside the domain of experience.

Though anticipated in mechanical experiences like Freud's self-encounter in a railway car or the experience of the actor in front of the camera,[16] uncanny shock only becomes emblematic of everyday experience with the advent of a lifeworld fully saturated by visual images. To fully appreciate the ensuing experiential condition requires us to adopt the perspective of "movement-vision" which Brian Massumi contrasts with ordinary mirror vision. As theorized by Massumi in his inspired analysis of Ronald Reagan's peculiar "completeness," movement-vision involves "seeing" from the standpoint *of movement itself,* which includes the perspective from which the seen is seen:

> Movement-vision is not only discontinuous with mirror-vision. It is discontinuous with itself. To see oneself standing as others see one is not the same as seeing oneself walking

as others see one. . . . Simultaneously occupying its place and the object's, the subject departs from itself. The subject-object symmetry of mirror-vision is broken. The subject overlays itself on the object in a super position of reciprocal functions. The gap left by the subject's self-departure is filled not by a new subject or object but by a process encompassing their disjunction in a tide of change. This disjunctive encompassing is a kind of continuity but is in no way a simple one like that of mirror-vision. . . . The continuity of movement-vision is an *included disjunction*. It is a continuous displacement of the subject, the object, and their general relation: the empirical perspective uniting them in an act of recognition. It is an opening onto a space of transformation in which a de-objectified movement fuses with a de-subjectified observer. This larger processuality, this *real movement*, includes the perspective from which it is seen. (Massumi, 51)

Just as Reagan-the-politician seeks to "see" himself from a perspective (or a disjunctive set of perspectives) normally occluded from his ordinary mirror vision, so too does video installation art—and nowhere is this more true than in Nauman's corridor works—aim to present the viewer-participant with her own image, as it were, in "movement-vision." Otherwise put, video installations expose the logic of the televisual apparatus—the logic that privileges the viewer's embodied spectatorial viewpoint—by compelling viewer-participants to experience what its normal operation must obscure: the completeness of the virtual self-image.

In contrast to Reagan's turbo-charging of his own virtual self-image, Nauman's corridor installations shock their viewer-participants by compelling them to experience what we might call a faulty coupling of actual embodied movement and partial movement-vision. Thus, in *Corridor Installation (Nick Wilder Installation)* and in *Live Taped Video Corridor,* the viewer-participant must move toward a monitor at the far end of a corridor on which is displayed her image from behind; yet as she moves closer to the monitor, her image becomes smaller and smaller. As Janet Kraynak has put it, these works create a "disturbing disjuncture . . . between vision and experience: I *feel* myself getting closer, yet I *see* myself receding further away. The two forms of sensorial information"—and we might add, the two activities of movement and vision—"do not coordinate but rather contradict each other. Such strangeness is not only unfamiliar but unsettling . . . " (Kraynak, 232). To put it even more concretely, these works create a disjunction between movement-vision and actual movement, not to mention between both of these modalities and mirror-vision itself, such that the viewer-participant finds herself dissociated not only from her mirror- (or self-) image (an experience that Morse's description, cited above, perfectly captures), but also from her embodied sense of self, from what phenomenologists and psychologists have termed the body or motor schema.[17] As a result of this dissociation, the viewer-participant comes to experience an uncanny shock far more profound than what Freud underwent faced with his own mirror image swinging toward him: she experiences sensing unanchored to her body as center of gravity and principle of continuity. She experiences, for the momentary duration that characterizes any experi-

ence of shock, the purely impersonal depresencing of the world itself: the world as it moves in and for itself, as it itself "sees" and "feels."

THE MISSING HALF-SECOND

The impersonal dimension of the shock effect at issue in these works correlates perfectly with Nauman's stated desire to manipulate the viewer-participant, and specifically to create effects that would happen over and over again, regardless of any prior knowledge or expectations concerning the installation situation. Thus Nauman admits his explicit intention to shock the spectator-participant: "When you realized that you were on the screen, being in the corridor was like stepping off a cliff or down a hole. It was like the bottom step thing—it was really a very strong experience. You knew what had happened because you could see all of the equipment and what was going on, yet you had the same experience every time you walked in. There was no way to avoid having it" (Nauman, quoted in Schimmel, 78). I want to suggest that there is some connection between the automaticity of this shock experience and the automaticity of the sensory materiality that comprises its impersonal, microtemporal content. More precisely, I want to link the automaticity in both cases to the temporality involved and to suggest that there is some concrete correlation between the timeframe of the coming-to-awareness constitutive of the shock effect of Nauman's corridor works and the timeframe of the phenomenon of awareness in the neuroscientific research of Benjamin Libet, who famously postulated on the basis of a series of much disputed experiments that conscious awareness lags behind neural activation by about half a second. What I want to retain from Libet, however, is not the length of duration of the time lag, nor the notion of "backward referral" that he postulates to preserve the chronology of events, nor even the ethical quandaries that famously result from his findings, but rather the crucial claim that the lag constitutive (necessarily constitutive) of awareness, no matter how long it may in fact turn out to be, *involves no element of memory* but *happens entirely within—and thus defines the scope of—a specious present.* "Awareness," Libet concludes, "is a unique phenomenon, with its separate neuronal requirements. Awareness is not a function of a memory process. It is not the equivalent of a formed, declarative memory trace. Nor is the absence of a report of awareness due to a rapid forgetting of an early actual sensory experience. . . . [A]wareness is the emergent result of appropriate neuronal activities when these persist for a minimum duration, of up to 0.5 sec" (Libet, 66–67).

As Libet defines it here, awareness thus names the experiential correlate of video modulation: a process that, to adapt the phrasing Belton used to describe the video raster, is not mediated for us by the brain (in a process that would generate memory), but is entirely immediate and purely present. Indeed, what happens in the moment of uncanny shock occasioned by Nauman's corridor works comprises a "missing half-second" in its own right, what critic Marcia Tucker describes as a "purely physiological reaction," a "highly charged emotional experience . . . similar in feeling to the impact of seeing, but

not immediately recognizing yourself in the reflective surface of a store window as you pass it" (Tucker, 94). Specifically, the missing half-second of uncanny shock "contains" a surfeit of sensibility spanning potentially disjunctive exteroceptive modalities prior to its emergence into perceptual consciousness. It is literally brimming over with sensory intensity.

If it thus correlates with what Shaviro calls "passion," the shock experience it informs differs fundamentally from the cinematic shock experience; it differs from it on account of its immediacy and pure presencing, on account of what Massumi might call its intensity or "viscerality." Not only does it occur in the duration of neuronal presencing, but it happens before this duration can be imprinted or enregistered in a form (as image) that could then be (subsequently) remembered or recollected: "Visceral sensibility immediately registers excitations gathered by the five 'exteroceptive' senses, *even before they are fully processed by the brain*. . . . [T]he immediacy of visceral perception is so radical that it can be said without exaggeration to precede the exteroceptive sense perception. It anticipates the translation of the sight or sound or touch perception into something recognizable associated with an identifiable object. Call that 'something recognizable' a quality (or property). . . . [V]iscerality subtracts quality as such from excitation. It registers *intensity*" (Massumi, 60–61). Indeed, in his own deployment of Libet's research, Massumi pinpoints the very condition we have associated with video sensation and whatever kind of shock might be built into it.

What is crucial for Massumi is that sensation occurs more rapidly than it can be processed, which means that it literally overflows the brain's capacity to linearize it into the flux of perceived and remembered experience: "sensation involves a 'backward referral in time'—in other words . . . sensation is organized recursively before being linearized, before it is redirected outwardly to take its part in a conscious chain of actions and reactions. Brain and skin form a resonating vessel. Stimulation turns inward, is folded into the body, except that there is no inside for it to be in, because the body is radically open, *absorbing impulses quicker than they can be perceived,* and because the entire vibratory event is unconscious, out of mind" (Massumi, 28–29). The gloss Massumi gives to the idea of backward referral transforms what is, in the end, no more than a highly contentious speculation (that the brain basically backdates its own events) into an intriguing proposition concerning the dynamism of neural processing. For what Massumi seems to be suggesting is that the brain is flooded with a surfeit of competing sensory processes prior to the emergence of any "experience" proper. In this sense, the missing half-second would not simply—and passively—mark the time necessary for a sensory process to reach the threshold of awareness, at which point it would become "eligible," as it were, to be inserted (necessarily with a "corrected" backdating of minus half a second) into the linear timeline; instead it would coincide with the operation of a veritable factory of sensory production out of which actual experiences—empirically salient sensations—emerge.

Massumi's deployment of the missing half-second thus makes common cause with biologist Francisco Varela's transformative appropriation of the neuroscientific findings

of Walter Freeman, who discovered that cognition emerged from a complex process of deterministically chaotic neural fast dynamics. In both cases, we encounter a domain of preexperiential sensation that is both hyperintense and virtual. In Varela's account of enactive neural dynamics, various microprocesses compete with each other during "gaps" that mark sensory-motor breakdowns in order to "become the behavioral mode for the next cognitive moment." What results from this is a situation that splits agency, as it were, between this preexperiential virtual "soup" and the ensuing actualized perceptions that emerge from it: accordingly, even if the particular microprocess which emerges as prevalent in each case can only be "inhabit[ed]" in the mode of presence (actuality), the virtual domain of intensity (or set of microprocesses) where it undergoes "gestation" is itself a part of a larger *empirical* process of emergence (Varela, 107), meaning that it continues to "fringe" (to speak with Massumi) the resulting perception. Understood in this way, not only does the missing half-second produce a sensory excess that informs the emergence of actual perception, but it also contains a subterranean virtual life of sensation that covertly continues to operate as part of perception following its emergence in actuality. That is why, for Massumi, it is not just the missing half-second, but the resulting body of sensation, that must be fundamentally rethought: since "something that happens too quickly to have happened is . . . *virtual,*" the body is "as immediately virtual as it is actual" (Massumi, 30).

With their respective efforts to bring the domain of neural virtuality into the realm of actuality, both Massumi and Varela help to couple the insights of researchers like Libet and Freeman—who both pinpoint the centrality of an incompressible durational unit of experience at timeframes well beneath that of consciousness[18]—with the operation of video installation art, such as we have analyzed it here. Specifically, the way that Massumi and Varela let the virtual bleed into the actual parallels and explicates, in a theoretical register, the effects Nauman elicits aesthetically from his spectator-participants. In Nauman's installations, shock becomes a mode of contact with the autonomous image, which is equally to say, with that which normally lies beyond the threshold of sensation, that which is transcendent to our experience, with what Deleuze calls "transcendental sensibility." We can thus specify yet further how shock in the regime of video differs from the physiological shock characteristic of cinema: shock does not result from the reliving of what could not be lived directly the first time, but rather from the exposure to that which is not supposed to be experienced at all, the part of sensation that is supposed to be lost forever as the price to be paid for the production of conscious perceptual experience. The exemplarity of video installation art as an aesthetic practice of particular contemporary relevance stems from this shock-generating expansion of experience: by staging a confrontation with the virtual self-image, video installation art suspends habitual sensory-motor perception and causes the perceiving body to open itself to an influx of prereflective and prerepresentational sensation that is virtual at the same time as it is actual. In short, what is exemplary about video installation art as a contemporary cultural practice is its capacity to facilitate empirical apprehension of *molecular stimuli* that can

only be bracketed out in philosophical models of sensation which gain explanatory force precisely *by subordinating sensory flux (intensity) to the twin principles of recognition* (fixation in an object) *and common sense* (identification of an object across different senses).[19]

THE LOGIC OF INTENSITY

In his study of the Irish painter Francis Bacon, Deleuze develops a "logic of sensation" which aims to overcome the twin reduction of sensation imposed by recognition and common sense.[20] According to this *logic,* the work of art constitutes an *apparatus* or *machine* that utilizes the intensity of sensation to generate effects of its own. For my purposes here, Deleuze's analysis of Bacon furnishes a model of sensation that might prove to be of more direct use for our analysis of video installation art than his study of cinema. Unlike the latter—where, as we saw, Deleuze retained a great respect for the integrity of the image—in the analysis of Bacon, he literally exerts all his critical energy to decouple sensation from the frame of the image and to allow it, as it were, to "self-modulate" its own effects.

What I want to suggest in this last section is that video installation art mimes the "logic of sensation" Deleuze depicts in describing Bacon's process of deformation and transformation, but that it does so with several crucial additions: (1) it compresses it temporally, (2) it renders it dynamic, and (3) it adds an element of self-reflexivity that incorporates the spectator-participant. What results from this is a transformation of Deleuze's conclusions, such that "transcendental sensibility"—the domain of sensation normally outside experience—is not simply made available to thought, but rather is opened up to actual experience.

Like Nauman, Bacon (or at least Deleuze's Bacon) is concerned with combatting the obstacle of the figurative and mirror-vision. His compositional process thus begins with a preparatory process aimed at purging the canvas of all the clichéd figurations which were projected by the mind onto the pictorial surface and which, in a sense, preinhabited and prestructured the blank canvas. Just as Nauman wants to get beyond the clichés of mirror-vision that structure our preanticipated self-images of ourselves to let us experience ourselves directly, so too does Bacon want to engage the canvas as a Figure where form can directly convey sensation, where forces or the violence of a sensation can act directly on the nervous system, as Bacon says, without passing through the detour of the brain (Bacon, 18; see D. Smith, 34). To produce the canvas as Figure, Bacon deforms the organic body, but *only in order to transform it into the support for sensation.* It is this double metamorphosis that produces the Figure, or, more precisely, that produces the Figure as the canvas: " [I]n Bacon's art, the human form finally is not itself the body without organs. The canvas is" (Bogue, 263). For Bacon, painting involves a transferal of sensation from the body to the canvas itself.

This logic of transferal is nowhere more apparent than in the phenomenon of autoscopia and its role in relaying hysteria in Bacon. "Autoscopia" names the experience that

ensues when the body-without-organs and the transitory organs "are themselves *seen*": "it is no longer my head, but I feel myself in a head [*je me sens dans une tête*], I see and I see myself in a head; or else I do not see myself in the mirror, but I feel myself in the body that I see and I see myself in this nude body when I am dressed . . . etc." (Deleuze, *Francis Bacon* 35). In Bacon's paintings, this *phenomenon* of dissociative excorporation becomes the *genetic basis* of the Figure: since the hysterical reality of the body is *lived* as a punctual confrontation with an excessive presence—a presence, as it were, out-of-time—"the painting as a whole [*tout le tableau*] . . . is hystericized." In other words, Bacon concentrates into the Figure *all of the forces constituting the hysterical reality of the body*. Such is the true import of his self-abandonment to the image: it allows him to pass into a pure presence that deforms his body as it generates the Figure. Hystericizing himself, in a before-the-event (*avant-coup*), Bacon sees himself as he would be seen by another: "in a head which belongs to the photomat apparatus [*appareil photomaton*]" to which he has abandoned himself, a head "which *has passed into* the apparatus" (36, emphasis added).[21] Subsequently, the force that initially compelled Bacon's self-submission, once captured as Figure, begins to function—after-the-event (*après-coup*)—as a power of painting itself: the power "to disengage the presences that are under representation, beyond representation" (37).

Far from producing a Figure that separates sensation from human embodiment and renders painting an autonomous power, video installation art deforms sensory perception precisely in order to open the lived body to the intensity of sensation. Video installations deform our *clichéd* body-image and our embodied point-of-view by confronting our natural perception with a virtual self-image, set free from its anchoring in our own movement perception. Rather than emancipating sensation from the lived human body, video installations generate a shock that throws this body into crisis. In the intensified duration opened up by this shock, we are able to experience the intensity of the sensory immediacy that informs our qualitative experience but that is normally shielded from our consciousness. This is precisely what Massumi, following Shaviro, calls "passion," and the crucial point here is that video installation art of the genre exemplified by Nauman's corridors makes it a part of our lived sensory experience. Thus, as the paralysis of the sensory-motor body and the intensification of the affective body, passion is the sensory experience that results from the spectator-participant's confrontation with the virtual body. It transpires as a duration—literally an enduring or living-through—of intensity: a direct empirical registration of molecular forces, prior to the constitution of the lived spatial and temporal domain that we know through emotion and, subsequently, action. As the "coupling of a unit of quasicorporeality with a unit of passion" (of a virtual perspective with a degree of intensity), the passion of affect thus brings together an ability to affect with a susceptibility to be affected. By staging a shock that opens an interval of intensity to unconscious bodily sensing, video installation art lets us experience passion directly through the bodily paralysis (hysteria) and corresponding excessive presence that comprise its two most prominent sensory effects.

That is, ultimately, why Nauman's corridors work again and again, despite the viewer-participant's full knowledge of how they work. The fact is that we simply can't *know* what it is they do, since what they do is something that *can't be known,* something that happens in a different register than anything that can be registered, imprinted, remembered, and (subsequently) turned into knowledge.

AFTERTHOUGHTS (2010)

This essay was written in the aftermath of my work on *Embodying Technesis* (2000) and specifically as a corollary to my account of Walter Benjamin's analysis of cinema as a form of physiological mimesis that allowed for an aesthetic experience of and a certain adaptation to the new urban lifeworld. In particular, I was interested in the fact that video, because of its technical differences from film, does not lend itself to a similar analysis: specifically, it does not generate shock experience as a necessary correlate of its functioning. In the original version, I sought to position video, and specifically video installation art, in the place that Benjamin has positioned film: namely, as a vanguard art form that would usher in a sensory revolution of experience rooted in the transformational potential of shock. This involved some fairly intricate arguments concerning the differences between cinema and video as well as the specificity of video installation art (and, though I didn't make enough of it then, the singularity of Nauman's art practice). In revising the piece, I have sought to keep the main argument concerning video as a successor to film but have tried to narrow the focus of the argument so that it can now be understood as addressing issues concerning the specificity of video in relation to a very precise historical question: namely, what explains Nauman's shift from making films and then videos of his *own* performances of repeated actions in the studio to constructing highly constrained video corridor installations that compel participants to experience uncanny shock and subsequent protracted intervals of hyperintense presencing? I have also abandoned the original paper's Benjamin-inspired language of homeopathic redemption and its closing invocation of Gregory Bateson's cybernetic concept of the body as "our own metaphor" in favor of a hopefully more modest suggestion that video modulation as it is here presented, and as it was—at least occasionally—employed in the late 1960s and 1970s, anticipates some of the more interesting contributions that digital media has made to our culture.

ABOUT THE AUTHOR

Mark B. N. Hansen is Professor of Literature at Duke University. He is author of *Embodying Technesis: Technology beyond Writing* (University of Michigan Press, 2000), *New Philosophy for New Media* (MIT Press, 2004), and *Bodies in Code* (Routledge, 2006), and the upcoming book *Feed Forward: On the "Future" of 21st Century Media* (University of Chicago Press, 2014), as well as numerous essays on cultural theory, contemporary litera-

ture, and media. He has coedited *The Cambridge Companion to Merleau-Ponty* (with Taylor Carman; Cambridge University Press, 2005), *Emergence and Embodiment: New Essays on Second-Order Systems Theory* (with Bruce Clarke; Duke University Press, 2009), and *Critical Terms for Media Studies* (with W. J. T. Mitchell; University of Chicago Press, 2010).

NOTES

1. Morse attributes this critical neglect to the crippling impact of Rosalind Krauss's influential dismissal of video art as narcissism. Krauss's essay was originally published in 1976 (Krauss, "Video: The Aesthetics of Narcissism").

2. The term "direct experience" is an allusion to the work of psychologist James Gibson. See J. Gibson, *The Ecological Approach to Visual Perception*.

3. By no means alone in this effort, Nauman is arguably the artist most preoccupied with exploring the embodied dimensions afforded by video art installation. Other important early video installation artists who explored this same avenue in live closed-circuit work include Peter Campus, Dan Graham, Richard Serra, Frank Gillette and Ira Schneider, and Bill Viola. See Morse for discussions of some seminal works by these artists. In recent work, moreover, Nauman has returned to the medium of video installation, in ways that both complement and diverge from his earlier preoccupations. For instance, in a work called *Learned Helplessness in Rats (Rock and Roll Drummer)*, Nauman places a yellow plexiglas maze, containing rats, in the center of a darkened room with video images projected on the wall; these projections alternate between images of a rat coursing through the maze and of an untutored drummer pounding away on a set of drums. A related work, *Rats and Bats (Learned Helplessness in Rats II)*, extends the role of video in a way that recurs to the early corridor pieces. Here, Nauman retains the maze and the videotaped images, but replaces the drummer with a man noisily beating the unknown contents of a duffle bag with a bat; still more significantly, he adds a third segment: live projected images of the viewer standing in the space as filmed by a panning closed-circuit camera. In order to disorient the rats—and, I would add, to establish a recursive loop between the rats and the spectator-participants—Nauman directed monitors bearing these images at the plexiglas maze. Like the early video corridor works, the aim here is to render the spectator-participants (as well as the rats who serve as their doubles) "helpless." Despite the return to video installation, however, there has been an appreciable shift in Nauman's approach: whereas the early corridors functioned through a disturbance of normal perceptual perspective and a deprivation of sensory information, these later installations "overload the senses, making it difficult to remain for long in the installation" (Benezra). Of the other artists mentioned above, only Bill Viola has continued to work in the video installation medium and to expand his work to encompass new technical possibilities, like video projection.

4. The films (each ten minutes or less) include two major types. First, a series of body manipulations captured at close range: *Thighing (Blue)*, Nauman manipulating his thigh with his hands; *Pinchneck*, Nauman manipulating his neck with his fingers; *Black Balls*, Nauman applying black make-up to his testicles (projected in slow motion); *Bouncing Balls*, Nauman making his testicles bounce (projected in slow motion); *Gauze*, Nauman pulling gauze from his mouth (projected in slow motion); *Pulling Mouth*, Nauman pulling his mouth apart with his hands (projected in slow motion); and *Art Make-Up, Nos. 1–4 (White, Pink, Green, Black)*,

a series of films depicting Nauman applying makeup to his face, arms, and torso. Second, a series of films involving bodily tasks within constricted spaces or temporal durations (most of which have sufficiently descriptive titles): *Bouncing Two Balls between the Floor and Ceiling with Changing Rhythms; Dance or Exercise on the Perimeter of a Square (Square Dance); Playing a Note on the Violin While I Walk around the Studio (Violin Film #1);* and *Walking in an Exaggerated Manner around the Perimeter of a Square.* The videos follow this rough division, though Nauman's interest (spurred by the increased length afforded by videotape technology) has clearly shifted to bodily tasks of the second sort. Two videotapes (each sixty minutes) involve body manipulations captured at close range: *Lip Sync,* in which Nauman mouths the word "lip-sync" (with a slight audio delay), and *Flesh to White to Black to Flesh,* in which Nauman submits his face, arms and torso to three transformations, culminating in a return to their original state. The other videotapes involve more protracted forms of bodily tasks performed within variously constrained spatial and temporal coordinates: *Bouncing in the Corner, No. 1,* in which Nauman repeatedly bounces in the corner for one hour (this piece was later recreated in a gallery setting, with three performers: Nauman, his wife Judy, and the dancer Meredith Monk); *Slow Angle Walk (Beckett Walk),* in which Nauman rotates and walks about his studio, both on screen and off, in exaggerated gestures; *Stamping in the Studio,* in which Nauman stamps about his studio, both on screen and off; *Walk with Contrapposto,* in which Nauman walks, in a highly stylized manner, to and fro in a corridor installation (later to be exhibited as *Performance Corridor*); *Wall-Floor Positions,* in which Nauman uses his body, in various permutations, to suture the space between floor and wall; *Bouncing in the Corner, No. 2: Upside Down,* in which Nauman bounces in the corner of his studio, as in No. 1, but with camera (and hence image) inverted; *Manipulating a Fluorescent Tube,* in which Nauman uses his body to move a fluorescent tube about; *Pacing Upside Down* and *Revolving Upside Down,* in which Nauman performs the designated activities with camera (and image) inverted; *Violin Tuned D.E.A.D.,* in which Nauman repeatedly plays a single note at five-second intervals, with the camera (and image) tilted sixty degrees counterclockwise; and finally, *Elke Allowing the Floor to Rise Up over Her, Face Up* and *Tony Sinking into the Floor, Face Up, and Face Down,* two videos from 1973 which employ actors and involve the correlation of physical position and mental state. For a discussion of some of these films, see Benezra; van Bruggen, 20; and Nauman, "Keep" 101; and for Nauman's comments on them, see Nauman, "Breaking."

5. On the problem of the artist as court jester, see Benezra.

6. Morse notes that she experienced a reconstruction of the piece during a 1988 retrospective at the Long Beach Museum.

7. Multimonitor, recorded installations perform a similar bodily dissociation. In such works, the spectator-participant's point-of-view is fractured through a distribution that allows the simultaneous apprehension of overlapping and incompatible perspectives. Such distribution produces an affective reaction not entirely unlike that of the closed-circuit works, since it involves the shock-generating confrontation between human perceptual capacities and the multiple, virtual image of the thing or image in itself. For a discussion of several important examples, including works by Mary Lucier, Muntadas, Joan Jonas, and Francesc Torres, see Morse, "Body" 163.

8. A notable exception here is Bolz. For a discussion of Bolz's work, see Mark Hansen, *Embodying Technesis* chapter 9.

9. This new perception is what Benjamin, somewhat misleadingly, calls the "optical unconscious."

10. The term "short-range apparent motion" has been proposed by Joseph and Barbara Anderson as an alternative to the persistence of vision as an explanation for the phenomenon of motion perception in cinema (See Anderson and Anderson). While I agree with the Andersons' claim that cinematic perception involves some active meaning-seeking on the part of the viewer, I would insist on the specificity of the cinematic situation (that is, perception while immobilized and placed before the image) as against the motile situation characterizing human perception in its typical form. The significance of this distinction—and the reason it supports the view of cinema as involving some form of passivity—has been well demonstrated by Held and Hein's classic study of immobile and mobile kittens, particularly as it has been extrapolated by Francisco Varela in his conception of "embodied enaction." According to this conception, motility of the perceiver is criterial for active engagement with the environment (Varela).

11. The notion comes from Deleuze, *Cinema 1*, 61–66. When he equates Deleuze's notion of an interval or gap between stimulus and response with the gap between "imprinting or a sensation and its reception," Shaviro diverges from Deleuze in a highly productive way, one that shifts the locus of the image's force from the image itself to the body of the spectator.

12. See, for example, "Postscript on Control Societies," where Deleuze contrasts confinement and control along the analog–digital axis: "The various placements or sites of confinement through which individuals pass are independent variables: we're supposed to start all over again each time, and although all these sites have a common language, it's *analogical*. The various forms of control, on the other hand, are inseparable variations, forming a system of varying geometry whose language is *digital* (though not necessarily binary). Confinements are *molds*, different moldings, while controls are a *modulation*, like a self-transmitting molding continually changing from one moment to the next, or like a sieve whose mesh varies from one point to another" (178–179).

13. On this point, in addition to his remarks in the "Conclusions" chapter to *Cinema 2*, see "Letter to Serge Daney: Optimism, Pessimism, and Travel" (Deleuze, *Negotiations*).

14. For a helpful discussion of Deleuze's notion of the time-image in the context of television and video, see Dienst.

15. From the fact that thought is already in the theorematic image, it does not follow that shock becomes superfluous. Indeed, by introducing what would appear to constitute a third point of difference between the two respective cinematic apparatuses—the new status of the Whole in the modern cinema—Deleuze grants thought itself the power to shock. In the classical cinema, the whole was the *open*; in the resulting cinema of the actual, the out-of-field referred "on the one hand to an external world which was actualizable in other images" and "on the other hand to a changing whole which was expressed in the set of associated images" (179). In modern cinema, by contrast, the whole becomes the "power of the *outside* which passes into the interstice" (181): "[w]hat counts is . . . the interstice between images, between two images: a spacing which means that each image is plucked from the void and falls back into it" (179). The modern cinema is thus a cinema of the virtual, a cinema whose principle of composition is the "irrational cut." Since it does not form part of either set of images it joins, the irrational cut does not actualize the outside; rather, it forms an interstice between two

virtual sets of images, both of which are without beginning or end, both of which exist together, despite incompatibilities, in a nonlinear virtual temporality. The virtuality of the respective series of anterior and subsequent images joined by the irrational cut is limited only by the white or black screen toward which both converge. In this cinema, it is not sensory-motor shock which gives birth to thought, but rather the confrontation with an unthought in thought, with an "irrational proper to thought, a point of outside beyond the outside world" (181).

16. In his meditation on film's difference from theater, Benjamin stresses the fragmentation imposed on the film actor's body: not only is the actor's self-presentation mediated by the camera, but his representation of his own body is fragmented into various part-images. "His creation," Benjamin notes, "is by no means all of a piece; it is composed of many separate performances," what we might think of as many separate parts that are only put together after the fact, through the process of editing. The subjective experience of the film actor anticipates the fragmentation of self-image in closed-circuit video installation: "The feeling of strangeness that overcomes the actor before the camera . . . is basically of the same kind as the estrangement felt before one's own image in the mirror. But now," Benjamin injects, "the reflected image has become separable, transportable" (*Gessammelte Schriften* 231). Inserted into this trajectory, closed-circuit video installation can be understood as a radicalization of the bodily fragmentation introduced by film: it functions by placing the viewer-participant in the position formerly occupied by the actor. Like the actor, the visitor to a video installation experiences her self-image as detachable from her perceptual perspective; yet because she can view it in real time, simultaneously with the habitual perspective that produces a normal self-image, the video installation participant experiences a much heightened form of the estrangement Benjamin describes.

17. For an account of the body schema, and its distinction from the body image, in relation to new media art and the image arts more generally, see Mark Hansen, *Bodies in Code*.

18. And again, I want to stress that my interest in Libet's work (and something similar can be said with respect to Freeman) is less directly a function of whether his findings are correct with respect to the interval of delay of awareness, or the contentious postulation of "backwards referral," but solely a function of his insistence that there is a minimum duration necessary to produce awareness and that this duration is, as it were, indivisible or incompressible, and hence not something that can occur as a result of memory. In his reading of Freeman, Varela would seem to make a similar evaluation in his emphasis on the fact that none of the microprocesses achieve consciousness except the one that triumphs, meaning that all of rest are subsequently lost to thought or not remembered. It is interesting that Freeman praises Libet both for his claims about the minimal duration and also for his postulation of backdating. See Freeman, 168.

19. Deleuze criticizes these twin principles, what he calls the dogmatic image of thought, in *Difference and Repetition,* chapter 3, and *Logic of Sense,* 74–81, 94–99, 109–117.

20. For an excellent account of Deleuze's critique of the "dogmatic image of thought" and its relation to the study of Francis Bacon, see D. Smith. For a helpful reconstruction of the Francis Bacon study, see Polan, "Francis Bacon."

21. The hysterical smile that Bacon frequently paints on his portraits is one Figure that results from this genetic process of deformation; the smile captures the "hysterical reality of the body" as Figure, as an unlivable presence: "Presence or insistence. Interminable presence.

Insistence of the smile beyond the face and under the face. Insistence of a cry that lies beneath [*subsiste à*] the mouth; insistence of a body that lies beneath the organism; insistence of transitory organs that lie beneath qualified organs. And the identity of an already-there and an always deferred, in an excessive presence. Everywhere a presence acts directly on the nervous system, and renders impossible the installation or placing at a distance [*la mise en place ou à distance*] of a representation" (Deleuze, *Francis Bacon* 36).

BRAINGIRLS AND FLESHMONSTERS

Holly Willis

I like the idea of contaminating the technology, of putting the blood, the guts
and the madness, all those nasty womanly things, into this beautiful, slick
technology, into the beautiful and pure machines.

LINDA DEMENT

American culture is obsessed with bodies, perhaps now more than ever, as we become
accustomed to the often disconcerting realities of the digital era. One response to these
anxieties is the creation of incredible man/machine hybrids such as the hypermasculine
Terminators and RoboCops from the recent past. Another response is the development
of disturbingly "perfect" cyberbabes and female sex robots, primed to serve (Wiedemann;
de Fren). However, feminist artists have offered a more interesting retort: they've
unleashed a bevy of grotesque monsters and female freaks whose uncanny physiques
refuse the norms and propriety of the proper feminine form. Indeed, these bodies turn
themselves inside out, making the internal external; they disassemble themselves into
an array of moaning body parts; and they recombine into discomfiting shapes and bizarre
forms. Moreover, these tweaked and twisted bodies often appear in the context of media
installations and websites that extend the critique of representations of the body by, in a
sense, calling attention to the process of the body in any act of spectatorship, whether in
the context of a gallery, museum, or screening room or in front of a computer monitor.
Continuing a long-standing feminist interest in the grotesque body, these new media
artworks use the body—in the artwork and as a site for the artwork's reception—as a site
for examining forms of representation in general, while considering the complex relation-
ships between the body and technology in particular.

From Michel Foucault we know that bodies are disciplined, and from Luce Irigaray
we recognize that the isomorphism between Western philosophy and the male body is
reflected not only in the privileging of the male form in logic and metaphysics, but in the

body politic as well. Further, as Mikhail Bakhtin demonstrates in his study of Rabelais, a culture's images of the body embody, so to speak, that culture's social relations. The manner in which we represent the body via various imaginaries reflects, in some manner, the way bodies are represented socially and politically, and there is perhaps no more striking proof of this than in the multi-tiered influences of the grotesque body, which provokes disgust and strategies of containment and exclusion.[1] The division between the proper body and the grotesque body constitutes the division between upper and lower, high and low, pure and impure, intellectual mind and material anatomy, along with a series of other similarly weighted oppositions. The normal body and the grotesque body are dialectically related, function in relationship to each other, and are historically specific. One depends on the other, and taken together, they affect not merely the physical contours of the individual body, but the larger cultural identities in play at any given time.

In feminist art practices, especially body art from the 1960s, depictions of the grotesque, abject body have been constant. Rather than accepting the clearly defined boundaries of the body and their regulatory function, women artists have delighted in probing the contradictions implicit in the formulation of the abject while reveling in cross-boundary celebrations of the grotesque. The imbrication of body and machine in technoculture raises new anxieties about the crossing of boundaries, however. The relationship between the body and technology has grown increasing complex, such that to speak of one is to speak of the other. Body and machine become coextensive, and yet the predominant trope for understanding the relationship between the two tends to presuppose a desire to be rid of the body altogether, or to view technology as a phallic prosthesis.[2] But, as Amelia Jones points out, the desire to displace the body in this manner is problematic, to say the least, and entails a sustained disavowal (A. Jones, 206). Borrowing Maurice Merleau-Ponty's notion of flesh as a tentative, shifting perimeter of the body, Jones argues for a "technophenomenological" subject, one that is continually situated in relation to the not-quite-locatable limit between the body and the world. For Jones, the technophenomenological subject is in a constant state of flux with the world around it.[3]

If embodiment and the limits between bodies and machines form one nexus of fascination, the seemingly unthinkable infinity of cyberspace forms another, bringing with it anxieties about openness and indeterminacy. Consider, for example, the rampant warnings about potential theft, abduction, and violence foisted on users of online services, as well as the nefarious but ill-defined threat of hackers, viruses, and worms. Add the hyperbolic vehemence with which the news media chronicles instances of web-based child pornography, the seduction of minors, and the addiction that afflicts many so-called stupefied gamers, and it is easy to see that the widespread use of the Internet has sparked a kind of national terror.

Because conceptions of space and those of the self are connected, understanding one necessitates understanding the other. Cyberspace adds a new realm for exploration, one that, Margaret Wertheim claims, encourages a continued inquiry of the relationship between body and mind. "When I 'go' into cyberspace," she writes, "my body remains at

rest in my chair, but some aspect of me 'travels' into another realm. . . . What I am suggesting is that when I am interacting in cyberspace my 'location' can no longer be fixed purely by coordinates in physical space" (Wertheim, 41).

The inquiry called for by Wertheim continues a long-standing investigation of the relationship between the body and mind in acts of spectatorship initiated by early feminist artists interested in video installation. Video installation became prominent in the early 1970s, in tandem with video and performance art, and is often associated with the phenomenological impetus of minimalism in which artists sought to engage viewers in the relationship between objects and space by making works that were site specific (Iles, "Between"). The emphasis shifted from the pictorial space within a frame to the object's situation within the architectural dimensions of a space. The work of Frank Stella and Donald Judd is exemplary, and their ideas about space were considered in early video installation by artists such as Bruce Nauman, Michael Snow, and Anthony McCall. Subsequent video installation art, however, moves well beyond the concerns shared by minimalists to include issues of performance, the viewing space itself and vis-à-vis its connection to an institution, and the relationship of the viewer to the work.

Although video installation art, especially that which incorporated live performance, was very prevalent in the 1970s, it gradually grew more scarce, in part because of large-scale arts funding cuts, the difficulty in mounting installation projects, and the lack of affordable projection equipment adequate to do the work justice. The form returned full-force in the 1990s, however, for several reasons, all of which in some sense orbit around the radical impact of the Internet and ideas of technology and cyberspace on our sense of the body and identity.

The first reason for the return of the form is the convergence of diverse artforms made possible by digital media.[4] As the tools for creating digital artworks have become more accessible, more and more artists and filmmakers have entered the realm of video installation, bringing with them ideas particular to their original discipline. Painter Jeremy Blake, for example, brought notions of painting to his large-scale projection pieces, while Diana Thater, in her installations, focuses on ideas about sculpture and its relation to space. Doug Aitken, whose background is in music videos and commercials, brings fractured narratives into tension with his multiscreen pieces, spatializing the narrative while alluding to the plenitude of cinema. In all these cases, however, the interest in digital media must, in some ways, confront the newly reconfigured relationship we have to technology, not only in our personal lives, but in larger social, economic, and political spheres.

Second, the metaphors used to describe cyberspace, along with the increasingly prevalent activity of "being" online, have sparked a transformation in how we understand space itself.[5] Architect Marcos Novak began to articulate this transformation in his seminal essay "Liquid Architectures in Cyberspace" in 1991. He writes,

> The notions of city, square, temple, institution, home, infrastructure are permanently extended. The city, traditionally the continuous city of physical proximity becomes the dis-

continuous city of cultural and intellectual community. Architecture, normally understood in the context of the first, conventional city, shifts to the structure of relationships, connections and associations that are webbed over and around the simple world of appearances and accommodations of commonplace functions. (249)

Novak here alludes to the prevalence of technology and the ways in which it expands in a postmodern era, such that it is imbricated not only in what Donna Haraway refers to as "the informatics of domination," but in the ways that we understand space, the world, and ourselves.

While many video installation projects are merely resituated cinematic works that use the gallery or museum space to accrue high-art status, many other installation video works share in the historical avant-garde's desire to disrupt the power of the museum by sparking insights that illuminate the contradictions implicit in creating a locus for art that is separate from the outside world. Installation art, by its very being, calls into question the location of art, if only in bringing to the foreground the space in which it is found, and the space the viewer needs to traverse in order to experience it. Indeed, installations often act as a space within which the negotiation of boundaries—between private and public space, or between art and the "real" world—are made literal. The acts of perception, reception, and movement are emphasized and the installation becomes, in Thomas Zummer's analysis, an interface, a device through which viewers negotiate the differing spaces, as well as the cultural status of art production and interpretation.[6]

In her essay "Video and Film Space," Chrissie Iles charts the evolution of three distinct phases of film and video installation in terms of their concerns. "The first phase can broadly be termed the phenomenological, performative phase; the second, the sculptural phase; and the third, the current phase, the cinematic," she writes (252). Although Iles's categories may work for delineating the larger history of video art, they do not reflect women's work as neatly, in part because women were often responding to different issues and traditions than those that concerned their male colleagues. For example, while much early video installation did indeed participate in the phenomenological phase noted by Iles, in which artists, influenced by the expanded cinema movement occurring in film and music, played with the relationship of the body to the image in large-scale, multiprojection projects, women's work concentrated on exploding the cinematic apparatus and depicting a fractured portrait of identity.

Joan Jonas's *Vertical Roll* (1972) is exemplary here, as it distorts the scopophilic gaze of traditional cinema, making it constantly slip away in an installation that dismantled generally invisible structures of looking, identification, representation, and disavowal. *Vertical Roll* begins with the loud pounding of two objects—Jonas hits the hard floor with a spoon, making a harsh, staccato sound that continues throughout the entire tape. As she pounds, the image slips vertically, fracturing the usually seamless sequence of images into a series of frames that slip endlessly off screen, not only referencing the segmentation of the cinematic filmstrip, which is composed of discrete frames, but making use of the television's

deficiencies. The frames seem to skip in time to the pounding, but the rhythm often shifts out of synch as well. As the pounding and rolling continue, Jonas appears onscreen in close-up, her body splintered into pieces that are initially impossible to make out. Caught in the unending desire to see the image and to find a degree of wholeness, the viewer is frustrated until the final shot of the tape, which shows Jonas's face, albeit sideways in the frame and outside the footage controlled by the vertical roll.

The piece embodies the sense of violence of representation but, perhaps more importantly, captures a more adequate portrait of the almost monstrous subject splintered under the unceasing gaze of the camera. Jonas's performance highlights the artist's anger over fetishized views of the female and adroitly plays along the edge of the viewer's ability to withstand the constant pounding and sliding of the image next to the desire to see the entire tape. And when her face finally appears in a stable image, her direct gaze at the camera is entirely unnerving.

For women, early video installation projects tended to be very much concerned with the relationship between the body and the technology being used, and with issues of identity. Similarly, later work is not so much cinematic as networked, concerned with the role and experience of bodies in an increasingly virtual environment, and with ways of creating a language for discerning insights gleaned through the body.

Overall, then, it is this intersection—where notions of the body's boundaries and ideas about space collide often in the form of the grotesque and monstrous—that fascinates many contemporary digital artists.[7] Their work concerns the complex interplay of body and machine, and the evolutionary possibilities of bodies in the future. For many feminist artists, the challenges posed by engaging issues of virtuality, interactivity, and the body/machine conjunction continue many of the longstanding goals of feminist artmaking since the 1960s. However, they add the allure of the computer and technology, along with the uncanny, infinite space of the Internet and its networked connectivity (Bureau of Inverse Technology; Vesna; Bookchin).

This essay examines several projects concerned with the body's boundaries, and their reception, including the grotesque and monstrous bodies depicted in a series of digital projects such as *Cyberflesh/Girlmonster* (1995) by Linda Dement, *Braingirl* (2000) by Marina Zurkow, and photographs and sculptural pieces made by Floria Sigismondi, as well as the Frankenstein-like monsters and robots created by S. E. Barnet and Heidi Kumao. Further, a series of collaborative media installations by Molly Cleator and Anne Bray show how artists create spaces within which viewers negotiate a series of boundaries using their own bodies. The importance of this work cannot be underestimated— one of the more insidious projects of information and communication technologies is the reconfiguration of the body such that it conforms to the needs of an aggressively policed culture.[8] Similarly, the evolution of the biotech industry in the past decade and its development of new forms of genetic modification and reproductive technologies bring to the foreground the fundamental necessity of grappling with the diverse incarnations of the body/machine conjunction (subRosa).

The ways in which these artists situate their work fall into three relatively character-istic categories: (1) projects which focus on the relationship between the viewer's body and space; (2) those which grapple with the spatialized body whereby spaces become sites for the depiction of the body; and (3) those which understand the body as an ephem-eral locus for memory, language, and identity.[9] In most cases, too, the relatively rigid, gendered space of the cinematic apparatus is exploded into a new apparatus, one in which differing ideas of identification, experience, and knowledge are possible. But more significantly, each of these artists creates a space within which spectators stage a complex negotiation of binary oppositions. In this sense, the installations and websites are indeed interfaces, as noted by Zummer, hovering ambivalently between polarized opposites. The fact that the contemplation of these binaries occurs in and through the body is also no accident—the projects return insistently to contemplate closed identities, of the sign or language in opposition to the body, and of identity itself, which is shown always to be divided. Further, these artists recognize that the body is not merely the "stuff" surround-ing a knowing intellect, but is itself a speaking, sensing, knowing entity. Overall, these projects and artists extend the discussion of the body and media by limning the borders of the social body and the monstrous female body. They bring together questions raised by body theory formulated in the 1980s and contemporary issues of technology, using the body as a site for considering them.

Linda Dement's *Cyberflesh/Girlmonster* ponders the body in parts, examining it in relation to the regulatory functions determining propriety.[10] The project is an early inter-active CD-ROM that invites participants to revel in the corporeal, presented as a series of images of limbs and organs which have been grafted together into familiar but simulta-neously monstrous forms. There are elbows with moaning mouths, multiple hands fused together at the wrists to create dangling tentacles, and bulbous eyes (or are they nipples?). Caressing the uncanny shapes with the mouse provokes sounds of pleasure, a surprising effect that registers as uncanny in Freud's sense of the word. Clicking intro-duces a piece of text, either written or spoken and accompanied by still or moving images. The texts tell partial stories and reference blood, violence, affection, and intense desire.[11] The strange monsters formed by the collaged body parts are self-sufficient and autoerotic. Indeed, an image of hands joined at the wrists invokes Luce Irigaray's notion of sexuality in which there is a fusion of touching/being touched, and a sense of the body folding back on itself. This body, while grotesque in being strangely shaped, melds interior and exterior, undoing the clear distinction between them. The body spills open and rolls inward, eschewing uniformity and offering models of bodies fitted to divergent needs.

The process of making the project was also fragmented: *Cyberflesh/Girlmonster* was initiated in 1994 in an Australian lesbian bar with Dement, seated at a table with a scan-ner, inviting women to choose parts of their bodies to scan. Participants also donated a line of narrative or a sound, making the project partly communal. Further, as with Dement's earlier CD-ROM project, *Typhoid Mary* (1991), there is no organizing interface

or controllable menu system. Instead, the viewer enters the project but, at the same time, relinquishes full control.

Los Angeles–based artist S. E. Barnet similarly plays with notions of the body in parts with her project *Mary Shelley's Daughter* (1999), a video installation which consists of nine video monitors arranged to suggest the outline of a body. A humorous reworking of the Frankenstein monster in more contemporary terms, the piece includes images of various parts of the body on different monitors. The body in pieces becomes the body in pictures of pieces. Next to the configuration of monitors, Barnet includes a bookcase holding stacks of tapes; viewers can eject and insert different tapes to assemble different sorts of bodies at will, as if playing with a large, mechanical paper doll. The project continues Barnet's interest in delineating aspects of subjectivity, as well as the well-established feminist tradition of using video installation to comment on the cinematic apparatus. However, while much earlier work—Jonas's *Vertical Roll,* for example—concentrated on exploding the cinematic apparatus and depicting a fractured portrait of identity seen through the relationship between the body and the technology being used, Barnet's concern is not so much singular identity reflected via cinematic structures, but networked subjectivity. The piece comments on the role and experience of bodies in an increasingly virtual environment.

Heidi Kumao, known for a series of sculptural pieces initiated in 1991 titled "Cinema Machines," also created a project titled *Misbehaving: Performative Machines Act Out* (2002–2008), which consists of three female robot-like figures. The first two robots are made up of pairs of legs similar to those of a young girl. They are outfitted with video screens and sensors, and they react to the presence of viewers, moving nearer to or away from them. A third robot has a pair of legs with a screen in place of the girl's torso. This robot walks back and forth between two projectors, becoming a screen for the projector that she's closest to. Viewers will get to see whatever fragment of narrative she screens as she moves. While reminiscent of the work of the surrealist Hans Bellmer, Kumao's interest in the basic workings of the cinematic apparatus and her focus on the conjunction between the animate and inanimate—referring here to that which moves versus that which does not—makes Edison's talking doll "Eve" a more apt reference point.[12] A clunky, barely functioning toy, Edison's doll was doomed to failure, but it represents a larger moment at the turn of the twentieth century when people were fascinated by the possibility of "mechanical life." But Kumao is also responding to the prevalence of very aggressive versions of robots—battle bots and destroy-and-conquer machines; she's more interested in creating a robot with hints of psychological complexity, and with addressing issues of performance and misbehavior, both of which are referenced in her project's title.

The work of music video director Floria Sigismondi continues, in some ways, the trajectory of Barnet and Kumao's assemblages. Known for her gothic-oriented music videos for MTV, such as "4 Ton Mantis" for Amon Tobin and "Megalomaniac" for Incubus, Sigismondi has created a series of mannequins based on women's bodies—the bodies, however, like Dement's, are strangely mutated female forms. Legs morph into

other legs and arms, and fashionably svelte torsos sprout a multitude of breasts. One handless mannequin looks down over her smooth belly, but where she should have genitals she instead sports a spike. Behind her stretches a broad tail. Sigismondi's somatic distortions reflect a sense of uncertainty about the body in an increasingly technologized culture, and while Kumao's robots deploy the clunkier, more awkward aesthetic of the handmade, Sigismondi's mannequins are highly polished, smooth creations, at once purifying the body by making it clean and sleek, and yet, in their distortions, compromising attempts to eroticize it.

Sigismondi's bodies also reflect the desire to parry danger. Several contain motion sensors in their eyes that detect and respond to noise in the gallery. Further, the bodies are perfectly attuned to a society of surveillance, deflecting the gaze through a degree of utter difference. If, as Gerfried Stocker notes in the "FleshFactor Opening Statement" for the Ars Electronica Festival 97, "our media are a second skin at the periphery of the body, a body whose sentient pores are formed by surveillance cameras, image recognition systems, 'eye in the sky' satellites, personal data record systems, networked databases and intelligent agents," then Sigismondi's bodies are the perfect, shimmering response. And where the digital male body is often half man/half machine (the "Six Million Dollar Man" or "RoboCop," for example), a "super" man catapulted to new heights of masculine power, the female body in each of these projects permutates, shapeshifting as needed, becoming an assemblage of parts that are at once organic and technological. As psyches shift in relation to the differing possibilities of technology, so too will the body shift, becoming altogether other.

Web artist Marina Zurkow engaged the grotesque body in more humorous terms with *Braingirl,* her Flash animation series made initially for the website RSUB featuring the eponymous character, a young woman who boasts a bulbous, wrinkled brain on the top of an open skull, combined with prepubescent nipples and strangely webbed fingers.[13] Braingirl is neither young nor quite adult, and while her breasts are bare, she is hardly eroticized (especially compared with the fantastically full-figured cyber females of much digital art). Zurkow's creation clearly critiques her feminine digital counterparts, but she is also an emblem of the body that has been formulated to undercut the dichotomy between inside and outside. Indeed, in some ways, the hapless Braingirl illustrates Elizabeth Grosz's model of embodiment—Grosz argues that the relationship between interior and exterior might be understood as a Möbius strip, where the one flows fluidly into the other, and where the psyche, in a sense, produces the body as the body produces the psyche (Grosz). Braingirl's protruding brain parodies the desire to situate intelligence in a single organ—Braingirl regularly removes her brain, with no discernible complications. While philosophy, dedicated to ideas and concepts, denigrates the body and situates thinking in some nonmaterial realm, Braingirl grounds thinking in the body (even if her thinking is not quite astute).

Braingirl's brain is not the only organ that comes and goes. In an episode titled "Braingirl's Brain," Braingirl awakens one day to discover that she has a penis. Perturbed,

she and her sidekick Bag Boy visit the doctor to see what can be done about the unwanted appendage. While waiting, Bag Boy presses the reset button on Braingirl's cerebrum, prompting a colorful tailspin downward through layers of sin, tumbling finally into the unfettered chaos of the unconscious. Braingirl emerges happily whole again, the extra organ nowhere to be found.

Braingirl flirts with the confusion of gender boundaries, and "Braingirl's Brain" is the most compelling episode in this regard. Although she suddenly has a penis, Braingirl remains female. And rather than being excited by the potential that having a penis might signify, Braingirl is instead disgusted, nicely twisting the common horror of the female genitals back on the male body. It is also not insignificant that the episode is titled "Braingirl's Brain" instead of "Braingirl's Penis"—the story moves beyond the acquisition and loss of the organ with ease. The confusion of genders extends to Bag Boy as well, who is clearly unsure of "his" gender and wants to have sex with the newly augmented Braingirl, until she reminds him that he is a boy. If the genders and desires seem unclear here, it is no mistake; the confusion reflects the general state of gender anarchy that rules the series, and which helps make all of the bodies gleefully grotesque—they readily cross or confuse boundaries and blur distinctions. And, as this episode suggests, they disregard the idea that gender must remain fixed and static; gender in the series mutates and is quite frequently up for grabs.

Finally, the episode also toys with the body/machine matrix—that Braingirl has a reset button is never questioned, but instead is accepted as entirely natural. Many factors in Braingirl's world hover similarly between the possible and impossible—it is an animation after all—but the casual incorporation of the machinery of technology is much more akin to Donna Haraway's utopian vision of the cheerful cyborg than it is to the anxious fantasy of abandoning the body, or in using technology as an armor against the threat of dispersal sparked by the postmodern dismissal of foundations.

Each of these projects contemplates the representation of the body and, not coincidentally, they do so in forms that move beyond traditional cinema while still employing moving images. Whether they're installations, web-based series, or photographs, each project asks viewers to consider their own somatic relationship to what they're seeing, a relationship actively brought to the foreground in the work of Los Angeles–based artists Anne Bray and Molly Cleator, who are interested in investigating cultural and social spaces through their video installation work. The pair, who began working together in the late 1980s, are known for their bold video/performance pieces exploring power, the role of media, and the very ability to express critical ideas in installations and performances that ask viewers to contemplate their experience of bodies in an increasingly virtual environment; by asking viewers to enter and move through spaces or to interact with their performances, they are helping create a language for discerning insights gleaned through the body.

Bray and Cleator's installation *Easy Chair, Electric Chair* (1992) incorporates two electronically rigged wheelchairs with small monitors situated to seem like heads of otherwise invisible people. Cleator's face adorns one, and Bray's appears on the other. The

chairs whirl and twirl in the exhibition space, with sensors and software determining their direction. The onscreen faces speak, offering competing riffs on television. Overall, the conjunction of video, performance, and installation nicely embodies the principles under scrutiny. The wheelchairs are like strange cyborgs, unusual amalgams of human and machine that forcefully illustrate the influence of media, suggesting that it speaks as much through us as to us. And yet the piece also asserts a way of slipping into a position of power, of stepping into the frame and becoming the revered spokesperson. But the key to the piece is in the dueling commentaries. They are interesting in themselves, but more importantly, they offer two diametrically opposed points of view that are similar only in their shared description of alienation.

In more recent projects, Bray and Cleator have begun to consider the idea of projection, in the filmic sense but also in a more philosophical manner. In *Double Burning Jagged Extremities* (1998), for example, three large, billowy female dolls seem to rise up on a slow intake of air, and then deflate in exhaustion with its release. On their tremendously tall bodies, Bray and Cleator project a series of appropriated movie images showing women being brutalized, creating a visceral scene that is all the more potent because of its size and immediacy. In their abundance and shared codes, the snippets of film footage confirm a frightening circulation of cruelty and, in their projection on the female forms, become a manifestation of the ways in which the female's role is precisely to act as a screen or placeholder for the identity projected onto her. The dolls designate the blank nothingness attributed to the category of the female. It is perhaps no mistake, then, that a performance version containing this piece in 2000 was titled "Weight and Volume," offering a connection to Luce Irigaray's scathing essay "Volume-Fluidity," which describes a system of hysterical fantasy that relegates feminine subjectivity to nondifferentiation and nothingness. "She is patient in her reserve, her modesty, her silence," writes Irigaray, "even when the moment comes to endure violent consummation, to be torn apart, drawn and quartered. . ." (*Speculum* 227).

Irigaray's portrait might also illuminate Bray and Cleator's *Dis Miss War Party* (1999), a piece of media manipulation that uses four video projectors, a live sound mix by A.R.M. (incorporating sampled Medieval chants and Elizabethan lute and drum grooves), and a disco ball. Pairing images of the tortured heroine from *The Passion of Joan of Arc* (1928, dir. Carl Dreyer) with images from the more recent film *Elizabeth* (1998, dir. Shekhar Kapur), Bray and Cleator show how the narratives of both female figures begin in the same place, with an incredibly powerful female caught in a system that does not know what to do with her; but these narratives gradually diverge. One woman's life culminates in torture and death, while the other's life becomes a pageant of highly codified, aestheticized displays of power. The impact for the audience in seeing the incremental parting of ways on screen embodies Bray and Cleator's entire project—what do viewers do when faced with total binary opposition? While we may feel inclined to bring them together, to find closure or a solution that will reconcile the two extremes, Bray and Cleator instead urge us to contemplate the space in between.

In another piece, *Pressure Drop* (2001), viewers are invited to move under the skirt of a gigantic female figure, on top of which is projected video and photographic images. We step into a space that is both comforting and totally taboo; it is at once much ado about nothing and the source of everything. Indeed, with this installation, Bray and Cleator have found an incredibly rich terrain. There are the obvious cultural references—the iconic image of Marilyn Monroe holding down her fluttering dress (and later unsuccessfully fending off an infuriated, jealous Joe DiMaggio, who beat her badly), for example. Or consider the myth of Baubo, the playful goddess who inspired a grieving Demeter to smile by pulling up her skirt and offering a flash of her vulva. One might even find a connection to Plato's cave, a womb-like cavity illuminated by phantom, illusory projections. There is also the very daunting threat of seeing what Freud described as a wound, and what Lacan designated as absence, lack, nothingness. And indeed, Bray and Cleator are flirting with the very core of gender and representation, inviting us to cross back and forth over the boundary between the visible and invisible, and to reckon with our own cultural phantoms and the fundamental fear that what we will discover is precisely the unrepresentable.[14]

Taken together, these projects continue a central facet of one arena of contemporary practices by women, namely the redefinition of the self as a mediated being situated at a matrix of not only the usual threads of race, class, and gender, but also at the conjunction of the social, the technological, and a revised space/time configuration. Much of this redefinition occurs through a questioning of identity and the body through depictions of the body. If the construction of identity is partly an induction into ideological hegemony and partly a negotiation of complex psychoanalytic processes, redefinition occurs on multiple planes: through the dissection of notions of citizenship in general and gendered citizenship in particular, and through interrogations of psychoanalytic processes such as fetishism and hysteria, where ambivalence and the recourse to the body in resisting the symbolic order figure predominantly. The body similarly hovers between planes, understood not merely as a physical entity acted upon by external events, but instead as a site for the complex interaction of disparate forces.

Why is this focus occurring now? In part, it is a response to shifting media and technology. Questions regarding subjectivity—central for more than forty years—gain renewed urgency as the Information Age becomes more fully entrenched. One could argue, however, that the most recent wave of questioning actually began with video art in the 1960s, when the indexical connection to the world via light hitting emulsion was severed, allowing for an image-based form founded on interpretation rather than documentation. That said, if we understand the trajectory of Western metaphysics as a system—begun with Descartes's division of the *res cogitans* and *res extensa*—that denigrates, disciplines, and renounces the body in favor of the unencumbered mind, the experience afforded by the instantaneous transmission of information made possible by the Internet and the ensuing sense of noncorporeality adds another twist to the questioning, if only in augmenting the anxieties initiated more than thirty years ago by video. Further, while

the hierarchy of mind and body, and its political manifestation in myriad forms, has been a central target in feminist attacks on Western metaphysics for more than twenty years, we have yet to articulate a satisfactory delineation or description that adequately accounts for a global, feminist, political subject. Finally, although much attention has been paid to subjectivity and consciousness in critical theory, less attention has been paid to corporeality and to a system that gets around the mind/body binary in representation—except, that is, in feminist media practices beginning in the 1970s and in contemporary feminist theory, where the body and its relationship to space and time have grown increasingly central over the past five years.

In their emphasis on the tactile body, many recent new media projects also challenge the hierarchy that privileges sight over touch and, in a sense, continue the desire for presence in the face of absence that subtends the evolution of body-centered feminist work over the past twenty years. Trading the "real" bodies of the earlier work that hoped to guarantee political presence through an indexical facticity for a dismembered body that encourages a distance between a created self and a body, many new media projects contribute to a critique of the earlier conceptions of the self.

Much of the most interesting feminist media work over the past twenty-five years, across a range of shifting and diverse political movements, attempts to reckon with the body, to chart the imprinting of history and the inscription of social power on the body. Because knowledge pertaining to these bodies is not recognized as knowledge, much of this work has been trivialized or ignored while, conversely, since the ability to maintain power stems from the ability to regulate subjects, the degree of increasingly precise forms of micropolitical surveillance, control, and punishment has grown steadily. There is thus a simultaneous abrogation of much body-centered work alongside a tremendous growth in the power of various technologies to chart and control those very bodies. Each of the artists cited above steps into this terrain, accompanied by unruly monsters and bodies out of control, helping to disrupt the status quo.

ABOUT THE AUTHOR

Holly Willis is chair of the Media Arts + Practice Division within the School of Cinematic Arts at the University of Southern California (USC), where she teaches, organizes workshops, and oversees academic programs designed to introduce new media literacy skills across USC's campus and curriculum. She is also the editor of *The New Ecology of Things* (Art Center College of Design, 2007), a collection of essays, words, images, and fiction that grapples with the potential and design challenges of pervasive computing, and she is the author of *New Digital Cinema: Reinventing the Moving Image* (Wallflower Press, 2005), which chronicles the advent of digital filmmaking tools and their impact on contemporary media practices. The former editor of *RES* magazine, she has written extensively on experimental media practices for a variety of publications. She holds a PhD in Critical Studies in Cinema–Television from USC.

1. As Julia Kristeva notes in *Powers of Horror,* that which is abjected, both by a culture and by the individual, is that which threatens the integrity of the self, crossing boundaries and blurring distinctions. Similarly, the body out of control, or the body with improper orifices or protuberances, incites abhorrence. The grotesque body is open, impure, heterogeneous, disproportionate, and rife with gaps, holes, and filth, in contrast to the smooth, clean, closed body. Also see Stallybrass and White; the authors explore the polarities between base and noble as they relate to the body. They write, "The grotesque returns as the repressed of the political unconscious, as those hidden cultural contents which by their abjection had consolidated the cultural identity of the bourgeoisie" (9).

2. N. Katherine Hayles, for example, opens her essay "Embodied Virtuality: Or How to Put Bodies Back into the Picture" by noting William Gibson's "fictional representation of the 'bodiless exultation of cyberspace'" and John Perry Barlow's description of a virtual reality experience as "my everything has been amputated" (1).

3. Also see Hayles, *How We Became Posthuman.* Here she ponders shifts in notions of embodiment and agrees with Jones that embodiment in the information age tends to get erased; Hayles refutes this erasure, though, offering instead the notion of the "posthuman." She writes, "What embodiment secures is not the distinction between male and female or between humans who can think and machines which cannot. Rather, embodiment makes clear that thought is a much broader cognitive function depending for its specificities on the embodied form enacting it. This realization, with all its exfoliating implications, is so broad in its effects and so deep in its consequences that it is transforming the liberal subject, regarded as the mode of the human since the Enlightenment, into the posthuman" (xiv). She will go on to argue, against many who posit the opposite, that the body is not disappearing but instead that a certain kind of subjectivity has emerged. "This subjectivity is constituted by the crossing of the materiality of informatics with the immateriality of information" (193).

4. Peter Lunenfeld charts this convergence to some extent in his book *Snap to Grid,* if only to resituate discussions of media outside the lineage of cinema.

5. See Margaret Wertheim's *The Pearly Gates of Cyberspace* for a discussion of the history of space and its evolution in cyberspace into a kind of "electronic *res cogitans.*"

6. Zummer writes, "These works/spaces performed an important series of translations between the somewhat circumscribed and insular context of the art world and a global field of increasing mediation." He continues: "Installations were reterritorialized spaces, simulating, co-opting, or contaminating the museum or theater, tampering with private spaces and public places, in order to confront or destabilize conventional positions of art and its audience" (77).

7. See, for example, Huffman, who considers "electronic volume," which she says "defined information as site, especially as it informs the influence of experimental art and the fundamental discourse relevant to the *reality* of data space" (200).

8. The members of Critical Art Ensemble characterize it well: "In order to bring the body up to code and prepare it for the high-speed social conditions of technoculture, a pancapitalist institutional subapparatus with knowledge specializations in genetics, cell biology, neurology, biochemistry, pharmacology, embryology, and so on have begun an aggressive body invasion. Their intention is to map and rationalize the body in a manner that will allow the extension

of authoritarian policies of fiscal and social control into organic space" (Scholder and Crandall, 23). See www.critical-art.net/.

9. As with this project as a whole, this emphasis is necessarily limited, selecting only a small corner of a larger terrain.

10. See www.digimatter.com/monster.html for more on *Cyberflesh GirlMonster*.

11. In some ways, *Cyberflesh Girlmonster* is akin to the visceral nature of Monique Wittig's *The Lesbian Body*, with its overtly graphic description of bodies, as well as the fiction of Kathy Acker. Both situate transgressive writing in the belligerent, almost assaultive use of text.

12. For more on Edison's doll and other "automatons," see Wood.

13. See the series at www.thebraingirl.com/.

14. Several recent projects move the mutated body into the realm of the economic. In *Metapet* (2002), Natalie Bookchin takes ideas of scientific management inaugurated by Frederick Taylor at the turn of the twentieth century to their next level, tackling issues of biotechnology and worker efficiency. To play the game, visitors to the site become managers of a company. As such, they need workers, so each player is given a "Metapet," an employee who has been biologically improved with the addition of an obedience gene. Designed to be loyal and productive, the Metapet still harbors a few unfortunate flaws—a tendency toward indolence, an appetite for drugs, a need for encouragement, and a penchant for rebellion when maltreated. The goal for each player is to coax maximum work from an unpredictable laborer, balancing exploitation and tyranny with doses of calculated compassion (www.metapet.net).

TECH-ILLA SUNRISE
(.TXT CON SANGRITA)

Meijican artists release recovered files of the tech-illa network.
Experts believe leaked document may be false.

Posted by Rafael Lozano-Hemmer and Guillermo
Gómez-Peña, post-chilango double agents compiling
illegal knowledge

Dear cibernautas angloparlantes,
Ever wonder what is in the root directory of your Mexican server? Wouldn't you
want to peek at the files of Chilicon Valley's most powerful sysadmins?

Scary, que no? What follows is a leaked document extracted from deleted files
of the tech-illa network, a rare glimpse at the webback underground's real agenda.
Whether the tequilianos were responsible for the dot bomb market collapse is still
unproven, but the latest electrical brownouts in the USA and Canada suggest that
they are still active and at large. It is unclear at this time if this information was
left in the cracked server on purpose, to be distributed by the hackers as a decoy.

Año de 2002 DT (despues de Technopalzin)
Go-Mex East Erra-fael
The year of the Stalking Fox
According to Mayan Astrology (Channel 55)

I. DECOMPRESS "MEXI-CYBORG" FILE.

Nosotros, los otros . . .
We are all ethno-cyborgs, chiborgs, cyBorges, ciboricuas y demás. If you want to know
the future of technology take a good look at us, check out Walter Mercado en Univision,
a true transgenic social spammer, the mero Miami bastard son Morpheo de Schwarzeneg-
ger y Liberachi.

330

Also, check out 60-year-old TV hostess & Venezuelan Extreme Beauty Queen Viviana de la Medianoche, with her designer body rebuilt from zero in Tijuana clandestine clinics; mil dólares, and this includes nose job, chin, inflatable chichis with silicon processors, removable ribs and voice change activator.

Don't forget to also research "Latino Frankenstein" sites,
Direct TV en español, and pop cultural phenomena like
274-year-old talk show host Don Francisco;
el Transgenic/trans-ethnic Ricky Martin invented in Epcott,
o La criminal pop star, Gloria Trevi, who also knows the secret of immortality . . .
We/our 207 facelifts & our 49 laser surgeries for composite identity
We/the Mexican Orlan
We/El Frankenstein de Los Mochis y La Novia de Chucky
We Los High-tecas de East LA y La Mision.com
We/our very sentimental feedback hearts
We/our rrrobotic jalapeño joystick enlargement methode
We/our identity morphing mask (we code-morphed before Transmeta's crusoe
 processor and IBM's daisy project)
We/our 1960s melanina pills still sold in Tijuana and Acapulco for "instant racial
 ID change"
We/our liposuctioned nalgas de estética infomercial bien 1970s
We/our peyote graphics engine
We/our mojado scuba technology
We/carne asada eating ebola bacteria
We/burrito powered robo-raza
We/los ciber-nacos en La Neta-scape
We R slowly corrupting your default configuration
We R going to zapata your PRAM
We R alien webbacks,
and we have strapped on
our new hybrid neural implants
that enhance the adaptability
of the epistemo-loco-perceptual apparatus
to nonlinear telesensory inputs.

You think we are getting sleepy when we are just resolving a recursive loop: why else have fuzzy logic cochlear processors, mex-plico? We're solving netaphysical dilemmas of sorts, tex-plico? Our bigote doubles up as an antenna for our spread spectrum wireless LAN connection (and yes, it is I-triple-E eight-o-two eleven-g and bluetooth compliant).

Question: What's the most powerful computer supercluster?

Answer: A 512-processor machine in New Mexico called "Los Lobos." No coincidence the cluster is programmed in "Object Oriented Chile ++" which is radically incompatible

with all your languages (you may utilize our machine translation program Mexicorama2 to view but not edit the code).

You feel pretty hot with your overclocked gigahertz Pentium when all the action is in our new yottaherz Sexium with speedy-g-spot inside (available from chip maker Advanced Mexican Devices AMD).

Have another drink, compadre.

II. ISSUE WHO IS COMMAND <LUPITA.XML.

Who do you think is your sysadmin?

It's Lupita, your service provider!

That's right, Lupita is the real motherboard, la Gran Coatlicue Digital, la Matrix Chola. Born multitasking and multithreading, she has protected memory and she wont grant you access privileges. Y wátchala porque se come a sus hijos! She laughs at your binary code,*&%$^& when you try to digitize,*#@$!%^ scan*!~@$+(* and sample**&^^^%R# the world with a simple YES/NO, a one or a zero*^%#)(+^ black/white, in/out. Norte/Sur. No wonder you are undergoing a crisis in representation/masculinity/sociability/ethics/technology.

She has long ago dropped the binary code in favor of a recombinant self-organizing system of neural nets interconnected via EMR fields that allow for complex emergent phenomena, lighter and deeper shades of brown.

El ciberespacio es café, no blanco ni negro, remember:
You try to ping her but get a 401
You try to trace her and you get a denial of service attack
You try to open her attachments but you get a blue screen of death
You try a portscan but you get an error type 2
You send her cookies and she hits you with the "I Love You" virus
You send her pirated MP3s (bad Polish pop tunes) and she hits you with the "I need you" virus
You are TC (technologically correct), she is TI (technologically incompatible)
Empty trashcan/la memoria está en el dedo
We know your sysadmin and she is mad as hell
Snooping on her registry could be your last fatal crash

It turns out that without a Mexican server you are just a client, a terminal, a dead end. Think about that next time Juan Valdez, Juan in a million, gets you a coffee.

III. DECOMPRESS HISTORY FILE ON "MEXICAN SCIENCE."

Back in the late 1930s, the theory of cybernetics was first postulated at the *Instituto Nacional de Cardiología*, when Mexican researcher Arturo Rosenbleuth investigated the heart's

autonomy from the brain. Until then, no explanation was available as to why the heart kept beating in brain-dead "Pacheco" (*mariguano*) bodies. O sea, how could the *corazón* keep pumping without receiving instructions from the brain? Also in Mexico City, Dr. Rosenbleuth's gringo colleague Norbert Wiener, interdisciplinary thinker extraordinaire, developed "the theory of messages and feedback" to explain self-regulation and in so doing laid the foundation for most current thought on control and communications.

Carnales, and you thought cybernetics was about hard- and soft-ware? When it was about wet-ware all along; about corazones sangrantes, errantes, punzantes, mecánicos, hidraúlicos: about pulsating hearts que jamás siguen instrucciones de arriba; puro heart-drive-ese

2 PAGES OF UNTRANSLATABLE SHAMANIC LEXICO-LOGICAL POETRY

And then Mexicans brought you color TV, thanks to Guillermo González Camarena's first patent in 1940. And followed through with the first stereo and telepresence recordings, gracias al maestro Juan Garcia Esquivel in the 50s.

Also in the '50s, Mexican wrestler hero and alternative scientist *El Santo* made several movies in which he clearly anticipated the Internet, laptop computers, web cameras, see-you see-me systems and Chicano performance art.

Then in the '60s, Chicano scientists from the Michoacán Institute of Technology (MIT) working in clandestine garages throughout the U.S. Southwest developed amazing hydraulic robotics for lowrider cars, which in retrospect make American robotics, from Moravec to SRL, frankly look naive.

More recent accomplishments you may know about are the laboratory synthesis of pheromones (abusado con los Latin lovers) and Miguel de Icaza's Gnome project, the most admired and adopted "open source software" ever developed. However, most of these breakthroughs have been ignored by the Logos Digitalis, and as of now remain unpublished except by *Mecánica Naciomal*.

What did you think happens at the Mac/illa-doras?
We are reverse engineering your ass, mi nerdisteca! Porque?
You want the naked truth?

According to an MIT spokesman "Latinos are currently interested in what (we) term 'imaginary' or 'poetical' technology. Its premise is as follows: Since most Latinos don't have access to new technologies, we imagine the access. All we have is our political imagination and our humor to interject in the conversation . . . It's an imaginary act of expropriation."

Pero eso sí, your Xbox is made in Guadalajara, a true Meiji-can Trojan burro.

IV. DECOMPRESS GASTRONOMY FILE.

While your fabs produced Silicon wafers with copper deposition, we Olmechs were already going submicron with carbon-based buckminsterfullerene biocompatible

processors . . . and eating them! Ever heard of nacho chips? Well, that happens to be the code name for our nano-EPROM-chips.

Our fat beer gut (see ../barriga.jpg) is our redundant array of lipid-soluble memory nanochips—digo "nano-chipos" de chipotle—that's right, tortilla coprocessor wafers made in TJ/Taiwana and East Japangeles.

We eat it all, de tocho! We can assimilate "low" or "high." Nos da igual. Our diet includes everything from crappy calculators, "Target" ionizers, and wrist/phone watches (o sea, refurbished Aztechnology) to sound systems with fake fancy brands "made in Tepito" & mas y more hydraulics for our hi-preco "lowrider" carruchas. (Just check the new Made-in-Kioto "Lowrider" Mag.) We especially like cables con chorizo, tamalgochis y web-os rancheros.

Why do you think the founder of Slashdot.org, the ultimate net destination for nerds, is called "CmdrTaco"? Cause that's where the action is, crossover edible biotech computers that thrive in diverse gene-pools . . .

O sea, que wáchala:
Somos "techno-canibales;"
Habitamos en Chilicon Valley,
Barrio sur del DDT (Digital Divide Tardio).
but we keep heading North . . .
Tranquilo, mi querido ethernet address 00:03:93:fb:1c:9e
Have a psycho-tropical tech-illa,
Y ponte las pilas web-on.

V. QUETZALCUA82L*1 (FROM "MEMORY BANK #36582").

In 1999, Americans were arming themselves in record numbers, preparing for the Y2K blackout to be protected from looters, riots, anarchy, you know, brown people. At the same time, Subcomandante Marcos was named by *Wired* magazine one of the top 10 technovisionaries of our era. If you can't escape from Latinos in the privileged final frontier of cyberspace, where can you hide?

The following warning has been circulating throughout the net by cyberterrorism watchdog groups:

Virus Alert!! Warning!! Do not open any email sent to you if the "subject" is in any language you do not understand: Spanish, French, Spanglish, Frangle, Inglenol . . . Opening these messages may corrupt your fragile sense of personal and national identity . . . If you have recently pointed your browser at any website with Latino content: Zap Net, Virtual Barrio, Inter-Neta.com, Lati-Net, Salsaparagringos.net, Chihuahuas.com—a subsidiary of Taco Bell Incorporated, Ricky Martin's Menudo unplugged Page, Pocho Magazine, Pochanostra.com, or any other "Latino" web site . . . you may be already infected.

NSA virus researchers at the Pentagon are calling this new Silicon infection QuetZalcoat-82L or simply "The Mexican Bug."

The dreaded Michelangelo virus '96 and the RTM virus are harmless compared to the Mexican Bug. Like a gang of microbites this "programa" loiters at seemingly nonthreatening Latino webs: Rock en español music sites, high ethnic crafts, el Carne Asada without Meat Club, vegan burrito recipes, and sexual tourism information pages, detecting and targeting gringos with an innocent fascination for ethno-exotica.

Soon after visiting these sites you receive a "friendly" looking email, announcing a nice Mariachi Festival or advertising a Salsa theme cruise to Baja. When you open it, a cute talking Chihuahua in a poncho and a pink sombrero appears on the screen and delivers the following message with a thick sabroso Spanish accent:

> There is no moral, physical or social repercussions to your actions in cyberspace. Digital technology has finally allowed us to create an inoffensive millennial mythology of the Latino, the Indigenous and the Immigrant Other. We are part of this new mythology. We are meant to cater to your most intimate fears and desires. (Heavily edited excerpt from an unsolicited email by "Cyber-Vato #127" Bob Sifuentes)

VI. EXCERPTS FROM THE CYBER-TESTAMENT.

> In the beginning there was nothing,
> only cyberspace,
> a vast untamed, unseen cyber-desert
> with no water, ice, fire, or wind.
> There were no animals or plants,
> not even microscopic creatures.
> and then we came,
> *El Gran Homo Digitalis.*
> In the absence of cardinal points,
> we moved in all directions,
> conquering every inch of virginal space,
> naming it as we saw it,
> mapping the uncharted terrain of our future.
> We were young, ambitious and white,
> & there was no one else around to bother us.
> It was the Cambrian era of cyberspace.
> Our dictum was unquestionable:
> borderless "communication," that is in English,
> free trade across continents & minds,
> mindless interactivity,
> a Theology of Interface,

unlimited belonging to a " total world,"
Our World.
Then came the Others,
brown people, tar people, e-mongrels of sorts,
speaking bizarre linguas polutas.
The cybarbarians came from the South of nothingness,
& rapidly moved North into "the zone,"
Our Zone.
In order to keep the webbacks "out,"
we constantly upgraded our systems & software
& made them increasingly expensive & complex,
but they began to pirate our programs.
We then created border firewalls,
intricate security codes, digital checkpoints,
but they figured all of them out.
Soon we were left with no other option
but to privatize the New World.
The "land grab era" was coming to an end
North, South, East, delete
We were then forced to utilize more severe
$ /tmp/.LmT # uname -a;id
in orther to AIX rs9 3 4 000962744Coo
& those living South of the digital divide
were uid = 103??(????) gid = o(system) euid = o(root)
#until the()65#@+8*&II
AT +++

ABOUT THE AUTHORS

Rafael Lozano-Hemmer was born in Mexico City in 1967. In 1989, he received a BSc in physical chemistry from Concordia University in Montréal, Canada. Using robotics, projections, sound, Internet and cell-phone links, sensors, and other devices, his installations aim to provide "temporary antimonuments for alien agency." His work has been commissioned for events such as the Millennium Celebrations in Mexico City (1999), the Cultural Capital of Europe in Rotterdam (2001), the United Nations' World Summit of Cities in Lyon (2003), the opening of the Yamaguchi Centre for Art and Media in Japan (2003), and the Expansion of the European Union in Dublin (2004). His work in kinetic sculpture, responsive environments, video installation and photography has been shown in two dozen countries and is in public and private collections. He has also won numerous prestigious awards for his work, given many workshops and conferences, and been widely published.

Performance artist Guillermo Gómez-Peña was born and in Mexico City in 1955 and raised there. He came to the United States in 1978 and has been exploring cross-cultural issues and North–South relations ever since. He works in a wide variety of media, including performance art, bilingual poetry, journalism, radio, television and video, and installation art. From 1983 until the mid-1990s, Gómez-Peña lived in San Diego/Tijuana, where he was a catalyst for the reinterpretation of American culture from the point of view of the contested terrain along the border between the United States and Mexico. His art focuses on the exotic and folkloric stereotypes of Mexico still popular in the United States and on the cultural nationalism often associated with politically charged Chicano art. He was a founding member of the Border Art Workshop/Taller de Arte Fronterizo and the editor of the experimental arts magazine *The Broken Line/la Linea Quebrada*. He has been a contributor to the national radio magazine *Crossroads* and the radio program *Latino USA*, and a contributing editor to *High Performance* and *The Drama Review*, two of the leading magazines dealing with performance art. In 1991, he was the recipient of the prestigious John D. and Catherine T. MacArthur Fellowship.

WORKS CITED

Aarseth, Espen J. *Cybertext: Perspectives on Ergodic Literature*. Baltimore: Johns Hopkins University Press, 1997. Print.

Abbott, H. Porter. "Narrative and Emergent Behavior." *Poetics Today* 29.2 (2008): 227–44. Print.

———, ed. *SubStance* 94/95 (2001). Special double issue: "On the Origin of Fictions: Interdisciplinary Perspectives." Print.

ABC. *The Young Indiana Jones Chronicles*. 1992–1996. Television.

Acconci, Vito. "Public Space in Private Time." *Critical Inquiry* 16.4 (1990): 900–18. Print.

Acker, Kathy. *Blood and Guts in High School*. New York: Grove Press, 1989. Print.

———. *Empire of the Senseless: [a Novel]*. New York: Grove Press, 1988. Print.

———. *In Memoriam to Identity*. New York: Grove Press, 1990. Print.

Adamic, Lada and Natalie Glance. "The Political Blogosphere and the 2004 US Election: Divided They Blog." *LinkKKD '05: Proceedings of the 3rd International Workshop on Link Discovery*. August 21–24, 2005, Chicago, IL, USA. Ed. Jafar Adibi et al. New York: ACM, 2005. 36–43. Web.

Adilkno. *The Media Archive*. Brooklyn, NY: Autonomedia, 1998. 99. Print.

Adorno, Theodor W. *The Culture Industry: Selected Essays on Mass Culture*. Ed. J. M. Bernstein. London: Routledge, 2001. Print.

Agamben, Giorgio. *The Coming Community*. Minneapolis: University of Minnesota, 1993. Print.

Albera, François. "Nauman's Kinematic Cinema." *Bruce Nauman*. Ed. C. van Assche. London: South Bank Center, 1998. Print.

Allen, Rhianon and Arthur S. Reber. "Unconscious Intelligence." *A Companion to Cognitive Science*. Ed. William Bechtel and George Graham. Oxford, UK: Blackwell, 1998. 314–23. Print.

American Historical Association. "New Technologies and the Practice of History." Special section in *AHA Perspectives* 36.2 (1998). Print.

Anderson, Chris. "The Long Tail." *Wired* 12.10 (2004). Web.

Anderson, Joseph and Barbara Anderson. "The Myth of Persistence of Vision Revisited." *Journal of Film and Video* 45.1 (1993): 3–12. Print.

Anderson, Steve F. *Technologies of History: Visual Media and the Eccentricity of the Past.* Hanover, NH: Dartmouth College Press, 2011. Print.

Appadurai, Arjun. "Dead Certainty: Ethnic Violence in the Era of Globalization." *Public Culture* 10.2 (1998): 244. Print.

———. *Modernity at Large: Cultural Dimensions of Globalization.* Minneapolis: University of Minnesota Press, 1996. Print.

Aragon, Greg. "The Next Act in the New Hollywood." *California Construction,* August 2004: 12. Print.

Ardolino, Emile, dir. *Sister Act.* Touchstone Pictures, 1992. Film.

Aristotle. *The Basic Works of Aristotle.* Ed. Richard McKeon. New York: Random House, 1941. Print.

Asmis, Elizabeth. "Plato on Poetic Creativity." *The Cambridge Companion to Plato.* Ed. Richard Kraut. Cambridge, UK: Cambridge University Press, 1992. 338–64. Print.

Associated Press. "CBS to Let Viewers Use, Post Clips from Shows on the Web." *The Boston Globe,* January 10, 2007. Print.

Auletta, Ken. "American Keiretsu." *The New Yorker,* October 20 and 27, 1997: 225–28. Print.

———. "The Big Ten." *Nation,* January 14, 2002: 27. Print.

Bacon, Francis. *The Brutality of Fact: Interviews with David Sylvester.* London: Thames and Houston, 1975. Print.

Baddeley, Alan. *Working Memory, Thought, and Action.* Oxford, UK: Oxford University Press, 2007. Print.

Bakhtin, M. M. *Rabelais and His World.* Tr. H. Iswolsky. Cambridge, MA: MIT Press, 1981. Print.

Bal, Mieke. *Narratology.* Toronto: University of Toronto Press, 1997. Print.

Barbrook, Richard. "HyperMedia Freedom." *Crypto Anarchy, Cyberstates, and Pirate Utopias.* Ed. Peter Ludlow. Cambridge, MA: MIT Press, 2001. 47–58. Print.

Barbrook, Richard and Andy Cameron. "The Californian Ideology." *Crypto Anarchy, Cyberstates and Pirate Utopias.* Ed. Peter Ludlow. Cambridge, MA: MIT Press, 2001. 363–87. Print.

Barlow, John Perry. "A Declaration of the Independence of Cyberspace." *Crypto Anarchy, Cyberstates and Pirate Utopias.* Ed. Peter Ludlow. Cambridge, MA: MIT Press, 2001. 27–30. Print.

Barnet, Richard J. and John Cavanagh. *Global Dreams: Imperial Corporations and the New World Order.* New York: Simon and Schuster, 1994. Print.

Barnet, S. E. *Mary Shelley's Daughter.* 1999. Video installation.

Barnouw, Erik. Private conversation. October 22, 1997. Personal communication.

Barnouw, Erik et al. *Conglomerates and the Media.* New York: The New Press, 1997. Print.

Barth, John. *Coming Soon!!!* New York: Houghton Mifflin, 2001. Print.

———. *The Last Voyage of Somebody the Sailor.* New York: Houghton Mifflin, 1991. Print.

———. *On with the Story: Stories.* New York: Little, Brown and Company, 1997. Print.

———. *The Tidewater Tales.* New York: J. G. Putnam's Sons, 1987. Print.

Barthes, Roland. "From Work to Text." *The Rustle of Language.* Tr. Richard Howard. New York: Hill and Wang, 1986. 56–64. Print.

———. *Image-Music-Text.* 1977. London: Fontana, 1982. Print.

———. "The Photographic Message." *Image-Music-Text.* Ed. Stephen Heath. New York: Hill and Wang, 1977. Print.

———. *S/Z.* Paris: Editions du Seuil, 1970. Print.

———. *S/Z.* Tr. Richard Miller. New York: Hill and Wang, 1974. Print.

Bartlett, Frederic C. *Remembering.* Cambridge, UK: Cambridge University Press, 1932. Print.

Bassett, Caroline. *The Arc and the Machine.* Manchester, UK: Manchester University Press, 2007. Print.

———. "How Many Movements?" *The Auditory Culture Reader.* Ed. Michael Bull and Les Beck. Oxford, UK: Berg, 2003. 343–56. Print.

Baudrillard, Jean. "Procession of Simulacrum." *Cultural Theory and Popular Culture: A Reader.* Ed. John Storey. Atlanta: University of Georgia Press, 1998. Print.

Baudry, Jean-Louis. "The Apparatus: Metapsychological Approaches to the Impression of Reality in Cinema." *Narrative, Apparatus, Ideology: A Film Theory Reader.* Ed. Philip Rosen. New York: Columbia University Press, 1986. 299–318. Print.

———. "Ideological Effects of the Basic Cinematographic Apparatus." *Film Quarterly* 28.2 (1974). Print. Reprinted in *Narrative, Apparatus, Ideology: A Film Theory Reader.* Ed. Philip Rosen. New York: Columbia University Press, 1986. 286–98. Print.

Baugh, Bruce. "Transcendental Empiricism: Deleuze's Response to Hegel." *Man and World* 25: 2 (1992). Print.

Bazin, André. "In Defense of Rossellini." *What Is Cinema?* Vol. II. Tr. Hugh Gray. Berkeley: University of California Press, 1971. Print.

———. "The Ontology of the Photographic Image." *What Is Cinema?* Vol. I. Tr. Hugh Gray. Berkeley: University of California Press, 1967. 9–16. Print.

———. *What Is Cinema?* Vol I. Tr. Hugh Gray. Berkeley: University of California Press, 1967. Print.

Beck, Howard. "Lakers' G.M. Leaves the Drama in the Past." *The New York Times,* May 27, 2008. Print.

Bellour, Raymond. "The Double Helix." *Electronic Culture.* Ed. Timothy Druckrey. New York: Aperture, 1996. 173–99. Print.

Belton, John. "Looking through Video: The Psychology of Video and Film." *Resolutions.* Ed. Michael Renov and Erika Suderberg. Minneapolis: University Press of Minnesota, 1996. Print.

Bender, Gretchen and Timothy Druckrey, eds. *Culture on the Brink: Ideologies of Technology.* Seattle: Bay Press, 1994. Print.

Benezra, Neal. "Surveying Nauman." *Bruce Nauman.* Minneapolis: Distributed Art Publishers, 1994. Print.

Benjamin, Walter. *The Arcades Project.* Tr. Howard Eiland and Kevin McLaughlin. Cambridge, MA: The Belknap Press, 1999. Print.

———. *Gessammelte Schriften.* Frankfurt am Main: Suhrkamp, 1972. Print.

———. "The Work of Art in the Age of Mechanical Reproduction." *Illuminations.* Ed. Hannah Arendt. Tr. Harry Zohn. New York: Schocken, 1968. 217–51. Print.

Berger, John. *Ways of Seeing*. New York: Penguin, 1973. 33. Print.

Berlet, Chip. "Right Woos Left." *The Public Eye*. Political Research Associates, 1990/1999. Web.

Berlin, Isaiah. *Four Essays on Liberty*. London: Oxford University Press, 1969. Print.

Bey, Hakim. *TAZ: The Temporary Autonomous Zone, Ontological Anarchy, Poetic Terrorism*. Brooklyn, NY: Autonomedia, 1991. Print.

Bhabha, Homi K. "Arrivals and Departures." *Home, Exile, Homeland: Film, Media, and the Politics of Place*. Ed. Hamid Naficy. New York: Routledge, 1999. vii–xii. Print.

Bhabha, Jacqueline. "Embodied Rights: Gender Persecution, State Sovereignty, and Refugees." *Public Culture* 9.1 (1996): 3–32. Print.

Bimber, Bruce. *Information and American Democracy: Technology in the Evolution of Political Power*. Cambridge UK: Cambridge University Press, 2003. Print.

Binkley, Timothy. "Camera Fantasia: Computed Visions of Virtual Realities." *New Technologies*. Special issue of *Millennium Film Journal* 20/21, Fall/Winter (1988–1989). Print.

Black, David A. "*Homo Confabulans:* A Study in Film, Narrative, and Compensation." *Literature and Psychology* 47.3 (2001): 25–37. Print.

Blackmore, Susan. *The Meme Machine*. Oxford, UK: Oxford University Press, 1999. Print.

Blakeslee, Sandra. "Cells That Read Minds: A New Look at Mirror Neurons." *The New York Times,* January 10, 2006. Print.

Bobbio, Norberto. *Left & Right: The Significance of a Political Distinction*. Tr. Allan Cameron. Cambridge, UK: Polity, 1996. Print.

Bogue, Ronald. "Gilles Deleuze: The Aesthetics of Force." *Deleuze: A Critical Reader*. Ed. Paul Patton. London: Blackwell, 1996. Print.

Bolter, Jay David. *Writing Space: The Computer, Hypertext, and the History of Writing*. Hillsdale, NJ: Lawrence Erlbaum, 1991. Print.

Bolter, Jay David and Richard Grusin. *Remediation: Understanding New Media*. Cambridge, MA: MIT Press, 1999. Print.

Bolz, Norbert. *Theorie der Neuen Medien*. Munich: Raben, 1990. Print.

Bookchin, Natalie. Metapet.net. No date. Web.

———. Personal website. http://bookchin.net. No date. Web.

Bordwell, David. *The Cinema of Eisenstein*. Cambridge, MA: Harvard University Press, 1993. Print.

———. "Grandmaster Flashback." *Minding Movies: Observations on the Art, Craft, and Business of Filmmaking*. With Kristin Thompson. Chicago: University of Chicago Press, 2011. 135–50. Print.

———. "Historical Poetics of Cinema." *The Cinematic Text: Methods and Approaches*. Ed. R. Barton Palmer. New York: AMS, 1989. 369–98. Print.

———. *Planet Hong Kong: Popular Cinema and the Art of Entertainment*. Cambridge, MA: Harvard University Press, 2000. Print.

Borges, Jorge Luis. *Ficciones*. Ed. John Sturrock. New York: Knopf, 1993. 83–91. Print.

Borsook, Paulina. *Cyberselfish: A Critical Romp through the Terribly Libertarian Culture of High-Tech*. New York: Public Affairs, 2000. Print.

Bourdieu, Pierre. *Outline of a Theory of Practice*. Tr. Richard Nice. Cambridge, UK: Cambridge University Press, 1977. Print.

Bourtchouladze, Rusiko. *Memories Are Made of This: How Memory Works in Humans and Animals*. New York: Columbia University Press, 2002. Print.

boyd, danah. *Profiles as Conversation: Networked Identity Performance on Friendster*. Hawai'i International Conference on System Sciences, January 4–7, 2006. IEEE Computer Society, 2006. Print.

Boyle, Dierdre. *Subject to Change: Guerrilla Television Revisited*. Oxford, UK: Oxford University Press, 1997. Print.

Brand, Stuart. *The Media Lab: Inventing the Future at MIT*. New York: Viking, 1987. Print.

Branigan, Edward. "Apparatus Theory (Plato)." *The Routledge Encyclopedia of Film Theory*. Ed. Edward Branigan and Warren Buckland. London: Routledge, 2013. Print.

———. "Butterfly Effects upon a Spectator." *Hollywood Puzzle Films*. Ed. Warren Buckland. New York: Routledge, 2014. Print.

———. "Concept and Theory." *The Routledge Encyclopedia of Film Theory*. Ed. Edward Branigan and Warren Buckland. London: Routledge, 2013. Print.

———. "Death in (and of?) Theory." *The Routledge Encyclopedia of Film Theory*. Ed. Edward Branigan and Warren Buckland. London: Routledge, 2013. Print.

———. *Narrative Comprehension and Film*. London: Routledge, 1992. Print.

———. "Nearly True: Forking Plots, Forking Interpretations—A Response to David Bordwell's 'Film Futures.'" *SubStance* 97 (2002): 105–14. Print.

———. *Point of View in the Cinema: A Theory of Narration and Subjectivity in Classical Film*. New York: Mouton, 1984. Print.

———. *Projecting a Camera: Language-Games in Film Theory*. London: Routledge, 2006. Print.

Bray, Anne and Molly Cleator. *Dis Miss War Party*. 1999. Installation.

———. *Double Burning Jagged Extremities*. 1998. Installation.

———. *Easy Chair, Electric Chair*. 1992. Installation.

———. *Pressure Drop*. 2001. Installation.

Brin, Sergey and Lawrence Page. "The Anatomy of a Large-Scale Hypertextual Web Search Engine." 1998. Web.

Brook, James and Iain A. Boal. *Resisting the Virtual Life: The Culture and Politics of Information*. San Francisco: City Lights, 1995. Print.

Brooks, Peter. *Reading for the Plot: Design and Intention in Narrative*. London: Oxford University Press, 1984. Print.

Bruner, Jerome. *Making Stories: Law, Literature, Life*. New York: Farrar, Straus and Giroux, 2002. Print.

Bruno, Giuliana. "Collection and Recollection: On Film Itineraries and Museum Walks." *Camera Obscura, Camera Lucida: Essays in Honor of Annette Michelson*. Ed. Richard Allen and Malcolm Turvey. Amsterdam: Amsterdam University Press, 2003. 231–60. Print.

Bureau of Inverse Technology. No date. Web.

Burgin, Victor. *The Remembered Film*. London: Reaktion Books, 2004. Print.

Burns, Ken, dir. *Baseball*. PBS, 1994. Television.

———. *Jazz*. PBS, 2001. Television.

Bush, Vannevar. "As We May Think." *The Atlantic Monthly* 176 (July 1945): 101–8. Print.

Cadigan, Pat. *Synners*. New York: Gollancz, 2013. Print.

Caldwell, John. "Alternative Media in Suburban Plantation Culture." *Media, Culture, and Society* 25.5 (2003): 647–67. Print.

———. "The Business of New Media." *The New Media Book.* Ed. Dan Harries. London: British Film Institute, 2002. Print.

———, ed. *Electronic Media and Technoculture.* New Brunswick, NJ: Rutgers University Press, 2000. Print.

———. "Racial Off-Worlds." *Emergences* 8.2 (1999): 373–88. Print.

———, producer/director. *Rancho California (por favor).* Berkeley Media, 2003. Video.

———. "Televisual Politics: Negotiating Race in the L.A. Rebellion." *Living Color: Race and Television in the United States.* Ed. Sasha Torres. Durham, NC: Duke University Press, 1998. 161–95. Print.

———. "Theorizing the Digital Landrush." *Electronic Media and Technoculture.* Ed. John T. Caldwell. New Brunswick, NJ: Rutgers University Press, 2000. 1–31. Print.

Caldwell, John and Anna Everett, eds. *New Media: Theories and Practices of Digitextuality.* New York: Routledge, 2003. Print.

Caldwell, John and Devora Gomez, co-directors. *Amor Vegetal: Our Harvest.* South Escondido, California: La Cosecha Nuestra Communidad, 1998. Video.

Calore, Michael. "iPhone: Calling the Future." *Wired,* January 12, 2007. Print.

Calvino, Italo. *Mr. Palomar.* Tr. William Weaver. New York: Harcourt Brace Jovanovich, 1983/1985. Print.

Cameron, James, dir. *Titanic.* Paramount Pictures and 20th Century Fox, 1997. Film.

Capotondi, Giuseppe, dir. *The Double Hour.* Samuel Goldwyn, 2011. Film.

Carey, James. *Communication as Culture: Essays on Media and Society.* Boston: Unwin Hyman, 1989. Print.

Carpentier, Alejo. *La Ciudaed de las Columnas.* Ciudad de la Habana: Editorial Letras Cubanas, 1982. Print.

Carter, Rita. *Mapping the Mind.* Berkeley: University of California Press, 1998. Print.

Casey, Edward S. "The Memorability of the Filmic Image." *Quarterly Review of Film Studies* 6.3 (1981): 242–64. Print.

Cassidy, John. "Me Media." *The New Yorker,* May 15 (2006): 50–62. Print.

Castells, Manuel. *The Rise of the Network Society.* Vol. 1. Cambridge, MA: Blackwell, 1996. Print.

Cavell, Stanley. "More of *The World Viewed.*" *The World Viewed: Reflections on the Ontology of Film.* Enlarged ed. Cambridge, MA: Harvard University Press, 1979. 161–230. Print.

———. "The World as Things: Collecting Thoughts on Collecting." *Cavell on Film.* Ed. William Rothman. Albany: State University of New York, 2005. 241–79. Print.

Champigny, Robert. *What Will Have Happened: A Philosophical and Technical Essay on Mystery Stories.* Bloomington: Indiana University Press, 1977. Print.

Chance, Karen. *Parallax.* Atlanta: Nexus Press, 1987. Print.

Chang, Shu Lea. *Brandon.* 1998–1999. Web art.

Chow-White, Peter and L. Nakamura, eds. *Race after the Internet.* Minneapolis: University of Minnesota Press, 2011. Print.

Chun, Wendy. *Control and Freedom: Power and Paranoia in the Age of Fiber Optics.* Cambridge, MA: MIT Press, 2005. Print.

———. *Programmed Visions: Software and Memory*. Cambridge, MA: MIT Press, 2013. Print.

Cilliers, Paul. *Complexity and Postmodernism: Understanding Complex Systems*. New York: Routledge, 1998. Print.

City of Escondido. "Project Workplan." Project Cosecha Nuestra (Our Harvest Project) Abstract, October 11, 1996. Print.

Clark, Andy. "Embodied, Situated, and Distributed Cognition." *A Companion to Cognitive Science*. Ed. William Bechtel and George Graham. Oxford, UK: Blackwell, 1998. 506–17. Print.

Clarke, Desmond M. *Descartes: A Biography*. Cambridge, UK: Cambridge University Press, 2006. Print.

Cockburn, Cynthia. "The Circuit of Technology: Gender, Identity, and Power." *Consuming Technologies*. Ed. Roger Silverstone and Eric Hirsch. New York: Routledge, 1992. Reprinted in *Electronic Media and Technoculture*. Ed. John Caldwell. New Brunswick, NJ: Rutgers University Press, 2000: 197–213. Print.

Combs, Allan. "All Levels, All Quadrants: A Review of Ken Wilber's *A Theory of Everything*." *Journal of Consciousness Studies* 8.11 (2001): 74–82. Print.

Comolli, Jean-Louis. "Technique and Ideology: Camera, Perspective, Depth of Field." *Narrative, Apparatus, Ideology*. Ed. Philip Rosen. Tr. British Film Institute. New York: Columbia University Press, 1986. 421–43. Print.

Conley, Darby. *Get Fuzzy*. May 6, 2003. Comic strip. Print.

Cooper, Merian C. and Ernest B. Schoedsack, dirs. *King Kong*. RKO Pictures, 1933. Film.

Coover, Robert. "The Babysitter." *Pricksongs and Descants*. 1969. New York: Grove Press, 2000. Print.

Cottingham, John. *Descartes*. New York: Basil Blackwell, 1986. Print.

———. *A Descartes Dictionary*. Oxford, UK: Blackwell, 1993. Print.

Cove, Alex. "Titanic Ambition." *Digital Hollywood*. Special issue of *The Red Herring*, January 1998: 73–8. Print.

Cowie, Norman. "A Pirate Manifesto." Visible Evidence V Conference, Northwestern University, Chicago, IL, August 20, 1998. Speech.

Crandall, William. "On River Side." *Onyx*, Winter (1997–1998). Web.

Crary, Jonathan. *Techniques of the Observer*. Cambridge, MA: MIT Press, 1992. Print.

Critical Art Ensemble. *Electronic Civil Disobedience and Other Unpopular Ideas*. Brooklyn, NY: Autonomedia, 1996. Print.

———. *The Electronic Disturbance*. Brooklyn, NY: Autonomedia, 1994. Print.

Crosland, Alan, dir. *The Jazz Singer*. Warner Brothers, 1927. Film.

Cubitt, Sean. *The Cinema Effect*. Cambridge, MA: MIT Press, 2004. Print.

Currie, Gregory. *Image and Mind: Film, Philosophy and Cognitive Science*. Cambridge, UK: Cambridge University Press, 1995. Print.

Curtin, Michael. "Feminine Desire in the Age of Satellite Television." *Journal of Communication* 49.2 (1999): 55–70. Print.

———. "Gatekeeping in the Neo-Network Era." *Advocacy Groups and Prime Time Television*. Ed. Michael Susman. Westport, CT: Praeger, 2000. Print.

Damasio, Antonio R. *Descartes' Error: Emotion, Reason and the Human Brain*. New York: GP Putnam's Sons, 1994. Print.

————. *The Feeling of What Happens: Body and Emotion in the Making of Consciousness*. Orlando, FL: Houghton Mifflin Harcourt, 1999. Print.

————. *Looking for Spinoza: Joy, Sorrow, and the Feeling Brain*. Orlando, FL: Houghton Mifflin Harcourt, 2003. Print.

————. *Self Comes to Mind: Constructing the Conscious Brain*. New York: Pantheon, 2010. Print.

Daniels, Jessie. *Cyber Racism: White Supremacy Online and the New Attack on Civil Rights*. New York: Rowman & Littlefield Publishers, 2009. Print.

Danto, Arthur C. *Narration and Knowledge*. New York: Columbia University Press, 1985. 155–9. Print.

Darley, Andrew. *Visual Digital Culture: Surface Play and Spectacle in New Media Genres*. London: Routledge, 2000. Print.

Dash, E. "Europe Zips Lips; US Sells Zips." *The New York Times*, August 7, 2005, sec. 4: 1, 5. Print.

Davila, Carlos Lage. "Seminario Nacional Internet." Havana, Cuba. June 17, 1996. Opening plenary speech.

Davis, Mike. *City of Quartz: Excavating the Future in Los Angeles*. London: Verso, 1992. Print.

de Certeau, Michel. *The Practice of Everyday Life*. London: University of California Press, 1984. Print.

de Fren, Allison. "Future Sex: The Evolution of Erotic Robots." *RES* 5.3 (2002). Print.

Dawkins, Richard. *The Selfish Gene*. Oxford, UK: Oxford University Press, 1976. Print.

DeJesus, Rosalinda. "Focus Turns to Improving Nutrition Habits." *Hartford Courant*, January 22, 1997: B1. Print.

————. "Study: City's Latino Children Not Eating Right." *Hartford Courant*, January 21, 1997: A3. Print.

de la Fé, Ernesto J. Personal website. www.delafe.com/cardenas/. No date. Web.

de Lauretis, Teresa. *Alice Doesn't: Feminism, Semiotics, Cinema*. Bloomington: Indiana University Press, 1987. Print.

Deleuze, Gilles. "The Brain Is the Screen." *The Photographic Image in Digital Culture*. Ed. Gregory Flaxman. Minneapolis: University of Minnesota Press, 2000. 365–73. Print.

————. *Cinema 1: The Movement-Image*. Tr. Hugh Tomlinson and Barbara Habberjam. Minneapolis: University Press of Minnesota, 1986. Print.

————. *Cinema 2: The Time-Image*. Tr. Hugh Tomlinson and Robert Galeta. Minneapolis: University Press of Minnesota, 1989. Print.

————. *Difference and Repetition*. Columbia University Press, 1991. Print.

————. *Francis Bacon: The Logic of Sensation*. Tr. D. Smith. Minneapolis: University of Minnesota, 2005. Print.

————. "Letter to Serge Daney: Optimism, Pessimism, and Travel." *Negotiations*. New York: Columbia University Press, 1995. Print.

————. *Logic of Sense*. Columbia University Press, 1990. Print.

————. "Postscript on Control Societies." *Negotiations*. New York: Columbia University Press, 1995. Print.

Delgado-P., Guillermo and Marc Becker. "Latin America: The Internet and Indigenous Texts." *Cultural Survival Quarterly* 21. 4 (1998): 23–28. Print.

DeLillo, Don. *Underworld*. New York: Scribner, 1998. Print.

Dement, Linda. "An Interview with Sadie Plant and Linda Dement." Ed. Miss M. www.to.or. at/sadie/intervw.htm. No date. Web.

———. *Cyberflesh/Girlmonster*. Digimatter.com. 1995. Web.

———. *Typhoid Mary*. Digimatter, 1991. CD-ROM.

De Michelis, Marco. "Spaces." *Bruce Nauman: Topological Gardens*. Ed. C. Basualdo and M. Taylor. Philadelphia: Philadelphia Museum of Art, 2009. Print.

Depocas, Alain, Jon Ippolito, and Caitlin Jones, eds. *The Variable Media Approach: Permanence through Change*. New York: Guggenheim Museum Publications, and Quebec: The Daniel Langlois Foundation for Art, Science, and Technology, 2003. Print.

Derrida, Jacques. *Archive Fever*. Chicago: University of Chicago Press, 1997. Print.

———. "Signature Event Context." *Limited Inc*. Evanston, IL: Northwestern University Press, 1988. 1–24. Print.

Dertouszos, Michael. *What Will Be: How the New World of Information Will Change Our Lives*. New York: Harper Collins, 1998. Print.

Dery, Mark. *Escape Velocity: Cyberculture at the End of the Century*. New York: Grove Press, 1966. Print.

Descartes, René. *Oeuvres de Descartes*. Ed. Charles Adam and Paul Tannery. Revised ed. Paris: Vrin/CNRS, 1964–1976. Print.

———. *The Philosophical Writings of Descartes*. Vols. I–III. Tr. John Cottingham et al. Cambridge, UK: Cambridge University Press, 1984–1991. Print.

Dewey, John. *The Quest for Certainty: A Study of the Relation of Knowledge and Action*. Gifford Lectures, 1929. New York: Minton, Balch, 1929. Print.

Dicker, Georges. *Descartes: An Analytical and Historical Introduction*. Oxford, UK: Oxford University Press, 1993. Print.

Didi-Huberman, Georges. *L'Image Survivante: Histoire de l'art et des temps des fantômes selon Aby Warburg*. Paris: Les Éditions de Minuit, 2002. Print.

Dienst, Richard. "Ineluctable Modalities of the Televisual." *Still Life in Real Time: Theory after Television*. Durham, NC: Duke University Press, 1994. Print.

DiOrio, Carl. "The after-effect: Slowing down after FX explosion." *The Hollywood Reporter*, December 10, 1997: 1. Print.

Doane, Mary Ann. "Temporality, Storage, Legibility: Freud, Marey, and the Cinema." *Endless Night: Cinema and Psychoanalysis, Parallel Histories*. Ed. Janet Bergstrom. Berkeley: University of California Press, 1999. 57–87. Print.

———. "Temporality, Storage, Legibility: Freud, Marey, and the Cinema." *The Emergence of Cinematic Time: Modernity, Contingency, the Archive*. Cambridge, MA: Harvard University Press, 2002. 33–68. Print.

Dodge, Martin. *Mapping Cyberspace*. London: Routledge, 2001. Print.

Dodge, Martin and Rob Kitchin. *Atlas of Cyberspace*. Harlow, UK: Addison-Wesley, 2001. Print.

Dominguez, Ricardo. "Zapatistias: The Recombinant Movie." *Digital Delirium*. Ed. Arthur and Marilouise Kroker. New York: St. Martin's, 1997. 135–42. Print.

Douglas, Jane Yellowlees. *The End of Books—or Books without End? Reading Interactive Narratives*. No date. Unpublished manuscript.

———. "'How Do I Stop This Thing?': Closure and Indeterminacy in Interactive Narratives." *Hyper/Text/Theory*. Ed. George P. Landow. Baltimore: Johns Hopkins University Press, 1994. 159–88. Print.

Draaisma, Douwe. *Metaphors of Memory: A History of Ideas about the Mind*. Tr. Paul Vincent. Cambridge, UK: Cambridge University Press, 2000. Print.

Dreyer, Carl. *The Passion of Joan of Arc*. Société générale des films, 1928. Film.

Drohan, Madelaine. "Grassroots Groups Used Their Own Globalization to Derail Deal!" OECD: Organization for Economic Co-Operation and Development. April 29, 1998. Web.

Duffy, J. C. Cartoon. *The New Yorker,* January 17, 2011: 59. Print.

Duguet, Anne Marie. "Performing the Projected Image." French Cinematic Futures Conference, Cornell University, Ithaca, NY, November 6, 1998. Paper.

———, ed. *Muntadas: Media Architecture Installation. Anarchive 1*. Paris: Centre Georges Pompidou, 1999. CD-ROM.

Dunning, Alan. *Greenhouse*. Calgary: Alan Dunning, 1989. Print.

Dyrberg, Torben Bech. "Right/Left in the Context of New Political Frontiers: What's Radical Politics Today?" *Journal of Language and Politics* 2.2 (2003): 333–60. Print.

Eco, Umberto. *Foucault's Pendulum*. London: Martin Secker and Warburg, 1989. Print.

Edmundson, Mark. "On the Uses of a Liberal Education." *Harper's Magazine,* September 1997: 39–49. Print.

Eisenstein, Sergei. *Beyond the Stars: The Memoirs of Sergei Eisenstein*. Ed. Richard Taylor. Tr. William Powell. London: British Film Institute, 1995. Print.

———. "The Dramaturgy of Film Form (The Dialectical Approach to Film Form)." *S. M. Eisenstein: Selected Works, Vol. I: Writings, 1922–34*. Ed. and tr. Richard Taylor. London: British Film Institute, 1988. 161–80. Print.

———. *Montazh* [Montage]. Ed. Naum Kleiman. Moscow: Muzei Kino, 2000. Print.

Eisenstein, Zillah R. *Global Obscenities: Patriarchy, Capitalism, and the Lure of Cyberfantasy*. New York: New York University Press, 1998. Print.

———. *Hatreds: Racialized and Sexualized Conflicts of the Twenty-first Century*. New York: Routledge, 1996. Print.

Elsaesser, Thomas. "Freud as Media Theorist: Mystic Writing-Pads and the Matter of Memory." *Screen* 50.1 (2009): 100–13. Print.

Ellul, Jacques. *The Technological Society*. New York: Knopf, 1964. Print.

Emery, Clark. "John Wilkins' Universal Language." *Isis* 38:3 (1948): 147–85. Print.

Etzioni-Halevy, Eva. "Elites, Inequality and the Quality of Democracy in Ultramodern Society." *International Review of Sociology* 9.2 (1999): 239–50. Print.

Everett, Anna. *Digital Diaspora: A Race for Cyberspace*. New York: SUNY Press, 2009. Print.

———, ed. *AfroGEEKS: Beyond the Digital Divide*. Santa Barbara, CA: Center for Black Studies Research, 2007. Print.

Faloutsos, Christos, Petros Faloutsos, and Michalis Faloutsos. "On Power-Law Relationships of the Internet Topology." *Proceedings of the ACM SIGCOMM,* September 1999: 251–62. Print.

Fara, Patricia and Karalyn Patterson, eds. *Memory*. Cambridge, UK: Cambridge University Press, 1998. Print.

Farina, Stephen Doheny. *The Wired Neighborhood*. New Haven, CT: Yale University Press, 1996. Print.

Feldman, Allen. "Violence and Vision: The Prosthetics and Aesthetics of Terror." *Public Culture* 10.1 (1997): 24–60. Print.

Fifield, George. "ZKM." *Artbyte,* December–January (1998–1999): 26–31. Print.

Figgis, Mike, dir. *Timecode.* Screen Gems, 2000. Film.

Fiske, John. *Media Matters: Everyday Culture and Political Change.* Minneapolis: University of Minnesota Press, 1994. Print.

Forgács, Péter, dir. *The Danube Exodus.* Lumen Films, 1998. Film.

———. *The Danube Exodus: The Rippling Currents of the River.* With The Labyrinth Project at the University of Southern California, Los Angeles: The Getty Center, 2001. Installation.

Forster, Kurt W. "Warburg's Versunkenheit." *Aby M. Warburg: "Ekstatishce Nymphe . . . taruender Flussgott": Portrait eines Gelehrtes.* Ed. Robert Galitz and Brita Reimers. Hamburg: Dölling und Galitz Verlag, 1995. Print.

Foster, Hal. "The Archive without Museums." *October 77,* Summer (1996): 97. Print.

Foucault, Michel. *The Archaeology of Knowledge.* Routledge, 1972. Print.

———. "Of Other Spaces." *Diacritics* 16.1 (1986): 22–7. Print.

———. "Space, Knowledge, and Power." *The Foucault Reader.* Ed. Paul Rabinow. New York: Pantheon, 1984. 239–56. Print.

———. *This Is Not a Pipe.* Berkeley: University of California Press, 1973. Print.

———. "What Is an Author?" *Language, Counter-Memory, Practice: Selected Essays and Interviews by Michel Foucault.* Ed. Donald F. Bouchard. Tr. Donald F. Bouchard and Sherry Simon. Ithaca, NY: Cornell University Press, 1977. 113–38. Print.

Fox. "Eine Kleine Frohike." *The Lone Gunmen.* 2001. Television.

Fox. *Sliders.* 1995–2000. Television.

Fox. *The X-Files.* 1993–2002. Television.

Frampton, Hollis. *(nostalgia).* 1971. Film.

———. *On the Camera Arts and Consecutive Matters: The Writings of Hollis Frampton.* Ed. Bruce Jenkins. Cambridge, MA: MIT Press, 2009. Print.

Frederick, Howard. "The U.S. National Information Infrastructure: Implications for Global Democracy." *Communications and Democracy: Ensuring Plurality.* Ed. Brij Tankha. Penang, Malaysia: Southbound, 1995. 39–60. Print.

Freeman, Walter. *How Brains Make Up Their Minds.* London: Weidenfield and Nicolson, 1999. Print.

Freud, Sigmund. "From the History of an Infantile Neurosis." *The Wolf Man by the Wolf Man.* New York: Basic Books, 1971. 173. Print.

———. "A Note upon the 'Mystic Writing-Pad.'" *The Standard Edition of the Complete Psychological Works of Sigmund Freud, Vol. XIX.* Tr. and ed. James Strachey. London: Hogarth, 1961. 227–32. Print.

———. *The Psychopathology of Everyday Life. The Standard Edition of the Complete Psychological Works of Sigmund Freud, Vol. VI.* Tr. and ed. James Strachey. London: Hogarth, 1960. Print.

———. "The 'Uncanny.'" Tr. Alix Strachey. *The Standard Edition of the Complete Psychological Works of Sigmund Freud, Vol. XVII.* Tr. and ed. James Strachey. London: Hogarth, 1955. 217–56. Print.

Friedman, David. *The Machinery of Freedom: A Guide to Radical Capitalism,* 2nd ed. La Salle, IL: Open Court, 1989. Print.

Friedman, Milton. *Capitalism and Freedom*. With the assistance of Rose Friedman. Chicago: Chicago University Press, 1962. Print.

Fuller, Matthew. *Behind the Blip: Essays on the Culture of Software*. London: Autonomedia, 2003. Print.

Galloway, Alexander R. *Protocol*. Cambridge, MA: MIT Press, 2004. Print.

García, Cristina. *Dreaming in Cuban*. New York: Ballantine, 1992. Print.

García, Maria Cristina. *Havana, USA*. Berkeley: University of California Press, 1994. Print.

Geertz, Clifford. "Thick Description: Toward an Interpretive Theory of Culture." *The Interpretation of Cultures: Selected Essays*. New York: Basic Books, 1973. 3–30. Print.

Genette, Gerard. *Narrative Discourse: An Essay on Method*. Tr. Jane E. Lewin. Ithaca: Cornell University Press, 1983. Print.

Gerrig, Richard J. "Reexperiencing Fiction and Non-Fiction." *Journal of Aesthetics and Art Criticism* 47.3 (1989): 277–80. Print.

Gibson, David, Jon Kleinberg, and Prabhakar Raghavan. "Inferring Web Communities from Link Topology." *Proceedings of HyperText 98* (1998): 225–34. Print.

Gibson, James. *The Ecological Approach to Visual Perception*. New York: Taylor & Francis, 1976. Print.

Gibson, Rachel, Paul Nixon, and Stephen Ward, eds. *Political Parties and the Internet: Net Gain?* London: Routledge, 2003. Print.

Gibson, William. *Neuromancer*. New York: Ace Science Fiction, 1984. Print.

Giddens, Anthony. *Beyond Left and Right: The Future of Radical Politics*. Cambridge UK: Polity, 1994. Print.

———, ed. *The Global Third Way Debate*. Cambridge UK: Polity, 2001. Print.

———. "Introduction: Neoprogressivism. A New Agenda for Social Democracy." *The Progressive Manifesto: New Ideas for the Centre-Left*. Ed. Anthony Giddens. Cambridge, UK: Polity, 2003. 1–34. Print.

———. *The Third Way: The Renewal of Social Democracy*. Cambridge, UK: Polity, 1998. Print.

———. *The Third Way and Its Critics*. Cambridge, UK: Polity, 2000. Print.

Ginsburg, Faye. "The Unwired Side of the Digital Divide." *Flow* 1.12 (2005). Web.

Gitlin, Todd. "Public Sphere or Public Spericules?" *Media, Ritual, and Identity*. Ed. Tamar Liebes and James Curran. New York: Routledge, 1998. Print.

Godard, Jean-Luc, dir. *Les Carabiniers*. Cocinor, 1963. Film.

Goffman, Erving. *Frame Analysis: An Essay on the Organization of Experience*. Cambridge, MA: Harvard University Press, 1974. Print.

Gold, Matthew K., ed. *Debates in the Digital Humanities*. Minneapolis: University of Minnesota Press, 2012. Print.

Golding, William. *Free Fall*. New York: Harcourt, Brace & World, 1959. Print.

Gombrich, Ernst H. *Aby Warburg: An Intellectual Biography*. Chicago: University of Chicago Press, 1986. Print.

———. "Aby Warburg und der Evolutionismus des 19. Jahrhunderts." *Aby M. Warburg: "Ekstatishce Nymphe . . . taruernderFlussgott": Portrait eines Gelehrtes*. Ed. Robert Galitz and Brita Reimers. Hamburg: Dölling und Galitz Verlag, 1995. Print.

———. "Warburg Centenary Lecture." *Art History as Cultural History: Warburg's Projects*. Ed. Richard Woodfield. Amsterdam: G+B Arts, 2001. Print.

Gómez-Peña, Guillermo. "The Virtual Barrio @ The Other Frontier (or The Chicano Interneta)." *Clicking In: Hot Links to a Digital Culture.* Ed. Lynn Hershman Leeson. Seattle: Bay Press, 1996. 179. Print.

Goodfellow, Kris. "Mayday! Mayday! We're Leaking Visuals! A Shakeout of the Special Effects Houses." *The New York Times,* September 29, 1997: D1. Print.

Gooding-Williams, Robert, ed. *Reading Rodney King, Reading Urban Uprisings.* New York: Routledge, 1993. Print.

Gordon, Eric. *The Urban Spectator: American Concept-cities From Kodak to Google.* Lebanon, NH: Dartmouth University Press, 2010. Print.

Gordon, Eric and Adriana de Souza e Silva. *Net Locality: Why Location Matters in a Networked World.* Malden, MA: Blackwell, 2011. Print.

Gray, Herman. *Cultural Moves: African Americans and the Politics of Representation.* Berkeley: University of California Press, 2005. Print.

Griffith, D. W., dir. *The Birth of a Nation.* D. W. Griffith Corporation, 1915. Film.

———. *Intolerance.* Triangle, 1916. Film.

Grossman, Lev. "Power to the People." *Time,* December 25, 2006: 42–56. Print.

Grosz, Elizabeth. *Volatile Bodies: Towards a Corporeal Feminism.* Bloomington: Indiana University Press, 1994. Print.

Grusin, Richard and Jay David Bolter. *Remediation: Understanding New Media.* Cambridge, MA: MIT Press, 1999. Print.

Hacker, Kenneth L. and Jan van Dijk, eds. *Digital Democracy: Issues of Theory and Practice.* Thousand Oaks, CA: Sage, 2000. Print.

Hall, Carla and Bill Shaikin. "Frank McCourt Confirms That Dodgers Wanted to Substantially Cut Player Payroll." *Los Angeles Times,* September 2, 2010. Print.

Hall, Stuart. "What Is This 'Black' in Black Popular Culture?" *Black Popular Culture: A Project by Michele Wallace.* Ed. Gina Dent. Seattle: Bay Press, 1992. Print.

Hamelink, Cee J. *Trends in World Communication: On Disempowerment and Self-Empowerment.* Penang, Malaysia: Southbound, 1994. Print.

Hannigan, John. *Fantasy City: Pleasure and Profit in the Postmodern Metropolis.* London: Routledge, 1998. Print.

Hansen, Mark. *Bodies in Code: Interfaces with Digital Culture.* New York: Routledge, 2006. Print.

———. "Cinema Beyond Cybernetics, or How to Frame the Digital-Image." *Configurations* 10.1 (2002): 51–90. Print.

———. *Embodying Technesis: Technology beyond Writing.* Ann Arbor: University Press of Michigan, 2000. Print.

Hansen, Miriam. "Of Mice and Ducks: Benjamin and Adorno on Disney." *South Atlantic Quarterly* 92:1 (1993): 27–61. Print.

Haraway, Donna. "A Cyborg Manifesto: Science, Technology, and Socialist-Feminism in the Late Twentieth Century," in *Simians, Cyborgs and Women: The Reinvention of Nature.* New York: Routledge, 1991. 149–81. Print.

Hardt, Michael, and Antonio Negri. *Multitude.* London: Hamish Hamilton, 2004. Print.

Hargittai, Eszter. "Cross-ideological Conversations among Bloggers." Crookedtimber.org. May 25, 2005. Web.

Harries, Dan, ed. *The New Media Book*. London: British Film Institute, 2002. Print.

Harries, Dan. "Watching the Internet." *The New Media Book*. Ed. Dan Harries. London: British Film Institute, 2002. Print.

Harris, James W. "Nolan: Innovator for Liberty." *The Liberator,* Summer (1996). Web.

Hay, James. "Unaided Virtues: The Neoliberalization of the Domestic Sphere." *Television and New Media* 1.1 (2000): 53–73. Print.

Hayek, Friedrich A. *The Constitution of Liberty*. Chicago: University of Chicago Press, 1960. Print.

———. *The Road to Serfdom*. London: Routledge, 1944. Print.

Hayles, N. Katherine. *Electronic Literature: New Horizons for the Literary*. Notre Dame, IN: University of Notre Dame Press, 2008. Print.

———. "Embodied Virtuality: Or How to Put Bodies Back into the Picture." *Immersed in Technology: Art and Virtual Environments*. Ed. Mary Anne Moser and Douglas MacLeod. Cambridge, MA: MIT Press, 1996. Print.

———. *How We Became Posthuman: Virtual Bodies in Cybernetics, Literature, and Informatics*. Chicago: University of Chicago Press, 1999. Print.

———. *How We Think: Digital Media and Contemporary Technogenesis*. Chicago: University of Chicago Press, 2012. Print.

———. *My Mother Was a Computer: Digital Subjects and Literary Texts*. Chicago: University of Chicago Press, 2005. Print.

———. "Narrating Bits." *Vectors: Journal of Culture and Technology in a Dynamic Vernacular* 6 (2010). Web.

———. "Simulating Narratives: What Virtual Creatures Can Teach Us." *Critical Inquiry* 26.1 (1999): 1–26. Print.

———. "Virtual Bodies and Flickering Signifiers." *How We Became Posthuman: Virtual Bodies in Cybernetics, Literature, and Informatics*. Chicago: University of Chicago Press, 1999. 25–49. Print.

———. *Writing Machines*. Cambridge, MA: MIT Press, 2002. Print.

Heath, Stephen. "Cinema and Psychoanalysis: Parallel Histories." *Endless Night: Cinema and Psychoanalysis, Parallel Histories*. Ed. Janet Bergstrom. Berkeley: University of California Press, 1999. 25–56. Print.

Heidegger, Martin. "The Question Concerning Technology." *Basic Writings*. Ed. D. F. Krell. San Francisco: HarperCollins, 1993. 307–42. Print.

Held, David. *Models of Democracy*. Cambridge, UK: Polity, 1987. Print.

Hemmet, Drew. "The Locative Dystopia." *nettime.org* 9 (2004). Web.

Herman, David, ed. *Narrative Theory and the Cognitive Sciences*. Stanford, CA: CSLI, 2003. Print.

Hernadi, Paul. *Cultural Transactions: Nature, Self, Society*. Ithaca, NY: Cornell University Press, 1995. Print.

———. "Why Is Literature: A Coevolutionary Perspective on Imaginative Worldmaking." *Poetics Today* 23.1 (2002): 21–42. Print.

Hernandez-Reguant, Ariana. "Socialism with Commercials: Consuming Advertising in To-day's Cuba." *ReVista, DRCLAS News,* Winter (2000). Web.

Hess, John and Patricia R. Zimmermann. "Towards a Definition of Transnational Documen-taries." *DOX*, Spring (1995): 17–22. Print.

———. "Transnational Documentaries: A Manifesto." *Afterimage*, January/February (1997): 10–4. Print.

Hesselberth, Pepita and Laura Schuster. "Into the Mind and Out to the World: Memory Anxiety in the Mind-Game Film." *Mind the Screen: Media Concepts According to Thomas Elsaesser*. Ed. Jaap Kooijman, Patricia Pisters, and Wanda Strauven. Amsterdam: Amsterdam Univeresity Press, 2008. 96–111. [Available through open access at www.oapen.org/search?identifier=340042.] Print.

Higgins, Dick. *Buster Keaton Enters into Paradise*. New York: Left Hand Books, 1994. Print.

Hillis, Ken. "A Geography of the Eye: The Technologies of Virtual Reality." *Cultures of the Internet: Virtual Spaces, Real Histories, Living Bodies*. Ed. Rob Shields. London: Sage Press, 1996. 70–98. Print.

———. "Perfect Clarity, Fractured Flesh, Digital Queers and Informational Subjectivity." Knowing Mass Culture/Mediating Knowledge Conference, University of Wisconsin—Milwaukee, May 1, 1999. Paper.

Hinton, Carma. *The Gate of Heavenly Peace*. 1995. Film.

Hirsch, E. D. *Cultural Literacy: What Every American Needs to Know*. New York: Vintage, 1988. Print.

Hitchcock, Alfred, dir. *Psycho*. Paramount Pictures, 1960. Film.

———. *Vertigo*. Paramount Pictures, 1958. Film.

———. *The Wrong Man*. Warner Brothers, 1956. Film.

Hoffman, David S. *High-Tech Hate: Extremist Use of the Internet*. New York: Anti-Defamation League, 1997. Print.

———. *Web of Hate: Extremists Exploit the Internet*. New York: Anti-Defamation League, 1996. Print.

Hogan, Patrick Colm. *The Mind and Its Stories: Narrative Universals and Human Emotion*. Cambridge, UK: Cambridge University Press, 2003. Print.

Horkheimer, Max and Theodor W. Adorno. *Dialectic of Enlightenment*. Tr. John Cumming. New York: Continuum, 1944/1972. Print.

Horrigan, John, Kelly Garrett, and Paul Resnick. "The Internet and Democratic Debate." Pew Internet and American Life Project. 2004. Web.

Huffman, Kathy Rae. "Video, Networks, and Architecture: Some Physical Realities of Electronic Space." *Electronic Culture: Technology and Visual Representation*. Ed. Timothy Druckrey. New York: Aperture, 1996. Print.

Hughes, Peter. "New Digital Media and the Project of Documentary." Visible Evidence VI Conference. San Francisco State University, San Francisco, CA, August 15, 1998. 3, 5. Paper.

Humphrey, Nicholas. *A History of the Mind: Evolution and the Birth of Consciousness*. New York: Copernicus, 1992. Print.

———. *Seeing Red: A Study in Consciousness*. Cambridge, MA: Harvard University Press, 2006. Print.

Hutchins, Edwin. *Cognition in the Wild*. Cambridge, MA: MIT University Press, 1995. Print.

Iles, Chrissie. "Between the Still and Moving Image." *Into the Light: The Projected Image in American Art 1964–1977*. Published on the occasion of the exhibition "Into the Light: The Projected Image in American Art, 1964–1977" at the Whitney Museum of American Art,

New York, October 18, 2001–January 6, 2002. New York: Whitney Museum of American Art, 2001. Print.

———. "Video and Film Space." *Space, Site, Intervention: Situating Installation Art.* Ed. Erika Suderburg. Minneapolis: University of Minnesota Press, 2000. 252. Print.

Institute Jacque-Dalcroze. *Ritm. Ezgegodnik Institituta Zhak-Dalkroza v Gellerau Bliz Drezdena. I tom* [Rhythm: Yearly of the Institute Jacque-Dalcroze at Hellerau near Dresden, vol. I]. Berlin: A. Borovskoy, 1912. Print.

Irigaray, Luce. *Speculum of the Other Woman.* Ithaca, CA: Cornell University Press, 1985. Print.

———. "Volume Fluidity." *Speculum of the Other Woman.* Ithaca, New York: Cornell University Press, 1985. 227–40. Print.

Jackson, Shelley. *Patchwork Girl by Mary/Shelley & Herself.* Watertown: Eastgate Systems, 1995. Electronic art.

———. "Stitch Bitch: The Patchwork Girl." *Paradoxa* 4 (1998): 526–38. Print.

James, David E. *Allegories of Cinema: American Film in the Sixties.* Princeton, NJ: Princeton University Press, 1989. Print.

Jameson, Fredric. *The Political Unconscious.* Bloomington: Indiana University Press, 1982. Print.

———. "Postmodernism, or the Cultural Logic of Late Capitalism." *Media and Cultural Studies: Keyworks.* Ed. Meenakshi Gigi Durham and Douglas Kellner. Malden, MA: Blackwell, 2001. Print.

———. *Signatures of the Visible.* New York: Routledge, 1990. Print.

———. "Video: Surrealism without the Unconscious." *Postmodernism, or the Logic of Late Capitalism.* Durham, NC: Duke University Press, 1990. Print.

Jameson, Fredric and Masao Miyoshi, eds. *The Cultures of Globalization.* Durham, NC: Duke University Press, 1998. Print.

Jarecki, Andrew, dir. *Capturing the Friedmans.* Magnolia Pictures, 2003. Film.

Jenik, Adrienne. *Mauve Desert.* 1992–1997. CD-ROM.

Jenkins, Henry. *Convergence Culture: When Old and New Media Collide.* New York: New York University Press, 2006. Print.

Johnson, Barbara. "My Monster/My Self." *Diacritics* 12 (1982): 2–10. Print.

Johnson, David Martel. *How History Made the Mind: The Cultural Origins of Objective Thinking.* Chicago: Open Court, 2003. Print.

Jonas, Joan. *Vertical Roll.* Collection of the Museum of Modern Art, New York. 1972. Video.

Jones, Amelia. *Body Art: Performing the Subject.* Minneapolis: University of Minnesota Press, 1998. Print.

Jones, Art. *Incidents in the Life Of.* 2002. CD-ROM.

———. *Culture vs. the Martians, Vols. 1 and 2.* 1997–1998. CD-ROM.

Jones, Philip Mallory. "Digital Multiculturalism." Ohio University Film Festival. May 5, 1998. Panel.

Joyce, James. *Ulysses.* New York: Vintage Books, 1961. Print.

Kafka, Franz. *The Trial.* Tr. Willa and Edwin Muir. New York: Everyman's Library [reprint edition], 1992. Print.

Kapur, Shekhar. *Elizabeth.* Polygram, 1998. Film.

Karon, Paul. "Hi-tech Hits 'Digital Coast.'" *Daily Variety,* February 19, 1998: 10. Print.

———. "Hollywood Dread Tech Wreck." *Variety*, April 6–12, 1998: 1. Print.

Katz, Jon. "Birth of a Digital Nation." *Wired* 5.04, April 1997. Web.

Kelley, John, Danyel Fisher, and Marc Smith. "Debate, Division, and Diversity: Political Discourse Networks in USENET Newsgroups." Working Paper for Stanford Online Deliberation Conference. 2005. Web.

Kelley, Robin D. G. *Yo Mama's Dysfunktional! Fighting the Culture Wars in Urban America.* Boston: Beacon Press, 1997. Print.

Kelly, Kevin and Paula Parisi. "Beyond Star Wars: What's Next for George Lucas." *Wired*, February 1997. Web.

Kieślowski, Krzysztof, dir. *The Double Life of Veronique.* Dir. Miramax, 1991. Film.

Kilbourn, Russell J. A. *Cinema, Memory, Modernity: The Representation of Memory from the Art Film to Transnational Cinema.* New York: Routledge, 2010. Print.

Kinder, Marsha. "Designing a Database Cinema." *Future Cinema.* Ed. Jeffrey Shaw and Peter Weibel. Karlsruhe, Germany: ZKM, 2003. Print.

———. "Hot Spots, Avatars, and Narrative Fields Forever: Buñuel's Legacy for New Digital Media and Interactive Database Narrative." *Film Quarterly* 55.4 (2002): 2–15. Print.

———. *Playing with Power in Movies, Television and Video Games.* Berkeley: University of California Press, 1993. Print.

———. "Reorchestrating History: Transforming the Rippling Currents of *The Danube Exodus* into a Dabase Documentary." *Cinema's Alchemist: The Films of Péter Forgács.* Ed. Bill Nichols and Michael Renov. Minneapolis: University of Minnesota Press, 2011. Print.

King, Susan E. *Treading the Maze: An Artist's Book of Daze.* Rochester, NY: Visual Studies Workshop, 1993. Print.

Kinney, Jay. "Anarcho-Emergentist-Republicans." *Wired* 3.09, September 1995. Web.

———. "Beyond Left and Right." *Whole Earth Review* 101, Summer 2000. Web.

———. "Digital Politics 101." 1995. Web.

Kleiman, Naum. "Memuary Eizenshteina: sistema koordinat" [Eisenstein's memoirs: a system of coordinates]. *Memuary* [Memoirs]. By Sergei Mikhailovich Eisenstein. Ed. Naum Kleiman. Moscow: Muzei Kino, 1997. Print.

Klein, Naomi. *No Logo: Taking Aim at the Brand Bullies.* New York: Picador, 2000. Print.

Klein, Norman. "Bleeding Through." Booklet accompanying the DVD-ROM *Bleeding Through: Layers of Los Angeles 1920–1986.* Karlsruhe, Germany: ZKM Center for Art and Media; Los Angeles: The Labyrinth Project at the University of Southern California, 2003. Print.

———. *The History of Forgetting: Los Angeles and the Erasure of Memory.* New York: Verso, 1997. Print.

Kleinberg, Jon M. "Authoritative Sources in a Hyperlinked Environment." *Journal of the ACM* 46.5 (1999): 604–32. Print.

Kolko, Beth E., Lisa Nakamura, and Gilbert B. Rodman, eds. *Race in Cyberspace.* New York: Routledge, 2000. Print.

Korten, David C. *Globalizing Civil Society: Reclaiming Our Right to Power.* New York: Seven Stories Press, 1998. Print.

Kracauer, Siegfried. *Theory of Film: The Redemption of Physical Reality.* Princeton, NJ: Princeton University Press, 1997. Print.

Krauss, Rosalind. "Video: The Aesthetics of Narcissism." *Video Culture: A Critical Investigation.* Ed. John Hanhardt. New York: Peregrine Smith, 1987. Print.

Kraynak, Janet. "Dependent Participation: Bruce Nauman's Environments." *Art and the Moving Image: A Critical Reader.* Ed. T. Leighton. London: Tate Publishing, 2008. Print.

Krebs, Valdis. "The Social Life of Books: Visualizing Communities of Interest via Purchase Patterns on the WWW." Orgnet.com, 2004. Web.

Kristeva, Julia. *Powers of Horror: An Essay on Abjection.* New York: Columbia University Press, 1982. Print.

Kroker, Arthur and Marilouise Kroker. "Code Warriors: Bunkering In and Dumbing Down." *Clicking In: Hot Links to a Digital Culture.* Ed. Lynn Hershman Leeson. Seattle: Bay Press, 1996. 247–257. Print.

Kroker, Arthur and Michael A. Weinstein. "The Theory of the Virtual Class." *Data Trash: The Theory of the Virtual Class.* 1994. Reprinted in *Electronic Media and Technoculture.* Ed. John Thornton Caldwell. New Brunswick, NJ: Rutgers University Press, 2000. 117–36. Print.

Kumao, Heidi. *Misbehaving: Performative Machines Act Out.* 2002–2008. Robotic figures.

Kumar, Ravi et al. "Trawling the Web for Emerging Cyber-Communities." No date. Web.

Kvavilashvili, Lia and George Mandler. "Out of One's Mind: A Study of Involuntary Semantic Memories." *Cognitive Psychology* 48.1 (2004): 47–94. Print.

Labyrinth Project. *Bleeding Through: Layers of Los Angeles, 1920–1986.* The Labyrinth Project, University of Southern California, 2003. DVD-ROM.

Lacan, Jacques. *Seminar Two: The Ego in Freud's Theory and in the Technique of Psychoanalysis, 1954–55.* New York: Norton, 1988. Print.

Laclau, Ernesto. "Identity and Hegemony: The Role of Universality in the Constitution of Political Logics." *Contingency, Hegemony, Universality: Contemporary Dialogues on the Left.* Ed. Judith Butler, Ernesto Laclau, and Slavoj Žižek. New York: Verso, 2000. 44–89. Print.

Laclau, Ernesto and Chantal Mouffe. *Hegemony and Socialist Strategy: Towards a Radical Democratic Politics,* 2nd ed. London: Verso, 2001. Print.

Lahr, John. "Command Performance: The Reign of Helen Mirren." *The New Yorker,* October 2, 2006: 58–65. Print.

Laity, Paul, ed. *Left Book Club Anthology.* London: Weidenfeld and Nicolson, 2001. Print.

Lakoff, George. *Don't Think of an Elephant! Know Your Values and Frame the Debate: The Essential Guide for Progressives.* White River Junction, VT: Chelsea Green, 2004. Print.

———. *Moral Politics: How Liberals and Conservatives Think.* Chicago: University of Chicago Press, 2002. Print.

Lakoff, George and Mark Johnson. *Philosophy in the Flesh: The Embodied Mind and Its Challenge to Western Thought.* New York: Basic, 1999. Print.

Landow, George. *Hypertext: The Convergence of Contemporary Critical Theory and Technology.* Baltimore: Johns Hopkins University Press, 1991. Print.

———. *Hypertext 2.0: The Convergence of Contemporary Critical Theory and Technology.* Baltimore: Johns Hopkins University Press, 1997. Print.

Lanier, Jaron. "Digital Maoism: The Hazards of the New Online Collectivism." *Edge* (2006). Web.

Lazzarato, Maurizio. "Video, Flows and Real Time." *Art and the Moving Image: A Critical Reader.* Ed. T. Leighton. London: Tate, 2008. Print.

Leake, David B. "Case-based Reasoning." *A Companion to Cognitive Science*. Ed. William Bechtel and George Graham. Oxford, UK: Blackwell, 1998. 465–76. Print.

LeDoux, Joseph. *The Emotional Brain: The Mysterious Underpinnings of Emotional Life*. New York: Simon & Schuster, 1996. Print.

Lefebvre, Henri. *Critique of Everyday Life and the Production of Space*. Tr. Donald Nicholson-Smith. Oxford, UK: Blackwell, 1991. Print.

Le Guin, Ursula K. *Always Coming Home*. New York: Bantam, 1987. Print.

Leirens, Jean. *Le Cinéma et le Temps*. Paris: Editions du Cerf, 1954. Print.

Lenhart, Amanda and Mary Madden. *Social Networking Websites and Teens: An Overview*. Pew Internet and American Life Project, 2007. Print.

Levy, Pierre. *Collective Intelligence: Mankind's Emerging World in Cyberspace*. New York: Plenum Trade, 1997. Print.

Lewis, George. "Singing the Alternative Interactivity Blues." *Front* 7.2 (1995): 18–22. Reprinted in *Grantmakers in the Arts* 8.1 (1997): 3–6. Print.

Lewitt, Sol. *Squares with the Sides and Corners Torn Off*. Brussels: MTL, 1974. Print.

Leyda, Jay. *Films Beget Films*. London: George Allen and Unwin. 1964. Print.

Libet, Benjamin. *Mind Time: The Temporal Factor in Consciousness*. Cambridge, MA: Harvard University Press, 2004. Print.

Lintsbach, Y. *Printsipy filosofskogo iazyka. Opyt tochnogo jazykoznanija* [The Principles of the Philosophic Language]. Petrograd, 1916. Print.

Lipsitz, George. *Dangerous Crossroads: Popular Music, Postmodernism, and the Poetics of Place*. London: Verso, 1994. Print.

Lister, Martin. "Introduction: The Photographic Image in Digital Culture." *The Photographic Image in Digital Culture*. Ed. Martin Lister. London: Routledge, 1995. 1–28. Print.

Loader, Brian D. *Cyberspace Divide: Equality, Agency, and Policy in the Information Society*. London: Routledge, 1998. Print.

Löfgren, Karl and Colin Smith. "Political Parties and Democracy in the Information Age." *Political Parties and the Internet: Net Gain?* Ed. Rachel Gibson, Paul Nixon, and Stephen Ward. London: Routledge, 2003. 39–52. Print.

Logan, Robert K. *The Alphabet Effect*. New York: William Morrow, 1986. Print.

Lovejoy, Margot. *Postmodern Currents: Art and Artists in the Age of Electronic Media*. Upper Saddle River, NJ: Prentice Hall, 1997. 154–78. Print.

Lowe, Lisa. *Immigrant Acts: On Asian American Cultural Politics*. Durham, NC: Duke University Press, 1996. Print.

Lowe, Lisa and David Lloyd, eds. *The Politics of Culture in the Shadow of Capital*. Durham, NC: Duke University Press, 1997. Print.

Ludlow, Peter. *Crypto Anarchy, Cyberstates, and Pirate Utopias*. Cambridge, MA: MIT Press, 2001. Print.

———, ed. *High Noon on the Electronic Frontier: Conceptual Issues in Cyberspace*. Cambridge, MA: MIT Press, 1996. Print.

Lull, James. *Media, Communication, Culture: A Global Approach*. New York: Columbia University Press, 1995. Print.

Lunenfeld, Peter. *Snap to Grid: A User's Guide to Digital Arts, Media, and Culture*. Cambridge, MA: MIT Press, 2000. Print.

Lynch, David, dir. *Lost Highway*. October Films, 1997. Film.

Lyons, Geanne K. et al. "Development of a Protocol to Assess Dietary Intake among Hispanics Who Have Low Skills in English." *Journal of the American Dietetic Association* 96.12 (1996): 1276–9. Print.

MacCannell, Dean. *The Tourist: A New Theory of the Leisure Class*. New York: Schocken, 1976. Print.

Mack, John. *The Museum of the Mind: Art and Memory in World Cultures*. London: British Museum, 2003. Print.

Macpherson, C. B. *The Political Theory of Possessive Individualism: Hobbes to Locke*. Oxford, UK: Clarendon Press, 1962. Print.

Magid, Ron. "Epic Effects Christen Titanic." *American Cinematographer,* December 1997: 62–4. Print.

——. "An Expanded Universe." *American Cinematographer* (February 1997): 60–62. Print.

Manovich, Lev. *The Language of New Media*. Cambridge, MA: MIT Press, 2001. Print.

——. "Reality Media." http://manovich.net. 2001. Web.

Manovich, Lev and Andreas Kratky. *Soft Cinema: Navigating the Database*. Cambridge, MA: MIT Press, 2005. Print and DVD.

Margolis, Michael, David Resnick, and Jonathan Levy. "Major Parties Dominate, Minor Parties Struggle: US Elections and the Internet." *Political Parties and the Internet: Net Gain?* Ed. Rachel Gibson, Paul Nixon, and Stephen Ward. London: Routledge, 2003. 53–69. Print.

Marker, Chris. "A Free Replay (Notes on Vertigo)." *Projections 4½*. Ed. John Boorman and Walter Donohue. London: Faber and Faber, 1995. Print.

——, dir. *Immemory*. Ed. Yves Gevaert. Paris: Centre Georges Pompidou and Les Films de l'Astrophore, 1997. CD-ROM.

——, dir. *La Jetée*. Argos, 1962. Film.

——, dir. *Le Joli Mai*. Sofracima, 1965. Potemkine, 2006 [recut]. Film.

——. *Passages de l'image*. 1980. Installation.

——, dir. *Sans Soleil*. Argos, 1983. Film.

——. *Silent Movie*. The Wexner Center, Columbus, Ohio, January 28–April 9, 1995. Installation.

Marks, Paul. "New Software Can Identify You from Your Online Habits." *New Scientist,* May 16, 2007: 32. Print.

Marshall, Lee. "The World According to Eco." *Wired* (March 1997): 145–8, 193–219. Print.

Marvin, Carolyn. *When Old Technologies Were New: Thinking about Electric Communication in the Late Nineteenth Century*. New York: Oxford University Press, 1988. Print.

Masschelein, Anneleen. *The Unconcept: The Freudian Uncanny in Late-Twentieth-Century Theory*. Albany: State University of New York Press, 2011. Print.

Masséra, Jean-Charles. "Dance with the Law." *Bruce Nauman*. London: Hayward, 1998. Print.

Massumi, Brian. "The Brightness Confound." *Body Mécanique: Artistic Explorations of Digital Realms*. Ed. Sarah J. Rogers. Columbus, OH: Wexner Center, 1998. Print.

——. *Parables for the Virtual: Movement, Affect, Sensation*. Durham, NC: Duke University Press, 2002. Print.

May, Timothy C. "The Crypto Anarchist Manifesto." 1988. *Crypto Anarchy, Cyberstates, and Pirate Utopias*. Ed. Peter Ludlow. Cambridge, MA: MIT Press, 2001. 61–64. Print.

———. "Crypto Anarchy and Virtual Communities." 1994. *Crypto Anarchy, Cyberstates, and Pirate Utopias*. Ed. Peter Ludlow. Cambridge, MA: MIT Press, 2001. 65–80. Print.

McChesney, Robert W. "The Media System Goes Global." *Rich Media Poor Democracy: Communication Politics in Dubious Times*. New York: New Press, 1999. Print.

———. *Rich Media Poor Democracy: Communication Politics in Dubious Times*. New York: New Press, 1999. Print.

McChesney, Robert W., Ellen Meiksins Wood, and John Bellamy Foster. *Capitalism and the Information Age: The Political Economy of the Global Communication Revolution*. New York: Monthly Review Press, 1998. Print.

McClintock, Anne, Aamir Mufti, and Ella Shohat. *Dangerous Liaisons: Gender, Nation, and Postcolonial Perspectives*. Minneapolis: University of Minnesota, 1997. Print.

McDonald, William. "Dazzled or Dazed? The Wide Impact of Special Effects." *The New York Times*, May 3, 1998: C1. Print.

McLuhan, Marshall. *Understanding Media: The Extensions of Man*. Cambridge, MA: MIT Press, 1994. Print.

McPherson, Tara. "Why Are the Digital Humanities So White? Or Thinking the Histories of Race and Computation." *Debates in the Digital Humanities*. Ed. Matt Gold. Minneapolis: University of Minnesota Press, 2012. Print.

McWilliams, Gary. "A Hollywood Star Called . . . NEWTEK?" *Business Week*, September 20, 1998. Web.

Meadows, Mark Stephen. *Pause and Effect: The Art of Interactive Narrative*. Indianapolis, IN: New Riders, 2003. Print.

Mellor, Anne K. *Mary Shelley: Her Life, Her Fiction, Her Monsters*. New York: Routledge, 1988. 52–69. Print.

Metz, Christian. *Film Language: A Semiotics of the Cinema*. Oxford, UK: Oxford University Press, 1974. Print.

———. "The Imaginary Signifier." *The Imaginary Signifier: Psychoanalysis and the Cinema*. Tr. Celia Britton et al. Bloomington: Indiana University Press, 1982. Print.

———. *Language and Cinema*. Approaches to Semiotics. The Hague: Mouton, 1974. Print.

Michaud, Philippe-Alain. *Aby Warburg and the Image of Motion*. Tr. Sophie Hawkes. New York: Zone Books, 2004. Print.

Michelson, Annette, ed. *Kino-Eye: The Writings of Dziga Vertov*. Berkeley: University of California Press, 1984. Print.

Milestone, Lewis, dir. *All Quiet on the Western Front*. Universal Pictures, 1930. Film.

Minsky, Marvin. *The Society of Mind*. New York: Simon & Schuster, 1986. Print.

Mitchell, W. J. T. "Visible Language: Blake's Art of Writing." *Picture Theory: Essays on Verbal and Visual Representation*. Chicago: University of Chicago Press, 1994. 111–50. Print.

Mitchell, William J. *City of Bits: Space, Place, and the Infobahn*. Cambridge, MA: MIT University Press, 1996. Print.

Monbiot, George. "They're Stealing Our Clothes." *The Guardian*, April 30, 2002. Web.

Montgomery, Robert, dir. *Lady in the Lake*. MGM, 1947. Film.

Moore, Rachel. *Hollis Frampton: (nostalgia)*. London: Afterall, 2006. Print.

Moravec, Hans. *Mind Children*. Cambridge, MA: Harvard University Press, 1988. Print.

Morley, David. *Home Territories: Media, Mobility, and Identity*. London: Routledge, 2000. Print.

Morse, Margaret. "The Body, the Image, and the Space-in-Between: Video Installation Art." *Virtualities: Television, Media Art, and Cyberculture.* Bloomington: Indiana University Press, 1998. Print.

———. *Virtualities: Television, Media Art, and Cyberculture.* Bloomington: Indiana University Press, 1998. Print.

Mouffe, Chantal. *The Democratic Paradox.* London: Verso, 2000. Print.

———. *The Return of the Political.* London: Verso, 1993. Print.

Moulthrop, Stuart. "Reagan Library." *Gravitational Intrigue: A Little Magazine Publication* 22, May 1999. CD-ROM.

Mumford, Lewis. *Technics and Civilization.* New York: Harcourt, Brace, and the World, 1963. Print.

Muntadas, Antoni. *The File Room.* 1994. Website/installation.

Murch, Walter. *In the Blink of an Eye: A Perspective on Film Editing,* 2nd ed. Los Angeles: Silman-James, 2001. Print.

Murray, Janet. *Hamlet on the Holodeck: The Future of Narrative in Cyberspace.* Cambridge, MA: MIT Press, 1997. Print.

Murray, Timothy. "Digital Lights." Society for the Humanities, Cornell University, Ithaca, NY, October 25, 1998. Lecture.

———. "Digital Lights Exhibition." Ithaca College, Ithaca, NY, April 29, 1998. Exhibition.

Naficy, Hamid. "Exile Discourse and Televisual Fetishization." *Quarterly Review of Film and Video* 13.1–3 (1991). Print.

———. "Framing Exile." *Home, Exile, Homeland: Film, Media, and the Politics of Place.* Ed. Hamid Naficy. New York: Routledge, 1999. 1–13. Print.

Nakamura, Lisa. *Cybertypes: Race, Ethnicity, and Identity on the Internet.* New York: Routledge, 2002. Print.

———. *Digitizing Race: Visual Cultures of the Internet.* Minneapolis: University of Minnesota Press, 2007. Print.

Nannucci, Maurizio. *Universum.* Rome: Biancoenero, 1969. Print.

Nauman, Bruce. *Art Make-Up, Nos. 1–4 (White, Pink, Green, Black).* 1967–1968. Film.

———. *Black Balls.* 1969. Film.

———. *Bouncing Balls.* 1969. Film.

———. *Bouncing in the Corner, No. 1.* 1968. Video.

———. *Bouncing in the Corner, No. 2: Upside Down.* 1969. Video.

———. *Bouncing Two Balls between the Floor and Ceiling with Changing Rhythms.* 1967. Film.

———. "Breaking the Silence: Interview with Joan Simon." *Bruce Nauman.* London: Hayward, 1998. Print.

———. *Corridor Installation (Nick Wilder Installation).* 1970. Installation.

———. *Dance or Exercise on the Perimeter of a Square (Square Dance).* 1967–1968. Film.

———. *Elke Allowing the Floor to Rise Up over Her, Face Up.* 1973. Video.

———. *Flesh to White to Black to Flesh.* 1968. Video.

———. *Gauze.* 1969. Film.

———. *Hanged Man.* 1985. Sculpture.

———. "Interview with Willoughby Sharp." *Bruce Nauman.* London: Hayward, 1998. Print.

———. "Keep Taking It Apart: Interview with René Pulfer." *Bruce Nauman*. London: Hayward, 1998. Print.

———. *Learned Helplessness in Rats (Rock and Roll Drummer)*. 1988. Installation.

———. *Lip Sync*. 1969. Video.

———. *Live Taped Video Corridor*. 1970. Installation.

———. *Manipulating a Fluorescent Tube*. 1969. Video.

———. *Pacing Upside Down*. 1969. Video.

———. *Pinchneck*. 1968. Film.

———. *Playing a Note on the Violin While I Walk around the Studio (Violin Film #1)*. 1967–1968. Film.

———. *Pulling Mouth*. 1969. Film.

———. *Rats and Bats (Learned Helplessness in Rats II)*. 1988. Installation.

———. *Revolving Upside Down*. 1969. Video.

———. *Slow Angle Walk (Beckett Walk)*. 1968. Video.

———. *Stamping in the Studio*. 1968. Video.

———. *Thighing (Blue)*. 1967. Film.

———. *Tony Sinking into the Floor, Face Up, and Face Down*. 1973. Video.

———. *Violin Tuned D.E.A.D.* 1968. Video.

———. *Walk with Contrapposto*. 1968. Video.

———. *Walking in an Exaggerated Manner around the Perimeter of a Square*. 1967–1968. Film.

———. *Wall-Floor Positions*. 1968. Video.

NBC. *Quantum Leap*. 1989–1993. Television.

NBC4 Los Angeles. "City Council Approves Development at Hollywood and Vine." NBC4 Los Angeles, November 6, 2006. Web.

Neale, Steve and Murray Smith, eds. *Contemporary Hollywood Cinema*. London: Routledge, 1998. Print.

Negroponte, Nicholas. *Being Digital*. London: Coronet, 1996. Print.

Neisser, Ulric and Ira E. Hyman, Jr., eds. *Memory Observed: Remembering in Natural Contexts*, 2nd ed. New York: Worth, 2000. Print.

Nelson, Alondra, Thuy Linh N. Tu, and Alicia Headlam Hines, eds. *Technicolor: Race, Technology, and Everyday Life*. New York: NYU Press, 2001. Print.

Nichols, Bill. "The Memory of Loss: Péter Forgács's Saga of Family Life and Social Hell." *Film Quarterly* 56.4 (2003): 2–12. Print.

———. *Newsreel*. New York: Arno Press, 1980. Print.

———. "The Work of Culture in the Age of Cybernetic Systems." *Electronic Culture: Technology and Visual Representation*. Ed. Timothy Druckrey. New York: Aperture Books, 1996. 142–3. Print.

Nielsen//Netratings. "Web Surfers Are More Politically Active Than General Population, According to Nielsen//Netratings." www.nielsen-netratings.com/pr/pr_040319.pdf. Press release, March 19, 2004. Web.

Nixon, Paul, Stephen Ward, and Rachel Gibson. "Conclusions: The Net Change." *Political Parties and the Internet: Net Gain?* Ed. Rachel Gibson, Paul Nixon, and Stephen Ward. London: Routledge, 2003. 234–43. Print.

Noble, David. "Digital Diploma Mills." *Monthly Review Press* 49.9 (1998): 38–52. Print.

———. *Progress without People: In Defense of Luddism*. Chicago: Charles E. Kerr, 1933. Print.

Nolan, Christopher, dir. *Memento*. Newmarket, 2001. Film.

Nooteboom, Cees. *Rituals*. Tr. Adrienne Dixon. Baton Rouge: Louisiana State University Press, 1983. Print.

Novak, Marcos. "Liquid Architectures in Cyberspace." *Cyberspace: First Steps*. Ed. Michael Benedict. Cambridge, MA: MIT Press, 1991. Print.

O'Donnell, Susan and Guillermo Delgado. "Using the Internet to Strengthen the Indigenous Nations of the Americas." *Media Development* 42.3 (1995): 36–39. Print.

Ophüls, Marcel, dir. *The Harvest of My Lai*. Norddeutscher Rundfunk, 1970. Film (for Television).

———. *Hotel Terminus: The Life and Times of Klaus Barbie*. Samuel Goldwyn, 1988. Film.

———. *The Memory of Justice*. BBC, 1976. Film (for Television).

———. *The Sorrow and the Pity*. Télévision Rencontre, 1969. Film (for Television).

———. *The Troubles We've Seen: A History of Journalism in Wartime*. Little Bear, 1994. Film.

Ortega, Luis. *Cubanos en Miami*. Havana: Editorial de Ciencias Sociales, 1998. Print.

Orwall, Bruce. "Behind the Curtain: Entertainment Industry Ops for High Tech Special Effects." *The Wall Street Journal,* March 19, 1998: B1. Print.

Orwell, George. *Nineteen Eighty-Four*. London: Secker & Warburg. Print.

Parisi, Paula. "Lunch on the Deck of the Titanic." *Wired,* February 1998. 148–58. Print.

———. "The New Hollywood." *Wired,* September 20, 1998. Web.

Pavic, Milorad. *Dictionary of the Khazars: A Lexicon Novel*. Tr. Christina Pribicevic-Zoric. New York: Vintage, 1989. Print.

Peckinpah, Sam, dir. *Pat Garrett and Billy the Kid*. MGM, 1973. Film.

Penley, Constance and Andrew Ross, eds. *Technoculture*. Minneapolis: University of Minnesota Press, 1991. Print.

Pérez, Fernando, dir. *Madagascar*. ICIAC, 1995. Film.

Pérez Firmat, Gustavo. *Life on the Hyphen: The Cuban-American Way*. Austin: University of Texas Press, 1994. Print.

Persson, Per. *Understanding Cinema: A Psychological Theory of Moving Imagery*. Cambridge, UK: Cambridge University Press, 2003. Print.

Peter D. Hart Research Associates. "Attitudes, Politics, and Public Service: A Survey of American College Students." Commissioned by the Leon and Sylvia Panetta Institute for Public Policy. May 2004. Web.

———. "Making a Difference, Not a Statement: College Students and Politics, Volunteering, and an Agenda for America." Commissioned by the Leon and Sylvia Panetta Institute for Public Policy. April 2001. Web.

Phillips, Tom. *A Humument: A Treated Victorian Novel,* 2nd revised ed. London: Thames and Hudson, 1997. Print.

Piper, Keith. *Relocating the Remains*. 1997. CD-ROM.

Plantinga, Carl. *Moving Viewers: American Film and the Spectator's Experience*. Berkeley: University of California Press, 2009. Print.

Plantinga, Carl and Greg M. Smith, eds. *Passionate Views: Film, Cognition, and Emotion*. Baltimore: Johns Hopkins University Press, 1999. Print.

Plato. *The Collected Dialogues of Plato, Including the Letters*. Ed. Edith Hamilton and Huntington Cairns. Princeton, NJ: Princeton University Press, 1963. Print.

———. *The Republic of Plato*. Tr. Francis MacDonald Cornford. London: Oxford University Press, 1941. Print.

Pohlmann, Ulrich. "Another Nature; or, Arsenals of Memory: Photography as Study Aid, 1850–1900." *The Artist and the Camera: Degas to Picasso*. Ed. Dorothy Kosinsky. Dallas, TX: Dallas Museum of Art, 1999. Print.

Polan, Dana. "Francis Bacon: The Logic of Sensation." *Gilles Deleuze and the Theater of Philosophy*. Ed. Constantin V. Boundas and Dorothea Olkowski. New York: Routledge, 1994. Print.

———. "The Professors of History." *The Persistence of History*. Ed. Vivian Sobchack. Los Angeles: American Film Institute, 1996. 235–56. Print.

Poster, Mark. "Cyberdemocracy: The Internet and the Public Sphere." *Virtual Politics: Identity and Community in Cyberspace*. Ed. David Holmes. London: Sage, 1997. 212–28. Print.

———. *The Mode of Information: Poststructuralism and Social Context*. Chicago: University of Chicago Press, 1990. Print.

Postman, Neil. *Technopoly: The Surrender of Culture to Technology*. New York: Knopf, 1992. Print.

Postrel, Virginia. *The Future and Its Enemies: The Growing Conflict over Creativity, Enterprise, and Progress*. New York: Free Press, 1998. Print.

Printup Hope, Melanie. *Prayer for Thanksgiving*. 1997. Multimedia installation.

Proust, Marcel. *Swann's Way. Remembrance of Things Past, Vol. 1*. Tr. Lydia Davis. New York: Penguin, 2003. Print.

———. *Swann's Way. Remembrance of Things Past, Vol. 1*. Tr. C. K. Scott Moncrieff and Terence Kilmartin. New York: Vintage Books, 1989. Print.

Pudovkin, V. I. "On Film Technique." *Film Technique and Film Acting: The Cinema Writings of V. I. Pudovkin*. Trans. Ivor Montagu. London: Vision Press Limited, 1954. 140. Print.

Queneau, Raymond. *Cent mille milliards de poèmes*. Paris: Gallimard, 1961. Print.

Rampley, Matthew. "Mimesis and Allegory: On Aby Warburg and Walter Benjamin." *Art History as Cultural History: Warburg's Projects*. Ed. Richard Woodfield. London: Taylor & Francis, 2001. 121–49. Print.

Readings, Bill. *The University in Ruins*. Cambridge, MA: Harvard University Press, 1996. 13. Print.

Recombinant History Project (M. Mateas, S. Domlike, and P. Vanouse). *Terminal Time*, 1999. Multimedia installation.

Reeves, Daniel. *Obsessive Becoming*. 1999. Film.

Resnais, Alain, dir. *Hiroshima Mon Amour*. Cocinor, 1959. Film.

Rheingold, Howard. *Smart Mobs: The Next Social Revolution*. London: Basic Books, 2003. Print.

———. *The Virtual Community: Homesteading on the Electronic Frontier*. Reading, MA: Addison-Wesley, 1993. Print.

Richardson, Lisa. "Child Poverty Level in O.C. Up 73%, Study Says." *Los Angeles Times*, May 4, 1996. Print.

Richerson, Peter J. and Robert Boyd. *Not by Genes Alone: How Culture Transformed Human Evolution*. Chicago: University of Chicago Press, 2005. Print.

Riding, Alan. "Why 'Titanic' Conquered the World." *The New York Times,* April 26, 1998, sec. 2: 1. Print.

Rieff, David. *The Exile: Cuba in the Heart of Miami.* New York: Simon & Schuster, 1993. Print.

Rivera, Alex. *Why Cybraceros?* 1997. Film.

Rizzolatti, Giacomo, Leonardo Fogassi, and Vittorio Gallese. "Mirrors in the Mind." *Scientific American,* November 2006: 54–61. Print.

Roach, Jay, dir. *Meet the Fockers.* Working Title, 2004. Film.

Robins, Kevin and Frank Webster. *The Times of Technoculture: From the Information Society to the Virtual Life.* New York: Routledge, 1999. Print.

Rockwell Group. "Live Broadcast Theater: Oscar's New Home." Los Angeles: The Rockwell Group, 2000. Print.

Rodman, Gilbert B. "The Net Effect: The Public's Fear and the Public Sphere." *Virtual Publics: Policy and Community in an Electronic Age.* Ed. Beth E. Kolko. New York: Columbia University Press, 2000. Print.

Rodowick, David. *Reading the Figural, or, Philosophy after the New Media.* Durham, NC: Duke University Press, 2001. Print.

Roediger, Henry L., III and Lyn M. Goff. "Memory." *A Companion to Cognitive Science.* Ed. William Bechtel and George Graham. Oxford, UK: Blackwell, 1998. 250–64. Print.

Rogers, Richard. "Introduction: Towards the Practice of Web Epistemology." *Preferred Placement: Knowledge Politics on the Web.* Ed. Richard Rogers. Maastricht: Jan van Eyck Akademie, 2000. 11–23. Print.

———. "A Narrative of the Software Project, IssueAtlas.net." Govcom.org. No date. Web.

———, ed. *Preferred Placement: Knowledge Politics on the Web.* Maastricht: Jan van Eyck Akademie, 2000. Print.

Rogers, Richard and Ian Morris. "Operating the Internet with Socio-Epistemological Logics." Ed. Richard Rogers. *Preferred Placement: Knowledge Politics on the Web.* Maastricht: Jan van Eyck Akademie, 2000. 145–57. Print.

Rogers, Sarah J. *Body Mechanique: Artistic Explorations of Digital Realms.* Columbus, OH: Wexner Center for the Arts, 1998. Print.

Rose, Frederick. "Poof! They're Gone! It's a Boom Time for Special Effects in Movies. And a Bust Time for the Companies That Create Them." *The Washington Post,* March 19, 1998, sec. r: 14. Print.

Rose, Mark. *Authors and Owners: The Invention of Copyright.* Cambridge, MA: Harvard University Press, 1993. Print.

Rosenstone, Robert. *Visions of the Past.* Cambridge, MA: Harvard University Press, 1995. Print.

Rosenthal, Alan, ed. *New Challenges for Documentary.* Berkeley: University of California Press, 1988. Print.

Ross, Andrew. *Real Love: In Pursuit of Cultural Justice.* New York: New York University Press, 1998. 7–34. Print.

Rossetto, Louis. "Rebuttal of the Californian Ideology." *Alamut: Bastion of Peace and Information.* October 17, 1998. Web.

Rossi, Paolo. *Logic and the Art of Memory. The Quest for a Universal Language.* Tr. Stephen Clucas. Chicago: University of Chicago Press, 2000. Print.

Roszak, Theodore. *The Cult of Information: A Neo-Luddite Treatise on High-Tech, Artificial Intelligence, and the True Art of Thinking*, 3rd ed. Berkeley: University of California Press, 1994. Print.

Roth, Laurent and Raymond Bellour. *Qu'est-ce qu'une madeleine? A propos du CD-ROM Immemory de Chris Marker*. Paris: Yves Gevaert Editeur/Centre Georges, 1997. Print.

Rothenberg, Erika. *The Road to Hollywood*. 2001. Los Angeles, California. Permanent public installation.

Roy, L. Somi. Executive Director, International Film Seminars. Telephone interview, October 14, 1997. Personal communication.

Ruiz, Raúl. "Three Thrusts at *Excalibur*." *Positif* 247, October (1981): 43. Print. Republished in *Screening the Past* 26. Tr. Adrian Martin. 2009. Web.

Rushdie, Salman. *Haroun and the Sea of Stories*. London: Granta Books, 1990. Print.

Sack, Warren. *Actor–Role Analysis: Ideology, Point of View, and the News*. MS thesis, MIT, Cambridge, MA, 1994. Print.

———. *Agonistics: A Language Game*. 2005. Web.

———. "What Does a Very Large-Scale Conversation Look Like?" *First Person: New Media as Story, Performance, and Game*. Ed. Noah Wardrip-Fruin and Pat Harrigan. Cambridge, MA: MIT Press, 2004. 238–48. Print.

Sacks, Oliver. "A Neurologist's Notebook: The Abyss (Music and Amnesia)." *The New Yorker*, September 24, 2007: 100–12. Print.

Sardar, Ziauddin and Jerome R. Ravetz. *Cyberfutures: Culture and Politics on the Information Superhighway*. New York: NYU Press, 1996. Print.

Sassen, Saskia. *Globalization and Its Discontents*. New York: The Free Press, 1998. Print.

Schacter, Daniel L. *The Seven Sins of Memory: How the Mind Forgets and Remembers*. New York: Houghton Mifflin, 2001. Print.

Schank, Roger C. *Tell Me a Story: A New Look at Real and Artificial Memory*. New York: Charles Scribner's Sons, 1990. Print.

Schank, Roger C. and Robert P. Abelson. *Scripts, Plans, Goals, and Understanding*. Hillsdale, NJ: Lawrence Erlbaum, 1977. Print.

Schiller, Dan. *Digital Capitalism: Networking the Global Market System*. Cambridge, MA: MIT Press, 2000. Print.

Schiller, Herbert I. *Information Inequality: The Deepening Social Crisis in America*. New York: Routledge, 1966. 27–58. Print.

Schimmel, Paul. "Pay Attention." *Bruce Nauman*. Minneapolis: Distributed Art Publishers, 1994. Print.

Schoell-Glass, Charlotte. "'Serious Issues': The Last Plates of Warburg's Picture Atlas *Mnemosyne*." *Art History as Cultural History: Warburg's Projects*. Ed. Richard Woodfield. Amsterdam: G+B Arts, 2001. 183–208. Print.

Scholder, Amy and Jordan Crandall, eds. *Interaction: Artistic Practice in the Network*. New York: DAP, 2001. Print.

Scholz, Trebor. "Market Ideology and the Myths of Web 2.0." *First Monday* 13.3 (2008). Print.

Schon, Donald A., Bish Sanyal, and William J. Mitchell, eds. *High Technology and Low Income Communities: Prospects for the Positive Use of Advanced Information Technology*. Cambridge, MA: MIT Press, 1999. Print.

Schrader, Ann. "Diabetes Program Launched State Campaign Targets Latinos." *The Denver Post,* March 28, 1997: B04. Print.

Schreibman, Susan, Ray Siemens, and John Unsworth. *The Companion to the Digital Humanities.* www.digitalhumanities.org/companion/. Oxford, UK: Blackwell, 2004. Web.

Sconce, Jeffrey. *Haunted Media: Electronic Presence from Telegraphy to Television.* Durham: Duke University Press, 2000. Print.

Scott, Ridley, dir. *Blade Runner.* Warner Brothers, 1982. Film.

Scott, Ridley, dir. *Gladiator.* DreamWorks SKG, 2000. Film.

Seiter, Ellen. *Television and New Media Audiences.* London: Oxford University Press. 1999. Print.

Sermon, Paul. *Telematic Dreaming.* June, 1992. Digital artwork.

Shaikin, Bill. "Questions Surround Umpire's Statement." *Los Angeles Times,* May 1, 2006: sports section. Print.

Shanahan, Murray. "Global Access, Embodiment, and the Conscious Subject." *Journal of Consciousness Studies* 12.12 (2005): 46–66. Print.

Shaviro, Steven. *The Cinematic Body.* Minneapolis: University Press of Minnesota, 1991. Print.

Shaw, Jeffrey and Peter Weibel, eds. *Future Cinema: The Cinematic Imaginary after Film.* Cambridge, MA: MIT Press, 2003. 260–71. Print.

Shirky, Clay. "Powerlaws, Weblogs, and Inequality." *Extreme Democracy.* Ed. Jon Lebkowsky and Mitch Ratcliffe. Self published, 2005. Web.

Siganos, Georgos, Michalis Faloutsos, Petros Faloutsos, and Christos Faloutsos. "Power Laws and the AS-Level Internet Topology." *IEEE/ACM Transactions on Networking* 11.4 (August 2003): 514–24. Print.

Sigismondi, Floria. *4 Ton Mantis.* 2000. Music video.

———. *Megalomaniac.* 2004. Music video.

Silverstone, Roger. "The Tele-technological System." *Television and Everyday Life.* London: Routledge, 1994. 78–103. Print.

Silverstone, Roger and Eric Hirsch, eds. *Consuming Technologies: Media and Information in Domestic Spaces.* London: Routledge, 1992. Print.

Sinha, Amresh and Terence McSweeney, eds. *Millennial Cinema: Memory in Global Film.* New York: Wallflower Press, 2011. Print.

Sitney, P. Adams, ed. "Poetry and the Film: A Symposium with Maya Deren, Arthur Miller, Dylan Thomas, Parker Tyler, Chairman, Willard Maas. Organized by Amos Vogel." *Film Culture Reader.* New York: Praeger, 1970. Print.

Smith, Daniel. "Deleuze's Theory of Sensation: Overcoming the Kantian Tradition." *Deleuze: A Critical Reader.* Ed. Paul Patton. New York: Basil Blackwell, 1996. 29–56. Print.

Smith, Greg M. *Film Structure and the Emotion System.* Cambridge, UK: Cambridge University Press, 2003. Print.

Smith, Marc A. and Peter Kollock, eds. *Communities in Cyberspace.* New York: Routledge, 1999. Print.

Smith, Murray. "Film Spectatorship and the Institution of Fiction." *Journal of Aesthetics and Art Criticism* 53.2 (1995): 113–27. Print.

Snow, Michael. *Cover to Cover.* Halifax: Press of the Nova Scotia College of Art and Design and New York University Press, 1975. Print.

————. *Wavelength*. Canyon Cinema, 1967. Film.

Sobchack, Vivian. "Democratic Franchise and the Electronic Frontier." *Cyberfutures*. Ed. Ziauddin Sardar and Jerome R. Ravetz. New York: New York University Press, 1996. 77–89. Print.

————. "History Happens." *The Persistence of History*. Ed. Vivian Sobchack. Los Angeles: American Film Institute, 1996. Print.

————. "Nostalgia for a Digital Object: Regrets on the Quickening of Quicktime." *Millennium Film Journal* 34, Fall (1999): 4–23. Print.

Soderbergh, Steven, dir. *The Limey*. Artisan Entertainment, 1999. Film.

Solás, Humberto, dir. *Miel Para Oshun* [Honey for Oshun]. DEJ Productions, 2001. Film.

Solove, Daniel. *The Digital Person: Technology and Privacy in the Information Age*. New York: New York University Press, 2004. Print.

Sonnenfeld, Barry, dir. *Men in Black*. Columbia Pictures, 1997. Film.

Sontag, Susan. *Against Interpretation and Other Essays*. New York: Farrar, Straus and Giroux, 1966. Print.

Southern Poverty Law Center. "Neither Left nor Right." *SPLC Intelligence Report* 97, Winter (2000). Web.

Spengler, Oswald. *The Decline of the West*. Tr. Francis Atkinson. New York: Knopf, 1926–1928. Print.

Spielberg, Steven, dir. *Indiana Jones and the Last Crusade*. Paramount Pictures, 1989. Film.

————. *Indiana Jones and the Temple of Doom*. Paramount Pictures, 1984. Film.

————. *Jurassic Park*. Universal Pictures, 1993. Film.

————. *Raiders of the Lost Ark*. Paramount Pictures, 1981. Film.

————. *Schindler's List*. Universal Pictures, 1993. Film.

Squires, Sally. "Keeping a Healthy Hispanic Kitchen." *Chicago Sun-Times*, September 25, 1996. Print.

Stairs, David. *Boundless*. Self published, 1983. Print.

Stallabrass, Julian. *Gargantua: Manufactured Mass Culture*. London: Verso, 1996. Print.

Stallybrass, Peter and Allon White. *The Politics and Poetics of Transgression*. Ithaca, NY: Cornell University Press, 1986. Print.

Stefik, Mark. *Internet Dreams: Archetypes, Myths, and Metaphors*. Cambridge, MA: MIT Press, 1997. Print.

Stein, Jeannine. "In New Urban Villages, City Living Becomes Trendy." *Los Angeles Times*, November 19, 2001: AI. Print.

Sternhell, Zeev. *Ni droite ni gauche*. Paris: Seuil, 1983. Print.

Stocker, Gerfried. "FleshFactor Opening Statement." Ars Electronica, 1997. Web.

Stone, Allucquère Rosanne. *The War of Desire and Technology at the Close of the Mechanical Age*. Cambridge, MA: MIT Press, 1995. Print.

Sturken, Maria. *Tangled Memories*. Berkeley: University of California Press, 1997. Print.

subRosa. Cyberfeminism.net. Web.

Suckling, James. "Unforgettable Cuba." *Cigar Aficionado*, June 1999: 62–72. Print.

Suderberg, Erika. "The Electronic Corpse: Notes for an Alternative Language of History and Amnesia." *Resolutions*. Ed. Michael Renov and Erika Suderberg. Minneapolis: University Press of Minnesota, 1996. Print.

Sunstein, Cass. *Republic.com*. Princeton, NJ: Princeton University Press, 2001. Print.

Swift, Graham. *Last Orders*. New York: Vintage, 1997. Print.

——. *Waterland*. New York: Knopf Doubleday, 1992. Print.

Tattersall, Ian. *The Monkey in the Mirror: Essays on the Science of What Makes Us Human*. New York: Harcourt, 2002. Print.

Taylor, Diana. *The Archive and the Repertoire: Performing Cultural Memory in the Americas*. Durham, NC: Duke University Press, 2003. Print.

Taylor, Paul. *Hackers: Crime in the Digital Sublime*. London, Routledge, 1999. Print.

Terranova, Tiziana. *Network Culture: Politics for the Information Age*. London: Pluto Press, 2004. Print.

Tobar, Hector. "An Era of Exiles Slips Away." *Los Angeles Times*, September 14, 1999: A-18. Print.

Toffler, Alvin. *The Third Wave*. New York: Morrow, 1980. Print.

Tolstoy, Leo. *The Kreutzer Sonata* (Modern Library Classic). Trans. Isai Kamen. New York: Random House, 2003. Print.

Tomasello, Michael. "Cognitive Linguistics." *A Companion to Cognitive Science*. Ed. William Bechtel and George Graham. Oxford, UK: Blackwell, 1998. 477–87. Print.

Toyoda, Masashi and Masaru Kitsuregawa. "Creating a Web Community Chart for Navigating Related Communities." *Proceedings of HyperText 01*, August (2001): 103–12. Print.

——. "Extracting Evolution of Web Communities from a Series of Web Archives." *Proceedings of HyperText 03*, August (2003): 28–37. Print.

TrizecHahn. "Press Release for Hollywood and Highland." Los Angeles: TrizecHahn Corporation, 2000. Print.

Tsivian, Yuri. *Immaterial Bodies: Cultural Anatomy of Early Russian Films*. Prod. Barry Schneider. Ed. Marsha Kinder. Los Angeles: Annenberg Center for Communication and University of Southern California, 2000. CD-ROM.

——. "Jakov Lintsbakh as Film Semiotician." *Elementa* 4.2, December (1998): 121–9. Print.

Tucker, Marcia. "PheNAUMANology." *Bruce Nauman*. London: Hayward, 1998. Print.

Tulving, Endel, and Fergus I. M. Craik, eds. *The Oxford Handbook of Memory*. New York: Oxford University Press, 2000. Print.

Turkle, Sherry. *Life on the Screen: Identity in the Age of the Internet*. New York: Simon and Schuster, 1995. Print.

Tyler, Ann. *Lubb Dup*. Chicago: Sara Ranchouse, 1998. Print.

Udovicki, Jasminka and James Ridgeway, eds. *Burn This House: The Making and Unmaking of Yugoslavia*. Durham, NC: Duke University Press, 1997. Print.

UNESCO. *Our Creative Diversity: Report of the World Commission on Culture and Development*. Paris: UNESCO, 1996. 104. Print.

U.S. Department of Health and Human Services. "Iron Overload Disorders among Hispanics." *Morbidity and Mortality Weekly* 45 (1996): 348. Print.

van Bruggen, Coosje. *Bruce Nauman*. New York: Rizzoli, 1988. Print.

Van Dijck, José. "Mediated Memories: A Snapshot of Remembered Experience." *Mind the Screen: Media Concepts According to Thomas Elsaesser*. Ed. Jaap Kooijman, Patricia Pisters, and Wanda Strauven. Amsterdam: Amsterdam University Press, 2008. 71–81. [Available through open access at www.oapen.org/search?identifier=340042.] Print.

van Dijk, Jan. "Models of Democracy and Concepts of Communication." *Digital Democracy: Issues of Theory and Practice*. Ed. Kenneth L. Hacker and Jan van Dijk. Thousand Oaks, CA: Sage, 2000. 30–53. Print.

Varela, Francisco. "Making It Concrete: Before, during and after Breakdowns." *Revisioning Philosophy*. Ed. James Ogilvy. Albany: SUNY Press, 1992. Print.

Venegas, Cristina. *Digital Dilemmas: The State, the Individual, and Digital Media in Cuba*. New Brunswick, NJ: Rutgers University Press, 2010. Print.

Vesna, Victoria. *Bodies, Inc.* University of California, Los Angeles. No date. Web.

———, ed. *Database Aesthetics: Art in the Age of Information Overflow*. Minneapolis: University of Minnesota Press, 2007. Print.

Virilio, Paul. *Art and Fear*. London: Verso, 2002. Print.

———. *Open Sky*. London: Verso, 1995, 1997. 22–34. Print.

———. "The Vision Machine." *The Virilio Reader*. London: Blackwell, 1998. Print.

Voland, John. "F/X Boutiques Go Boom in the Land of Big Houses." *Variety*, July 28–August 3, 1997: 9. Print.

Waag Society. *People's Communication Charter*. 1998. Web.

Wardrip-Fruin, Noah. *Expressive Programming: Digital Fictions, Computer Games, and Software Studies*. Cambridge, MA: MIT Press, 2009. Print.

Waugh, Thomas. *"Show Us Life": Toward a History and Aesthetics of the Committed Documentary*. Metuchen, NJ: Scarecrow Press, 1984. Print.

Wegner, Daniel M., Toni Giuliano, and Paula T. Hertel. "Cognitive Interdependence in Close Relationships." *Compatible and Incompatible Relationships*. Ed. William Ickes. New York: Springer-Verlag, 1985. 253–76. Print.

Weinberger, David. *Everything Is Miscellaneous: The Power of the New Digital Disorder*. New York: Times Books, 2007. Print.

———. *Small Pieces Loosely Joined : A Unified Theory of the Web*. Cambridge, MA: Perseus, 2002. Print.

Weinbren, Grahame. "Another Dip into the Ocean of Streams of Stories." *Future Cinema: The Cinematic Imaginary After Film*. Ed. Jeffrey Shaw and Peter Weibel. Cambridge, MA: MIT Press, 2003. 260–71. Print.

———. *Frames*. Commissioned by NTT/ICC Tokyo, 1999. Interactive cinema.

———. "Mastery: Sonic C'est Moi." *New Screen Media: Cinema/Art/Narrative*. Ed. Martin Reiser and Andrea Zapp. London: British Film Institute, 2002. Print.

———. "Navigating the Ocean of Streams of Stories." *Millenium Film Journal* 28 (1995): 15–30. Print.

———. "Ocean, Database, Recut." *Database Aesthetics: Art in the Age of Information Overflow*. Ed. Victoria Vesna. Minneapolis: University of Minnesota Press, 2007. 61–85. Print.

———. "The PC is a Penguin." *Bild Medium Kunst*. Ed. Yvonne Spielmann and Gundolf Winter. Munich: Fink, 1999. Print.

———. *Sonata*. 1991–1993. Interactive cinema.

Weinbren, Grahame and James Cathcart, with Sandra McClean. *Tunnel*. Collection of the City of Dortmund, Germany. 2000. Interactive cinema.

Weinbren, Grahame and Roberta Friedman. *The Erl King*. Collection of the Solomon R. Guggenheim Museum. 1983–1986. Interactive cinema.

Welles, Orson, dir. *Citizen Kane*. RKO, 1941. Film.

———. *F for Fake*. Janus, 1975. Film.

Wertheim, Margaret. *The Pearly Gates of Cyberspace: A History of Space From Dante to the Internet*. New York: Norton, 1999. Print.

Wertsch, James V. "Mediated Action." *A Companion to Cognitive Science*. Ed. William Bechtel and George Graham. Oxford, UK: Blackwell, 1998. 518–25. Print.

West, Cornel. "The New Cultural Politics of Difference." *Out There: Marginalizations and Contemporary Cultures*. Ed. Russell Ferguson et al. Cambridge, MA: MIT Press, 1990. Print.

White, Hayden. *The Content of the Form: Narrative Discourse and Historical Representation*. Baltimore: Johns Hopkins University Press, 1990. Print.

———. *Tropics of Discourse*. Baltimore: Johns Hopkins University Press, 1978. Print.

Wiedemann, Julius, ed. *Digital Beauties: 2-D and 3-D Computer Generated Digital Models, Virtual Idols and Characters*. New York: Taschen, 2001. Print.

Wilber, Ken. "An Integral Theory of Consciousness." *Journal of Consciousness Studies* 4.1 (1997): 71–92. Print.

Williams, Emmett. *VoyAge*. Stuttgart: Edition Hansjörg Mayer, 1975. Print.

Williams, Raymond. *Marxism and Literature*. Oxford, UK: Oxford University Press, 1977. Print.

———. *Television: Technology and Cultural Form*. New York: Schocken, 1975. Print.

Wilson, Rob and Wimal Dissanayake, eds. *Global/Local: Cultural Production and the Transnational Imaginary*. Durham, NC: Duke University Press, 1996. Print.

Wilson, Robert A. and Frank C. Keil, eds. *The MIT Encyclopedia of the Cognitive Sciences*. Cambridge, MA: MIT Press, 1999. Print.

Winston, Brian. *Technologies of Seeing*. London: British Film Institute, 1997. Print.

Wittgenstein, Ludwig. *On Certainty*. Ed. G. E. M. Anscombe and G. H. von Wright. Tr. Denis Paul and G. E. M. Anscombe. New York: Harper & Row, 1969. Print.

———. *Philosophical Investigations*, 4th ed. Tr. G. E. M. Anscombe, P. M. S. Hacker, and Joachim Schulte. Oxford, UK: Wiley-Blackwell, 2009. Print.

———. *Tractatus Logico-Philosophicus*. Tr. D. F. Pears and B. F. McGuinness. London: Routledge, 1961. Print.

Wittig, Monique. *The Lesbian Body*. Tr. D. LeVay. Boston: Beacon Press, 1986. Print.

———. *Les Guérillères*. Tr. D. LeVay. Urbana: University of Illinois Press, 2007. Print.

———. *The Opoponax*. Tr. H. Weaver. Plainfield, VT: Daughters, 1976. Print.

Wood, Gaby. *Edison's Eve: A Magical History of the Quest for Mechanical Life*. New York: Knopf, 2002. Print.

Woolery, Reginald. *www/mmm*. 1997. CD-ROM.

Yates, Frances A. *The Art of Memory*. London: Routledge and Kegan Paul, 1966. Print.

Yuen, Eddie, George Katsiaficas, and Daniel Burton Rose, eds. *The Battle of Seattle: The New Challenge to Capitalist Globalization*. New York: Soft Skull Press, 2001. Print.

Zaitchik, Alexander. "Bogus Think Tank 'Third Way' Pops up to Thwart Health Care Reform." *AlterNet* 30, June 2009. Web.

Zemeckis, Robert, dir. *Contact*. Warner Brothers, 1997. Film.

———. *Forrest Gump*. Paramount Pictures, 1994. Film.

Zimmer, Michael. "Critical Perspectives on Web 2.0." *First Monday* 13.3 (2008). Print.

Zimmerman, Paul. *High Tension*. Rochester, NY: Visual Studies Workshop Press, 1993. Print.

Zimmermann, Patricia R. *States of Emergency: Documentaries, Wars, Democracies*. Minneapolis: University of Minnesota Press, 2000. Print.

Žižek, Slavoj. "Cyberspace, or the Unbearable Closure of Being." *Endless Night: Cinema and Psychoanalysis, Parallel Histories*. Ed. Janet Bergstrom. Berkeley: University of California Press, 1999. 96–125. Print.

———. *The Parallax View*. Cambridge, MA: MIT Press, 2006. Print.

———. *The Plague of Fantasies*. London: Verso, 1997. Print.

Zukin, Sharon. *The Culture of Cities*. London: Blackwell, 1995. Print.

Zummer, Thomas. "Projection and Dis/embodiment: Genealogies of the Virtual." *Into the Light: The Projected Image in American Art 1964–1977*. Published on the occasion of the exhibition "Into the Light: The Projected Image in American Art, 1964–1977" at the Whitney Museum of American Art, New York, October 18, 2001–January 6, 2002. New York: Whitney Museum of American Art, 2001. Print.

Zurkow, Marina. *Braingirl*. 2000. Web.

INDEX

Page numbers in *italic* indicate figures.

Aarseth, Espen, 27, 250

accessibility: digital divide in context of, 162–63, 167, 187–88, 284–85, 288, 333; engagement or production in context of, 168, 199, 202–5, 207–9, 208, 210n7; Internet access in Cuba and, 260, 270n2; video art in context of body of viewer/spectator and, 291, 292, 311n1. *See also* digital divide (privilege versus access)

Acconci, Vito, 241

accuracy, and memories, 14, 104–7, 110, 114n15, 114n17, 114n19

Acker, Kathy, 329n11

actor-network model, 277

Adamic, Lada, 212, 213

aesthetic production, in context of political economy, 185–86, 189–91

affective adaptations, and video art in context of body of viewer/spectator, 175, 294–95, 300–301, 309, 312n7

affects: cultural theory in context of, 9, 43; postmedia aesthetics and, 42–43

agency: La Cosecha Nuestra project's interactive narrative in context of, 174, 276–77, 285; digital media in context of, 247–50; interactive narrative cinema and, 16, 130, 133–35, 137; mobile phones and, 157; video art in context of body of viewer/spectator and, 294, 307

Aitken, Doug, 318

alienation, 325–26

Allen, Rebecca, xv

All Quiet on the Western Front (dir. Milestone), 103

Amerika, Mark, xv

Amor Vegetal (video), 282–84, 287

analog computers: La Cosecha Nuestra project's interactive narrative analog "wrench" and, 173–74, 276–77, 285; digital media in comparison with, 24–25, 26–27, 167, 183, 191. *See also* digital computers

anarchism, 221, 224–28, 233nn22–23, 234n38

Anderson, Barbara, 313n10

Anderson, Chris, 216

blackness, in context of cyberspace, 168, 202, 205–6

Blade Runner (dir. Scott), 236

Blake, Jeremy, 318

Blake, William, 22, 32n10

Blanchot, Maurice, 296, 297

Bleeding Through (DVD-ROM; Kinder), 247–50

Bobbio, Norberto, 216–17, 224, 225, 228, 231n4

body/ies: body-image as "virtual" and, 292, 307; body-image confrontation and, 293–94; in cyberspace, 317–19; male, 316–17; politics of digital media and, 166, 175; space's relationship with, 176, 318, 320, 321, 325; technoculture's relationship with, 176–77, 316–17, 320, 323, 324, 328nn2–3, 328n8, 330–37; transnational/national digital media and, 167, 181, 184–85

Bogost, Ian, xv

Boissier, Jean Luc, 187

Bolter, Jay, 119, 126–27, 135–37, 145n1, 247

Bolter, Jay David, 21, 23

Bond, Larry, 255

Bookchin, Natalie, 329n14

borders, in context of digital media, 177, 333, 335

Bordwell, David, 4, 8–9, 11

Borges, Jorge Luis, 14, 16, 106–7

Bourdieu, Pierre, 67

Bourtchouladze, Rusiko, 73n16, 73n32, 76n33

Boyle, Deirdre, 276

Braingirl (flash animation; Zurkow), 176, 320, 323–24

Brandon, Teena, 187

Branigan, Edward, xv, 10, 17, 69. *See also* memories, and productive precursors

Bray, Anne, 320, 324–25

Brin, Sergey, 214

Brooks, Peter, 17, 145n2, 146nn3–4, 146n4

Brooks, Sawad, xv

Buchanan, Nancy, xv

Burdick, Anne, 31

Burgevin, Leslie, 184

Burns, Ken, 110, 119, 120

Bush, Vannevar, 21

Cadigan, Pat, 30

Caldwell, John T., xv, 175, 208–9, 210n6, 289

calligram, in context of text messaging, 154–55

Calvino, Italo, 134

Camarena, Guillermo González, 333

camera, as mirror, 68

Cameron, Andy, 222–23, 233n27

Cameron, James, 181, 189

Capturing the Friedmans (dir. Jarecki), 156

Les Carabiniers (dir. Godard), 296

Carey, James, 199

Cartesian dualism, 74n24, 178

Casey, Edward S., 45

Cassell, Justine, xv

Castro, Fidel, 262–63, 265

Cavell, Stanley, 47, 48

cave parable, 50–51, 54–55, 57–58, 60, 62, 70nn4–6

CD-ROMs: display in context of, 15; future imaginaries in context of, 116–18, 124–25; hypertext in context of, 6; interactivity in context of, 150, 152, 191, 285; mobility in context of, 18; performativity in context of, 191–92, 197n21; spherical modality of, 190. *See also specific CD-ROM projects*

Chance, Karen, 28

Cheang, Shu Lea, 187

Chun, Wendy, xv, 163

cinema or cinematicness: context and, 140; desire in context of, 17, 130, 131, 135, 138–39, 146nn3–4, 146n6; filmmakers and digital media in context of, 123; firefly text messaging in movie theaters in context of, 18, 150–52, 155, 157; mediums in context of, 18, 147; narrative in, 16, 127–28, 251; of photography, 119; transnational/national digital media in comparison to, 167, 182, 187. *See also* film/s

cinematic and telematic confrontation (firefly text messaging in movie theaters), 18, 150–52, 155, 157. *See also* text messaging

cinematic model of sensation, 296–97, 313nn9–11

Citizen Kane (dir. Welles), 119, 125

Citron, Michele, xv

city database. *See* database city

Civjans, Gunars, 97

Clarke, Arthur C., 64–65

Clarke, Desmond M., 72n11

Cleator, Molly, 320, 324–25

closure, and interactive narrative cinema, 17, 134, 138–41

CMC (computer-mediated communication), 8, 37, 169, 179n1, 212–17, 220, 231n2

cognition: digital image's relationship with, 176, 328n3; extended cognition or arcades memory and, 66–67, 79n46; information processing in context of, 38–39; writing and reading cognitive environments and, 29–30

Comella, Rosemary, xv

Communication Decency Act, 220

communication model, and postmedia aesthetics, 39–41

community: La Cosecha Nuestra project's interactive narrative in context of, 284, 285–87; exilic discourse for Cuban-Americans and, 269; political topography linkages with web topology and, 215, 231n11

compilation, 15, 115, 119, 123

computer-mediated communication (CMC), 8, 37, 169, 179n1, 212–17, 220, 231n2

computer-related interactive forms, 16–17, 127, 133, 141–44

computers, digital, xiv, xviiN1, 16–17, 103, 111, 113n7, 135, 143

conceptual system, for postmedia aesthetics, 37–38, 43nn3–4

condensation concept, in dreamwork theory, 17, 128–29, 130

Conley, Darby, 52

connectivity, in context of mobile phones, 18, 151–52, 156–57

conservatism, 215–18, 229, 233nn19–20

consumer data collection industry, 241

consumer websites, and Cuban merchandise, 268–69, 271nn14–15

Contact (dir. Zemeckis), 189

convergence processes: media installation/websites in context of feminism and, 318, 328n4; mobile phones in context of, 17, 148–49, 151, 158; transmedia frictions in context of, xvi; transnational/national digital media in context of, 181, 192–93

Cooper, Merian C., 236

Coover, Robert, 23

copies/doubles, 49, 51, 54, 58, 60, 62, 64, 67. *See also* double concept

copyright law, and MSA, 21–22, 32n3

Corridor Installation (*Nick Wilder Installation;* video by Nauman), 294–95, 303–6, 312n6

La Cosecha Nuestra project, and interactive narratives: overview of, 172–74, 272–74, 285–89; actor-network model and, 277; agency and, 174, 276–77, 285; *Amor Vegetal* (video), 282–84, 287; analog "wrench" and, 173–74, 276–77, 285; "black-boxing" effect and, 274; community in context of, 284, 285–87; digital divide discourse and, 284–85, 288; digital media history and, 173, 272–73; economic contexts and, 173, 284–85, 290n8; food and food security issues and, 278–79, 280, 281, 281–84; identity in context of, 282, 283, 287; interactivity and, 276–77, 284; lived versus virtual space and, 274, 276–77, 282–83, 289; local actions in context of digital media and, 277, 289; materiality of spaces and, 274, 288–89; memories and, 284, 287; mobilized privatization and, 173, 273–74, 277, 289, 290n10; multilaterality digital media debates and, 288–89; new media fieldwork and, 173, 274, 276, 284–85, 288; new media theory and, 272–73, 277, 285, 289; oral histories and, 284; participatory media and, 173, 276; performativity in context of, 284; podcasting services and, 273–74, 288–89, 290n10; production practices and, 276–77; race in context of, 286; real-world politics and community tension in context of, 276, 285–89; self-disclosure on camera approach and, 282–83; social contexts and, 173, 276–77, 284–85, 290n8; soil wrench in context of, 173–74, 276; Southern California and, 274, 275, 276; space and, 272–73, 273–74, 276–77, 288–89, 290n7; technological determinism and, 277; websites and, 277

C++ programming language, 24, 165

Crandall, William, 24

Crane, David Wade, 230

Crosland, Alan, 147

cross-cultural relations (North-South relations). *See* North-South relations (cross-cultural relations)

Cuba as homeland, and exilic discourse, 259, 262–64, 267–69

cultural discourses: connections in context of mobility and, 18, 152, 156–57; La Cosecha

Nuestra project's interactive narrative and, 173, 276–77, 284–85, 290n8; cyberspace in context of social relations and, 168, 198–202, 205; digital historiography in context of, 111–12; identity in context of media installations or websites and, 316–17, 321, 325–26, 329n14

cultural identities, in context of media installations or websites, 316–17, 321, 325–26, 329n14

cultural politics, and cyberspace: overview of, 167–68, 198, 209; accessibility in context of engagement or production and, 168, 199, 202–5, 207–9, 208, 210n7; binarism critique in context of, 168, 199–202, 204–5, 207, 209, 210n2; black cultural politics in context of, 200–201, 202, 204–5, 206–8, 210n5; blackness in context of, 168, 202, 205–6; cultural relations in context of, 168, 198–202, 205; difference in context of, 170, 201–2, 204–9; embeddedness of race and, 167; global capitalism in context of, 168, 199–200, 204, 206, 208; globalization in context of, 168, 203, 205–6, 208; hegemonics in context of, 199, 202–7, 209; historical contexts and, 199–202, 205, 208, 210n6; identity in context of, 168, 202–3, 205, 207; neoliberalism and, 199, 201, 208; new digital media in context of, 168, 199–204, 206–9, 210n3, 210n6; post-structuralism in context of, 202, 205; race in context of, 202–5, 207; World Wide Web in context of, 205

cultural politics theories, 166. *See also* cultural politics, and cyberspace

cultural specificity, xvii, 57, 60, 73n16, 75n25

cultural theory: affects in context of, 9, 43; postmedia aesthetics in context of, 39–43, 44nn6–7; recent cultural forms and, xvii, 13; software in context of, 38–43, 44n7

Currie, Gregory, 48

Cyberflesh/Girlmonster (CD-ROM; Dement), 320–22, 329n11

cyberspace, and productive precursors: overview of, 9–10, 11–12, 13, 80–81; art effects in context of social demands of art medium and, 10, 12; Esperanto in context of, 87–88; historical specificity and, 11, 13, 81, 84–85,

87; images clusters by Warburg to communicate art ideas and, 11, 81, 83–87; literary allusions in context of, 83–85; materiality of medium or objects and, 12, 82, 84, 85; precursors as term of use and, 12, 81; spherical book of Eisenstein and, 11, 81–83, 87; universal multimedia language of Lintsbach and, 11, 81, 87–88, 89–91, 92–98. *See also* hypertext versus print media

cyberstructuralism, 4–5, 17, 162, 163. *See also* structuralism

cyborg reading practices, 30

Dalcroze, Émile Jaques-, 95

Daniels, Jessie, 163

Danto, Arthur, 100

The Danube Exodus (installation; Forgács), 14–15, 115–18, 121–25. *See also* filmmakers, and digital media

Darley, Andrew, 4

database city: overview of, 170–72, 236–39, 257–58; *Bleeding Through* (DVD-ROM; Kinder) and, 247–50; consumer data collection industry and, 241; digital possessive in context of, 236, 239, 240–44, 255, 258n1; freedom in context of participation and, 246–47; history in context of, 238–39, 243–44, 246, 254–57; Hollywood and Highland project in context of, 238–39, 244–46, 253–57, 258n2; Hollywood and Vine project and, 255; interactive digital media, 246–47; Internet search in context of, 250–52; memories in context of, 255–56; personal control and narrative structure tension in context of, 247–50; physical space in context of, 253–55; real versus virtual reality in context of, 251–52; social networking sites and, 240, 242–44, 256–57; spectatorship and, 236, 239, 243, 247, 252, 256, 258n1; UED and, 238, 256–57; urban development surrounding Hollywood and Highland project in context of, 254–56

databases, in context of digital historiography, 101–3

de Certeau, Michel, 38, 151

DeFren, Allison, xv

de la Fé, Ernesto, 267–68

delay, in context of real experience, 292, 297–98

Deleuze, Gilles: common sense and recognition, 292; dogmatic image of thought, 314n19; logic of sensation, 308–9, 315n21; mobile use as new space, 152; movement- and time-images in film, 298–301, 313n12; nomadic activity theory, 186; shock/nooshock in film, 301–2, 313n15; stimulus and response gap, 297, 313n11; transcendental sensibility, 307

DeLillo, Don, 21

Dement, Linda, 176, 316

De Michelis, Marco, 293–94

depth with three-dimensional operation, and hypertext versus print media, 26–27

Deren, Maya, 136

Derrida, Jacques, 145n2, 183, 192–93

Dery, Mark, 181

Descartes, René, and topics discussed: dualism, 74n24; forgetting or loss of information, 63–64, 77n35; identity in context of object, 56–57, 72n15, 74n19; if-then-else command, 62; interactive media in context of memories, 62; sealing wax interobjective frame, 56–58, 60–62, 65, 72nn11–12, 72n14, 73n17; thinking and memory, 56–57, 72nn12–14, 73n17

design, and digital media, xiv

desire: cinematicness in context of, 17, 130, 131, 135, 138–39, 146nn3–4, 146n6; narrative forms in context of, 9, 13, 17; politics of digital media and, 166, 172, 177

de Souza e Silva, Adriana, 252

Dewey, John, 252, 255

DeWolfe, Chris, 240

Díaz-Balart, Lincoln, 265

Didi-Huberman, Georges, 86, 87

difference, in context of cyberspace, 170, 201–2, 204–9

digital, as term of use, 8

digital arts, xv, xvii, 10, 12, 152, 167, 183–85, 187–90

digital-camera-equipped phones, 147, 155–56

digital computers, xiv, xviiN1, 16–17, 103, 111, 113n7, 135, 143. *See also* analog computers

digital culture preservation, 13–14, 103, 111–12, 113n5

digital divide (privilege versus access), 162–63, 167, 187–88, 284–85, 288, 333. *See also* access

digital historiography: overview of, 12–15, 100–101, 112; accuracy in context of, 14, 104–7, 110, 114n15, 114n17, 114n19; artificial intelligence-based interactive multimedia and, 13–14, 108, 108–14, 109, 114n19; binaries and, 110; CMC or computer-mediated communication and, 109; computer scientists in context of historians and, 103, 111, 113n7; cultural discourses in context of, 111–12; databases in context of, 101–3; digital culture preservation and, 13–14, 103, 111–12, 113n5; documentary conventions in context of, 104–5, 111, 114n15; encyclopedic model and, 13–15, 105, 107, 112; encyclopedic model in context of, 14, 104–5, 114n15, 114n17; film in context of memories and, 14, 101–3, 105–6, 113n5, 113nn8–10, 114n17; historians in context of physical archives and, 103–5, 113nn8–11, 114nn13–15; history in context of discontinuities and, 16, 107–12; ideology in context of documentary conventions and, 111; literature in context of memories and, 14, 16, 106–7; memories and, 14, 101–3, 105–7, 113n5, 113nn8–10, 114n15, 114n17; oral histories or nonfiction narratives and, 13–14, 16, 100–102, 104–6, 114n16; recombinant model in context of, 13–14, 103–5, 108–12, 114n19; *The Survivors Project* and, 13–15, 104–5, 107, 112, 114nn13–18; *Terminal Time* and, 13, 14, 16, 108–12, 114n19; time/temporality in context of, 14, 104–5, 107, 108–10; total knowledge/archives and, 13–15, 104–7, 112, 113n11, 114nn13–14, 114n16, 114n18; Vietnam War films in context of, 105, 114n17

digital humanities, xiii-xiv, xvi, xviiN1–2, 178

digital media theory and practice: overview of, xiv, xiv-xvii, 162–63, 170, 178, 183; pressure point/tension in, xiii, xiv, xvii, 13, 116. *See also* new media theory

digital possessive, 236, 239–44, 255, 258n1

Dimitrovsky, Isaac, 141, 143

experienced time, 131, 133, 140

extended cognition (arcades memory), 66–67, 79n46

Faloutsos, Christos, 215

Faloutsos, Michalis, 215

Faloutsos, Petros, 215

fast or real-time connection media, 153

Feingold, Ken, 187

female robot-like figures, and installations, 320, 322–23

feminism. *See* media installations or websites, and feminism

F for Fake (dir. Welles), 119

fieldwork, and digital media, 173, 274, 276, 284–85, 288

Figgis, Mike, 117

The File Room (website and installation; Muntadas), 192

filmmakers, and digital media: overview of, 12–13, 14–15, 115–17, 124–25; autobiography and, 115, 120, 123; cinematicness and, 123; compilation and, 15, 115, 119, 123; *The Danube Exodus* (installation; Forgács) and, 14–15, 115–18, 121–25; digital permanence and, 116; digital theory and practice pressure point/tension and, 13, 116; disappearance/loss and forgetting, 115–16; display and, 15, 116–17, 122–23; enigmas/elusiveness and, 120, 122; film preservation and, 116, 118–19; history as reclaimed and, 110, 119, 122–23; interactivity and, 120–21; juxtapositions and, 116, 118, 121; The Labyrinth Project and, 115, 117; memories and, 110, 119–20, 123–25; multilinearity and, 116, 123; nonfiction narratives and, 13, 115–16; pastness in context of, 15, 119–20; photograph preservation and, 118–19; presentation and, 116–17, 123–24; time/temporality and, 116, 118; total knowledge/archives and, 13, 15, 115–16, 117–19, 123–24

film/s: accurate memories in context of, 105, 114n17; binaries in context of, 110; digital media in context of, xiv; filmstrip structure and, 132; fragmented database structure in, 15; impermanence versus permanence of, 118; media installations or websites in context of feminism in context of, 319;

medium specificity in context of, 45, 48; memories in context of, 14, 101–3, 105–6, 113n5, 113nn8–10, 114n17; movement- and time-images study and, 298–300, 313n12; myth of total cinema and, 18, 149; passivity in context of, 296, 313n10; preservation of, 116, 118–19; "real time" video image versus, 292, 296, 298, 300–302; resilience of cinema and, 18; self-image in, 314n16; shock effect in, 292, 295–98, 301, 313n9; shock/nooshock in, 301–2, 313n15; short-range apparent motion and, 296, 313n10; spherical book and, 81–83, 87; tactile effects of cinematic perception and, 296–97, 313n11; visual telephony in comparison with sound in, 147; as wax-like photographicity, 48. *See also* cinema or cinematicness; filmmakers, and digital media; *and specific films*

fingerprint, in context of thumbnail picture, 147, 155

firefly text messaging in movie theaters (cinematic and telematic confrontation), 18, 150–52, 155, 157. *See also* text messaging

Fisher, Danyel, 212–13

Fisher Gallery, xiv

Fiske, John, 200–202

Flanagan, Mary, xv

flashmobs (screen-based association), 18, 156–57

food and food security, and La Cosecha Nuestra project's interactive narrative, 278–79, *280*, *281*, 281–84

Forgács, Péter: film in context of digital medium and, 115–16, 125; interactivity and, 18; multilinearity and, 116; nondigital works with fragmented database structure, 15; reclaimed record and, 116. *See also The Danube Exodus* (installation; Forgács)

forgetting (loss of information) and disappearance, 63–64, 76nn33–35, 77n35, 115–16

form, and digital media, xvii. *See also specific forms*

formalism, xvii, 8, 66, 77n34, 162–64, 167, 171, 176. *See also* neoformalism

Forrest Gump (dir. Zemeckis), 102

Forster, Kurt W., 85

Foster, Hal, 101

and, 168, 202–3, 205, 207; film in context
of, 319; North-South relations in context of
digital media and, 177, 333–35; object in
context of, 47, 56–57, 56–59, 72n15, 73n16,
74nn18–19, 74n19; politics of digital media
in context of, 166, 174
ideology: display in context of, 15; documentary
conventions in context of, 111; politics in
context of digital media and, xvii
ideology transversals, and political topography
in context of web topology, 213–15, 217–23,
226–30, 227–28, 231nn4–6, 232n15
if-then-else command, 61–62, 76n28
Iles, Chrissie, 319
Ilich, Fran, xv
images clusters by Warburg to communicate art
ideas, 11, 81, 83–87
Immemory (CD-ROM; Marker): overview of, 115,
124–25; autobiography and, 115, 120, 123;
cinematicness and, 123; compilation and,
115, 123; display and, 15; enigmas/
elusiveness and, 120; film preservation
and, 118–19; history as reclaimed and, 119,
123; interactivity and, 121; juxtapositions
and, 116, 118, 121; The Labyrinth Project
and, 115, 117; memories and, 119–20;
multilinearity and, 116; nonfiction
narratives and, 13, 115–16; as open-ended
project, 16; pastness in context of, 15,
119–20; photograph preservation and,
118–19; presentation and, 116–17; time/
temporality and, 116, 118; total knowledge/
archives and, 13, 15, 115–16, 117–19. *See also*
filmmakers, and digital media
implicit memories (prospective memory),
65–68, 78n42, 79nn46–48
Indiana Jones films (dir. Spielberg), 103–4,
113nn8–10
information and communication technologies
(ICT), 212–15, 218, 220, 231n2, 231n9
information behavior, and postmedia aesthetics,
38–39, 44n5
information theory, and postmedia aesthetics,
39–41
installations (museum installations), 17–19. *See
also specific installations*
instantiations, 8, 21, 23
integral realism, 148–50, 158, 189

intensity of sensation, and video art, 176, 306–7,
309
"interactive art," and postmedia aesthetics,
36–37
interactive digital media: database city in
context of, 246–47; filmmakers in context
of, 120–21; freedom in context of participa-
tion and, 246–47; memories in context of,
46, 61–65, 62, 76n29, 76n30; spectator-
ship in context of, 243, 247; uncanny
effects in context of memories and, 62–66,
76n32, 77n34, 77n36, 78n39
Interactive Frictions conference, xiv-xv, 3, 14,
164, 179n1. *See also* transmedia frictions
interactive narrative cinema: overview of, 16–17,
144–45; agency and, 16, 130, 133–35, 137;
artist's labor in context of medium and,
143–44; cinematic narrative and, 16,
127–28; closure and, 17, 134, 138–41;
computer-related interactive forms and,
16–17, 127, 133, 141–44; condensation
concept in dreamwork theory, 17, 128–29,
130; desire in context of cinematic and, 17,
130, 131, 135, 138–39, 146nn3–4, 146n6;
dreamwork theory and, 17, 128–30, 137–38;
duration or running time and, 131, 133;
embeddedness of nostalgia and, 126, 142;
endings as abandoned and, 137–41, 146n6;
experienced time and, 131, 133, 140;
filmstrip structure and, 132; horizontal
investigations in context of montage effect
and, 136; juxtapositions and, 140; Kuleshov
effect and, 132, 140; lived experience and,
134–35; materiality of medium and, 129,
131, 143, 144; montage effect and, 132,
136–37; narrative text and, 127–29, 133,
146n3; ocean as trope and, 16, 126–27,
134–35, 137; as open-ended project, 16,
138–40; pleasure and, 16, 17, 130;
preservation of, 141–43; random access
and, 141–43; real time and, 131, 138;
response model and, 134–35; space in
context of time and, 132–33; spectator's
actions and, 132–34; story space and, 126,
135–37, 145n1; story time and, 131, 136;
subjunctive mental state and, 135–36; time/
temporality and, 127, 130–33, 136, 138,
139–40, 145, 146n7; versions and, 17,

interactive narrative cinema *(continued)* 143–44; vertical investigations in context of montage effect and, 136. *See also* interactive digital media; *and specific interactive narrative cinema*

interactive narratives, in Southern California, *274, 275, 276,* 282–84. *See also* La Cosecha Nuestra project, and interactive narratives

interactivity: CD-ROMs in context of, 18, 150, 152, 191, 285; La Cosecha Nuestra project's interactive narrative, 276–77, 284; discs in context of, 18; filmmakers in context of digital media and, 120–21; medium specificity in context of, 10; as tautology, 36; transference and dialogue as models, 17; websites in context of, 191. *See also* interactive digital media; interactive narrative cinema

Internet (the net): connectivity in context of, 18, 153; Cuba in context of access to, 260, 270n2; database city in context of search on, 250–52; digital divide and, 162–63; digital possessive in context of, 240–44; distinct mediums on, 43n2; "good enough" aesthetic in context of, 18; hegemonics in context of, 220; libertarianism in context of, 215; metaphors in context of, 186; "net art" versus art on, 36–37, 43n2; political discourses for Cuban-Americans on, 260–62, 264, 268; power struggles and debates in context of, 9–10; social networking sites and, 240, 242–44; terror versus openness in context of, 317, 334–35. *See also* websites; World Wide Web (the web)

interobjective sealing wax frame, 56–58, 60–62, 65, 72nn11–12, 72n14, 73n17

intersubjective frame: aviary frame as, 48–50, 51, 56, 58, 60, 65, 70n7, 72n13; language-game frame as, 56, 59–60, 62, 65, 66, 76n31

intimate screen form, and mobile phones, 17, 147–48, 157–58

Intolerance (dir. Griffith), 238, 246

Ippolito, Jon, 141

Irigaray, Luce, 316–17, 325

issue-events, in context of political topography linkages with web topology, 213–15, 225, 229–30, 231n5, 231nn7–8

Jakobson, Roman, 9, 42

James, LeBron, 78n42

Jameson, Frederic, 153, 171, 231n5, 254

Jarecki, Andrew, 156

Jazz (dir. Burns), 120

The Jazz singer (dir. Crosland), 147

Jenik, Adrienne, 190

Jenkins, Henry, xv, 7–8, 177

La Jetée (dir. Marker), 118

La Joli Mai (dir. Marker), 116

Jonas, Joan, 176, 319–20, 322

Jones, Amelia, 176, 317

Jones, Art, 192

Jones, Philip Mallory, 167, 190

Joyce, Michael, 126–27, 135–37, 145n1

Judd, Donald, 318

Julien, Isaac, xv

Jurassic Park (dir. Spielberg), 102

juxtapositions, 116, 118, 121, 140

Kafai, Yasmin, xv

Kafka, Franz, 241

Kaino, Glenn, xv

Kang, Kristy, xv

Kapur, Shekhar, 325

Katz, Jon, 233n21

Kay, Allan, 8, 37–38

Kelley, John, 212–13

Kinder, Marsha, xvi, 18–19, 69, 145n1, 171, 247–50. *See also* medium specificity

King, Susan E., 29

King Kong (dir. Cooper and Schoedsack), 236

Kinney, Jay, 221–22, 228–29, 233n23

Kitchin, Rob, 231n9

Kitsuregawa, Masaru, 231n11

Kittler, Friedrich, 44n7

Klein, Norman, xv, 248–49

Kleinberg, Jon, 215, 231n11

Klüver, Billy, xviiN1

Kolko, Beth, 205

Kracauer, Siegfried, 45, 48

Krauss, Rosalind, 292, 311n1

Kraynak, Janet, 304

Krebs, Valdis, 212

Kreutzer Sonata (Tolstoy), 136, 140

Kroker, Arthur, 188, 220

Kroker, Marilouise, 188

Kuleshov effect, 132, 140

neoliberalism, 172, 199, 201, 208, 218–19, 230, 233n20; political topography linkages with web topology in context of, 218, 233nn19–20

the net (Internet). *See* Internet (the net); websites; World Wide Web (the web)

"New Left," 222–23. *See also* left/right axis discourse; political topography, and web topology

new media theory: La Cosecha Nuestra project's interactive narrative and, 272–73, 276–77, 285, 289; politics of digital media in context of, 162–64, 168, 170, 173, 176, 179n1. *See also* digital media theory and practice

"new right," 218, 222, 233n20. *See also* political topography, and web topology

Nichols, Bill, 190, 210n7

Noble, David, 185

Nolan, Christopher, 67

Nolan, Dave, 224–25

nondigital works, 7, 9, 14, 15. *See also* precomputer culture; predigital forms

nonfiction narratives: digital historiography and, 13–14, 16, 100–102, 104–6, 114n16; filmmakers in context of digital media and, 13, 115–16

Nooteboom, Cees, 65

North-South relations (cross-cultural relations): body's relationship with technoculture and, 176–77, 330–37; borders in context of digital media, 177, 333, 335; digital divide and, 333; history in context of identity and, 177, 334–35; hybrid and global subjects in context of, 176–77, 332; identity and, 177, 334–35; materiality in context of identity and, 177, 333–35; postethnic world and, 177, 332; postidentity politics, 176, 332; race in context of digital media and, 177, 330–37, 335–36; "Tech-illa Sunrise" (Lozano-Hemmer and Gómez-Peña), 176–77, 330–37; transnational/national digital media and, 167, 184, 187, 189–90

nostalgia (dir. Frampton), 55–56, 66

Novak, Marcos, xv, 318–19

objective wax block frame, 47–54, 65, 67–68, 79nn47–48

Obsessive Becoming (dir. Reeves), 189

ocean, as trope, 16, 126–27, 134–35, 137

O'Neill, Pat, xv

online: community, 173; film shot lengths tool, 12; labor issues in context of courses, 185; The Labyrinth Project, 12; libraries, 186; media archives, 112–13; transnationals activity tracking, 185–86

On Translation (website and installation; Muntadas), 192

On With the Story and Coming Soon!!! (dir. Barth), 137

open-ended: networks as, 5, 9, 16; projects as, 16, 138–40

openness versus terror, and Internet, 317, 334–35

Ophüls, Marcel, 14, 105–6

oral histories, 13–14, 16, 100–102, 104–6, 114n16, 284

Orange Wednesday, and firefly text messaging, 150–51

O'Reilly, Tim, 239

Ortega, Louis, 269

Orwell, George, 241

Packer, Randal, xv

Page, Lawrence, 214

PageRank, 214–15, 251

Panushka, Christine, xv

paradoxical else, in context of time, 64, 78n38

Parks, Lisa, xv

participatory media, 173, 276

Passages de l'image (installation; Marker), 121

passion: film in context of, 296–97, 306, 309; video art in context of, 175, 306, 309

The Passion of Joan of Arc (dir. Dreyer), 325

pastness, and limitations of medium, 15, 119–20

Pat Garrett and Billy the Kid (dir. Peckinpah), 61, 63

Pavic, Milorad, 23

Peckinpah, Sam, 61, 63

Pérez, Fernando, 263–64

performance art, 318

performativity: CD-ROMs in context of, 191–92, 197n21; La Cosecha Nuestra project's interactive narrative and, 284; transnational/national digital media in context of, 167, 191–92, 197n21

permanence, and digital media, 116

personal control, and narrative structure
tension, 247–50

Phillips, Tom, 28

photography: cinematicness of, 119; film as
wax-like photographicity and, 48; images
clusters to communicate art ideas and, 11,
81, 83–87; media installation/websites in
context of feminism and, 320, 322–23;
memories in context of, 55–56, 60; mobile
phones and, 147, 155–56; preservation and,
118–19

physical space, in context of database city,
253–55

Piper, Keith, 187

place, and digital media, xvii, 165–66. *See also*
cultural politics, and cyberspace; cyber-
space, and productive precursors; space

Plato, and topics discussed: aviary intersubjec-
tive frame, 48–50, 51, 56, 58, 60, 65, 70n7,
72n13; cave parable, 50–51, 54–55, 57–58,
60, 62, 70nn4–6; copies/doubles, 49, 51,
54, 58, 60, 62, 64, 67; forgetting or loss of
information, 63; identity in context of
object, 56–57; if-then-else command in
context of, 62; interactive media in context
of, 62, 76n29; language in context of aviary
frame, 51, 70n7; materiality of medium in
context of cave parable, 54; materiality of
medium in context of wax block frame,
47–54; mirroring activity, 63; virtual reality
versus memory, 78n37; wax block objective
frame, 47–54, 65, 67–68, 79nn47–48

pleasure: interactive narrative cinema and, 16,
17, 130; of narrative forms, xvi, 9, 15–17,
146n3, 287

podcasting services, 273–74, 288–89, 290n10

Pohlmann, Ulrich, 86

Polan, Dana, 103

political discourses: community tension with
real-world, 276, 285–89; exilic Cuban-
Americans on Internet and, 260–62, 264,
268

political topography, and web topology: overview
of, 169–70, 211–12, 229–30; anarchism in
context of, 221, 224–28, 233nn22–23,
234n38; authoritarianism/libertarianism
axis in context of, 216–17, 224–25; CMC in
context of, 212–17, 220, 231n2; community

in context of, 215, 231n11; conservatism in
context of, 215–18, 229, 233nn19–20;
globalization in context of, 213, 218–19,
224–27, 228–29; hegemonics in context of,
212, 214, 216–23, 225, 229, 232nn13–18,
233n21, 233nn23–24, 233nn26–27;
hierarchizations in context of, 215–16, 221,
227–28; ICT in context of, 212–15, 218,
220, 231n2, 231n9; ideological transversals
in context of, 213–15, 217–23, 226–30,
227–28, 231nn4–6, 232n15; issue-events in
context of, 213–15, 225, 229–30, 231n5,
231nn7–8; left/right axis discourse in
context of, 211–14, 218, 220, 224–25;
libertarianism in context of, 213, 215–17,
223–26, 231n5, 232nn16–17, 233n19;
neoliberalism in context of, 218, 233nn19–
20; "New Left" in context of, 222–23; "new
right" in context of, 218, 222, 233n20;
technological determinism in context of,
222; Third Way politics in context of,
218–19, 222, 226–30, 232n18, 234nn33–38,
235nn39–41; topography as term of use
and, 231n2; topology as term of use and,
231n2; virtual class in context of, 220–24,
223nn26–27, 229, 233nn21–24; World
Wide Web in context of, 212, 215, 217,
223–26, 231n2, 231n9, 232n15, 233nn28–
29, 234nn30–31

politics, and digital media, xvii, 161–66, 177–78.
See also La Cosecha Nuestra project, and
interactive narratives; cultural politics, and
cyberspace; database city; exilic discourse
for Cuban-Americans, and cyberculture;
media installations or websites, and
feminism; North-South relations (cross-
cultural relations); political topography,
and web topology; transnational/national
digital media; video art, and body of
viewer/spectator

Poster, Mark, 169, 212, 213

postethnic world, 177, 332

post-Fordist economy, 166–67, 181, 189

posthuman, 174, 175, 184, 328n3. *See also* body
/ies

postidentity politics, 176, 332

postmedia aesthetics: overview of, 6, 7–9;
affects and, 9, 42–43; art on Internet

Rieff, David, 172

Rivera, Alex, 189

Roach, Jay, 150

The Road to Hollywood (installation; Rothenberg), 244

Roberts, Sara, xv

Robins, Bruce, 210n6

Rodman, Gilbert B., 199, 210n2

Rodowick, David, 154

Roediger, Henry L., III, 76n33

Rogala, Miroslav, 187

Rogers, Richard, 213–14, 231nn7–8

Roschen, William, 255

Rose, Mark, 21–22, 32n3

Rosenbleuth, Arturo, 332–33

Rosenstone, Robert, 103

Rossetto, Louis, 221

Roth, Laurent, 120

Rothenberg, Erika, 244

Ruiz, Raúl, 52

running time (duration), 131, 133

Rushdie, Salman, *Haroun and the Sea of Stories*, 16, 126, 134–35, 137

Sack, Warren, 231n5, 232n11

Sandoval, Chela, 164

Sans Soleil (dir. Marker), 116, 118

Sardar, Ziauddin, 182

Sassen, Saskia, 185

Saussure, Ferdinand de, 251

Schindler's List (dir. Spielberg), 104

Schoedsack, Ernest B., 236

Schoell-Glass, Charlotte, 84, 85–86

scholars and scholarship on digital media, xv

Scott, Ridley, 102, 236

screen-based association (flashmobs), 18, 156–57

scriptons, 27–28, 32n10

sculpture, and media installations, 320, 322–23

sealing wax interobjective frame, 56–58, 60–62, 65, 72nn11–12, 72n14, 73n17

Seiter, Ellen, xv

the Self, and memories, 56–57

the self, and politics of digital media: overview of, xvii, 165–66, 177, 292; media installation/websites in context of feminism and, 317, 326–27, 328n1

self-disclosure on camera approach, 282–83

self-image: as autonomous or bodily dissociation in video art, 295, 303–4, 312n7, 314n16; uncanny effects in context of, 303–5

sensation: cinematic model of, 296–97, 313nn9–11; intensity of, 176, 306–7, 309; logic of, 308, 310

Sermon, Paul, 152

Shaviro, Steven, 296–98, 301, 306, 309, 313n11

Shirky, Clay, 215

shock effect: experience of , 296–97, 313n11; in film, 292, 295–98, 301, 313n9; shock/nooshock in film and, 301–2, 313n15. *See also* video shock

Sigismondi, Floria, 320, 322–23

Silent Movie (installation; Marker), 120

simulations, 6, 8, 21, 23

Sister Act (dir. Ardolino), 236

Smith, Marc, 212–13

Snow, Michael, 28, 131, 318

Sobchack, Vivian, xv, 148, 156, 182–83

social contexts, for La Cosecha Nuestra project's interactive narrative, 173, 276–77, 284–85, 290n8. *See also* cultural discourses

social networking sites, 240, 242–44, 256–57

Soderbergh, Steven, 61, 63

software, and cultural analysis, 38–43, 44n7

software theory, 43

soil "wrench," and La Cosecha Nuestra project's interactive narrative, 173–74, 276

Solás, Humberto, 263–64

Solove, Daniel, 241

Sonata (installation; Weinbren), 16–17, 130, 132–33, 136, 138, 140, 144, 145n2

Sonnenfeld, Barry, 189

Sontag, Susan, 4

Sorensen, Vibeke, xv

the South (the global South), 167, 184, 187, 189–90. *See also* North-South relations (cross-cultural relations)

Southern California, and interactive narratives, 274, 275, 276, 282–84. *See also* La Cosecha Nuestra project, and interactive narratives

South Florida Cuban exile community, 264. *See also* exilic discourse for Cuban-Americans, and cyberculture

space: boundaries in context of, 319, 328n6; La Cosecha Nuestra project's interactive

narrative and, 272–73, 273–74, 276, 288–89, 290n7; database city in context of physical, 253–55; exilic discourse for Cuban-Americans in context of, 263–65; hypertext versus print media in context of navigable, 29; lived versus virtual, 274, 276–77, 282–83, 289; time in context of, 132–33. *See also* cultural politics, and cyberspace; cyberspace, and productive precursors

spectatorship: database city in context of, 236, 239, 243, 247, 252, 256, 258n1; in films, 175, 295–97; mass media in context of, 247; scholarship on, 151; space's intersection with, 176, 318, 321. *See also* video art, and body of viewer/spectator

spherical book, 11, 81–83, 87

spherical modality, of CD-ROMs, 190

Spielberg, Stephen, 13–14, 102, 103–4, 113nn8–10

Spivak, Gayatri, 164

SPLC (Southern Poverty Law Center), 227

Stairs, David, 27

Stallabrass, Julian, 151

Stefik, Mark, 186

Stella, Frank, 318

Stocker, Gerfried, 323

Stone, Allucquère (Sandy), xv, 200, 209

story, and memories, 56, 59

story space, 126, 135–37, 145n1

story time, 131, 136

structuralism, 4–5, 40, 44n6, 164, 251. *See also* binaries (structuralist binaries); post-structuralism

Stryker, Beth, xv

subjective mystic writing-pad frame, 51–55, 56, 58, 65, 72nn8–9

subjectivity, in context of media installations or websites, 322, 325–27, 328n3

subjunctive mental state, and interactive narrative cinema, 135–36

Suckling, James, 262

Sunstein, Cass, 212

The Survivors Project (Shoah Foundation's Visual History Archive), 13–14, 15, 104–5, 107, 112, 114nn13–18. *See also* filmmakers, and digital media; Holocaust

Swift, Graham, 137

tactile effects of cinematic perception, 296–97, 313n11

Taylor, Diana, 4–5

"Tech-illa Sunrise" (Lozano-Hemmer and Gómez-Peña), 176–77, 330–37

technological determinism, 3–4, 8, 10, 168, 222, 277

"technophenomenological subject," 176, 317

Teena, Brandon, 187

TEI (Text Encoding Initiative), xiii, xiv, xviiN1

Telecommunications Act in 1996, 220

telling mistakes, in context of memories, 53, 72n10

templates, in context of memory theories, 61, 72n27

Terminal Time (installation; Recombinant History Project), 13, 14, 16, 108–12, 114n19

Terranova, Tiziana, 157

terror versus openness, and Internet, 317, 334–35

Tetris (video game), 140–41

text: endings as abandoned in modernist, 146n6; MSA and, 20–21; pleasure of, 9; in print media, 6–7, 9, 20. *See also* hypertext versus print media; literature; narrative

Text Encoding Initiative (TEI), xiii, xiv, xviiN1

text messaging: calligram in context of, 154–55; firefly text messaging in movie theaters and, 18, 150–52, 155, 157

textons, 27–28, 32n10

Thater, Diana, 318

The Gate of Heavenly Peace (website project; Hinton), 192

thinking and memory, 56–57, 72nn12–14, 73n17

Third Way, 169

Third Way politics, 218–19, 222, 226–30, 232n18, 234nn33–38, 235nn39–41

Thomas, Dylan, 136

Tidewater Tales (dir. Barth), 137

time or temporality: digital historiography in context of, 14, 104–5, 107, 108–10; encyclopedic model in context of, 14, 104–5, 107; film in context of, 101–2; filmmakers in context of digital media and, 116, 118; history in context of, 101–2; interactive narrative cinema and, 127, 130–33, 136, 138, 139–40, 145, 146n7; memories in context of, 45, 58–59, 64,

time or temporality *(continued)*
78n38; paradoxical else in context of time, 64, 78n38; real time and, 131, 138, 292, 296, 298, 300–302; recombinant model in context of, 108–10; video image versus film and, 298–301
Titanic (dir. Cameron), 189
TNCs (Third World Network), 189–90
Tobar, Hector, 264
Tobias, James, xv
Toffler, Alan, 220
Tolstoy, Leo, *Kreutzer Sonata*, 136, 140
topography, as term of use, 231n2. *See also* political topography, and web topology
topology, as term of use, 231n2. *See also* political topography, and web topology
total knowledge/archives, 13–15, 104–7, 112, 113n11, 114nn13–14, 114n16, 114n18. *See also* archives
Toyoda, Masashi, 231n11
traditional idea, of medium, 34–37
transformability and mutability, in context of hypertext versus print media, 27–28, 33n10
transmedia, as term of use, xv-xvi
transmedia frictions, xiii-xvii, 3, 7, 13, 14, 116, 164, 179n1
transmedia precursors, xvii. *See also* medium specificity
transnationalism, 166, 181. *See also* global capitalism
transnational/national digital media: overview of, 166–67, 180–84, 192–93; aesthetic production in context of political economy and, 185–86, 189–91; analog in comparison to digital media in context of, 167, 183, 191; archive in context of, 191–92, 197n21; bodies in context of digital media and, 167, 181, 184–85; cinematic in comparison to, 167, 182, 187; convergence processes in context of, 181, 192–93; digital art in context of, 167, 183–85, 187–90; digital divide and, 167, 174, 187–88; economic structures and, 166–67, 181, 189; future imaginaries in context of, 167, 181–82, 184, 186; global capitalism in context of, 166–67, 181, 185; the global South in context of, 167, 184, 187, 189–90; history in context of, 166–67, 180, 181–82, 184; labor

issues in context of medium and, 184–85; memories in context of, 167, 184, 186; metaphors in context of, 186–87, 190; performativity in context of, 167, 191–92, 197n21; posthuman in context of, 184; race in context of, 167, 180, 182, 187; real versus virtual reality in context of, 167, 183–84, 189–91; transnationalism in context of, 166, 181; websites in context of, 194–95
Trope, Alison, xv
Tsivian, Yuri, xv, 12, 80, 98, 98n1. *See also* cyberspace, and productive precursors
Tucker, Marcia, 305–6
Turkle, Sherry, 164
Tyler, Ann, 27
Typhoid Mary (CD-ROM; Dement), 321–22

UED (urban entertainment district), 238, 256–57
uncanny effects: memories in context of, 62–66, 76n32, 77n34, 77n36, 78n39; of self-image, 303–5, 303–7; self-image in context of, 303–5
United States Holocaust Memorial Museum, 114n14
United States websites, and exilic discourse for Cuban-Americans, 261, 263, 270n4, 270nn5–6
universal multimedia language, 11, 81, 87–88, 89–91, 92–98
UNIX operating system, 165
urban development, 254–56. *See also* database city
urban entertainment district (UED), 238, 256–57

van Dijk, Jan, 231n9
Varela, Francisco, 306–7, 313n10
Venegas, Cristina, xv, 269–70
vertical investigations, and montage effect, 136
Vertical Roll (film installation; Jonas), 319–20, 322
Vertigo (dir. Hitchcock), 119
Vertov, Dziga, 118, 190, 300
video art, and body of viewer/spectator: overview of, 174–75, 176, 177, 291–93, 310, 311n3; accessibility in context of, 291, 292, 311n1; affective adaptations and, 175,

Weinstein, Michael, 220

Welles, Orson, 119, 125, 298, 301

Wertheim, Margaret, 317–18

West, Cornel, 168, 198, 202–3, 206, 208, 210n5

White, Hayden, 102, 103, 107, 113n6

Whitman, Robert, xviiN1

Why Cybraceros? (digital animation; Rivera), 189

Wiener, Norbert, 333

Williams, Emmett, 25

Williams, Raymond, 3–4, 169, 277

Williams, William Carlos, 22

Willis, Holly, xv, 327. *See also* media installations or websites, and feminism

Wilson, William, 294–95

Wittgenstein, Ludwig, and topics discussed: *The Erl King* (film), 138; forgetting or loss of information, 64; language-game intersubjective frame, 56, 59–60, 62, 65, 66, 76n31; language theory, 59–60, 74n22; story, 56, 59

Wittig, Monique, 329n11

Wolting, Femke, xv

Woolery, Reginald, 191–92, 197n21

World Wide Web (the web): CMC or computer-mediated communication and, 109; consumer data collection industry and, 241; cultural politics in context of cyberspace and, 205; digital possessive in context of, 239; interactive media and, 132; political topography linkages with web topology and, 212, 215, 217, 223–26, 231n2, 231n9, 232n15, 233nn28–29, 234nn30–31; politics of digital media and, 170–72; postmedia aesthetics in context of, 36, 39. *See also* Internet (the net); media installations or websites, and feminism; websites

www/mmm (CD-ROM; Woolery), 191–92, 197n21

Yates, Frances, 39

Yonemoto, Norman, xv

Zamenhof, L. L., 87–88

Zellen, Jody, xv

Zemeckis, Robert, 102, 189

Zimmerman, Eric, xv

Zimmerman, Paul, 23. *See also* transnational/national digital media

Zimmermann, Patricia R., 193–94

Žižek, Slavoj, 143, 184

ZKM (Center for Art and Media Karlsruhe), 187

Zork (interactive computer game), 246

Zukin, Sharon, 238

Zummer, Thomas, 319, 328n6

Zurkow, Marina, 176, 320, 323